RECEIVED

JUN 23 2023

NO LONGER
SEATTLE LIBRARY

D1554502

ALSO BY ANNIE COHEN-SOLAL

Mark Rothko: Toward the Light in the Chapel

Leo & His Circle: The Life of Leo Castelli

New York Mid-Century (with Paul Goldberger and Robert Gottlieb)

Painting American: The Rise of American Artists, Paris 1867–New York 1948

Sartre: A Life

PICASSO THE FOREIGNER

PICASSO
THE FOREIGNER

An Artist in France, 1900–1973

ANNIE COHEN-SOLAL

Translated from the French
by Sam Taylor

Farrar, Straus and Giroux
New York

Farrar, Straus and Giroux
120 Broadway, New York 10271

Copyright © 2021 by Annie Cohen-Solal
Translation copyright © 2023 by Sam Taylor
All rights reserved
Printed in the United States of America
Originally published in French in 2021 by Librairie Arthème Fayard, France, as
Un Étranger Nommé Picasso
English translation published in the United States by Farrar, Straus and Giroux
First American edition, 2023

Library of Congress Cataloging-in-Publication Data
Names: Cohen-Solal, Annie, 1948– author. | Taylor, Sam, 1970– translator. |
 Cohen-Solal, Annie, 1948– Étranger nommé Picasso.
Title: Picasso the foreigner : an artist in France, 1900–1973 / Annie Cohen-Solal ;
 translated from the French by Sam Taylor.
Other titles: Étranger nommé Picasso. English
Description: First American edition. | New York : Farrar, Straus and Giroux, 2023. |
 Includes bibliographical references and index.
Identifiers: LCCN 2022053332 | ISBN 9780374231231 (hardcover)
Subjects: LCSH: Picasso, Pablo, 1881–1973. | Expatriate artists—France—
 Biography. | Artists—Spain—Biography. | Noncitizens—France—Biography.
Classification: LCC N6853.P5 C596513 2023 | DDC 709.2—dc23/eng/20221109
LC record available at https://lccn.loc.gov/2022053332

Designed by Patrice Sheridan

Our books may be purchased in bulk for promotional, educational, or business use.
Please contact your local bookseller or the Macmillan Corporate and Premium Sales
Department at 1-800-221-7945, extension 5442, or
by email at MacmillanSpecialMarkets@macmillan.com.

www.fsgbooks.com
www.twitter.com/fsgbooks • www.facebook.com/fsgbooks

1 3 5 7 9 10 8 6 4 2

To the artists who,
in pursuit of their careers,
traverse the plains of Africa
or cross the Mediterranean
in a makeshift boat

With loving gratitude
to Marc and to Archibald,
whose life commitments
inspired each of this book's pages

CONTENTS

EPILOGUE:
THE MEDITERRANEAN AS HIS KINGDOM: 1955–1973

ENCOUNTER WITH AN ALIEN SUSPECT

Anyone can consult the archives of the Paris police. All you have to do is take Line 5 of the Métro, get off at the Hoche station, then make your way through the sad, winding country lanes of Le Pré-Saint-Gervais, a small commune in the northern suburbs, until you reach a modern building that—with its two entrances, one for deliveries and the other for customers—is reminiscent of a factory from the 1950s. Behind the reception desk, the police employee creates your reader's card with the cold formality of someone processing a passport request. He hands you the key to a gray locker, where you leave your coat, bag, and private documents. Once they have located what you're looking for, you are allowed to take a few pages of blank paper and a pencil into a freezing, glass-walled room where three other police employees keep watch as you are led to a cardboard box full of papers.

I have just encountered a suspect—a "foreigner" who, on October 25, 1900, arrived in Paris for the first time, only to find himself trailed by the police a few months later. His case file would grow with every passing year for the rest of his life: reports; interrogation transcripts; residence permits; ID photos; fingerprints; rent receipts; naturalization requests; letters of transit; documents from various investigations; information on his wife, son, parents, and friends;

testimonials about his moral character; summaries of his political views; a list of his addresses; and correspondence from not only police chiefs but also high-ranking politicians such as the foreign minister and the prime minister. Among all these documents, I did not spot a single crime, apart from that of his not being French. On some of these papers you see the word SPANISH stamped in capital letters, signaling the suspect's difference, his exclusion, his stigma.

Certain phrases betray xenophobia or political suspicion: "Although he was 30 years old in 1914, he did not serve our country during the war [. . .] despite enjoying in France a situation enabling him, as a 'so-called modern painter,' to earn millions of francs (apparently kept abroad) and to buy a chateau near Gisors, [he] retained his extremist ideas while veering toward communism." Sometimes the allegations are not much more than gossip: "On May 7 he was the subject of a report stating that recently, while in the café located at 172 Blvd St Germain, he was taken to task by an off-duty Polish officer for openly criticizing our country and defending the Soviets." In some cases, the wording betrays an eagerness to suspect him on the basis of his associates: "[He] is known to our services, having been identified as an anarchist in 1905, when he was living at 130 b Blvd Clichy with one of his countrymen, also an anarchist, who was under police surveillance." Other phrases reveal condescension toward this "foreigner": "The building's concierge has never heard him expressing subversive opinions, but it is true that he speaks very bad French so that it is very difficult to understand him." The last documents in the file announce the authorities' final verdict, as clear-cut as a guillotine: "This foreigner does not qualify for naturalization; moreover, given the previous material, he must be considered highly suspect from a national point of view."

I feel as if I am seeing the entire history of a country and its ghosts unfolding before my eyes. "I swear that I am not Jewish, under the terms of the law of June 2, 1941," this "foreigner" writes, in red ink, to renew his residence permit on November 30, 1942.

Stigma is the word that haunts me after those hours spent looking through dozens of yellowed pages. During the years I have spent

using archives for my research, I have become convinced that all archives *speak*. In fact, those sickening papers gave me a completely new image of this man, one that goes far beyond the documents I already knew.* Sitting in the Métro car on the way home, feeling overwhelmed, I found myself staring at the names of the stations on Line 5, starting with "Place d'Italie" in the south of Paris. In the other direction, toward the north, after "Hoche," I see "Église de Pantin," then "Bobigny-Pantin-Raymond Queneau," before the final station: "Bobigny-Pablo Picasso." This is the name of the suspect whose files I have just consulted: foreigner number 74.664, his police records established more than a century ago. Today, we would call this the file of an alien suspect—in French, *un Fiché S*—a foreigner under active police surveillance because he was, at one point, "suspected for any number of reasons of wanting to harm the security of the State."

■ ■ ■

A few days after my discovery of the stigma attached to Picasso in the police archives, a new exhibition opened at the Musée du Quai Branly: *Picasso Primitif*. I was immediately struck by the imposing black-and-white poster facing the Seine, showing two huge faces (each nine feet high) staring calmly at the people of Paris: the triumphant sixty-year-old artist and, beside him, an African mask. What you see is their all-powerful eyes: Picasso's black pupils and the empty sockets of the mask. What are they looking at? The visitors swarming in the gardens of the museum? The Seine, once celebrated by Picasso's friend Apollinaire, still flowing implacably before them? Or what if it were something else? What if Picasso, photographed at the height of his fame, were gazing triumphantly toward the Pont de l'Alma, calmly and simply indicating the precise place where, in October 1900, during his first ever trip to Paris—at eighteen years

* Pierre Daix and Armand Israël: *Pablo Picasso: Dossiers de la Préfecture de Police (1901–1940)*, Lausanne, Acatos, 2003.

old, unable to speak a word of French—he rushed to the Spanish section of the Grand Palais at the Exhibition Universelle where—what an honor for someone so young!—one of his paintings was being shown.

In the spring of 2017, I see in this poster of Picasso at the Musée du Quai Branly a staggering clash between the image of the Fiché S locked away in the police archives and that of the legendary artist celebrated all over the world. What has become of that brilliant, fervent kid who came to Paris with his friend Carles Casagemas, the Pablo Ruiz Picasso who entered Paris on the eve of his nineteenth birthday like a meteor, with no doubt at all about his ability to conquer the city? In the self-portrait *Yo, Picasso*, painted in May 1901 during his second trip to Paris, he depicts himself in a white shirt and orange ascot, a dynamic, arrogant, invincible young man, convinced of his own genius.[1] "The highest walls melt away before me," he would write soon after this, on the back of a photograph. A few months later, however, in December of the same year, in his blue *Self-Portrait*, he looks isolated, exiled to the right of the frame, bundled up in a large dark coat.[2] Everything is blue, except for the pale mask of his face. The world he leans against is solid, impenetrable, turquoise. The coat he wears is an impervious mass of navy. The shadows of his face are delicate and bluish. He doesn't move, asks no questions, makes no appeal. He is a vulnerable, dejected young man, his gaze strangely vacant. His slight divergent squint is barely perceptible. Picasso's early years in Paris are reflected perfectly in these self-portraits: after the initial exaltation of his arrival, life grew difficult, hostile, disturbing, almost baleful.

How many round trips between Barcelona and Paris would it take him before he could finally display, to the Parisian avant-garde, the superiority behind his arrogance? What if I followed the gaze of that black-and-white poster by the Seine? What if I obeyed the artist's calm injunction to slip behind the scenes of his life in France, almost 120 years after it began? That life has been buried under layers and layers of words, so that it seems to have vanished from sight. How

can we retrace, in all its vicissitudes, the odyssey of the virtuoso arriving in Paris? Today, the ghosts of Picasso are locked away, in every corner of the city, in cardboard boxes full of papers, which I will open to reveal a trajectory even more complex and arduous than it first appears. I will have to make connections between history, social history, the history of art, of administration, of immigration, of the police; I will have to cross-check sources, track down undiscovered archives, fill out forms, order boxes, undo—one after another—the white ribbons tied around them, carefully unfold the files so as not to tear the old paper, explore the different sections, dig up buried documents, open envelopes, decipher handwritten manuscripts, disclose unpublished writings, letters, and drawings, all in an attempt to detect the faintest traces of his voice. I will set out upon a series of expeditions around Paris where the archives are kept, take the Métro to Le Pré-Saint-Gervais, to Pierrefitte, to La Courneuve, to La Butte Montmartre, and even to the center of Paris sometimes, breathlessly pursuing this treasure hunt, diligently following the triumphant gaze of Picasso as he looks back from the peak of his glory years into the hidden recesses of his past.

I

INTO THE LABYRINTH OF PARIS

1900–1906

The foreigner does not consider the new model [being offered to him] as a refuge, but rather as a labyrinth in which he has lost all sense of direction.[1]

—Alfred Schütz

1.

WITH THE CATALANS OF MONTMARTRE

There is very little difference [. . .] between the poet or artist
and the hoodlum, when one considers the anarchist, more
or less a poet or artist himself. Consequently, for both the
anarchist and the hoodlum, the Butte de Montmartre is a
fabulous shelter.[1]

—Louis Chevalier

With Baron Haussmann's transformation of Paris,[2] and with the first
attempts at introducing electric lights in 1878, first to the Avenue de
l'Opéra and then to the Grands Boulevards, the charm and magic
of Montmartre resided in its obscurities, its mysteries, in its quiet
streets illuminated by gas lamps, against which—in Francis Carco's
beautiful phrase—"the splash of light from the Moulin Rouge ap-
peared suddenly in the night."[3] But there was more. "The churchy
types took up residence on Rue Saint-Rustique," writes Roland
Dorgelès, "while the beardless pimps hunkered down in the bars
of Rue des Abbesses, where they spent their days reading their fu-
tures in slot machines. Only the artists were at home everywhere
they went, drinking hot chocolate with pilgrims and aperitifs with
ruffians, eating lunch at the local café with house painters."[4]

Paris, October 25, 1900. When the young Pablo Ruiz Picasso
arrived in Paris for the first time, accompanied by his friend Casage-
mas, he was leaving behind the effervescent city of Barcelona, where

he had lived since the age of fourteen. His father was the dean of the École des Beaux-Arts there and, although Andalusian by birth, was sufficiently influenced by the political and cultural fever that gripped the Catalan capital in those crucial years to spend his free time rubbing shoulders with the city's intellectual and artistic avant-garde. In Barcelona, inspired by the regular columns in *Desde el Mulino* ("from the Moulin de la Galette"), Pablo would dream of the view from La Butte Montmartre, with "the immensity of pale, diaphanous Paris stretching out in the background as if vanishing into a silver sea," from which "emerge the pale colors of broad domes and high spires."[5]

Just after their arrival in Paris, still euphoric and intoxicated from their journey, Casagemas and Picasso together wrote letters to their friends the brothers Jacint and Ramon Reventós. These letters were strange documents in which the two authors took turns writing in Catalan and Spanish and illustrating their words with pictures. "Peyo is here and the day he arrived he sent us a pneumatic letter telling us to meet him at midnight [. . .]. We stayed for an hour, then Utrillo and Riera turned up and the party went on into the early hours. Picasso made puppets and I wrote verses in 11, 13 and 14 syllables and we sent it all to Marquina [. . .]. Tomorrow there'll be a big meeting of Catalans of varying degrees of illustriousness, who will all eat together at the restaurant [. . .]. We met this Catalan bastard called Cortada, rich as Croesus but stingy as a whore. We have often eaten dinner with him [. . .]. He pretends to be an intellectual but he's really a pain in the ass and a brown-nose to boot. Among all the pseudo-intellectuals here, we hear more gossip than in Barcelona. They make stupid schoolboy jokes and they don't approve of anyone. [. . .] When it comes down to it, though, none of them are capable of making valid arguments against the others."[6]

Today, we have forgotten the names of the people who welcomed Casagemas and Picasso to Montmartre. We have forgotten Peyo (Pompeu Gener i Babot), Miquel Utrillo Morlius, Alexandre Mos Riera, Eduard Marquina, Alexandre Cortada. "The story of migrations is always partly that of the networks that take care of the new

arrivals, encircle them, support them [. . .] and help them settle into their new surroundings," write the urban sociologists Alain Faure and Claire Lévy-Vroelant.[7] It should come as no surprise, then, that the two friends proudly boasted about their trump card, the powerful Catalan network that had been growing for decades in Montmartre. "Do you know Nonell?" Casagemas went on. "He's a really nice guy; in fact, he and Pichot are the only two agreeable people here. Although we met Iturrino today, and he seems a good sort too [. . .]. What news of Perico? Is he bored? Tell him to come to Paris, and tell Manolo the same thing. Tell them there's enough space here for everyone and money for those who work [. . .]. If Nonell hadn't been travelling down there [and delivering the letter] we wouldn't have written such a long letter, because they're pretty expensive to mail. If you see Opisso, tell him to come . . ."[8]

In addition to Isidre Nonell i Monturiol, Ramon Antoni Pichot i Gironès, Francisco Nicolàs Iturrino González, Santiago Rusiñol i Prats, Perico (Pere Romeu i Borràs), and Manuel Martínez i Hugué (a.k.a. "Manolo"), there were also Pau Cucurny i Guiu and Ricard Opisso Vinyas: these painters, illustrators, collectors, poets, writers, or café owners composed the Catalan colony in Paris. Organized, united, dynamic, as exuberantly convivial as if this were Barcelona, the exiled Catalan artists—of all generations and all different types— had for years been exchanging recommendations and addresses, in the grand tradition of mutual aid that characterizes immigrants the world over, creating the ideal framework for organizing places to live and to work. Three years earlier, Isidre Nonell (ten years Picasso's senior) had told his friend Casellas about his enthusiasm for Monet and Degas, for the Durand-Ruel gallery, and for Paris in general. In October 1900, it was Nonell who sublet his studio on Rue Gabrielle to Casagemas and Picasso, who procured models (Germaine and Odette, who both spoke Spanish) and even an art dealer (Pere Mañach from Barcelona) for them. Nonell, Germaine, Odette, and Mañach would be their first guides, the first intermediaries between the young artists and the new world of Paris.

At 49 Rue Gabrielle, between Rue Chappe and Rue Ravignan,

Casagemas and Picasso—who would soon be joined by their friend Manuel Pallarès in a studio that would sleep six (three men and three women)—set up their headquarters on a bucolic hillside scattered with trees and gardens, small squares, cafés and bars in a quarter that clung to the steep slopes of the Butte: long flights of steps connecting each street and each cul-de-sac, solid iron handrails helping pedestrians avoid falls, allowing for life to exist in this world of disequilibrium and vertigo. It was a remote place, a far cry from the heart of the metropolis. "A few steps from Place Blanche, astonished tourists would discover ancient trees, noisy henhouses, farmhouse porches, a game of pétanque," wrote Roland Dorgelès. They were in the countryside, but they were overlooking the city; it was always there below them, an all-encompassing presence, a permanent backdrop.

Picasso didn't write much. Why would he? In a few seconds, a few pencil lines, three daubs of pastel, he could capture a moment, sketch an instant, snatch up a shred of life, and say everything there was to say. The long figure of a redheaded woman with her hair in a bun, snub-nosed and smiling, in an orange dress with a bold pattern, very thin black straps pushed to the sides. A plump woman in a blue suit, a small white dog trotting beside her, orange scarf, straw boater tipped slightly forward, and again that snub nose, signifying a likable, sophisticated personality: that was how Picasso saw Parisian women. A scene in a tiny café packed with people and action, à la Toulouse-Lautrec—a raw, spirited document, like an anthropologist's notebook. Right away, in the artist's pencil strokes, you can see the people of Montmartre—"Picasso's people"—appearing on paper, the same people that would haunt his works for the next six years: young prostitutes, old lesbians, drug addicts, and others.

"We've already started work," Casagemas wrote jubilantly. "We even have a model. We're going to the theater tomorrow and we are having to work like demons because we are already thinking about the paintings that we will send to the next salon. But we are also preparing for the exhibitions in Barcelona and Madrid. We're working hard. As soon as there's enough light (daylight, I mean, because there's always artificial light), we go to the studio to paint and draw.

We're going to make it, just wait and see!"[9] One of the first Parisian canvases signed P.R. Picasso—a total contrast to *Last Moments*, his academic painting shown within the Spanish pavilion at the Exposition Universelle—was finished around November 11, 1900. This was *Moulin de la Galette*: a dark room flickering with electric lamplight, a formless mass of elegant couples embracing as they dance— bourgeois men in top hats and tailcoats, prostitutes in hats, cropped jackets, long pale skirts—with that mischievous, seductive lesbian couple in the foreground, at the table to the left, one of them dressed in red, kissing in public. Driven by his fascination for eroticism in public places, which had haunted him ever since his arrival in Paris, the young Picasso chose a theme already marked out by his elders (Degas, Toulouse-Lautrec, Manet), demonstrating his sympathy with the world of pleasure in the French capital, but he imbued everything he painted with mastery and a unique new perspective.

Public kisses, private caresses, couples hugging under gas lamps: once in Paris, Picasso painted many works with the theme of the embrace. And Montmartre—with its cafés bringing together high society and the underworld, welcoming adulterous couples and forbidden loves—undoubtedly exercised a powerful erotic influence on the young artist. "We decided we were getting up too late, that we were eating at unearthly hours, and it was all starting to go to the dogs," Casagemas announced in a heavily sexist passage. "Not only that, but [. . .] Odette got into the habit of drinking herself into a stupor every night. So we decided that neither the women nor we should be going to bed any later than midnight and that we'd finish eating lunch before one o'clock every day, and that after lunch we'd devote ourselves to our paintings while the women would deal with feminine tasks—knitting, cleaning, kissing us, and letting us fondle them. So, my friend, we're living in a sort of obscene Eden or Arcadia."[10] Alcohol, sex, work . . . the two friends seemed on the point of mastering the Parisian reality; soon, in another letter, Casagemas would even describe his girlfriend Germaine as "the queen of my thoughts, for now."[11]

Mañach would sell *Moulin de la Galette* to the gallery owner

Berthe Weill who, for 250 francs, found a buyer in Arthur Huc, the editor of a Toulouse newspaper—a record price for such a young artist. Later, Mañach, who took a 20 percent commission, would sell Mrs. Weill three pastels of bullfighting scenes brought from Barcelona and offer Picasso monthly payments of 150 francs. Despite these early successes, despite the debauched atmosphere, the next four years would prove a veritable odyssey for the young Picasso: Casagemas's suicide, three years of hardship, two more wasted trips between Barcelona and Paris, conflicts with his dealer. But in 1900, he had a simple plan that would become his guiding principle in life, his only and absolute priority: to work. "The Exposition Universelle is about to close and yet the only thing we've seen is the painting section." They might have rushed to the Louvre ("to see the Poussins"), to the Musée du Luxembourg and to certain galleries; they might have had endless encounters with other Catalans in their Montmartre bubble, but Picasso and Casagemas neglected the Exposition Universelle, with the sole exception of a visit to the Grand Palais. In a charcoal sketch called *Leaving the Exposition Universelle*, Picasso drew himself (ridiculously small) on the Place de la Concorde, beside Ramon Pichot (ridiculously big), Carles Casagemas, Miquel Utrillo, Odette, and Germaine (all dressed up, with hats and fur collars)— four mismatched Spanish artists and two Parisian women—arms linked, dancing drunkenly, flanked by two scampering dogs, far from the extravagant, colossal Exposition and even farther from the great metropolis as it wakes to greet the advancing century.

2.

THE MOVING WALKWAY AND THE "GENIUS OF FRANCE"

Let particular congratulations be addressed in the name of the Republic to those among our fellow citizens who, in the multiple domains of its activity, have so perfectly represented the genius of France![1]

—Émile Loubet, president of the French Republic

In one of his memorable speeches to celebrate the Exposition Universelle, on August 17, 1900—two months before Casagemas and Picasso arrived in Paris—the president of France, Émile Loubet, declared: "The eminent representatives of other nations were able to observe how France, faithful to her history, has remained the country of bold initiatives tempered with common sense, of generous progress prudently conceived and methodically prepared, the country of peace and work [. . .]. The congresses that have gathered and that will continue to gather in great number have provided scientists, artists, farmers, and workers from all over the world the opportunity to get to know one another, to hear one another, to communicate the results of their experiments and to discuss, with an exceptional support network of knowledge and skills, problems concerning the material and moral improvement of individuals and societies."[2]

In Montmartre, far from the French president's perorations,

Picasso and Casagemas would eat dinner with Ramon Pichot, get drunk with Miquel Utrillo, Alexandre Riera, the writers Pompeu and Eduard Marquina, and—according to them at least—visit the whorehouse only once. No, during their first trip to Paris, Picasso and Casagemas would not have any opportunity to encounter artists from all over the world, as the president had pompously suggested; in fact, they didn't do much more than go to see Picasso's painting. They had little time to discover the great new wonders of Paris—electric lights, the new line of the Métropolitain that had recently connected Porte Maillot to Porte de Vincennes, or the new Pont Alexandre III that spanned the Seine between the Champs-Élysées and the Esplanade des Invalides, not to mention the recently inaugurated Grand Palais and Petit Palais. Above all, what Picasso and Casagemas were able to observe during their first Paris trip, from the moment they alighted at the Gare d'Orsay with the magic of its electric trains, was the fragmentation of the composite city, the juxtaposition of these "little worlds that touch without intermingling," the breakup of these heterogeneous "Parisian countries" with their varied customs and myriad dialects.[3] These striking contrasts were reproduced, and even highlighted, within the walls of that manifestation of excess—the Exposition Universelle would last eight months, attract fifty million visitors, and present the largest exhibition of works of art ever assembled in the world up to that point—with its historic pavilions such as "Old Paris" facing off against glimpses of the future, including the "moving walkway" and the "electricity pavilion."

"I took refuge in Old Paris," wrote the journalist André Hallays. "It's a melancholy place. Those medieval alleys, those darkened *Chat Noir*–like cabarets, those low-ceilinged shops selling random objects such as fans and napkin rings [. . .] amid houses occupied by entertainers from the great fair, evoke the settings of operas and historical dramas."[4] Later, faced with the moving walkway that ran alongside the southern bank of the Seine—one of the highlights of the Exposition—Hallays, who clearly perceived the inconsistencies brought together by megalomania and the "genius of France," went

on: "The rolling platform is the base, the continuous base of the entire Exposition. On top of this loud, relentless noise, this regular rhythm, we hear the din of workers hammering nails, the fiddles of Gypsies, the whistles of passing tugboats, the flutelike sounds of Oriental orchestras, the racket of the electric train, the metallic clanking of the Eiffel Tower elevators. But this ceaseless roar is the very expression of the Exposition's formidable iron and cardboard city. It deafens us, dazes us, puts us in the ideal cerebral state to stroll endlessly through these extraordinary, incoherent, mismatched miracles and follies."[5]

These discrepancies between Old Paris and the moving walkway, these gaps between the official speeches full of pompous nationalism and the obvious geopolitical reality, were also highlighted by a Montmartre-based Catalan, a bicultural man educated in Paris, a globetrotter who had lived in the United States, Cuba, Germany, and Belgium, the artist and critic Miquel Utrillo, with whom Casagemas and Picasso (though both twenty years younger than him) spent a great deal of time. In his columns for the newspaper *Pèl & Ploma*, he refused to be hoodwinked by President Loubet's grand words and stated unambiguously that "if [. . .] Paris has taught us nothing new during the seven months of the Exposition Universelle, it will, in the medium or long term, pay the consequences of its greed by losing more and more of the influence that it still enjoys in the major cultivated countries."[6] It was not by chance that each of Utrillo's articles was informed by the aesthetics of the Nouvelle Peinture against the strictures of the academic school of painting: "We said it in May and we will repeat it at every opportunity: in France there is a clear divide between the great artists and public opinion. While the public stares in rapt fascination at the cold, impeccable works of Meissonier, the beautiful colors of Bouguereau, Detaille's painted wax figures, and Bonnat's overpopulated portraits, the genuine art lovers, the real connoisseurs, recognize in Manet, Corot, Monet, Degas, Whistler, Millet, and others those who, despite the public's negative reactions, have followed the true path of art."[7] With great assurance, Utrillo

went on to describe the deadly way that France's official and institutional classes continued to stifle radical new artists. "And so it is that Rodin, the greatest of sculptors, has only two works in the official exhibition. To understand the full scope of his production, you must visit his private exhibition, organized in a semiofficial capacity."[8]

Utrillo's articles are a world away from the trumpeted speeches delivered by the institutional representatives of all nations, such as at the farewell dinner for foreign officials given under the arbor at the Hotel Continental, in the presence of His Excellency the Duke of Sesto, royal commissary general of Spain, when Dr. Max Richter, commissary general of the German Empire, saluted a "demonstration of the noblest of human activities in all areas of intellectual and material life," a demonstration that, "as much for its general imprint as for the value and perfection of the exhibited objects, [had] far exceeded all its European and non-European predecessors."[9] And yet, for several years, certain French institutional figures had quietly begun to express their anxieties. In an official report to the government dated 1850, Léon de Laborde, an archaeologist and member of the Académie des Inscriptions et Belles-Lettres, alerted to the international expansion of the industrial arts, emphasized the "threat to French superiority," with the country in danger of being left behind by Great Britain.[10] A few years later, in his report on the fine-arts budget, Antonin Proust determined that the Exposition Universelle of 1878 had shown that "the people of other countries" had become "no longer imitators but rivals."[11]

Did the young Picasso, during his first stay in Paris, even hear about the moving walkway? During all those Catalan dinners in Montmartre, did he join in with the criticisms that Miquel Utrillo must have made of the endless boasts about the "genius of France"? In any case, if he had visited the retrospective of French art at the Petit Palais, he would have seen another example of the French system's rigidity: the strict hierarchy established by the commissioners Émile Molinier, Roger Marx, and Frantz Marcou between the fine arts (painting and sculpture) and the "minor arts" (bronze, iron,

ceramics, tapestry, fabrics and embroideries, leather, gold and silver, enamels, wood, and furniture), whose "less than dazzling history in the nineteenth century" they contemptuously dismissed. In the next seventy years, Picasso would affirm his own aesthetic language and impose his own conception of what made a masterpiece—in direct contradiction to this traditional academic classification. Very soon, with his first cubist experimentations, the arbitrary distinction between the "fine arts" and the "minor arts"[12] would be joyfully transgressed. In the city where the kings of France all left their mark, in the capital refashioned by Baron Haussmann and magnified by the splendors of the Second Empire, in the triumphant city of the Exposition Universelle of 1900, Pablo Ruiz Picasso entered through the back door, the servants' entrance, and for several years his encounter with Paris would retain the bitter taste of a missed opportunity.

3.

"THE RIDE FROM COACH DRIVER BECKER REMAINS UNPAID"

That was when Casagemas shot at her but missed. Thinking he'd killed her, he put a bullet in his own right temple (testimony of Dr. Willette, 27 Rue Lepic). (The ride of coach driver Becker remains unpaid.)[1]

—Logbook of the police station in the 18th arrondissement, Grandes Carrières quartier

As the French nation, with its delusions of grandeur, glided smoothly and ironically into the future on its moving walkway, the path trodden by the two hotheaded young artists, freshly arrived in Montmartre, proved far slower and bumpier. Their access to the Parisian art world, through the intermediary of a Catalan art dealer, remained precarious, but what choice did they have? What a strange couple they must have made, Casagemas and Picasso! With his wounded expression, his long nose pointing up to the sky, and his receding chin, Casagemas was a sickly-looking young man, too tall, too skinny, too frail, his helmet of black hair topped off with a hat. He towered over his stocky, dynamic, muscular sidekick. The two of them left Paris together in December and went back to Barcelona. A few weeks later, in February 1901, Casagemas returned to Paris alone. And a few days after that, he killed himself. Although Picasso was not in Paris

at the time, many of his paintings are haunted by morbid themes, circling obsessively around the image of Casagemas on his deathbed.

Imagining that this event must have been recorded by the French police, I returned to Le Pré-Saint-Gervais. The logbooks of the police stations, divided by quartier, led me on an interminable paper chase: for the 18th arrondissement, I had to choose between Goutte-d'Or, Grandes Carrières, and Clignancourt.

As I searched through these musty black folders, I read the policemen's steady, elegant handwriting and learned some extraordinary stories: of secret prostitution, vagrancy, suicide, armed robbery, insanity, abandoned children, betrayal of trust, abortion, submissive women, indecent exposure, arson, begging, infractions of the Law of August 8, 1893 (regarding foreigners), death threats, a dead horse, a biting dog, suicide by hanging, pimping, adultery, etc. This was a chronicle of the daily life of a working-class quartier at the beginning of the twentieth century, tales worthy of Eugène Sue. On the page for December 28, 1900, I discovered an incident reported at 49 Rue Gabrielle: "Manach Pedro [sic]: Aggravated assault, damage to property, and insulting behavior."

"Manach Pedro"? This was Pere Mañach, Picasso's first art dealer, whom the two young artists met on arrival in Paris through the Catalan network. "49 Rue Gabrielle"? This was the address of the studio that Isidre Nonell rented the two artists during their first stay in the French capital. "December 28"? This was the day after they set off on their return to Barcelona. I kept reading, and it became a veritable playbill, with each character introduced in turn: "Schuz, David, 58 years old, concierge at 49 Rue Gabrielle; Manach Pedro [sic], 30 years old, born in Barcelona on March 28, 1870, son of Salvador and Maria Jordi, single, art dealer, 27 Rue des Entrepreneurs—interviewed; Moncoyoux, Jean, 38 years old, police officer; Giordani, Antoine Joseph, 25 years old, student, Rue Du Sommerard; Vaillant Jacques Émile, 21 years old, student at the Beaux-Arts, 7 Rue de la Cerisette." And now came the story itself, told in a breathless and not especially literate style: "Arrested at 3 o'clock in the afternoon on

Rue Gabrielle on charges of damage to property, at the request of the
concierge at 49 Rue Gabrielle. This individual had been invited into
the house by one of the tenants, Mr. Pailleret, a Spanish national;[2]
since this man was absent from Paris, Mr. Manach took various ob-
jects into the night. Entrance to the house had been prohibited to him
by said concierge, who had padlocked the door. Around 3 o'clock,
he arrived and was determined to enter said room and he broke the
padlock and was leaving with a painting at the moment when he was
arrested at this moment he broke an umbrella and smashed windows
and violently attacked the concierge and then the tenants who came
running and he caused him harm. He punched police officer Mon-
coyoux in the face. He also called the police officers pigs."[3]

There can be no doubt that on December 28, 1900, Mañach
attempted to break into and enter Picasso's first Paris studio. Was
Picasso ever made aware of this incident? Did he ever find out that
as soon as he left Paris, his own dealer had tried to rob the paintings
from his studio? According to all his biographers, Picasso quickly
grew suspicious of Mañach. And yet he had to stay at the dealer's
home in May 1901, during his second trip to Paris for his exhibition
at the Vollard gallery, which Mañach himself had organized. Later,
Picasso would paint him looking stiff and arrogant—in a white shirt
and red tie—for an ironic portrait that is now exhibited at the Na-
tional Gallery of Art in Washington, D.C. Thanks to the testimony
of Jaume Sabartés, who was already a close friend of Picasso's at this
point, we know the circumstances of the artist's split with the art
dealer in the winter of 1901: "We spent the night in Durrio's studio
and we were in the street at a very early hour. Picasso wanted to go
to [Manach's] studio [. . .]. When Picasso opened the door [. . .]
Manach was lying face down on the bed, fully dressed, and talking to
himself, as if delirious [. . .]. Picasso glanced at him contemptuously
[. . .]. There was now no doubt that he could no longer work here."[4]

As for evidence of Casagemas's suicide, I tracked it down to an-
other quartier of the 18th arrondissement, Clignancourt, in a folder
marked October 1, 1900, to June 4, 1901. On February 19, 1901, the
police captain noted (misspelling the dead man's name): "Casajemas:

Attempted murder and suicide." The protagonists were listed as: "Casajemas, Charles, 20 years old, born in Barcelona, Spanish, artist, 130 b Blvd de Clichy; Florentin, Laure, 20 years old, model, 11 Rue Chiappe; Lenoir Louise, model, 11 Rue Chiappe; Pallarès, Manuel, 28 years old, artist, Blvd de Rochechouart, Spanish national; Huguet, Manuel, 26 years old, artist, 130 b Blvd de Clichy." And then his description of the incident: "On February 17, around 9 o'clock in the evening, at the wine tavern located at 128 Blvd de Clichy Mr. Casagemas shot at the lady Florentin [. . .] with a revolver, but missed. Turning his weapon against himself, he then shot a bullet into his right temple. Transported initially to the Dojour pharmacy at 81 Blvd de Clichy, then to the Bichat hospital in the carriage belonging to the tenant Theis, 116 Rue de Crimée, driven by the coach driver Becker Michel (no5/915) accompanied by police officer Prat of the 18th arrondissement, he died in that establishment the same day around half past 11 at night. He was in love with the lady Florentin née Gargallo Laure, 20, who was not his mistress. He had eaten dinner with Pallarès, Huguet and the two women at the wine merchant's at 128 Blvd de Clichy. At the end of the meal, he gave the lady Florentin a packet of letters and begged her to read them. She became frightened and drew away. That was when Casagemas shot at her but missed. Thinking he'd killed her, he put a bullet in his own right temple (testimony of Dr. Willette, 27 Rue Lepic). (The ride of coach driver Becker remains unpaid.)"[5]

This clinical account by a police captain describes the facts without any commentary whatsoever, even emphasizing that Laure Gargallo (Germaine) was not Casagemas's mistress. It was, then, for personal reasons that Casagemas, clearly incapable of controlling the emotions that quietly tortured him, killed himself in public in a café on Boulevard de Clichy, in front of Laure Gargallo (a.k.a. Germaine), his first guide in Paris, his model, whom he had described as "the queen of my thoughts, for now." Later, I would discover that he suffered from a physiological deformity that rendered him impotent.[6] A few months after the suicide, Picasso would devote numerous canvases to his friend's tragic death. Sometimes he would address

the subject directly—*Casagemas Dead*, *The Death of Casagemas*, *Casagemas in His Coffin*, *The Burial of Casagemas (Evocation)*—and sometimes more obliquely (*The Life*, *Au Lapin Agile*), using mirroring effects and identifications in a moving way by switching faces and personalities in fantasy situations related to life, death, love, and even fatherhood.

A young artist conned by his dealer, an impotent lover rejected by his beloved, a police officer (Moncoyoux, thirty-eight years old) insulted as a pig, a coach driver (Becker Michel, no5/915) never paid for his work, a failed robbery, and a successful suicide . . . such are the few prosaic traces left to us by the French police, in a tragicomic sequence following Picasso's first stay in Paris.

"Let me tell you why [. . .] Moreno Carbonero is the best draftsman here," the teenage Picasso had written to his friend Joaquín Bas three years before. "It's because he went to Paris. But don't be fooled: in Spain we are not as stupid as we have always seemed; it is simply that the way we are taught is very bad. So if I had a son who wanted to be a painter, I would never leave him in Spain."[7] In his dreams of glory, the young Picasso had no idea of the judicial measures that had just been implemented in the country where he would later live. Yet the French government's decree of October 2, 1888, stated quite clearly: "Article 1: any foreigner [. . .] who intends to set up residence in France must, within two weeks of his arrival, make a declaration at the mayor's office in the *commune* where he plans to reside, stating his full name, nationality, place and date of birth, previous address, occupation and financial resources, wife and children. Article 2: in Paris, declarations will be made to the prefect of police, and in Lyon to the prefect of the Rhône department." A few years later, the head of the Sûreté Générale, the French secret police, warned police prefects about "a great number of foreigners who have not made the declaration required by the decree of October 2, 1888, or by the law of August 8, 1893." With a further turn of the screw, he would target "individuals who avoid making their declaration," in other words "those whom we have the most reason to monitor due to

their backgrounds." He went on: "I would particularly like to bring this disagreeable state of affairs to your attention [. . .]. It is not acceptable that foreigners should continue to escape the application of the law through the negligence of local councils."[8]

Picasso had probably never heard of Prefect Lépine who, with the prefectural decree of February 2, 1894, created a General Directorate of Research, bringing together all three investigative divisions of the police headquarters—"accommodations," "morals," "security"—and which, with its "research brigades," would establish a genuine "secret police" in France. Such decisions were undertaken in the context of the Dreyfus Affair, which deeply affected French society between 1894 and 1906. Eventually, the situation was marred by "administrative perfectionism," by "misplaced professional pride," and by "xenophobic feelings generally shared and encouraged by the application of punctilious laws";[9] it would grow gradually worse over the following decades, reaching a nadir in 1940 with Vichy France. Examining this organization will reveal the power and development of law enforcement measures that, a few years later, would trigger the creation of the bulging "Picasso file."

From his first stay in Paris, when he was welcomed and supported by the Catalans of Montmartre—the only way into the French capital for him at the time—how could Picasso have anticipated that this help and hospitality would one day be used against him? We know that on December 29, 1900, a group "calling itself the Spanish colony of Paris"—among whose names were those of Picasso, Casagemas, and Pallarès—signed a "manifesto, which was published in the Barcelona newspaper *La Publicidad*, calling for an amnesty for deserters from Cuba and the Philippines."[10] For the French police, the most visible "Spanish anarchists" were those expatriate Catalans (such as the art dealer Pere Mañach), some of whom were also political exiles (such as the writers Jaume Brossa and Pompeu Gener). Picasso knew these men; he ate and drank with them; he had even stayed with one of them. Consequently, as soon as he returned to Paris, he was marked as a suspect.

4.

FINOT, FOUREUR, BORNIBUS, AND GIROFLÉ, POLICE CHIEF ROUQUIER'S INFORMANTS

From the foregoing, it is concluded that Picasso shares the ideas of his compatriot Manach who is granting him asylum. Consequently, he must be considered an anarchist.[1]

—Police Chief André Rouquier

That morning, discovering the file "Anarchist plots 1899–1901" for the first time at the National Archives Office, I entered the world of informers at the turn of the nineteenth century. This was a world teeming with documents that veered, at times, close to insanity, as when someone known as Dupont, domiciled at 14 Rue des Tournelles in Versailles, sent the police the portrait of an elegant man taken at the photographer's studio of E. APPERT, 24 Rue Taitbout, accompanied by a handwritten note on a piece of cardboard torn in two, which stated: "With the special aptitudes for psychology that I genuinely believe I possess, I see in this photograph one of those men with a passion for Anarchy: to monitor."[2]

However, other notes attempted a more in-depth analysis, like the one that described the anarchist milieu of Montmartre: "The Anarchists were not overly weakened by the fallout from the Dreyfus Affair; it was a powerful distraction but it did not, as we thought

it might, scatter or annihilate them [. . .]. At the appointed hour they will return to the stage, and at the moment they are like actors rehearsing a scene [. . .]. The so-called 'Faurist' groups cannot develop because they live in a closed circle [. . .]. Among them, there are the 'Iconoclasts,' who meet every Wednesday in the artists' café at 11 Rue Lepic; this is the largest anarchist group [. . .]. Iconoclasts include Roger Satrin, Janvion (group leader), Moreau (from the newspaper *Le Camarade*), Le Kelec, an anarchist singer, Bordy (16 Rue Ravignan), Alice Canova, born in Bonifacio and still very young [. . .]. There are several Italian comrades, Martini, Morelli, etc. Anarchy is trying to find its way. The immediate ploy is the all-out war on militarism [. . .]. Moreover, there are anti-militarist publications in circulation [. . .]. Anarchy is, at this moment, anti-militarist. In the future it will be 'pro-bombist.'"[3]

My attention was soon drawn to reports by the informers Finot, Foureur, Bornibus, and Giroflé. Well aware of the value of their information, they produced handwritten reports almost every day on loose sheets of paper for Chief Rouquier in the third office of the police headquarters. These texts were a veritable barometer of the activities of the anarchists of Montmartre. It was these informers who, in May 1901, during Picasso's second trip to Paris, would spot him. It was these men—Finot, Foureur, Bornibus, and Giroflé, spies for the local police—who, following their chief's orders, began to put in place the machinery of surveillance by preparing the first police file on Picasso. On May 5, 1901, this time accompanied by Antoni Jamandreu Bonsoms, Picasso returned for his second stay in Paris to prepare the exhibition at the Vollard gallery organized by his dealer, Pere Mañach, in whose apartment at 130 b Boulevard de Clichy he would stay for the next ten months. This was a dual exhibition (sixty-four paintings by him, twenty-five by his friend Iturrino), and it was a prodigious feat (starting with the sheer number of works that Picasso managed to produce in only seven weeks) that would command the attention of several critics, who were blown away by the talents of this "very young Spanish artist."

But did Picasso "make his declaration to the foreigners depart-

ment" at police headquarters, as required by the decree of October 2, 1888? It was June 6 before he registered with the authorities because, as during his first stay, he was working furiously, producing as many as three paintings every day. His friend Sabartés, who would join him from Barcelona a few months later, wrote a wonderful description of his energy when working: "The palette is on the floor: the white, kept in the center in abundance, constitutes the base for a sort of mortar that is mostly composed of blue. The other colors brighten the edges. I don't remember him ever holding the palette in his hand. He tells me he did, though, sometimes, like all painters. It's possible, but I always saw him mixing his colors leaning over a table, or a chair, or the floor."[4] While Picasso was working, the informer Foureur alerted the Paris police chief: "The prohibition on the anarchist congress, combined with the more active surveillance of foreign anarchists since the most recent attacks, has completely changed the situation for observing the anarchist movement. On Monday, Grandidier said: 'The anarchists will split up this winter.' [. . .] But since they got into the habit of attending meetings in the evenings during the Dreyfus campaign—public meetings, libertarian lectures, and small local meetings—what is happening is that the anarchists are splitting into smaller and smaller groups but they are not disappearing."[5]

In Montmartre, Picasso was hard at work, and soon afterward Sabartés would continue his reporting: "The palette is on a chair and he is standing. Around 1901, I usually find him on a low, wobbly chair. He isn't bothered by discomfort and even seems to seek it out, as if he took pleasure in this kind of mortification and enjoyed dressing his mind in the hair shirt of difficulty to keep himself alert. He puts the canvas on the lowest notch of the easel, forcing him to paint almost bent double. As he fills the canvas, his only thought is to free what is inside him. He sees and hears everything that is done and said around him and he can sense what he doesn't see, but nothing distracts him unless you go out of your way to get his attention."[6] Meanwhile, the informer Finot was becoming impatient: "There is still no news. There is nothing surprising about this at the moment,

because the comrades have had no opportunity to meet. This is the problem with the absence of groups. This absence prevents all serious surveillance and, in the meantime, isolated individuals can plan and carry out serious operations that we only find out about too late, ignorant as we are of all the preparatory details. It would perhaps be a good idea not to wait for the groups to organize, because that may take a while, and resourceful people are not willing to wait. [. . .] There is one in Montmartre whose members meet at the home of their comrade Lisle. [. . .] The creation of new groups will make surveillance of anarchists more effective."[7]

But on Boulevard de Clichy, far from the wanderings of the informers, Picasso was at work in his studio, fully focused on his art. "He is so meditative, so deep in silence," Sabartés would note, "that whoever sees him, from afar or close-up, understands and keeps quiet. The faint murmur that rises from the distant street to the studio melts into this silence, which is broken only by the rhythmic creak of the chair on which his body moves with all its weight in the fever of creation."[8] When you contemplate the sixty-four works on cardboard produced in record time—*Absinthe Drinker*, *The Wait (Margot)*, *Mother and Child*, *Dwarf Dancer*, and *At the Moulin Rouge*, among others—you are faced with capsized characters painted in violent colors with splashes of red that look like wounds. These are the people of Paris whom he encountered in the rough urban streets, in the cafés and alleys of Montmartre, around the network of Catalans that Picasso had joined: flamboyant dwarfs, glassy-eyed morphine addicts, flirtatious old women wearing too much makeup, mothers wearily dragging their children behind them. These tragic paintings reveal a world of poverty and exhaustion.

A few hundred yards from Picasso's studio, but a thousand leagues from his creative intensity, Finot, Foureur, Bornibus, and Giroflé—each sitting behind a pint of beer at a café in Montmartre—were listening, watching, asking questions: four snitches, four pale-faced men, diligent, dull-witted, producing notes, reporting gossip, copying texts. "We have long known," wrote the historian Marianne

Enckell, "that the guilty lie or distort the facts; that informers exaggerate; that all it takes is for your name to be mentioned twice in police reports and you are labeled a 'very dangerous anarchist.' That does not mean that you are anything of the kind."[9]

The first police report on Picasso, written by Chief Rouquier, was dated June 18, 1901. The date here is crucial, as will be the case for all the police files that follow. Despite the prior existence of information on Picasso compiled by our friendly informers since the beginning of May, it was a newspaper article, published in Le Journal on June 17, 1901, that triggered and shaped the final document: the critic Gustave Coquiot's review of the Picasso-Iturrino exhibition, which had opened a week earlier at the Vollard gallery.[10] Coquiot praises Picasso as the "frenzied lover of modern life" and predicts that "in the future, the works of Pablo Ruiz Picasso will be celebrated." But Chief Rouquier took only one element from the review: the subjects painted by the artist—"girls, fresh-faced or ravaged-looking," such as "the sloven, the drunkard, the thief, the murderess," or "beggars, abandoned by the city." Then, building on the informers' reports that had been gathering dust for several weeks, he quickly concocted a summary: "Picasso recently painted a picture showing foreign soldiers hitting a beggar who'd fallen to the ground. Moreover, in his room there are several other paintings showing mothers begging for charity from bourgeois men, who push them away." Swept along by the hysteria of the times, by the French State's rage against "the foreigner that, like a parasite, is poisoning us,"[11] Chief Rouquier deftly transformed Picasso's paintings into evidence that could be used against him.

The policeman then stirred in bits of gossip gathered from the concierge of the apartment building where he was staying: "Picasso asked the concierge to reserve for him the first room that becomes available. He works from home as an artist," and added some sweeping allegations and slanders. "He is visited by several known individuals. He receives a few letters from Spain, as well as three or four newspapers whose titles are unknown. He does not appear to use

general mail delivery. His comings and goings are highly irregular; he goes out with Manach every evening and does not return until quite late at night,"[12] before ending with this stunning payoff: "From the foregoing, it is concluded that Picasso shares the ideas of his compatriot Manach who is granting him asylum. Consequently, he must be considered an anarchist."[13]

A conclusion that blithely ignores the fact that the artist was never seen by Finot, Foureur, Bornibus, or Giroflé at any anarchist meeting, whether with the "Faurists" or the "Iconoclasts"! The only thing he did was to sign—along with many others—the December 1900 petition for an amnesty in support of Spanish deserters. So shouldn't it have been his antimilitarism that brought him to the attention of the French authorities? Particularly since, as was then possible in Spain, he owed his exemption from military service to the money paid by his uncle Salvador. In fact, in his own way, Picasso would enlist in (almost) all the wars of the twentieth century, even if he never took up arms. This point would soon be held against him, in the next few police reports, along with his lack of patriotism. For now, on June 18, 1901, Chief Rouquier—driven by his professional conscientiousness, by his personal zeal, and by the generalized hysteria of the Third Republic—filed his report. A few days later, just to rub it in, his direct superior—the director-general of research—would furiously underline in red pencil the words "he must be considered an anarchist." This gives us a pretty clear insight into the back-room bureaucracy of the era.

Today, the sixty-four paintings completed in the spring of 1901, by an intensely focused nineteen-year-old artist for his first exhibition in a Parisian gallery, are considered undisputed masterpieces and sold for stratospheric sums. In 1901, however, those paintings were used as evidence against the young man whose only fault was to have wanted to make his career in Paris and to have accepted the support of the Catalan colony in order to do so. "Throughout the last two centuries, when examining French officialdom," wrote the sociologist Gérard Noiriel, "we continually encounter this obsessive fear of 'non-native

cells' [. . .] that might pursue political ends."[14] This fear would push the French authorities, for decades on end, to practice a policy aimed at atomizing refugees and to be fanatically suspicious of their every move. In this way, the blessing of the Catalan network that welcomed Picasso to Montmartre—that quarter of Paris where "the world of pleasure met the world of anarchy"[15]—would very quickly become a curse that would haunt him for more than forty years.

Faced with this insanity, one politician—the flamboyant Montmartre deputy Clovis Hughes—had been trying for years to analyze the anarchist movement from a very different angle, as he explained to David Raynal,[16] minister of the interior for the Casimir-Perier government: "Never forget that our immortal revolution was fought in defense of individual liberty! [. . .] Since our government appears to have forgotten this, I have the honor of reminding it today [. . .]. Using the excuse that the anarchist party contains men desperate enough to do anything, you have also suppressed not only all those who align themselves with violence but all those whose interests are purely theoretical. Because one poor wretch, a bastard in his family and in society, has suffered so miserably in his own life to the point that he has forgotten the value of others' lives, you have searched the homes of more than 2,000 citizens who had nothing to do with Vaillant's [bomb] attack [on the French Chamber of Deputies]; you have carried out more than 60 arrests, as if tracking down some abominable, vast-ranging conspiracy. But what I ask you, minister, is this: what conspiracy?"[17]

For now, a world away from the denunciations of Finot, Foureur, Bornibus, and Giroflé, roaming the corridors of the Louvre in a constant dialogue with the nineteenth-century masters discovered in the cellars of the Vollard gallery (Toulouse-Lautrec, van Gogh, Puvis de Chavannes, Gauguin, Cézanne, Ingres, Delacroix), with the Spanish masters discovered at the Prado (Goya, Velázquez, Zurbarán, El Greco), and with his Catalan elders (Nonell, Rusiñol i Prats, Casas, Utrillo), the young Picasso was engaged in a sort of "communion of saints"—a situation similar to that of the writer, as described by Sar-

tre : "Art again became sacred to the extent that it turned aside from life [. . .] one joined hands across the centuries with Cervantes, Rabelais, and Dante. One identified himself with this monastic society. The priesthood [. . .] became a club, all of whose members were dead except one, the last in point of time, who represented the others upon earth and who epitomized the whole college [. . .]. As for the past, [the writer] concluded a mystic pact with the great dead [. . .]. He was up in the air, a stranger to his century, out of his element, damned."[18]

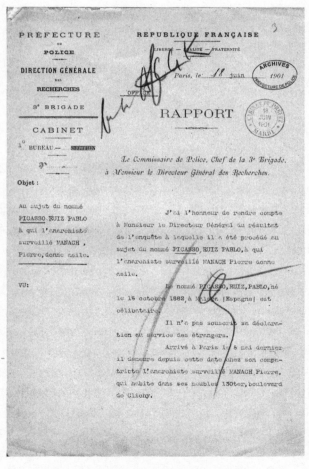

The first police report on Picasso, dated June 18, 1901 (Archives de la Préfecture de Police de Paris)

5.

THE "MYSTERIOUS LOOKS"
OF ANARCHISTS

The anarchists [. . .] are sharing mysterious looks again, a
serious clue that must not be ignored.[1]

—Anonymous report to the Paris police prefect

Intrigued by my discoveries about the police informers in Montmartre, I decide to investigate the period leading up to this, to trace the roots of these French upheavals, so I visit the National Archives Office in Saint-Denis. After the Saint-Lazare station, the packed cars of the Line 13 Métro train roar fast through the darkness. Outside, three worlds somehow coexist: the suburban bus terminal where, in front of a fruit stall, a few lonely travelers wait for the 353 or the 255 (one of those three-figure vehicles that crisscross northern Paris); the university campus labeled "Université Paris 8"; and, to the right, behind a gray barrier, inside an elegant enclosure—young bamboo trees growing out of oversized flower pots, and a metal sculpture half-sunk in a rectangular lake—a large, contemporary building where France's national archives have resided since 2013.

In a hot, humid room, I examine the files on late nineteenth-century anarchist plots. "Special measures decreed against foreign anarchists," proclaimed a dispatch from the Ministry of the Interior sent to all the police stations in France. "I believe that in the current

circumstances, all foreigners professing or displaying anarchic [*sic*] or revolutionary opinions must be expelled [. . .]. Contact me urgently with your suggestions for expulsion." And in the newspaper *La Libre Parole*, I discover that "it was perhaps in Montmartre and its environs, in a bar on the Rue des Abbesses, that the arbitrary arrests were most numerous."[2] But it was the file on the assassination of the French president Sadi Carnot that monopolized attention that year. Lyon, June 24, 1894. "Long live anarchy! Long live revolution!" shouted Sante Geronimo Caserio, the assassin, as he was captured. He made no attempt to resist arrest. Two months later, before being guillotined, he refused to speak with a priest. His last words were: "Have courage, my friends! Long live anarchy!" He also refused to plead insanity as a means of avoiding the death penalty.[3]

"Protests against Italians, with people shouting 'Long live Carnot! Down with the Italians! Long live France! Down with Italy!' Cafés pillaged and set on fire," reported the police chief of Lyon to his superior, before his men made about one thousand arrests. One by one, the police prefects of each French department made the necessary preparations. In Grenoble, the prefect wrote, "Major protest against Italy. Many French workers armed with pickaxe and shovel handles, waving French and Russian flags, mobilized in the city center." The newspaper *L'Intransigeant* published an editorial entitled "A Call for Calm," condemning the violence against Italians— "Yesterday in Lyon, houses were burned because they were inhabited by Italians. An Italian man was killed in Toulon. This must stop"— all the while maintaining: "Foreigners are invading our country and the competition they bring to the national jobs market is harmful [. . .]. Once again we demand measures to protect French workers."[4]

In a folder marked "Surveillance of foreign anarchists," the documents that I leaf through have been handled so many times that they crumble when I touch them. The file on Sante Geronimo Caserio, a nineteen-year-old bakery worker who murdered President Sadi Carnot, proves surprisingly enlightening. His personal file, begun four months before the assassination, did not seem particularly suspicious. "Caserio

San [*sic*] Geronimo—bakery worker in Cette [*sic*]—Anarchist," read
the large handwritten words on the cover of the gray folder. As for
the personal note, written at the Hérault police station on February 2,
1894, it contained a fairly banal description: "Name: Caserio; First
names: San Geronimo; Address: 50 Rue du Pont Neuf; City of resi-
dence: Cette; Occupation: baker; Born: about 19 years ago in Motta
Visconti, Italy, province of Milan; Parents Antoine and Broglia,
Martina; Marital status: married; Description: Height: 1m 68; Fore-
head: regular; Chin: round; Hair: chestnut; Eyes: gray; Face: oval;
Eyebrows: chestnut; Nose: aquiline; Complexion: pale; Mouth: aver-
age; Distinguishing features: speaks French badly."[5] Would anyone
reading this insipid file have imagined that the man being described
would stab the president of France to death a few weeks later and end
up on the guillotine?

The parallels between the Caserio report and another police re-
port, kept nearby in another cardboard box and written barely seven
years later, draw my attention because they are so striking. Writ-
ten by Chief Rouquier of the Third Brigade, it was addressed to
the director-general of research and concerned the investigation into
"Picasso, Ruiz Pablo, who is staying in the home of the anarchist
Manach Pierre (under surveillance)." This is the first police file on
Picasso, the one dated June 18, 1901. Under the section "distinguish-
ing features," the Caserio report states that the bakery worker from
Sète (an Italian), aged nineteen, who "speaks French badly," is an
anarchist, while the Picasso report states that the artist living in Paris
(a Spaniard), aged nineteen, who "speaks French very badly and is
barely comprehensible" is "wanted," "noteworthy," and considered
an "anarchist." Excessive negligence in one case, excessive suspi-
cion in the other? How can we justify the differences between the
two files? How can we justify the French police's attitude toward the
artist?

Between 1894 and 1901, fin-de-siècle France—struggling to find
its feet in an unstable landscape of industrialization and an aging
population—lived through seven years of violence. The assassina-

tion of Sadi Carnot was the zenith of a decade of political and social tensions, of which the Dreyfus Affair and anarchist attacks were only the most obvious symptoms. Violence, repression, fear, trials, death sentences. Certain names were on everyone's lips: François Claudius Koenigstein (a.k.a. Ravachol), who, after a series of bombings in Paris in protest of police brutality, was guillotined in 1892; Émile Henry, son of a communard, who sent a bomb to the police station in the 1st arrondissement, killing five people, and was guillotined in 1894; and, lastly, Auguste Vaillant, who threw a nail bomb in the National Assembly in 1893 and was guillotined the following year. Some politicians opposed to the death penalty, such as Georges Clemenceau, rose up in protest: "I feel an inexpressible disgust at this administrative slaughter, carried out without conviction by upstanding functionaries," he wrote. "Henry's crime was an act of savagery. Society's response seems to me an ignoble vengeance."[6]

In a political climate rendered volatile by anger directed at anarchist assassins and the "harmful" foreigners "invading" France,[7] a certain fringe of the population began to react to a new issue: immigration, particularly since the 1881 census revealed that more than a million foreigners now lived in metropolitan France. In addition to extremist nationalists, other forms of xenophobia were rife throughout the nineteenth century: anti-immigrant protests accompanied the Industrial Revolution for more than a decade, at first taking the form of recurring incidents between French and foreign workers before finding their way into political speeches. In 1898, the French writer Maurice Barrès told the electors of Nancy, "From the top of society to the dregs of the provinces, in terms of both morality and materialism, in the worlds of commerce, industry and agriculture, at all the building sites where he competes with French workers, the foreigner, like a parasite, is poisoning us. One essential principle on which the new French politics must be based is to protect our people against this invasion."[8] With an increasingly aging population, the growth of industrialization, and a dearth of manpower, France turned to foreign workers, becoming "the first country to systemati-

cally use immigration as a means of fighting the 'rigidities' of the jobs market," while during those same years Europe was transformed into a continent of emigrants.

Through its mass recruitment of "a labor force that did not [possess] the rights granted to citizens," employers could "legally force people to perform industrial jobs refused by French nationals."[9] But there was more: this wave of forced migration, provoked by industrial needs, also took the form of a rural exodus with peasants bringing their physical labor to industry. These events were occurring at the very moment when the country was in the process of constructing the social concept of the nation of France, which for the first time made "the distinction between the [French] national and the immigrant"[10]—antagonists who consequently became foreign and more French, a disparity exacerbated by the distinction between citizens and noncitizens, with the former (men only) having been granted rights that the latter did not possess. Picasso arrived in Paris at the end of the period 1870 to 1900,[11] just when the country's authorities, who had changed their "definition of a foreigner," made it a priority to decide the new targets for police surveillance and the list of "groups to be monitored."[12] The differentiation that arose at that moment between "citizens and nationals" and "non-citizens and non-nationals"[13] would become crucial in the decades that followed.

It was this new gulf between "the French" and "the Other," between the "national citizen" and the "foreigner" that would inform every police file on Picasso. Deplorably conflating foreigners with murderers, the French population would sometimes attack immigrant workers. One of the most extreme examples of this phenomenon was the massacre at Aigues-Mortes, in the sunbaked salt mines of the Camargue on August 17, 1893. How many Italian workers were killed during this savage and gratuitous attack?[14] The definitive figure remains uncertain, but there were certainly dozens of men dead or missing. "From 1880," wrote the historian Ralph Schor, "the idea that the presence of foreigners in France was responsible for many delicate social and political problems became increasingly accepted.

[. . .] The decree of October 2, 1888, and the law of August 8, 1893, enabled them to be monitored more easily: every time an immigrant arrived in a commune to take up a new job, he had to register with the authorities; this had to be repeated every time he changed his address."[15] This was the context in which the "villainous laws" of 1893 and 1894 were passed against anarchists. The laws were immediately condemned by the Socialist politicians Jean Jaurès and Léon Blum. "Must we suspend all the country's freedoms?" Jaurès demanded on July 31, 1894, in *La Dépeche*, because "anarchism is the symptom, the spontaneous product of a society in the throes of breakdown." At nineteen, fascinated by the freedom of Parisian women in cafés, was Picasso aware of the troubles afflicting France at that time? Had he even heard of Alfred Dreyfus? Did he realize that he was entering a society that was on the verge of civil war? Had he learned, through the press in Barcelona, that the Exposition Universelle had almost been canceled due to pressure from foreign public opinion? Because after the Rennes trial—which had found Alfred Dreyfus "guilty of high treason with extenuating circumstances" and sentenced him to ten years in prison[16]—the other European countries had publicly criticized the affairs of the French government, endangering its international image.

On April 23, 1894, a handwritten note set out the guiding principles: "The police will, using all its available officers, carry out surveillance of anarchists' meeting places, their secret conversations, their points of connection, cabarets, etc. It goes without saying that the police employ some secret affiliates. Recently, we have been using a new procedure that, although simple, appears no less effective. We have drawn up complete lists of all the anarchists living in suburban communes, and all the anarchists living in Paris. Every morning, and sometimes even two or three times a day, our officers walk past the homes of these individuals, frequent the places where they eat their meals and find their entertainment, watch them emerging from studios, check their status on a regular basis. In summary, our agents do everything they can to make it clear to these people that the police

are watching them closely."[17] This, then, is the origin of the pages of pernicious gossip about Picasso piled up in Chief Rouquier's drawers: the decision, in April 1894, to create a "new procedure," "simple" but "effective," which involved drawing up a list of suspects and gathering teams of informers such as Finot, Foureur, Bornibus, and Giroflé whose job it was to "watch [the suspects] closely."

In early November 1897, the prefect of the Paris police sent the minister of the interior a report from an anonymous informer indicating that "the anarchists [. . .] are sharing mysterious looks again, a serious clue that must not be ignored." "Mr. André, find out more about these 'mysterious looks,'" the prefect added in bold red letters. The work carried out by Chief Eugène André to assess those "mysterious looks" was monumental. "We have long been aware of these mysterious looks," he explained. After distinguishing between the "anarchist leaders [. . .] who belong to the 'Libertarian' clan" and "individualist anarchists [. . .] half-pimp, half-robber, always black-mailers, who keep their distance from the libertarians and from fights at public meetings," Chief André claimed: "The quality and I would even say the devotion shown by the police's current secret agents has allowed us to know all the comings and goings of the anarchists we are watching, the movements of foreign anarchists, their addresses, their relationships, their false identities [. . .]. After seeing their conversations reported, their secretly planned meetings known about in advance, finding the police constantly on their heels when they thought they were operating in freedom, the anarchists have started to become suspicious of one another. They are now behaving very cautiously and shroud themselves in great mystery to communicate the most banal things, [. . .] imagining that yesterday's friend is today's snitch. Half of the anarchists now regard the other half as secret agents employed by the police [. . .] hence their mysterious looks."[18] With minds as sharp as these at work, employing categories as sophisticated as "mysterious looks," clearly the future of France was in safe hands. . . .

During his third trip to Paris, in October 1902, accompanied by

Julio González and Josep Rocarol, his most disastrous and disturbing stay yet—three months of abject poverty—Picasso came closer to the tensions of the city. He stayed in cheap furnished rooms and produced those pictures of pale, numb prostitutes, painted completely blue as an expression of exhaustion: "wet and blue like the damp depths of the abyss, and pitiful,"[19] as his friend Apollinaire would later write. Reading those files at the National Archives, I dive deep into the bowels of French society, with its unprecedented spiral of violence and repression, in a world where denunciations and anonymous letters proliferated, and where informers and secret agents prospered, a world under the control of Paris police chief Eugène André, the man charged with the surveillance of anarchists.[20]

6.

"A BLIND MAN SITTING AT A TABLE"

I make a painting of a blind man sitting at a table, there's a
piece of bread in his left hand and with the right is reaching
for his jug of wine.[1]

—Pablo Picasso to Max Jacob

Beginning in 1900, Picasso organized his entrée into Parisian life de-
liberately and systematically, like a general drawing up a battle plan.
He had to enter the French capital, find some stability there, exist,
survive, exhibit his paintings, get his bearings, visit the city's muse-
ums, impose himself, overthrow the avant-garde. But how do you
penetrate a territory when you don't know its topography, its lan-
guage, or its codes? How do you find your way through a labyrinth
when you are advancing blindly? How could the speeding meteor
put up with the time-wasting irritations of the city's intermediaries:
the deceptions of a Mañach, the oppressive attentions of the police
bureaucracy, the frustrations of communicating in a new language?
How could he bear his dependence on others when he was in such a
hurry to distinguish himself? He quickly abandoned Ruiz—his fa-
ther's family name—and came to see that he had only one option: to
rely on the experts (writers, dealers, collectors) and, above all, to seek
out the *locals* who would understand the solutions to these problems
so much better than any expatriate Spaniard.

The first person he befriended was Max, a man who was also an exile (from Quimper, in Brittany) and who was also weighed down by multiple identities: not only was he a Frenchman but he was also a Breton, a poet, a homosexual, a Jew, and soon to be a Catholic; a man who, like Picasso, was anxiously, intensely seeking out new worlds. He was sensitive, empathic, devoted, available, fervent in his beliefs. "It's like the first spark of a fireworks display," Max wrote after reading Picasso's palm in 1901, a few months after their first meeting. "This kind of living star is encountered only rarely and only among predestined individuals [. . .]. Skilled in all the arts."[2] Max Jacob idolized Picasso from the outset—"I met Picasso; he told me I was a poet: this was the most important revelation of my life after the existence of God," he would confide to one of his correspondents in 1931[3]—and for Picasso he would become a tutor, landlord, broker, representative, a man who would teach him French through the poems of Vigny and Verlaine, offer him his mattress, his tiny room, and what little money he had, who would even approach Parisian galleries and magazines on his friend Pablo's behalf, to sell his drawings and illustrations. Max's later notes retain the glow of his first impressions, raw and authentic, and they can be read almost like a sociological document:

> Picasso.
> Small, dark, stocky, anxious, with dark piercing eyes, ample
> gestures, small feet and small hands.
> a brutal, colorful disorder
> everyone welcome at his table
> not made for Paris [. . .]
> mattresses for his friends
> "are you working?"
> rough and fierce as a criminal
> espadrilles, old cap [. . .]
> coarse cotton shirt 2 francs in Square St. Pierre
> soft little old hat for dinners with art dealers.

elegance in the time of fortune
smell of dog and paint
father a professor at the École des Beaux-Arts.[4]

As for Picasso, he tethered himself to Max more or less from the moment of their first meeting, a few days after the opening night of his exhibition at the Vollard gallery in June 1901. During the disheartening year of 1902, Picasso returned to Barcelona and wrote his French friend a series of sad letters. He wrote in a phonetic French that he crafted with admirable spontaneity and creativity, just as he did—and as he would always do—with every work of art he made: paintings, drawings, sculptures, ceramics, lithographs, poems, everything. In July 1902, for example, lamenting that he was no longer in Paris, he described the contrast between the Parisian scene (he had brought back sketches of the Saint-Lazare hospital, which fed into the work he was producing) and the Catalan scene (with its pseudo-artists, its bad writers who wrote bad books, its mediocre artists who painted "moronic" pictures with boring, old-fashioned themes). And, as if that were not enough, he illustrated his pages with a little sketch, "Picasso in Spain": wearing local costume and standing as if trapped in the narrow space between a bullfighting arena and a church, looking petrified and hemmed in.

My dear Max, it's long time that I don't write you—it's not that I don't remember you but I am working very much and that's why I don't write you. I show what I do to my friends the artists from here but they say it has too much soul but no form it's very funny you know talking with stupid people like that they write very bad books and they paint moronic pictures but that's life you know. Fontbona works very much but he does nothing. I want to make a painting of the drawing I am sending you with this (the two sisters) it's a painting that I am doing—it's a whore from S. Lazare and a mother [. . .] Farewell my friend write me, your friend Picasso.[5]

What Picasso wrote to "good old Max"—in his broken and awk-
ward French—was a very personal expression of the pain he felt from
being torn within. "I do not want to be where I am and I cannot be
where I want: misery on every side!" wrote Saint Augustine.[6] "If I can
work here I will stay here but if I see I can't do anything I will clear
off back to Paris,"[7] Picasso wrote of his decentered consciousness,
which could not exist in repose, only in an exhausting to-and-fro
between two extremes.[8] In Barcelona he felt out of place, impris-
oned. Other than his aesthetic isolation, what tormented him most
were his precarious circumstances, his poverty. Obsessively, he wrote
about *galette* (cash), about his desire to *foutre le camp* (beat it), about
the dilemma of *s'amuser ou s'emmerder* (having fun or being bored):
all these expressions he had recently picked up in Paris. So, for in-
stance, on August 29, 1903: "I am working with very much difficulty
but maybe soon I will get some cash and then I can go to Paris but
I don't know yet."[9] Or on August 6, 1903: "I am working the best I
can but I don't have enough cash to do the other things I want [. . .]
but I don't know yet if I can do it because I need cash first." He stub-
bornly sought a way out. "Dear Max I just received your postcard. I
am working to make something for the salon but I don't think I will
have the time. I don't know what drawings you're talking about I
don't know which ones."[10] Time after time, work is the only option
for a young man whom we will never again see in such a frenzy of
frustration, defeatism, despondency. "This drawing that I am send-
ing you [. . .] is a sketch of a painting that I did. I made another
painting like that. You do right not to go out with anybody men are
very bad and very stupid I don't like them in person."[11]

This young man who had never feared anything, who made light
of everything, who was at fourteen already a better artist than his fa-
ther, now found himself tangled up in the knots of a foreign language:
"I know I don't write you often but don't think it's because I forgot
you. If I knew more French I would write you more often but it's very
difficult for me to write you in French."[12] Uniquely for him, he also
admitted to Max how much it pained him that they were separated:

"You would write me often, no? Goodbye my old Max with love, your brother Picasso."[13] And again: "Write me when you can I am very happy to read letters from you. Farewell my dear."[14] And still again: "Goodbye my old friend, with love Picasso. Write me soon a long letter."[15] Having not heard from Max, he grows anxious and asks his neighbor, Louis Bergerot, as well as his friend the sculptor Julio González, who like him divides his time between Barcelona and Paris. "Amigo Pablo," González replies, "I saw Max Jacob a few days ago and he was talking about you (the very day when he was taking your drawings to the publisher). Believe me, if your plans are taking shape as quickly as he tells me, you will make me very happy. I hope you can understand me."[16]

Back in Barcelona, Picasso was feeling downhearted. His three trips to Paris had brought mixed results, and now he found himself in the throes of loneliness and despair. Paralyzed, he sought new means of support to help him in the French capital because, alone, he could not succeed. In 1900, with Casagemas, there had been the Exposition Universelle, the meeting with Mañach (a first contract, but also the first suspicions about his art dealer), and Carles's suicide. In 1901, guided by Jamandreu Bonsoms, there was the exhibition at the Vollard gallery, the bust-up with Mañach, success, and the meeting with Max Jacob. In 1902, accompanied by Julio González and Josep Rocarol, there were dingy rooms on the Left Bank and the failure of his exhibitions with Berthe Weill. "Why do people leave home?" asked the sociologist Nels Anderson. "The hobo is a migrant worker, a man who travels in search of work."[17] During Picasso's third (and most dismal) stay in Paris, in 1902, he lived like a hobo, in what he saw as a "jungle," a violent, brutal place with its "squatting laws" and "codes of etiquette," where he had to come up with new survival strategies, "scrounging" from his family, staying in cheap furnished rooms and brothels, making friends with shady types, shuttling from room to room to avoid being harassed by the people he depended on.

"To start with, the *garni* [a cheap furnished room] was for single people, but also very much for men," wrote Claire Lévy-Vroelant.

"The police would be suspicious of anyone staying in such a place[. . .]."[18] It was Max Jacob who helped Picasso write the (highly literary) first draft of a letter to the owner of the Hôtel du Maroc when the artist was begging for a few more days to pay for his room: "Sir, I cannot for the moment pay you the money I owe you for the rent of my room, but I promise to pay you within four or five days. I beg you not to misuse this letter or what it contains; there are certain things that are very important to me and I hope you will be kind enough to keep them in the room. I think you should put your trust in my word. Thank you, sir. Until soon, Pablo R. Picasso, artist, c/o Mr. Max Jacob, 150 Blvd Voltaire."[19]

For a few months, then, Picasso became a vagrantlike figure, before taking refuge with Max, then returning to Barcelona. "My old friend Max," he would later write, "I am thinking about the room on Boulevard Voltaire and the omelets the beans and the Brie cheese and the pommes frites and I am also thinking about the days of poverty and how sad they were and I remember the Spanish on Rue de Seine with disgust. I am thinking about stay here next winter to do something. With love, your old friend Picasso."[20] At last, Max writes an elegant letter in response to the "predestined individual" he had met not long before: "It goes without saying that *my room is yours* and that I expect you *in my room*. There are already two of us here but that doesn't matter, we can always manage with a mattress on the floor. I can't wait to see you. Tell me what time and at which station you'll be arriving. Until soon, my dear friend."[21] And, a few days later: "Beloved friend, I have plenty of bedding [. . .]. So it will not be a problem for me at all if you accept the hospitality I am offering you. If you don't accept it, I would advise you not to take a hotel room but a studio, because I can give you what you need to sleep on, and you have no need for any other furniture. I will see you soon, dear friend, Max. P.S. Bring my trunk with you—it will be a useful place to store my papers."[22] How could Picasso not cling to Max? "Do they give you time off at [the newspapers] *Paris Sport* o *Paris France*? If they do you should come to Barcelona and see me you have no idea

how happy that would make me."[23] As the poet, dignified and penniless, explained to André Level: "My friends were the wharfs of my river and those wharfs were surrounded by beautiful trees like the prophetic wharfs of Quimper."[24]

Picasso's fourth trip to Paris, undertaken with Sebastià Junyer i Vidal in 1904, would bring his breakthrough. "Picasso returns incessantly to Paris. That is where he will be judged and discussed," wrote Carles Junyer Vidal in *El Liberal* on March 4, 1904, underscoring the young artist's local charisma, his impatience for success.[25] And, once again, it would be the solidarity of the expatriate Spanish community that would enable Picasso to settle permanently in the French capital. Consider this account by Palau i Fabre:

> Not long after his arrival, probably on May 6, 1904, the artist moved into the Bateau-Lavoir after buying some furniture and objects from Gargallo, who had left them in his studio on Rue Vercingétorix [. . .] a cot, a mattress, a chair, a table and a basin, all for the sum of 8 francs. In order to make the move, he had to travel almost all the way across Paris from Rue Vercingétorix to the Bateau-Lavoir, climbing the Butte at the end. Picasso, aided by Manolo, hired a handcart and, with the help of a Spanish kid who was just as lost as they were, if not more, they managed to transport everything to Rue Ravignan. Picasso promised 5 francs to the kid, who did most of the pushing. Manolo "directed," so he barely got tired. When they reached the Bateau-Lavoir, the kid collapsed, completely exhausted. After a while, Picasso said that if he gave him the 5 francs he'd promised, he and Manolo would have nothing to eat.[26]

A few months later, one of Max Jacob's favorite notebooks ("laundrywoman's workbooks, 5 centimes") would also become Picasso's for a time.[27] Its pages alternate sketches in the artist's hand with scraps of poetry in the poet's, a sign of their intimacy—similar to the shared letters that Casagemas and Picasso had sent to the Reventós

brothers in October 1900. For now, Picasso and Max, those "two worries trying to make their way,"[28] were getting ready to meet again after their trans-Pyrenean correspondence. But let us remember that in 1903, illustrating his words yet again with a small sketch, Picasso had sent Max perhaps his most moving letter, with the first example of blindness in his work. He would return to the theme later, with its double, the heartbreaking *Blind Minotaur Guided by a Young Girl at Night, Vollard Suite* (1935): "I make a painting of a blind man sitting at a table, there's a piece of bread in his left hand and with the right is reaching for his jug of wine."[29]

7.

THE BATEAU-LAVOIR AND OTHER DISGRACEFUL LODGINGS

> Ruiz is now under observation by the *garnis* department [. . .] and will be the subject of a report as soon as his place of residence is known.[1]
>
> —Police chief Rouquier, archives of the police headquarters

"Box springs in a corner. A small, rusty cast-iron stove with a yellow earthen bowl on top that serves as a washbasin; a towel and a sliver of soap were placed on a white wooden table beside it. In another corner, a poor little trunk painted black was used as an uncomfortable seat. A straw chair, some easels, canvases of all sizes, tubes of paint scattered across the floor, paintbrushes, jars of turpentine, a bowl for aqua fortis, no curtains. In the drawer of the table, there was a small tame white mouse that Picasso tenderly cared for and showed off to all his visitors."[2] This cool, meticulous description of Picasso's studio was provided by his future lover and model Fernande Olivier, who lived there for three years. After three abortive attempts to settle in the capital, Picasso finally took over the studio of his Barcelonan friend Paco Durrio in a building that Max Jacob nicknamed the Bateau-Lavoir—the laundry boat—located at 13 Rue Ravignan, in the Grandes-Carrières quarter of Montmartre.

For five years—from April 1, 1904, to September 1, 1909—this would be his sole residence. There, he became part of a community

crammed into one of the most precarious and dilapidated lodgings in the capital, which would be destroyed in a fire a few decades later. "Dear Sir, a fire destroyed the building where I live," wrote a certain Mr. Mucchielli a couple of days after the disaster. "Access is prohibited, since the stairs have collapsed and the supporting beams were burned [. . .]. Would you please cancel my property taxes for the current year?"[3] In the logbook at the National Archives Office of properties built in Paris, 13 Rue Ravignan is described as an unusually heterogeneous construction, made of "cinderblocks, wood, and bits of plaster" with, on either side, "a winged building [. . .] simple and deep, raised above the first-floor cellars" and, opposite, "a building at the back of the double courtyard constructed partly on cellars and partly on a habitable basement, a first floor, a square second floor, and a wood-paneled third floor."[4]

Everything about the building screamed poverty. The façade on Rue Ravignan, constructed on a hillside, revealed only two narrow floors under the roof. You had to walk around the hill and go to 6 Rue Garreau to discover the terrible truth: at the back, at a different height, was a rundown, three-story hovel, thirty feet high and ninety feet long, jerry-built from wooden planks and glass panes. It was a pitiful place, flea-ridden and miserable. Fernande Olivier wrote: "A few studios on the first floor, and some others below that were accessed by a creaking, dusty flight of stairs. At the foot of the staircase was the only faucet for the twelve tenants. To the right, beyond the faucet, a foul-smelling corridor led to the only toilet, a dark place whose door, lacking a bolt, would flap open whenever there was the slightest draft—in other words, every time the main wooden street door was opened [. . .] it was a strange and sordid house echoing from dawn to night with all sorts of noises: conversations, songs, shouts, the sound of buckets being emptied and then dropped onto the floor. The sounds of pitchers clattering against the grating under the faucet, of doors being slammed shut, dubious moans from behind the closed doors of studios with walls made only of planks. Laughter, crying . . . you could hear everything. There was no privacy at all."[5]

The Bateau-Lavoir was one of those shameful habitations that the capital offered its immigrants and marginals, the kind of buildings that would regularly catch fire. "The immigrant is, first of all, he whom others consider an immigrant," wrote the urban sociologist Claire Lévy-Vroelant, "and a large part of his condition stems from the way that he is received: migrants' lodgings give rise to a host of important questions [such as] the place that French society wishes to grant those who come from outside, a place that varies according to the context but that shows certain unchanging characteristics."[6] How do the police describe the inhabitants of a city in order to categorize them? It all starts with their lodgings, which city planners classify into three groups: people "with ordinary lodgings; those in furnished apartments, shabby hotels, and *garnis*; and, lastly, those lodged in so-called special buildings: boats, wooden huts, trailers, carnival carts, shared dormitories."[7]

Shanty towns, huts, hovels, shelters—there are so many terms to describe this kind of marginalization in our societies. What cannot be doubted is that the Bateau-Lavoir belonged to that category of buildings at the very bottom of the social ladder. In the archives of the Ministry of Culture, I discovered that the Bateau-Lavoir is now a historical monument. This "building of uncertain origin belonged to a locksmith in 1867 and was bought in 1899 by Mr. Thibouville, who asked the architect Paul Vasseur to transform it into artists' studios," reads the text, before admitting that the studios, "built in wood, [. . .] were ramshackle and fragile," and that—after the fire in 1970—"a new building was constructed on the same site in 1978," thus preserving the legend.[8]

It was in May 1901 that police chief Rouquier began investigating Picasso. His police file, built from the same deficient, erratic system of information—as ramshackle in its own way as the Bateau-Lavoir—remained the only administrative document related to the artist in France until 1945, and even beyond. But let us return to its genesis. At the police archives office in Paris, two documents dated May 1905 revealed strange connections between the different de-

scriptive categories—lodging, administrative status, political position, name—that characterized an individual. Although the situation of Picasso and the other foreign artists who converged on Paris at the start of the twentieth century was obviously very different from that of the Ivorian immigrants who would perish in the fire on Rue du Roi-Doré a century later, in the eyes of the police Picasso was (and would remain for a long time afterward) at the very bottom of the social ladder. Once the police had drawn up a file on someone, their official categorization would generally remain unchanged.

At the Paris police archives, I found note no. 6420 in file no. 36,942. The chief of the police station's first office asked the director-general of research "to please transmit to the cabinet any *new* information that it might have or be able to procure relating to Picasso, Ruiz Pablo, born October 15, 1882 [*sic*], in Málaga (Spain), who was already the object of a report from the Third Brigade dated June 18, 1901, when he was living with his compatriot, the *anarchist under surveillance* Mañach, Pierre, 130 b Boulevard de Clichy." And here the police chief added: "Please investigate the aforementioned Picasso and find out his current beliefs." This document, then, presented Picasso as a fugitive protected by a dangerous anarchist; the alarm bells were ringing. Yet by May 1905, Picasso had not been in contact with his dealer, Mañach, because he'd discovered that the man was exploiting him. And yet this note was written more than a year after Picasso's move to Rue Ravignan, and after returning twice to Barcelona (in 1901 and 1902). When he moved to the Bateau-Lavoir in early April 1904, however, Picasso did register his new address with the police station in the 18th arrondissement. So what was behind this resurgence of interest in him in May 1905? The report was written on May 17, 1905, and was doubtless provoked by the exhibition of Picasso's paintings at the Serrurier gallery organized by the critic Charles Morice, who had mentioned his name in an article published in *Le Mercure de France* on March 15, 1905, and then reprinted in *La Plume* on May 15 of that year. As had been the case on June 18, 1901 (when Picasso had an exhibition at the Vollard gallery),

and as would be the case again in July 1932 (for his retrospective at the Georges Petit gallery), the revival of police interest in Pablo Picasso was sparked by a newspaper article.

One week after the May 17 report, the police chief of the 18th arrondissement, head of the Third Brigade, replied to the director-general of research at the Paris police headquarters, specifying that Picasso Ruiz, Pablo, having "vanished since June 6, 1901," had since been "sought without success," that they "do not know what has become of him," and that "Ruiz is now under observation by the *garnis* department."[9] Why all these files, all these informants, all these police chiefs so excited over Picasso's whereabouts? Why were they so paranoid? On reflection, these stacks of falsehoods produced a vicious circle of stereotypes and wild guesses, categorizing the outsider by his presumed place of residence, his presumed political affiliations, his presumed administrative status. "Ruiz is now under observation by the *garnis* department." This phrase tells us everything we need to know. Back then, the *garnis* department was a section of the criminal police that included the vice squad. The *garnis* department, then, covered anyone who lived in a *garnis*—a cheap furnished room— such as those new arrivals in the capital, the foreigners. "Neither his status [. . .] nor his revenue enables [the migrant] to own property, for which he has no use anyway," wrote the sociologist Abdelmalek Sayad in 1970. "An immigrant with property remained practically inconceivable" to the French police.[10]

Where Picasso is concerned, I could not find the slightest hint of a complaint about his living and working conditions during the five years he spent on Rue Ravignan. Indeed, it was there that he painted his entire series of circus performers, leading up to the masterpiece of this period, *Family of Saltimbanques*, in 1905.[11] In the fall of the following year, he would transform the Bateau-Lavoir into a crucible of cubism, and whenever he was asked in later years, he would tell people that he had spent the best years of his life there and felt a genuine nostalgia for the place.[12] Yet the legendary gallery owner Daniel-Henry Kahnweiler would later write the following of his first

visit to Picasso, in the summer of 1907: "I entered the room that served as Picasso's studio. Nobody could ever imagine the poverty, the lamentable wretchedness of those studios on Rue Ravignan. The wallpaper hung in shreds from the thin wooden walls. His drawings were covered in dust, his canvases rolled up on the sagging couch. Next to the stove was a sort of mountain of lava—actually clumped ashes. It was horrible [. . .] a fleapit."[13]

French society is haunted to this day by the issue of the disgraceful lodgings offered to foreigners by the public authorities, and that of slumlords profiting from the poor people inhabiting their unsanitary buildings. Between April and August 2005, fires would destroy three dilapidated buildings occupied by immigrants in Paris's 3rd, 13th, and 14th arrondissements, causing the deaths of fifty-two people. The building on Rue du Roi-Doré—the last of those to burn—had been included in the "vast plan to eradicate substandard housing," but Bertrand Delanoë, the mayor of Paris, stated that "legal delays prevented us from acting earlier."[14] Three years earlier, that five-story hovel, occupied by families of Ivorian squatters, had already been decreed "irreversibly unsanitary," and the city of Paris's semi-public property company, which managed it, had planned to do "the bulk of the work" at a later date. The president of France expressed his "deep compassion" to the victims' families, while the Ivory Coast's ambassador shared his "disgust" at this third disaster in a matter of months, highlighting the problem of immigrant lodgings in Paris. Claire Lévy-Voelant states that "Paris could not have become the capital city it is without its cheap hotel rooms and its *garnis*." Ironically, the building at 8 Rue du Roi-Doré—which was damaged in the fire of August 29, 2005, where seven people died—is located in the Marais, at the corner of Rue de Thorigny and Rue Turenne, only a minute's walk from the magnificent Hôtel Salé that has been home, since 1985, to the Musée National Picasso.

8.

LETTERS FROM MARÍA: THE ADORING MOTHER AND THE GOLDEN BOY

Lots of kisses from your mama who loves you so much and never forgets you.[1]

—María Picasso y Lopez to her son

Where Rue Vieille-du-Temple meets Rue de la Perle, behind high walls and an impressive blue gate, hides an eighteenth-century mansion under reconstruction, the Hôtel de Rohan. To gain access, I have to call a staff member on his cell phone so that he can meet me at the entrance. Ignoring the majestic staircase to the left, he leads me to the elevator, which takes us to the sixth floor. There, we walk through icy corridors in a state of disrepair (caused by the leaking roof and the construction) before reaching the tiny reading room with a broken blind. Pierrot Eugène, the helpful staff member who greets me, is not very talkative. All the same, he insists on introducing me to Jeanne Sudour, with whom he has worked at the Musée Picasso for several decades and who—in her erudite, warmhearted way—will teach me about Palau i Fabre, Christian Zervos, and many others, as if sharing her innermost secrets. But on this day, January 11, 2017, it is Pierrot Eugène who brings me the three large archival boxes: "Here are the letters from María!" he says with such pride and complicity that it feels like we belong to the same family.[2] I had known nothing about the existence of these archives, but on the spur of the moment I'd

asked to consult the young expatriate Picasso's correspondence with his family. I claim the high table in front of the window and open the first box, the first stack of letters, the first envelope. I struggle to decipher the handwriting, and I start to read. The few extracts that follow punctuated Picasso's first long stay in Paris, after he'd moved into the Bateau-Lavoir.

Barcelona, August 11, 1904. My dear son Pablo, we received your card with the same joy that we feel every time you write to us. I rejoice with all my heart that the heat of this summer hasn't bothered you the way it did last year, and I feel more at ease. We are having a very bad summer, but we hope it will be cooler soon and I am happy that you have been eating with [the] Canals, because family meals are better than meals in a restaurant, and even if it's an inconvenience, it's still better [. . .]. Lots of kisses from your mama who loves you so much and never forgets you, María.³

Barcelona, March 1, 1905. My dear son Pablo [. . .] If I'd had any money, I would have come to see you in Paris. If a news-paper here mentions the exhibition and you want to see what it says, I'll send it to you. Papa's shoulder hurts. Mañach said he received your paintings, he asked us if we wanted to see them and to choose one, Papa told him he'd like one, and that evening he sent it to us, it's the one you did here in your studio, a café scene. Mañach also had some aqua fortis, he was supposed to come but he didn't come, and I understand that he's very busy. [. . .] Papa is very happy about your new exhibition, send him a catalogue and send one to Uncle Salvador too. With all the affection of your mother who loves you, María.⁴

Barcelona, January 27, 1906. My dear son Pablo, Thank you for your letter. During the good periods, you should think about the future, you should think about the moment when you won't have the strength you have now, like Papa thought about some-

thing official; if he hadn't been able to paint, for example, because his eyesight was failing, what would we have done? You ask what we say at home about your uncle. You say in your letter that you want to spend some time with us (I believe it since you say it) and you know how much we want that, and I am going to tell you that as long as I live, even if my house is very small, there will always be a bed made up for you, because I can't get used to the idea that you are no longer here, and when you come you will always find your silverware on the table and your bed made, to give you the best of what we have [. . .]. I wanted to send you the letter from María[5] so you could see that she talks about you too, but I can't find it; in fact, she says you haven't written to her for more than a year, when you should pay them more attention; I know my letter will annoy you, because you can't stand it when I give you advice. You also know how happy it would make us if you answered it quickly. Papa, Lola and Juan send their love, and your mother sends you kisses, María.[6]

Barcelona, September 29, 1906. Dear son Pablo, I just want you to tell me [. . .] if I can count on you when I need something, as all mothers do when they have sons. Tell me. If I realize now that you are not there for me, it will make me sad because I'll understand how little affection you feel for me [. . .] it is through gestures that you show [your mother] whether or not you are interested in her pains and worries. With all the affection of your mama who loves you and doesn't forget you, María.[7]

Barcelona, March 18, 1907. It is nine o'clock in the morning, I was crying (with anger), but now I am crying with joy because I have your letter near me and I can see that you have not forgotten us. Believe me, Pablo, I didn't sleep all night, because you hadn't written, I thought that you [. . .] had forgotten my affection, when, since you were born, I have lived for you more than any other mother has ever done, I brought you your meals

in bed [. . .] now you don't do anything for me, if I could afford
it I would come to see you in Paris. Remember, Pablo, I told
you, I am as fragile as all those who love and imagine how much
it hurts me to spend so much time without seeing you [. . .] I
have your drawing, [but] when I don't see a drawing by you on
top of the dresser, as I have done ever since you were six years
old, it makes me terribly sad.[8]

Picasso's mother wrote her son two to four letters per week,
sometimes a letter every other day or even every day, depending on
the period, from 1904 to 1938, the year of her death, by which time
the artist himself was almost sixty. Sometimes she used the writing
paper of the school where her husband taught (Escuela Superior de
Artes e Industrias y Bellas Artes, Barcelona), and sometimes she sent
a postcard, a *tarjeta postal*. With between sixty and one hundred let-
ters per year, spanning thirty-eight years, I find myself facing four
thousand pages of handwritten missives. The "letters from María,"
some of them in very poor condition, are kept in white Ministry of
Culture envelopes, categorized by address and by date, held together
with rubber bands. All the envelopes seem to have been opened by
Picasso, by hand during his years on Rue Ravignan, and with a pa-
per knife from 1911 onward, when he moved to Boulevard de Cli-
chy. The oldest letters, stained with coffee, wine, or paint, seem to
have been folded up and stuffed in pockets, whereas the others were
kept flat and looked after much more carefully. It is remarkable how
simple envelopes can say so much about the artist's social status. For
days on end, María's quirky, unexpected voice will echo in my head,
her nagging repetitions, her orders, her suffocating affection . . . *Mi
querido hijo Pablo [. . .] Hombre, hasmelo saber [. . .] Recibe tantos
besos de la tua madre que tanto te quiere y que es María [. . .] Recibe
tantos besos de la tua madre que nunca te olvida.*

These letters possess an incantatory beauty, like a long, uninter-
rupted love song. By turns a chronicle of the minor events and ac-
tions of a traditional Spanish family at the beginning of the twentieth

century, a conduit between different cities and different countries, and a resource network, this correspondence is addressed to a son who was unquestionably gifted, but also somehow lost. María gives a regular, detailed update on everybody's health (the father has pain in his shoulder; later he will suffer with a sore throat, then have a prostate operation and be fitted with a catheter). She often includes in the envelope a letter she's recently received from her daughter Lola and her son-in-law Juan Vilato, after they left Barcelona. María was the liaison between Pablo's immediate family—his father, Lola, Juan, his uncle Salvador—and his friends—Canals, Sabartés, Mañach, Pallarès, Soto—who came to pick up objects or gifts that they would then take to Paris. She became the central cog in this national and transnational network. The more of María's letters I read, the more I understand the complexity and weight of this family history until, out of the blue, there comes a moment when Picasso manages to loosen her grasp on him—as we will see—by swiftly and clearly imposing his own rules.

This correspondence is also a provincial chronicle. María Picasso y Lopez enables her son to stay abreast of local news and, during the first years of his stay in Paris, regularly sends him copies of *El Noticiero Universal* while also providing descriptions of local exhibitions, the weather, and her constant worries about natural catastrophes—like the Seine flooding in February 1910. In that sense, it is a conversation that, despite all its frustrations, anxieties, and criticisms, never stops.

Behind the banality of an epistolary exchange between mother and son, something noteworthy is taking shape: the story of the greatest artist of his time and his dazzling breakthrough in a hostile environment. Reading these letters also gives me a much stronger sense of a little-known character, María Picasso y Lopez, who is revealed as one of the few fixed points in the artist's life. Despite his countless moves, his encounters, his love affairs, despite the aesthetic pirouettes, the metamorphoses, and the successive lives of Pablo Picasso, his mother assures him, almost daily, of her unswerving affection until the day of her death. This is how family correspondence

feels when a member of that family escapes their constellation and becomes a meteor. The collision between two realms—that of the traditional Andalusian family (with its age-old rhythms of religious rituals, celebrations, birthdays, weddings, births, deaths, etc.) and that of artistic creativity, laser-focused and totally dedicated to the all-powerful demands of work—is deeply felt.

The one constant, then, in the artist's existence, was this strong "epistolary pact" with his mother which, paradoxically, despite the geographical distance and the long separation, kept the family intact. "The epistolary rhetoric of time and space tend to unite correspondents," wrote Cécile Dauphin and Danièle Poublan, emphasizing that "the family solidarity revealed in long-term correspondence belongs to a logic of social ascension: a family member moves away and yet, through his success, he triggers the social mobility of all his siblings to maintain or re-create a semblance of cohesion amid the threat of rupture."[9] María sought vainly, as we will see, to keep her son anchored in the archaic order of the traditional calendar with its celebrations and venerations, like that of the synaxarium (a collection of the lives of the saints) used in Eastern churches, also keeping him connected to a much longer timescale.

Walking around the family house in Málaga and seeing the imposing white embroidered sheets, Juan Ruiz's impeccably starched waistcoat, the framed picture of little Pablo aged two all dressed up in black for a trip to the photographer's studio, it is easy to surmise all the conventions of this short, plump, bourgeois mother, always dressed elegantly in black, with hat and veil. Graphologists would undoubtedly note her stylish, sprawling handwriting, which takes up the entire surface of the page, as well as the envelope. Quite often, María ends her letters by writing over her own words in the opposite direction, like a palimpsest. And perhaps this metaphor of the palimpsest (with successive layers overlapping, intersecting, accumulating) is a key that will help us open the door to the story that follows.

9.

MONTMARTRE BARS AND BELLEVILLE APACHES

I can't stop thinking about you. I'm afraid when you go out at night, because you might be attacked by one of those cursed Apaches, whom God will unmask in the end.[1]

—María Picasso y Lopez to her son Pablo

When the scoundrels, rascals and Apaches feel themselves under surveillance in Paris, they take refuge in the communes of the suburbs where surveillance is less active.[2]

—Athanase Bassinet, radical Parisian senator, during one of his speeches

"We have the advantage of possessing, here in Paris, a tribe of Apaches for whom the heights of Ménilmontant are the Rocky Mountains," wrote Henry Fouquier on October 2, 1907, in *Le Matin*. He was not describing the Apache people of North America but a "semi-nomadic tribe of young people without families or trades or any fixed address who constitute what even the police themselves call the army of crime."[3] Despite the solidarity and the swindles of the Catalan network, living in Montmartre in those years also meant exposure to the great and growing city itself, a jungle full of hidden dangers, at least according to the tabloids of the time. "From

1899 onward," noted Dominique Kalifa, "'banditry' or 'suburban insecurity' became hot topics, and the peripheral communes were seen as crime-infested wastelands."⁴ But Picasso was not cowed; he continued to explore, to advance. "My dear son Pablo, Why haven't you written for so long?" his mother would ask him later, revealing her anxieties once more. "I can't stop thinking about you. I'm afraid when you go out at night, because you might be attacked by one of those accursed Apaches, whom God will unmask in the end."⁵

Despite the worries of his family in Barcelona, he made his own way in Paris with unerring confidence and determination. Indeed, the French police's stigmatization of "foreigners" and "anarchists," which he probably wasn't even aware of, would only partially hinder his meteoric rise. At this point, in fact, we could see the weight of the French police's attempts to monitor and control "foreigners" as the identical twin to the "domestic biopolitics" endlessly fomented by his mother's attempts to control her lost and silent son.⁶

At the same time, Picasso was collecting business cards and methodically, religiously filling up his address book. This was a tiny object, small enough to fit in a man's palm, its checkered paper covered with the names and addresses of all his contacts in Paris and Barcelona, mixed together indiscriminately: "Max Jacob, 33 Blvd Barbès," we read at the top of one page, the small letters cramped into a single line, then "Nonell, Soler, Casas, Sabartés, Rafael Llopis, Monturiol, Dr Julien Chaussée d'Antin 12, Fernando Loring Brussels, Jacinto [sic] Reventós, Dr Salmon, Miss Weill, 3 Rue Victor Massé, Gustave Coquiot Rue des Arènes Carles Junyer."⁷ His address books are a fascinating record of his comings and goings, his priorities and his places of refuge. During the years when he was traveling miserably back and forth between Paris and Barcelona, he was quite deliberately forging the path of his future by cultivating Max Jacob's friendship, by gathering information, learning how to blend into his new environment. "Max, 8 Rue du Parc, Quimper," we read at the top of a page, "Coquiot, 4 Rue de Verneuil, Rue Poulletier 9," "Salmon, 33 Rue des Feuillantines."

Friends, critics, dealers . . . they were all systematically, scientifically cultivated to smooth his progress. All his energy went into work, social exploration and integration, and his dialogue with the masters. His friend, the Italian artist Ardengo Soffici, remembered that Picasso "would go from museum to museum to feed himself on good painting, ancient and modern [. . .]. And since I was doing the same thing, we would quite often find ourselves together in the Luxembourg, in the impressionists' room, or at the Louvre, where he would constantly return to the first-floor rooms and roam around them like a hunting dog in search of game, between the Egyptian and Phoenician antiquities—between the sphinxes, the basalt idols, the papyruses, and the brightly painted sarcophaguses."[8]

Gradually he developed a social network notably different from that of his first stay with the Catalans of Montmartre. Frédé, the owner of the bar Le Zut, moved to the corner of Rue des Saules and Rue Saint-Vincent to open the Lapin Agile, a café frequented by artists and writers, where Picasso soon became a regular, and which was brought gloriously to life by Roland Dorgelès in his novel *Le Château des Brouillards*: "'It's the banquet of life!' shouted Frédé over the tumult. 'Everyone is welcome at the Lapin. Let's drink from the cup of art and the cup of beautiful girls!' It was true: everyone was welcome . . . as long as they weren't too well-dressed. Here, there were artists, poets, budding journalists, cut-rate humorists, a few notaries' sons starting out at law school, and—to make up the numbers—a crowd of apprentice artists, less interested in creating art than in looking the part. These young men would be decked out in ascots, tightly knotted velvet ties, Hussar pants, Breton waistcoats, Spanish capes, and none of them would even think of leaving the house without the portfolio of drawings that gave them the right to despise passersby."[9] The Tuscan artist Gino Severini recalled that "in summer, we would hang about outside on a sort of terrace closed off by a concrete balustrade and continue the conversations and discussions that we'd started in our studios. In winter, we'd stay shut up in two little rooms filled with works donated by the artists. At

the back of the second room hung an immense Christ on the cross which, even though it was made of plaster, looked as though it had emerged straight from a Grünewald panel, and towered over the entire room. All the artists, including Picasso, had one of his paintings hung on the wall. Among the bourgeoisie, this cabaret had a bad reputation: they called it the 'murderers' cabaret,' and there were all sorts of sinister stories about it." "The Apaches again!" exclaimed the journalist from *Le Matin* in July 1900. "We have already told our readers about the audacious attacks carried out in Belleville and La Villette by a gang of villains known as the 'Apaches.' These dangerous bandits continue their sinister exploits, giving the population of Paris no peace."[10]

Meanwhile, Picasso kept working, kept painting the world he saw around him. In his painting *Au Lapin Agile*, he shows himself looking pensive and morose, glass in hand, a sad harlequin, showing no interest in the seductive, mischievous "high-class girl" beside him, with her feathers and hat and extremely red lips. This is Germaine, the model over whose affections Casagemas killed himself and whom Picasso briefly courted. In the background, Frédé, in a trapper's hat, plays his guitar while keeping his eyes peeled. This painting, which Picasso gave to Frédé in lieu of paying his bar bill, was sold to the German gallerist Alfred Flechtheim in 1914, then acquired for $40 million by the American collector Walter Annenberg, who donated it to the Metropolitan Museum of Art in New York, where it now hangs.

But it is perhaps the strange atmosphere of a unique and troubling work in Picasso's bestiary titled *Woman with a Crow* (Toledo Museum of Art)—a small gouache and pastel on paper—that best evokes this café perched high above the city, seemingly protected from all harm by the creativity of its artist customers, by the cockiness of its owner, and by the animals (crow, donkey, who knows what else) that he kept there. An orange mass on a blue background, shoulders exaggeratedly hunched, the fingers of her left hand exaggeratedly long as they caress the bird's black feathers, this mysterious, delicate, sickly young woman kisses the head of the "majestic crow, worthy of

ancient days" that could have sprung straight from a poem by Edgar Allan Poe. The model is Margot, a waitress at the Lapin Agile and the owner's daughter-in-law, pictured with her domesticated crow. A few years later, Frédé's son would be killed in the bar by a bullet in the head during a brawl between Apaches. Attempting to restore order to the city, a police administrator would release the necessary funds to employ more policemen, and note with relief: "We provided the requested money and the Apaches immediately became peaceful, while the Gypsies disappeared completely," before adding a note of caution: "Although the respite is no doubt temporary."[11]

Letter from María Picasso y Lopez to Pablo Picasso, September 14, 1904 (Musée National Picasso-Paris)

10.

"ANY MAN WHO TAKES HIS MOTHER'S NAME IS HEADED TO RUIN . . ."

You know what papa said the other day? "Any man who takes his mother's name is headed to ruin," but he was just joking.[1]

—María Picasso y Lopez to her son Pablo

At the French National Archives, an entire box is devoted to anarchists with the name Ruiz. There are hundreds of them, the Ruizes, Spanish immigrant workers, and anarchist militants, at the start of the twentieth century. Ruiz y Lopez Juan, born May 6, 1888, in Santelices, Spain, LEGALLY EXPELLED on February 3, 1921; Ruiz de Gabaretta Benito Jose, Spanish national born March 21, 1886, in Pamplona (Spain), hairdresser in Bordeaux (Gironde), and his brother Ruiz de Gabaretta Miguel, ANTIMILITARIST ANARCHISTS; Ruiz Gomez Francisco, born January 1, 1905, in Melilla (Spain), LEGALLY EXPELLED by order of the police prefect of the Seine-Inférieure; Ruiz Ibarruri Amaya; Ruiz Isquierdo Bartolome; Ruiz Jimenes Eduardo; Ruiz Garcia Manuel; Ruiz Fernandez Riccardo; Ruiz Martinez Innocent; Ruiz Serrando Lucio; Ruiz Gomez Hilario . . . they are all locked away in the archives, and all share a name with the artist "Ruiz Picasso Pablo, known as Picasso Pablo."[2]

In 1895, the teenage Pablo would sign his drawings "P. Ruiz Picasso," using his full name in the Spanish style, appending his father's

name (Ruiz) to his mother's (Picasso). In 1900, at the Exposition Universelle in Paris, for his painting *Last Moments*, he was "P.R. Picasso." Then, from June 1901, at the time of his exhibition at the Vollard gallery, he signed his name as simply "Picasso." He would never change his signature after that. The hasty construction of an artist's identity. The deliberate construction of a foreigner's identity, in a country quick to label any Lopez, Gomez, or Ruiz a Spaniard, a foreigner, an *other*. All the envelopes sent to Rue Ravignan or Boulevard de Clichy, however, remained unfailingly addressed to "Mr. Pablo Ruiz Picasso." In her large, looping calligraphy, María would take an evident pleasure in tracing her son's formal patronym over and over again.

She questions: "Why don't you write?" She suggests: "I would advise you not to forget that Thursday 19th is Saint-Juan."[3] She shows her disappointment: "There aren't many like you who never write and who don't care about us."[4] She expresses her anxieties: "I can't stop thinking about you: if you go out at night, you could get in trouble."[5] She makes no attempt to hide her disapproval: "The photograph [that you sent us] is passed from hand to hand and we are not happy to see it. You look terrible! If you go out in the street like that, without a hat, you must really seem like a freak."[6] She vents her frustrations: "You put on these fancy airs, but you ought to make a contribution to your sister's wedding."[7] She gives him orders: "I am thrilled to the depths of my soul with the surprise you gave us, but remember that tomorrow is your father's birthday and Friday is Saint-Dolores, and congratulate him please."[8] She reveals her anger and even her mood swings: "Yesterday I was in such despair before receiving your card that I started writing everything I was thinking. And then I calmed down. I wanted to tell you that you are a bad son, but I won't say that now. All I will say is that you are a son who behaves badly. You don't understand how disgusted your father is by your behavior."[9]

Much later, when the first articles about cubism appeared in the local press, she will gush proudly: "My dear son Pablo, The other

day, during a visit to the doctor, I happened to see a newspaper that [. . .] described you as the talented Picasso. It was written by Utrillo, but I can't remember what newspaper it was. It would make you happy to see the way they described cubism."[10] However, when she read "Pablo Picasso"—the patronym her son had chosen as far back as 1901—she felt as if she were reading about a public figure. And so, for the first time, María Picasso y Lopez gives her opinions on the question of his name. Her reaction is firm but bittersweet: "I think that you used to sign your paintings Ruiz Picasso and, when the newspapers mentioned you, that was the name they used, but now I see that they call you Pablo Picasso. You know this isn't important for your papa, but the other day he said to me that it's a shame to lose such an ancient, noble family name as Ruiz Almoguera; I'm sure you remember that papa had the family's genealogical tree, but he sent it to your uncle and now his daughters have it, but in fact it's for you. You know what papa said the other day? 'Any man who takes his mother's name is headed to ruin,' but he was just joking. Kisses from your parents, María."[11]

Picasso's mother would slowly reconcile herself to his name. In 1911, when her son lived on Boulevard de Clichy, she sent her letters to "Mr. Pablo R. Picasso," but in 1915, when he was residing on Rue Victor-Schoelcher, she addressed the envelopes to "Mr. Pablo Picasso," and then to "Pablo Picasso." Finally, one day, she gives in: "As for what you say about family names, papa told me the same thing just before we received your card; in fact, like you, he cited Velázquez, and then he named lots of people who decided to go by their second family name only."[12] Picasso, like all expatriates, navigated between several worlds, several kinds of solidarity: the "mechanical" solidarity of home, family, tribe—the family solidarity that his mother orchestrated unerringly for forty years—and the "organic" solidarity that he had with his friends, his colleagues, who became interdependent as they began to settle down.

His address books from that period reveal the way in which all his worlds (Málaga, A Coruña, Barcelona, Madrid, Paris) overlapped,

crisscrossed, intermingled, telescoped, coexisted. Likewise, his works in that period (1900–1906) reveal the same about his aesthetic explorations and his languages (French, Spanish, Catalan): *Dwarf Dancer* (1901, Picasso Museum of Barcelona) is a nod to Toulouse-Lautrec; *Two Saltimbanques (The Harlequin and Companion)* (1901, Pushkin Museum, Moscow) seems to belong to the Pont-Aven School (Émile Bernard, Paul Gauguin); in the blue *Self-Portrait* (1901, Musée National Picasso, Paris) he presents himself as the twin brother of Vincent Van Gogh; *Moulin de la Galette* (1900, Solomon R. Guggenheim Museum, New York) echoes Degas or Renoir; *La Coiffure* (1906, Metropolitan Museum, New York) resonates with the works of Puvis de Chavannes; and the melancholy scenes of his Blue period refer back to his Barcelona elders (Casas, Rusiñol, Nonell).[13] But in those eclectic expressions that brought an end to the nineteenth century, there are an infinite number of others, because Picasso has fun saluting Goya with *The Cutter of Heads* (1901, Musée National Picasso-Paris), citing El Greco in *The Burial of Casagemas (Evocation)* (1901, Museum of Modern Art, Paris) or in *Couple* (Merzbacher Kunststiftung), and flirting with Velázquez for *Portrait of Benedetta Canals* (1905, Picasso Museum of Barcelona).

The foreigner's "rites of integration" are accompanied by "rites of separation," and consequently the foreigner finds himself "floating between two worlds."[14] This phenomenon is well-known to anthropologists, and Picasso does not deviate from the rule: while reluctantly continuing to communicate with his family in Barcelona, he immediately affirms his own ethic, his work (the absolute, sacred, uncompromising priority), at the same time as he maintains his "spheres of belonging"[15] (plural, efficient, acrobatic), now at the core of his identity, which he imposes on everyone (family, friends, public) by signing his name in a resolute, angry hand, a single word, like an order: Picasso!

11.

ON THE SIDE OF THE SALTIMBANQUES, WITH "THE GREATEST OF LIVING POETS"

I am Croniamantal, the greatest of living poets.
I have often seen God face to face.
I have borne the divine rapture, which my human eyes tempered.
I was born in eternity.
But the day has come, and I am here before you.[1]
—Guillaume Apollinaire, translated by Matthew Josephson

In a letter dated June 12, 1867—fourteen years before the birth of Picasso in Málaga, thirty-three years before his first arrival in France, and almost four decades before his themes and variations on saltimbanques—Gustave Flaubert wrote to George Sand: "I swooned, eight days ago, at the sight of a Romani camp. What's most remarkable is the way these people are the object of bourgeois hatred, even as they're as harmless as sheep [. . .]. This hatred stems from something very deep and complex. It is characteristic of all people of order. It's the same hatred displayed toward the Bedouin, the Heretic, the Philosopher, the loner, the poet. And there is fear in this hatred."[2] Toward the end of 1905, when Picasso was painting *Family of Saltimbanques*, one of the last canvases in his series on circus performers, we can imagine that he would have fully subscribed to Flaubert's dichotomy between the "people of order" and the Bedouin or poets, proving that nothing had changed since 1867. Even today, nothing has changed.

After exploring the world of prostitutes, rebels, and prisoners at the Saint-Lazare hospital, whom he met in 1901 through Dr. Julien; after sketching countless studies of the customers in Parisian cafés such as those women addicted to morphine or to drinking absinthe; or all those men who scraped by in the shady backstreets of the great modern metropolis; Picasso turned his attention to the "Bohemians" that Flaubert had spotted decades earlier. He chose the world of the circus, since he attended performances—at the Cirque Medrano near his home in Montmartre, on the corner of Boulevard de Rochechouart and Rue des Martyrs, or at the Cirque d'Hiver (built as a permanent structure in 1852) on Boulevard des Filles-du-Calvaire near the Place de la République—with obsessive frequency, as attested by the eighty white or red entrance tickets preserved in his archives. He pursued this subject for an entire year (from December 1904[3] to December 1905), producing an outpouring of virtuosity (drawings, sketches, watercolors, gouaches, paintings, etchings, engravings, sculptures), using various materials (paper, card, canvas, earth, pencil, India ink), and depicting an endearing cast of characters from every generation, sometimes sketched while performing but more often while rehearsing in the wings or resting, looking sad, tired, pale, and melancholic, immortalized in the company of their child or their monkey, their dog or horses, their lives celebrated with tenderness and empathy. Among many others, these pictures included *The Actor, Young Acrobat on a Ball, Acrobat and Young Harlequin, Two Acrobats with a Dog, Seated Harlequin with Red Background, Family of Acrobats with Monkey*,[4] *A Horsewoman, The Athlete, Six Circus Horses with Riders, Juggler with Still Life, Hurdy-Gurdy Player and Young Harlequin*.

From this crowd, a few touching, individual features haunt the viewer's memory, such as in *Seated Harlequin with Red Background*, where the performer, as a pensive puppet, sits with his legs dangling, eyes glazed, the body of a child with an old man's face, a bicorn hat askew on his head, alone; or in *Family of Acrobats with Monkey*, the first Picasso painting acquired by a new collector, Leo Stein,

showing a harlequin and a female dancer leaning affectionately over their young baby, watched by their monkey. Confronted with the Parisian labyrinth that had, since 1900, seduced and haunted him, lured and threatened him, stimulated and intimidated him, Picasso started exploring the city with a sort of clinical precision, focusing on clowns and street entertainers. He had arrived in Paris just as the French government was starting to develop a "formal definition" of the term "foreigner," determined by a series of markers—residence permit, substandard lodgings, name, language, social codes—that functioned as so many obstacles to integration. By choosing to adopt a theme that had already been used by other artists (Watteau, Seurat, Manet, Degas, Bonnard, Toulouse-Lautrec, Renoir), Picasso was certainly not innovating.[5] And yet, developing the theme in his own way (prolifically, with more than one hundred works in all) and through an original approach (backstage scenes, unspoken moments), he was undoubtedly starting to advance it. The appearance of Apollinaire, another creative spirit in this wildly ambitious undertaking, would do the rest.

"My dear friend, If you haven't already, you must go right away to Boulevard Haussmann to hang your paintings. We were expecting you yesterday at one o'clock," the critic Charles Morice wrote anxiously to Picasso on February 18, 1905. "The paintings must be hung without delay."[6] One week later, at the Serrurier gallery, Morice inaugurated the group exhibition that he had organized, featuring three artists: Albert Trachsel, Auguste Gérardin, and Pablo Picasso, who, for his part, was showing thirty-four paintings, drawings, and etchings, a large number of which belonged to this new series.[7] This exhibition would prove important because Picasso's works would spark enthusiastic articles written by a new friend, and a great poet at that, a man who would become one of the artist's most fervent admirers. A few days before this, Manuel Martinez i Hugué (a.k.a. Manolo, the Catalan sculptor whom Picasso and Casagemas had convinced to come to Paris in 1900) had been praising the artist's talents to the elegant Jean Mollet, "secretary, admirer, promoter, and

general factotum"[8] for Guillaume Apollinaire, a penniless poet who had arrived in the capital two years earlier. One evening in February 1905, in a café in the Saint-Lazare quarter, thanks to Mollet, Picasso had his first meeting with Apollinaire.

One year older than Picasso, the poet is stateless, and therefore is considered a foreigner in France. He had been gripped by the power of words at a very young age, memorizing entire pages from dictionaries in order to find strange sounds or esoteric terms. In contrast to Picasso's artistic genealogy, the poet had no poetic forebears in his family. Born in Rome to an unknown father and a Polish aristocrat mother fallen on hard times, and named Wilhelm Apollinaris de Kostrowitzky, Apollinaire was a bastard child with wanderlust, roaming around Europe while juggling words in several languages (Italian, Polish, French, German, Yiddish). The cities that delineated his geographical space (Rome, Monaco, Nice, Munich, Vienna, Prague, Cologne, Koblenz, London) became so many steps that, "decentered, atomized,"[9] continued to mark his work, giving his trajectory a clear mythological dimension. Apollinaire's geographical mobility, so deep a part of the poet's identity, must have dazzled Picasso, whose own movements within the Iberian peninsula (Málaga, A Coruña, Barcelona, Madrid) followed his father's career. When they met in Paris, these two rootless individuals, eager to leave their mark on the world, instantly recognized their twinship as being anchored in an "in-between territory."

The two creators, each with their own torn, complex history, began an immediate, close, and intense friendship. It quickly included their traveling companions (Max Jacob for Picasso, André Salmon for Apollinaire) and turned into an inclusive conviviality that developed exponentially. "Apollinaire dragged us along with him as he roamed around Paris, from one sidewalk to another, through all the arrondissements, at all hours of the day and night," Jacob recalled. "He would turn in circles, roaming, watching, laughing, revealing details about past centuries, his pockets so full of papers that his hips looked swollen; then he would laugh again, become frightened."[10]

The poet's erudite tours of the city were answered in kind by the artist's explorations of Parisian circuses. And so Apollinaire revealed his memories of Rome—in order, he said, to fertilize Picasso's imagination. "We had been standing outside a house to watch the parade and, to amuse us, my mother wanted us to go inside to see a show," he explained. "But no matter what she did, she couldn't persuade me to go in—I was terrified of the clowns. For me, there was always something mysterious about them, and I sowed that feeling into Picasso's soul, which then germinated his wonderful artworks."[11] Apollinaire's faith in the poet's sacred mission, his attraction to the coarseness of street life, his curiosity for anything exotic or eclectic, his talent for recycling incongruous materials, his obsession with bric-a-brac stores, his joyous transgression of conventional norms between elite and mass culture, his literary virtuosity at navigating different registers of language, and—later—his pseudonymous erotic publications enchanted, thrilled, and dazzled the still slightly reserved Spaniard,[12] who, in return, in endless mirror effects, bombarded his friend with caricatures at a frantic rate.

Stimulated by the poet's fearlessness, Picasso—a born caricaturist—had a field day, giving free rein to his talent for blurring "high and low, sacred and profane, serious and trivial" until it made your head spin.[13] He depicted Apollinaire as a sailor, a picador, a duelist, the pope, even a coffee pot. One fine day, a little worried since he hadn't heard from him, the artist sent his friend a note, "I don't see you anymore. Are you dead?" with a sketch of Apollinaire holding a stack of books and folders outside the Paris stock exchange, an umbrella hanging from his forearm, with his mother's ridiculously tiny dog at the end of a leash. Accentuating his slightly oafish face, Picasso gave the poet a pear-shaped chin, then dressed and disguised him (with a bowler hat or bicorn hat, with a pipe or cigarette), in a teasing gesture of appropriation. And there was both tenderness and admiration in these distortions.

"Poets will have a freedom unknown until now," Apollinaire would later write in his prophetic attempt to define the modernity—or

the "new spirit"—sweeping through the country where he had chosen to live. "Conductors of an orchestra with extraordinary scope," he went on, "they would have at their disposal: the entire world, its sounds and appearances, thought and human language, song, dance, all arts and artifices."[14] The artist was fascinated by this myth of the poet developed by Apollinaire, prefiguring the close relationships with poets that Picasso would enjoy throughout his life, from that first meeting with Max Jacob to the long list of others who would punctuate his existence. This fascination was intensified, of course, by the memory of his torments with the French language— wrestling with words in Barcelona, and in Paris leaning on Max as he made his way through the city. The poet, in turn, admired the painter for his work ethic, his energy, his talent and productivity, but also for his innate charisma and magnetism. "His reputation had not yet spread beyond the confines of the Butte," Apollinaire would write. "His blue electrician's overalls, his sometimes cruel words, the strangeness of his art were well-known, however, within Montmartre. His studio, filled with drawings of mystic harlequins—so many drawings that you ended up walking on them, drawings that anyone was allowed to take with him—was the meeting point for all the young artists and all the young poets."[15] In the challenges that they would set each other, in the intoxication of their erudition, in the insolence of their virtuosity, Picasso and Apollinaire would soon meld their powerful minds, engaging in a friendly rivalry in "that weird wooden house on Rue Ravignan." Soon after their first meeting, in the space of barely two months (April–May 1905), Apollinaire would produce the most beautiful descriptions yet of Picasso's art:

"If we knew, all the gods would awaken [. . .]. Despite their eternal sleep, there are eyes that reflect humanity as if they were divine, joyous phantoms. These eyes are as attentive as flowers that wish always to contemplate the sun [. . .]. More than all the poets, sculptors, and other artists, this Spaniard bruises us like a brief frost. His meditations undress in silence. He comes from afar, from

the rich composition and brutal decoration of seventeenth-century Spain."[16] Picasso and Apollinaire, two virtuosos united in this adventure, clung to each other as they entered a new world, joyously casting off the moorings of the previous century to mark out their own territory, triumphant, moving beyond conventional, academic language, through the cracks in French society—Picasso exalting the condition of the circus performer, Apollinaire exalting the art of Picasso, the two of them building, for and with each other, a Jacob's ladder that would never stop rising. The city of Paris had intimidated a man as daring as Picasso? The Catalans had opened the doors of Montmartre to him? His friend Max had given him access to the French language? The friendship with Apollinaire, spurring the artist to confront the modern metropolis, would quickly embolden him.

Later, Apollinaire would continue to celebrate their friendship in a solo work with prophetic overtones. In *The Poet Assassinated* (published in 1916, after a gestation period of fifteen years), he would mix biographical and autobiographical details to magnify their meeting through the blazing friendship of two mythical characters, Croniamantal, the poet, and the Bird of Benin, the artist:

> In the early days of the year 1911, a young man who was very badly dressed went running up the rue Houdon. His extremely mobile countenance seemed to be filled with joy and anxiety by turns. His eyes devoured all that they saw and when his eyelids snapped shut quickly like jaws, they gulped in the universe, which renewed itself incessantly by the mere operation of he who ran. He imagined to the tiniest details the enormous worlds pastured in himself. The clamour and the thunder of Paris burst from afar and about the young man, who stopped, and panted like some criminal who has been too long pursued and is ready to surrender himself. This clamour, this noise indicated clearly that his enemies were about to track him like a thief. His mouth and his gaze expressed the ruse he was employing, and walking slowly now, he took refuge in his memory, and went forward,

while all the forces of his destiny and of his consciousness re-
tarded the time when the truth should appear of that which is,
that which was, and of that which is to be.

The young man entered a one story house. On the open door
was a placard:

Entrance to the Studios

He followed a corridor where it was so dark and so cold that he
had the feeling of having died, and with all his will, clenching
his fists and gritting his teeth he began to take eternity to bits.
Then suddenly he was conscious again of the motion of time
whose seconds, hammered by a clock, fell like pieces of broken
glass, while life flowed in him again with the renewed passage
of time. But as he stopped to rap at a door, his heart beat more
strongly again, for fear of finding no one home.

He rapped at the door and cried:

"It is I, Croniamantal!"

And behind the door the heavy steps of a man who seemed
tired, or carried too weighty a burden, came slowly, and as the
door opened there took place in the sudden light the creation of
two beings and their instant marriage.

In the studio, which looked like a barn, an innumerable herd
flowed in dispersion: they were the sleeping pictures, and the
herdsman who tended them smiled at his friend. Upon a carpen-
ter's table piles of yellow books could be likened to mounds of
butter. And pushing back the ill-joined door, the wind brought in
unknown beings who complained with little cries in the name of
all the sorrows. All the wolves of distress howled behind the door
ready to devour the flock, the herdsman and his friend, in order
to prepare in their place the foundations for the NEW CITY.[*,17]

On Wednesday, November 1, 1905, on a cobalt-blue card bear-
ing no information other than the date and the artist's name and

* Translation by Matthew Josephson.

address, Apollinaire sent to "Mr. Picasso, artist" two handwritten poems, "Spectacle" and "The Saltimbanques." In return, the artist gave the poet his *Jester Holding a Child*, a drawing in India ink and colored pencils.[18] Did Apollinaire's poems trigger the creation of the magistral *Family of Saltimbanques* (now hanging at the National Gallery of Art in Washington, D.C.)? Evidently, the pink-hued canvas is deeply imbued with the atmosphere of the poem ("the plain with quiet gardens / Where singing minstrels stroll away" with their "burdens round or square," their "drums [and] golden tambourines"). Haunted by the "pale Harlequin" ("having unhooked a star / He proffers it with outstretched hand"), saturated with the magic of "sorcerers from Bohemia / With fairies and enchanters,"[19] the painting echoes the poem.

With its six life-sized characters, *Family of Saltimbanques* marks an obvious break from Picasso's variations on acrobats, jugglers, and consorts. Often connected with the six characters that inhabit Manet's *The Old Musician*, the figures assembled by the artist generated innumerable exegeses and interpretations. Undoubtedly, the Harlequin conjurer to the left, with his back to us, evokes a larger-than-life Picasso, standing next to the obese, powerful, red-suited Apollinaire in tights, ruff, and jester's hat. But who are the others? Could the two acrobats suggest Jacob and Salmon?[20] And the little girl? And the "woman from Mallorca," seated to the right, apart from the others? "Maybe I will go to Mallorca 'the golden isle' they say it's very beautiful," the artist wrote to Max Jacob in 1903 while staying in Barcelona.[21] In fact, Picasso never went to Mallorca. So that "woman from Mallorca" remains a representation of the woman from the "golden isle"—archetypal, aloof, unapproachable—whom Picasso might have met and painted had he traveled there like his colleagues Sebastià Junyer i Vidal, Hermen Anglada-Camarasa, and Isidre Nonell.

And yet the Harlequin, the red jester, the two young acrobats, the little girl, and the woman from Mallorca remain mysterious.[22] Static, they are transporting bundles and baskets; they seem to be

in transit during a break in their journey, a journey beyond space and time, headed who knows where. While their legs are firm and muscular, solidly planted in the earth, their fingers, unfinished, dissolve into the surrounding air, and their eyes are no more than black holes, vague and absent. They are posed there, strangers to one another, in a world where all communication is frozen. Barely can we perceive an affectionate gesture between the Harlequin and the little girl. But who are they? And where are they going? What connects them? What is their story? Such are the questions left unanswered by the artist. The preparatory work, the successive stages leading up to the finished painting, the decisions made and then repented show certain untaken paths (such as a Degas-like horse race), the most radical of all being the absolute erasure of all context.

In February 2017 and May 2018, during research trips to the National Gallery of Art, in Washington, D.C., I often sat in front of this painting, in the beautiful rotunda that also hosts other wonders such as *Woman with a Fan* and *Portrait of Pere Mañach*. After the museum's conservator and curators—Ann Hoenigswald, Harry Cooper, Kimberly Jones—successively revealed Picasso's visible traces, unveiled a few meaningful *pentimenti*, and rediscovered the personality of Chester Dale (the painting's last owner), and after I considered the vast literature about it,[23] I wondered why I was so magnetized by the image, and why, after walking away, I kept coming back to it. "I like most what I do not understand at first," Ileana Sonnabend, the gallerist, used to claim. Gradually, I gathered that my relationship with this painting stemmed from the same phenomenon. As opposed to any of the pictures, drawings, or sketches produced by Picasso over the past year, this one does not attempt to *represent* the saltimbanques' world but instead leads us elsewhere. Enhanced by Apollinaire's imagination and travels, it epitomizes the common status shared by poet and artist in the city of Paris—a capital that, in 1905, was struggling to integrate the different populations that it attracted.

■ ■ ■

The saltimbanques prevail. With the abstract power of myth, they become the nomadic heroes of all time—like Ulysses, Orpheus, or Don Quixote—signaling the triumph of "Bedouins" over "people of order." But there is more. They also prevail against the flat, arid, desolate, silent backdrop, the world of those "villages without a church" suggested by the painting. "There are countries without place and stories without chronology; cities, planets, continents, universes whose trace we could never find on any map or in any sky, quite simply because they do not belong to any space," Michel Foucault argued in 1967. "These cities, continents, and planets are probably born [. . .] in people's minds or, truth be told, in the gaps between their words, in the density of their accounts."[24]

With its distressing backdrop, *Family of Saltimbanques* precisely echoes the notion of "counter-space," as defined by Michel Foucault. A counter-space, the philosopher wrote, belongs to "those different spaces, those other places, those mythical and real disputes of the space where we live." In other words, it belongs to "those heterotopias, [those] utterly other spaces [. . .] reserved for individuals whose behavior is deviant when compared with the average or the required norm [. . .]. Society pushes [the counter-space] to its margins, to the empty beaches that surround it" because "there is probably not a single society that does not consist of its heterotopia."[25] And it was as if, "having unhooked a star," Harlequin-Picasso—the ultimate trickster* and the first of the acrobats—also managed, by erasing the city, to represent, "in the manner of eternity,"[26] those *cracks in society*, that counter-space, that heterotopia, the very space they inhabited.[27]

Less than ten years after it was finished, following a series of tribulations that we will come back to, *Family of Saltimbanques* was purchased by Hertha Koenig and hung in her Munich home. One of her friends, the poet Rainer Maria Rilke, fascinated by the masterpiece, asked for permission to stay in her apartment for the summer

* See Yve-Alain Bois, "Picasso le Trickster," in *Les Cahiers du Musée National d'Art Moderne*, no. 106, Winter 2008, 2.

in order to live close to the painting. Later, he dedicated his "Fifth Duino Elegy" to his hostess, in which he managed to capture, in turn, the saltimbanques' powerful magic:

> But who are they, tell me, these Travelers,
> Even more transient than we are ourselves . . . [★,28]

★ Translation by A. S. Kline.

12.

A STORY OF MANTILLAS AND FANS

Ahora con toda la precipitacion posible acabo de salir y comprarte la mantilla; yo creo que sera de tu agrado, pues me parece bonita el porom e algo modernita [. . .] Escribe pronto para saber si te ha gustado la mantilla.[1]

—María Picasso y Lopez to her son Pablo

Barcelona, November 1, 1905. My dear son Pablo, Canals came to the house and told me that he was leaving for Paris and that he was expecting me to give him something for you; at that moment, I couldn't go out because I was waiting for papa to return, but now, in haste, I have bought you the mantilla. I think you'll be happy because it seems to me pretty, light, and even modern (in fact they almost all look the same). [. . .] Thank you for your letters; you turn a deaf ear to everything I tell you. With kisses from papa and Lola and all your mama's affection, María.

Why did the artist, who had been away for eighteen months, ask his mother for an accessory that cannot be found in Paris? Probably to give a more Catalan look to the beauty of Benedetta Bianco Coletta (his friend Ricardo Canals's Italian fiancée), whose portrait he planned to paint just before their wedding. Why did the artist's mother carry out his request with such urgency, sending him a mantilla, the ultimate emblem of Catholic Spain—a lace veil with which

local aristocratic women had, since the sixteenth century, covered their faces when they went to church? Probably because she considered herself an important cog in the ambitions of her adored and highly gifted son, who had left his homeland to further his career. The *Portrait of Benedetta Canals*, painted a few days after this letter, so quickly that it looks almost unfinished, is the work of a virtuoso. The classical beauty of the model and the elegance of the black mantilla against the pink background, a flower planted in its center, immediately evokes *The Lady with a Fan* (1640), one of Velázquez's most accomplished and mysterious portraits.

Ten days before this letter, on October 18, 1905, the opening of the third Autumn Salon at the Petit Palais caused a scandal in Paris: the president of France, Émile Loubet, known for his conservative tastes, refused to go. This was the first time since its creation in 1902 that the Salon had veered so far toward the avant-garde. Critics denounced a "cage of wild beasts," "random gaudy colors," "frenzied paintbrushes," a "pot of paint flung in the public's face," a "mix of bottle wax and parrot feathers." Spectators, however, rushed to Room 7 to discover Matisse, Vlaminck, and Derain's paintings, which exploded with violent colors and unexpected juxtapositions. Among these scandalous works was Matisse's *Woman with a Hat*, a disorienting portrait of Mrs. Matisse wearing extravagant headgear.

But why would Picasso—who had of course visited Room 7 of the Salon with great interest—respond in such a traditional manner to the advances of his elders Matisse and Vlaminck? Why would the young Spanish prodigy, with his *Portrait of Benedetta Canals*, offer this masterly demonstration of his technical ability but in a style so out of sync with the Parisian avant-garde? Why hide behind the shield of Velázquez, at the risk of appearing like a virtuoso trapped in the Grand Siècle? He was twenty-four; Matisse and Vlaminck were, respectively, thirty-six and twenty-nine. It would not be long before Picasso went on the offensive: less than a year later, following his stay in Gósol, he would take over as the leader of the avant-garde. Then, during a period of relentless work that stretched from the fall of 1906

to the fall of 1907, he would produce *Les Demoiselles d'Avignon* (The Young Ladies of Avignon). In 1908, with *Woman with a Fan*, he would respond to Velázquez as well as Matisse by using the fan, an object every bit as Spanish as the mantilla, but in a completely new aesthetic language, midway between painting and sculpture, between western Europe and Africa, in an irreversible step forward that heralded the birth of cubism.

In March 1906, courtesy of the "Manet-Redon" exhibition at the Durand-Ruel gallery, Picasso encountered the genius of Manet ("Manet is a giant!"[2]); he admired the twelve latest paintings by Cézanne at the Vollard gallery; he discovered Iberian sculpture at the Louvre (courtesy of an exhibition devoted to findings from the archaeological sites at Osuna and Cerro de los Santos); and, lastly, he rushed over to Gustave Fayet's apartment on Rue de Bellechasse to see his collection, including twenty-five wonderful Gauguins.[3] It was also during this month that Picasso became fully aware of Matisse's place in the "movement carrying the Nouvelle Peinture toward color."[4] Matisse was omnipresent in Paris at the time: there were fifty-five new works (notably *Le Bonheur de Vivre*—The Joy of Life) at the Eugène Druet gallery, still more new paintings at the Salon des Indépendants, and recent acquisitions of his art by new collectors, the Steins. Picasso was obsessed by the breakthroughs made by his colleagues in the avant-garde (Matisse, Derain, Vlaminck, Braque, van Dongen), to which he himself did not feel he belonged. He was uninterested in color, paying far more attention to the exploration of contour as a generator of light and volume. He heard people talking about Derain's African discoveries at the British Museum. He was getting nowhere.

At the time of the 1905 Autumn Salon, however, Picasso—after taking refuge in the influence of Velázquez—suddenly found inspiration. He met an American family of collectors—who, like him, had come to the French capital just after the Exposition Universelle—and this encounter would profoundly alter his working conditions in Paris. "The Autumn Salon is over," wrote Leo Stein to a friend

in October 1905. "Unfortunately all our recent acquisitions are by people you've never heard of, so there's not much point trying to describe them to you [. . .] but there are two works by a young Spaniard named Picasso whom I consider to be a genius, one of the best draftsmen around today."[5] At the Autumn Salon and the Salon des Indépendants, Leo Stein bought Cézannes, Matisses, Picassos, Gauguins; saw works by van Gogh and Seurat (whom he'd never heard of before); and sold his Japanese stamps in order to fund his new passion. One of the first galleries frequented by Leo Stein was undoubtedly Ambroise Vollard's strange bric-a-brac shop on Rue Laffitte. "We got along well," Stein would later explain. The canvases he chose were innovative works that provoked only sarcasm or indifference among the wider public, works such as the aloof *Madame Cézanne*, the insolent *Woman with a Hat* by Matisse, and Picasso's curious *Family of Acrobats with Monkey*. "Picasso had some admirers," Stein would write, "and Matisse had some, but I was alone in recognizing these two as the two important men."[6]

The year 1905, then, was notable not only for the crucial first purchases of Picasso's masterpieces but for an instant sympathy that sprang up between the young artist and the Steins (Leo and his sister, Gertrude); it was love at first sight for all of them. The Stein siblings both helped the impoverished artist, with Leo becoming his providential collector and Gertrude his model. Picasso was blunt and transparent when asking his new friend for money, for example on August 11, 1906: "My dear Stein, we have been here three weeks and, alas, penniless, our small inheritance having been happily spent in the mountains. Could you lend me 50 to 100 francs and I will pay you back before you leave either with the little profits from my trade or with my brain, my best memories to your sister and to you too, your Picasso."[7] Before long, the artist was able to triumphantly announce: "Vollard came this morning the deal is done (2,500 francs)."[8] Financial transactions, artistic transactions: these were the subjects of the messages that these two expatriates exchanged in a language that neither of them really spoke fluently. And yet, for the five years of

their friendship, Leo Stein and Picasso were linked by "mutual wor-
ship" of Cézanne, Gauguin, Toulouse-Lautrec, and El Greco.[9] "We
will go to your home next Monday to see the Gauguins and before to
eat lunch. With much friendship to your sister and to you PICASSO," the
artist wrote on a drawing entitled "A very beautiful heathen dance."[10]

What more can be said about the ninety visits that the collec-
tor's sister made to Picasso's studio between the winter of 1905 and
the spring of 1906 when she was posing for the famous portrait
Gertrude Stein? These encounters have been mythologized to such
a degree that it is difficult to uncover the truth. All that remains is
the correspondence preserved in the archives of the Musée Picasso
in Paris and the Beinecke Library at Yale, enabling us to reveal the
steps that led to the construction of the relationship—can it be called
a friendship?—between Gertrude and Pablo, from December 1905
to the start of World War I. It was a relationship that like the one
with Max Jacob was also a story of creativity, and like the one with
Apollinaire was also one of fearlessness, of obsessive work, where
words, lines, and colors were crafted as never before, Gertrude push-
ing the linguistic envelope of French, English, and Italian. "I will
come to your studio tomorrow Friday afternoon for my Gertrude
Stein portrait," she wrote on March 9, 1906, on a postcard decorated
with a Hans Holbein portrait, *Gattin und die Kinder des Künstlers*,
if you please![11] But immediately after the opening of the Salon des
Indépendants (on Monday, March 20), Picasso interrupted his work:
"Spring arrived and we were coming to the end of the sittings," Ger-
trude Stein recalled. "One fine day, Picasso suddenly painted over
the entire head: 'I don't see you anymore when I look at you,' he
said angrily, and left the portrait like that."[12] Meanwhile, at the end
of April, Picasso met Matisse for the first time. Matisse was eleven
years his senior, and Picasso already considered him his archrival.
The French artist was driven to Rue Ravignan by Leo Stein and ac-
companied by his daughter, Marguerite.[13]

"Picasso realized then that he was dealing with a very high-level
painter and someone who rivaled him in audacity," the biographer

Pierre Daix stated. On the walls of their apartment on Rue de Fleu-rus, the Steins' collection featured a powerful dialogue between two important portraits. The first had been executed by Cézanne in 1881, the second by Matisse in 1905, and both were of the artists' favorite model, their wives. Picasso was stunned by both of these paintings. His model at the time was Gertrude Stein: as soon as they met, the artist decided, as a sort of challenge to himself, to paint her portrait. It is hard not to conclude from his inability to finish this painting—which would have allowed him to measure himself against *Portrait of Madame Cézanne* and *Woman with a Hat*—that he was hampered by a genuine and obsessive incapacity, which only intensified his frus-tration. Picasso never showed his work at any salons and, since the exhibitions at the Vollard gallery in 1901, the Weill gallery in 1902, and the Serrurier gallery in 1905, he hadn't shown any of his paint-ings publicly. The Steins' home became, for him, the only real ex-hibition space. But while visitors in April 1906 could admire *Family of Acrobats with Monkey* or *Girl with a Basket of Flowers* on the walls of the apartment on Rue de Fleurus, his incomplete, unfinished, un-satisfactory portrait of Gertrude Stein was, for now, still missing. Picasso left Paris.

13.

"MILLIONS OF FEET ABOVE SEA LEVEL" . . . GÓSOL!

The mountain is the mountain. An obstacle, in other words.
And, at the same time, it is a shelter, a country for free men.
Because [here] none of civilization's constraints weigh down on
man.[1]

—Fernand Braudel

Joyously caracoling on the steep, narrow, impractical streets, danc-
ing and whirling to the sound of oboes and drums, two gentle gi-
ants (each twelve feet high) make their way around the mountain
village. Behind them stretches a colorful crowd, children carried on
shoulders watching the two magnified villagers who stand out against
the clear blue sky, beneath the impressive Pedraforca mountain. I
am in Gósol, on August 15, 2018, for the Giants' Procession—"a
secular procession," as the locals are keen to point out—which is
one of the most important parts of the region's annual festival, the
Festa Major. The traditional costumes—bouquet of flowers, wide
gray skirt, white scarf covering the women's heads and shoulders,
the men wearing Catalan flags and black capes on their backs, red
berets on their heads—remind us that they belong to an age-old cul-
ture. But what victory are these giants celebrating? Is it for having
warded off the challenges of their legendary mountain that they gloat

and dance? Around them, like monstrous elves, gambol some secular dwarfs with zany, deformed, or grimacing masks, and a menacing red devil wearing horns. This year, for the first time in the procession, appears someone in a striped sailor shirt, armed with a palette and paintbrush, face hidden behind a scowling Pablo Picasso mask. Seeing this popular celebration, mingling generations, I instantly understand that Gósol is a genuine *communitas*.[2] How did this tiny mountain village—capable of producing, in August 2018, an improbable, secular procession from the depths of the ages—affect a twenty-four-year-old Picasso in 1906? How to decipher the links that united Picasso to Gósol, that still link Gósol to Picasso?

While the dates and circumstances have long remained vague and mysterious, we do at least know that he spent the summer of 1906 here with Fernande Olivier. A few rare pieces of evidence prevail, such as that beautiful photograph taken by Vidal Ventosa before they left for the Guayaba Café in Barcelona, and some correspondence. It was only recently that the precise dates of this excursion were established with any certainty: May 27 to July 23, 1906. Today, despite the experts' disagreements on particular points—is the Gósol period a continuation of or a break from the Rose period?—the consensus is that, as far as Picasso's work is concerned, there is very much a *before Gósol* and an *after Gósol*. Fifty-nine days in that Pyrenean village, "and we can state with certainty that it was in Gósol that Picasso's first modern works were created."[3] The philosopher Jèssica Jaques Pi is categorical: what Picasso produced in Gósol was "not part of the same line as his previous periods." With 302 works (7 large canvases, 12 medium-sized canvases, 2 sculptures, and a vast array of sketches and drawings), the artist "entered his own modernity," abandoning the tradition of representation that had prevailed since the Renaissance to develop "his own genealogy." If the stay in Gósol provoked such an aesthetic rupture in his work,[4] it was above all because of the social rupture from the world of Paris. He returned transformed, stimulated, restored in his powers and able to measure himself differently in the battle of the avant-garde. From every point of view, the

position of the village was crucial. But how much did Picasso know when, accompanied by Fernande on May 27, 1906, he began his exhausting journey, riding a mule along a seemingly endless medieval road that in fact measured only seventeen miles?

■ ■ ■

"*Mano de mujer sobre el ombro de un* danseur"[5]
"Woman's hand on the shoulder of a *danseur*
[in French in the text]"

"*Mano de mujer/ sobre el ombro del* danseur"[6]
"Woman's hand/ on the shoulder of the *danseur*
[in French in the text]"

"*Mano derecha de mujer cojida al bailador*"[7]
"Woman's right hand attached to dancer"

The "Catalan notebook" is a tiny object, only 12 centimeters by 8 centimeters, which Picasso used in Gósol as a sort of journal: sketches, drawings, poetry, texts, addresses, vocabulary, and maps are all mixed up in its pages, as are Catalan, Castilian, and French, the three languages that he constantly juggled.[8] The Catalan notebook is a precious document that reveals Picasso as an ethnographer. He noted down absolutely everything in its pages: folklore, anthropology, linguistics, sociology, literature, geography, eroticism . . . it is all here, joyous and excited, setting out an ambitious, all-encompassing plan, a desire to "make the world submit to [him] alone."[9] In this case, the "world" he wanted to make his own was a group of about one hundred mountain people, in this practically inaccessible village, south of Cerdanya, at an altitude of five thousand feet.

On May 28, 1906, during his first night out in Gósol—for the ritual Sunday evening ball on the Plaça Major—he took out his little notebook and, very quickly, in a sketch of breathtaking virtuosity,

immortalized two dancing couples in traditional costumes, the four figures caught in the rhythm of the sardana, the women's wide skirts flying to the right, their right feet in the air. Then, again and again, he zoomed in on a woman's hand: her left hand gripping her male partner's shoulder, her right hand placed inside the man's hand, clasping his thumb. Sketches, captions, establishing shots, closeups: he went at it fiercely, starting over, exulting, drawing and scribbling comments. In his first impressions of this new world, did Picasso really focus on the hands as points of contact between man and woman, or was his gaze drawn rather to the miracle of these *two* bodies merging into *one*—to the dancing couple caught in the rhythm of the music (as if to resolve a physics question about movement)? What did his voracity, his feverishness, his frenzy reveal, if not a genuine attempt to capture his model? "My dear Guillaume, Sunday on the square, a ball, when the music ends the girls are afraid, I will write you, Picasso, Gósol, May 29, 1906," he would write to Apollinaire two days later, scrawling those few words, his mind as electrified as it had been during his first nights in Paris. What was it he noticed, if not the details of women's behavior in public places, of men's violence toward them, the social interactions between teenagers, the girls' fear of men's excesses or abuses?

During his fifty-nine days in Gósol, Picasso would continue to examine the villagers' costumes and postures, the craftsmen's weaving techniques, details of ironwork on the walls, the corners of the houses, the asymmetry of the roofs, the village's organic inscription in its mountain, as a single physical mass. Intrigued by the strange etymologies of the word "*pinces*" (pliers) or the word "*thym*" (thyme), he translated them himself from Catalan to Castilian: "*els molls = las tenazas,*"[10] "*farigola = timo.*"[11] He drew the pure, simple profile of a woman with a Greek nose, her head covered by a hood. He translated for Fernande one of Joan Maragall's Catalan poems into rough French. He even drew up, with perfect accuracy, the itinerary of their return journey—"Gósol, Vallvé, Puixcerdà, Ax, Paris"— along with the appropriate form of transportation for each stage of

the trip, written half in Catalan, half in Spanish: "*matxos, coche, coche, tren*" ("mule, stagecoach, stagecoach, train").[12] Curiosity, precision, control: the Catalan notebook gives a glimpse of Picasso on the alert, dynamic, antennae twitching as he explores his surroundings with his eyes and hands. This is the creator in a dialogue with himself as he was seizing new territory. The Catalan notebook reveals the first secrets on this intriguing experience: it is the mechanics of Picasso at work, at a key moment in his trajectory.

"I don't see you anymore when I look at you," he had told Gertrude Stein before bringing an end to their ninety sittings. This was in March. On May 15, 1906, he took the train to Barcelona, using the 2,000 francs he'd received from Ambroise Vollard for a batch of twenty-seven paintings and gouaches,[13] the contents of his studio, with the exception of the huge canvas *Family of Saltimbanques*, which Picasso preferred to keep on Rue Ravignan. In Barcelona, he told friends about his preoccupations, his dissatisfactions, the dead end he felt he had reached. The suggestions from his sculptor friends (Enric Casanovas and Manuel Martinez i Hugué) matched the advice given by his doctor friend (Jacint Reventós): all three uttered the word "Gósol" as if it were an incantation—Enric had a house there, Jacint sent his patients there—and they described this village in a hollow of the mountains as a place where he would be able to work in peace and perhaps find a way out of his rut.

As usual, he didn't write much, asking Fernande Olivier to take care of communicating with the outside world and only picking up his pen under exceptional circumstances. "*Aqui me tengo trabajando come dios me da a entender y como yo lo entiendo*," he confessed to Leo Stein in Spanish: "Here I am working like God taught me and as only I know how." He also scribbled a few lines to Apollinaire and Casanovas, exhorting the latter to send him ammunition (paper, tools, sculptor's knife). He barely found the time to thank him for his favors (sending postage stamps)—"*le doy un million de gracias por sus sellos y por la molestia que me dispense*"[14]—or to admit that the village was beautiful or that the rain had stopped. Because Picasso was in a

hurry and everyone else had to follow his tempo. "Can you urgently send me 20 sheets of Ingres paper in a cardboard tube?" he asked Casanovas. "I've used up the few sheets I brought from Barcelona. I'm sorry to ask you all this, but you are the only one I trust for these things, and I will pay you back. Tell me if you want me to send you money or if I can just reimburse you when you come here. Tell me honestly. Until now it's been quite cold but today it is warmer, with sunshine and no rain."[15]

Fernande Olivier had a hard time finding her footing in this world. It was an ordeal for this woman who would be Picasso's French companion for almost ten years, teaching him the language and the mores. Later, she would describe the torture of those seventeen miles on a mule from Guardiola de Berguedà on the impossible mountain paths of Camí Reial, weighed down by her own trunks, the little dog she'd just been given, Picasso's painting supplies (rolled canvases, paintbrushes with the handles broken off to save space), so overcome by vertigo that she had to keep her eyes closed to avoid fainting. "It's almost unbearably cold [. . .] and the rain here isn't normal [. . .] when it rains, the village is flooded [. . .] and braver people than I would be intimidated by the sound of thunder in these massive mountains [. . . .] and by everything that accompanies thunder in general; and the echo! Oh, the echo, it bothers me so much," she wrote to Apollinaire. In expressive language, Fernande went on: "The landscape! . . . mountains in front, mountains behind, mountains to the right, mountains to the left, and mountains in between all these points [. . .]. But there is nothing in this place, no patisserie, no confectionary, no bakery, no haberdashery, nothing, nothing, the tobacconist's does not have any 10-centime stamps or 25-centime stamps and [. . .] most of the time the tobacconist himself is out in the fields and his shop is closed."[16]

Picasso felt none of this. The storms, the vertigo, the Pedraforca mountain . . . all of it was a source of stimulation. Fernande Olivier described him as "cheerful, happy to go off hunting or to climb the mountain above the clouds."[17] In his bedroom-studio on the second

floor of the Cal Tampanada inn, which looked out onto the Plaça
Major, or sitting at the big guest table with the inn's owner, the impos-
ing, ninety-three-year-old Josep Fontdevila, Picasso would work—
drawing in his little notebook or on large sheets of Ingres paper, on
canvases or tree trunks. He played cards with the local craftsmen but
also, when they were there, with the shepherds and cattle farmers
who knew how to train their animals before selling them as beasts
of burden to La Seu d'Urgell, or with the *esquiladors*, those indisput-
able experts who traveled all over Catalonia speedily shearing sheep
before sending their fleeces to the spinning mill. While Fernande
moped around, Picasso bloomed. At twenty-four, having zigzagged
across the Iberian peninsula, he had already survived so many re-
locations. At the center of his own constellation, in between several
worlds (Andalusian, Galician, Catalan, Castilian, French), he had
to adapt and readapt to new climates and new cultures—a talent
that was now ingrained in his character. Gósol required yet another
adaptation: it was his first experience of both high mountains and
the Pyrenees, a territory famous for its "violent history [of] primi-
tive cruelty [. . .] if we can even talk about Pyrenean civilization,"
according to historian Fernand Braudel.[18] This might well explain
Picasso's extravagant exaggerations in his letter to Apollinaire: "We
are at an altitude of 16,000 feet and completely surrounded by snow,
but also by sunlight," he wrote.[19] A few days later, in Spanish, he
would raise the stakes even higher, assuring his *"querido amigo Stein
[. . .] Aqui me tiene a no se cuantos milliones de Métros sobre el nivel del
mar"*: "Here I am at I don't know how many millions of feet above
sea level."[20]

One must truly live the experience of Gósol to appreciate that
summer of 1906. One must reach the village by the small, zigzagging
road that crosses, from west to east, the Cadi-Moixero, that formi-
dable mountain fortress at an altitude of 8,200 feet. But whether one
approaches it from La Seu d'Urgell and Josa de Cadi to the west or
from Puigcerdà and Saldès to the east, one must cover about sixty
miles between the few villages with names like Tuixent, Sorribes

de la Vansa, Cornellana, Fórnols, and Adraén, towered over by a vertiginous wall of mountains so steep that you can still make out the geological thrust that formed them when tectonic plates shifted and collided. Once there, one must learn to correctly pronounce the name "Gó-sol": tonic stress on the first syllable, phonetic opening of the first *o*, Catalan transformation of the *s* into *z*. In fact, in her letters to Spanish friends, Fernande wrote "Gozol."

One must witness the confrontation between the upper-class houses sheltered by high walls and dry stone on the northern slope of the village, and the more modest, more exposed dwellings around the laundry on the southern slope. One must refer to the church bell tower that dialogues with the Pedraforca mountain hovering above it. "El Pedra," the locals call it, proudly defying this majestic, two-headed mountain, recognizable among all, which rises to an altitude of 8,192 feet. In the mornings, sometimes lit up, it stands out against the blue sky. In the afternoons, the clouds roll in nicely, hatching the night's storms. It is, with the Montserrat (a "Christian" mountain), one of the two mythical peaks in the Catalan Pyrenees, but El Pedra remains a pagan mountain, hence the animist feelings toward it, and every Catalan in this region must face it at least once in his life, as a sort of initiation. El Pedra sets the tone, and Picasso sketched it several times, behind Fernande, or a village woman carrying a bundle of sticks. One must experience those terrifying night storms and live through the moments that sent Fernande Olivier into a panic, locking all the doors and shutters—in the pathetic illusion that they might protect you from the elements—before appearing again in the morning, groggy and exhausted after a sleepless night, and sharing with the others emotions akin to those felt by the survivors of Noah's Ark.

14.

"A TENOR WHO SINGS A NOTE HIGHER THAN THE ONE WRITTEN IN THE SCORE: ME!"

Un tenor que da una nota más alta que esta escrita en la partija: Yo![1]

—Pablo Picasso

In the summer of 2018, Gósol is invaded by hikers, all converging on the central square, where a banner hangs from the balcony of the mayor's office, decorated with a yellow ribbon: DEMOCRACIA *En defensa dels nostres drets i llibertats* LLIBERTAT PRESOS POLITICS. Next door is the Picasso Center, its entrance blocked by children sitting on the ground, playing cards.

Gósol is located less than six miles south of Cerdanya—the border territory between Spain and France that was divided between the two countries by the Treaty of the Pyrenees in 1659. "The French State 'annexed,' 'integrated' and ultimately 'assimilated' the part of the valley it acquired in 1659," wrote the historian Peter Sahlins. "The Spanish State did the same, but from a very different point of view, resulting in a very different reality."[2] So, while *in administrative terms*, Gósol did not belong to Cerdanya, as a *border zone of a border zone*, it has been molded by those fluctuations of identity. The villages of

Cerdanya, Sahlins went on, were organized in "village communities" that, "thanks to the relative weakness of the seigneurial system in the Catalan Pyrenees, enjoyed a great deal of autonomy in managing their affairs."[3] How would the vibrations of this "small, enclosed, and relatively prosperous world" with its singular geopolitical position and its location "completely encircled by mountains"[4] mark the young artist who had come straight from the crucible of Paris?

He left the capital well aware of the psychosis gripping France. With the unprecedented rise in crime, with the Apaches' attacks, Parisian society in the Third Republic had a suspicious view of those it described as "Gypsies," "vagabonds," and "bohemians." He left Paris feeling complete sympathy with the marginals and pariahs of that world,[5] figures celebrated in the impressive array of works he'd produced in the previous few months representing prostitutes, beggars, syphilitic women, acrobats, street performers, and circus people. In March 1906, Georges Clemenceau became the new minister of the interior. Appalled by the poverty of the police in his country, the minister was preparing a major reform of that obsolete institution charged with maintaining public order. "The only police force that a democracy can acknowledge, the judicial police, the police of crimes and misdemeanors, protectors of all the country's citizens [. . .] is clearly insufficient," he would declare soon after this,[6] targeting the very people who, in 1901, had mistakenly labeled Picasso an "anarchist under surveillance."

Among the "peddlers, merchants, and smugglers who rode mules along the dozens of paths connecting the two sides of the mountain chain," Picasso went off to live with those who, since the Middle Ages, with their mobility, pragmatism, and know-how, had invented a Pyrenean economy that was simultaneously cross-border and underground: a border patrol run by bandits. For the sociologist Laurence Fontaine, the world of peddlers was "first and foremost the domain of the mountain people" who developed those "high trade routes" to "avoid tolls and customs."[7] Since the thirteenth century, "heavy commodities were sent by sea [while] luxury products were

transported by land." And so "caravans of mules loaded with silk, [. . .] indigo, gold and silver thread, took the high roads, and all the mountain passes shared the flow of traffic; commerce irrigated the mountain in a multitude of threads throughout the year." Such was the case for Gósol where, since the thirteenth century, "traveling salesmen have specialized in the distribution of fragrant oils, a highly lucrative product that was easy to transport, but an activity that carried high risk due to the fragility of the glass bottles and the olfactory power of the oils. Because when a bottle broke, the smugglers, traveling by mule on the winding mountain paths, were easily tracked down by the police—and risked the death sentence for their crimes."[8] Until 1829, there was no fiscal surveillance at Spanish ports and borders, so "smuggling became an accepted habit among the Spanish."[9] This is reminiscent of "informal" economies that mix religious, financial, and social aspects, and which economists, suddenly deprived of their fundamental methodologies and concepts, "force us to categorize under anthropology."[10]

During those two summer months, Picasso lived at the Cal Tampanada, run by Josep Fontdevila, *contrabandista*, *hostaler*, and one of the heroes of the village. In the house of this innkeeper-smuggler, in a village of smugglers where, even now, the police rarely set foot, Picasso blossomed. They still talk admiringly here of his skill at card tricks. It's even said that old "Pep" Fontdevila was so fascinated by the young artist that he thought about joining him in Paris. But what exactly happened to the artist-ethnographer in the paradigm shift between Paris and Gósol? He came to seek out the tools he needed to join the avant-garde. But what he discovered here was an experience that enabled him to see the world in a different way and to find his own path—a bit like Gauguin (in Polynesia or Pont-Aven), Matisse (at Collioure or with the African masks), or Derain (at the British Museum). "The equipment of our social being can be dismantled and reconstructed by the voyage," the philosopher Maurice Merleau-Ponty would write sixty years later. "It provides [. . .] a sort of lateral universal, which we acquire through the ethnological experience and

its incessant testing of the self through the other person and the other person through the self."* In fact, after a few weeks, Picasso began signing his letters to Casanovas with the illuminating phrase "*Un abrazo de tu amigo Picasso dit El Pau*[11] *de Gósol.*"[12] Meanwhile, the only self-portrait he would create while he was there (*Self-Portrait*, 1906, charcoal on paper, private collection) was a geometric composition, presenting the artist as a rough, stubborn boy, accentuating the skull beneath his hair, the size of his ears and mouth, reducing his eyes and pupils by freezing them in a slight squint. What a world away this image is from the colorful, dynamic Parisian dandy of 1901's *Yo, Picasso!*

By the middle of that summer, it would seem that Picasso was experiencing the "fundamental antagonism" between "complex, evolved States"[13] and "societies in pandemonium"[14] described by Roger Caillois. France represented the sovereignty of the lawmaker's world,[15] a bureaucratic, standardized society where the State, "regarded as the paradigm of centralization,"[16] had since the seventeenth century practiced the "cult of the Nation."[17] Gósol represented the sovereignty of "the frenetic, an inspired and terrible god, unpredictable and paralyzing, an ecstatic, powerful magician, the master of metamorphoses, frequently the leader and guarantor of a troupe in bizarre masks."[18] So, compared to Gósol, Paris was a legal State next to a *communitas*—a community that belonged to a territory beyond the law, on the margins of the center of power. High up in the mountains, Braudel wrote, "social archaisms (such as the vendetta) persist, [. . .] above all for the simple reason that the mountain is the mountain [. . .]. Here there is no tight urban network, and therefore no administration, no cities in the full meaning of the word; there is also no police. The mountain is the refuge of freedoms, democracies, peasant 'republics.'"[19] In Paris, Picasso was always resistant to institutions. In Gósol, he became a genuine *social agent*. "He was

* Translation by Richard C. McCleary.

really like a fish in water here," insists Clareta Castellana, who runs the general store in the village.

"Until now, I continued drawing as I had in Paris, and I began one or two new things."[20] The artist pursued his work on the theme of the harem (following his shock at seeing Ingres's *The Turkish Bath*) and on adolescents (started by *Boy Leading a Horse* in early 1906) before exploring new subjects. After all the clowns and acrobats, the prostitutes and absinthe drinkers of his Parisian period, in the Pyrenees he focused on three models: Fernande, Fontdevila, and a local woman named Herminia. The artist-ethnographer worked more furiously than ever. As we can see from his letter to Stein, he was aware of the aesthetic evolution he was undergoing. The same thing went for his correspondence with Casanovas: "The village is very beautiful and yesterday I began something," he announced a month after his arrival. "We'll see what happens [. . .]. I continue to work and, this week, I was given a tree trunk and I will start something else."[21] His Gósol experience functioned as a nexus bringing together all his previous influences: Ingres, Gauguin, El Greco, Velázquez, Iberian art, and above all Cézanne,[22] to which was added the local Roman art. It was hardly surprising, then, that Picasso should find inspiration in the vicinity of the solemn Roman-era wooden Virgin locked away in the village church.

Like Cézanne slaving away on the Sainte-Victoire mountain, Picasso obsessed over his portraits of Fernande (*Fernande with Shawl*), Herminia (*Woman with Loaves*), and Pep Fontdevila (*"Death Mask" of Josep Fontdevila*). Little by little, he abandoned details, anecdotes, narration, representation, and moved toward stylizations, simplifications, archetypes. *Woman's Torso* is perhaps one of the best examples of these "characters without narration" that he was seeking.[23] Who was this unidentified woman? We don't know and it doesn't matter. On the left, two clay pitchers and the sketch of a table corner melt into ocher shadings, while all we see of the character are three-quarters of the face, the ear, the neck, the shoulder, the breast, the naked torso, and the left hand holding the dress and the strap

lowered over the hips. Who was this woman? An archetype. *The Harem, Reclining Nude (Fernande), Two Youths, Peasants, Nude Boy, Girl with a Goat, Teenagers, The Hairstyle, Standing Female Nude, La Toilette*: so many works in which the outline seems hazy, a development that would continue to mark his ineluctable progress.

The rugged, dignified portraits of Fontdevila with sunken eyes and a jutting jawline gave way to pared-down lines, and the portrait became an icon. Picasso continued to move toward the universal. It was his discovery of "the solution of the mask," which "cancels out emotions, expressions, feelings, anecdotes, and allows the human figure to reach the anonymity required by pictorial purity."[24] That August, Picasso wrote a short phrase in his little ethnographer's notebook, a sudden, impassioned realization, addressed to himself: "*Un tenor que da una nota más alta que esta escrita en la partija: Yo!*" ("A tenor who sings a note higher than the one written in the score: Me!") Now convinced of his capacity to lead the avant-garde, totally convinced that he had passed his initiatory experience in the village of the Pedraforca with flying colors, no longer harboring the slightest doubt about his genius, he sent an urgent note to Casanovas, begging him not to tell anyone about his decision (and especially not his mother), and he went back to the French capital, following the route described in his notebook: "Gósol, Vallvé, Puixcerdà, Ax, Paris, mule, stagecoach, stagecoach, train," without returning to Barcelona.

There can be little surprise, then, that after becoming a protagonist in his own right in his Pyrenean "shelter"—this "country for free men"—Picasso found the aesthetic solutions to create his own modernity. But there was more to this, and again it is Braudel who enlightens us: "No civilization was forced to work on itself, to 'share' itself, to tear itself apart as much as the Iberian civilization at the height of its pomp, from the Catholic kings to Philip IV," he wrote. "It could have remained a bridge between Europe and Africa [. . .] for centuries [. . .]. Europe reached the peninsula via the Pyrenees, the Atlantic, and the inland sea."[25] For Picasso, the ultimate

offspring of an Iberian peninsula torn apart and divided among its multiple affiliations, it was once more the Pyrenees and the smugglers' paths that, at the start of the twentieth century, would lead him back to Europe, this time journeying the other way, to gloriously inseminate the continent with all its Iberian dimensions.

Today, it's almost as if Picasso never left Gósol, so haunted does the village seem by his presence. Beyond the existence of the Picasso Center, the villagers refer to the road he took on his way back to Paris as the Cami Picasso, and the street outside the Cal Tampanada as the Carrer Picasso. And when families sit together on the circular benches of the Plaça Major, the statue in the middle of the circle is *Dona dels Pans* (Woman with Loaves) by Josep Ricard Garriga, based on Picasso's painting—yet another way of looking at their own history through his eyes. On Saturday, August 11, in the municipal sports hall, the theater company Cia LoPereBufa is presenting a comedy entitled *L'Afinador* (The Tuner), performed by three young Catalan actors. The male character, Pere, when talking about his job, returns to the social figure of the artist, in words that Picasso would not have contradicted: "I am an actor, as they say. Braggarts, low-lifes, smugglers, bandits, actors, and musicians. We're all tarred with the same brush . . ."[26] In the summer of 2018, the appearance of the artist's face on the mask of someone spinning through the crowd, like a magic spirit escorted by giants, makes it feel as if Picasso is back to stay.

The 2018 festivities began with the arrival of a churros hut on the Plaça Major, then the installation of a gigantic inflatable monster for children to play on, just in front of the second-floor balcony of the Cal Tampanada, the very same balcony where Picasso must have stood 112 years earlier. The balcony has, for several months, been covered by a green tarpaulin because it is on the verge of collapse. The techno party began around 1:30 a.m., seven hours after the start of the traditional ball. The ball always takes place on the Plaça Major, where girls in shawls and espadrilles dance the sardana, whirling their long skirts and always placing their left hand on their partner's

shoulder and their right hand inside his left hand. After four crazy days, Gósol's Festa Major ends with a magical witches' sabbath, the procession wandering around for hours, dancing and whirling to the sound of drums through every sloping street in the village, a thousand fireworks sizzling into the serene sky.

15.

SIXTY WORLD LEADERS VISITING THE BATEAU-LAVOIR

Only when President Macron celebrated the centennial of the 1918 armistice did I realize the dramatic gap between Picasso's reception when he first arrived in Paris as a young "foreign" artist and his current fame in the country, gained by dint of his own efforts. Musée d'Orsay, Saturday, November 10, 2018. Right palm raised to face the visitor as if to say "Halt!," left hand lowered, it is *Woman with a Fan*, freshly arrived from the United States, who greets them all. Hieratic, stiff, isolated, at the start of the show, what mysterious signals is she sending today? They are sixty world leaders, all official guests of the French government, on the eve of a grand-scale commemoration (the Armistice of 1918). A concert has been planned in their honor. Was this a coincidence? A bit of last-minute opportunism? The visit of the *Picasso: Blue and Rose* exhibition has been chosen over the musical evening, and it is *Woman with a Fan*, one of Picasso's most enigmatic creatures—we don't know the model's identity, we don't understand her gesture, we can barely make out the influence of Ingres—who has become the unlikely mistress of all ceremonies.

So it is she, the inexplicable, the cryptic, the mute creature who's apparently protecting the three hundred masterpieces gathered in this Paris exhibition for three months—and this, it would seem, for the very last time. It is a marvel, a tour de force, an impressive event.

Throughout the halls, Picasso's people appear, one after the other: those he rubbed shoulders with from 1900 to 1906 in the seedy, bohemian parts of the metropolis; gaudily clad dwarf women; the morphine addicts with their stupefied grins; old gals done up like a dog's dinner; isolated girls, worn out, tormented, their arms raised; exhausted ironing ladies, their backs hunched; mothers wearily dragging their children along; hookers, battered and bruised; absinthe drinkers, wandering, lost; prostitutes forced to wear a special hat as a mark of their trade, pale and frozen to the bone; and other ladies of the night at the bar—all of them completely in blue, exuding weakness and exhaustion through these tragic paintings "wet and blue like the humid depths of the abyss," according to Guillaume Apollinaire—followed by the cohort of those nomadic performers, elegant, otherworldly, acrobatic, rose-tinged, almost all of them here, his clowns, his carnies, his harlequins, his saltimbanques, the child precariously balancing on a ball, the trained monkey, the tame crow.

As the visitors approach the days to come, filled with the remembrance of our millions of dead, ready to debate peace, patriotism, the need for multilateralism, and of some hybrid form of governance in the face of war, how can one assess the impact of the show? Who, of these sixty leaders, will read the documents, photographs, and letters on display in Hall 12? Who will understand the meaning of the enlarged black-and-white image that covers an entire wall in the central corridor? Who will recognize, in that pitiful, flea-ridden, miserable building the slum of the Bateau-Lavoir, where Picasso produced all his works at the time? Who will know that those "cinderblocks, wood, and bits of plaster," hastily cobbled together with planks and panes of glass on the side of a Montmartre hill, had only a single faucet providing drinkable water for more than thirty studios? Who will make the connection to the fire in Marseille that, only a few days before, destroyed a slumlord's ramshackle building—another "special" lodging—and took ten human lives? Who, in the end, will be sensitive to the irony of such a visit?

Actually those masterpieces so highly regarded today seemed very different in the France of 1901 when used as evidence by police chief

Rouquier against the young Picasso—intruder, "foreigner," "anarchist under surveillance" in fin-de-siècle France. Tonight, among the visitors to the Musée d'Orsay, who will grasp the contemporary echoes to the challenges that faced Picasso, in a French society still marked by social and political tensions after the anarchist attacks of the late nineteenth century? Doesn't the scandal of the greatest artist of his age, stigmatized and targeted *because he was a foreigner*, resonate now with the rebirth of our ordinary xenophobias? Doesn't it amplify the manifestations of hostility (retreat into nationalism, hatred of the other, social stratification, the building of border walls) in the face of our terrible migration crisis? Will the sixty world leaders visiting the Musée d'Orsay make the link between the alleged threat of "Picasso the foreigner" and that of today's migratory caravans? Will the *Woman with a Fan*, an immigrant from Washington, D.C., succeed in alarming some of these bureaucrats with her warning gesture? Could this encounter with Picasso's people, the photograph of the artist's slum, have any effect on the chaos and criminality spread by the occupant of the most famous building in Washington? And what are we to make of the message sent by *Family of Saltimbanques*, the one great masterpiece absent from this exhibition? Since 1963, due to a stipulation set down by the collector who donated it to the museum, *Family of Saltimbanques* has found itself bizarrely cloistered in the National Gallery of Art in Washington, D.C., directly opposite the White House. In that hall on the second floor of the East Wing, the label on the wall beside the painting reads: "Circus performers were regarded as social outsiders, poor but independent. As such, they provided a telling symbol for the alienation of avant-garde artists such as Picasso." Pertinently, the caption also mentions the "placelessness" of the six characters "in the cracks of [French] society."

■ ■ ■

At this point in my inquiry, if we take into account the unpublished archival sources (particularly those concerning the history of the

French police), one can easily discern cycles, structures, and re-currences in Picasso's first six years in the labyrinth of Paris. His situation as a foreigner appears very different and much more un-comfortable than I'd imagined, a web of anomalies, discrepancies, even scandals at times, and I believe this provides us with a new key, which gradually becomes obvious, to reading his work. "Painting is just another way of keeping a diary," the artist declared in 1932. The revelations discovered in those new archives allow us a differ-ent reading of Picasso's "diary" during his time in France, while resonating strangely with some of the most burning questions in to-day's societies. In fact, it was only gradually that Picasso was able to assert his identity in the labyrinth of Paris, during an odyssey in five stages. And most of the time it was other pariahs—whether groups or individuals—who acted as "gate-openers": the network of Cata-lans in Montmartre (whose generosity became a curse); Max Jacob (who provided access to the French language and the first mores); Guillaume Apollinaire (who communicated the power of poetry, the fearlessness of creativity); the Steins (who contributed the financial means and the freedom of aesthetic choice); and, lastly, the commu-nity of Gósol (which enabled him to access an integrated identity).

What was Picasso's relationship, throughout his life, to his vari-ous ties: Spanish, French, Andalusian, Catalan, Castilian, anarchist, Communist? How did his work reflect his living conditions (initially precarious, then ever more complex)? How did the artist manage to take advantage of the cracks into which French society marginalized the *foreigner* it saw in him? How, in the face of the political hazards of the twentieth century, through two world wars, a civil war, and a cold war, in a continent torn apart by nationalism, did he impose his masterful work on the world? How did he organize his alliances, his strategies, his own territories? How did the young man who arrived in Paris for the Exposition Universelle of 1900—one of those historic moments when the intensification of nationalism and the "genius of France" reached new heights—succeed in developing a new concep-tion of his cultural affiliation?

At the same time, on the other side of the Atlantic, a figure who would become famous in the United States was also worrying about his cultural affiliation. Twelve years older than Picasso, W.E.B. Du Bois was about to set sail for Paris. It was mid-June, 1900. He was taking several boxes to "one of the finest, perhaps the very finest, of world expositions" as he himself put it, because he believed that the event in Paris "typified what the European world wanted to think of itself and its future."[1] Du Bois would present, at the Social Economics pavilion, a selection of five hundred photographs entitled "The Exhibition of American Negroes"—a global first, since African-Americans had been excluded from the World's Columbian Exposition of Chicago in 1893.[2] Complete with maps, charts, and commentaries, these photographs showed Black people in all their diversity, with an emphasis on smiling, affable doctors, lawyers, and intellectuals, taken in flattering social situations. In the pages of the *American Monthly Review of Reviews*, a delighted Du Bois explained that there was "no more encouraging answer than that given by the American Negroes, who are here shown to be studying, examining and thinking of their own progress and prospects."[3] Du Bois was thus able to reveal the "other face" of his community to the vast numbers of people who rushed to Paris that year (almost fifty million visitors!) while also denouncing the prejudices and stereotypes that stalked Black people in the United States.[4]

During the last week in July, Du Bois traveled to London to attend the first Pan-African Congress, which took place at Westminster Town Hall. There, during the closing ceremony, as the guest speaker, he delivered the final address, "To the Nations of the World." "In the metropolis of the modern world, in this closing year of the nineteenth century," he announced gravely, "there has been assembled a congress of men and women of African blood, to deliberate solemnly upon the present situation and outlook of the darker races of mankind."[5] This prophetic speech contained the central thesis of Du Bois's book *The Souls of Black Folk*, which, three years later (and thanks to a geopolitical vision that now went beyond the example of

the United States), would become a cult success.[6] The book opened
with these powerful words: "Herein lie buried many things which if
read with patience may show the strange meaning of being black here
at the dawning of the Twentieth Century. This meaning is not with-
out interest to you, Gentle Reader; for the problem of the Twentieth
Century is the problem of the color line."[7]

In this magnificent book comprising fourteen chapters inter-
spersed with traditional songs, Du Bois responded to his country's
racism and segregation by refusing to be defined externally, whether
by another person's gaze or by the drastic choice of the double
conscience—between assimilation and separation, between U.S.
American identity and Black identity. As a radical activist trained in
Europe, he suggested the option of the cosmopolitan intellectual who
manages to integrate internally all the worlds of which he is made.
For Du Bois, as would also be the case, later, for Léopold Sédar Sen-
ghor, "reflection on the Black condition was in itself emancipation, in
the sense that it liberated them from unbearable internal contradic-
tions and this double identity."[8] Picasso responded to the xenophobia
of French society by refusing, in the same way as Du Bois did in the
United States, to be defined as "foreign" in the eyes of the other—
neither separate nor assimilated.[9] With his experience of Gósol—
overcoming the binary opposition imposed on him and integrating
the plurality of his cultural affiliations—the artist became that "tenor
who sings a note higher than the one written in the score." And,
from then on, as a pioneer of cosmopolitan contemporary forms,
Picasso—as global artist living in France—was able to take the lead
in the avant-garde.

II

LEADING THE AVANT-GARDE

1906–1923

The advent of strategy

1906–1914

■ ■ ■

16.

"PROFOUNDLY SCULPTURAL WORK!" . . .
VINCENC KRAMÁŘ

35, 1907 (cardboard, gouache)
Flat tree, perfect black outlines blue
Malachite in middle branches around red. Edges of leaves
 Veronese [. . .]
Lower left corner dark red, filled with black (like velvet.) [. . .]
stunning from a decorative point of view. Colored. Splendid like
 enamel.
Precious metals. Like *cloisonné*.
He wants to paint like Matisse.
The blue in the center resonates against the larger yellow surfaces.
Red against green. So, complementary.
Magnificent work.[1]

<div align="right">Vincenc Kramář</div>

"*Picasso: vystava u Thanhausera 1913 jaro*" ("Picasso: exhibition at Thannhauser, spring 1913"), wrote the art collector Vincenc Kramář on the cover of his notebook—and I wish I knew enough Czech to fully appreciate the enthusiasm radiating from its thirty-four pencil-scrawled pages, intercut with sketches, on cheap paper. The adjectives ("stunning," "splendid," "magnificent") speak for themselves, however, and—scattered with exclamations of surprise and spontaneous judgments captured as they were made—Kramář's notes read like a long prose poem in celebration of Picasso's work.

This historic document was a reflection of the event that inspired it. The Munich exhibition, with its seventy-three paintings and thirty-eight drawings produced by the artist between 1901 and 1912, was his first retrospective in Germany.

The Boy with a Pipe (1905), a marvel from the Rose period, receives the ultimate compliment—"the most beautiful work of the first period"—while *Seated Harlequin* (1902) leaves the visitor perplexed— "attempt [. . .] at sculptural abbreviation, but remains on the surface [. . .] arms like rubber. [. . .] Unattractive."[2] Intrigued by the mysterious *Landscape* (1907), Kramář picks up on the juxtapositions of colors that resonate with one another, compares the tangled lines to the compartmentalization of enamel, emphasizes a probable rivalry with Matisse, and notices the beauty of the crosshatched black in the lower left-hand corner because it seems "like velvet," a remark that incidentally celebrates the artist's transcendence of the line between fine arts and applied arts. Faced with *Still Life with Flowers* (1908), elegant, structured, Cézanne-like yet classical, Kramář is convinced: "Superb work. The first true Picasso. Beginning of crystalline shapes and chiaroscuro."

But it is his commentary on *Woman's Head* (1908) that interests me most. Produced barely three years after *Boy with a Pipe*, this garish, violent, dissonant, even brutal work, with its cold colors, from Picasso's African period, demonstrates very clearly, like a Stockhausen sonata played after a Bach prelude, the aesthetic revolution Picasso's work had undergone. With its asymmetric green mask—"slice of Brie" nose, large mismatched eye sockets (one pale yellow, the other blue), thick blue lips—savagely crosshatched in blue, white, and brown, it instantly caught Kramář's attention. "Profoundly sculptural work!" he wrote, overcome.

Reading Kramář's notes (February 1913) is enchanting, like jumping into the wonderland developed for Picasso by his dealer Daniel-Henry Kahnweiler and finding ourselves, like Alice in the land of the cubists, pushing open "doors leading to other worlds and to all times."[3] The reception to cubism here was like a deep dive into

the continent woven from multiple threads that went far beyond national frontiers, now on the edge of the abyss, only eighteen months before the start of World War I. The historian François Hartog described this period as a "time of disorientation [. . .] between two chasms and two eras." He takes us back to the predictions of Paul Valéry who, a "good seismograph" of the "deep faults that had opened [. . .] in the European world," wrote in 1919 of "the European Hamlet" standing "on a vast terrace in Elsinore" and watching "millions of ghosts": "He thinks about the boredom of reliving the past, of the madness of always wanting to innovate. He totters between two chasms."[4] But didn't Picasso, too, foretell this catastrophe? Picasso, who would devote himself to deconstructing the world, unwinding the clocks, highlighting the dismemberment at work while Einstein was discovering relativity?[5]

We left Picasso in August 1906 on his way back from Gósol, with the conviction that nothing could stop his becoming the leader of the avant-garde. The mechanism had been set in motion and it began to run at full tilt. Pursuing his explorations of Paris, discovering new horizons (Cadaqués in 1910, Céret in 1911, Sorgues in 1912), seeking out new contemporary trends (from Henri Bergson's philosophy to cinematography and aviation), borrowing techniques inherited from arts and crafts in the equipment and materials of Georges Braque, he passed through a succession of spectacular phases (primitivism, the influence of Cézanne, analytic cubism, the breakup of homogeneous shape, synthetic cubism, collages and papiers collés), producing works at a frenetic rate. The very first work to build on the lessons he had learned in Gósol was undoubtedly *Gertrude Stein* (1906), which he finished very quickly, by applying the idea of the mask to the writer's face (a solution he had experimented with on old Fontdevila). There followed a burst of other artworks, including his "exorcism painting"[6] *Les Demoiselles d'Avignon* (1906–07), the wonderfully angular *Self-Portrait* (1907), *Nude with Red Drapery* (1907), *Three Women* (1908), the sumptuous *Woman with a Fan* (1908), *Woman's Head (Fernande)* (1909), the series of portraits depicting his art dealers (1910), *Still Life*

with Chair Caning (1912), *Woman in a Chemise* (1913), and *Artist and His Model* (1914).

It was a period so prolific, so dense and revolutionary, that it is sometimes considered by critics the only period among Picasso's long career worthy of serious study. The Leonard A. Lauder Research Center in New York, for example, was solely created to examine the cubist period and four artists: Picasso (obviously), Braque, Léger, and Gris.[7] The sheer volume of literature devoted to cubism—often concerned primarily with formal style questions—is dizzying, almost oppressive. For weeks, I accumulated exhibition catalogs, which piled up precariously on my bookshelves: *Picasso and Braque: Pioneering Cubism; Matisse-Picasso: The Enemies of Cubism; Cubism: The Leonard A. Lauder Collection; Icons of Modern Art: The Shchukin Collection.* In recent years these studies have toppled the barriers between cultures and languages, revealing new information, putting a new global spin on old questions, looking at the art in new ways, unearthing new archives. By venturing into the labyrinth of aesthetic questions, by seeking out new angles, by charting Picasso exhibitions in countries other than France, by capturing these multiple facets, these works contribute to enriching the history of ways of thinking. My investigation into Picasso's cubist years took the form of a determined, chaotic quest, with advances, periods of stagnant questioning, and occasional regressions. And so, switching back and forth between the catalog (in German) for the Picasso exhibition at the Moderne Galerie in Munich and Kramář's handwritten notes (in Czech, with an English translation),* I found myself in Munich, back in February 1913, discovering one by one the 114 works by Picasso (sent by Kahnweiler, the Parisian dealer, to Thannhauser, his colleague in Germany), each one commented upon by Vincenc Kramář, the collector from Prague.

It was a privilege to experience this exhibition through Kramář's eyes by reading his personal notes. The sole cubism collector with

* Thanks to the Digital Archives Initiative accessible at the Leonard A. Lauder Center.

a first-rate background as an art historian, Kramář was an unusual character. With the thesis he defended in 1901, *Frankreichs Verhältnis zur Gotik in der Neuzeit* (France's relationship to the Gothic in modern times), he was the protégé of his three prestigious teachers from the Vienna school: Aloïs Riegl, Franz Wickhoff, and Heinrich Wölfflin, all of whom had impressive backgrounds of their own. These three art historians taught him to "see," to "cultivate one's gaze" based on the shapes themselves in order to analyze the historical conditions of artistic creation, before confronting the artist's social position. Wölfflin drew on the lessons of his own ethnological teacher, Wilhelm Heinrich Riehl, who used the phrase "the eye of an era" to explain to Kramář: "Each generation sees in a different style [. . .]. With each major mutation in the morals of a society, there also comes a new way of looking."[8] Thanks to his years in Vienna during a crucial period (the early twentieth century), Kramář was able to penetrate the closed circle of these legendary figures, these German-speaking art historians circulating at the borders of the Austro-Hungarian Empire, the German Empire, and German-speaking Switzerland, for whom the history of art "was regarded as a natural way of learning to see the world."[9] They enhanced the tools of their discipline with philosophy, psychology, ethnology, philology, and history in order to ascend to the level of supreme wisdom. The art historian, they believed, must possess, simultaneously, "the foundations of universal culture"[10] and the capacity "to observe and embrace the phenomena of the present."[11] These men were also tireless travelers, attentive to artists living in far-off places or artists producing forms of "applied" art (like Riegl with his research into Egyptian textiles or Oriental rugs) that were sometimes regarded by other critics as inferior. In 1905, in *Über die Methode geschichtlicher Forschung auf dem Gebiete der modernen Kunst* (On the historical research method in modern art), Kramář critiqued the outdated methods of Bohemian academics and reaffirmed the necessity, when faced with contemporary art, to maintain the rigor of the "scientific approach" developed for classical art, a sign of his audacity for the period.[12]

From his very first trip to Paris, where he stayed for the entirety

of October 1910, Kramář was interested in Picasso. "Paris is an incomparable wonder and I feel at home here," he wrote to his fiancée, having toured the museums of Rome, Berlin, London, Vienna, Venice, Florence, and Munich. He would systematically visit the Louvre, the Luxembourg, the Petit Palais, the Moreau-Nélaton collection, the Thomy-Thiéry collection, and even the Panthéon, where the murals by Puvis de Chavannes disappointed him because they were "too anemic, even academic, for [those of us] with Gauguin in our hearts."[13] And then this conscientious, conventional-looking man, with his perfectly manicured mustache, his bow tie, and his eternal three-piece suit, began a methodical tour of all the city's art galleries: Bernheim-Jeune, Durand-Ruel, Berthe Weill, Kahnweiler, Georges Petit, Ambroise Vollard. It was on October 7, 1910, at the Vollard gallery, that Kramář spotted a work by the man who would become his favorite artist. "Picasso, a large painting. Magnificent. (1902?) similar to Matisse," he wrote.

The next day, electrified, he confided to his brother: "In the last few days I have spent all my time visiting art dealers, and everything I've seen of modern art is beyond my wildest dreams. Yesterday was one of the best days. I couldn't even sleep afterward."[14] On October 20, at the shop belonging to art dealer Clovis Sagot, Kramář bought his first two Picassos: an engraving, *The Lovers* (100 francs), and the drawing of a head, most likely executed in Gósol (50 francs). Five days later, at the Kahnweiler gallery, he acquired a copy of Apollinaire's *L'Enchanteur Pourissant* (The Rotting Magician), illustrated by Derain. On April 28, 1911, back in Paris, he went straight to Kahnweiler's gallery at 28 Rue Vignon to pursue his obsession with Picasso—particularly with his years of change and acceleration—and, as usual, filled his notebook. Back in "the crucial year" of 1907, Picasso, "almost without warning, [. . .] becomes passionate about New Caledonia, New Guinea, Easter Island, the Marquesas Islands."[15] By 1909, he was in "transition toward his last period, but still moving slowly [. . .]. Lots of delicately colored still lives, but also figures with bright edges. The start of crystals. Gray

too, and green. Cold chromatic harmony." Then came the year 1910, which Kramář saw as "the next stage in Picasso's evolution. Crystals and grays, sometimes blues. Some purely linear and crystalline compositions already." And then there was 1911, with its evidence of "new progress, a new period in other words—lines, planes, crystals, harmonies: mostly grey, black, and brown." On May 22, at an auction in the Hôtel Drouot, Kramář bought a gouache, *Harlequin* (275 francs), and four days later spent 600 francs at the Vollard gallery on the 1909 sculpture *Head of Fernande*. He did not stick to one period or one material but was obsessed with the idea of acquiring a collection that followed the development of the artist's aesthetics. He was also increasingly in love with Paris: "I speak to people in my terrible French. They are admirably patient with me, more tactful than any German would be [. . .]. I work in a fever [. . .] all the pleasure I feel now is tainted with bitterness at the idea that I wasn't able to spend a year or two studying in Paris."[16]

Did the people Kramář spoke with in Paris understand that next to being a budding collector he was also becoming an expert, an art historian who would one day become a cubism theorist? In fact, Kahnweiler went out of his way to help his client see the El Grecos in the artist Zuloaga's private collection. "My dear friend," the dealer wrote to Picasso, "I am writing to ask you for a favor on behalf of Dr Kramář. [. . .] Do you know whether Zuloaga is in Paris &, if he is, whether you might intervene to ask him to grant Dr K permission to go and see his collection? Thank you in advance, on my own behalf and that of Dr Kramář, Your friend, K." Picasso immediately went to his table and in his elegant handwriting composed a request to his compatriot and colleague. *"Amigo Zuloaga, Quiere Usted enseñarle sus Grecos al senyor K de Viena que le presente que ha hecho casi el viaje per verlos [. . .]. Gracias, Maestro y mande a su amigo Picasso, 27 Mayo 1911."*[17] On May 30, in possession of the precious note from Picasso that Kahnweiler had given him—"Zuloaga is in Paris [. . .]. Picasso advises you to arrive tomorrow around noon with this letter, as that is the time of day when you are most likely to find him"—Kramář

went to 54 Rue Caulaincourt and visited Zuloaga's studio, where he was able to admire the private collection of El Grecos. It may have been at least partially in gratitude that the next day he wrote a check of 3,500 francs to Kahnweiler (for works by four artists including Braque, Vlaminck, and van Dongen), while further extending his Picasso collection to include two paintings—*Woman's Torso*, 1908 (1,000 francs), and *The Port at Cadaqués*, 1910 (800 francs)—plus a gouache, *Seated Nude*, 1909 (350 francs). He also bought two Picasso watercolors (*Reclining Woman* and *Standing Female Nude*) and a sketch (*Female Nude*) from the Sagot gallery.

After this, everything accelerated. Kahnweiler sent Kramář photographs of some new paintings, fresh from Picasso's studio, and Kramář—completely addicted—expressed his desire for *Girl with Mandolin*. Kahnweiler replied that it had already been sold, but suggested a still life, *The Glass* ("you don't have one yet"), as well as two very large paintings produced in Céret the previous summer: *Man with a Clarinet* and *The Poet*. The fall of 1911 saw the artist, the collector, and the dealer engaged in a three-way dance more intense than ever, and when Kramář returned to Paris in late November, his passion for Picasso grew even more fevered. "Picasso's oldest things have all been sold," he wrote to his wife. "Everything he's done this year, though, is still available. I've already chosen three of them. Yesterday, spoke with Picasso and Vlaminck."[18] In his ever-more detailed notes, Kramář picked out, with unerring precision, paintings revealing the advances that Picasso made, season by season (from the winter of 1906 to the spring of 1909), toward a radical aesthetic breakthrough: "1906 winter: heads still primitive like his self-portrait, dark eyes drawn in an almost cursory way.[19] 1907 spring: figures already more sculpted (nose) [. . .] 1908 spring: major steps (*Two Women*) [. . .] simplified colors, more serious. 1908 summer: calmer and more harmonious [. . .] 1908 fall: at Rue des Bois near Verneuil, Oise (green painting at Stein's) [. . .] 1909 spring: great progress."[20]

Finally, as if afraid of missing something, Kramář continued roaming the city until he was "exhausted" and "on [his] last legs."

Kept on tenterhooks by the dealers, excited by his visits to the art-
ist, stimulated by his discovery of private collections (including the
Steins', of course), obsessed by his own fascination with this work
and the way it was changing before his eyes, Kramář examined it as
if trying to exorcise it, and he kept buying: "I bought some unique
pieces like Picasso's 1907 self-portrait. I'll be bringing back about 10
paintings [. . .]. Sunday morning at 11, I go to Picasso's studio, and
I see him every day, late in the afternoon."[21] On December 8, 1911,
the collector would spend almost 7,000 francs at the Kahnweiler and
Vollard galleries to purchase eight major paintings by Picasso, span-
ning the years 1907 to 1911, the period that he found spellbinding.

Barely three months later, Kramář was back in France again. "I
feel good in Paris. As you know, this is the place where I feel most
at home," he wrote to his wife, "and you should perhaps get used to
the idea that we will be moving here to live. I'm going to make the
decision before I leave."[22] In his notebooks, he sketched *Portrait of
Clovis Sagot*, *The Jester*, *Woman with a Fan*, and wrote a long com-
mentary on *Gertrude Stein*, with its allusions to Cézanne and Ingres.
He bought another Picasso gouache, at the Sagot gallery this time,
for 800 francs. But it was during the morning of April 30, 1912, in the
studio on Rue Ravignan, that something new clicked into place for
Kramář. That day he visited the artist's inner sanctum again and felt
the immense privilege of discovering another new aesthetic break-
through, witnessing and admiring several new works-in-progress
including *Still Life with Chair Caning*, Picasso's first-ever collage—
"On a table covered with linoleum, in the foreground, a glass con-
taining something grayish-orange, a beautiful, heavy, carved glass,
wonderfully analyzed and complex"—and *Still Life with Violins*, a
description of which filled three long sheets: "very quickly done, like
Girl with Mandolin in 1910. Infinitely rich. Perhaps nowhere closer
to Ingres."[23] Now admitted into the creative intimacy of his favor-
ite artist, Kramář was still blown away by earlier paintings such as
Two Women at a Bar ("models like mountains furrowed by life and
fate"), *Young Acrobat on a Ball*, *Boy Leading a Horse* ("a painting of

pure naïveté, absolute candor"),[24] which were described at length in his notes, so he wouldn't forget them. At Kahnweiler's gallery, he thought about buying five more new paintings before reluctantly traveling to Spain, as this message to his wife clearly shows: "I should stay here, study the Picassos [. . .]. If only we'd come to live in Paris after getting married! Then I wouldn't find it so hard to leave!"

On May 5, 1912, Kramář bought *The Poet* and a still life from Kahnweiler. On July 8 of that year, on his return from Spain, he would also feel compelled to purchase *The Boxer*, *Absinthe and Cards*, *The Chop*, and *The Ice*, four large paintings that cost him an extra 2,850 francs. In the meantime, however, Kramář stopped off in Sorgues, where Picasso was working, and what had to happen happened: now it was the artist who, charmed by his collector's passion and erudition, began to desire his gaze, seek his approval, continue to conquer and charm him. On July 3, Picasso wrote anxiously to Kahnweiler: "You tell me that Kramář took some recent things with Ripolin I think maybe. I'm curious to know which ones (and it's not a bad idea to keep *The Poet*)."[25] For both the artist and the dealer, the collector had become so integral to creation that, whenever Kramář was in the vicinity, Picasso would mention him constantly. "Kramář is here. Have the paintings from Céret arrived?" he wrote on June 29 from Céret, where Kramář had gone to visit him. "If not, I'm going to write to Manolo and demand to know why. I told him to send them right away and it would have been good if you'd been able to show them to Kramář."[26]

In December 1912, Kramář mentioned his intention to write about this "new art," and Kahnweiler started bombarding him with press releases on his favorite artist: "This will be the first article about Picasso written by someone who knows what he's talking about [. . .]. I hope that the text will also appear, translated, in French, German, and Italian magazines because I am eager to read it."[27] But let us leave Picasso in Sorgues with Eva, his new girlfriend, in one of the most euphoric periods, both personally and professionally, of his life.

In the spring of 1913, during the aforementioned exhibition at the Thannhauser gallery, the imperturbably analytical Kramář rushed to admire the 114 assembled artworks by an artist he knew so well, in their first complete chronological presentation.[28] In just over two years since his first trip to Paris in October 1910, Vincenc Kramář had developed an extraordinary ability to understand Picasso's evolution during the most audacious and difficult period of his career. And if, discovering *Woman's Head* (1908) with such enthusiasm— "profoundly sculptural work!" he'd noted—Kramář was still capable of refining his conception of Picasso's development, this was surely due to the aesthetic dialogue about the artist begun by the gallery owner Daniel-Henry Kahnweiler. This dialogue, conceived by the dealer as essential to his mission to serve artists, aligned perfectly with Kramář's investigations. This should not be surprising: Kramář and Kahnweiler, as we will see, worked within the same realm of references, codes, reflexes, and cultural horizons.

17.

THE MYSTERY OF 28 RUE VIGNON . . . DANIEL-HENRY KAHNWEILER

I didn't know any art dealers, enthusiasts, artists, or critics in Paris.[1]

—Daniel-Henry Kahnweiler

Let us leave the magical threesome to their passions in the summer of 1912—the collector to his limitless desires, the artist to his creative power, the dealer to his need for control—and return to Kahnweiler's first steps in Paris. "The art dealer Eugène Druet has moved to Rue Royale [. . .]. Close to here, I have found a small boutique, at 28 Rue Vignon. It is occupied by a Polish tailor. His business can't be doing too well. All he wants is to sell it. I am convinced that he was happy to con me, because he rented it to me for 2,400 francs per annum and it was only costing him 1,800 [. . .]. I brought in a decorator who tried to steal from me because he thought I was just a kid [. . .]. He put sackcloth on the walls as I asked him to. We vaguely refurbished the ceiling [. . .]. And then, one fine day [. . .] I raised the metal shutters, I hired a young, somewhat feeble-minded boy named Georges, and I opened up the gallery."

Paris, February 22, 1907. A Polish artisan who was trying to "con" him, a decorator trying to "steal from" him, a tiny space (169 square feet) hidden behind the Place de la Madeleine with fabric

hung hastily on the walls to cover their poor state, and—to crown it all—the hiring of a "feeble-minded boy" as his only assistant. By his own admission, these were the conditions that prevailed at the inauguration of one of the greatest art dealers of the twentieth century during one of the most radical aesthetic revolutions in history. Naïveté? Candor? Innocence? Ingenuity? A cunning dissimulation? How can we reconcile the account of these pathetic beginnings with the legendary story that will follow? Because this is the only official history that Kahnweiler ever gave, in the two interviews that he granted Francis Crémieux in May and June 1960. He presents himself as too young, too green, held back by his age and his appearance, a complete outsider to the Paris art scene.

The next, equally sorry, part of his adventure is fully in keeping with this beginning. "I didn't know anyone in Paris, only the people I'd met while I was working at the stock exchange [two years before]. I also knew a few dealers in engravings because I went to their stores to buy stamps. But that's it. I didn't know any art dealers, enthusiasts, artists, or critics in Paris," Kahnweiler said, painting himself as an intruder in the small world of the French capital's galleries.[2] Was the interviewer expecting revelations about his sales techniques, the sophistication of his access to artists, his discovery of collectors? If so, he would have been disappointed: "There was nothing, no press campaign, no cocktail parties, no anything [. . .]. I didn't spend a cent on publicity before 1914 [. . .]. I didn't even put an ad in the papers, I didn't do anything [. . .] there was no official opening."[3] This is clear, smooth, transparent. But barely has Kahnweiler's account begun than he describes his aesthetic discoveries: "I'd visited the Salon des Indépendants every year—that was the real hothouse for modern art, and everyone, except Picasso, exhibited their work there."[4] On March 21—one week after opening his doors for the first time—Kahnweiler, well-aware of the fauvist period that had been developing over the previous couple of years, bought a small number of paintings by Derain and Vlaminck, as well as a Derain drawing, *The Jetty at Estaque*, yet again being "conned." "In my naïveté, I paid

the asking price. I found out later that not only did everyone haggle but that an art dealer—even a future art dealer—had a right to expect a considerable reduction. I didn't know any of that."[5]

This portrayal of himself as the village idiot in the land of the cunning seems to go on indefinitely. A few days later, the artists themselves, Derain and Vlaminck, came to deliver their canvases to the new arrival. And soon there was the first exhibition—featuring works by Derain, van Dongen, Vlaminck, Matisse, and Signac—with simpleminded Georges hanging the paintings on the sackcloth walls of the former Polish tailor's boutique. And clients? "I think the first real client was a very dear friend [. . .] Hermann Rupf, from Berne [. . .] who had lived with me in Paris for a year."[6] Even if Kahnweiler was ever-reluctant to congratulate himself for his first instincts as an art dealer, these early actions were nevertheless the start of his career. Because this neophyte, with his outsider's manners, suddenly shook the world of Parisian galleries. Is it possible to imagine worlds farther apart than the galleries of Kahnweiler and Ambroise Vollard? From the outset, everyone who met Kahnweiler was struck by the precision, rigor, and seriousness of his work. What a difference from Vollard, the old dealer in his beret, born in La Réunion, so disconcerting with his sluggishness, his mood swings, and his strange premises on Rue Laffitte. His gallery was "a total shambles, with paintings by contemporary artists piled up [. . .] haphazardly on the floor, without frames, a stock of canvases bought in bulk from the artists themselves." With the pleasure of excellent, boozy dinners in his cellar and the possibility of glimpsing a few treasures in his reserves if he deigned to open his famous "storage room"—filled to the brim with works by van Gogh, Gauguin, Cézanne, Degas, Manet, and Renoir—Ambroise Vollard had become a veritable institution in Paris. Even if, according to Picasso, "he was very secretive [. . .] he had a knack for shrouding his paintings in mystery in order to raise the price [. . .] keeping almost all of them behind a partition at the back of his shop and not letting anyone rummage around in there."[7] Compared to the Aladdin's cave of treasures in Vollard's gallery, Kahnweiler's approach struck everyone as systematic, organized, and precise.

What happened next occurred organically: after spotting the first artists at the Salon des Indépendants (where Picasso, as we have seen, never exhibited), Kahnweiler simply had to wait. Because it was Picasso himself, escorted by Vollard—alerted by his artists—who turned up to visit. As the young gallery owner from Stuttgart put it: "One fine day, I was in my little shop and I saw a remarkable looking young man come in. He had crow-black hair and he was short, stocky, badly dressed, [. . .] but his eyes struck me as magnificent [. . .]. Without a word, he began to look at the paintings, going all around the little shop [. . .] and then he went away. The next day, I saw him come back in a carriage with [. . .] a bearded, rather fat man. This time the two of them went all around the shop, again without a word, and then left."[8] But what was behind this visit from the crow-haired artist with his magnificent eyes? Why such curiosity, such impatience to case out this new dealer with his interest in young artists? Just back from Gósol and high on his new artistic powers, Picasso had been ferociously pursuing his experimental works in the studio on Rue Ravignan, and eager to become the leader of the avant-garde—all of this is well-known. What is less well-known, however, is that, at the same time, Picasso was strategically scouting the city for a dealer up to his own standards—a tenor in search of his conductor. So, alerted by the "old boar"[9] on Rue Laffitte (Ambroise Vollard), he visited twice the new little gallery on Rue Vignon, without introducing himself, to scope out this Kahnweiler, the first time alone and the second time escorted by Vollard.[10]

Stranger still, Kahnweiler had been alerted—by Wilhelm Uhde, an art historian, collector, and part-time gallery owner, who, born in East Prussia, had emigrated to Paris in 1904 and become one of Kahnweiler's first contacts in the capital—about the existence of a "strange painting that the artist Picasso was working on" (this was *Les Demoiselles d'Avignon*, to which we will return later). All Kahnweiler knew of Picasso were the works he had seen at Sagot's and Vollard's galleries. Intrigued, he visited Rue Ravignan in July 1907. "I knocked and a young man opened the door. He was disheveled looking, in a shirt and no pants. He shook my hand and invited me

inside," he wrote. "This was the same young man who had come to my gallery a few days earlier, and the old gentleman who'd accompanied him was Vollard." Years later, Kahnweiler would highlight "the incredible heroism of a man like Picasso whose moral solitude at that time was something frightening, because none of his artist friends had followed him. The painting he'd just completed was considered by everyone around him as mad and monstrous."[11] Kahnweiler, on the other hand, was so struck by the power of this mysterious, unappreciated work that he described the experience of first seeing it as an epiphany. But how was this novice gallery owner able to decipher Picasso's intentions?

For weeks, I've lived surrounded by maps showing the expanse of the German Empire, the Austro-Hungarian Empire, the Russian Empire, and German Switzerland before World War I, and I use them to assess the size of that eastern territory where, between 1907 and 1914, with growing intensity, in an increasingly vast geographical space (taking in Frankfurt, Munich, Düsseldorf, Cologne, Berlin, Leipzig, Vienna, Budapest, Prague, Moscow),[12] aided by his network of "satellite galleries"[13] (Otto Feldmann in Berlin, Alfred Flechtheim in Düsseldorf and Berlin, Hans Goltz in Munich, Simon Meller in Budapest, Francis Gerard Prange in London, Emil Richter in Dresden, Ludwig Schames in Frankfurt, Alfred Stieglitz in New York, Gottfried Tanner in Zurich, Heinrich and Justin K. Thannhauser in Munich, Paul Cassirer in Berlin, Hugo Miethke in Vienna), Kahnweiler sold the works of Picasso (and others) as those paintings and sculptures came out of the artist's studio.

For weeks, I've been pondering the mystery of Rue Vignon: how did a tiny Parisian gallery, hidden behind the Madeleine Church, run by an absolute novice, become—in only seven years—the sole springboard for the conquest of a territory spanning eleven million square miles? How did an inexperienced young man freshly arrived from Stuttgart, competing against two of the most innovative Paris art dealers of the age in Durand-Ruel and Vollard, competing with galleries belonging to Clovis Sagot and Berthe Weill, create from scratch a genuine dialogue between Parisian artists and an extensive

network of foreign critics, art historians, dealers, collectors, and museum curators? How on earth did Kahnweiler, with his "old head on young shoulders,"[14] complete this impressive aesthetic transfer of art into the collections, galleries, and museums of the Western world in such a brief timespan?

For weeks, I have been musing about the character of Daniel-Henry Kahnweiler. In contrast to the dizzying amount of literature devoted to cubism, there is very little in the way of documentation about this crucial figure. After the exhibition organized by Isabelle Monod-Fontaine at the Centre Pompidou in 1984, after the biography by Pierre Assouline in 1988, after articles by Werner Spies and Yve-Alain Bois, there have been very few new analyses of the gallery owner and, with the archives difficult to access, his persona has taken on a mythical dimension. Behind his impassive face and his protruding ears, beneath his helmet of black hair that would soon recede to total baldness, Kahnweiler still seems unfathomable to me. In photographs as in his own words, his life appears smooth, simple, even banal. But why does this man who formed the cornerstone of the cathedral of cubism—and whose impact on the global art scene was considerable—come across as someone with no past? The more I think about Kahnweiler, the more I am struck by his countless resources and his multiple identities. Behind these, I feel certain, are truths that I must patiently attempt to unfold.

"I had the idea of becoming a conductor [. . .] and then I gave up on that idea," he told Francis Crémieux. "Deep down, I think it came from the same need that drove me to be an art dealer: the awareness that I was, not a creator, but . . . how can I put this? . . . an intermediary in a relatively noble sense."[15] Let us savor for a moment this strange concordance in the two men's choice of musical metaphors—a tenor in search of his conductor / a conductor in search of his musicians—before examining the vocation of mediator. "I found in painting the possibility of helping people I considered great artists, of being an intermediary between them and the public [. . .]. If there is any moral justification for being an art dealer, that has to be it." But why would a young, educated, bourgeois German man

feel such determination to help artists in Paris? "At the elementary school I went to, there was a degree of anti-Semitism," he recalled soberly. "And I was this little Jew in a place that was almost entirely Protestant [. . .]. And one day, I was walking down the street pursued by a gang of little thugs my own age all yelling '*Judenbub!*,' which means 'Little Jew!'" The discomfort of being called *Judenbub*, this banal-seeming insult, coexisted with another image, of a high-school student with great intellectual abilities, respected by his classmates. "There was nothing like that in high school [. . .]. I was considered a bit of a whiz kid there, in fact; the other students liked me and even sometimes admired me."[16] Just as the capital of Baden-Württemberg became the crucible of the nascent automobile industry in the late nineteenth century courtesy of local engineers such as Karl Benz, Robert Bosch, Gottlieb Daimler, and Wilhelm Maybach,[17] who registered patent after patent, young Daniel-Henry Kahnweiler, defined by the opinions of others, was making his way between the stigmatizing status of *Judenbub* and the more flattering label of whiz kid. How could he work out what he really was? It was one of the folders containing my photographs of Kahnweiler as a child that gave me the clue I needed. In those pictures, you can clearly see the *Sittlichkeit*[18]—social respectability—craved by his parents, "sensible local bourgeois people," whether it's in the snapshot of the adorable, chubby-cheeked kid in his bobble hat or, years later, the young man in his cap, striped sweater, gaiters, and polished ankle boots calmly pushing his bicycle—the *Judenbub* and the whiz kid.

With his wounds and his wealth, his scars and his meteoric rise, Kahnweiler is the archetype of an invisible, symbolic (but complex and considerable) heritage—in other words, he was a German Jew. He was following in the footsteps of other intellectuals with the same heritage—Moses Mendelssohn, Heinrich Heine, Aby Warburg—who also found their vocation as intermediary. But this genealogy of German Jews is also in a dialogue with the wider Protestant context. "I often think now that I was actually quite strongly influenced by my teachers in Stuttgart and that my state of mind is Protestant [. . .].

According to Fichte, one must arrive at one's identity oneself: I think that's already pretty good. I am not hiding from myself the fact that this ideal is essentially Prussian, but I think it's the only one possible as things stand."[19] In 1932, in a private conversation with his son-in-law Michel Leiris, Kahnweiler opened up a little more. This was the fate of German Jews, and had been for generations: given the rigorous education or, rather, the progressive *training* of the individual—the traditional Lutheran *Bildung*—that they received in schools and universities, they grew up like bourgeois Germans. However, since they generally did not share the social respectability—*Sittlichkeit*—of those bourgeois Germans, they did not live with them. Raised in this world woven from endless contradictions, united by their ambivalent heritage, German Jews—whatever friendships they might make along the way—lived separately from the rest of society.

Daniel-Henry Kahnweiler, then, was a German citizen of Jewish faith—*deutscher Staatsbürger jüdischen Glaubens*—who, like his fellow German Jews, was vacillating between the sense that he was experiencing a strong "Judeo-German symbiosis" and of being a victim of "an alliance built on fraud."[20] Because, as Gershom Scholem wrote, "the dialogue never took place: when the Jews spoke to the Germans, they spoke to themselves." The figure of the mediator would then appear, like a savior, helping them to escape this infernal dilemma—mediators like Moses Mendelssohn in the eighteenth century, like Heinrich Heine in the nineteenth, like Aby Warburg and Daniel-Henry Kahnweiler in the twentieth—in a German society where Jews had no space, where they felt tolerated, where they felt as if they were sitting on a folding seat, forced to find another fictional space where they could function. Later, Hannah Arendt would make the famously daring statement that the German Jew, tragically caught between being a pariah and a parvenu, had no way out: all traditional forms of worship signifying the preservation of a lost past, all assimilation leading to failure and signifying the loss of one's roots. The German Jew's dilemma was similar to that of the African-American, so subtly expressed by W.E.B. Du Bois at the Exposition Universelle

of 1900, and also to that of Picasso, a foreigner with multiple affiliations in a France (the country with the highest immigration rates in Europe) obsessed with the idea of a national cultural purity. It was a dilemma resolved for Kahnweiler, Du Bois, and Picasso through the decision to absorb this rift internally, to accept life as a broken foreigner, instead of trying, like so many other Jews, Blacks, or immigrants, to fill the void by becoming more German than the Germans, more American than the Americans, more French than the French.

Stuck in their strange no-man's-land, German Jews would often look to Paris as "the capital of the world" and toward France as the country which, immediately after the start of the Revolution (1790), gave French citizenship to Jews, almost a century before they were granted equal civil rights in Germany (1871). For Kahnweiler, as had been the case for Heine seven decades earlier, there was also the advantage of having learned French as a child. "We always had French nannies," he explained, "and, yes, I spoke French."[21] This tradition held in the lives of German Jewish families, for whom the recruitment of a nanny from the other side of the Rhine represented a sort of "salvation from the French utopia"—like a viaticum, a protection—that they could offer their children. "That my first foreign language should have been French," wrote the Berlin-educated historian George L. Mosse, "was only natural in a family that looked to France for inspiration, as did so many German Jews [. . .]. Foreign languages were seen as a necessary part of the Bildung."[22]

Upon closer examination, it is clear that Kahnweiler, who was married very early to a young Frenchwoman, was also choosing to escape the pressures of an oppressive family dynasty that—between the Rhineland, Baden-Württemberg, Franconia, and northern Bavaria, in a quadrilateral caught between Frankfurt, Baden-Baden, Bayreuth, and Munich[23]—saw the Manasse-Kahnweilers, the Neumanns, the Herzfelds, the Fränckels, the Josephthals, and the Goldscheiders reproduce with one another from village to village, through century after century, in accordance with rigorously intra-faith matrimonial alliances. Despite living since the Middle Ages in a place where they

were forbidden to own land, despite having to survive regular per-
secutions and pogroms, these families had achieved a remarkable
social ascension, succeeding in the import-export business, special-
izing in colonial commodities—beginning with coffee before moving
on to precious metals including gold. Such was the case for "Uncle
Sigmund"—Sigmund Neumann, one of Kahnweiler's mother's three
older brothers—who made his fortune importing gold from South
Africa, through the Kimberly Diamond Mining Company, before
marrying the daughter of a banker from Alexandria and founding
his own bank (Neumann, Luebeck & Co.) in London in 1910. Uncle
Sigmund was "a great tycoon" (according to his nephew) who gave
the young Kahnweiler his first financial support: the magical 22,000
gold francs that enabled him to rent the shop on Rue Vignon, deco-
rate the walls with sackcloth, hire Georges the simpleton, and buy his
first paintings. But let us return for a moment to Kahnweiler's own
account, which mentions another family member, very different from
Sigmund the businessman, a man named Joseph Goldscheider, who
was known as "the amico uncle." It was this maternal grand-uncle,
an intellectual freethinker full of original and extravagant ideas, who
most influenced young Daniel-Henry. "He was a typical 1848 revo-
lutionary, a man with a passion for liberty, literature, music, even for
the theater and for actresses," Kahnweiler explained. "A very curious
man, who was also a writer [. . .]. When I was young, I used to go
walking with him a lot."[24]

Let us finally mention the extraordinary intellectual investments
made by this young man who described himself as a "puritan" and
who, from his first stay in Paris in 1902, working as an intern at
a foreign-exchange brokerage, gave free rein to his passion for the
theater (a season-ticket holder at the Théâtre de l'Oeuvre, he saw all
the modernist stagings of Lugné-Poe), for music (a Debussy fanatic,
he attended almost every production of *Pelléas et Mélisande*, eventu-
ally seeing that opera sixteen times),[25] for politics (he participated
in a protest at Zola's tomb in the Montparnasse cemetery), for lit-
erature (he devoured the works of Goethe, Hölderlin, Novalis, and

Nietzsche), for painting (he would leave the brokerage whenever he could to visit the Louvre, the Autumn Salon, the Salon des Indépendants), and for travel (he would take the train every Sunday to visit French cathedrals and châteaux). But that was not all. Like Kramář, Kahnweiler was educated during the golden age of German-speaking art historians who, during the nineteenth century, became emissaries for a new vision of the world by forcing themselves to "bring together the artistic productions of humankind into a sort of universal story, including the most distant times and peoples."[26] A look at the map of the German Empire shows the flowering of cities and demonstrates "the virtues of the polycentrism of Germanic space."[27] They were learned, curious, mobile, open-minded, and discerning, straddling several cultures and disciplines: Aby Warburg was *"Amburghese di cuore, ebreo di sangue, d'anima Fiorentino"*;[28] Anton Springer divided his time between Bohemia, Austria, and Germany; Giovanni Morelli was a doctor who considered himself "an Italian soul with a German education"; as for Julius Meier-Graefe, who regarded *"Kunst als hochste Freude"* ("art as the highest joy"), he was Romanian.

These art historians were mostly Protestant, often the sons or grandsons of Lutheran pastors, such as Jacob Burckhardt, Carl Justi, Franz Theodor Kugler, Giovanni Morelli, and Friedrich Schlegel. And the relationship between their religion and art ("we do not represent God"), the place occupied within it by the Old Testament, led to a very different approach from that of Catholic countries. But what did it mean for German Jews to choose to study the history of art or to play a part in the art world? They were seeking involvement in a world with a sacred dimension. Adolph Goldschmidt, Carl Einstein, Max Raphael, Aby Warburg—Jews, often the sons or grandsons of rabbis or cantors—were all of this kind. It was to this end that they became art historians, and Kahnweiler's career path followed the same impulse. It was "artists [who] *create* the visual universe of humankind," Kahnweiler said when describing his passion for Rembrandt, the Protestant artist par excellence.[29] "I've read quite a lot of books on ancient painting," Kahnweiler revealed. "But those books

could not serve me as an aesthetic guide. They served me as an historic guide, a scientific guide, but from an aesthetic point of view I had to get by on my own [. . .].[30] So the art that I loved then [. . .] I still love today, Rembrandt especially. His *Bathsheba* in the Louvre struck me then and still strikes me now as the one of the most beautiful paintings in the world."[31]

With this genealogy more oppressive and convoluted than that of Candide in Paris, then, we now return to 1907, when Kahnweiler's path crossed that of another "foreigner" who had, a few months before this, forced his way through the labyrinth of Paris to become one of the leading lights of the city's art scene. Yes, it is time to tell the story of Kahnweiler the conductor and Picasso the tenor! But, for now, let us get back to the Bateau-Lavoir. Because we must rediscover the years 1907 to 1914 in all their glory, those seven years when a young art dealer from another land and another culture, in love with France, managed to succeed in his mission to invent his own space in the cracks of Parisian society, before being caught by institutional France, by the consequences of reality.[32]

18.

RETURN TO THE BATEAU-LAVOIR

A plainclothes policeman showed his card [. . .] and ordered
Picasso to follow him because he had to appear before the
examining magistrate at nine o'clock. Trembling, Picasso
dressed in haste [. . .] he was out of his mind with fear.[1]

—Fernande Olivier

We last saw Picasso in August 1906, on his return from Gósol, filled
with new energy after discovering the solution of the mask that al-
lowed him to finish his portrait of Gertrude Stein. Although he was
now working full-out on a new project of unprecedented ambition,
producing a painting that would prove key to the rise of cubism,
that would in time set off a pictorial revolution, he was not out of the
woods yet. Behind the scenes, a situation was developing that—for his
family and also for the police—would prove full of twists and turns.
In January 1907, the minister of the interior Georges Clemenceau
surprisingly appointed the police officer Célestin Hennion as the
head of the Sureté Générale, the French secret police. Hennion was
"a career bureaucrat, hard-working and extremely zealous,"[2] and he
was tasked with creating the intelligence agency that would monitor
foreigners, in the shape of the famous Tiger Brigades (twelve regional
brigades of traveling police)—"the only police force a democracy
can admit to"—to monitor the movements of "nomads, Gypsies, and
street performers."[3] On February 28, 1907, Clemenceau addressed

the Chamber of Deputies. To describe what he had conceived as the symbol of modernity in policing, necessary for suppressing illegal anarchists, the minister of the interior offered a rare instance of self-criticism: "Our system of repression is archaic, prehistoric [. . .]. What we need is a judicial police, a police designed for the regular pursuit of scoundrels."[4]

At the time, Picasso was working to develop his own voice, exploring all avenues of possibility. In March 1907, at the Salon des Indépendants, he stopped in front of Matisse's *Blue Nude (Souvenir de Biskra)* with its crosshatching, its powerful, distorted thighs; he carefully examined Derain's *Bathers* with its three sculptural, mysterious, geometric bodies against a blue background. During the same period, following letter after letter filled with reproaches, anger, sadness, frustration, and demands, María Picasso y Lopez suddenly changed her tone: "My dear son Pablo: I've just received your letter and I am thrilled to the bottom of my heart that you are well and that you are planning to paint a large canvas . . ."[5] Even though all he mentioned was the extraordinary size of the painting (which would become *Les Demoiselles d'Avignon*), it is interesting that Picasso should tell his family about this colossal new project. "Even if I know what I'm saying is a little exaggerated, I know that you are the best," his mother would write adoringly a few months later.[6]

To support the monumental undertaking of this "large canvas," Apollinaire too would become involved, feeding Picasso's passion for primitive art by helping him to acquire "two stone sculptures from the Hispano-Roman period, a man's head with short strands of hair, and a woman's head with a veil, her ears covered with circular tresses"; two "Iberian heads" very similar to the ones Picasso had admired in Room 7 of the Louvre. This was how the two friends became caught up in a fantastical, compromising episode that could also have been highly dangerous in such difficult times for foreigners. It was the introduction of a third person—Géry Piéret, a schemer and criminal whom Apollinaire had hired out of kindness not long before as his "secretary and factotum"—that led them into this situation. It

is hard to imagine a more bizarre scenario: Picasso, obsessed by his quest for a new form of art; Apollinaire, naïvely employing a "secretary" he doesn't dare fire, who turns out to be a crook prepared to do anything to pay back his gambling debts, including hoodwinking these two creative types. "My poor Kostro, I'm in the most awful situation imaginable," the conman wrote to the poet. "The day after I saw you and we spent the evening together, my creditor told me I could have some more money [. . .] I'm in Paris, with 2 silver francs in my pocket. I've been here for two days. I'm starving and homeless. I don't even have a shirt anymore, because all my luggage has been held back at the Hôtel Terminus in Nice, where I wasn't able to pay for my room."[7]

On April 7, 1907, in another letter to Apollinaire, the rogue continued his wheedling. "My dear friend, Amazing news: I will be married at the end of this month," he lied. "My fiancée is a tobacco dealer, and I met her barely three weeks ago [. . .]. I sacrificed myself on the altar of her charms, putting my life in the balance. But this is why I am writing to you: Annette asked me for her engagement present and, for the moment, I barely have two louis to rub together—and I need those for clothes. I wanted you to ask dear Piccasso [*sic*] to quickly paint me something good so you could send it to me before October 25. You can tell Piccasso that I'll pay him 175 francs for his painting in May. I plan to spend my honeymoon in Paris. I also firmly intend to spend one night in the rats' asylum to taste the horror one last time."[8] This was how "Piccasso," in his obsessive quest for powerful objects from other places, unwittingly became a fence for stolen goods. Needless to say, he did not produce the requested painting, but he did buy those two Iberian statues from Piéret (who remained very discreet about their provenance) for 50 francs. Not only did those statues influence what André Malraux later called his "exorcism painting," but he would keep them with him for the next four years.

It was during the summer of 1911 that the case took a critical turn. To be more precise, it was on August 28, when the theft of

the *Mona Lisa*, the Louvre's most famous artwork, sent the Sureté Générale and the whole of official France into turmoil—from police chiefs to gendarmes to customs officers. That same day, *Paris-Journal* offered a reward to anyone who returned the *Mona Lisa*. At that point, Apollinaire's former "secretary" resurfaced, drawn by the lure of money. He brought the newspaper's editors some sculptures that he had stolen from the Louvre four years earlier. The news made headlines. When Apollinaire saw Piéret's name in the papers, along with the crime he'd committed, he realized the danger they were in and wrote to Picasso, urging him to return from Céret, where he was painting at the time. Picasso hastily rejoined his friend in Paris. "They went out to try and drown those compromising statues in the Seine," Fernande Olivier recounted, "but their nerve failed. They had the feeling that the policemen patrolling the riverbanks were eyeing them suspiciously."[9] Olivier went on to describe that terrifying night that the two friends spent under the same roof. "In the end, unsure how to fill the long hours of the night that they'd decided to spend together for safety, they began playing cards, the pair of them looking like fugitives and talking about the tragic possibility of being expelled from France as undesirables," she remembered.[10] Because that was precisely the risk they ran as foreigners—a Russian citizen and a Spanish citizen—whose presence was only "tolerated" in France. "I can still see them now: two contrite, frightened children, thinking about fleeing abroad."[11]

The investigation continued and, on September 7, the police searched Apollinaire's home. They came with an arrest warrant for his complicity in the theft; they suspected that he was the leader of a gang of international thieves. Incarcerated in the Prison de la Santé, where he was kept in isolation, Apollinaire sent a telegram to his lawyer, José Théry: "Very serious case—Come—Ask for Judge Drioux—Have named you my lawyer." Despite all the precautions taken by Apollinaire and Picasso, the press soon sensed a scoop. "In the evening, it was stated that the foreigner was none other than Mr. Guillaume Krostrowisky [sic], secretary to Mr. Guillaume Apollinaire,

man of letters, both of whom reside at 37 Rue Gros," wrote the reporter from the *Petit Journal*. "Since the Sureté Générale and the public prosecutor's department refused to provide any information on the case, we asked a high-ranking figure at the police headquarters if the arrested Russian subject was indeed Mr. Guillaume Kostrowisky, and our informant replied in the affirmative."[12] The next day, another article in the same newspaper declared: "The judges [suspected] an international crime gang that had come to France to steal from museums. The Russian was placed under arrest and, after a preliminary interrogation, was sent to the Prison de la Santé under a committal order [. . .]. In fact, Mr. Guillaume Kostrowisky, known in the world of arts and letters under the pseudonym Apollinaire, is not Russian but Polish."

Russian? Polish? Who cares! He was a foreigner, a fact that immediately led to the suspicion of "an international crime gang that had come to France to rob from museums," and that transformed an embarrassing situation—two friends manipulated by a con man—into a potentially dangerous situation. The poet and the artist would emerge from this event terrified, and would act in an increasingly cautious manner thereafter. "For a long time, Picasso and Apollinaire thought they were being followed," recalled Fernande Olivier. "Picasso would only go out at night in a taxi, and he would change taxis several times to throw his 'pursuers' off the scent."[13] The artist would return the statues, and from that day on Apollinaire did all he could to be naturalized as a Frenchman. As for the Picasso police file, it contains the following handwritten note: "In September 1911, Picasso, Pablo Ruiz was interviewed on the subject of the statuettes that were in his possession and that had been stolen from the Louvre by a third party."[14] Apollinaire was apparently exonerated for his involvement in the case. And strangely, even if Picasso too was interviewed by the police, the incident was never referred to again in his file. In any case, he had already discovered the best way to protect himself: he worked.

Work was the reason that, in the summer of 1909, Picasso defied his mother's orders and decided to skip his sister Lola's wed-

ding, provoking a major family crisis. "We received some newspapers from Málaga yesterday, and I am copying down what we read in one of them," wrote María Picasso to her son on July 10: "'A few days from now, in Barcelona, a wedding will take place between the beautiful Miss Dolores Ruiz Picasso, who is related to several distinguished families in Málaga, and an illustrious doctor from the town of Condal.' You can't imagine how happy it made us to read such a thing!"[15] With detailed descriptions of the engagement ring and the wedding dress, with various attempts to heap pressure and guilt on Pablo, the voices of his mother and sister would alternate over the coming days at an intensified frequency. "You are my only brother and you must understand how sad I will be if you are not there" (Lola, undated); "You put on these fancy airs, but you ought to make a contribution to your sister's wedding" (María, April 2, 1909); "If you don't come to my wedding, it will be a great void without you" (Lola, July 2, 1909); "As you will understand, I am not refusing your financial offer; on the contrary, it will be very useful and will help me to resolve many problems [. . .] look, Pablo, when I write to you like this, you can surely imagine how I feel [. . .]. So will you come?" (María, July 10, 1909); "Yesterday I had the joy of receiving your letter and your check, I will put part of it in the savings bank where the money will be safe and you can take some if you need to, here is the list of the family's wedding gifts, jewelry, etc., there are so many things to do, and I wanted to know if you are coming" (María, undated); "We received your check yesterday, a thousand thanks for that, now I have a favor to ask you: please come to my wedding" (Lola, undated); "What is going on, my son, why don't you write?" (María, July 17, 1909); "Papa is happy about Lola's wedding, he will feel the separation, for the moment he says nothing to me, but what do you think?" (María, August 7, 1909). As the big day (August 18) grew nearer, the pressure was ratcheted up. Picasso spent that summer with Fernande in Horta de San Juan, Catalonia. He could easily have taken the train to Barcelona, three hours away, but he chose not to.

How do we explain this pivotal moment in the life of an artist pursuing aesthetic advances? It can only be seen as a rite of passage—

a rite of separation from his original home, of integration with the artistic world of his new home. Picasso decided to withdraw himself from the archaic constraints of family rituals, to loosen the suffocating grip enacted by his mother: he compensated for this with a financial transaction, in effect buying his own freedom. He knew that he could only continue to make artistic progress at the cost of this dual movement: emancipation and integration. On May 13, 1909, he visited Barcelona on his way to Horta. "I am working despite everything (not a lot) I have started two landscapes and two figures still the same thing. I am thinking of taking photographs of here I will send them to you when I have them the country is very beautiful," he wrote to Leo Stein, a few lines that suffice to demonstrate the force of his concentration.[16]

In September 1909, courtesy of a windfall from his art, he moved to a bourgeois apartment in a building located at 11 Boulevard de Clichy. "Dear son Pablo," wrote María Picasso that month, in her first letter to the new address, "Since we have had no news of the furniture or its condition upon arrival, I am writing to find out if you received it without telling us, and to ask you to do so because that would calm papa down." One week later, she wrote again: "Dear son Pablo, We received your card and we are happy to know that you are all settled in. Yesterday, papa went to the moving company to find out if they knew the arrival date for the furniture, and they told us that you received it on the 25th or the 26th."[17] In 1909, then, Picasso moved into what the police called "an ordinary house where one lives with one's own furniture." Fernande Olivier described "the movers' surprise at seeing the difference in the two studios, the old one and the new one. One of them said, 'These people must have won the lottery!'"[18] In fact, she added, "there was very little to move from the old studio, except for some canvases, easels, and books. He had lived there for years as if he were just camping, and all his makeshift attempts to improve the atmosphere had added nothing to the place's comfort." She also stated that, on Boulevard de Clichy, Picasso "works in a large, airy studio [. . .], eats his meals in a dining room, served by

a maid in a white apron, and sleeps in a bedroom." How things had changed! It was Fernande, too, who described the famous furniture sent to his son by José Ruiz y Blasco: "Behind the bedroom, at the back, there's a small living room with a divan, a piano, and a pretty Italian dresser inlaid with ivory, mother-of-pearl, and tortoiseshell that his father sent him, along with some other beautiful old pieces." For years, Picasso's parents had, in their letters, raised the question of his return to Barcelona. During the cubist revolution, the correspondence from Barcelona remained just as it had always been, and María Picasso continued to regard her son as a part of her epistolary theater. But he found his own strategies to protect his work, and his absence at his sister's wedding in 1909 was the first indication of this. As for his father's decision to send him the "pretty Italian dresser inlaid with ivory, mother-of-pearl, and tortoiseshell" to furnish his new apartment on Boulevard de Clichy, this was undoubtedly an acknowledgment on his part that Pablo would never return home, that the family had finally digested all the subliminal messages he'd been sending them. However, none of this—the change of address, the posh new furniture, the recent respectability conferred by a rise in income—could modify the image of the artist in the files of the French police, as we will soon see. During my investigation into his cubist years, it was here—in Picasso's interactions with the police over the case of the stolen statues, in his transactions with his family over his sister Lola's wedding, in the density of all these details and annoyances—that I came closest to the space occupied by the "foreigner" who is both building his own territory and urgently producing his own work. But now it is time to portray the fourth accomplice, who entered the scene in the summer of 1907.

19.

A DUET OF REVOLUTIONARY VIRTUOSOS . . . PICASSO AND BRAQUE, BRAQUE AND PICASSO

1st Movement: Themes and variations in the vein of Cézanne (1907–1910)

2nd Movement: Explosion and dissonance (1910–1911)

Braque is the woman who loved me the most.[1]

—Pablo Picasso, quoted by Roland Penrose

We lived in Montmartre, we saw each other every day, we spoke. During those years, Picasso and I thought things that nobody will think ever again, that nobody will be able to think ever again, that nobody will be able to understand ever again [. . .] things that gave us so much joy [. . .]. It was a bit like being roped together on a mountain.[2]

—Georges Braque

Montmartre, late summer 1907. Picasso and Braque, Braque and Picasso were neighbors on the Butte. If he took the Passage des Abbesses and the Rue des Trois-Frères, Picasso could reach Braque's studio on the Rue d'Orsel in only four minutes. They were the same age, had the same energy, and soon shared the same art dealer. What

an incredible duo they were—the son of the highly classical José Ruiz y Blasco, dean of the École des Beaux-Arts in Barcelona, and the son of an artisan decorator from Argenteuil (himself from a long line of craftsmen who, after attending a vocational school like his father, decided to become an artist, studying at the Académie Humbert and then exhibiting his work at the 1905 Autumn Salon with the fauvists). Physically, they were a very odd couple. Picasso was stocky, muscular, dynamic, a man filled with laughter, euphoria, and a joie de vivre that gave him the confidence to optimize a multiplicity of talents, while Braque appeared as impressively tall but discreet, reserved, almost shy. "Braque was a very good-looking man," Kahnweiler later revealed, "and he said himself that he played Beethoven symphonies on the accordion. He could also dance and box."[3] Was it Apollinaire who brought them together, as he claimed? No. In September 1907, Braque wrote to Picasso: "Greetings to you and your two friends," proving that they met before in Montmartre, and contradicting Apollinaire's account.[4]

From the fall of 1906 onward, Picasso did not stop exploring and exploiting everything around him—like Gauguin's wonderfully free and sensual *Two Nudes* (which he saw during the "savage" artist's retrospective at the 1906 Autumn Salon), like the pre-Christian Iberian sculptures that he kept visiting after discovering them in Room 7 of the Department of Antiquities (or in the Eastern section) in the Louvre before his departure for Gósol, like the African sculptures (nkisi nkonde, from the Yombe of the Congo) that he devoured after being dragged by Derain to the Museum of Ethnography in the Trocadéro. He was plunging ever farther ahead in his exploration of other fertile sources, seeking out objects with magical powers that served as spiritual intercessors, crudely sculpted heads with asymmetric eyes, jutting chins and angular distortions, drinking in all these wonders that rolled back the borders of his own world and helped him radically deconstruct academic tastes. On his return from Gósol, just after finishing *Gertrude Stein*, Picasso began the most ambitious project he'd ever attempted (on a canvas more than six feet tall and almost

ten feet wide), producing an endless series of studies, sketches, and preparatory drawings, working at night, living the intense, unruly life of the Bateau-Lavoir with all its artists and writers during memorable evenings punctuated by hallucinatory episodes.

The painting, begun in 1906 and finished in July 1907, would remain in Picasso's various studios until 1917, seen only by his friends and visitors and provoking some violent and mixed reactions. What is certain is that Picasso set himself apart by integrating highly academic influences with highly iconoclastic ones—daring to create a dialogue between Europe and Africa, mixing the classical with the contemporary and the antique. Gertrude Stein perceived in the work "something painful and beautiful, something dominant and imprisoned";[5] Wilhelm Uhde thought he could detect the influences of Egyptian or Assyrian art. As for Matisse and Leo Stein, they would laugh and remark ironically, "It's the fourth dimension!"[6] In his *History of Cubism*, André Salmon described a canvas containing six large female nudes that a friend of the artist nicknamed "the philosophical whorehouse," a group of prostitutes "more or less stripped of all humanity [. . .] they are naked problems, white figures on the black background."[7] Later, some would talk of "Eros and Thanatos" or "the Avignon whorehouse." "It's like drinking kerosene or eating hemp fibers," exclaimed a stunned Braque when he saw the painting. Picasso himself described it as an exorcist canvas. But it is indeed this sole painting *Les Demoiselles d'Avignon*, which, by "sweeping away, so to speak, all the tradition of the nineteenth century," opens the door to all Cubist research.[8]

A few weeks after encountering Picasso's new work, Braque abandoned landscape painting and the fauvists, and responded with his imposing *Big Nude* (June 1908). Though still influenced by Cézanne, Braque clearly introduced elements taken from Picasso—notably in the multiplicity of viewpoints and the references to African art. In her memoirs, Fernande Olivier would comment, "Some time after talking about eating hemp [after seeing *Les Demoiselles d'Avignon*], Braque exhibited a large cubist canvas at the Salon des Indépendants

that he had apparently painted in secret. He hadn't spoken about it to anyone. Not even to his inspiration, Picasso [. . . who] had only mentioned his new direction to a few close friends, and was a bit put out."[9] After this first tribute to Picasso by Braque, it was Picasso's turn to bow down before the series of landscapes by Braque[10] that had just been rejected by the jury for the Autumn Salon and that Kahnweiler picked up for a show of his own. On November 9, 1908, the young dealer exhibited Braque's rejected works at 28 Rue Vignon, presenting his gallery as a subversive presence in the narrow-minded Parisian art world. The exhibition provoked a sarcastic article by Louis Vauxcelles, who—quoting Matisse—described a style made up of "little cubes." Was this the first cubist exhibition? In any case, it marked the very first emulations between Braque and Picasso, each bringing his own influences to the table, Cézanne and African art melding together in a single crucible.[11]

Their story began with some impressive "themes and variations in the vein of Cézanne." Who initiated this development in the summer of 1908, with those remarkably similar, almost interchangeable landscapes and still lifes, which were often produced hundreds of miles apart? That summer gave rise to Picasso's *La Rue-des-Bois* and Braque's *Houses at l'Estaque* and *The Viaduct at l'Estaque*. In the winter of 1908 to 1909 there was *Fruit Tray* by Picasso and *Fruit Dish and Glass* by Braque. In the summer of 1909, Braque painted *The Castle of La Roche-Guyon* while Picasso produced *Houses on the Hill, Horta de Ebro*. Who decided to move on to something new? And when did this Cézanne-inspired vein run dry? Was it in the winter of 1909 to 1910 in Paris, when they each made their own version of the Sacré Coeur in Montmartre, Picasso with his vertical, slanting lines—almost a drawing—and Braque with his denser, more geometric shapes tangled in a symphony of ochers and browns? Or in the spring of 1910, with two oval versions of a woman holding a mandolin? Or in the summer of 1910, when Picasso painted *Glass and Lemon*, and Braque completed *Rio Tinto Factories at l'Estaque*? "The great step forward had been taken," Kahnweiler would write

later, describing the artist's stay in Cadaqués during the summer of 1910. "Picasso blew up the homogeneous form."[12,13]

During their first stay in Céret in the summer of 1911, the two artists created an increasingly arcane visual language, with pyramidal structures "melting into backdrops of layered structures":[14] Picasso painted the oval-shaped *Man with a Pipe* (summer 1911) while Braque worked on *The Portuguese* (1911–1912), in which he stenciled printed letters, freed of all descriptive functions, as with "0,40," or with "D BAL," which probably belongs to a poster for a "GRAND BAL." Picasso responded to this with *Still Life on the Piano* (summer 1911 to spring 1912): a very large rectangular format featuring the stenciled letters "CORT" (for the pianist Alfred Cortot). The months between summer 1911 and spring 1912 also saw the frenzied production of Picasso's *The Accordionist, Man with Mandolin, Man with Guitar,* and *Man with a Clarinet.* Music and alcohol became the markers of their world: Picasso painted *Still Life with Bottle of Anis del Mono* (1909) and *Bottle of Rum* (1911), while Braque created *Clarinet and Bottle of Rum on a Mantelpiece* (1911). They supported and confronted each other, stimulated and assessed each other, measured themselves against the other and invited each other to their respective countries, displayed their skills and borrowed from each other's experiences, even from each other's pasts. During the Cézanne phase, it was clear that Braque set the tone and that Picasso let him "lead the dance." But years later, with his famous one-liner "Braque is the woman who loved me the most," Picasso described their professional symbiosis in terms of a male-female couple.[15] Was this a way of suggesting that it didn't take him long to gain the upper hand and to "be the man" in their "artistic tango"?[16] The alliance with Braque undoubtedly remains essential to this period, when Picasso's love life was marked by his breakup with Fernande Olivier and his love for Eva Gouel, whose portrait—*"Ma Jolie" (Woman with Guitar)*—he first painted in Paris during the winter of 1911 to 1912.

It is traditional among literary historians in France to celebrate the friendships between writers (Montaigne and La Boétie, Verlaine

and Rimbaud, Sartre and Camus), as French schoolchildren know all too well. But the first definitive judgment on one of the most fertile friendships in the history of art—the relationship between Picasso and Braque (1907–1914)—actually came from the United States, in 1989. "The fact that Cubism unfolded essentially through a dialogue between two artists extending over six years makes it a phenomenon unprecedented, to my knowledge, in the history of art," wrote William Rubin in the catalog for *Braque and Picasso: Pioneering Cubism*, his legendary MoMA exhibition: "No other modern art style has thus been the simultaneous invention of two artists in dialogue with each other. Over the years of their association, Picasso and Braque not only produced an exceptional number of masterful works, but they also created a pictorial language usable by others, with a wide variety of esthetic, literary and political projects. [They] contributed to a shared vision of painting that found them both at their best when they were closest to one another—a vision which neither, I am convinced, could have realized alone."[17] Rubin's voice is categorical. It calmly builds on emphatic adjectives such as "unique," "majestic," "exceptional," which—here—are not misplaced. And it reveals for the first time a truth that had been hidden: that the greatness of cubism comes from the fact that it was atypical, that it was the fruit of a radically new moment in the history of art—a long, intense, and fertile coproduction between two artists. This was written twenty-six years after Braque's death and sixteen years after Picasso's.

It was as far back as March 1936 that the young director of the Museum of Modern Art, Alfred H. Barr, first lent legitimacy to the cubist experiments. With *Cubism and Abstract Art*, he integrated the movement into the history of art, emphasizing its originality alongside the quest for abstraction. More recently, in the spring of 2013, it was once again from the United States that news came of a particularly welcome initiative: the collector Leonard Lauder decided to bequeath his cubist collection of 78 paintings (33 Picassos, 17 Braques, 14 Grises, and 14 Légers) to the museum, a collection now valued at $1 billion, and to open a center for scientific research at the

Metropolitan Museum of Art devoted exclusively to cubism. This collection alone enables the visitor to explore the crucial moments of a period of art history that—between Montmartre and Montparnasse, Horta de San Juan and Cadaqués, Céret and Le Havre, l'Estaque, Avignon, Rue des Bois, and La Roche-Guyon—played out between the summer of 1907 and the summer of 1914 in a historical context of rare intensity and dizzying quality. In summary, then: Alfred H. Barr Jr. in 1936, William Rubin in 1989, Leonard Lauder in 2013 . . . in the United States, these three great names of the art world have, thankfully, helped to set the record straight on cubism.

In France, meanwhile, we have floundered. First, Apollinaire was condescending in his assessment of Braque's contribution to the movement. In a 1907 article, he stated that "while cubism first developed in the mind of André Derain, the most important and audacious works were those by Picasso [. . .] whose inventions were backed up by Braque's common sense."[18] Then, in *Chroniques d'Art* and *The Cubist Painters*, the poet contrasted Picasso's "heroic gesture," part of the "great revolution of the arts," with Braque's "stubborn continuity," relegating him to a subordinate, verifying role.[19] After Apollinaire's dismissal of Braque, there followed a long period when cubism was ignored as a moment in art history or disparaged as a foreign importation, erasing those heroic years. During the too-brief period of the Front Populaire (with Jean Zay at the Ministry of Culture, and Jean Cassou in his cabinet), there was a political will to integrate Picasso's works into the national collections, but it never happened.[20]

Futhermore, numerous voices favored Braque over Picasso, including Jean Paulhan in his book *Braque le Patron*. "If the great artist is he who contributes to painting the idea that is simultaneously the sharpest and the most nourishing, then I would hail Braque without hesitation as the leader."[21] In 1952, there began a staggering wave of national glorifications presenting Braque as the French artist par excellence. "Braque is *so* French," declared one television journalist during the inauguration of *The Birds*, the ceiling in the Louvre painted in

his honor. André Malraux—de Gaulle's minister of culture—added to the hyperbole in 1961, at the opening of the exhibition *Braque's Studio* (also at the Louvre): "It is good that France should honor, at the Louvre, *one of the greatest artists in the world*," as if Braque needed to be cleansed of the residue left by his cubist period and situated neatly on the straight and narrow path of French art, between Corot and Chardin. The Gaullist government continued to write an alternative history of art: on the night of September 3, 1963, between the Louvre Colonnade and the church of Saint-Germain-l'Auxerrois, Malraux eulogized the artist in a trembling voice, giving Braque a state funeral, like Victor Hugo, and turning him into a national hero.

And yet, with his very brief allusion to Braque's cubist years, Malraux somehow managed to avoid mentioning Picasso's name, declaring that "by revealing, with infectious power, the freedom of painting, Braque and his friends [. . .] also revealed the entirety of art's past in rebellion against illusion, from Roman times to the present century: bent patiently or furiously over their insulted paintings. These artists resurrected the world's past for us."[22] So cubism was invented by "Braque and his friends"? Really? What kind of art history did Malraux imagine he was celebrating by erasing Picasso's name? The whole of his extravagant speech followed this pattern. "You have recognized [. . .] the music you just heard, before those bells that used to toll for kings: it is the *Funeral March on the Death of a Hero*. Never has a modern country dedicated such a tribute to one of its dead artists," the minister began. "Since all French people know that there is a part of France's honor named Victor Hugo, it is good to be able to tell them that there is a part of France's honor named Braque—because a country's honor also consists in what it gives to the world [. . .]. These paintings expressed France just as fully as Corot's did—but more mysteriously, because Corot often represented it. Braque expressed it with a symbolic strength so great that he belongs at the Louvre just as much as the Smiling Angel of Reims belongs in her cathedral [. . .]. Tomorrow morning [. . .] let us tell the sailors and farmers of Varengeville, who loved Georges

Braque, obviously without understanding his art: 'Yesterday, when he was outside the palace of kings and the world's premier museum, there was, in the rainy night, an indistinct voice that said thank you; and a very simple hand, a peasant's worn hand, which was France's hand, was raised one last time in the night to gently caress his white hair.'"[23]

In 1953, with *Le Cubisme (1907–1914)* at the Musée National d'Art Moderne, Jean Cassou attempted for the first time to legitimize the movement in France. A half-century later, Pierre Daix insisted upon the importance of both artists in *Picasso Cubiste*. Analyzing their first exchanges (1905–1909), he highlighted how moved Picasso was by his discovery of the Estaque landscapes (1908) and described "their complementarity [with] a friendship and closeness that neither of them had ever experienced" before.[24] Then, in 2013, at the Georges Braque retrospective, it was Brigitte Léal's turn to bravely attempt to redress the balance: this was a delicate operation, because in doing so she had to erase the nationalist narrative that had become dominant in France since the publication of *Braque le Patron*. Arguing that the Gaullist government's apologia for Braque had harmed his reputation by burying him alive as a sort of official artist, she declared that it was time to "rehabilitate" him for the generations that had come after. It was also necessary to "discover in all its scope and depth, a body of work that had been underestimated because it was so demanding, because it resisted easy categorization."[25] This retrospective provoked a backlash from those nationalist commentators who had chosen Braque over Picasso, including Michel Déon (who praised Braque's "radiant goodness" and "supreme honesty") and Henri Cartier-Bresson, who celebrated "his handsome face, craggy like supple, weathered leather, its color reminiscent of the finest tobacco [. . .] this handsome and serious face radiating silent suffering." The headline in the *Irish Times*, which quoted these two commentaries in an article on the cultural conflict over Braque and Picasso, was unambiguous in its conclusions: "Braque Is Back: French Cubist Finally Escapes Picasso."[26]

The magnificent exhibition *Cubism* at the Centre Pompidou (2018) gave Brigitte Léal the opportunity to go one step further, offering visitors a balanced French reading of cubism stripped of its nationalist overtones. "The fruit of complex heritages [. . .], it was a living, dynamic, permanently growing quest that did not correspond to any preexisting plan but followed its own winding, empirical, and experimental path," she wrote. "Between 1907 and 1914, Georges Braque and Pablo Picasso were together engaged in a profound conceptual transformation of painting and sculpture. The old optical perceptions were refuted. The illusionist tradition was swept away. A new visual and tactile language [. . .] replaced them [. . .]. New forms of trompe-l'oeil representation were invented [. . .]. Unusual materials and unorthodox operating techniques created new relationships between images and words, building bridges between the perceptible universe and the materialist system, opening up to the world."[27]

Over the years, analysis of the Braque-Picasso duet took the form of an opposition with national connotations: in 1989, Rubin presented the two artists as "the Frenchman and the Spaniard," "the moon and the sun," "the feminine and the masculine," "the inhibited and the risk-taker"—two personalities emulating each other. In the first phase of their cubist production, this osmosis played a crucial role. Picasso made no attempt to deny this, as proved by what he said to Françoise Gilot years later: "Almost every evening, I would go to see Braque in his studio, or he would come to mine. We absolutely had to talk to each other about the work we'd accomplished during the day. No painting was ever finished until we both decided it was."[28] Kahnweiler gave a similar account long after the events in question: "Picasso still says to me now that everything that was done in the years 1907 to 1914 could only have been done by working as a team."[29] We are still guided by Pierre Daix's analysis, which followed upon William Rubin's: let us return to a moment with multiple meanings, which Picasso decided to include in one of his favorite large paintings, *The Reading of the Letter* (1921), a canvas that the artist

would keep in his personal collection until he died. Which pair of friends could be referenced in the painting, the two of them enclosed inside a pink cloud and fraternally embracing as they read a letter at the same time—the man in white leaning his left hand on the shoulder of the man in brown, his right forearm on the other's knee, while holding a Kronstadt hat, the very type favored by Cézanne? Was this a reference to Picasso and Apollinaire (who had died a few years before this, on November 9, 1918)? Or to Picasso and Max Jacob (deciphering letters had been the story of their meeting and, in 1921, Max had just retired to the seminary in Saint-Benoît-sur-Loire after his conversion)? Or could it be to Picasso and Braque, who, inspired by their shared unconditional admiration for Cézanne, had bought a real Kronstadt hat in 1909—the very hat featured in the painting? Or perhaps *The Reading of the Letter*, in its portrayal of two friends that seems to allude to all of Picasso's close relationships, was actually an attempt at representing friendship itself?

But let us leave them for a while, this pair of friends who, in Braque's beautiful phrase, were like two climbers "roped together on a mountain," and let us end this chapter with another painting, *Still Life with Hat*, a classical, highly colored work from spring 1909 that really stands out from his cubist work of that period. The famous Kronstadt is depicted in sumptuous black, placed majestically between a bright yellow lemon and a golden pear, in a fruit bowl standing on an acid-green cloth patterned with pink and black. The hat is luminous, isolated on a corner of the table, isolated in a corner of the ocher room, like a secret code, in tribute to the artists' common master.

20.

"A BOTANIST [LOOKING] AT THE FLORA OF AN UNKNOWN LAND" . . . LEO STEIN

The Autumn Salon was new, I started there [. . .] I looked again and again at every single picture, just as a botanist might at the flora of an unknown land.[1]

—Leo Stein

For several years now we have understood the role played by the Stein family (with their collection and their salon, as well as the Matisse Academy) in their interactions between modernist avant-garde artists and American artists living in Paris at the start of the twentieth century. Looking back through recent exhibitions and publications tracing the connections between this unlikely family, which moved to the capital between 1902 and 1905, and Picasso, it is clear that there was a more complex dynamic at work, and also that Leo Stein—an erudite collector and orator, and even an occasional artist—was uncontestably the dominant figure in the family. "I took the plunge and picked more or less at random,"[2] he recalled casually of his search for new art in 1905, an expedition that would net him one of the most revolutionary collections of the era. His French tropism had been nurtured since childhood in the bosom of a globe-trotting, cosmopolitan

family—the Stein parents brought up their five children to venerate the culture of the Old World, between California and the East Coast, and then in Vienna, Paris, and London, through piano and violin lessons and trips to museums—and Leo Stein was an anomalous figure in the France of Jean Jaurès, Jules Guesde, and Charles Péguy. After studying philosophy at Harvard, and before settling in France, this young snob spent the whole of 1895 touring the world, visiting as many museums as possible. Year after year, he would become obsessed with certain paintings, observing and thinking about them until they became "perfectly intelligible."[3] And then there was also his passion for Mantegna, the discussions with art historian Bernard Berenson (in the gardens of the I Tatti villa in Florence, no less), his musical soirées with the cellist Pablo Casals, his ritual summer vacations at the Villa Bardi or the Casa Ricci (every year from 1904 to 1911) on the Fiesole hill outside Florence, his regular stays in the chic neighborhoods of London for dinner with Bertrand Russell. When he moved permanently to Paris after all these accumulated experiences, Leo Stein saw himself as "a Columbus setting sail for a world beyond the world."[4]

A world away from the controversies dividing the French at that time (the law separating church and state in 1905, negotiations over the welfare state in 1907), a world away from the preoccupations of the ministers and economists of the time such as Waldeck-Rousseau or Leroy-Beaulieu, Leo Stein went to galleries, salons, and museums—a cultural sphere whose borders extended to Cambridge and San Francisco, London and Florence, Baltimore and Paris—the way other people might go to market, with the arrogance, carelessness, and perhaps even the helplessness of one whose life is not anchored to reality by any economic necessity. "As I have indicated to you several times in my gentle and persuasive accents," he wrote to a female friend, "there will be no good books on art till Berenson and I shall have written them."[5] It was Leo who bought out the salons, Leo who discovered Picasso at Clovis Sagot's gallery in October 1905, Leo who, amid the strange bric-a-brac of Ambroise Vollard's shop,

acquired his first masterpieces (*Family of Acrobats with Monkey, Girl with a Basket of Flowers, Young Acrobat on a Ball, Boy Leading a Horse, Two Women at a Bar, Woman with a Fan*: several miracles from the Blue and Rose periods); it was Leo who would publicly develop the first critical analysis of the artist's work, Leo who would sometimes pay for his coal or his rent at the Bateau-Lavoir, Leo who would invite him to see his Gauguins, Leo who would take Henri Matisse and the Russian collector Shchukin to Rue Ravignan, Leo who—in his words—was the first person "to admire Matisse *and* Picasso."[6]

"My dear Pablo, Come tomorrow Tuesday after noon to see a Greco [Doménikos Theotokópoulos] at my place. Regards Stein."[7] The five years between 1905 and 1910 were marked by a series of financial transactions, swapped favors, and suggestions between Picasso and Leo Stein—his first collector and his generous protector in dark times—written on both sides in a very direct and sometimes harsh manner. They shared the same obsession with Cézanne, Gauguin, El Greco, and Renoir. Very quickly, however, the artist started to sell paintings directly to his patron by provoking his curiosity, his desire, his jealousy, and by encouraging a rivalry between potential buyers: "Work is going well and the big painting is progressing";[8] "My dear friends, The studio is ready I am just waiting for your visit, Regards Picasso";[9] "I found a buyer for the drawing of a harlequin that I showed you, he is offering me 250 francs, since you said you would like it, I wanted to know if you would take it at that price. Send me an answer so I can give a response to that gentleman. Regards to both of you, Picasso."[10]

In 1905, the very close sibling couple formed by Leo and his younger sister, Gertrude—they can be seen posing with their arms interlocked that year in the courtyard of Rue de Fleurus, smiling radiantly in their expensive bohemian clothes, wearing hats, black velvet capes, and pocket watches—entered the lives of Pablo Picasso and Fernande Olivier. As we have seen, on his return from Gósol the artist immediately set to work on *Gertrude Stein*, using the solutions he'd found in the Catalan mountain village. Leo and Gertrude

continued to follow the artist along this new path, buying directly from his studio some of the more peripheral (but still important) works that he was creating around *Les Demoiselles d'Avignon*, with those geometric and oddly masculine female nudes. In *Nude with Towel* and *Three Women*, Leo saw the primitive aesthetic that he so loved in Gauguin's paintings, while Gertrude sensed the conceptual work on form that she admired in Cézanne. Astonishingly, they acquired number 10 of the sixteen extraordinary notebooks that Picasso filled while preparing *Les Demoiselles d'Avignon*, the only one that Picasso ever agreed to part with. The notebooks constitute a fascinating series of documents: they contain a total of almost one thousand drawings and provide a voyeuristic glimpse into the artist's inner sanctum and his free-wheeling, iconoclastic creative dynamic. "As soon as you open the first notebook, you are projected into a vast construction site operating at full capacity, with exhaustive studies of every idea, every character, every seemingly insignificant detail," wrote Brigitte Léal. "Slowly decanted, they take shape through multiple U-turns, redrafts, and digressions [. . .] expressly leaning upon the store of ideas and images collected in Gósol [. . .] disturbing morphology, androgynous bodies—stocky, muscular, but indisputably feminine—and the 'Iberian' canon of masked faces with dark, hemmed eyes, prominent ears, flattened noses, arched eyebrows [. . .] blank, asexual faces."[11]

For Leo Stein (or was it Gertrude?), to take possession of something as precious as this notebook[12] seems an act akin to stealing the Golden Fleece. Picasso's preliminary sketches (a brothel scene in the presence of two clients, a sailor and a medical student) seem, in their dizzying progression (the student's metamorphosis into an androgynous woman, the crossings out, the obscene poses), driven forward by the artist's new fearlessness, until the "gendered" bodies become openly transsexual. "The masks weren't ordinary sculptures, they were magical objects. *Les Demoiselles d'Avignon* had to arrive that day, not at all because of the forms, but because it was my first exorcism painting!"[13] This was how Picasso himself would later

describe—in an interview with André Malraux—the genesis of the disturbing masterpiece that would remain in his studio, almost all his visitors reacting with sarcasm or incomprehension, until it was sold to the collector Jacques Doucet in 1925. Even so, Picasso remained a source of fascination for his admirers: after spending the summer of 1908 convalescing in a country house to the north of Paris (on Rue des Bois), he celebrated his return to Rue Ravignan with a brief note to his American collectors—"The studio is ready"[14]—accompanied by an invitation. The Steins, delighted, rushed to the studio and immediately bought three still lifes. During the summer of 1909, while spending part of the summer in the little village of Horta de San Juan in Aragon, he continued piquing the Steins' curiosity, keeping them in suspense over his new style—a stripped-down, geometric cubism—and involving them day by day in his work, bombarding them with photographs.

When the two Americans announced their desire to see his native country, he bent over backward to organize their welcome. "Spain awaits you," he wrote magniloquently,[15] before describing what he'd sent them: "My dear friends I am sending you three photographs of four of my paintings. I will send you more one day soon";[16] "Tell me if you have received the photographs of four of my paintings. One day soon I will send you others of the country and of my paintings."[17] Back in Paris, he kept up the pressure: "My paintings will not be hung until the day after tomorrow," he announced, "and you are invited to the opening, Wednesday afternoon."[18]

Picasso's strategy worked to perfection, and the Steins, flattered by his attentions, immediately bought the best two works in the series, *Reservoir at Horta de Ebro* and *Houses on the Hill, Horta de Ebro*. Gradually, the selection of Picasso paintings hanging on the walls of the Steins' apartment on Rue de Fleurus came to represent the best summation of all the works produced by the artist during the first decade of the twentieth century (1901–1909), taking in the Blue period, the Rose period, the Gósol period, the *Demoiselles d'Avignon* period, the Rue des Bois period, and the Horta de San Juan period. This was

also the moment chosen by Gertrude Stein to offer, for the first time, her analysis of the kinship between photography and the artist's new aesthetic—notably the resemblance and syntactical equation between reality photographed and reality represented in paintings.

Business was booming for Picasso, with new (Russian) collectors entering the fray, and in September 1909, as already mentioned, he was able to leave the Bateau-Lavoir for the new apartment on Boulevard de Clichy. Leo Stein was immediately informed of this new social status, as seen in this amended expense claim: "my dear friends I was wrong here are the correct figures bistro: 250, studio: 130, house: 110 = 490 so give me 500 and I can buy a house regards and see you soon Picasso," the artist wrote from his new address.[19] The Steins had known him when he was poor. Leo helped him once again to move into this apartment, and then, after five years of unswerving support, the collector decided to distance himself from the artist. "In 1910, I bought my last picture from Picasso, and that was one I did not really want," he would later write. "But I had advanced him sums of money, and this cleared the account."[20] How can this defection be explained? Was Leo weary of Picasso's financial demands, repelled by his aesthetic evolution (which is what he would later claim), or did he feel he'd been replaced by his own sister, who wanted to become what Leo had been until then—the artist's first critic—and had just moved her partner Alice B. Toklas into the apartment on Rue de Fleurus?

Their split brought an end to five glorious years. Because Leo Stein—hailed by Alfred H. Barr Jr. as "the most erudite man of his time"—had "actively proselytized" on behalf of Picasso's work since discovering this "young Spaniard [. . . this] genius of very considerable magnitude" in 1905 and had immediately heralded him as "the most notable draftsman living." Stein was peerless in his ability to create connections between cultures, to build bridges between separate worlds, a talent that he would put to good use in the Paris of the Roaring Twenties: "The Americans, as I first knew them, were not experimenting," he wrote later. "They were not even going abroad.

Beyond the official salons, they knew nothing and had heard of nothing."[21] In fact, for those young artists eager for beauty who were "slowly emerging from a silent past" and who had left the New World even more reticent about anything related to art since they were considered "lost souls," Stein became the ideal intermediary and incubator with regard to the Parisian avant-garde.[22] Driven by his "heroic proselytizing," he gave them a crash course in French culture during his "Saturday soirées": an invitation to dinner with some close friends, and also "open table" sessions when all you had to do was ring the bell and give the name of a friend. He convened a sort of perfect circle where young artists freshly arrived from Maine, California, or New York could encounter the current glories of Paris.[23] "Paintings by Cézanne, Toulouse-Lautrec, Manguin, Matisse, Picasso, Renoir, and Vallotton covered the walls of the studio on Rue de Fleurus. The collections in the Musée du Luxembourg seemed old-fashioned in comparison."[24] The German artist Paula Modersohn-Becker, who had been enchanted by some of the rooms in the Musée du Luxembourg two years before this, came to believe, after discovering Leo Stein's collection, that, considering the museum was "the only public exhibition site for modern art, [it was] somewhat pathetic."[25]

The salon created by Leo and Gertrude, which followed in its own way the French tradition of society salons—with their aesthetic debates and witty conversations[26]—developed in the cracks of French society, ending up patronized almost exclusively by expatriates. With Leo giving a running commentary of his art collection, sometimes revealing his own "flashes of genius," this Babel-like salon became indisputably his first and most important accomplishment. One of his early followers was the American artist Max Weber, who described the experience with real passion: "For hours, we stood around a large table in the corner of the spacious and well-lighted room, examining portfolios full of drawings by Matisse, Picasso and others, and folios well stocked with superb Japanese prints," he recounted. "This salon was a sort of international clearing house of ideas and matters of art, for the young and aspiring artists from all over the world. Lengthy

and involved discussions took place, with Leo Stein as moderator and participator. Here one felt free to throw artistic atom-bombs and many cerebral explosions did take place."[27]

Not everyone felt a sense of belonging to this strange group, however. "In those early days," Mabel Dodge would write, "when everyone laughed, and went to the Steins' for the fun of it, half-jestingly giggled and scoffed . . . Leo stood patiently night after night wrestling with the inertia of his guests, expounding, teaching, interpreting, [praising] the Big Four: Manet, Renoir, Degas & Cézanne."[28] As for Apollinaire, he amusingly poked fun at "this American woman who, with her brothers and some of her kin, formed the most unexpected patrons" of their time: "Their bare feet are shod in Delphic sandals / They rise to the sky from scientific fronts / The sandals sometimes got them in trouble with caterers and café owners. These millionaires want to cool down on a café terrace but the waiters refuse to serve them and politely explain that only very expensive drinks are served to people in sandals. As it happens, they don't care and calmly pursue their aesthetic experiments."[29] During the first decade of the century, and even beyond, however, Michael, Leo, and Gertrude Stein (three of Daniel and Amalia Stein's five children)—as well as Michael's wife, Sarah, and, later, Gertrude's partner, Alice B. Toklas—helped revolutionize art and literature in the Western world at a crucial moment, with uncommon generosity and boldness. And while Leo, Gertrude, and Sarah each played a role on the Parisian scene, none of their adventures would have been possible without the soothing presence of the eldest sibling, the wise, patient, tolerant Michael, who—upon the death of his parents—became the guardian of his younger brothers and sister, managing the shared inheritance left by the family business without ever commenting on how it was being spent.

During the Steins' soirées, Picasso's physical presence left such a strong impression on the people he met that they would later attempt to describe it. "When Picasso had looked at a drawing or a print," Leo Stein remembered, "I was surprised that anything was left on the pa-

per, so absorbing was his gaze."[30] Andrew Dasburg went further: "Picasso [. . .] was looking at some drawings that Stein had [. . .] they were in a folio, but his looking was so intent [. . .]. When he looked, he really lifted what he was looking at from the paper. Of course, by that time, I was really in seventh heaven. That was the first time that the world of art was open to me."[31] Similarly, Marsden Hartley enthused to Rockwell Kent: "I was at Gertrude Stein yesterday looking at her collection of Picassos and Cézannes. I assure you this man Picasso is a wonder. It was from his watercolors that I got most inspiration as expressing the color & form of 'new places.'"[32] Among Stein's young imitators, the one who became closest to Picasso—sharing his passion for African art and the work of Henri Rousseau—was undoubtedly Max Weber. "Dear Mr. Picasso," he wrote (in bad French) before his departure, "I greatly regret that I cannot go to see you before leaving: but I hope that I will see you soon. Sincerely and wishing you great great success [. . .]. Many wonderful Congo things at the British Museum. I hope that you will see them soon."[33]

21.

"AS PERFECT AS A BACH FUGUE" . . . ALFRED STIEGLITZ

Standing Female Nude is [. . .] as perfect as a Bach fugue.[1]

—Alfred Stieglitz to Arthur Jerome Eddy

With all the young American artists in Paris who had seen Stein's collection and who, during those Saturday soirées, had listened to Leo's "flashes of genius," news of the avant-garde spread rapidly through the United States. One of the first to respond was Alfred Stieglitz, an unusual character in that country where he was sometimes described as a "Renaissance man." "He stood on the floor of the Galleries from ten o'clock in the morning until six or seven o'clock at night. He was always talking, talking, talking, talking," explained the photographer Edward Steichen, "talking in parables, arguing, explaining. He was a philosopher, a preacher, a teacher, and a father-confessor. There was not anything that was not discussed openly and continuously in the Galleries at 291 [. . .]. The difference was Stieglitz."[2] Alfred Stieglitz was, first of all, an artist of many talents: a remarkable photographer but also a gallery owner and a crusading editor. Not only that but culturally Stieglitz was a hybrid, an American who was profoundly European. Like the Stein parents, Stieglitz's mother and father emigrated from Germany when they were children, prior to the Civil

War, then returned to Germany with their own children to have them educated there. His father, Edward Ephraim Stieglitz, was born in Stadtslengenfeld—a small town in Thuringia, just north of Bavaria, two hours' walk from Kahnweiler's hometown—and he left there in 1849. Aged nineteen, Alfred Stieglitz began studying mechanical engineering and photochemistry at the Technische Hochschule in Berlin (a city where he would live for ten years); one of his professors there was Hermann Wilhelm Vogel, who taught him dye sensitization. He quickly grasped the importance of technical mastery in order to represent tonality in his platinum prints, met some European "pictorialist" photographers,[3] and skillfully exploited the burgeoning photography market in the United States. On his return to New York in 1890, he created the company Heliochrome, became an expert in photoengraving, founded the Camera Club and then the magazine *Camera Notes*, modeled on the Vienna Secession art movement (1891),[4] galvanizing local photographers on a technical, formal, and political level, revolutionizing tastes in that city. "American photography is going to be the ruling note throughout the world unless others bestir themselves [. . .]. It is Stieglitz who arranges terms, gets the pictures together, is responsible for their return. What an influence then he must have become," wrote Alfred Horsley Hinton in 1904. "As one sees him today he is a man of highly nervous temperament, of ceaseless energy and fixed purpose."[5]

In November 1905, Stieglitz further extended his field of operations, opening the Little Galleries of the Photo Secession, a tiny store near Washington Square—elegant, minimalist, decorated entirely in gray: a revolutionary look for a city that still lagged years behind Paris—that he used to showcase his passion for avant-garde photography. Aided by his young colleague Edward Steichen (who had been working as a photographer for Rodin since 1900, dividing his time between Paris and New York), Stieglitz became a New York–based promoter of European avant-garde art. "I was ever really fighting for a new spirit in life that went much deeper than just a fight for photography," he would later write. "I did not know that in time I would

be broadening the fight, a fight that involved painters, sculptors, lit-
erary people, musicians."[6] Fluently bicultural, Stieglitz would move
constantly between the two continents, spending all his summers in
Europe in an attempt to have the best of both worlds. In Paris, dur-
ing the summer of 1908, Steichen took him to visit Rodin's studio in
Meudon, then Matisse's studio on Rue de Sèvres. He immediately
decided to exhibit their work: fifty-nine erotic drawings by Rodin
(January 1908) and the first American presentation of Matisse (April
1908) with paintings, aqua fortises, and lithographs—two very dar-
ing initiatives in a country still largely mired in philistine and puritan
attitudes. The exhibitions proved a *succès de scandale*, leading several
Camera Work readers to cancel their subscriptions. "As for the red
rag," Edward Steichen advised him, "I am sure Picasso will fill the
bill if I can get them but he is a crazy galloot who hates exhibiting.
However we will try him."[7]

During the summer of 1909, although personally a little am-
bivalent about Picasso, Steichen led Stieglitz to Rue de Fleurus to
visit the Steins' collection. There, Leo launched into such a wildly
enthusiastic speech—with allusions to Whistler's painting, Matisse's
sculpture, the old masters . . . and Picasso, of course—that Stieglitz
instantly offered to devote one, two, even three special editions of
his magazine, *Camera Work*, to the collector's essays on his favorite
artists—essays that Leo Stein would never write.[8]

How could Picasso's art have escaped the notice of Alfred Stieg-
litz? In their growing dynamic during those years, Picasso's experi-
ments were very much in line with the ideas promulgated by Stieglitz,
a man educated in Berlin at the best German university. The history
of art was taught there by Adolph Goldschmidt (who brought a "sci-
entific approach" to medieval art) and, later, by Heinrich Wölfflin,
providing him with all the conceptual tools needed to understand
what Heinrich Riehl would describe as "the eye of an era."[9] As for
Wilhelm von Bode, assistant curator at the royal museums of Berlin,
he and his colleagues were preparing the logistics necessary to ac-
quire works from the English, Italian, and French markets in order

to enlarge the city's collection to include non-European art—a global
and transindividual approach to history that drew its inspiration from
the work of Johann Gottfried Herder.[10] Notwithstanding his visit to
Leo Stein, however, Stieglitz would find his way to Picasso's work via
another route.

In January 1910, *The Architectural Record* published the first pho-
tographs in the United States of Picasso in his studio—sitting in a
chair, pipe in hand, in front of his collection of African masks. The
photographs had been taken by the journalist Gelett Burgess, who'd
managed to meet all the avant-garde artists in Paris. Burgess pho-
tographed *Three Women*, along with two preliminary studies for *Les
Demoiselles d'Avignon* (a work still unknown to the public, despite the
controversy already surrounding it), *Study* and *The Woman*. "Picasso
is a devil," wrote Burgess. "I use the term in the most complimentary
sense, for he's young, fresh, olive-skinned, black eyes and black hair,
a Spanish type, with an exuberant, superfluous ounce of blood in
him [. . .]. He is the only one in the crowd with a sense of humor; you
will surely fall in love with him at first sight, as I did [. . .]. Picasso
is colossal in his audacity [. . .]. So we gaze at his pyramidal women,
his sub-African caricatures, figures with eyes askew, with contorted
legs, and—things unmentionably worse—and patch together what-
ever idea we may . . . But if Picasso is, in life and art, a devil, he at
least has brains and could at one time draw."[11]

Among the Americans in Paris at that time, it was Burgess who
proved best at insinuating himself into the private worlds of the
avant-garde artists, whom he labeled collectively "*les Fauves*" (the
wild beasts) as a way of hinting at part of their secret. "Les Fauves
are not so mad, after all," he wrote. "They are only inexperienced
with their method. I had proved, at least, that they were not char-
latans. They are in earnest and do stand for a serious revolt [. . .].
[Their art] sets one thinking; and anything that does that surely has
its place in civilization [. . .]. Perhaps these Wild Beasts are really
the precursors of a Renaissance, beating down a path for us through
the wilderness."[12]

Entering Stieglitz's orbit now was the artist Max Weber who, after three years in Paris (where, as we have seen, he became friends with Picasso and studied with Matisse), returned to New York in December 1909 and began living in the same building where Stieglitz's gallery, 291, was located. The gallery was overflowing with Picasso-related memories: the friendship with Henri Rousseau, the exchange of African art, the acquisition of a still life, and others. Next to enter the scene was the Haviland family and its consorts: Paul Burty Haviland (a wealthy Franco-American photographer who offered the gallery financial support), his brother Frank Burty Haviland (a Montparnasse artist who in 1909 became friends with Manuel Martinez i Hugué ["Manolo"] and then with Picasso), and, lastly, their cousin Hamilton Easter Field (another artist, critic, and patron who in July 1910 bought eleven artworks from Picasso to decorate his library in Brooklyn—the first direct sale to the United States that Picasso had made).[13] And the final piece of the puzzle was Marius de Zayas, a young Mexican illustrator who had moved to New York for political reasons and who spent a year in Paris, starting in October 1910, where he befriended Picasso. It was Zayas who proved the catalyst, sealing an agreement (on behalf of Stieglitz) with Picasso to exhibit his work in New York. After an initial disappointment at the Autumn Salon ("I looked, but I did not see"),[14] Zayas quickly became one of the most perceptive critics on the Parisian art scene: "The real article is a Spaniard whose name I don't recall, but Haviland knows it, because he is a friend of his brother," he wrote enthusiastically to Stieglitz on October 28, 1910,[15] before expressing his gratitude to Photo Secession for "preparing him to see with open eyes."[16] A few months later, he added emphatically that Paris is "where you have to get all your ammunition for your future fights."[17]

From that moment on, Edward Steichen's initial reticence toward Picasso's art was overwhelmed by the artist's fans. A combination of Haviland, Zayas, Steichen, and Picasso himself made the selection of works before Steichen sportingly surrendered while boldly standing his ground: "I am sending the Picassos on the next boat

[. . .]. Haviland and Picasso selected the Picasso pictures themselves. I came in for a little advice in the end to make the collection a little more clear by its evolution. It shows his early work and his 'latest'—certainly 'abstract'—nothing but angles and lines that has got [to be] the wildest thing you ever saw laid out for [a] fair. Picasso was a man I never could see [. . .]. I admire him but he is worse than Greek to me [. . .]. Picasso may be a great man, but it would be rank snobbery for me to say I see it now."[18]

From March 28 until April 24, and then during the entire month of May 1911, Alfred Stieglitz finally put on the exhibition he'd been planning for the previous three years: *Early Recent Drawings and Water Colors by Pablo Picasso of Paris*. With forty-nine works on paper (dating from 1906 to 1910), more than thirty-four other drawings for the storehouse, and a short, enthusiastic text by Marius de Zayas available to people visiting Stieglitz's gray, sober, sophisticated gallery, could Picasso's first foray into the American art scene have gone any better? "I want to tell at present of Pablo Picasso, from Málaga," wrote Zayas, "who finds himself in the first rank among the innovators, a man who knows what he wants, and wants what he knows, who has broken with all school prejudices, has opened for himself a wide path, and that has already acquired that notoriety which is the first step towards glory [. . .]. Egyptian art without Greco-Roman prejudices [. . .] they transformed matter into form [. . .]. Something of this sort happens in Picasso's work, which is the artistic representation of a psychology of form in which he tries to represent in essence what seems to exist only in substance."[19]

The first piece that visitors saw in Stieglitz's exhibition was *Peasant Woman with a Shawl*, from Picasso's time in Gósol: a classic, full-length drawing of an old woman in profile, a timeless image showing the first signs of that 1906 evolution. This was followed by the distorted bodies (preparatory drawings for *Les Demoiselles d'Avignon*), the African statues, the heads with twisted noses, the calm landscapes of Horta, the dynamic cubist drawings . . . it was all there. Through this fine selection, lent coherence by its chronological order

and bold presentation, American art lovers were able to perceive the draftsman's virtuosity, from *Peasant Woman with a Shawl* (bought by Field) to *Standing Female Nude* (bought by Stieglitz). "The city's new sensation," "disturbing," "troubling," "disconcerting": the local critics' reactions were many and varied, unsurprisingly so given that this was the first showing by such an audacious artist in a country known for its traditionalism. Some reviewers deplored the use of African sources: "It would be an error to apply to Señor Picasso's method any term that implied progress, or advance, or development [. . .] these things of Picasso's are neo-African. They remind one of nothing so much as of the carvings in ebony or blackened wood, rudely representing the human figure, made by the natives of the west coast of Africa."[20]

Despite the crowds of visitors—more than seven thousand—drawn by the newspaper articles, and despite the show's run being extended throughout May, sales were disappointing. Still, Stieglitz knew that something important had just happened. "The exhibition is a very great success," he wrote to Zayas. "In a way this is the most important show we have had [. . .] the future looks brighter than it has in a long while."[21] Marius de Zayas, for his part, predicted: "The Picasso exhibition will help a lot in anchoring Photo-Secession's place in the art world."[22] Galvanized by the situation, and enthused by the artist's work, Stieglitz suggested to the director of the Metropolitan Museum, Bryson Burroughs, that he could buy all the remaining works for two hundred dollars, but Burroughs replied that he "[saw] nothing in Picasso" and vouched "that such mad pictures would never mean anything in America."[23] Clearly, Burroughs was no fortune-teller! Following the exhibition, Stieglitz's interest in Picasso only grew, and in the summer of 1911, Zayas took him to meet the artist. Comparing this visit to those he'd made to Matisse and Rodin, he would later write: "Picasso appears to me the bigger man. I think his view point is bigger; he may not as yet have fully realized in his work the thing he is after, but I am sure he is the man that will count."[24]

In a sense, it was the photographer, more than the gallery owner,

in Stieglitz who was most strongly moved by Picasso's experimentation, as if Picasso's art was awakening something in his own. "You don't understand what Picasso & Co. have to do with photography!" he wrote to his friend Heinrich Kuhn. "Now I find that contemporary art consists of the abstract (without subject) like Picasso etc., and the photographic [. . .]. Just as we stand before the door of a new social era, so we stand in art too before a new medium of expression—the true medium (abstraction)."[25] This viewpoint would be expressed in Stieglitz's magazine, *Camera Work*, in 1912, not by the editor himself but by Gertrude Stein. (She had been made aware of the connection between Picasso's work and photography in 1909, when the artist sent her his photographs of Horta de Ebro.) But Stieglitz was also a collector, and for sixty-five dollars he acquired one of the most original and difficult works in the entire exhibition, a work ridiculed by one critic who compared it to a "fire escape."[26] In fact, *Standing Female Nude* (1910) is a wonderful charcoal drawing, vertical, dynamic, and suggestive, with its vertical lines, its slanting lines, its curved lines, its furious horizontal shading—visible or faded, intense or light—creating a composition that undeniably evokes music. "As perfect as a Bach fugue," as Stieglitz put it in a letter to his friend Arthur Jerome Eddy, explaining why he'd bought it[27]—a phrase reminiscent of Kramář's verdict when he first saw *Woman's Head* (1908) in Munich. So, the first two Picasso works to enter collections in the New World represent two women: the drawing of the old peasant woman from Gósol, with its shift toward the iconic, and the cubist nude.

A few months after his first Picasso exhibition in New York, Stieglitz, convinced of his righteousness in fighting for the European avant-garde in a country still resistant toward it, began to sound like a visionary: "In my opinion, the United States is undergoing a silent revolution," he explained to Paul Burty Haviland, "and the large majority of people have no suspicion of it."[28] Only two years after the *Early Recent Drawings and Water Colors by Pablo Picasso of Paris* exhibition, a hastily prepared event known as the Armory Show (with several Picasso paintings in its cubist room) would set off a huge controversy in New York.[29]

But let's not get ahead of ourselves. While Picasso's reputation spread across Germany in a systematic and coordinated way (supported by the local history of art school's theoretical frames of reference, by a vast contingent of knowledgeable critics, and by a network of galleries throughout the country), in the United States it was a very different story. Pragmatic and random, it relied on the sagacity of a few special individuals like Stieglitz, who was, as previously mentioned, educated in Berlin between 1880 and 1890, and whose exposure to avant-garde artists undoubtedly put him on the same wavelength as visionary figures such as Vincenc Kramář, Daniel-Henry Kahnweiler, Carl Einstein, and Wilhelm Uhde.

To highlight his empathy with Picasso's work, artist to artist, Stieglitz decided to print *Standing Female Nude* in volume thirty-six of *Camera Work*, a special edition that he published in late 1911, just after his exhibition, and that was devoted to a series of sixteen of his own photographs dating back to 1892. This sublime series of masterpieces—including *Lower Manhattan* (1910), *The City of Ambition* (1910), *The City Across the River* (1910), *The Hand of Man* (1902), and *The Terminal* (1892)—is a portrait of New York, its ports, its railways, its smoky skies. But the key photograph in the series was *The Steerage* (1907), which shows a crowd of people crammed onto two decks of a ship—the lower deck and the upper deck, people divided by class, with the peasants below in their prayer shawls, headscarves, and pants held up by suspenders, and the fedoras, straw boaters and elegant women on the upper deck, the two classes separated by a long, white gangway, empty and slanting downward, its sides protected by chain barriers, like a paradigmatic vision of immigration.

22.

"KNEE TO KNEE," PORTRAIT TO PORTRAIT . . . GERTRUDE STEIN

The twentieth century [will] be no longer European because perhaps Europe is finished.[1]

—Gertrude Stein

"Until Gertrude bought a cubist Picasso, she was never responsible for a single painting that was bought, and always said so," wrote Leo Stein to the collector Albert Barnes.[2] Later, he added: "God knows what a liar she is! [. . .] Practically everything she says of our activities before 1911 is false both in fact and in implication, but one of her radical complexes [. . .] made it necessary [. . .] to eliminate me."[3] It is hard to maintain a balanced view when discussing a family whose internal conflicts were as public and as violent as the Steins'. There is something savage and indecent about such clashes, revelatory of the most primal human urges. But let us return for an instant to Gertrude Stein's relationship with Picasso. A few years ago, in the archives of the Musée Picasso, I was able to admire how their own *koinè* worked back in 1905. "*Bonjour, bonjour, Bellissima cita questa and molta bella cavallo fait des bois*," she wrote on a postcard showing a Donatello sculpture. "This photograph is prettier than the other

one I send you," she continued in French. "It's very beautiful this horse is well placed in a wonderful room."[4] On Saint Paul's feast day, on a somewhat "romantic" card with the word "Pablo" written in the hand of a starry-eyed girl, she went on: "I wish you many happy returns on your saint day, I'm a little late but better than never. Sincerely yours."[5] Later, on a reproduction of *Contessa Spini* by Il Piccio, Gertrude noted: "She's very pretty, don't you think. Whadda you up to down there. Are you alone. The happy catalans are really pretty. Nothing new. Greetings. Gertrude."[6] "I speak French badly and write it even less well," she noted one day in French, "but it's the same thing with Pablo, he says we write and speak a French that belongs only to us."[7]

Gertrude Stein and Picasso communicated in a language of their own invention. But while she never really bothered to master French, it was different for Picasso: by 1935, he would become an accomplished poet in his adopted language. "There is for me only one language and that is english," stated Gertrude Stein. "One of the things that I have liked all these years is to be surrounded by people who know no english."[8] She enjoyed the solitude conferred upon her by her status as an expatriate, living in a country where nobody understood what she wrote and where she could easily isolate herself in a linguistic bubble. And so she and Picasso, each of them busy reinventing the codes of their respective languages—the English language and the art of painting—created their very own jargon in order to communicate, a sign of the intimacy of their relationship. While Leo was inarguably the force behind the Steins' art collection, Gertrude's closeness with the artist began with the sittings she made for her portrait, just before the summer of 1906.

Whose idea was that portrait? How was it funded? Nobody really knows. "Gertrude poses and Picasso, sitting on the edge of his chair, nose to the canvas, holding a very small palette covered in a uniform grayish-brown, starts to paint. This was the first of 80 or 90 sittings."[9] Ninety sittings in only three months? It is hard to think of this number without smiling. In any case, Gertrude obtained a

privileged position with regard to Picasso during that period, a genuine physical closeness that put her in contact with his pure creative flame and for a time ousted the other pretenders who clamored to be near the penniless tenant of Rue Ravignan. This is the version Gertrude herself gave in her *Autobiography of Alice B. Toklas*: "It was only a very short time after this that Picasso began the portrait of Gertrude Stein, now so widely known, but just how that came about is a little vague in everybody's mind. [. . .] They neither of them can remember [. . .], there is a blank. How it came about they do not know. Picasso had never had anybody pose for him since he was sixteen years old, he was then twenty-four and Gertrude Stein had never thought of having her portrait painted [. . .] she posed to him for this portrait ninety times and a great deal happened during that time."[10] This text is riddled with errors, vague descriptions, omissions, approximations, deliberate inaccuracies, artistic blurrings, and blatant exaggerations. So how can we rescue the Stein family from its literary fog and restore some historical truth without getting lost in its infernal labyrinth?

Let us focus on the physical intimacy between the two, with its hint of a sexual spark, strongly suggested in this passage from *The Autobiography of Alice B. Toklas*: "These two even to-day have long solitary conversations. They sit in two little low chairs up in his apartment studio, knee to knee and Picasso says, *expliquez-moi cela*."[11] Focus, too, on the perfect symmetry (as in his friendship with Apollinaire) between the pictorial work of one and the poetic work of the other—the two artists stimulating, spurring, challenging, and confronting each other. In 1905 and 1906, before Gósol, Picasso painted *Gertrude Stein* (but couldn't finish it), while Gertrude wrote *Three Lives*. Between the summer of 1906 and the summer of 1907, Picasso finished that portrait, then plunged into the formal experimentations of *Les Demoiselles d'Avignon* while Gertrude followed suit with *The Making of Americans*. Two lessons learned in Gósol—the renunciation of physical resemblance and the discovery of the "solution of the mask"—which, as we have seen, signaled the start of a new

era for Picasso, came together on his return to Paris in August 1906: Picasso added a mask to the portrait. And Miss Stein—with her masculine pose borrowed from Ingres's *Portrait of Monsieur Bertin*, with her primitive mask and asymmetrical eyes—came to epitomize the female poet.

While Picasso embarked upon the vast project that would become *Les Demoiselles d'Avignon*, Stein developed *The Making of Americans*, her first magnum opus written while in Picasso's orbit—a wildly ambitious, one-thousand-page manuscript whose aim was to recount a universal history of Americans, based on the true story of her grandparents (German Jews who emigrated to the United States) and her parents, written in a language "inspired by the modernist fragmentation of [the painter's] paintings, with their lack of differentiation and structure," that would represent "the peaceful Oriental penetration into European culture or rather the tendency for this generation that is for the twentieth century to be no longer European because perhaps Europe is finished."[12]

It is difficult to find one's bearings in the world of the Steins, since everything written about them seems falsified, twisted, counterfeit. Starting with the name of the tiny village on the border of Franconia and Bavaria that Daniel Stein—father of Michael, Simon, Bertha, Leo, and Gertrude—left with his parents at the age of seven, on July 14, 1840, to travel to Baltimore, where they arrived on September 2, 1841 (after a crossing on the ocean liner *Pioneer*). All the books on the Steins refer to the name of that village as "Weigergruben," a place that does not exist, each of them repeating the same mistake, as if the family were immune to historical accuracy. How could I get a handle on these quirky siblings, constantly playing with questions of identity in a city (Paris) completely disconnected from their obsessions? Once again, it was geography that saved me. I spent some time searching for Weigergruben among all the little hamlets of Upper Bavaria . . . Weilheim? Weissenburg? Weissenhorn? Weissenstadt? Wertingen? Weiden in der Oberfalz? Weikersheim? Weingarten? In fact, it was Weickersgrüben, a minuscule farm village in the Saale Valley where, in 1840, six Jewish families (rag-and-bone merchants,

cattle traders, bookbinders) were still allowed to live under the statute of the *Schutzjuden* (protected Jews) in the *Thüngensches Judenschloss* (castle of the Jews of Thungen), an imposing, fortified medieval building, flanked by a large, square, fifteenth-century tower. This *Judenschloss*, which in bygone years had been a customs office for tithes, served successively as a Catholic church, then a Lutheran temple (when the ruling family decided to convert). When the Steins were there, it was also home to a prayer room and religious school for Jewish families.

While Picasso contorted the bodies in the Avignon brothel and explored other worlds under the influence of his friend Gertrude (one of the envelopes he sent her was addressed to "Miss Gertrude Stein, man of letters"), she was confidently reinventing the genesis of the United States, based on stories her father had told her, into a universal fable. Was Gertrude Stein aware of the status of Jews in Bavaria before the 1848 revolution? It was under the rule of Karl VI, *Graf von Thüngen* (1776–1841)—a man who was the Bavarian ambassador to Athens, Darmstadt, and Kassel before becoming the king's minister—that Gertrude's paternal grandfather, Michael Stein (a respected man and apparently the leader of the Weickersgruben community), left his village in dramatic circumstances. His wife, Hannah, was the one who urged their departure, while Michael was hesitant. In the village archives, traces still remain of this family tragedy—the father's reticence, delays for the necessary paperwork, the costs of such a journey, the anticipated sale of all his goods, the uncertainty (unless he paid an extra fee) over the situation of Schmeie Stein, the eldest son, who had not fulfilled his military obligations— a risk that was also a gamble on the future. At the bottom of the official document dated May 12, 1840, in which the local municipality duly recorded their departure, the signatures of the father and his five sons were written in Hebrew letters. As for the mother, she drew three little crosses . . .[13]

In the pages of Gertrude's book, we can find the many allusions to Picasso that she wove into her family's story. For example, the invented Californian city where she has her family live is named

Gossols. "They were living, the father and the mother and the three children, there had been two other children but they had died in the beginning, they were living then the five of them and the servants and governesses and dependents they had with them, in the ten acre place in that part of Gossols where no other rich people were living [. . .]. They had foreign women as servants in the house with them when they could get them. Sometimes they could not get them. They had three governesses in their whole living in Gossols before the children grew too old to have one."[14] In this way, Gósol/Gossols—now the location where Picasso became cubist and the Steins became American—took its place in the heart of a fantastical geography in which America and Spain stood out from the rest of the Western world. But Gertrude went further: she made cubism a "natural production of Spain," an aesthetic revolution born from the depths of the Spanish identity: "In the shops in Barcelona instead of post cards they had square little frames and inside it was placed a cigar, a real one, a pipe, a bit of handkerchief etcetera, all absolutely the arrangement of many a cubist picture and helped out by cut paper representing other objects. That is the modern note that in Spain had been done for centuries."[15] If Gertrude Stein was convinced that she was capable of penetrating cubism before the others and using it in turn to revolutionize literature, was it because—according to her—Spain and America were "the only two western nations that can realize abstraction"?[16]

If, in her case, the artistic quest and the quest for identity were partly linked, it was because the work was not a simple object of contemplation. It was the medium of an experience and the precipitate of a particular relationship with the world, often considered in national terms: the Spanish/American/French/German mind, etc. The approach of works that were promoted in the Steins' salons was based on an Anglo-Saxon psychological aesthetic influenced by the pragmatic philosophy of William James, the father of the cognitive sciences and Gertrude Stein's mentor when she studied at Harvard. Knowing this, it is easier to understand the necessity, constantly restated at Rue de Fleurus and Rue Madame (where Michael and

Sarah Stein lived), for direct contact with the paintings, since this alone could spark the immediacy of the experience. But the makeup of the family's collection was not only about aesthetic judgments; it was also inextricably tangled up with fraternal rivalries, financial wagers, personal ambitions, petty vengeances, and quasi-religious conversions. "The Steins, then, were among the first to conceive of and develop their collection as a psychological vector participating directly in the construction of their personal and family identity, in a way that went well beyond the simple fact of possession."[17]

In October 1911, after completing the huge manuscript of her family epic, Gertrude Stein entered a period of "heroic proselytizing,"[18] writing portraits of Parisian celebrities that would be published in the magazine *Camera Work*: "Matisse" (1912) was followed by "Picasso" (1912) and "Mabel Dodge at the Villa Curonis" (1913). For the happy few who had attended Stieglitz's New York exhibitions and who read his magazine, Gertrude Stein became the ultimate American mouthpiece for the Parisian avant-garde, teaching the uninformed public while in some sense trading roles with Picasso: now they were no longer just "knee to knee" but "portrait to portrait," too. Because, in a fairly elaborate *mise en abyme*, the model for *Gertrude Stein* (1906) became the author of *Portrait of Picasso* (1912). She wrote of him: "One whom some were certainly following was one who was completely charming. One whom some were certainly following was one who was charming. One whom some were following was one who was completely charming. One whom some were following was one who was certainly completely charming [. . .]. He was working, he was not ever completely working."[19] A flash of genius or of bravado? Either way, Leo Stein's little sister, the youngest of the clan, had written her name into history.

In March 1912, Gertrude Stein bought *The Architect's Table*, the first Picasso she had bought solo after her brother's departure, and this time not directly from the artist.[20] "I have the pleasure to confirm that I am selling you Picasso's painting, *The Architect's Table*, for the price of 1,200 francs," Kahnweiler wrote to her, "payable half on signature of this agreement and half upon your return to Paris in the

autumn."[21] In the lower part of the oval painting, Picasso depicted a business card on which he handwrote the name "Gertrude Stein": was this a little added bait to Gertrude's narcissism, with its reference to a missed appointment? There is more to this work, however: in the shades of beige and gray, like a coded trompe l'oeil cut up into a jigsaw puzzle, the artist brings together a haphazard, fragmentary collection of his own favorite objects and his own passions for the era—"MA JOLIE" refers to a song that was fashionable at the time, and to Eva, his new muse and girlfriend; "MARC" to his favorite brand of alcohol; "Gertrude Stein" was a greeting to his collector. All these truncated words were floating amid a sea of truncated objects—two full glasses, a bottle of alcohol, a musical score, a fringed curtain tieback, a violin scroll—that would become so many markers of cubism. Did this woman who heralded "the peaceful penetration of the East in European culture," who affirmed that "the twentieth century [will] be no longer European because perhaps Europe is finished,"[22] really have the ability, with her displaced expatriate culture, to predict World War I?

In 1935, after the publication of *The Autobiography of Alice B. Toklas*, a few horrified celebrities decided to publish a "Testimony Against Gertrude Stein" in the magazine *Transition*, to reestablish the facts in contrast to her vision of the world. Georges Braque's contribution needs no additional comment: "Miss Stein understood nothing of what was happening around her [. . .]. In the early days of cubism, Picasso and I were engaged in what we thought of as the quest for an anonymous personality. We tended to erase our personalities in order to achieve originality. It would sometimes happen that art lovers would confuse my paintings with Picasso's and vice versa. We were indifferent to that because what mattered most to us was our work and the questions it posed [. . .]. Clearly Miss Stein saw everything from the outside, but never the real battle that we were fighting. For someone who considers herself to be an authority of her time, it might be said that she has never moved beyond the status of a tourist."[23]

23.

"ONLY PARIS WAS OUR COUNTRY" . . . RUPF, UHDE, HESSEL, AND EVEN DUTILLEUL!

Paris had become a destiny, a necessity [. . .]. I knew a few
artists and friends of artists, most of them also foreigners. As a
foreigner, I lived in the margins of life and I loved that city.[1]

—Franz Hessel

Between 1905 and 1911, with their soirées on Rue de Fleurus open to
anyone, the Steins brought a breath of fresh air to the French capital.
The people around them were mostly other foreigners—wealthy ex-
patriates and travelers—who gradually formed a constantly growing
micro-society, existing simultaneously on two continents, a hundred
or so artists, writers, journalists in perpetual movement. Uniting
and atomizing this crowd was a push-and-pull of rivalries and al-
liances, attractions and hatreds, friendship, affections, love affairs,
and power games played according to several criteria: creativity,
money, spheres of influence. Little by little, the Steins' world began
to appear to me not only as a swarm of potential ideas, exchanges,
hybridizations, and cross-fertilizations, but also as a sort of boxing
ring where the predatory instincts of certain people were given free
rein. We will examine some of these people in this chapter—part

portrait gallery, part investigative report—by observing the Steins' involvement in the very Parisian rivalry between the two most famous artists in the capital: the young Picasso and the great Matisse, eleven years his senior.

In January 1908, Matisse agreed to create a Matisse Academy where he would teach art. It was Michael Stein's wife, Sarah, who came up with this idea and found two convents—the first on Rue de Sèvres, the second on Boulevard des Invalides—to house this innovative project. For Matisse, the opening of the academy became "a way of setting out [his] theory of painting at a time when his prestige was starting to be rivaled by the rise of cubism."[2] The growing competition between the two camps intensified the following year, and for the Steins it soon became a family affair: Rue de Fleurus (Leo and Gertrude) versus Rue Madame (Michael and Sarah), the former growing closer to Picasso with the acquisition of his cubist landscapes of Horta de Ebro in 1909 while making clear their aversion to Matisse's drift toward the decorative. Their friend Harriet Levy felt that the two factions had confused their own identities with those of the two artists.[3]

The Matisse Academy was "an aesthetic conception founded on the idea of experimentation,"[4] since the Steins (on both Rue de Fleurus and Rue Madame) had become a melting pot for dialectic thought based on the art that was being made in the presence of the artists themselves. As soon as this new institution opened, the tensions between Matisse and Picasso awakened the latent conflicts at the heart of the Stein family—Sarah versus Gertrude, Gertrude versus Leo—and their visitors in turn divided into two camps: "Matisseites" versus "Picassoites," as Gertrude mischievously labeled them.[5] Showing an interest in Picasso was considered an act of heresy at Rue Madame, just as confusing a Picasso with a Cézanne was sacrilege at Rue de Fleurus.

According to the Swedish artist Isaac Grünewald, the 120 students who swelled the ranks of the Matisse Academy were "mostly Scandinavians, Germans, Hungarians, and Russians, with only two

French artists."[6] American friends the Steins had met in San Francisco flocked to Rue Madame as well as to Rue de Fleurus, and were put at ease by the family's informal welcome. Others attended their salons with an almost mystical seriousness, as if entering a sanctuary. "Only Paris is our country," declared the German writer Franz Hessel; born in Stettin, he traveled to Paris in 1906, following in the footsteps of Heinrich Heine, Wilhelm Uhde, and Daniel-Henry Kahnweiler. He planned to stay for a few months and ended up living there for six years. "It is strange and difficult to explain," he went on. "Paris became a destiny, a necessity [. . .]. I knew a few artists and friends of artists, most of them also foreigners. As a foreigner, I lived in the margins of life and I loved that city [. . .]. From time to time, everyone would gather around the French poets' table and each of us would jabber away in an idiosyncratic version of French, the beloved 'language' we all shared. But, like the elect of all the nations on Pentecost, we understood one another."[7]

One of the central figures in this German colony in Paris was Wilhelm Uhde, a collector and part-time gallery owner, from a Protestant family in East Prussia, who bought his first Picasso in 1904 as soon as he arrived in Paris. He purchased *The Blue Room* at Père Soulié's shop on Rue des Martyrs, opposite the Cirque Medrano, the very same bric-a-brac shop where Picasso bought a painting by Henri Rousseau. Soon after, Uhde met Picasso at the Lapin Agile, before opening his own gallery at 73 Rue Notre-Dame-des-Champs. "It was a long road that took me from the wasteland of the eastern provinces to Paris, where I felt at home; that road took me far from everything Prussian, Lutheran, reactionary, Bismarckian, toward the free domain of art," he wrote in his memoirs, *From Bismarck to Picasso*.[8] In his apartment on Rue de Fleurs, he welcomed art lovers, but also ordinary people—including the sworn enemies of cubism—and played the role of intermediary for this colorful crowd of artists and collectors, French people, and foreigners. For Uhde, the opening of Kahnweiler's gallery in 1907 represented "a crucial event" for the Paris art scene. "From that moment," he wrote, "we waged war

together—a hard, beautiful war for the great things to come that we believed in."[9]

The art historian, gallery owner, and editor Julius Meier-Graefe also arrived in Paris during this period. In his book *Entwicklungsgeschichte*, he championed a dynamic approach to the art world based on the exceptional quality of a few works and the genius of a few artists, each one the custodian of a complex culture, constructed from connections with artists of the past. "Often I don't even feel like I'm in Spain," he wrote during his stay in Madrid. "Sometimes the entire trip seems to be a fiction [. . .]. I am not traveling through Spain but through Titian, Rubens, El Greco, Tintoretto, Poussin; through beings so much greater and more curious than any that can be found in Spain. Those beings are continents . . ."[10] The paradox of Meier-Graefe, according to one of his colleagues, was that "he wrote a 'German' book with a cosmopolitan viewpoint while he was *in Paris*."[11] Meier-Graefe was not shy about expressing harsh opinions on the elitism of art in France, deploring the snobbery toward the "applied arts," for example—a situation that would be resolved by Picasso, who in the 1950s became a ceramist and organic artist in Vallauris.

It is little surprise, then, that a growing coterie of German artists (led by Hans Purrmann and his cohort from the Café du Dome) converged on Rue de Fleurus, Rue Madame, Rue de Sèvres, and then Boulevard des Invalides. The warm reception given to aesthetic experiments in those years by the German public (both in Paris and in Germany itself) stood in total contrast to the few sympathetic comments made by French critics, collectors, or the general public about cubism. Among the French intelligentsia, in the French artistic scene, in the press (specialized or mainstream), even in the National Assembly, avant-garde art was continually attacked, in all sorts of ways. Along with futurism, cubism was the target for most of this ire. The very term "cubism" was drawn from a pejorative phrase intended to ridicule a style of painting that transformed reality into "cubes." It first appeared in that article by Louis Vauxcelles who,

commenting on Braque's Estaque landscapes, wrote: "Mr. Braque despises form, reduces everything, places and figures and houses, to geometric diagrams, to cubes."[12] After that, the press—used to deriding the profusion of isms (futurism, primitivism, scientism, neo-Mallarmism)—rushed to add that dreaded suffix to the term "cube" chosen by Louis Vauxcelles to describe this new pictorial style, then saw in it the symptom of a decadent era where artists aspired only to originality and visibility.[13] It was a way of suggesting that this new style amounted to nothing more than the megalomaniacal folly of yet another school of modern art. The term "cubism" retained this violently negative undertone for years afterward, even within modern-art circles.

But why did the French blame modern art in general and cubist artists in particular? "The rich buyer is often so afraid to appear a vulgar 'bourgeois' [. . .] that it is possible to sell him anything you want."[14] This is just one more illustration of the cultural divide between France and Germany during this very particular historical period—after the humiliating French defeat at Sedan (1870), before the start of World War I (1914)—when Germany remained for France both the "hereditary enemy" and the "supreme model." When Kahnweiler saw *Les Demoiselles d'Avignon* for the first time at the Bateau-Lavoir, he "immediately recognized that the painting was not aimed at a judgment based on taste, that its description evoked neither distortion nor expressiveness," explained art historian Werner Spies. Moreover, "disregarding the purely narrative character of the composition, he understood the 'problems' that Picasso was solving."[15] Following Wilhelm Uhde and Meier-Graefe, inspired by Immanuel Kant's motto "A thing of beauty should not be liked," it was not only Kahnweiler but the entire German colony in Paris that became interested in Picasso during his cubist years.[16] "If French culture was traditionally the guardian of taste," remarked the historian Michel Espagne, "the alternative to the standard of taste is the search for origins. Not only is medieval literature rehabilitated in this way, becoming a sort of new Antiquity, but the search goes

far beyond that, into the mythical realms of the Indo-Germanic and Sanskrit."[17]

And yet even someone whose vision of art was "based purely on taste"—since he belonged to a traditional family from the north of France and had been raised in a house filled with eighteenth-century furniture, some of which even came from the Palace of Versailles, as well as paintings by Hubert Robert, Jean Boucher, and Horace Vernet—could join this club of foreign art lovers. Guided by Kahnweiler, he would become one of the most refined and voracious collectors of Picasso's cubist phase, buying more than works belonging to that aesthetic revolution, with a particular predilection for the widely misunderstood papier collé period of 1913. "I have no particular merit," Roger Dutilleul would later explain in one of his rare interviews. "It was out of necessity that I sought out the younger artists. I really liked Cézanne, but by 1907 the prices at the Bernheim gallery were beyond my means [. . .]. But, above all, that taste drove me to frequent the shop that Kahnweiler—who was twenty-three at the time—had just opened. Sensitive, intelligent, he spent a long time talking with me, encouraging and strengthening my penchants. It was he who led me to Picasso. I became his disciple, in truth. And since the artists would often visit his shop between four and seven in the afternoon, I gradually got to know them and forged friendships with them that have never been broken." Picasso himself once met Roger's brother, Bernard Dutilleul, and praised the collector's "courage."[18] From time to time, Roger Dutilleul would write polite notes to the artist expressing the wish to smoke a pipe together "one of these days, if that wouldn't disturb you."

The chief executive of the concrete company Portland du Boulonnais, Roger Dutilleul was a sophisticated, elegant man with an impressive mustache who lived off the revenues of the family farmland and woods, dividing his time between the sixteenth-century Bellinglise château, located near Compiègne, and his Paris apartment on Avenue Marceau, overlooking the park of the same name. "For me, Roger Dutilleul was a type of French bourgeois, highly

enlightened and refined, who already seemed to belong to a vanished era," remembered Kahnweiler. "But he was a deeply likable and admirable man, very much in the vein of the great art connoisseurs."[19] In an apartment crammed with paintings (which were piled up even on the walls of the bathroom), Dutilleul read books, bought art, kept himself constantly informed. In the margins of the books in his library, he wrote comments in his tiny but precise calligraphy, carrying on a secret dialogue with the authors of those books, making remarks, praising them, insulting them when necessary. "Idiot!" he wrote neatly in a book by René-Xavier Prinet that included these contemptuous comments about Henri Rousseau: "For certain contemporary artists, clumsiness becomes a virtue, under the pretext of synthesis. Henri Rousseau, an amateur artist and self-proclaimed 'leader of a school,' owes the success he has enjoyed less to his real gifts than to his lack of culture and to the fact that he remained a child for his entire life."[20] In contrast, agreeing with the analyses of André Salmon, the collector underlined the following passage: "Picasso had understood Cézanne's secret, treating his characters like shapes in space, as if they were still lifes."[21] But a collector's reputation also depends on the friendship and trust that he creates with the artists, the way in which he becomes part of their world. In this regard, Dutilleul was exemplary: on June 16, 17, and 18, 1919, Modigliani (an impressive collection of whose work Dutilleul had just acquired) spent three days at Avenue Marceau to work on a portrait of the collector surrounded by his paintings—his "children," as he called them—employing the same palette (emerald green, ocher, and gray) used in Picasso's gorgeous *Still Life with Fish and Bottles* (1909) hung on the wall in the background. The collector inspired Modigliani's dialogue with Picasso by integrating a masterpiece into the personality of his model, by taking again from Picasso the asymmetry of his eyes, all of which contributed to a sublime *mise en abyme*.

But let us return to those expatriate travelers and other lovers of Paris. After 1908, some Russian collectors made regular visits to

the city, too, among them the industrialist Sergei Shchukin and his young colleague Ivan Morozov. First at the Steins' apartment, then at Kahnweiler's gallery, then at Picasso's studio, Shchukin began—slowly at first, then with increasing passion—to collect Picasso's masterpieces, buying them from the Steins when Leo and Gertrude had their sibling "divorce" in 1913. And so these "black icons" in the "Picasso room" of Sergei Shchukin's house in Moscow—open to the public like a museum—very quickly inspired young Russian artists, including Natalia Goncharova and Mikhail Larionov.

Meanwhile, the Bateau-Lavoir (where Picasso kept a studio until 1912) was gradually becoming a sort of commune for foreigners. How and where do we place Picasso within the School of Paris, that "imaginary construct"[22] invented by the critic André Warnod in 1925?[23] This was the name given to that collective of living, nonacademic artists, many of whom arrived in the French capital after 1900. These artists found themselves in a paradoxical situation: true, the city offered them the artistic riches of its museums, the stimulation of its salons, the conviviality of its cafés, the liberty of its morals, the welcoming warmth of that composite population who mixed with French artists, finding solidarity and recognition in a marginalized subculture. But Paris also offered the paranoia and xenophobia of its police force, who strove to subdue all the bubbling energy that nationalist critics perceived as threatening, even harmful. Despite everything, Picasso continued to develop his system of references and relations: he was like a sounding board of his times, spotting, grasping, and catalyzing influences as no one else could, stubbornly constructing his art as if it were his own private language—beyond the borders of French society's labyrinth, despite it, and because of it. So, when the American critic Walter Pach announced an international exhibition of modern art in New York, Picasso picked up his pencil and wrote a list of colleagues who ought to be represented. In his precise, elegant handwriting, the artist noted: "Juan Gris, 13 Rue Ravignan, Metzinger, Gleizes, Leger, Duchan, Delaunay, Le Fauconnier, Marie Laurencin, De la Fresnaye," furiously underlining each

name before adding one last name, as if it were almost too obvious to mention: "Braque."[24]

Picasso also socialized with two new Bateau-Lavoir occupants: both of them from Florence, and both his own age. Ardengo Soffici was a poet, critic, artist, and intellectual, while Giovanni Papini was a writer and critic who worked for the magazines *La Voce* and *Leonardo.* In his memoirs, the futurist painter Gino Severini remembered that "Bergson's ideas on intuition were starting to circulate between artists [. . .]. We were talking now about rhythm, volume, the three-dimensional space of bodies; we were talking about color and drawing considered as things in themselves, and no longer as a function of reality [. . .]. From that came the aversion—already initiated by Cézanne—to depicting real things in an objective or purely descriptive way."[25] Papini and Soffici, his Italian friends, introduced Picasso to Bergson's philosophy.[26] After the publication of *Creative Evolution* (1907), after his meeting with William James (in 1908), after his travels through England, Italy, and the United States and the translation of all his works, including his famous seminars at the Collège de France, Bergson's philosophical ideas were widely known. According to Papini, "in Picasso's new vision, *intuitionism* occupies a central place, rendering possible a return *to spontaneity and the fullness of the vital instinct.*"[27] And, "in this intoxication created by the idea of conquering the world," Bergson's philosophy became an "element of inevitable confrontation."[28]

Soffici, as a Bateau-Lavoir resident, was one of the few people able to admire *Les Demoiselles d'Avignon* in Picasso's studio. From that day on, he was a tireless supporter of cubism, going far beyond the "stupid, ugly boasts" being made elsewhere. As for Severini—who arrived in Paris two years after him—he jotted down his thoughts on a yellow sketch pad about this artist "who helps us understand all that is great in this occupation." In these beautiful remarks, transmitted to me by the artist's family, Picasso is portrayed as a hero on the march. "Picasso. From the beginning, he burns the bridges behind him, imposes on himself the most difficult conditions in which he

must sink or swim," Severini wrote in Italian, in a note to himself. "Once the problem is posed, he has to find solutions, and his are almost always unique and brilliant, so that the spectator who sees them is punched in the face and must admit, if he is honest, that this punch is logical, necessary, acceptable, beautiful, magnificent, sublime [. . .]. This is what makes Picasso so exceptional. In each of his paintings, he proceeds by 'destruction,' not by 'addition': what willpower, what energy it must take to function like that! To destroy, then start over, reinventing everything and taking each part back to square one: such is the greatness of Picasso." Another day, Severini reverently scribbled a few simple phrases as they came from the artist's mouth, in French this time: "Picasso says: for me, a painting is a sum of destruction. I make a painting, then I destroy it. But in the end nothing is lost: the red that I remove from one part is found in another part [. . .]. When you begin a painting, you often find pretty things. You must beware this, destroy your painting, remake it several times. Each time you destroy a beautiful discovery, you do not really get rid of it—you transform it, condense it, make it more substantial. Success is the result of rejected discoveries. Otherwise you become your own fan. I don't sell anything! [. . .] Everyone wants to understand painting. Why not try to understand birdsong?"[29]

On April 15, 1912, in the magazine *Je Sais Tout*, the journalist Jacques des Gachons described a visit he had made to the Kahnweiler gallery. He asked the dealer about artists recently described by certain journalists as "cubists." The dealer became visibly annoyed by this conversation about the people he affectionately called "my artists." "I don't want people to try to ridicule them," he replied. "My artists, who are more than my friends, have real convictions, they are genuinely searching for something. They are artists, quite simply." Then, changing his tone, he slowly, patiently tried to convince the journalist with a magnificent speech, which was essentially a statement of the "mission" he had imagined when envisaging his career. "Oh, I know that it is quite difficult to understand the latest Picassos and Braques," he admitted, before uttering a revelatory statement:

"I am an initiate. I witnessed the birth of those paintings. I know exactly what the artist wanted to achieve."[30] And yet, day after day, despite Kahnweiler's efforts to "educate" the public, to protect his artists as if in a bubble, to stake out a place for his gallery in the voids of French society, xenophobia continued to thrive.

24.

A DUET OF REVOLUTIONARY VIRTUOSOS . . . PICASSO AND BRAQUE, BRAQUE AND PICASSO

3rd Movement: *Allegro vivace* (1907–1910)

PICASSO:	I remember exactly what I told them [. . .]. I thought we were going to have some fun. But instead it became terribly annoying.
KAHNWEILER:	So, essentially, you condemn what has been called "analytical cubism"?
PICASSO:	Yes.
KAHNWEILER:	And you've searched for more spiritual methods of expression?
PICASSO:	Yes.[1]

How to evaluate the most stunning period of cubism—that of papiers collés, known as synthetic cubism—the only one that Picasso would never disavow, because he knew its prodigious subversive power?[2] The works speak for themselves. When, in 1912, Picasso stuck a square of oilcloth in the middle of a still life painted on an oval canvas, imitating the cane work of a chair, and surrounded it with a sailor's rope (*Still Life with Chair Caning*), or when Braque, in turn, stuck strips of fake wood onto a vertical canvas, imitating oak paneling, then drew a smashed glass and a bunch of grapes in

charcoal (*Fruit Dish and Glass*), they immediately provoked the admiration of Kramář, Kahnweiler, Einstein, and Raphael. A little later, the inclusion of prosaic objects and found materials in a work of art blew up the system of representation that had prevailed for centuries and set off a torrent of questions about the function of art. And yet, for most observers, particularly in France, Braque's and Picasso's use of various everyday elements profaned the sacrosanct conception of what constituted a masterpiece. Not long before that, the first of these provocative works—Braque's *Violin Mozart Kubelick* (spring 1912) and Picasso's *Souvenir du Havre* (spring 1912)—had sparked productivity on an unprecedented scale: in two years, Braque produced fifty-seven papiers collés, while Picasso made three hundred![3] How to describe the bubble in which the two artists were working back then? And how to rediscover the timbre of their voices, the grain of their dialogues?

The cubism catalogs—inexhaustibly rich and erudite—continue to pile up precariously on my shelves, and I am forced to admit the obvious: no other chapter has been this difficult to write. I finally find the answer I'm looking for in the suburbs of Paris in a vast industrial warehouse belonging to a transportation company. I find it after roaming the building's interminable basement corridors, among the 200,000 archival materials belonging to the Musée Picasso, inside folder 17, which holds Braque's correspondence.[4] Here, there are postcards, as well as a few (rare) sheets of paper bearing simple, brief, direct messages, the kind of banal greetings that are made between men. The salutations are cordial and without frills. I read: "Handshake," "Good handshake," "I shake your hand warmly," "Hello, G. Braque," "Hi, GB," "See you Sunday or Saturday. GB," "Hello to everyone," "Greetings from my family. Yours, GB," "Hello my friends," "Good memories." As for the messages, they relate to weather, forthcoming meetings, friends he's seen (Carco, Manolo, Max, the artist Étienne Terrus). The envelopes are postmarked Le Havre, La Ciotat, Rouen, Évreux, Saint-Mars-la-Brière, Argenteuil, Orléans, Sorgues, Avignon. And I discover an unexpected world in

these photographs of Sergeant Braque in uniform, a member of the
16th company of the 329th infantry regiment, sent to his friend Pi-
casso. Was Braque the first to grant Picasso entrance to such a pro-
foundly French geographic and cultural territory? After three years
of military service, which he performed earlier, Braque was sent
to the Camp d'Auvours, near Saint-Mars-la-Brière in the Sarthe de-
partment. "Hello. After 20 hours on the train, I arrived in St Mars,"
he wrote on March 31, 1911. "I will try to go to Paris on Sunday.
Now I'm going to sleep on straw. My God." Or: "Dear friend, this
weather! I'm so cold, I can't even write. I'm so terribly bored. Thank-
fully we leave the camp on Tuesday, and by Wednesday we'll be
released. And maybe on Thursday we'll be at [the nearby village of]
l'Ermitage. We are organizing concerts, there are some pretty good
songs. See you soon G. Braque."[5]

The more I read, the stronger my impression that Braque and Pi-
casso truly formed what is commonly called an odd couple. When he
discusses art, as on November 6, 1911, after their first trip to Céret,
Braque sticks to technical details—a long way from the vision of an
Apollinaire or the analyses of a Max Jacob. "My dear friend. I have
nothing new to tell you. Life is still as quiet as ever and I'm happy.
Work is going pretty well. I've started another [still life] (60 cm).
[. . .] I am also working at the moment on the pretty reading woman
that I think you saw me start. I'm glad that you liked the large still
life because I wasn't sure how it might go down in Paris. Manolo will
be happy with the hope you've given him. He received a letter from
you, only he was at the café when [the] mailman arrived. I bought ten
quintals of wood at 1.25 francs, some cambajons and putifaros. Your
old bedroom is full of them. That's all. Cordially, G. Braque." One
year later, in the middle of the papier collé period, there is very little
aesthetic information to be found in Braque's missives. "Tuesday, My
dear friend. I just left Kahnweiler and your paintings have finally ar-
rived. They're very pretty the *Violin* especially seems to me a highly
important painting and very very pretty [. . .]. I'm hoping to find
lots like that from my trip to Sorgues. Paris is impossible parties on

the boulevards it puts me in such a state that I got into a fight with a coach driver a real battle but I didn't get hurt. I helped Max move yesterday—hard work! A handshake to you G. Braque!"[6]

In 1908, on the very day when Louis Vauxcelles briefly wrote about Braque's exhibition "at Kahn Weiler [*sic*], 28 Rue Vignon," another article in the newspaper *Gil Blas*, further down the same page, announced: "Conquest of the Air. Le Mans, November 13, 1908. Wilbur Wright wins prize for altitude." The French people, fascinated by the exploits of their first aviator, Louis Blériot (who flew across the channel in 1909), were wary about the achievements of the two American engineers Wilbur and Orville Wright. During the summer of 1908, however, the people of Le Mans succumbed to the charms of the two brothers when they looped the loop over and over again during a demonstration of their prowess above the local airfield. Four years later, in the spring of 1912, Braque and Picasso— thrilled by the Wrights' "conquest of the air"—identified themselves with the American brothers, Braque becoming an Argenteuil-born Wilbur. "The efforts of the airplane constructors interested us a great deal," Picasso later admitted. "When one wing wasn't enough to keep the plane in the air, they attached another one to it with string and wire."[7] So Picasso took the tire manufacturer Michelin's advertising slogan—"*Notre avenir est dans l'air*" ("Our future is in the air")—and appropriated this declaration of intent in a very powerful painting: on the right was a red, white, and blue flag on which he wrote an abbreviated version of the slogan, "*Notre avenir est dans l'A*," with that final A floating, alone and mysterious in the air. That same spring, Picasso continued to use Ripolin—the most basic and industrial brand of paint available—for his art, sending out a public challenge that echoed the year's events.[8]

In France, just like the cubists, the Wright brothers were described as charlatans, and I think that epithet requires some examination. What *was* a charlatan in the reactionary, narrow-minded France of those years?[9] It was a swindler taking advantage of a man of good faith, a bluffer fooling an honest man, a forger conning a sincere man,

a vulgar crook stealing from a refined man. In this country proud of its tradition and "good taste," describing a cubist artist as a charlatan was a quick way of discrediting him, using morality as a weapon. We will come back to this. But far, far away from these slurs, Kahnweiler will evoke their intensity, obsession, and anxiety. "There were no Sundays, no Saturdays, just constant work [. . .]. Braque and Picasso [. . .] would work and work, then at five o'clock they would meet and come here, to [my shop on] Rue Vignon, and we would talk."[10]

Attentive to the new images that, with the advent of advertising, were appearing on walls all over the city, Picasso and Braque began experimenting—with joy, humor, and enthusiasm—in every way possible, to capture the times in which they were living. They couldn't care less if they were attacked for the banality of their new tools. In addition to their fascination with early aircraft, they were also thrilled by the invention of cinema. "We blindly entered a century without traditions, a century that was to contrast strongly with the others by its bad manners, and the new art, the art of the common man, foreshadowed our barbarism,"*[11] Sartre wrote in *The Words*. In the total porosity of those times, Picasso and Braque embraced all new technological discoveries, starting with the first movies—the "art of the common man" par excellence. The caustic works that Braque and Picasso were preparing to produce in this new stage of their collaboration were fully attuned to the drive toward fragmentation of those years, the "horizontal aesthetic" of film, and everything that exploded the traditional system of representation.[12]

During their work trips outside of Paris, even before they signed exclusive contracts with their dealer (Braque in November 1912, Picasso the following month), they always turned to Kahnweiler. He became their banker, their advisor, their compass. In the Kahnweiler archives was kept a folder with the forty frantic letters that Picasso sent him during the summer of 1912. In one of the early crises of his life (he was trying to avoid Fernande Olivier, was in love with Eva Gouel, moved house every six months, and was the head of an

* Translation by Bernard Frechtman.

extended family of women, friends, and animals), Picasso—a rich
man at last—was organizing a large network of people (Kahnweiler,
Manolo, Braque, Haviland, Gris, Mrs. Pichot, Terrus) to keep watch
over his loved ones and his works in progress. In a hurry, like a junkie
in withdrawal, so anxious and agitated was he as he tried to control
everything and everyone, by turns strategic, egocentric, tyranni-
cal, selfish, with only one preoccupation: his work. Soon, to indicate
his priorities amid the oppressive mass of documents that reached
him, Picasso would start writing "*Ojo*"[13] on certain letters and enve-
lopes—a technique intended to weed out less important matters by
singling out his major projects. "My dear friend, I received your letter
and Braque's yesterday," he wrote to Kahnweiler on May 24. "You
tell me you have sent me the canvas I think that must be the roll I
had in the studio on Rue Ravignan or another on Bd de Clichy. You
should also send the paintbrushes at Rue Ravignan, the dirty and the
clean and the frame also at Rue Ravignan. I will need others but will
write you later or write to my color merchant. The palette on Rue
Ravignan too you have to send it if it's dirty wrap it with the frame
paper and the letters and the numbers and the combs to make fake
wood. For the colors send those from Rue Ravignan and those from
Bd de Clichy I will tell you where they are and I will give you the list.
(I feel bad about giving so much trouble for you)."[14]

Sometimes the letters to Kahnweiler became prosaic. This one
sent in May, for example: "For the dogs I told Braque to send Fricka
and the other animals the monkey and the cats its Mrs. Pichot who
takes them she told me. You will have to do the canvas that's rolled
up at Rue Ravignan and the signs and send them here (still at Ma-
nolo's address). The canvases at Rue Ravignan that are only drawn
in charcoal (the violin too) you have to get them fixed by Juan Gris
and I say Juan Gris because maybe it's easier for you than taking all
that's needed and doing it yourself. For the colors and frames I don't
need to bother you I will write to Morin he will send them to me.
As for paintings to sell you I will write later for that I have to think
[. . .]. Don't give my address to anyone for now."[15] On June 1, 1912,
he changed his mind: "My dear friend, I need my painting things.

Manolo gave me a few colors but I work only with green composed of violet and cobalt and vine black and mummy brown and pale cadmium and I don't have a palette. Terrus lent me an easel [. . .]. I am working despite everything." There were also strange confessions: "I wrote to Braque, you know how much I love him" (June 17). And personal opinions on his own work: "I am sending you the paintings I think they are not too bad the Ripolin or Ripolin style paintings are the best, you know my system of work" (June 20). On July 4 he wrote again to this man who was not yet his official dealer: "I am working I started like I told you on other things the ones from Céret but I have to leave them and it was good that I sent the others to you because I would probably have damaged them if I had continued [. . .]. I started here a still life and have already made good progress: a landscape with a factory, making houses and advertisements, and a bust of a woman from Arles and a canvas about 60 *marine*, a man. If I wasn't so bored I would work well here the light is good and I can work outside in the garden."[16] Sometimes, Picasso would open up a little: "Write to me because I need to receive letters from friends. So do you like them? Tell Max Jacob that I love him and it doesn't mean anything that I don't write him" (July 4). And again, later: "I behave very badly with all my friends I don't write to anyone but I am working on things and I don't forget anyone and you" (April 11, 1913).

Meanwhile Picasso was producing major canvases that left behind the genre of portrait painting. Produced in part with the use of a steel comb, *The Aficionado* marks the invention of a "radically abbreviated writing which redefines portraiture in a manner beyond any traditional figuration"[17] by using bits of objects, bits of words, bits of references, detonated into a very powerful sculptural puzzle. "These aficionados from Nîmes, all I can think about is them," he noted on July 19, after his meeting with the bullfighters in a local corrida, "and I have already transformed a painting that I had started of a man into an aficionado. I think he can be holding his banderilla and I am trying to give him a face from the South."[18] Then there was *Spanish Still Life* (1912), a small oval miracle that Dutilleul would

buy, with terraced geometric shapes vaguely resembling a bottle, a glass, a guitar in shades of mauve in the upper part of the canvas and shades of red in the lower part, with a few letters floating amid the images. We will return to this painting a little later. "I have discovered an indestructible white, velvet on the brush, and I use it too much," Braque wrote to Kahnweiler in September 1912. "I am still working on my reader and my emigrant, but I have begun another still life [*Woman Reading*]. It's a Portuguese emigrant on the deck of a boat with the port in the background."[19] The second stay in Céret (August–September 1912) featured an escalation in genres, themes, techniques, an attempt to outdo each other with treasures and goads, a festival of reciprocal provocations, confessions, nods, and winks; it was tit for tat, virtuoso celebrating virtuoso, virtuoso surpassing virtuoso. Braque had the idea of adding sand to his paint, creating "another sort of optical rupture in the pictorial paste, with completely new effects in terms of texture and relief."[20]

But as soon as Picasso left for Paris, Braque—stimulated by his friend's boldness—produced *Fruit Bowl on a Table* (September 1912), "leaping into the unknown"[21] with the introduction of "three strips imitating wood" and producing his first papier collé. In the studio on Boulevard Raspail, Picasso, too, was innovating (and he in fact remained one step ahead): "My dear friend Braque I am using your latest paper and dust methods," he confessed on October 9. "I am imagining a guitar and using a bit the dust against our horrible canvas. I am very glad you are happy in your Bel Air villa and you are pleased with your work. I am starting work a bit as you see."[22] *Guitar on a Pedestal Table* was Picasso's first "sanded" painting. Then came Braque's *Violin and Pipe*, composed with elements such as cardboard, collage, chalk, charcoal, and papiers collés (a strip of wallpaper, newspaper, black paper, fake wood): all these fragments of material produced a trompe-l'oeil imitation of reality with added textural effects. With *Bottle of Vieux Marc, Glass and Newspaper*, and *The Poet*, Picasso saw his friend's bet and raised it, in terms of techniques and the use of found objects—the key elements in their shared machine of subversion.

Then, in solo, Picasso continued the escalation, with *Still Life with Chair Caning* (1912), sticking a scrap of oilcloth onto an oval canvas to imitate the cane work of a chair, surrounding it with a sailor's rope, and in the process producing the first "good example of the anticlassical principle of mixed techniques." This work would remain in the artist's possession until his death and was not shown to the public until 1939 during the MoMA retrospective, then in 1955 in Paris (Musée des Arts Décoratifs). Let us remember the contempt shown toward the applied arts by the French fine-arts establishment at the Exposition Universelle in 1900: it was precisely this breach between high and low, between fine and applied arts, that Picasso— aided by Braque's know-how—had just rushed into, blurring the lines. While it is certain that "Picasso's work gives the impression of a vast undertaking aimed at destroying the hierarchy between high and low,"[23] wasn't it in those years—1911 to 1914—that Picasso, with the help of Braque, developed his own revolution against academic tradition? The cubist salons would follow suit: in Kahnweiler's stable first, with Juan Gris and Fernand Léger, and then with Metzinger, Le Fauconnier, Gleizes, Puteaux's group, the Section d'Or, and the theoreticians of dynamism such as the Duchamp brothers, Delaunay, and Picabia; developments of all kinds spreading through North America, Russia, Austria, and Germany before the start of World War I. And yet, as Pierre Daix would later emphasize, "the cubism of Braque and Picasso [. . .] with its synthetic framework [. . .] is a world away from the various simplifications, geometricizations, and fragmentations that were exhibited in Paris, causing a scandal at the Salon des Indépendants."[24]

The two artists were also united by more personal connections: Picasso introduced Braque to his future wife, Marcelle Lapré, a model from Montmartre; Braque was the first to be let into the secret, in 1912, that "Fernande [had] cleared out with an Italian futurist," and he was also the first to meet Eva Gouel, Picasso's new girlfriend, and to console his friend when she died of cancer a few years later. Their complicity reached its zenith during the period of

"*Notre avenir est dans l'air*," when they proclaimed the anonymity of their creations. "I remember one day," Kahnweiler would recount later, "when they came [to me] to get cash. They imitated a pair of workers, cap in hand: 'Boss, we've come for our pay!'"[25]

For Picasso, the friendship with Braque was his first opportunity to plunge into the traditions of French craftsmanship, a tradition always described as "age-old"[26] and that, in Braque's case, had been handed down from father to son through generations. One might even conclude that cubism—with its happy hybridization of their respective cultures—represented the coproduction of two artists transgressing and exalting the traditions from which they came. On the one side, the "artisan heir," born into a long line of artisans and trained as such, who decided to break with family tradition by becoming an artist; on the other, the son of the dean of the École des Beaux-Arts in Barcelona, a hugely gifted artist who, by associating with a French artisan, exploded every idea of what constituted a masterpiece that his father had patiently instilled in him. Nowadays, in the Centre Européen de Formation (European Training Center)'s description of its "painter and decorator" course, we find the following terms: "patinas, material effects, decorative coatings, imitation wood or marble, stencil ornamentation, panoramic perspectives, painted sets, colors, limewash coatings, polished concrete, metal sheets, background preparation—application of paint."[27] Among other things, this is a list of the techniques taught by Braque to Picasso during their heroic years: stenciled lettering, faux marble, faux wood, patinas . . . all these elements that contributed to the originality of works such as *Spanish Still Life* and *"Notre Avenir est dans l'Air."*

So what exactly was the nature of their relationship? Was it a professional rivalry, as Fernande Olivier suggested, or a "spiritual alliance," in the words of Wilhelm Uhde? "Picasso's vertical tendency and Braque's horizontal tendency," Uhde went on, "could be joined together because they agreed on one essential point: reality is not to be found under the banal façade of daily life but in a purer, more elevated form, a *supra verum* that amplifies the essential with passion."[28]

For his part, Max Jacob still remembered the teenager he'd met at a vernissage at the Vollard gallery in June 1901, who—two years later—had written those sorrowful letters from Barcelona, and to whom he'd offered his words, his bed, what little food and money he possessed. So perhaps Jacob is the person most likely to understand this impressive alliance. "Braque's physique, that of a former corporal and a Frenchman from Argenteuil, was a major part of the reason Picasso let him exhibit his work first at the Salon des Indépendants. Picasso thought that the public wrath would crash harmlessly against Braque's power, equilibrium, and nobility, his methodical reliability and his broad shoulders," Jacob wrote.[29] In an interview with André Malraux, many years later, Picasso looked back at his relationship with Braque in a few phrases that could serve as the climactic conclusion to this discussion of their collaboration: "We weren't geniuses all day long! How could we live? That was another thing that separated me from Braque. He wasn't interested in exorcisms. Because he didn't feel what I called Everything, or life or, what, the Earth? that surrounds us, that isn't us, he didn't find it hostile. He didn't even find it foreign! He was always at home . . . even now . . . He doesn't understand those things at all: he's not superstitious!"[30]

25.

28 RUE VIGNON,
A DISTINCTLY SUBVERSIVE GALLERY

[It is] artists [who] create the visual world of humanity.[1]

—Daniel-Henry Kahnweiler

In the summer of 1907, on his first visit to the studio at the Bateau-Lavoir and his first contact with Picasso's great exorcism painting (*Les Demoiselles d'Avignon*), Kahnweiler had understood the intentions of this man whom he would later describe as an "impatient titan" working at the time "in a terrible spiritual solitude."[2] As for Picasso, from his first forays into the gallery on Rue Vignon, from the first time he saw the young art dealer react to his work and immediately reach for his wallet, he understood that Kahnweiler was in a different league than the likes of Pere Mañach, Clovis Sagot, Eugène Soulié, Berthe Weill, even Ambroise Vollard, all of whom had been or still were his dealers. Picasso was wary: he'd clashed with Mañach, he feared Sagot's craftiness, he sensed that Weill lacked a head for business, he continued to be paid decent sums of money (2,000 francs here, 2,500 there) each time Vollard came to buy up his studio backlog (February 1906, February 1907, summer 1907, fall 1909, fall 1910, fall 1911), but he also knew that this "old crocodile" looked half-asleep in his gallery, moved the rolled-up canvases that littered

the floor with his feet, and was both disorganized and insufficiently focused on the future.

From 1907 through 1910, Picasso would receive Kahnweiler at his studio and sporadically sell him paintings (particularly in 1911, when his works became difficult to understand for the French public: *The Mandolin Player, Man with Guitar*) while also agreeing to illustrate Max Jacob's occasional writings published by the gallery. And yet, for almost five years, Picasso carefully tested Kahnweiler before anointing him as his official art dealer. When the young gallery owner, irritated by the Autumn Salon jury's rejection of Braque's paintings, decided to offer the French artist his own exhibition at the gallery on Rue Vignon (November 9–29, 1908), Picasso barely reacted. But in the months that followed, Picasso began a daily dialogue with Braque that, as we have seen, would develop into one of the rare instances of an enduring artistic duet in the history of painting.

In the fall of 1908, Matisse brought Sergei Shchukin, the Russian collector, to the Bateau-Lavoir. Shchukin was far wealthier than the Steins, and Picasso knew this. The Russian businessman immediately bought one of the artist's key works, *Woman with a Fan*, and from then on Picasso's other collectors would have to reckon with him. In this new period when Picasso was becoming more strategic, he would poke and prod at his collectors (we saw him working on the Steins, and on Kramář), pit them against each other (Stein against Shchukin, Kramář against Stein), challenge them, charm them, handpick them, and sometimes sell them paintings directly. He did the same thing with his dealers: he challenged them, charmed them, put them in competition.

Such behaviors shine a new light upon the extraordinary series of portraits on which the artist embarked in 1910. In the space of a few months, Sagot (1909), Uhde (spring 1910), Vollard (summer–fall 1910), and Kahnweiler (winter 1910) were captured in the artist's snare (he would paint them as they posed for him, or from photographs that he himself had taken beforehand). The aesthetic evolution

visible throughout those months is quite stunning: the influence of Cézanne in the portrait of Sagot; the cut-up into readable facets for Uhde; the more fragmentary cut-up for Vollard; and the accelerated deconstruction of the image for Kahnweiler, based on a photographic portrait taken in the studio on Boulevard de Clichy, as if Picasso were assigning each of them a separate stage in his rapid dynamic evolution. It is hard to think of a name for this type of strategy other than a sort of power game being played by the artist on the Parisian art scene. In those months of ever-increasing change (aesthetic work, financial status, social status, love life), with the move to Boulevard de Clichy in September 1909 (with its concomitant suggestion of an upward social move), in those moments of euphoria (when Picasso freed himself from bureaucratic and family constraints), the only episode that put a halt to this implacable progress was the case of the Iberian statues and Guillaume Apollinaire's arrest.

In his writings, Kahnweiler implies that he began working as Picasso's dealer in 1907. In fact, their relationship grew gradually: it was not until 1911 that things really started, and it was only during the summer of 1912 that they reached their climax. That summer, Picasso, anxious and disarmed, asked Kahnweiler to perform all kinds of material tasks for him, and the dealer executed his demands so devotedly that he was considered to have passed the test. A little later, now staying in Sorgues, Picasso made more and more requests before giving the order: "Don't give my address to anyone for now." How would the exceptional aesthetic advances of the summer of 1912 have been possible, during such a destabilizing period—with the artist's moves from studio to studio and from town to town (Paris, Céret, Sorgues)—had Kahnweiler not agreed to act as a faithful servant to the confused, needy, even tyrannical artist? The ordeals of that summer strengthened the confidence that the artist was developing in the dealer.

And so, a few months later, it was Daniel-Henry Kahnweiler, the unknown young man from Stuttgart, whom Picasso chose to be his exclusive, official dealer—a relationship sealed by a contract created on

the artist's initiative on December 18, 1912. In contrast to the usual order of things in the art world, and also in contrast to the contracts signed by Kahnweiler with Derain (March 1908), Braque (November 1912), Gris (February 1913), Vlaminck (July 1913), and Léger (October 1913), in Picasso's case it was the artist who imposed his own terms. Every aspect of that letter (the style, the legal vocabulary, even the spelling) suggests that it was written with the aid of a friend—André Level, perhaps? We will come back to him in the following pages. Every aspect of that letter reveals Picasso's strategic skills: "My dear friend, I confirm our conversation as follows. We have made an agreement for a period of three years, starting on the second of December 1912. I engage during this period not to sell anything to anyone but you. The only exceptions to this condition are the old paintings and drawings still in my possession [. . .]. I engage to sell to you at a fixed price my entire production of paintings and sculptures and drawings, engravings, keeping a maximum of five works per year for myself. Moreover, I will have the right to keep as many drawings as I consider necessary for my work. You will leave it to me to decide if a painting is complete [. . .]. You engage, for your part, to buy during those three years all the paintings and gouaches I produce, as well as at least twenty drawings per year [. . .]. Yours sincerely, Picasso."[3] It is, of course, worth noting the clause enabling Picasso to keep as many drawings as he deems necessary for his work—an essential point for the artist to be able to protect his archives (drawings, sketches, notebooks), which might give rise to later works, as would be the case in the papier collé phase of 1913.[4]

Why did Picasso choose Kahnweiler? The gallery's archives reveal that the management of his artists' work was impeccably organized: photographs of each painting, a press index for every article, in every language, archives of purchases and sales kept with perfect rigor. But there was more to the decision than mere efficiency: we know that Picasso had decided not to show his work in salons. In France, then, his works were visible only in a handful of galleries or in the homes of his few collectors. Werner Spies was correct to state that

Kahnweiler "procures tranquility for his artists, saving them from the obligation to confront a public that has no understanding of their newest works."[5] In this sense, the dealer's reply to Jacques des Gachons, quoted earlier—"I would prefer your magazine not mention my artists. I don't want people to try to ridicule them"—is revealing, and his suspicion justified: the press at the time was, as we have seen, very quick to ridicule cubism, presenting the movement as a gigantic hoax organized by bad artists (charlatans) prepared to do anything to promote themselves. Once he'd been assured that the journalist from *Je Sais Tout* had no intention of mocking anyone, the dealer agreed to comment on "today's extreme avant-garde." Kahnweiler protected his artists, Picasso most of all, and—committed to his mission within a society that was hostile to avant-garde art—supported those few who "create the visual world of humanity."[6]

The relationship between the gallery owner and the artist sometimes verged on dependence (see the correspondence from summer 1912), but Picasso quickly understood all of Kahnweiler's abilities, including his systematic practice of photographing all the art (enabling the artist to see his works when he was far from Paris and to regularly assess his own creations). "I had thought about selling you [my latest painting]," Picasso wrote on June 5, 1912, "but I think it still needs work [. . .] I always want to have several works on the go so that I can work without fatigue." To which the dealer, a little exasperated, replied the next day: "Tell me, you will be doing me *the greatest service* if you could tell me [. . .] which of your paintings you consider to be finished."[7] But it was always the artist who retained the upper hand in their dealings: "You will leave it to me to decide if a painting is complete," he specified on June 18, 1912. What developed between them was almost like the pact between a jockey and a horse: steered by Kahnweiler, Picasso was able to gallop ever faster, to leap over every obstacle in his path, to peacefully subvert the grand old European tradition of what constituted a masterpiece.

Later, in an article written in German, Kahnweiler would elucidate his position in the context of the French art market. "The State

should never be allowed to decide which living artists to support," he wrote, "because the money is never given to the right people. Instead it is wasted on artists who are unworthy, the kind of artists who should in fact be discouraged since there are too many of them."[8] Faithful to this position, the dealer was resolutely opposed to what was happening in France, and built his little gallery into a bulwark, an isolated republic—just as, years before, Paul Durand-Ruel's gallery on Rue Laffitte had honored Courbet and Delacroix after the Académie des Beaux-Arts rejected them. Surely it wasn't by chance that Dutilleul described Kahnweiler's gallery as a "revolutionary space" in which he—the French collector who transgressed the tastes of his surroundings—defined himself as the dealer's "disciple." In the gallery at 28 Rue Vignon, with ever greater numbers of private collectors coming to visit, Kahnweiler achieved something unprecedented: he constructed a territory that escaped the official functioning of the State (the country's top collector). But this territory also escaped the control exercised on contemporary art by the all-powerful Académie des Beaux-Arts.

From 1907 to 1914, the little gallery developed its impact courtesy of the network of German collectors and critics drawn by its artists' work but also by the talent, erudition, and professionalism of Kahnweiler. The most important of these critics was undoubtedly Carl Einstein. Like Kramář, like Stieglitz, like Uhde, like Meier-Graefe, he belonged to the Austro-German tradition of art theoreticians.[9] And what he discovered in Paris, in cubist art from 1905 on,[10] echoed his own theories on time, space, and sensation—theories that he was attempting, "clumsily and hesitantly" (in his own words), to put into practice in his novel *Bebuquin*, which he was writing at that time. "For us, the work of art exists only to the extent that it determines its era and is, in turn, molded by it," he would write. "The works occupy us only insofar as they contain means capable of modifying reality, the structure of man, and the appearance of the world."[11] There was no way that Einstein was ever going to ignore the experimentations of cubism when the art that he himself practiced

"prioritized the mixing of genres, temporal ruptures, discontinuity, and intervals."[12] In emphasizing their revolutionary potential, Einstein described cubist artists as creators of a new reality. To his mind, the objects that surround us, the daily sights to which we are habituated, carry within them, in their very texture, the liberal bourgeois ideology he was fighting against. It was only by breaking with these habits of representation that works of art could become "anything other than doors opening on familiar ghosts"[13] and enable the spectator to see the world in a different light. "Picasso understood that the death of reality is a necessary precondition for the creation of independent work," he would write later, "but he strengthens it in another way by throwing blocks of imagination at it. He draws what is psychologically true, humanly immediate, and in this sense his realism is all the more powerful because his art is free of all naturalism."[14] Cubism, as Einstein would define it in a letter to Kahnweiler in June 1923, had, for him, never been a simple case of painting or optics: "I have long known that what people call 'cubism' goes far beyond painting."[15] Einstein was one of the first thinkers to understand the philosophical and political reach of cubism, and not incidentally he had also been—with his book *Negerplastik*, published in Leipzig—one of the first European theorists to write about African art.

Max Raphael, another German intellectual who arrived in Paris in 1911, belonged to the same lineage, with his view of the world influenced by Bergson, whose lectures he attended at the Collège de France. After studying in Berlin (philosophy with Georg Simmel and art history with Heinrich Wölfflin),[16] Raphael met Picasso at the Bateau-Lavoir before returning to the German capital in 1913. His book *From Monet to Picasso*, published that year, directly confronts the origins of modernity by reformulating the questions in accordance with the new parameters outlined by vitalist theorists: "How does art come about and where does its future lie?"[17] Carl Einstein, Max Raphael . . . these were the intellectuals who fashioned Kahnweiler's perspective on the cubist avant-garde. Some of the gallery owner's more enlightened contemporaries (including Jean Cassou,

with whom he often talked) had spotted, in his system of German references, "genuine keys to understanding art and life [that were] notoriously subversive but still unknown in France at that time." During this peculiar period (between the aftermath of one war and the first warning signs of another), Germany was seen by the French people—as we have already noted—as both a hereditary enemy and a supreme model. "To defeat Germany, we must imitate her," the historian Fustel de Coulanges had predicted.[18]

So what connection can we draw between the German-language theories of aesthetics and philosophy espoused by an Einstein or a Raphael and the anxieties felt by French society during those years? The French press, as we have seen, was rife with fear that cubism was a direct threat to the country's identity. Such fears could also be perceived in the debates of the Chamber of Deputies on December 3, 1912: "You cannot see what the cubists do and call it art!" fulminated the deputy Jules-Louis Breton. "One does not encourage garbage!" his right-wing colleague Charles Benoist added. "There is garbage in the arts as there is elsewhere." As for Marcel Sembat, a Socialist deputy from Montmartre, he firmly stated, "I have absolutely no intention [. . .] of defending the cubist movement! In whose name would I defend it? I am not an artist. And against whom? I am not standing in front of an assembly of artists [. . .]. What I defend is the principle of freedom of experimentation in art."[19] This debate was the culmination of what historians of cubism describe as the "xenophobic controversy of 1912" or the "Autumn Salon crisis of 1912."[20] Three months earlier, on October 3, 1912, in an open letter to Léon Bérard (assistant to the state secretary for the fine arts), the photographer Pierre Lampué, recorder of the fourth commission of the Paris city council, had expressed his outrage that the State had made the Grand Palais available to the Autumn Salon for an exhibition that "piles up the most banal ugliness and vulgarity imaginable." He went on to attack the cubist artists, whom he described as "a gang of miscreants who act in the world of art like the Apaches in ordinary life."[21]

As time went on, the "Autumn Salon crisis" turned its fury on the salon's jury who, according to some, had "for the past three years [included] too many foreigners." The solution was obvious: a "restriction on foreigners." "Next year, they will be curbed and the evil will be stopped in its tracks," the xenophobes predicted.[22] Pierre Lampué's open letter drew a response from the managing editor of the magazine *Gil Blas* that escalated the xenophobia to dangerous levels: "[The cubists] are foolish young people. [They] do not represent in any way the leading trends of the Salon. We were probably wrong to give them an importance they do not actually possess. We were also wrong to let the jury be invaded by foreigners. These are mistakes that will not be repeated [. . .]. The courageous company president [. . .] will take the necessary measures to prevent this happening again. And everything will return to order."[23] Not to be outdone, the Salon's committee members declared that "foreigners will no longer control the company's destiny; [. . .] the jury will show an intelligent severity."[24] In *Gil Blas*, again, the critic Louis Vauxcelles, who had first used the term "little cubes" in 1908, launched a direct attack on Kahnweiler and Picasso: "I don't want to further invoke the nationalist argument or support the idea that all this turmoil is caused by foreigners," he claimed hypocritically, before adding: "The fact that there are too many Germans or Spaniards in the fauvist and cubist movements or that Matisse is a naturalized Berliner or that Braque now swears by Sudanese art, or that the art dealer Kahnweiler is not exactly a compatriot of Père Tanguy, or that that lecher van Dongen is from Amsterdam, or that Pablo is from Barcelona, none of this has any importance in itself. Van Gogh, too, was Dutch. The issue is not what language the cubists speak, but whether they have anything to say. Alas, I doubt it."[25]

26.

CHARLATAN OR GENIUS?
PICASSO ALL OVER THE PLACE

When one enters into the Picasso room in the gallery of
S. I. Shchukin, one is seized with a feeling of subtle terror.[1]

—Nicolai Berdyaev

If there was one pivotal year for Picasso, it had to be 1912. In that year, he was suddenly propelled to the forefront of the international avant-garde scene, hailed as Matisse's equal. It has to be said that this confrontation between the two great artists of their day was deliberately exploited, abroad as in France. In Paris that year, Juan Gris exhibited *Portrait of Picasso* at the Salon des Indépendants—a public tribute to the artist, and a response to Matisse's *Portrait of Olga Merson* the previous year. But it was probably in London, at the *Second Post-Impressionist Exhibition*, that Picasso's rise became most obvious. The *Times* headlined its article on the show "A Post-Impressionist Exhibition: Matisse and Picasso," highlighting the rivalry between the two of them. "Three or four years ago, Matisse was the prince of the Fauvists. [. . .] At the Salon des Indépendants of 1912, [there were] few if any students of Matisse. The fashion now is for cubism [. . .] the master has been abandoned; his painting is doubly left behind. What a fall from grace, Matisse, what a fall!"[2]

Picasso's work could now be admired all over the Western world.

After the 1910 exhibitions in Budapest[3] and London,[4] there came the 1911 exhibitions in New York and Amsterdam, before it was the turn of the German-speaking world to show its enthusiasm for the artist the following year, with no fewer than seven exhibitions (two in Munich, two in Berlin, one in Cologne, one in Leipzig, then another one in Munich!) before shows in Vienna, Budapest, and Prague; in 1913, there were the exhibitions in Moscow, happening at the same time that the Armory Show was causing controversy in New York, Boston, and Chicago. This conquest of both the East and the West was orchestrated by Kahnweiler, who had developed a sophisticated strategy for promoting Picasso in the Anglo-Saxon, Germanic, and Russian lands: first, hook the visitor with his more accessible pre-cubist work (notably his Blue period), then contextualize the cubist revolution as part of an overall artistic trend toward ever greater degrees of abstraction, from the Blue period to synthetic cubism.[5] By showing viewers the constant evolution of his work, Kahnweiler was able to present Picasso as a "true" artist (able to reproduce reality) before showing him as a virtuoso surfing from style to style, then finally initiating the public into the subtleties of cubism.

On the Eastern front, nothing showed the necessity for this "educational" approach more than the career of Sergei Shchukin, heir to a textile wholesaling fortune and major collector of modern art, who would be completely hidden from history during the Soviet era, then rediscovered in the years that followed, first in Russia, then in the rest of the world. As a member of the new industrial bourgeoisie who wanted to modernize Russia,[6] Shchukin decided to transform the Troubetskoi Palace in Moscow—which he had just bought—into a center of modern art. Influenced by his brother Ivan, who lived in Paris, he started acquiring more and more paintings, with Matisse his favorite artist. He discovered Picasso in 1907, having been taken to the Steins' salon by Vollard. He remained quite cautious until 1912, buying only a handful of paintings—two in 1910 (*Portrait of Jaime Sabartés*, from the Blue period, and a small preparatory painting for *Les Demoiselles d'Avignon*) and two in 1911 (*The Absinthe Drinker*,

from the start of the century, and *Still Life with Jug*, from the Rose period).

In 1912, Shchukin completely changed his operating methods, buying up Picassos like they were going out of fashion (eleven paintings in 1912, thirteen in 1913), often straight from the studio. Then, through the intermediary of Kahnweiler, he bought some important pieces from Stein, whose culture and boldness he envied. Soon, his collection covered all the key moments of the artist's development (Blue period, proto-cubist period, the 1909 Green period, cubist experiments). Finally, little by little, Shchukin ventured toward more innovative and provocative pieces: for example, he dared to acquire the dark, geometric, mysterious *Woman with a Fan*, despite the aversion he felt toward it. Legend has it that he placed the canvas in a corridor and, overcoming the unease it inspired in him, kept going there to look at it. "Once he had accustomed his eye to the aesthetics of the painting, Shchukin was ready to take more risks," explained the artist Kazimir Malevich.[7] The collector even created a hard-to-find "Picasso cell" in the Troubetskoi Palace, as if this dangerous artist had to be carefully confined in isolation, with only visitors already initiated into the mysteries of modern art able to find their way there.

Soon, the entire Russian avant-garde was arguing over the pictorial UFO that was cubism.[8] Artists, art historians, philosophers, and critics all took up positions and participated in the debate. Among them were Malevich, Rodchenko, Larionov, Goncharova, Tugendhold, and many others. From 1912, as Anne Baldassari recalled, "numerous initiatives, taking the form of exhibitions, magazines, pamphlets, communal studios, plays, ballets and operas, and movements such as Der Blaue Reiter and Jack of Diamonds, often bringing together European and Russian avant-garde artworks, gave this debate an extreme intensity in Russia. In the arts, the prerevolutionary situation [. . .] anticipated the 1917 Bolshevik Revolution, in which many of these young artists would participate."[9] In Russia, as it had in Western Europe (as pointed out by Carl Einstein), cubism carried a subversive political charge against the established order, demonstrating—if demonstration were needed—that radical aesthetics and radical politics

are in league with each other. Paradoxically, while Shchukin contributed to the revolutionary process with his subversive art collection, he was forced to flee Russia in 1917 with the rest of the capitalist elite, throwing his collection into the shade until 1991.

While Picasso's invasion of the East was making impressive advances, the same was true in the West. Leo Steinberg recounted how the Steins bought *Three Women* (1908) from the Bateau-Lavoir studio even though they initially found the painting "frightening"—the characters closing their eyes and clinging to one another to form a single bloc, like ancient sculptures against a background of wild nature.[10] Later, according to Steinberg, the painting—by now hung in the apartment on Rue de Fleurus—caught the eye of Morgan Russell, a young American artist, who faithfully sketched it in pencil (1911) before returning to New York. There, along with Stanton Macdonald-Wright, another Stein salon regular, he became one of the kingpins of the synchromism movement. Still later, as the Stein collection was broken up, *Three Women* was sold by Kahnweiler to Shchukin, then hung in Moscow in the Picasso cell of the Troubetskoi Palace. It was there that the critic Yakov Tugendhold discovered the painting and hailed "Picasso's female nudes [. . .] built from stone, united in the dark concrete of their contours. Such are the *Three Women*, [painted in] a brick-red that has the weight and relief of a monument."[11] Other than the (sometimes diametrically opposed) reactions provoked by this painting,[12] what cannot be overstated is the phenomenal impact of its influence in the second decade of the twentieth century spreading both east and west to Moscow and New York, two cities that would oppose each other for almost a century through a series of massive geopolitical eruptions (World War I, the Russian Revolution, World War II, the Cold War).

It was in New York, in the spring of 1911, at Alfred Stieglitz's 291 Gallery, that Picasso first divided American opinion. With the Armory Show, which opened its doors in February 1913, a groundswell arose in American society, and important collectors became impassioned by the art being produced in Paris. These modernists influenced by the French avant-garde (courtesy of the Stein collection,

the Matisse Academy, and Stieglitz's gallery) went by the names of Stanton Macdonald-Wright, Arthur B. Davies, John Marin, Jo Davidson, Alfred Maurer, and Max Weber. But who in France had ever heard of them? In 2012, at the Grand Palais, the exhibition *Matisse, Cézanne, Picasso: The Steins' Adventure* revealed to the French public the audacity and courage of those American collectors, as well as the pale local imitations that their collections would inspire. Four years later, at the Fondation Louis-Vuitton, another exhibition—*Icons of Modern Art: The Shchukin Collection*—would demonstrate the same qualities, for the same French public, of that Russian collector, along with the emulators encouraged by his collection. How is it possible that the effect of Picasso's works—produced at the Bateau-Lavoir, on Rue Victor-Schoelcher, or in Céret—on Russian and American artists a century before did not provoke surprise, even disbelief in Paris?

The international furor surrounding Picasso just before World War I contrasted sharply with France's difficulty in accepting the cubist revolution. The art historian Yve-Alain Bois pulled no punches in his condemnation of the opprobrium to which cubism fell victim in France. He analyzed the divide that grew during the course of the twentieth century between France, Germany, Russia, and Czechoslovakia in this regard, before delivering the shocking verdict (albeit one that the reader of the previous chapters of this book should be thoroughly prepared for) that France, at best, completely missed the point of cubism, and that, at worst, it destroyed an exceptional aesthetic movement that it had helped engender. Bois wrote: "*Kubismus* by Vincenc Kramář, a book written by a peerless eyewitness—just like Kahnweiler's *Der Weg zum Kubismus* (1920) and Aksionov's short work on Picasso, published in Moscow (1917)—provides a lesson on humility to anyone whose art criticism is imbued with nationalism: these books, written in German, Russian, and Czech, are so much more insightful than all the articles and catalog prefaces published in France by the many defenders of cubism [. . .]. These French texts, though written with the best of intentions, are flawed by their authors' complete blindness regarding the true meaning of Picasso

and Braque's experiments [. . .]. They are simple historical documents, useful if one is compiling a history of the (negative) reception given to cubism in France, but they also confirm the decline of art criticism in France after Félix Fénéon stopped writing. The books by Kahnweiler, Aksionov, and Kramář are another thing altogether, and they remain unmissable for anyone willing to think deeply about cubism rather than merely regurgitating the conventional clichés [. . .]. One could even wager that, had their French translations been available immediately after they were first published, the general incomprehension to which cubism has been submitted in our country until very recently—with well-known disastrous results in terms of national collections, a lamentable situation that the Musée Picasso has thankfully been able to redress—could have been, if not avoided, at least mitigated."[13]

The situation of the avant-garde in France was caused by an entire system that the artists of the Nouvelle Peinture—led by Courbet—had attempted to denounce a half century earlier. It was caused by an unhealthy tradition of bureaucratic inbreeding at the highest levels of officialdom, which produced mandarins with many hats—professor at the École des Beaux-Arts, member of the Académie des Beaux-Arts, member of the Salon jury—whose overall mission was to defend establishment art against innovation and to excoriate anything alive and new. And even after 1863, when the political authorities—in this instance, Emperor Napoleon III—had, after being alerted by a new generation of artists, chosen to ridicule the established order by accepting the organization of a "Salon of Rejected Artists," the establishment's influence proved tenacious. In 1900, at the Exposition Universelle, the most emblematic of this old guard, Jean-Léon Gérome—who kept his privileges for four decades and blocked the progress of as many generations of innovative artists—made himself the center of attention by rushing to stand in front of the French president Émile Loubet and barring him from entering the booth that was showing the works of a few impressionists, with the words: "Do not enter, Monsieur le Président, it is the dishonor

of France!" In 1912, then, ignoring the fact that Georges Braque was born in Normandy, the collusion between a German art dealer, a Spanish artist, and collectors from Russia, Germany, and North America made cubism an avant-garde movement that "good Frenchmen" could point to as being run by forgers and charlatans, creating a "danger" to the integrity of the nation. It was a battle of good and evil, tradition versus the new, the France of honest men against an invasion of dangerous foreigners.

The excellence and education of Kramář, Kahnweiler, Stieglitz, Einstein, Raphael, Meier-Graefe, and others provide an indication of the gulf between France and Germany in terms of their art-history traditions. But what seems to have been forgotten nowadays is the "culture of defeat," the "mark of Sedan" that weighed so heavily on French minds for four decades. To rediscover the traces of that unhappy era and the desire for revenge, one must reread the poet Charles Péguy, who in 1905 praised the French as a "people of culture" and France as a "guide nation [. . .] revolutionary, (Catholic), civilizing," opposed to Germany, a "barbaric people [. . .] a people of obedient subjects." In another text, hammering away at ideas of shame, tension, and fate in a morbid litany, Péguy—beyond his own exaggerations—offers a revealing portrait of a situation that escapes us today. "One must imagine," he wrote, "what life had become for those two haunted peoples; shame, perpetual tension; an obsession; a charged front; a fixed gaze, sunken and punctilious; an impression of not being in oneself and for oneself, an impression that one existed only in terms of the other, one to confront the other, each to be the instrument of their own fate, and at the same time, indivisibly, indissolubly, the instrument of the opposite fate; these two unhappy peoples no longer existed like ordinary peoples; they were like two living, opposed tensions; like two living, opposed threats." In his writings, Péguy evokes the state of mind of a country that, utterly lost, long remained deaf to the cultural hybridizations that were occurring on its own territory, all the while ignoring or stigmatizing some of the intellectuals and artists who had done it the honor to come and live there.

27.

GUTENBERG 21-39: FROM ONE BUSINESS CARD TO ANOTHER

André Level, acts I and II

Thursday, May 9, 2018. In the press this morning, *Girl with a Basket of Flowers* (1905) is unanimously hailed as an important marker. A few hours ago, at an auction of the Rockefeller collection in New York, the painting was sold for $115 million. With four works now having gone for more than $100 million, journalists announced, "Picasso has broken the record previously held by Leonardo da Vinci and Vincent van Gogh." Paris is deserted this morning, and there are very few of us working in the stifling warmth of the attic room in the Hôtel de Rohan where the Picasso archives are kept. Yesterday was VE Day, and tomorrow is another public holiday, Ascension Day. An École du Louvre intern has just displayed a handwritten letter inside a beautiful upholstered box for the exhibition *Picasso: Blue and Rose*, which will open in the fall at the Musée d'Orsay. Pierrot Eugène, who is supervising the documentation room, plugs in a fan for me, but the jet of air sends my papers flying. So he turns off the fan and goes back to writing long lists at his desk, and the room becomes an oven again. Black-and-white portraits, taken from previous exhibitions, are lined up vertically on the walls on thick wooden planks: Picasso at forty on Rue La Boétie in front of the famous Henri Rousseau painting unearthed in Père Soulié's boutique, the sultry Dora Maar smoking a cigarette on Rue des Grands-Augustins, the young Picasso

standing with his coat collar turned up in front of a gas lamp on Rue Ravignan, Picasso with Fernande and their dog Flicka, Apollinaire, Cocteau . . . they are all here, locked in with us in this oppressively hot *huis clos*. Now and then, Pierrot looks up and stares into Picasso's eyes, respectful and familiar. With his placid smile and his helmet of black hair, Pierrot is a discreet, affable man with an occasionally mischievous streak. How else could he have put up with living in this prison of ghosts for the past three decades? Anyway, this morning, Pierrot, Olga, Flicka, Apollinaire, and Cocteau are my companions as I dive into the Picasso archives. They begin on January 24, 1908.

I am eager to have access to folder 86. All the information I've been able to glean about it—from reading the memoirs of the collector André Level—intrigues me. He sketches his descent from the Balzac character "le cousin Pons" with a certain elegance: "He has almost no descendants [. . .] my grandmother, who had danced with Balzac, claimed to have known the prototype for the cousin Pons (who was single)—a doctor living on the Île Saint-Louis."[1] His definition of a "true collector" is written with great confidence, too: a person who, "at the entrance to a street not yet walked or to a shop not yet entered" is capable of "sensing whether he will return empty-handed or in the possession of some priceless treasure."[2] In a 1918 sketch, Picasso represents Level (who was eighteen years his senior) as a highly proper-looking man, with a long oval face, a neat mustache, and a calm, kind gaze, the only flaw a slight asymmetry between his pupils. Level is a well-known figure to art historians: we know that, in January 1908, on Rue Ravignan, he bought *Family of Saltimbanques* direct from Picasso—that immense painting from the Rose period that we have already discussed at length, and which influenced Apollinaire and inspired Rilke.

Having been attentive to young artists since 1902, Level became one of Picasso's first French collectors, picking up drawings, watercolors, and pastels in Berthe Weill's gallery or from amid the chaos of Père Soulié's store. "On a Monday, at Soulié's strange place, where

he sold bedding and unframed paintings hung from a crib, I would see a Picasso self-portrait, a rather hard sketch in the harsh light of day, and that Saturday I would find the painting in the same place and only then decide to pay 15 francs to buy it."[3] But how did Level come up with the idea of La Peau d'Ours, the first consortium of collectors[4] (co-opting his brothers, cousins, and friends), whose articles of association stated that it must, when it was dissolved (ten years later), share 20 percent of its sales with the artists, prefiguring the famous *droit de suite* artists' royalty?[5] "I couldn't resist [. . .] the desire to buy these works, which obsessed me," he admitted. "So why not come together to form a joint collection? [. . .] That was how this friendly little nest egg came about [. . .]. It was the opportunity [. . .] for an unbridled hunt for the rare piece that we had to acquire, despite our modest budget."[6] This was at the moment when Picasso, after three failed attempts to live in Paris, finally settled down on Rue Ravignan. In the meantime, the collection amassed by Level and his friends developed, and in 1906, his committee even voted for an "all-Picasso year," purchasing six of his works from Clovis Sagot.

Two years later, alerted by Sagot that Picasso was "hoping to sell a large painting of fairground workers drawn and painted separately by him on various occasions,"[7] how did André Level immediately win the artist's empathy toward him? In January 1908, Level went to Rue Ravignan for the first time, escorted by the art dealer Lucien Moline and accompanied by a few members of his famous committee. Picasso showed him the canvas. "We didn't hesitate long. The painting was admirable, but our budget was minuscule," Level recalled. The collector told the artist how his consortium worked and offered 1,000 francs—barely a third of the sum Picasso had been hoping for—with an immediate advance of 300 francs along with a trial period of one month, after which the artist could approve or decline the offer. Presumably in dire need of money, Picasso accepted. But, very quickly, he decided to speed things up. "Less than two weeks later, he came to my office, not to pay us back but to pick up

the balance," Level explained.[8] So why did Picasso, who "hoped to obtain a higher price from [foreign] art enthusiasts,"[9] accept Level's offer? Why did Picasso choose Level to take possession of this magnificent painting, which he had always refused to include in the studio stock sold to Vollard and which he had of course never offered the cubism dealer? All these questions are buzzing in my mind before I open folder 86.

We know that Picasso never threw anything away, so his archives are vast. But why did he preciously keep *all* of André Level's visiting cards (at least twenty of them, all identical), along with his telephone numbers, scrawled in pencil on the small pages of a graph-paper notebook ("Gutenberg 21-39," "Wagram 28-59")? As I read through the 104 letters inside this folder, as I penetrate the arcana of the Level family, I discover something more than a simple friendship between artist and collector: it was a long-term alliance, an unbending shield that would protect Picasso from the French bureaucracy until his death. Gradually, I come to understand that what occurred between them was located in a new kind of space, deep inside those cracks of French society, far deeper than I'd imagined. If reading someone else's correspondence is an act of voyeurism, it is also a privilege. To decipher a stranger's handwriting, you have to hang on their words, reconstruct a story, make sense of the tiniest detail. This process begins with the evolution in the opening words or the letterhead, which in this case reads: "3 Rue Cernuschi," in other words the elegant part of the 17th arrondissement of Paris, the neighborhood around the Parc Monceau.

André Level was a businessman, a lawyer by training, a bourgeois Frenchman who addressed the arts with consideration and respect in a careful but not ostentatious language, using some occasional, elaborate, and old-fashioned phrasing, as evidenced in his very first letter to Picasso. It is dated January 24, 1908. "Dear Sir, My framer (Mr. Louis, 32 Rue Fontaine) should return to your studio tomorrow, Saturday afternoon at three o'clock, to take the measurements for a frame. If that time is not convenient to you,

dare I ask you to inform me of the moment when you would be able to receive him? Until soon, dear Sir. Yours sincerely, A. Level." The sale of *Family of Saltimbanques* in January 1908 marked the beginning of a sort of pact between Picasso and Level, visiting card to visiting card. Long before Level's phone number, Gutenberg 21-39, became—with the passing of time—a sort of magic key for Picasso, opening doors that had previously been locked to him, the artist sensed that, despite the modesty of the sum paid for his painting, the collector's offer included other important benefits. He immediately understood, for instance, that La Peau de l'Ours represented a revolutionary economic model, with the guarantee of future profits.

The wheel turned and, in 1914, as agreed, the works owned by La Peau de l'Ours were auctioned at Hôtel Drouot. "It was the first time such a complete collection of modern artworks had been put on public sale, works that were genuinely avant-garde and whose artists belonged to the ranks of those 'madmen' who were ridiculed by the crowds that flocked to the Salon des Indépendants," wrote André Salmon in his vivid account of the event. "On March 2, 1914, at two o'clock. A memorable date [. . .]. This sale has been something like an *Hernani* premiere for painting."[10] Another commentator described it as "a battle on behalf of young, bravely innovative art."[11] More generally, the auction of the La Peau de l'Ours collection brought in unexpected sums of money and was a game changer for Parisian galleries, because it proved that "the work of living artists [can be] profitable." From that day on, a wind of speculation began to blow across France, and the "avant-garde ceased being the prerogative of selfless enthusiasts."[12] But the success of the sale of *Family of Saltimbanques* at Drouot, which brought together the artist (a Spanish painter), the gallery owner (Kahnweiler, a German art dealer), and the buyer (Thannhauser, another German art dealer), triggered an additional wave of xenophobia in Paris. The journalist Maurice Delcourt, for example (in an article entitled "Before the Invasion"), explained that "huge prices were

paid for vile, grotesque paintings by undesirable foreigners," and that "it was the Germans who paid and pushed the prices up that high!," while warning "naïve young artists" not to "fall into the trap" of "imitating the imitator Picasso who, pastiching everything and then finding nothing else to imitate, sank into that cubist nonsense." They had to do all they could to "destroy Kubism [*sic*],"[13] (a xenophobic reference to the so-called German influence on cubism), which would soon provoke rage in France. Five months later, the president of the Autumn Salon, pursuing what was now presented as a sort of crusade, would shout out with relief, "Finally, cubism is over!"[14]

In March 1914, six years after his first purchase, a second letter from Level, just as courteous as the first, was sent to the artist. "My dear friend, As you know, the Association de La Peau de l'Ours decided, upon its formation, to share 20 percent of any net profits with the artist. We will be delighted to see you accept the attached check number 62,297 from the Banque Nationale de Crédit, remunerating you for your fully deserved rights in this masterpiece [. . .] in accordance with our articles of association. I am, my dear friend, your sincere and devoted A. Level." That year brought a series of spectacular turnarounds: on March 3, *Family of Saltimbanques* was sold to Heinrich Thannhauser, the Munich art dealer, for 11,000 francs (eleven times the price paid by Level to Picasso six years before). The check that Level then sent to Picasso was made out in the sum of 3,978 francs and 85 centimes—roughly a fifth of the artist's earnings for the year. Level had the letter hand-delivered to the artist, and Picasso replied with equal elegance, producing his collage *Bottle of Bass, Wineglass, Packet of Tobacco and Visiting Card*—a public tribute to the collector. There was humor, too, in the way he placed Level's dog-eared visiting card in the foreground, balanced precariously on the edge of the table.

At the start of August 1914, Picasso, happy with Eva, was working in Avignon while Kahnweiler was mountain climbing in the Aus-

trian Tyrol with his wife, Lucie. When the war began, blowing up his entire system of alliances, Picasso would again contact André Level, who—courtesy of his magic number "Gutenberg 21-39"—would soon become one of the artist's unconditional admirers, and more besides.

28.

"A SPLENDID SERIES. FREE AND JOYOUS AS NEVER BEFORE . . ."

Lieber Herr Doktor

Ja gewiss, es ist eine herrliche Serie. Frei und freudig wie noch nie . . . [1]

—Daniel-Henry Kahnweiler to Vincenc Kramář

For weeks, I continue cutting my way through the dense tangle of the cubist years. From January 1913 to August 1914, each of the characters kept on functioning in their own geographical space—works of art were developed in the studios of Montmartre, Montparnasse, Sorgues, and Avignon; financial transactions were made in the tiny gallery on Rue Vignon and its satellites; critics continued thinking about the function of art (which Carl Einstein believed was to "transform the representation of the world"),[2] while Kahnweiler pursued his "mission," showing his collectors the latest stage in cubism's evolution. But I discovered the final key as I was reading Kahnweiler's last, poetic letter to Kramář, just before the cataclysm.

On January 21, 1913, Picasso traveled back from Barcelona with Eva Gouel to his studio on Boulevard Raspail. As he proclaimed at the time in his paintings, he loved Eva (*"j'aime Eva"*), and his new contract with Kahnweiler gave him a financial stability that he

had never experienced before. And yet, 1913 was a year of constant movement (Barcelona, Paris, Céret, Barcelona, Paris, Céret, Paris, Avignon, Paris), a year of sickness (in March, Eva displayed the first symptoms of the disease that would kill her in December 1915; in June, Pablo had a case of "typhoid" that lasted a month), and a year of grief (the death of his beloved Fricka, the dog he'd had since the Bateau-Lavoir years; and the death of his father on May 3). "I am writing to inform you that my father died on Saturday morning. You can imagine what kind of state I'm in," he explained to Kahnweiler.[3] The letters from Barcelona became almost daily around this time, intensifying the family drama, his mother switching between reflections on grief and loss, repeated affirmations of the indestructability of family ties, and the added pressure she felt permitted by such an event to heap on her absent son.

"Dear Pablo, I am disgusted with you because I have received nothing and, when I know nothing about you, I have the impression that my life is falling apart, but you don't realize, it has been more than a month since you wrote to me" (May 15).[4] "The day before yesterday, I received your drawings and we are all very happy because, seeing them, it was as if we were seeing a part of you, in particular it's the blue of your drawings that I love so much, because it reminds me of happy moments when I used to see you working" (May 21).[5] "Dear Pablo, I received your letter and I am happy about everything you tell me because I see you haven't forgotten me. Today is a very sad day, the Day of the Dead, and even more so because it coincides with the loss I suffered six months ago when papa died. I haven't found the strength to go to the cemetery, even though I wouldn't have had to go there alone because Juan's mother would have accompanied me" (November 2).[6] After that, Picasso responded to his mother's harassment with regular monthly payments. This was his response to the infernal cycle of "ask-receive-ask again,"[7] to the extent that we could even compare his case to that of the migrant Congolese workers who choose to send money back to Africa in order not to suffer *social death* in their homeland.[8] Similarly, María Picasso y Lopez was surprised

to receive a check from her son: "Dear Pablo [. . .] I was agreeably surprised by the check for a thousand [pesetas] that you sent me from San Sebastian for [the bank] El Hispano Africano,[9] I don't know how to express my gratitude, I will just say that God is too good to me because, in fact, I do not deserve so much."[10]

Despite everything, Picasso created a long series of highly elaborate papiers collés: *Still Life "Au Bon Marché"*; *Bottle of Marc de Bourgogne, Glass and Newspaper*; *Bottle and Glass*; *Violin, Glass and Bottle*; *Guitar and Violin*; *Guitar, "Ma Paloma"*; *Guitar Player with Armchair, Figure*, with plaster relief effects on canvases using paper and sand. And then there were more guitars: *Bottle of Vieux Marc, Glass, Guitar and Newspaper*; *Bar Table with Guitar*; *Guitar*; *Violin*; *Guitarist*; *Card Player*; *Head of a Man*; *Violin in a Café*; *Head of a Girl*; *Clarinet, Bottle of Bass, Newspaper and Dice*; *Guitar, Newspaper, Glass and Ace of Clubs*, produced one after another. There was a return to blue, to red, to green, to sand, to newspapers, to scraps of wallpaper, to mysterious messages inserted into the paintings, enigmatic and elliptical, as the artist drew the viewer into his canvas, magnetized him, led him through a dizzying treasure hunt, still using techniques borrowed from Braque for this "third generation of papiers collés."

For his part, in Montmartre, in his room at the Hôtel Roma on Rue Caulaincourt, where he now had a studio, Braque was busy creating paper sculptures or drawings and papiers collés such as *Guitar* and *Guéridon*. As for Picasso, he went on working at a frantic pace and, amid this flood of works and techniques (but also the articles and catalogs analyzing these moments of permanent frenzy), it is once again Kramář's notes that help me to see clearly. This time, it is the network of Czech artists in Paris who put me on the right trail, beginning with Emil Filla, Kramář's principal informer on the French capital's art scene. "I was at the Steins'," Filla wrote in early May. "Very respectable collection, but all the dust and grime on the paintings is appalling."[11] At the time of his February 1913 visit to Thannhauser's Moderne Galerie in Munich, Vincenc Kramář gloated to his wife, "Today, I can tell you that I bought one Picasso,

namely the oval still life with violin, highly colored, from 1912," before admitting to her that "seven months ago, it was 50 percent cheaper!"[12] But he paid the requested price (4,100 koruna) and, aware of the value of his new treasure, immediately commissioned the architect Pavel Janák to create an oak frame for the canvas, after lamenting the rise in prices in a letter to Kahnweiler. "I told Thannhauser the minimum prices for all the paintings I made available to him," the gallery owner replied, writing a five-page letter to explain in detail the way the prices were determined. Thannhauser "naturally also wanted to earn something for himself on top of that," he added, "so he increases the prices on his side too. I only found out the price the work was sold for from you, and obviously I will only receive a part of that price myself." Ending on a positive, reassuring note, Kahnweiler congratulates his client on his excellent choice: "It is the most important painting of the period, and therefore a very good acquisition for you."[13]

One month later, Kahnweiler, who was expecting to see Kramář toward the end of April, was becoming impatient. "Every morning, when I open my store, I hope to see you, but until now there has been no sign of you. If you don't have an important reason to remain in Prague, I would urgently advise you to come as soon as possible; the longer you wait, the fewer Picassos you will find here because, obviously, people are buying them all the time. Many have already been sold. And Mr. Shchukin, who will also undoubtedly buy several pieces, is arriving on May 20. So, if you can, come before then— that's my advice."[14] Times, as we can see, were changing in Paris. Exeunt the Steins, with the "divorce" between Leo and Gertrude and the dispersion of their collection, which Kahnweiler had to inventory. And, of course, a new character—Sergei Shchukin, the Russian businessman—entered the stage a few years before this; having taken the Steins' collection as his model, he was now in the process of buying up the most important works from it, using Kahnweiler as his intermediary. Shchukin also advised his young colleague Ivan Morozov to do the same. And he did: in 1914, Morozov acquired

one of the jewels of the Stein collection, *Young Acrobat on a Ball*, for 16,000 gold francs—a record, and one hundred times the painting's original price.

In financial terms, 1913 and 1914 were very good years for Picasso, as these entries in his accounts book reveal:

October 15, 1913, K: 15,850
November 15, 1913, K: 4,950
December 22, K: 3,250
April 4, 1914, K: 5,688
May 11, K: 1,650
June 8, K: 12,400[15]

Given that Kahnweiler had signed the artist a check for 27,250 francs (twenty-three recent paintings, three old paintings, twenty-two gouaches, and fifty drawings),[16] Picasso's total earnings for 1913 exceeded 50,000 francs—a considerable sum for the time (the equivalent of $192,000 in 2021). And 1914's figures do not include the check from Level (for his share of the painting auctioned by Drouot): 4,000 francs (more than $15,000 in 2021).

At last, on May 7, 1913, Kramář arrived in Paris, ecstatic and exhilarated. He stayed for a month and a half, noting down everything—as testified by his notebooks, his diaries, and his letters to his wife. "Every time I arrive in Paris, I feel the old regrets returning: if only I had lived here for a year or two. I also feel, particularly regarding Picasso's evolution, that I stayed away too long. If I can't live here, I have to come at least twice a year, in recompense. Picasso's latest paintings do not look anything like my still life and they are very beautiful."[17] More in tune than ever with the artist, the collector's admiration shaded into obsession: on his visits to the Musée Cernuschi or the Musée du Luxembourg, a Japanese mask or a painting by Cézanne would make him "think of Picasso." On June 1, he rejoiced to Mrs. Kramář: "This afternoon, I am going to see a private collection containing lots of Picassos that I have never seen before." A

few hours later, at Roger Dutilleul's apartment on Avenue Marceau, he went into ecstasies over *Spanish Still Life* (1912), an oval canvas that mesmerized him, even if, in his notebook, he wrote down the wrong title ("Bottle and Glass"). It is a pyramid-shaped composition (painted exactly one year before, on June 5, 1912) in which we can see the neck and body of a bottle, several other bottles, a wine glass, several whole or deconstructed wine glasses, and some truncated lettering such as "CIDA" (from the Barcelona newspaper *La Publicidad*) and "SOL [. . .] SOMBRA" (from *Sol y Sombra*)—allusions to his homeland, the first taken from a headline in the newspaper, which on April 26 published an article on cubism, and the second a reproduction of an entrance ticket for the corrida, "sunlight and shade" marking out two different parts of the arena.[18] With its glorious contrasts—pink brushstrokes, prosaic and horizontal at the top; vertical rectangles of the Spanish flag, varnished and shiny, in Ripolin red and yellow at the bottom—and its white space, like limewash, to the right, facing the dark density on the left-hand side, it is without doubt a special work. Brooding constantly over his frustration at not living in Paris, inconsolable at the thought that this kind of masterpiece would escape him, resigned but faithful to his preoccupations with color, Kramář wrote sadly in his notebook: "raspberry red at the top and Ripolin red at the bottom."[19]

A few days later, still obsessed by his favorite artist, the art historian and collector copied down some sentences he saw in Apollinaire's latest articles: "A Picasso studies an object like a surgeon dissects a corpse"; "Most of the cubist artists live in the company of poets [. . .]. As for Picasso, who [. . .] is the highest artistic figure of our times, he has only ever lived among poets, and I have the honor of being one of them."[20] During this stay, Kramář bought a recent *Mandolin* (by Picasso, of course) for 800 francs from Kahnweiler, as well as a "large Braque painting," apparently a *Violin* (400 francs), and a drawing—"both of them cheap," he added. Finally, on June 23, the collector rejoiced that "Picasso is back from Céret" before noting triumphantly the next day: "With Picasso at Kahnweiler's."[21] On June 25,

sated at last, Vincenc Kramář left Paris for Prague. Kahnweiler would wait four months before contacting him again with a few tenuous scraps of news: "Picasso has just rented a new studio," "Picasso is busy moving," "Picasso hasn't finished anything new since your last visit," "Picasso is illustrating Max Jacob's *The Siege of Jerusalem*." In November, the dealer assured him that the artist "is in rude health and working hard" and sent him a few photographs of "studies for sculptures in paper and bits of wood," while making clear that Picasso "considers them simple experiments [. . .] nothing intended to be sold or exhibited."[22] But at least Picasso was working. After months of relocations and emotional turmoil, thanks to his new studio on Rue Victor-Schoelcher that anchored him in Montparnasse—"the studio of happiness," according to Pierre Daix—and thanks to his stay in Avignon (with Braque and Derain) that provided him with several summer weeks of uninterrupted peace in the same place, Picasso was working. But now that his dialogue with Braque had lost its intensity, the rift in their common goal continued to deepen.

Back from his third stay in Céret (fall 1913), Picasso pursued his deconstructions of the portrait genre with *Student with Pipe*, inventing complex works full of humor that, in addition to pointillism (which he'd seen in paintings by Severini and which he borrowed from lightly), and in addition to references to various objects, also integrated heterogeneous materials: "oil, gouache, papercutting, plaster, sand, and charcoal on canvas." A little later, a few masterpieces like *Woman with Shirt Sitting in a Chair* and *Man Sitting at the Glass* would see the light of day. For Vincenc Kramář, however, the news from Paris in spring 1914 was far less significant than before. "Kahnweiler hung the beautiful Picasso from the Nemeš collection, *Guitarist*, very beautiful and in my opinion the prettiest and densest," wrote Emil Filla. "He also showed me another still life with a bottle of Bass (in the bottom left-hand corner) [. . .]. Otherwise there are no Picassos."[23] After that, Kramář learned from the same source that Shchukin had bought, from Kahnweiler's gallery, a large painting "that Derain said took him two years to paint" and that "Braque is

going to hand over most of his harvest in two weeks and [. . .], according to what I heard from Gris, they will be mostly drawings and papiers collés."[24]

Such were the rumors from Paris that reached Vincenc Kramář in Prague in the spring of 1914. His wait went on: in April and May, most of the news Emil Filla gave him concerned Braque. "I went to Braque's studio with Gutfreund. He received us very kindly. He is mostly producing papiers collés, and so is Picasso, from what I hear. We saw things there on the floor, the table, the walls, on easels, everywhere [. . .]. In every corner there were what he calls 'sculptures'— generally, still lifes (bottle, glass, pipe, etc.) in pasteboard."[25] The references to Picasso remained fleeting and disappointing. "Uhde has the large Picasso painting *Guitarist* at his apartment, the one we saw last year at Kahnweiler's gallery (the large canvas with that beautiful green marble) [. . .]. Mrs. Stein is moving apparently, because the studio where she kept her collection is available for rent from April 15. I went there with Kars; she was especially unpleasant. Picasso came with his girlfriend, and Kars introduced me. Picasso invited me to go see him, but I haven't yet found the time. He isn't home most of the time."[26] What could Vincenc Kramář glean from this trivial roundup of Paris life? That "Braque strongly advised the hotel owner to put a plaque on the door stating 'cubists on all floors'"?[27] That the critic Roger Allard, one of the first champions of cubism, upset by the rising number of cubist salons, was now changing his position with some columns that were tainted with nationalism? "The avalanche of cubist (or, rather, cubist-influenced) painting," he wrote, "perpetrated in Berlin, in Munich, in Montparnasse, and in Montparnasse's Little Poland and Little Chicago, threatens to bury those who impetuously set it in motion."[28]

That spring, Picasso produced a very beautiful little sculpture, *Absinthe Glass* (consisting of a wax glass, a real spoon, and a fake sugar cube),[29] from which Kahnweiler decided to cast six bronze proofs that Picasso would paint in various colors, having fun innovating with each one, in a series so creative that it was described as "the first

cycle of Picasso variations [capable of] extending the possibilities of painting in a meaningful way."[30] There would be other sculptures that month, such as *Glass, Pipe, Dice and Ace of Clubs*, with powerful contrasts of shapes and colors that brought in elements of wood and metal on a background of oil paint on wood. So, Picasso was producing a large number of works while Kahnweiler photographed, numbered, recorded, and selected them.

After this long lull, there was a sudden shift of gears in early June 1914, when everything accelerated: Kahnweiler launched a series of alerts aimed at his foreign collectors. He began in Moscow, informing the wealthiest among them of the new artworks' serial numbers, titles, dimensions, and prices. "Dear Mr. Shchukin, I have the honor of confirming to you my letter of the sixth. Picasso, prior to his departure for the countryside, has just finished an admirable series of paintings, his first in more than a year. Among them are many paintings that I would strongly recommend you buy; in particular, there is the large painting of the seated woman in a shirt, which would in every sense be a work worthy of entering your collection. In any case, I am sure that you will find things in this collection that suit you. I would be very obliged to you if you could let me know as soon as possible. I hope we will soon have the pleasure of seeing you in Paris."[31] Kahnweiler had no qualms about giving his Muscovite client the hard sell. As far as he was concerned, nothing could stop Picasso. His letter, with nine photographs of new works, was accompanied by a list, which read as follows:

No. 361, *Woman with Shirt Sitting in a Chair*, oil, 100 x 150, 15,000

No. 366, *Woman with Guitar*, oil, 130 x 90, 10,000

No. 364, *Guitar, Bottle and Card*, oil, 107 x 66, 6,000

No. 363, *Student with Newspaper*, oil, 73 x 60, 4,000

No. 362, *Pipe, Glass, Bottle of Vieux Marc*, papier collé, 73 x 60, 1,500

No. 379, *Composition with a Bunch of Grapes and a Sliced Pear*, papier collé, 53 x 72, 2,000

No. 378, *Bottle of Wine*, papier collé, 52 x 70, 1,800

No. 377, *Glass and Lemon*, papier collé, 51 x 70, 2,000

No. 380, *Fruit Bowl and Glass*, papier collé, 52 x 70, 2,000[32]

But the only work on this list that interested Shchukin was no. 379, *Composition with a Bunch of Grapes and a Sliced Pear*.

On July 3, 1914 (precisely two weeks after this letter was sent), Kahnweiler sent Kramář thirty-four photographs of Picasso's latest productions, including the papier collé artwork *Pipe, Glass, Bottle of Vieux Marc*, and also *Woman with Shirt Sitting in a Chair* and *Woman with Guitar*. "As you will see," he explained, "there is also a sculpture. It is in bronze and painted in oil. There are five copies, each one different of course [. . .]. You will see that, in many of the works, Picasso has used every material possible: paper, gouache, oil, pencil, Conté sticks, sawdust, etc." In response to Kramář's interest, he provided the prices for certain pieces: two small paintings, *Glass* and *Pipe, Glass, Bottle of Rum*, were 600 francs each; a papier collé, *Le Citron*, was also 600 francs, while another, *Pipe, Glass, Bottle of Vieux Marc*, was 1,500 francs; the sculpture, *Absinthe Glass*, was on sale for 1,000 francs.

Finally, on July 22, two hours before leaving Paris for the summer, Kahnweiler pushed Kramář to make his choice from the latest series of paintings because, as he put it, "the most important works have already been sold."[33] He also announced that he would soon be sending "photographs of a few Picassos that you do not yet have (thirteen in all)." And so, like other great art dealers such as Joseph Duveen or Leo Castelli, Kahnweiler sent his client the subliminal message not that he was being *sold* these paintings but that he was *building his collection*. In 1913 and 1914, month after month, it was a race against the clock—a race between Picasso and Braque, between Shchukin and Kramář, the latter race orchestrated, of course, by the "conductor" Kahnweiler. On July 18, 1914, describing emphatically Picasso's latest masterpieces for Kramář's benefit, Kahnweiler added yet another little phrase that, retrospectively, has an ironic ring: *"Lieber Herr Doctor, Ja gewiss, es ist eine herrliche Serie. Frei und freudig*

wie noch nie" ("Dear Professor, You will see that it is truly a splendid series. Free and joyous as never before . . .").[34]

At the same time, in Vienna, Stefan Zweig noted in his journal, "In the vines of Baden [. . .] an old winemaker told us: 'We haven't had a summer like this in a long time. If it goes on, we'll have a wine like nothing before! People will remember this summer!'"[35]

The final missives between our characters in July 1914 leave no doubt: each of them was looking forward to the summer.

Avignon, July 15. "I saw Derain, who is very happy to be here and promises himself he'll have a good season. Picasso hangs out with the Avignon elite. We spent the day together on Saturday" (Braque to Kahnweiler).[36]

Avignon, July 21. "My dear friend Kahnweiler, I received some photographs and I am waiting the others they are not bad [. . .]. I am painting only large canvases or rather I am thinking only of painting them. I started one which is already quite advanced. It was very difficult for me to get going before to get used to working in a dark attic but now I have started and I hope the good lord does not want me to stop. . . . I often see Braque and Derain" (Picasso to Kahnweiler).[37]

Prague, July 27. "It is an emotional time, with farewells everywhere [. . .]. Of course, all of this does not yet mean that we will have a war. Personally, I don't believe anything will happen" (Vincenc Kramář to his wife, the day after mobilization began).[38]

Barcelona, August 3. "Dear Pablo, We are all fine but despairing over this devil of a war, because of rumors that were circulating yesterday; I didn't sleep, thinking of you, and now that it is eight in the morning I am writing this letter to see what is happening to you, I know you will be able to decide what is best for you and above all I am certain that you do not get involved in politics, but that doesn't mean that they won't be able to cause trouble for you, so think carefully [. . .]. You know I am not the kind of person who worries too much, but the news tonight is very pessimistic" (María Picasso to her son).[39]

On August 3, 1914, Picasso accompanied Braque and Derain, who were in uniform, to the Avignon train station. He returned to

his papiers collés and continued to live in a place otherwise occupied solely by women. During the months that followed, a national campaign would encourage French citizens to regard foreigners as "spies or profiteers, while good French people are fighting." As for Marcel Duchamp, who left for New York, he explained simply: "In 1915, men in civilian clothes were spat upon."

Dismantling the Picasso international

1914–1923

■ ■ ■

Picasso did not return to Paris until the fall [of 1914]. Kahnweiler (a German subject, but unwilling to fight against France) was kept by the war in Italy, then in Switzerland, where he would remain until February 1920. His goods, his gallery, and the paintings were all sequestered: Picasso's entire cubist output—at least since the winter of 1912, with the exception of what he was able to keep in the studio, under the conditions of his contract with Kahnweiler—became inaccessible until the sales of 1921 [. . .]. Kahnweiler did not manage to reestablish contact [with Picasso] as he did with all his other artists in the fall of 1919. There are obviously several reasons for that, which can only be sketched here. More than any of the other artists in the gallery, Picasso no longer needed Kahnweiler in 1919. He had found other clients, other patrons; he was moving in a new world. The evolution of his art was seen by his former comrades [notably Gris and Braque] as strange and disconcerting, and they even accused him of being motivated only by money: this incomprehension was exacerbated by the gulf that grew between those who had gone to war, losing several years of painting in the process, and Picasso, who had been able to continue painting [. . .]. Lastly, a dispute about money came between them, a serious misunderstanding, upon which a begging letter from Kahnweiler to Picasso (written on February 10, 1920) sheds some light. Picasso did not reply to any of the dealer's letters. He even took legal action against Kahnweiler regarding a sum of 20,000 francs that he should have received in late 1914 and that had never been paid. Kahnweiler gave him the following explanations: "There was never any money in my account at that time for a very simple reason: the bank gave me credit, and I was using that credit for my

work [. . .]. Then the war came with the moratorium. First, the bank suspended my credit. Second, the people who owed me money—money I was going to use to pay your 20,000 francs—refused to pay (for example, Shchukin owed me a large amount of money, and Rosenberg owed me 12,000 francs)." Picasso refused to back down, and the pair remained at odds until 1922 and 1923.[1]

—Isabelle Monod-Fontaine

29.

WITH THE WOMEN, THE RETIREES, AND THE EXPATRIATES

Braque and Derain have gone to war.[1]

—Pablo Picasso to Gertrude Stein

"My dear Gertrude, I have just received your letter. We are in Avignon and we are thinking of staying for now," Picasso wrote. "Braque and Derain have gone to war. You must be in London better than Paris all the same maybe you would be better to stay a few days go before the mobilization we had been in Paris for a few hours the time to arrange my affairs a little."[2] Two weeks later, Eva Gouel added: "They say Guillaume enrolled. We heard from Braque, who is in Le Havre waiting to leave, we haven't heard anything from Derain, he left us his dog, Sentinelle. As for us, we are staying for now, because we don't know what will happen with all these sad things."[3] In the first weeks of the war, during the Battle of the Frontiers (August 14–24), France lost almost forty thousand men. On September 2, German troops came within thirty miles of the capital, forcing the French government to leave Paris for Bordeaux. During the Battle of the Marne (September 6–11), with the requisition of 630 Paris taxis to speed up the transportation of troops, the French and British armies managed to stop the Germans' progress. Picasso, as the

citizen of a neutral country, stayed in France with the women, the retirees, and the expats. Among his friends, Braque, Derain, and Léger were mobilized (as would soon happen to Apollinaire, a Polish subject of the Russian empire who volunteered to fight for France). As for Kramář, an Austro-Hungarian citizen, and Uhde, a German citizen, they fought against France, on the side of the Triple Entente.

"My dear Gertrude I am very happy to know that you are still in England," wrote Picasso on September 11. "We are thinking of staying here until the end of the war and we are not bad and even I work a little but I am very worried I think about Paris and my house and all my things." Eva Gouel added: "I would very much like to see you again and for the war to be over. Derain and Braque left long ago, and we have not heard from them in a few days. Derain is a cyclist in his regiment, which is in Lisieux in Normandy. Braque had to become a sublieutenant. Juan Gris is in Collioure and, without money, I don't know how he will manage. Matisse is in Paris he may be called."[4] On the back of a postcard, Picasso wrote: "A regiment left Avignon for the border. We are full of enthusiasm in France."[5] On September 27, the French government issued a decree, the first article of which read: "Because of the state of war and in the interests of national defense, all commerce with subjects of the German and Austro-Hungarian empires, or with people residing there, is and will remain forbidden." "My dear Gertrude, When do you think you return to Paris?" Picasso asked on Monday, October 6. "But don't rush too much. I don't know yet if I will be forced to go to Paris soon to pick up a check but I am waiting a letter and then I will know."[6]

On October 13, the *garde des sceaux* (the French equivalent of the attorney general) sent a formal memo to the country's prosecutors and judges: "I invite you to proceed with the seizure and sequestration of all merchandise, all money, and generally all assets of value belonging to German, Austrian, and Hungarian companies practicing trade, industry, or agriculture in France."[7] In this first wartime decree, the criterion of nationality is obviously crucial. The trade association of art merchants immediately began making in-

ventories of German and Austro-Hungarian companies. By the fall, the Kahnweiler gallery, transformed into a "company of enemy nationality," as well as its entire network, had become the archetype of the "Kraut gallery." As a pan-European, Daniel-Henry Kahnweiler refused to join the German army and—labeled a deserter—sought exile in Switzerland. "This war was the one event I hadn't planned for," he wrote to Derain. "I didn't want to believe in it until the very last minute. And, if not for the scheming of the Austro-German militarist clique, we could have avoided it."[8] Later, during one of his interviews with Francis Crémieux, Kahnweiler would add: "Obviously it was absolutely impossible that I should fight for Germany. I didn't think about it for a single minute. I wondered if I should return to France as a volunteer, and in the end I gave up on that idea too."[9] Despite his confusion in the early days of the war, Kahnweiler remained categorical: "Killing people I knew, deliberately, that disgusted me."[10] During this time, after the French victory at the Marne, the conflict stagnated into a war of attrition stretching from the North Sea to the Swiss border. Meanwhile, in the south of France, Picasso, anxious about Eva's health and her need to see a doctor, changed his plans. "My dear Gertrude, We think to leave next Tuesday at six in the evening and we hope to be in Paris the morning after around seven in the morning we will come to see you the same day," he wrote on Saturday, November 14. "I have already started rolling up my canvases and tidying my brushes and colors. And that's all."[11] On December 10, the French government returned to Paris, and the armies' positions grew more entrenched.

Let us measure the extent of the damage: on the one side, Kahnweiler, the foreign gallery owner and "enemy subject" who has lost all his belongings to the French State; on the other, Picasso, the foreign artist from a neutral country who rages against his dealer—whom, according to Gertrude Stein, he had always urged to become French—before starting legal action against him because of his recently sequestered artwork, and because of the money he was owed. How are we to understand Picasso's reactions faced with this catastrophic

situation? How are we to gauge the impact of those war years on his trajectory as a foreign artist in France, an artist who was now famous? We recall his years of struggle in 1903 and 1904, his tearful letters to "good old Max" before he moved to the Bateau-Lavoir and became settled in Paris. We remember his anxiety at being unable to join the Paris avant-garde before his departure for Gósol. And we have just seen how, returning to Paris in August 1906, his fearlessness restored, working on *Les Demoiselles d'Avignon*, then working in tandem with Braque, he began to earn money through his official dealer; we have seen how his innovations and the exponential increase in his income helped make him a leader of the avant-garde movement. But how are we to assess the exact number of his recent works that had now become inaccessible to him—all those papiers collés, those sculptures, those trompe-l'oeil paintings, including the most audacious of that glorious period? The total number of his sequestered works was close to 700. The art historian Vérane Tasseau calculated that there were, in all, 311 drawings, paintings, and sculptures, as well as 368 engravings, a screen, and a fresco (the 368 engravings were in fact prints, taken from 5 different engravings). How could Picasso not think about his vanished tondo *Souvenir du Havre*? About the five copies of *Absinthe Glass*, those multicolored bronzes, which had disappeared? *Man with Guitar, "Ma Jolie", Buffalo Bill, Woman with Mandolin* . . . All gone.

The exportation of cubist art organized by Kahnweiler from his gallery on Rue Vignon—with Roger Fry and Clive Bell in London; with Thannhauser in Munich; with Flechtheim in Berlin, Dusseldorf, Frankfurt, Cologne, and Vienna; with Stieglitz and, more recently, Bremmer in New York, not to mention Amsterdam, Budapest, Prague, and Moscow—was one of the most striking manifestations of what economists and political commentators today consider the first wave of globalization, which took place between 1870 and 1914.[12] "My business was always based on foreign relations," Kahnweiler would explain later. "I earned far more from exports than I did from sales within France."[13] This economic interdependence was opposed to the irrationality of war—a war rendered even less prob-

able by the financial importance of international networks. In his preface to the second French edition of *The Great Illusion*—a best-seller first published in 1910 and eventually translated into twenty-five languages—the British journalist Norman Angell wrote: "My goal is to prove not so much that war is impossible, but that it is useless; that the economic evolution of modern times has made it impossible to obtain any social or economic advantage by conquest [. . .]. Are not we right to hope that this [. . .] French thought and this intellectual ferment that one feels bubbling up today will play an important role in the political reconstitution of Europe, which must be the task of the twentieth century, and [. . .] that they will accomplish what the French weapons tried in vain to accomplish at the beginning of the nineteenth century, namely, the reestablishment of European unity?"[14]

In France, Angell's theories were taken up most vigorously by Jean Jaurès, an internationalist and pacifist and a founding member of the French section of the Second International. "This book tells the truth. And what does it say, gentlemen? [. . .] That the network of economic and financial interests obliges all peoples to spare one another, to avoid the great catastrophes of war," he stated in his speech of January 13, 1911, in the Chamber of Deputies.[15] Even on the day he was murdered, July 31, 1914, Jaurès was still exhorting his colleagues to avoid war: "The greatest danger at this moment is not, if I may say so, the events in themselves. [. . .] It is in the growing annoyance, the spreading nervousness, the sudden urges born of fear, the intense uncertainty, the prolonged anxiety. [. . .] What matters most of all is the continuity of action, the perpetual awakening of working people's thoughts and consciences. This is the true safeguard. This is the guarantee of the future," he wrote in a leader for his newspaper *L'Humanité*. But the declaration of war, which brought Norman Angell's warnings and Jean Jaurès's exhortations to a sudden end, also signaled the failure of that first wave of globalization and made Kahnweiler one of the first expiatory victims of those events.

"The foreigner is fixed inside a particular spatial group, but his

position inside this group is determined by the fact that he has not belonged to this group from the start," noted the sociologist Georg Simmel in 1908,[16] perfectly describing the squaring of the circle in which the German art dealer was trapped. "Throughout economic history, the foreigner appears everywhere as the trader, and the trader as the foreigner. As long as an economy is self-sufficient [. . .] it has no need of traders, but to find openings outside of the zone of production, the trader must be a foreigner."[17] This passage offers a different perspective on the singular territory to which the gallery owner belonged, in a position that was increasingly uncomfortable and increasingly tragic after his search for the "salvation from the French utopia" in order to escape the infernal dilemma to which German Jews were prey. Kahnweiler was informed of the confiscation of his apartment and gallery as "enemy assets" on December 1, 1914, forcing him once again to find a new place to live and work.

It was on that very same day that André Level sent Picasso the first letter since war had been declared. It was a sober, precise, matter-of-fact letter, which testified to the urgency of the situation: "My dear friend, I went to the police station and was sent by them to the prosecutor's office. It was not until today that I was able to go to the courthouse. The trustee has not yet been named. Consequently we cannot go to see him, and our only remaining option is to talk to the solicitor. I will be at Mr. Danet's office at 85 Rue de Richelieu a little before 10 o'clock tomorrow morning. Try to meet me there, and bring your contract. You will be sure to find me. Best regards, A. Level."[18] What does this tell us? That Picasso, distressed by the sequestration of his works and the money owed to him by his dealer, dialed "Gutenberg 21-39" the way you might dial 911. In a period of generalized chaos, the artist shrewdly adopted this bourgeois Frenchman as his legal and financial advisor, and also as his bureaucratic shield—functions that Level, and then his nephews, Max and Raoul Pellequer, would carry out on Picasso's behalf until the artist's death (as the 798 letters kept in the archives of the Musée Picasso will attest). Level strove to find out whether the trustee was

employed by the police or by the Ministry of Justice, deploying his contacts, navigating the labyrinth of French bureaucracy with assurance, elegance, and efficiency, calming the artist's anxieties, even playing the role of messenger boy between Picasso and Apollinaire, Picasso and Max Jacob, Picasso and Juan Gris, Picasso and Braque, all these friends who were now estranged from him. "Picasso is the greatest modern artist, we all know it, but how far back in time does his superiority go?" he wrote to Guillaume Apollinaire at the front, on Christmas Eve, 1914.[19] "One of my friends claims that when we talk about our art the way we talk about the Egyptians' art, looking back at a span of several dynasties, we will say Giotto and Picasso, without mentioning anyone else in between."[20] A little later, it was Level who, in a terse message, would inform Picasso of the contents of Apollinaire's postcard: "Wounded in the head yesterday, shrapnel got through helmet, I hope it will be okay, the shrapnel is quite deeply embedded and it's possible they'll leave it there. Current address: sublieutenant de Kostrowitsky, Ambulance 1/55, sector 34."[21]

Having spent a few weeks reading and rereading the correspondence from those years, and examining the artworks, I am trying to look cautiously at this through Picasso's eyes. So many snap judgments have already been made about Picasso's evolution after the summer of 1914: critics have spoken of betrayal, renunciation, regression; they have described the avant-garde artist disappearing and being replaced by a classicist under the influence of Ingres, a "return to order." Today, with the benefit of historical hindsight, with our geopolitical tools and problems, we tend to formulate the questions in a different way. How did Picasso react to the catastrophe? How did he reinvent his space? How, in these new circumstances, did he choose to reconstitute his sphere of belonging? If he seems to emerge, phoenix-like, to begin his "third Parisian life," how are we to understand this development? "Picasso hangs out with the Avignon elite," Braque had written on July 15.[22] "I found Gris painting patriotic pictures," he would note later. "As for Picasso, he is creating a new genre à la Ingres [. . .]. What is constant in any artist is his

temperament. For me, Picasso remains what he always was: an incredibly talented virtuoso."[23]

The few works that Picasso produced during the first months of the war show his distress. *The Painter and His Model* is particularly intriguing, a small canvas that remained invisible, hidden away in the artist's private spaces until his death. It is a work in progress, a painting deliberately stopped before completion, a painting that seems as if it is being composed before our eyes. Picasso prepares his canvas. He draws, in black pencil: to the left, a doorframe, then a Cézanne-like painter, pensive, mustachioed, sitting crookedly on a rustic chair, leaning on one elbow, looking older, his hands heavy, staring absently at the ground; to the right, a rustic, thick-legged wooden table covered with a cloth and a basket of fruit. In the center, Picasso paints the model, a young, dark-haired woman, present and available, her pretty little face made up, holding a cloth around her thighs; behind her, on an easel, a landscape painting, and a blue wall with the palette hanging from it. An apparition in the artist's dream? An artist disconnected from his model? Two temporalities merged together? An irredeemably broken world? However you interpret it, *The Painter and His Model* is a cryptic work and one you should keep in mind while reading the next few pages. But there is more: why all those French flags, all those messages of *"Vive la France"* that Picasso added to most of his letters and drawings during these months, and that surprised many of his correspondents, not least his mother? "I received your very patriotic postcard," she wrote, "and I am happy to see your hopefulness and the hopefulness of everyone. May God let it be like that, but for now there is no end in sight for this catastrophe, because this backward step is ruining many families."[24]

If the declaration of war signaled the sudden collapse of his professional world—the end of so many friendships with other artists; no more art dealer, no more collectors, no more critics, no more income—it is hardly surprising that Picasso withdrew into his own private world, writing more regularly to his mother. She in turn sent him alarming letters from Barcelona, where hundreds of people had

been dying of typhus since 1911, and every month he would send her a check for 200, 300, or even 500 francs. "I have a terrible fear of airplanes because sometimes they can drop a bomb there where you least expect it," wrote his mother. "I pray to God with all my soul that this war spares you all misfortune. Here, we hear all sorts of rumors, true or false, but they scare us. What I am asking is that you do not get mixed up in anything, because, since Spain is neutral, a Spaniard cannot get involved, even if in Paris they are talking about Spain ending its neutrality and fighting on the same side as the French."[25] In Barcelona, María Picasso y Lopez prayed constantly for her son, particularly in a letter written on New Year's Day, 1915: "Dear Pablo, today is the first day of the new year, may God let it be better than the one that just ended, not a day passes without me asking God to give you good health and let you have whatever you want, today I imagine that I will ask Him for the whole year, two nights ago I didn't sleep much and in my slumber I wondered if you will be happy or if it will cause you problems not to have the money that you sent me."[26]

Despite his mother's prayers, however, 1915 became one of the darkest years of Picasso's life. His own letters show this, as do Eva's: "My dear Gertrude, Eva had her operation yesterday morning when I was at the clinic she was fine" (Picasso to Gertrude Stein in January);[27] "Eva has been in a hospital almost a month. She had an operation and I was very worried and I didn't have a single moment to write you" (Picasso to Apollinaire in February); "Greetings to you, my old brother";[28] "I am not in very good health, but I am happy, my Pablo loves me and tells me so [. . .]. He is [. . .] much less annoyed, but I understand now that he is also very annoyed with business and this terrible war" (Eva to Joséphine Haviland, July 12);[29] "I am much worse [. . .]. I often despair of getting better. Pablo tells me off when I tell him I don't think I will ever see 1916" (Eva to Joséphine Haviland, October 25);[30] "My life is hell. Eva was always sick and now she's been in a hospital for a month. This is the end. My life is not very happy and I hardly work at all anymore I run to the hospital and spend half my time on the metropolitain" (Picasso to Gertrude

Stein, December 9);[31] "My poor Eva died in the first days of December. It was very painful for me and I know you will miss her she was always so good for me" (Picasso to Gertrude Stein, January 8, 1916).[32]

For Picasso, as for all foreigners, French bureaucracy remained an impenetrable mystery. Level did his best to demystify it for him. It was Level who would meet in person with all the men he described ironically as "those little guardians of French order": the solicitor, the trustee, the tax collector, the administrative assistant, the police chief; he would knock them down one after another while telling the artist all about their quirks and idiosyncrasies. The correspondence between Picasso and Level is a veritable gold mine. It enables us to gauge just how anxious the artist was about his vanished works. It also enables us to discover that ironic cortege of new characters (Zapp, Danet, and Nicolle) who were now in charge of Picasso's cubist works and whose existence he would have to get used to. "My dear friend," wrote Level on December 11, "I went to see the solicitor this morning and told his assistant about your remaining anxieties. We think that once the trustee has been named and we have been able to confer with him, it will be possible to arrange a meeting or, better still, to obtain a ruling—different in form to the way we imagined it originally—that will give you satisfaction and remove all your worries. However, it would not be surprising if the nomination of the trustee takes ten days or so, given the volume of similar cases. With most friendly wishes, A. Level."[33]

A shrewd advisor, a protective shield, an unconditional champion in his battles with French bureaucracy: such were the functions that Level fulfilled for Picasso during the war years, after Kahnweiler's exit from the stage. The artist's talent, his repeated worries, the gifts that he would lavish on Level during that period . . . do they explain the absolute devotion that this bourgeois Frenchman showed to Picasso's cause? Because all of it went away, the financial problems, the bureaucratic and legal difficulties. Level took care of the 20,000-franc debt that Kahnweiler owed Picasso; he took care of the contract

that had been signed between the two of them on December 18, 1912; he took care of the works that had been sequestered from the dealer's storeroom; he even, somewhat paternally, took care of Picasso's taxes! "Dear friend, Here is the letter to the tax collector that I would like you to sign and to send by registered mail. Please pin the receipt from the post office to the legal notice that I am returning to you and keep it in your little folder. I have kept a double of the letter to the tax collector. I am curious to read his reply, assuming he doesn't just pocket the stamp I sent to encourage him to write back. Mail it tomorrow. I must go. Until soon, AL."[34] In another letter, Level informs the artist that the trustee "has begun the inventory [. . .] found the works at Kahnweiler's gallery and [. . .] the list of creditors so that he can work out how much money he can expect to recover,"[35] while also taking an ironic swipe at French bureaucracy in yet another letter: "Avignon deserves better than these bureaucrats. In the Middle Ages, when you would have been the pope's favorite artist, the tax collector unwise enough to ask you to pay taxes you actually owed would have been thrown into a bottomless pit, never mind this man who is asking you to pay taxes you don't owe. If we don't get the reply we want, we'll yell at him and threaten to bring in a deputy or an ambassador."[36]

Meanwhile, Germanophobia was spreading quickly through the art world. On July 6, 1915, a professor from the Académie des Beaux-Arts in Lyon, Tony Tollet, gave a pompous speech at an official meeting of the Académie des Sciences, Belles-Lettres et Arts, the title of which—"The influence of the Jewish-German trade association of art dealers in Paris on French art"—gave his listeners a good idea of what was to come. He outlined a mind-boggling vision of the world, presenting the prewar period as being infiltrated by the "enemies" of France "in all orders of ideas." But who were these enemies of France? They were, of course, "Jews, art dealers" who, extorting fortunes for their clients through dubious means, were, he said, "playing their role." But "if, on top of that, [I inform you that] they are also German," Tollet added, "you will understand the methodical war

that they waged on French culture, the influence that they tried and often succeeded in exercising over French taste." He went on, venomously reviling these "enemies of France" who, "were it not for their pride and impatience, would probably have had us at their mercy, so implacably and methodically did they proceed."[37]

So who was this Tony Tollet? Some lone madman? An extremist? Not at all: he had been a student at Alexandre Cabanel's studio before becoming a professor, then chairman of the municipal art classes in Lyon, earning a living as the official portraitist to Lyon's leading bourgeois families. He was a respected man, in other words, even an eminent man. When it came to defining art, his speech descended into platitudes: "What is art? The search for beauty. [. . .] What is beauty? What I love." Or: "Art is not only the sensation of infinite Beauty, but the expression of this Beauty through a shape, a color, a sound, a verb."

Who was Tollet targeting when he deplored "the enormous importance given to impressionists, cubists, futurists, almost all of them presented by art dealers"? To what was he alluding when he remarked regretfully that these art dealers had "violently criticized [our] École and [our] teachers, [our] traditions and the elevation of [our] ideas"? What was he so afraid of when he wondered "what acquisitions will be made by our museums, in that exhibition where a part of that Jewish-German corporation of Parisian art dealers has found a foothold"? And how are we to evaluate his optimistic conclusion when he says he is "convinced that, if all honest French people, who have the atavism of good taste, gave their opinions simply, frankly, freely, without worrying about the opinions of others, without being cowed by ignorant snobs or audacious experts, we would soon set things straight, and art would become French again, to the great benefit of France"? But let us leave Tony Tollet to his nationalist ravings and return to the innovations of cubism, the fruit of hybridizations in this cosmopolitan world, nurtured by the understanding of Kramář (educated in Vienna), Kahnweiler (educated in Stuttgart), Leo Stein and his sister (educated at Harvard and in museums the world over),

Alfred Stieglitz, Carl Einstein, and Max Raphael (all three of them educated at the University of Berlin). Let us return, lastly, to this line from Jean Jaurès's prophetic speech to French deputies in 1911: "The interests of all peoples are so entangled that a disaster for one is a disaster for all."[38]

30.

TOWARD A NEW TRANSNATIONALISM

All artistic life during the war is artificial [. . .] and can only be harmful [. . .] to the genuine artistic life that will begin after the war when all the soldiers will return to their places in civilian life [. . .]. There are many foreigners, too many foreigners [. . .]. I feel this so strongly that [. . .] I do not want to be seen at these vernissages and soirées and that I have completely abandoned the artistic milieus of Montparnasse.[1]

—Juan Gris to Léonce Rosenberg

Over the course of the next quarter-century, Picasso's trajectory within French society was defined by new oppositional pairs that became particularly salient with the declaration of war: France/Germany, French/foreign, victorious/defeated, military/civilian, patriot/pen-pusher, honest Frenchman/sneaky Kraut, soldier/profiteer, etc. It was a period of grand strategic maneuvers during which the country united around the idea of the nation, the concept of an "*union sacrée*" ("sacred union"), followed by another right-wing national bloc known as the "*chambre bleu horizon*" ("sky-blue chamber," named for the color of the uniforms worn by French soldiers). On February 25, 1916, the League for Perpetuating the Memory of German Crimes Throughout the Ages, bringing together members of the Académie des Beaux-Arts and other notables (including the sculptor Auguste Rodin), sent the following memo to its members: "We must ensure

that, when the war is over, the pernicious dream of international pacifism is not allowed to reestablish relations between Latin civilization and the partisans of 'Kultur'! Remember the river of blood that separates us, and never forget it! [. . .] If there is one area where the SACRED UNION will endure, it is here."[2]

For Picasso, the primary effect of the war years was to atomize the networks he had patiently constructed since first moving permanently to Paris in 1904. The artist suffered a series of disintegrations on multiple levels. At a national level, his personal and professional relationships were badly damaged—Braque, Derain, Léger, and soon Apollinaire went off to fight; Gertrude Stein and Kahnweiler sought exile in England and Switzerland, respectively—while his position as a foreign noncombatant and leader of the artistic avant-garde made him a target for French nationalist firebrands, who were always eager to depict him as a "pen-pusher" and a "traitor" responsible, with "Kubism," for France's moral and aesthetic decline. At a transnational level, the connections he'd established before the war with art dealers, collectors, and theorists were seriously jeopardized by the return of a nationalist agenda. Kramář, an Austro-Hungarian citizen, and Uhde, a German citizen, joined the troops of the Triple Entente. The cubist international fell to pieces and the ground gave way beneath Picasso's feet. Even on the most intimate level, the artist's world was swept away during the war, with Eva Gouel dying of cancer in December 1915.

He bounced back very quickly, however, and began to create a new network, which would prove essential to the next stage of his artistic career. Though rendered vulnerable and disoriented by the collapse of the world he knew, Picasso actively started forging new connections in order to survive this troubled period. To protect him from the rising xenophobia, he had André Level, whose role we have already described: Level strove to preserve, as much as possible, Picasso's social position in a country where his artistic status and reputation were suddenly under threat. Faced with the demonization of cubism and the disintegration of the avant-garde, in 1915 Picasso

chose another world—the world of Jean Cocteau, a twenty-five-year-old poet from a well-connected bourgeois Parisian family (his father a lawyer and amateur artist, his paternal grandfather a notary and mayor of Melun, his maternal grandfather a foreign-exchange broker and art collector, his maternal uncle a diplomat) who had grown up in a right-wing milieu where nationalist ideas were widespread. On November 28, 1914, only three months into the war, Cocteau collaborated with the decorative designer Paul Iribe to create the magazine *Le Mot*, intended to offer a "cultural response" to the national crisis. While this publication considered itself the voice of moderation amid the more gung-ho nationalist outpourings of the time (Cocteau and Iribe's stance was, essentially: yes, we should boycott German products, but that doesn't mean we have to stop listening to music by German composers), its position regarding the artistic avant-garde was ambivalent at best. The magazine took up the paradoxical right-wing position that had become a sort of orthodoxy by 1914: before the war, France had been decadent and divided, in a state of ideological civil war, and the war against Germany was a conflict against the nation responsible for France's moral and aesthetic decline.

Pursuing this logic, the magazine had a different view of the mobilization: 1914 was the date of the liberation of France because the war saved it from its division and decadence by enabling its people to unite again around virtuous values, far from the frivolity and insanity of its prewar art. In fact, the magazine had been founded, according to Cocteau and Iribe, to celebrate this liberation.[3] The magazine's artistic tastes were, however, more eclectic and less patriotic than its ideological stance, and its pages featured composers such as Igor Stravinsky and Maurice Ravel, artists such as Albert Gleizes and Pierre Bonnard, poets such as Anna de Noailles and Paul Claudel. Even cubism could be praised, despite its demonization during the war years, but only certain periods—*Le Mot* preferred the cubism of the artist Roger de La Fresnaye, who used its language for patriotic ends by separating formal subversion from ideological subversion. Picasso, whose iconoclasm had always openly mocked bourgeois

and nationalist values, was not mentioned in the magazine. In fact, on January 23, 1915, the seventh edition of the magazine *Le Mot* stated baldly: "There is no single *métèque**** who can appreciate this publication."[4]

How can we reconcile Cocteau's political positions with his new-found friendship with Picasso, whom he bombarded with a gushing, one-way stream of letters beginning in the spring of 1915, before composing poems in his honor? "Be happy. Shake my hand. I love and admire you with all my heart," he wrote on September 25, 1915, sometimes addressing Picasso with terms like "Dear Magnificent," "Dear Lord," "Dear Wonderful," or "Beloved Maestro," while the artist stuck to more conventional greetings like "My dear Jean" or "My dear Cocteau." The answer is simple: despite his nationalist opinions, this ambitious young writer was attempting to penetrate the artistic communities of the Left because they fascinated him and had done since before the war, when their aura had been so power-ful, so ambiguously alluring. More than anyone else, Picasso had the power to attract Cocteau far from his fin-de-siècle tastes and anchor him in the avant-garde and modernity. Like Gertrude Stein, Cocteau even dreamed of himself as Picasso's literary twin: "none / better than you Pablo anatomy / none better than me alexandrine / arithmetic."[5]

When he was demobilized in April 1916, Cocteau wrote *Parade*, the scenario for a new artistic project intended for Serge Diaghi-lev (founder of the Ballets Russes, with whom he had worked since 1912), a total work of art that would mix painting, music, and also modern dance, with a very simple theme: outside a street theater on a Parisian boulevard, a group of circus artists (an acrobat, a Chinese magician, and an American girl) perform excerpts from their acts to encourage passersby to enter the theater. After choosing Erik Satie

* Here, "*métèque*" is being used as a xenophobic slur, comparable to "dago" in English. During one of the most xenophobic periods in French history (1914 to 1944), under the banner of fascist or extreme right-wing groups, reactionaries would refer to foreigners as "*métèques*."

to compose the music, Cocteau suggested to Diaghilev that he hire Picasso to create the sets and costumes. Though hesitant at first, Picasso ultimately accepted. "Picasso is doing *Parade* with us," Cocteau announced triumphantly in a postcard to Satie on August 24, 1916.[6] Thus began Picasso's collaboration with the Ballets Russes, which would continue beyond *Parade* with *The Three-Cornered Hat* in 1919 and *Pulcinella* in 1920.

Later, the poet would emphasize just how revolutionary Picasso's participation in *Parade* had been, in terms of the avant-garde: "[Picasso's] entourage didn't want to believe that he would follow me. There was a sort of dictatorship in Montmartre and Montparnasse. Cubism was going through its austere phase. The only pleasures allowed were a few objects standing on a coffee table and a Spanish guitar. Painting sets, particularly for the Ballets Russes [. . .], was a crime. Mr. Renan never scandalized the Sorbonne more than Picasso did the Café de la Rotonde when he accepted my offer."[7] In a letter dated January 11, 1917, Picasso set out the terms of the contract he would sign with Diaghilev: "Dear Mr. Diaghilev, Confirming our verbal accord, I agree to take charge of the mise en scène (sets, curtains, costumes and accessories) for the ballet *Parade* by Jean Cocteau and Erik Satie. I will take care of all the necessary drawings and models and will personally supervise all the manufacturing work. All those drawings will be ready by March 15, 1917. For this work, you will have to pay me the sum of 5,000 francs plus an extra 1,000 francs for my journey to Rome. My drawings and the models will remain my property. Half of the aforementioned sum must be paid upon delivery of the drawings and models, and the other half on the day of the premiere."[8] As with the contract he signed with Kahnweiler in 1912, Picasso here sets his own terms. Despite his difficult situation, despite still being traumatized by the effects of the war on his networks and status, the artist insists upon maintaining control of his own work. As with the Kahnweiler contract, this legally perfect letter appears to have been written with the aid of a friend—probably André Level.

On February 17, 1917, Cocteau and Picasso left Paris for Rome in order to prepare *Parade*, a trip the poet described as "like an engagement."[9] "How happy I am," he wrote, "to be creating on these splendid ruins, with the artist I admire most in all the world, and with such a young troupe. Long live Corot! They should have buried him in Raphael's tomb. He directs our gaze. Rome seems made for him. Picasso talks only of this master who moves us more than the grandiose Italians. [. . .] Picasso is working in a magnificent studio behind the Villa Medici. We take him eggs and local cheese [because] he refuses to leave when painting possesses him."[10] In Rome, Picasso recommenced his dialogues with antiquity, a new and deep source of inspiration: antique art (discovering the ruins of Rome, Pompeii, and Herculaneum), popular Italian art (the commedia dell'arte, the character of the Harlequin, and traditional costumes that were fashionable at the time in Rome),[11] as well as nineteenth-century French painting (Corot and Ingres) that openly acknowledged its debt to antique art. His works from that time bear the traces of multiple influences but also the honing of his cubist experiments. For *Parade*, the sets and costumes evoked a deliberately dissonant, exploded aesthetic. During that trip, Picasso became part of a new network, with Cocteau and the Ballets Russes troupe—in particular, the choreographer Léonide Massine and the composer Igor Stravinsky. He even fell in love with a ballerina named Olga Khokhlova, whom he married a few months later, on July 12, 1918. The wedding took place at the Russian Orthodox Alexander Nevsky Cathedral, in Paris, with Cocteau, Apollinaire, and Max Jacob as witnesses—this happy occasion bringing together old and new friends.

Although not especially subversive before the war, the Ballets Russes sparked a controversy in Paris when the artists returned. On May 10, 1917, at the opening of the Paris season, Diaghilev walked across the stage of the chatelet waving a red flag in celebration of the revolution that had just brought down the czar in Russia. This gesture scandalized the French patriots who were enraged by the Russian withdrawal from the conflict, a decision made by the new Bolshevik

government. The following week's premiere of *Parade* was highly anticipated—it had sold out two weeks before—but it caused a huge furor. The first wave of applause was followed by a sequence of disjointed noises (sirens, dynamos, typewriters), and the audience began to jeer and whistle. At the appearance of the managers—those figures in cubist costumes, each about seven feet tall—the theater was in an uproar. "Go to Berlin!" people yelled. "Goddamn *métèques!*" "Opium smokers!" "Cowards!" Perceived as a provocative, absurdist ballet, whose playfulness was an insult in a time of war, *Parade* was booed. At last, Apollinaire, his head bandaged after his war injury, went on stage and managed to calm down the audience by testifying to the patriotism of the artistic team. Diaghilev "listened, white-faced, to the furious public. He was frightened," wrote Cocteau, "and he was right to be. Picasso, Satie, and I couldn't reach the backstage area. The crowd recognized us, threatened us. If it hadn't been for Apollinaire, for his uniform and that bandage around his head, [the] women [in the audience] would have stuck pins in our eyes."[12]

Despite all the setbacks he had suffered, Picasso achieved something extraordinary: he replaced the international success of avant-garde art with the international success of the Ballets Russes, a troupe that had been highly fashionable in bourgeois Parisian circles since 1909. Faced with a resurgence of nations, borders, and accusations of treason leveled against anyone who blurred the lines of national purity, Picasso sought—through the antique art that he researched in Rome—to situate himself in an ancient, global lineage. Greco-Roman antiquity, which could be seen as the first manifestation of globalization (the Roman Empire at its zenith stretched from England down to Syria, from Germany to Carthage), could also be seen as an antidote to the fiercely defended borders of nationalism. In this way, Picasso managed to reinvent himself as part of a transnational European geography (i.e., the Ballets Russes) and as part of a global history (i.e., Greco-Roman antiquity). Courtesy of this dual strategy, horizontal and vertical, Picasso was able to emerge from the isolation that had beset him since 1914. At a time when Maurice

Barrès, the champion of French nationalism, was stoking his obses-
sion with "rooting individuals in the earth and among the dead,"[13]
Picasso decided to choose travel (across Europe and back in time to
the Roman era) over roots, global history over national history. And
yet, for all Picasso's political intelligence, the decree of April 2, 1917,
which instituted the creation of an identity card for the use of foreign-
ers, changed his status in France. "Any foreigner residing in France
for more than two weeks and aged more than fifteen years must,
within forty-eight hours of arriving in the first locality where he will
reside, request an identity card from the relevant police authority,"
the decree read. Like all the others, Picasso "would receive a receipt
for his request, which would serve him for safe conduct while the per-
manent document was created. The card must be worn permanently
on one's person, so that one can prove one's identity at any moment.
Article 3 of the decree specifies that the card is mandatory."[14]

31.

ART DEALERS IN WARTIME: BETWEEN PATRIOTISM, PERFIDY, AND DENUNCIATION

A Kraut art dealer? Ugh, how horrible! Surely you know that only French art, from France, is sold abroad! I can't see Picasso being published in Berlin or Frankfurt! The Picassos would reach us with a vague stench of sausages or sauerkraut![1]

—Léonce Rosenberg to Picasso

The sequestration of artworks and the nationalist hysteria gave certain Parisian art dealers the opportunity to rise up against Kahnweiler. Léonce Rosenberg was the first to poke his head over the barricades. Born in Paris in 1906, he was twenty-seven years old, the eldest son of a grain merchant born in Bratislava who had then opened an antique store on Avenue de l'Opéra in 1872. Léonce Rosenberg bought a small Picasso painting on Rue Laffitte, from Clovis Sagot's—"a bric-a-brac dealer who also sold a few paintings"[2]—then acquired another seven from Kahnweiler's gallery. Kahnweiler even took Rosenberg to visit the artist in his studio one day in June 1914. And yet Rosenberg did not honor his debts to the dealer: in 1914, he still owed him 15,000 francs (in other words, 75 percent of Kahnweiler's debt to Picasso). Once war had been declared, the man now calling

himself Léonce Alexandre-Rosenberg tried to win Picasso over with flattering letters. On October 30, 1914, he wrote: "Dear Sir, I possess fifteen works by you, all from the latest period, which sometimes help me to forget the horrors of the moment. Art is a religion that elevates the soul above human contingencies and consoles it amid all misfortunes [. . .]. Have you begun the new procedure to which you felt yourself inclined—that of the foreign bodies—and which you told me about when I had the pleasure of visiting you with Mr. Kahnweiler last June?"[3]

Apparently, Picasso yielded to Rosenberg's discreet request, including him in a visit to Gertrude Stein that he organized for André Level just before Christmas 1914. Rosenberg was suitably grateful: "Thank you again, dear Mr. Picasso, for the great joy you gave me by taking me with you to see Miss Stein. I am still moved [by that visit] and eager to see old works by you. I wish I could see again the new view of Avignon that you painted this year; you were kind enough to show it to me when I came for the first time since your return; do you still have it? [. . .] Your profound and sincere admirer, L A-R."[4] And so the wheel turned: exit Kahnweiler (the German art dealer) and enter Léonce Rosenberg (the French collector).

In his attempts to become Picasso's dealer (revived by his soldier's patriotism), Léonce Rosenberg framed all his arguments with an anti-German slant. It was part of the Zeitgeist, of course, but there can be little doubt that he had Kahnweiler in his sights. "Yesterday I saw the Triennale, alas, although perhaps it is a good thing. It will prompt disgust more quickly than otherwise might have been expected! That is Kraut art!" he wrote on March 2, 1916, in a letter to the artist. "All the philistines are Krauts! Apart from Matisse and one painting by Degas, there is nothing worth seeing! If I don't hear from you at Rue Lavoisier, that will mean that you are in the 'boteglia di maestro Picasso,' the one that will be visited by all the princes of art, the way Giotto and Titian's studios were visited!"[5] Four days later, he suggested patriotically: "Dear friend, there are two courses of action open to you: 1) stay independent, and this will become merely a

question of means, diplomacy, and relationships. If this strength lies in you, I cannot question it. But experience has taught me that artists who attempt to double up as businessmen lose something in their art as well as their authority [. . .]. Durand-Ruel? Bernheim? Vollard? Who else? A Kraut art dealer? Ugh, how horrible! Surely you know that only French art, from France, is sold abroad! I can't see Picasso being published in Berlin or Frankfurt! The Picassos would reach us with a vague stench of sausages or sauerkraut! [. . .] So, think about this and draw your own conclusions! Very cordially yours, Léonce Rosenberg."[6]

From the summer of 1918, Léonce's younger brother Paul Rosenberg entered the scene, too, and the siblings teamed up in their attempts to conquer Castle Picasso, with a single ambition and two opposed strategies: the aesthetic, obstinately cubist strategy (with military metaphors) pursued by Léonce, and Paul's more pragmatic, financial strategy. "Dear Friend, I am about to begin an energetic and large-scale operation throughout Europe and America, and it would be ridiculous to let myself be distracted from my work by . . . childish nonsense," wrote Léonce Rosenberg on March 24, 1916. "With me, moreover, as you have surely noticed, the straight line is always the shortest way; the curved lines and all their little affectations, well, I forgot all that twenty years ago! The reason I am pushing for a decisive agreement is not because I fear defection—if someone doesn't want to work with me, that's their loss—but because, like a good housekeeper, I desire to know how many people will be eating dinner with us, so I can get organized! Until soon, dear friend, and very cordially yours, Léonce Rosenberg."[7] Three years later, it was the turn of his brother Paul—who became Picasso's dealer in the summer of 1918—to deploy patriotism by ostracizing Germany: "My dear Casso [. . .] business is quiet, I can't find anything to buy [. . .]. I am going to occupied Kraut-land, but what courage I will need to do that. I am sure you know, illustrious as you are, how difficult it is to procure information and how, the more information you gather, the less informed you are. So, I am going to leave next week,

and if I don't find any paintings, I will at least bring back some eau de cologne, so that's something we'll get from the 200 million they owe us."[8] Then Paul Rosenberg expanded his strategy to an international level: "Dear Picasso [. . .] I won't hide from you the fact that I need a large quantity of paintings for this winter. I am organizing an exhibition of cubist and non-cubist works by Picasso in America's big official museum. Think of the impact it will have, in the Old World and the New. In one of the biggest cities in America, and in one of the country's best museums, next to Verrocchio, Pollaiuolo, and great masterpieces from the past. Picasso, returning to America in glory, through the most beautiful window (made by Picasso), and don't think that this is a desire, it's all arranged, agreed, decreed [. . .]. So, shower me with an abundance of paintings! I'd like to order 100, to be delivered by the fall! [. . .] My dear Picasso, I am most devotedly yours, Paul Rosenberg."[9]

Picasso skillfully played on the rivalry between the two brothers, sometimes abusing his power to the extent that he once planned an exhibition with each of them less than four months apart: in October 1919, on Rue La Boétie, Paul presented an exhibition of sixty-nine drawings and watercolors by a "Picasso returned to classicism," four months after Léonce had put on an exclusively cubist show at his gallery, L'Effort Moderne, located at 19 Rue de La Baume, only a three-minute walk from his brother's place. But these complex moves on Picasso's chessboard, including feints, flattery, and double dealing, would grow even subtler a few years later, as we will see, when many of the Picasso works sequestered from Kahnweiler went on sale. At that moment, Léonce, who had succeeded in being appointed the auction's "expert,"[10] also became—as part of a strategy worthy of Clausewitz—the second most prolific buyer during the first auction, all while reassuring his "dear and glorious friend" Picasso: "Don't worry about the Uhde and Kahnweiller [sic] sales. Your good things will sell very well, and the less important works in a satisfactory way."[11]

But the most saddening document I found is the letter that Léonce

Rosenberg wrote to Jean Zapp, "registration inspector, trustee, and liquidator," which is transcribed here in its entirety. It is dated April 25, 1921, just after Kahnweiler—who had spent the war in Berne with his friend Rupf, where he wrote *Der Weg zum Kubismus*—had returned to Paris:

> Monsieur the Inspector, I believe it will be useful to keep you
> up-to-date with the latest machinations of Mr. K. who, like his
> friendly compatriots, refuses to accept defeat, is outraged in fact,
> with unbelievable impertinence, because the French State has dared
> decide to sell his stock, and is prepared to do anything to prevent
> this happening. Attached you will find a cutting from the periodical
> *Aux Écoutes*, which will enlighten you regarding his little schemes.
> Mr. K., who lived in Paris from 1905 until 1914, at 28 Rue Vignon,
> made it his specialty to sell works by Georges Braque, André
> Derain, Pablo Picasso, Maurice de Vlaminck, Fernand Léger, and
> Juan Gris, artists with whom he had exclusive contracts. You will
> find those contracts in his sequestered archives.
>
> When war was declared, K. courageously headed for Italy,
> not wanting to risk his life either for his homeland or for the country
> where he'd enjoyed such fruitful hospitality; [instead] he waited,
> without risk, for the war to end [. . .] all the while preparing [. . .]
> the plan for his return to France after the armistice [. . .] and K.'s
> former gallery reopened its doors, [this time] at 29 *bis* Rue d'Astorg
> under the name GALERIE SIMON, with K. as its authorized signatory!
> Next, K. wrote to all the aforementioned artists and offered them
> contracts with better terms than those offered by French dealers,
> while luring them with the idea that Germany was highly favorable
> to their art and ready to cover them with gold [. . .]. The artists,
> unfortunately resembling many other artists in this respect [. . .],
> agreed to sign up with this returned Ulysses. K. also told them
> that their agreement would enable him to obtain the restitution of
> his former stock, and that the sale of this stock would permanently
> damage the market [for their work], whereas if the works were

restored to him, it would, he claimed, give him the power and importance of a major dealer capable of supporting them and making them rich. He did such a good job of scaring them that the French artists Léger, Braque, Derain, Vlaminck resolved to convince the public authorities, by vaunting their supposed qualities as combatants, to restore K.'s stock to him. So, there are two possibilities: either the paintings in K.'s stock are bad, in which case you should sell them as soon as possible before they go out of fashion, so that the State gets at least some money; or they are good (something that the persistence of K. and his associates in this matter tends to prove), in which case I can assure you that good paintings never sell for less than they are worth [. . .]. As I have had the honor of informing you, the two pillars of the K. sale are Picasso and Derain, whose works—three hundred paintings in all in K.'s stock—are today worth fifteen to twenty times what they were worth in 1914. This sharp appreciation is a guarantee for the final result of the sale.

If K. is so fond of his stock, what is there to prevent him from buying it at auction? He would certainly be among the bidders: what bothers him is having to pay their current value for them, rather than their 1914 value.

To return to his scheming, I can tell you that having failed with the public authorities, he plans on stirring up public opinion. Unfortunately for him, the only people he's found willing to support his argument are pamphleteering publications like *Aux Écoutes*, and the article from that magazine is easy enough to refute.

If, for example, K. had failed financially and been declared bankrupt, wouldn't his creditors have the right to demand the public sale of his stock in order to have their debts paid, irrespective of a few articles?

Can the State allow the principle that the producer intercedes in the sale of his production, whose rights he legally ceded to a third party? Even if, in the present case, he was mobilized, like so many millions of Frenchmen, myself included, can the State favor the

schemes of a German ostracized by all French trade, even if that
German is manipulating certain French investors to act in his favor?
If so, then any bankrupt shopkeeper can simply buy in order to
prevent his stock being sold.

While K. has never borne arms against France, and while he was
(to his supposed glory) a German deserter, that was obviously out
of self-interest and cowardice and it should not make him any more
sympathetic to us. It would have been better if *Aux Écoutes* could
have described how K., out of gratitude toward France, where he
had enjoyed such cordial and fruitful hospitality, had, to prove his
attachment to this country, joined the Foreign Legion, as did a few
Germans and Austrians who lived and worked in France.

Monsieur the Inspector, I am sincerely yours, Léonce Rosenberg.

P.S. Don't you think, as I do, that it is completely unacceptable that
a subject of an enemy power, whose goods have been sequestered,
can return as soon as hostilities are over, establish himself in France
under a false name, compete against French traders, and plot not
only against them but also, more seriously, against the public
authorities that alone tolerate his presence here?

P.P.S. The best response the prosecutor's office could make to all
these controversies caused by the Uhde and Kahnweiller [*sic*] sales
would be simply to expel Mr. K. from France. When the press
learned that this sequestered German had come back to live in Paris
under a borrowed name and carry out his schemes, the controversy
would end as soon as his expulsion became public, since everyone
involved in this affair is unaware that K. has dared to come back
here and throw his weight around as if he were in a country defeated
by his compatriots.[12]

Even later, in 1923, Léonce Rosenberg would continue to attack
Kahnweiler in order to make himself look good to Picasso: "It was
Max Jacob who told him before the war about all the artists in the

group. That does not diminish his merits [as a dealer], because he showed understanding and boldness, but as far as modern painting is concerned, it's an interesting detail: is it true as far as you are concerned? It's a shame that the war deprived Kahnweiller [*sic*] of the fruits of his efforts, but there was one way he could have saved his stock—if he'd joined the Foreign Legion, as did a few other Germans whose business was based in France."[13]

32.

A COLLATERAL VICTIM OF
GERMANOPHOBIC HYSTERIA

Mr. Kahnweiler Henri [*sic*], German subject [. . .] charged
with espionage in 1915 [. . .] demonstrated suspect activity
in Italy and then in Switzerland [. . .]. [He] is represented as a
dangerous enemy of France.[1]

—Report to the advisory committee for war sequestrations

I have now, for the second time, fully savored the pleasure of
witnessing my own execution.[2]

—Daniel-Henry Kahnweiler to Wilhelm Uhde

What can we take from those four years of war? The tens of millions
of dead, not to mention the countless wounded? The insane financial
cost of the conflict, the figure for which was close to $186 billion? The
immense political and territorial upheaval, with the dismembering of
the Austro-Hungarian Empire?[3] Or what if we go back to Picasso
and his works, which had been in state hands since December 1914?
The peace treaty was signed in the Hall of Mirrors inside the Palace
of Versailles, the very same place where the German Empire was
proclaimed in 1871, and article 231 of that treaty determined the
"reparations" that Germany had to pay France after its defeat: this
was the precise legal and political context in which the four sales of

Kahnweiler's sequestered artworks were framed. They took place in Paris, at the Hôtel Drouot, in four stages: June 13–14, 1921; November 17–18, 1921; July 4, 1922; and May 7–8, 1923. Altogether, nearly seven hundred of Picasso's paintings, sculptures, papiers collés, and drawings, among them his most "heroic," were sold at auction.[4]

"The first sessions of this major sale [. . .] were successful far beyond all expectations," wrote the journalist Marius Boisson in *Comoedia*. "Two more sessions will not be enough to disperse this heap of modern artworks and sequestered German goods."[5] The atmosphere was a mix of a liquidation sale, a feeding frenzy, a high-society event, a public settling of scores, and a brawl between profiteers and crooks. Some attended the sales for voyeuristic reasons, others out of jealousy or revenge, and yet others were driven by patriotic and xenophobic feelings. The collector Roger Dutilleul, as ever dressed impeccably in suit and tie, attended all the sales without buying (almost) anything. Instead, faithful to his friendship with Kahnweiler, he watched and took notes in his precise, regular handwriting. His catalogs—lent to me by his great-nephew Francis Berthier—were hugely helpful in providing me with a distant idea of what happened there. Because every aspect of those auctions left behind a strange aftertaste, beginning with the misspelling of Kahnweiler's name: the catalogs' printed covers list him as "Kahnweiller," just as (coincidentally?) Léonce Rosenberg did in all his letters denouncing the German between 1914 and 1940. As we have seen, the aim was to "disperse this heap of artworks," and in his conversations with Francis Crémieux in 1961, Kahnweiler gave his estimation of the damage: "Seven or eight hundred paintings were sold, not counting the drawings and all the rest." To the question "How many billions [of francs] do you think those works were worth?" the dealer replied simply: "Many billions . . . Many billions [. . .] Some paintings recently sold for sixty or seventy million each."[6]

On June 13, 1921, every European art dealer was in Paris for the first sale, including Paul Durand-Ruel, Alfred Flechtheim, the Brummer brothers, Bernheim-Jeune, Paul Guillaume, and Léopold

Zborowski.[7] But according to the art historian Vérane Tasseau, "the atmosphere was tense," and "Braque threw a punch at Léonce Rosenberg."[8] She also revealed the presence of Kahnweiler in the room, as well as the act of aggression to which he was victim: a young Parisian antique dealer "took off the wooden leg that replaced the one he lost in the war and used it as a weapon against the German, forcing [Kahnweiler] to leave the room."[9] In his catalog, Roger Dutilleul notes the estimation of only "800 francs" for lot number 72, Picasso's *The Green Plant*, but adds the word "pretty" preceded by an assured horizontal line.[10] Next to lot number 77, *Still Life*, he notes the estimation of "1,500 francs," the sale price of "2,500 francs," then the comment "a gift from the artist to Kahnweiler." Derain was clearly the star of those two days, eclipsing Picasso with prices varying between 4,500 francs and 20,000 francs. And what can be said about the catalog, which on page 19, lot number 84, states simply: "Portrait, 3 ft. 3 by 2 ft. 4 (see reproduction)," then on page 25 presents a (barely recognizable) black-and-white reproduction of Picasso's *Portrait of D.-H. Kahnweiler*, bought by the Swedish painter Isaac Grünewald? Even so, certain well-informed art lovers took full advantage of the situation, among them the Swiss collector Raoul La Roche, who spent more than 50,000 francs over the course of the two days.

"Room 6 of the auction hall was invaded by a noisy crowd, perhaps a little too noisy, [consisting of] French and foreign art lovers, dealers, and critics. People stamped their feet or banged their walking sticks on the floor, as at the theater, when Mr. Zapp and Mr. Léonce Rosenberg, the expert, began the sale," recounted Marius Boisson on November 18, 1921, describing the second day of the second sale. "Derain 3,700 [. . .]. Picasso's *Bottle of Rum* went for 1,250; a *Head* for 1,050; a *Head of a Woman* for 760 [. . .]. In summary, prices were settling down; but the evidence is significant nonetheless: contemporary art was bought by art dealers and also by ordinary art lovers. There were no artificial attempts to raise prices yesterday, no fake counterbids, only normal purchases. There has been a curious turn-

around in public opinion: fanatical admirers of modern artists who, only a few years ago, heralded them as geniuses, now look pitiful or noisily recant. And the result, fascinatingly, is that it's the original protestors who, money in hand, are defending the reputation and vitality of what was called cubism, and which is simply one of the most expressive faces of modern art."[11] Violence once again reared its head at this event when Adolphe Basler, an art critic and dealer, "became angry with Léonce Rosenberg, the two men insulting each other before Basler hit Rosenberg with his walking stick."[12]

The third auction saw prices drop even lower. As for the final stage of these macabre events, the poet Robert Desnos described the chaos and sadness while Isabelle Monod-Fontaine defined it ironically as "the first cubist exhibition in Paris." The Picassos "are admirable for their scandalousness and freedom of thought," Desnos admitted. "They have not dated in fifteen years, and they show up today's second-rate cubists as the clichés they are. I particularly noted that *Still Life* (no. 73); *Lemonade*; *Pipe, Glass, Bottle of Vieux Marc*; *Head of a Young Girl* (no. 340-347); *Pointe de la Cité*; and *Still Life* (no. 360), doubled with a romantic scene, were also much in demand. For my own part, I was tempted only by Braques and Picassos; I had noticed a charcoal drawing listed in the catalog as lot number 20 and described as an unsigned Braque, which I had originally taken to be a Picasso. Surprised, I showed it to my friend Paul Éluard, who confirmed me in my doubt. It was a pretty drawing, and I wasn't risking anything by buying it, so I asked Paul to bid for it on my behalf. He got it for 37 francs plus charges. When it was delivered to me, I took it out of its frame to show it to [Braque and Picasso] and ask them what they thought. I removed the backing, then some newspapers from 1913 [. . .] and reached the drawing. The first thing I noticed was that the dimensions in the catalogue (14 in. by 18 in.) referred to the cardboard frame, not the drawing, which actually measured only 9 in. by 12 in. The second thing was the signature on the back [. . .] that of Picasso. The mystery was solved: the attribution to Braque had been a guess, and it was likely that the same was true for other

artworks, and that other buyers [must have] found themselves in the same situation as me."[13]

As we have seen, the dark dealings that had preceded those four auctions had included the accusing letter about Kahnweiler written by Léonce Rosenberg. Picasso himself had grown increasingly anxious, and it was André Level who'd sprung into action. In fact, Picasso had begun by threatening to hand Mr. Zapp, Kahnweiler's trustee and liquidator, an invoice for monies owed to him from the sale of his art. "Within forty-eight hours I will have organized all the measures to be taken to ensure that, if there is an auction, it will pay you off, and that your invoice will be produced at the right time," Level reassured him. "I don't know if you have kept the check or if it's in the file. The examination of that will probably result in a brief delay on that point, and on others."[14] Navigating among the solicitor Henri Danet, who negotiated with the trustee, the Montrouge tax collector, and the registration administrator Mr. Nicolle—the "elusive Nicolle," whom Level would track down to his private home, but "Mr. Nicolle is never there or does not receive guests," he added—then going back to the principal clerk for the Danet office (another solicitor), who himself negotiated with Jean Zapp or the general office "created for the payment of debts on enemy goods," while verifying the orders of the judge and seeking the opinions of an advisory committee . . . André Level, the bourgeois legal expert, once again fought in the corner of Picasso, the foreign artist.

For seven consecutive years, from the first notification of sequestration (December 1914) until the first auction (June 1921), he constantly comforted and reassured Picasso: "I hope you feel calmer now";[15] "Don't hesitate to let me know if something happens";[16] "But don't worry, there's no rush";[17] "You must be thinking that I've forgotten you, but I haven't";[18] "At the office, they are certain that your fears of a secret sale are unfounded and that you have nothing to fear on that score";[19] "So you can leave without anxiety. But when you arrive, give me your address in case I have something to communicate to you on this subject";[20] "I still believe you are in a good

position. But apparently there will be no division of the spoils for the first small sale. It's likely we will have to wait for the sale of the paintings."[21] Level cleared the minefield of French bureaucracy with perseverance and good humor. At the same time, aided by Braque and Léger, Kahnweiler was busy organizing a syndicate of friends and relatives who could buy back a few works from the auctions (because he himself was banned from doing so). "We did what we could, but at that moment we discovered a law deciding to liquidate sequestered German assets," he would explain later. "I will spare you an account of all the different things that the artists and I tried to do. All those attempts foundered in the face of the narrow-minded stupidity, not only of the authorities but of certain critics and journalists."[22]

Throughout the Western world, the success of Picasso's cubist period was widely hailed through public means such as galleries, museums, and collections, courtesy of the work of critics, collectors, and art dealers (Kahnweiler in particular). But that was not the case in France. The works that Picasso developed through his interactions with Braque blossomed in his various studios or thanks to meetings in Montmartre cafés, but they were never really visible or public because they belonged to private collectors—like the Steins in Montparnasse or Dutilleul on Avenue Marceau—or were exhibited in small, obscure galleries like Kahnweiler's on Rue Vignon, in the "cracks of French society," those extraterritorial territories frequented by cosmopolitan or marginal individuals. And yet, in August 1914, the war suddenly brought back into focus the preeminence of the nation-state, with its incontrovertible oppositional pairings. And with the sequestration of "enemy assets," new actors entered the scene to confront cubism. These were the solicitors, clerks, trustees, and tax collectors, those representatives of "institutional France," which now had the upper hand over the artistic avant-garde. How could Picasso not feel robbed?

For a long time, historical accounts of artists' reactions to World War I were received in France with great unease. Philippe Dagen was the first to publish a book on the subject, the very important *Le Si-*

lence des Peintres (The Painters' Silence), which brilliantly underlined the complexity of the problem. "The questions raised by [the artists'] attitude to the war concern not only style but a historical and anthropological analysis in which art, politics, and technique are all intimately, inescapably linked."[23] There was a rash of new books and catalogs on the subject published around 2018 for the centenary of the war's end, such as those related to the exhibitions *Cubism and War: The Crystal in the Flame* and *Picasso and War*.[24] With the aid of Emily Braun, the academic behind the Leonard A. Lauder Research Center for Modern Art, who remains one of the leading experts on this period, I go through every document, every surprise. She points out new bibliographical sources that have never been translated into French.[25] In fact, where the painful issue of the sequestrations and sales of artworks is concerned, the reaction in France is still one of unease. The few articles that mention it often do so in a convoluted, confused, or indirect way. Vérane Tasseau decided to write her doctorate on the subject and, thanks to three years spent in the United States, she was able to access a wealth of new material. To my question about the files on the Kahnweiler sequestration and on the four auctions (whether in the archives of the Ministry of Foreign Affairs[26] or the archives of the city of Paris), she responded that, oddly, she discovered some documents were missing, despite several clues suggesting that such files had existed. In fact, on the National Archives website, under files on war sequestrations, the following list appears: "BEER and SONDHEIMER, 1918–1938; BEIER, Ernest, 1920–1921; DUHNKRACH, 1932–1933; ELLMER, Max, 1921–1922; FEHR, Elisabeth, 1921–1922; HERMANSEN, Axel, 1921; KREISS, 1931; OTTIKER, Thécla, 1936–1937; SCHAUER, Charles, 1948; WIEDMAYER and REICH, 1920–1935; WINSBACK. 1924–1925."[27] But Kahnweiler's name is nowhere to be found. What happened to his file? Who removed it, and when? As we have seen, the auctions were widely reported in the French press at the time, so what is the reason for this strange amnesia?

I spend several weeks trying to answer this question. But the inner workings of France during the Third Republic remain mysterious, a

society infected by a combination of traditions, toxic presumptions, perverse relations, personal interests, and endogenous connections. The Académie des Beaux-Arts exercised an inordinate influence over the creative world, imposing its religion of "good taste" while stifling new art, producing a climate that was suspicious of the "culture of the present." "The decline of French taste [. . .] is attributable not to a social class, the bourgeoisie, but to an institution, the Académie des Beaux-Arts," wrote the historian Jeanne Laurent. "Its aim was clear: to let this art, which they considered far removed from the French tradition, be thrown onto the market in order to bring it down."[28]

How can we ignore the most obvious signs at work in this society of the Third Republic, like the infatuation with "elites," often more interested in building their own careers than in the fate of artists? Such is the paradigmatic example provided by the career of Paul Léon. "In 1907, I fulfilled my destiny. Until then an academic, I became a bureaucrat,"[29] boasted this man whose administrative trajectory—head of the Beaux-Arts from 1919 to 1932, elected to the Académie in 1922, elected to the Collège de France in 1932, decorated with the Grand Cross of the Legion of Honor, a member of the Superior Committee on Historical Monuments from 1907 until his death—might seem impeccable to some but who was responsible for immeasurable damage to contemporary art in general and to cubism in particular. How could one man be allowed so much power to suppress the remarkable experimentations that the cultural context of Paris had allowed to flourish?

In his memoirs, Paul Léon forcefully recounts the details of the calculations he made, the deals he sealed, the bowing and scraping he did to obtain an "immortal" seat on the Académie des Beaux-Arts and to be appointed a commander in the order of the Legion of Honor—two objectives that guided his career. On the Kahnweiler sequestration and the sale of those sequestered works, however, there is not a word. As for World War I in general, he wrote: "The board of the Beaux-Arts [. . .] was not inactive during the great upheaval. The safeguarding of monuments was not its only objective, [. . .]

but I succeeded in creating a photographic department for wartime operations."[30] While Claude Monet met Georges Clemenceau to accomplish the "great impressionist's final dream" (donating the *Water Lilies* to France), Paul Léon, senior official of the republic's elites,[31] head of the Beaux-Arts, neglected to inform his minister about the possible repercussions of the Kahnweiler sales and also neglected to point out that the State had the right to preempt all bids.[32]

But let us take a step back: the law on the liquidation of sequestered assets was passed on October 7, 1919. Could the disaster that then befell cubism in France, with the deplorable auctions that ensued, have been avoided? What might have happened, for example, had the people in power at the time been respectful of contemporary art? Among others, there was the deputy Marcel Sembat, who always took the side of the artists during debates in the National Assembly; there was the president of the Council of Paris, Georges Clemenceau, a personal friend of Monet, who at that time was in charge of installing the *Water Lilies* in the Jeu de Paume museum; there was the secretary Jean Marx, who worked at the department of French works abroad in the 1920s and alerted Léon to the "leak" of French paintings to the United States; there was even Étienne Dujardin-Beaumetz, the former undersecretary of state to the Beaux-Arts (and an artist himself), who had just died. And that's without mentioning André Level or Olivier Sainsère (one of the first collectors of Picasso's art and secretary-general to the president's office under Poincaré), who was fascinated by the artist and always tried to protect him. "Olivier Sainsère [. . .] was very good. There were other people who were also very good. But they couldn't do anything. There was also the absolute hostility of my colleagues," Kahnweiler would later explain.[33] "The people on Rue La Boétie and the surrounding streets who really hoped they could 'sink' me [. . .] who simply hoped to 'sink' cubism. There was also a man whose name I mentioned in a complimentary way earlier, Léonce Rosenberg, who wanted cubism to triumph, but who naïvely imagined that those auctions would lead to its triumph."[34] Moreover, the rapid succession of ministers during

the course of the Third Republic gave someone like Paul Léon an excessive amount of power. With the prestige of the Académie des Beaux-Arts behind him, he was able to prioritize his career while simultaneously destroying cubism.

Amid those liquidation sales, Kahnweiler (who was only thirty-four at the time) was transformed into the scapegoat of the country's xenophobia and the expiatory victim of his jealous Parisian rivals, while speculation on the cubist paintings in his stock created a new market. How was this young German Jew supposed to reconcile his idealistic "mission" to serve emerging artists from his beloved French capital with the sordid "punishment" that was visited upon him? In September 1920, Kahnweiler stubbornly opened a new gallery with an associate, the Simon gallery, at 29 bis Rue d'Astorg. Later, he would receive damages of 20,000 marks from the German government and send Picasso a check for 20,000 francs in order to clear his debt.[35] From 1923 until the artist's death, Kahnweiler and Picasso would become friends and professional partners once again. As for the 909,000 francs, the "mediocre product of the sales of the sequestered works," they were not even used to fund fine arts in France. Instead, the sum was delivered "to the Ministry of Finance, which assigned it to a special account to cover war damages," where the 909,000 francs was "merely a drop in the ocean," as Jeanne Laurent puts it.[36] And so, after failing impressionism with the Caillebotte bequest (1894–1897),[37] the French State also failed cubism with the Uhde and Kahnweiler auctions (1921–1923), meaning that the works from these two aesthetic movements remained vastly underrepresented in public collections, evidence of an ethical and political flaw in France's cultural history. Once again, the State refused to let works of contemporary art (impressionist, postimpressionist, fauvist, cubist) enter the national collections out of a desire for "purity."

33.

"COUNTING THE HOURS": NOTRE-DAME DE PARIS, THE EMMANUEL BELL, AND THE PICASSO INTERNATIONAL

The ringing of the bells punctuates the lives of the faithful, counting the hours and proving that the cathedral is a place of life.

—Official website for Notre-Dame de Paris, 2018

As I walk down the Montagne Sainte-Geneviève, I hear the Notre-Dame bell tolling. It is unusual to hear this funereal sound in the morning in Paris. The tolling is monotonous, extremely slow and grave, casting a tragic pall over my day. A little later, I will understand why: the note is an F-sharp, made by a tenor bell weighing more than thirteen tons that answers to the pretty name of Emmanuel, cast in 1682 and sponsored by Louis XIV. I learn from the cathedral's official spokesperson that this bell is reserved "for the great moments" because "it signifies that the diocese and France have lived through something important." At the same time, the French president is giving a solemn speech in the Invalides. He is paying tribute to a gendarme who heroically volunteered to be exchanged for a hostage and was later murdered by the terrorist involved. The hero's name will soon be known throughout France: Arnaud Beltrame. Tonight,

from the Place de la Nation to the Place de la République, there is
another form of tribute, a "white march" that will salute the memory
of Mireille Knoll, an elderly, disabled Jewish lady and Holocaust sur-
vivor who was murdered in her own home in the center of Paris. This
day—March 27, 2018—marked by these recent victims, reopens the
deepest wounds in the nation's collective memory. In the streets, a
few red, white, and blue flags appear in windows, and the phrases
"Islamic terrorism," "Fiché S," and "anti-Semitic murder" are heard
over and over again throughout the course of this drab, rain-soaked
day. This is the day that I have a meeting with Georges Helft.

Georges Helft spends a lot of time traveling between Buenos Ai-
res, Montevideo, New York, Paris, and the rest of the world, but almost
as soon as I contact him, he responds. I have known him for almost
thirty years; I know his tastes, his passions, his choices, but this is the
first time I have ever asked him explicitly about his history: I have
just been reading the archived correspondence between Picasso and
three of Georges's relatives—his father, Jacques Helft, his uncle Yvon
Helft, and in particular his uncle by marriage, Paul Rosenberg (the
artist's dealer from 1918 to 1940), as well as Paul's brother Léonce. I
am trying to understand the deep connections between this extended
family and Picasso. Georges Helft is extremely open, does not dodge
any of my questions, and makes no attempt to embellish the truth.
He talks about his maternal grandfather, Georges Loévi, a self-made
man born in Paris, who lived at 1 Boulevard de Magenta, between
the Marais quarter and the Place de la République. At the beginning
of the twentieth century, this shrewd man sold cheap Algerian wine
in Paris and made his fortune. The eldest of his daughters, Mar-
guerite, married Paul Rosenberg; the two younger girls, Madeleine
and Marianne, married two brothers, Yvon and Jacques Helft. There
were quite a few art dealers in the Loévi-Helft-Rosenberg family,
several of them having connections with Picasso.

In Georges's small office overlooking the Seine, portraits of
Borges and Brecht are hung next to a black-and-white photograph
of his grandfather Léon Helft, smiling and elegant in a three-piece

suit, standing outside the doorway of his store, À La Vieille Bretagne. Georges describes the roots of each branch of the family: from Alsace to Paris for the Loévis, from Slovakia to Paris for the Rosenbergs, from Poland to Germany to Alsace, then Nantes, for his great-grandfather Helft, who became a door-to-door salesman. But the family's trajectory did not end in Brittany: horrified by an article that appeared in the local newspaper, they abruptly left for Paris, where grandfather Helft opened the antique store in that photograph on Rue La Fayette. He would never throw away the newspaper article (published in 1845) that had defamed his own mother with an anti-Semitic slur, stating that Mrs. Hélène Helft was "inundating noble Brittany with her pigs." Georges recounts the next stage of his family's interminable exodus: "I left Paris two weeks after my fifth birthday [. . .]" In 1939, the seventeen members of his family set off for Floirac, then Cintra, then New York, where they arrived three months later. Georges mentions Léonce and Edmond Rosenberg living in Paris throughout the Occupation, as well as Albert Borel (the husband of their sister Lucie-Amélie, a.k.a. "Mimi"), who committed suicide when Paris was liberated.

Why does this interview filled with various exiles, exoduses, expatriations, wars, forced migrations, xenophobia, suicides, and new beginnings all centered around Picasso resonate so powerfully in a city whose old ghosts have reawakened, on this day haunted by the F-sharp tolling of Notre-Dame's great bell? Today, with a century of hindsight, amid another "migration crisis," we have a different view of those European networks intersecting around the great artist, who arrived from Barcelona as a "vertical immigrant" in 1904. We see those networks redeployed in a sleepwalking Europe that carries on as if nothing had happened. In 2018, as we commemorate the centenary of the end of World War I, we can shine a different light on the behavior of the obsessive artist, clinging to his pencils and paintbrushes, focused on his experiments, moving always within his own little world of women, animals, canvases, notebooks, and colors.

Suddenly, the story of those three families as told by Georges

Helft appears to me to offer an incredible counterpoint to Picasso's cubist works. While the artist rarely ventured outside France, while his paintings made no real inroads on his adopted country's official museum collections until 1947 (when he made a personal donation), in many ways this is a story about the global circulation of his work, and to a large extent it was networks of Jews forced to move around the world that ensured Picasso's work became so visible in Germany, Russia, Czechoslovakia, and the United States. With the exception of Vollard, the names of Picasso and Berthe Weill, Kahnweiler, the Rosenberg brothers, and Georges Wildenstein tell a global story of modernity. As indeed do those of Justin Thannhauser (who would sell *Family of Saltimbanques* to Hertha Koenig, in Munich, in 1914), F. Valentine Dudensing (who would sell the same painting to Chester Dale, in New York, in 1931), and Germain Seligman (who would sell *Les Demoiselles d'Avignon* to MoMA, in New York, in 1939). This is, in fact, a perfect illustration, an eschatological diagram, of those trading networks at the heart of twentieth-century Western capitalism, just as the network of Sephardic Jews, harried out of Spain, were responsible for trade around the Iberian Peninsula, in Europe, Africa, and beyond.[1]

When Picasso arrived in Paris in 1900, the country had for several years been engaged in a deliberate effort to build up the idea of a nation. It was Gósol and the mountains that enabled the artist to experience for the first time that feeling of extraterritoriality and fearlessness. The Steins' salon and Kahnweiler's gallery did the rest, but in August 1914 the cosmopolitan bubble burst. As the political scientist Suzanne Berger admits, "the web of investments and commercial relations of the first globalization was not able to produce a political environment less conducive to war."[2] The Third Republic continued to hold those universal aspirations to build a nation that was at once faithful to its citizens' civic and territorial identities, but in practice it remained "horribly discriminating, geneticist, and exclusionary" toward foreigners, as proved by the hostility of official France to cosmopolitan cubism. The massive upheaval caused by

World War I, the scale of which is still hard for us to truly grasp, forced Picasso to make a deliberate, strategic reorganization of his entire existence.

Faced with the collapse of his comradely networks, the artist managed to forge new links: André Level was assigned to anything related to the French nation; the Ballets Russes provided Picasso with a new European artistic network; while Paul Rosenberg organized the spread of his art into North America. The new period that was opening up to Picasso at this time (with his choice to prioritize trans-nationalism over an aesthetic direction) shows up clearly in the first letter that Kahnweiler sent to Kramář after the war, six years after the one he wrote in July 1914, announcing "a splendid series. Free and joy-ous as never before." This letter laconically explains one of the artist's most mysterious aesthetic shifts.

"Dear Sir, it was a great pleasure to receive your letter. I don't know if I have told you our story. [. . .] Here, too, there has been an uproar over Picasso's volte-face. It is very difficult to see it clearly. I would rule out the idea that greed or some other ulterior motive has played any role in his turnaround. The fact remains, though, that Picasso has made a wrong turn, and God knows where it will lead him. [. . .] When you are Picasso, it is perfectly possible to think about Raphael while painting something cubist. [. . .] In any case, he will always bring his talent, his genius, to everything he does. But I think he's mistaken. His current work doesn't satisfy me, which is why I haven't bought any. How did this happen? Picasso remained alone during the war. Braque wasn't there anymore. There were also none of the sounding boards that Picasso needs so much. I see him as a Spanish flamenco dancer, surrounded by a circle of people yell-ing 'Olé!' to encourage him and stimulate him to dance better. Dur-ing the war, all those friends and admirers were far away. In their place, Picasso made the acquaintance of the poet Jean Cocteau, who introduced him to 'high society.' Through Cocteau, he joined forces with the Ballets Russes, designing the sets for three of their shows. All of this seriously harmed Picasso, who ended up marrying one of

the Ballets Russes dancers. In that way, he fell increasingly under the influence of these high (or not so high) society figures. People who want their portrait painted, but not a cubist portrait—God forbid, no! The dealer Paul Rosenberg, too, is besotted with anything that isn't cubist. So Picasso is living in that world, well-dressed, in a large apartment on Rue La Boétie. He has his own box at the Ballets Russes and attends every performance in a tuxedo. And he is *unhappy, unhappy, unhappy*."[3]

III

THE ALL-POWERFUL POLICE,
A DISTRAUGHT ARTIST

1919–1939

Prologue: Like a smashed mosaic

Now we must start. How? With what? This doesn't really matter: one enters a dead man's life as one enters a mill. The essential thing is to begin with a problem.[1]

—Jean-Paul Sartre

Disconcerting, mercurial, a betrayer of cubism, elusive, multiple, contradictory: all these words have been used to describe the work that Picasso produced after his cubist art was sequestered in December 1914. The exhibition *Magic Paintings*, presented at the Musée National Picasso-Paris in the winter of 2019,[2] allows a deeper understanding of a little-known artistic phase, adding a new layer to the complexity of that period. Prior to this exhibition, other events had portrayed the work of those years as a random assemblage: *1932: Erotic Year*; *Guernica*; *Picasso-Giacometti*; *Olga Picasso*; *Picasso the Poet*; *1932: L'Amour Fou*; *Dora Maar*; *Picasso and Exile*. How are we to make sense of such an abundance? How, for example, should we regard the fact that two paintings with such divergent aesthetic styles, one of them neoclassical (*Paul As a Pierrot*), the other proto-surrealist (*The Three Dancers*), should have been produced in the same studio only a few months apart (March–June 1925)? Compared to the aesthetic analyses that defined Picasso's work during his Blue and Rose periods, or the ever-evolving cubist work, the analyses of this postwar

Picasso's wildly heterogeneous works, genres, moments, networks, and lives seem as erratic as what they are attempting to analyze.

We know *Guernica* as one of the most famous masterpieces in world art; we can bring to mind numerous portraits of Olga Khokhlova as a classical or pastoral muse, the immense stage curtain for *Parade*, the powerfully erotic nudes of his sleeping lover Marie-Thérèse Walter, the monumental sculptures with erect phalluses in the middle of her face, the heartbreaking *Blind Minotaur Guided by a Young Girl at Night*, the landscapes of Boisgeloup in rain and the fascinating series of his bathers who, during successive summers on various beaches in western France, seemed to be engaged in a frenetic stylistic race. We have discovered, to our stupefaction, the enormous number of poems he wrote, beginning in 1935 and continuing for years afterward; we have admired the compartmentalizations and recognition games of the 1930s; we have seen the photographs of the artist with Cocteau, Diaghilev, Stravinsky, Leiris, and Éluard; we have spotted Picasso hobnobbing with high society; we have discovered, one after another, his lovers and muses as if they were close friends of ours; we have opened, one after another, the doors of his many houses, such as the opulent apartment on Rue La Boétie (from 1918) or the Château de Boisgeloup with his Hispano-Suiza motor car, chauffeur, and pedigree dog (from 1930)—offering such a contrast with the Bateau-Lavoir and those studios in Montparnasse—and we have witnessed the spectacular rise of his international fame.

The interwar works are disturbing for their aesthetic rupture with the previous periods. Looking through the 150 works collected in *Magic Paintings*, concentrated on four years (1926–1930), we are able to make a little headway through the maze of this mystery. "Picasso experiences the tension of opposites with great intensity," wrote Carl Einstein,[3] and his truth resides in "the underlying identity."[4] The interwar period plays a pivotal role in Picasso's work and trajectory. In it we can find recurring connections, themes, patterns, correspondences, such as the surprising *Crucifixion* (1930), a small exorcism painting in violent colors that provides an essential stepping-stone

between his two most groundbreaking and important works of those years, *The Three Dancers* (1925) and *Guernica* (1937). So we must persist in looking at the disturbing, disorienting mosaic and find another way to consider the anomic object before our eyes. "Picasso is a form of perpetual movement. We seek him here and he is already elsewhere, never taking the same path twice," noted the perceptive critic André Warnod in 1925. "He is all anxiety. [. . .] Picasso has what it takes to make his followers despair."[5]

■ ■ ■

On July 14, 1919, Maurice Sachs, a young writer with many artist friends, wrote in his journal: "We had no age anymore. Unless everyone was twenty. It was very hot, but we only felt the heat when there were no more soldiers passing by to watch. The yelling and the joy that rose from throats and floated like a vapor over the intoxicated crowd moved away, following the troops [. . .]. It took me two hours to walk from Avenue de la Grande-Armée to Rue de la Faisanderie. It seems possible that the streets will never be empty again, that we will see all these happy, shimmering, friendly, enthusiastic people rushing along them for years. I am exhausted. Such sights will never be seen again. Because there will be no more war."[6]

The British writer Robert Graves described the interwar period as Europe's "long weekend." It was a period marked by human losses; it was the occupation of the Rhineland and the Ruhr by Allied troops and, more enduringly, by French troops; it was the Great Depression, bringing back the old hostility toward foreigners; it was the Rif War (which France entered in 1925), the Spanish Civil War (1936), and the emergence of nebulous policies accompanying the rise of fascism—and, always, that nagging pain of national pride, connecting the different countries like a taut rope. Picasso, however, was now an established figure in the European landscape. Since 1907, he had been exhibited, celebrated, collected in the museums of Germany, Austria-Hungary, Russia, and the United States.

The paradox remained that in France, where he lived, he was still invisible to the general public. After the First Balkan War (1912–1913), Picasso reacted to the geopolitical tremors. In August 1914, he understood what the cataclysm of open hate between France and Germany meant for him personally, the wave of frenzied patriotism that would soon submerge the entire country.

The first consequences of the war were demographic. "For fifty-one months, a thousand Frenchmen would die on the front every day. Almost one in five men were conscripted, and 10.5 percent of the country's active male population was killed. France suffered more losses than any other Western power: the British had half the number of dead and missing. The Germans and Austro-Hungarians, who suffered heavy losses, were well below the 10 percent marker. In France, more than 1.4 million people were killed; more than 1 million of them were gassed, disfigured, crippled, amputated, irreversibly mutilated," wrote Eugen Weber.[7] And, while the historian's statement that "the 1930s began in August 1914" is undeniable, the impact of World War I was, paradoxically, just as devastating for someone like Picasso, who did not participate in it. The fanatical pacifism that would soon sweep France was accompanied by a whiff of xenophobia toward the "internationalists," who were considered threatening. Indeed, when those internationalists began to worry about the rise of fascism or insist that refugees be welcomed into France, they were accused of trying to drag the country into a new war against its European neighbors.

The gradual dismantling of Europe that began in August 1914 seemed to herald a catastrophe for Picasso and his work. The three empires that had been the first to recognize his genius, a few years earlier, were entering decades of famine, civil war, revolution, and totalitarian regimes,[8] while the artistic avant-garde came to be superfluous, suspect, or even outlawed. Picasso quickly understood that he needed to adapt urgently to this new geography. He continued to devote himself fearlessly to his work. His first contract with Diaghilev was signed in January 1917, barely four years after the one with

Kahnweiler, as if he were trying to erase it from history. We know that, all over France, the blame was directed at "pen-pushers" with "cushy jobs," and we remember Juan Gris, who did his best to erase himself from the parties in Montparnasse. Although far from the front, Picasso was deeply affected by the death of Guillaume Apollinaire on November 9, 1918. He paid tribute to his friend first with a self-portrait in pencil (in which his gaze is serious and stunned), then with a large painting, *The Reading of the Letter*, and finally with a *Monument* to his memory. Losing Apollinaire meant losing one of his best friends and most faithful supporters. Through Braque (who suffered a head injury) and through Cendrars (whose right hand was amputated), Picasso had some idea of what was happening on the front, even if at a distance. And so it was with distance that he considered the pacifists, patriots, war heroes, orphans, and destroyed families. His own wounds were of a different kind, but they were still violent: the sequestration of his most heroic works was itself a kind of amputation. But who would feel any compassion for Picasso's loss when compared to what his friends were suffering?

■ ■ ■

During those twenty years, Picasso organized things in his own way. Just as he'd done in 1904 with the Steins, then with Kahnweiler and Uhde, he sought ways out as he moved forward, responding to requests from marginalized groups, and from time to time joining forces with the ones who interested him. While his sequestered cubist works were sold off in 1921, 1922, and 1923, Picasso—cheered on by small circles of fanatical admirers—continued to surprise as he pursued his creativity. Through four different phases (mercurial set designer for Serge Diaghilev's Ballets Russes and Étienne de Beaumont's society balls, then artist-magician in the orbit of the surrealists, then sculptor and Minotaur in his Boisgeloup domain, and finally political artist on the side of the Spanish Republicans), he continued to move through that European and extra-European space

in his own way, between circles of expatriates and circles of marginals, unprotected from the turmoil of his era, but with strategies so far from the norm that, to understand them, we must systematically follow the path taken by this Icarus who had had his wings burned but who, despite everything, remained on the lookout for every latest development, more attentive than ever to his own spaces of freedom.

34.

MERCURIAL DESIGNER
(FROM THE BALLETS RUSSES
TO SOCIETY BALLS)

Hôtel Westminster, Rue de la Paix, Paris

April 15, 1919

My dear Picasso,

I would like you to take charge of the staging of the ballet *The Three-Cornered Hat*, music by E. de Falla, for my Ballets Russes shows. You will draw sketches for the curtain, the set, and all costumes and necessary accessories [. . .]. For said work, I will pay you the sum of 10,000 francs [. . .].

Yours devotedly,
Serge Diaghilev[1]

Picasso's participation in the Ballets Russes is surprising; in the same way, the friendship between Picasso and Cocteau defies expectations. We remember the cubist artist disguised as a mechanic, he and Braque going cap in hand to Kahnweiler and saying: "We're here for our pay, boss!" That this same man should, four years later, be dressed in top hat and tails to greet King Alfonso XIII in his Madrid palace, or enjoy the opera from a private box with Diaghilev, came as a shock to many people. We still have in mind that first letter from Kahnweiler

to Kramář after the war, describing Picasso taking a "wrong turning" and being "unhappy, unhappy, unhappy." And yet in the photograph of the artist in cap and work overalls, sitting among his assistants in Rome, taken in May 1917 while they were creating the set for *Parade*, he does look happy, in his element. And the cubist costumes of the American manager with the skyscraper on his back, or the horse with its echoes of a Dogon mask, suggest his creativity was intact and as intense as ever.

In 1915, when Cocteau gave in to Diaghilev's insistent request that he be introduced to Picasso, the Russian impresario was already well-acquainted with the artist's work. Since 1910, Diaghilev had had the opportunity to admire the fifty major paintings (some of them cubist) bought by Sergei Shchukin over the years and exhibited at his Troubetskoi Palace in Moscow. It's no surprise that Diaghilev was aware of Picasso: in 1898 he founded the magazine *Mir Iskousstva* (The World of Art), bringing together the avant-garde artistic movements, then conceived the Ballets Russes as a total work of art (*Gesamtkunstwerk*) fusing music, painting, poetry, photography, cinema, fashion, and literary criticism. "I have been to western Europe several times and have always been surprised—and felt my national pride offended—by the ignorance of foreigners when it comes to the representatives of Russian art," he explained later in his usual affected manner.[2] With *Parade* (1917), *The Three-Cornered Hat* (1919), *Pulcinella* (1920), *Cuadro Flamenco* (1924), and *The Blue Train* (1924), the creator of the Ballets Russes offered Picasso the opportunity to become part of his team and to collaborate with prestigious contemporary composers such as Erik Satie, Igor Stravinsky, and Manuel de Falla.

There was a parallel between the artistic frenzy of Barcelona that Picasso experienced from 1895 and that of Saint Petersburg where Diaghilev, then a young musician from a background of minor nobility, lived circa 1890. Diaghilev had listened to every work created by Tchaikovsky, Borodin, Rimsky-Korsakov, and Massenet, he had read every novel by Tolstoy (whom he visited regularly); he had been to

every museum in every European capital; and, in the syncretism typical of those years (symbolist movement in France, Pre-Raphaelite movement in Britain), he embarked on a tour of the West to promote the musical, choreographic, and artistic schools of his own country. He saw himself as an ambitious visionary. "We must have solid preparation and the audacity to meet every test. We must charge straight ahead to collaborate permanently, not just occasionally, on the development of universal art," he wrote at the time.[3] As an ambassador for the artists of his homeland, aware of "their passionate faith in the future,"[4] he organized a series of exhibitions, concerts, and operas by Russian artists in Paris, from 1906 on—a program that culminated with the triumphant performance of *Boris Godunov* at the Palais Garnier in May 1908. So perhaps Picasso's partnership with the Ballets Russes, and his meeting with Serge Diaghilev, were in fact part of a natural convergence of the European avant-gardes (which the young Picasso had helped set in motion seven years earlier). That moment of synergy brings to mind Natalia Goncharova and Mikhail Larionov, those early Picasso imitators who would create the sets and costumes for Rimsky-Korsakov's *The Golden Cockerel* in Paris in May 1914. "The time and the place has come to talk about Goncharova as a smuggler from the East to the West, carrying art that was not only old Russian but also Chinese, Mongolian, Tibetan, Indian," wrote the critic Marina Tsvetaeva. "Our age is most willing to take what is oldest and most distant from the hands of a contemporary who makes it newer, brings it closer."[5] The role of Eastern emissary to the West played by Diaghilev and Goncharova is echoed by the extraordinary impact made on European and North American collections before World War I by Picasso's works—breaking down barriers between cultures, disciplines, and historical eras.

With "his access to the groundbreaking experiments of the Russian avant-garde,"[6] Diaghilev offered Picasso a crucible for his own experiments. And, in those troubled times, the artist was more than happy to accept this offer. How thrilled he must have been to find himself, with *Parade*, on the same team as Erik Satie, that late-blooming

bohemian composer who wore a monocle, worked in an office near the factories of Arcueil, and whose wanderings had led him to Barcelona where, at the Quatre Gats, he hung out with his friends Rusinol, Casas, and Utrillo. "Satie and Picasso met each other and liked each other. It was inevitable," noted the astute Henri-Pierre Roché,[7] a witness to their first meeting. In 1918 Satie, despite being twenty-five years older than the artist, declared himself "a disciple of Picasso," comparing synthetic cubism to his own syncopated compositions. Together they joined forces against Cocteau; together they took part in the adventure of *Parade* (1917), then *Mercury* (1924), with the famous dancer and choreographer Léonide Massine, the most "attentive, respectful, and inventive collaborator" Picasso ever had.[8] "Dear Monsieur Picasso," Massine wrote enthusiastically. "Monsieur Diaghilev organized a big party for me; he brought me your paintings. Now I live among them; I am happy no longer being alone. Seeing them as I work, I have more confidence [. . .]. When will we begin our joint work? I wish it were already done, that we had been successful, and that you were satisfied by your collaboration with me, your most affectionate and devoted collaborator."[9] Soon, however, tensions emerged: in June 1919, Diaghilev suddenly seemed to doubt himself and, in a vulnerable state, sought the artist's support. "Dear, dear Pica, You know how much I love you and how much I believe in your friendship—that is why I am writing to you so honestly. Massine made a pathetic speech to me about the decadence of my tastes and my activities, based on the phrase that you and Derain used— that 'Diaghilev does what is done at the Folies Bergères, only they do it better' [. . .]. I am ready to admit that I am old and tired [. . .]. I feel disheartened and useless. Tonight will be a triumph if you and Derain can give me some support and view the rehearsal."[10] That Picasso should, in such a short period of time, have become a barometer of taste for Diaghilev, who was ten years his senior, says a great deal about the artist's influence.

Some people consider the Picasso of the Ballets Russes a traitor to himself, an artist unduly influenced by Olga Khokhlova, his young Russian ballerina wife, whose own tastes were more conventional

than his. But surely that is not the only possible interpretation. Why must we persist in seeing him as a man who lost his soul by befriending Cocteau, a poet whose political convictions were so opposed to his own? In fact, after having been used by Diaghilev as a conduit to Picasso when *Parade* was being created, Cocteau was ejected from the team for *The Three-Cornered Hat* and *Pulcinella* by the Russian visionary. Eugenia Errázuriz, on the other hand, grew very close to the artist: this rich Chilean set designer, a friend to the Ballets Russes, welcomed Picasso to her villa in Biarritz after his marriage to Olga Khokhlova, gave him free use of her Parisian apartment on Avenue Montaigne, then organized the sale of his works, sending him astronomical sums (for example, the equivalent of 50,000 francs four times a year during 1917)[11] to provide for his every possible need. "*Voy a tenerle mandado hacer un traje azul para su regreso*"—"I am going to ask them to make a blue suit for your return"—she told him in February 1917.[12] Not only did she help sell his paintings, she also acted as a benefactor in other ways.[13] What can be said, for example, about this note she sent him a few months later? "Tell me if you need money. Even if I don't have much, I can easily make some available. And write me a few lines at the same time so that I know you haven't forgotten me."[14] What if, after the Kahnweiler nebula and the golden age of German art history, the Diaghilev nebula and the "new spirit" of the Russian empire represented, for Picasso, another community of avant-garde expatriates, to which he came, quite naturally, to join? Perhaps Picasso the master strategist had seen in Diaghilev the opportunity to extend that first period of globalization that had, with Kahnweiler's sequestration, been tragically cut short in August 1914. In that case, why should we deny the authenticity of the transplants and hybridizations that took place during those years?

■ ■ ■

For some time now, I have been contemplating the photographs of Picasso at a ball in 1924, with his wing collar, his bow tie, his waistcoat embroidered with gold thread, and his brooding gaze, standing

between two women dressed in white—the aged and extravagantly dressed Eugenia Errázuriz and Olga Khokhlova, deferentially lifting up her skirt. By 1919, the artist had become a regular visitor to the private mansion known as the Hôtel de Masseran, where he was a guest of the Count Étienne Bonnin de La Bonninière de Beaumont and his wife, Edith, née Taisne de Raymonval, people far less well-known than Diaghilev and his Ballets Russes or Charles and Marie-Laure de Noailles. Like many others, I find myself incredulous at this new Picasso, increasingly distanced from the bohemian Montmartre scene where he developed as an artist in Paris. But the archives of the Musée Picasso and the Institute of Contemporary Publishing contain still more secrets that will prove fascinating.

"Dear friend, I can't tell you how enchanted I was by my visit to Miss Stein. My jealousy over her collection is enough to make me Bolshevik," joked Étienne de Beaumont. "Would the two of you like to come for tea next Monday with Princess George of Greece, whom you saw at the homes of Princess Hélène Soutzo and Princess Sixte de Bourbon? It won't be a gathering of intellectuals. But only come if it amuses you because you know that, as your friend, I always prefer to see you alone. Étienne—P.S. Perhaps I'll drop by tomorrow (Saturday) morning, around 11:30."[15] What a wildly different world Picasso was now inhabiting! This journey through the French aristocracy of the 1920s will reveal a part of my country that has tended to remain in the shadows ("a bibliographical desert," as the historian Myriam Chimènes puts it), providing us with the sort of false-bottomed story that researchers dream about.

As a result of the intermingling of classes caused by the war, Picasso began rubbing shoulders for the first time with the French aristocracy, just as that social class, long buried by the Revolution, had elicited a jolt of national sympathy—as the first sector of the country to suffer in the war[16]—and at the precise moment when it appeared (thanks to the glorious, philanthropic role of its women in the Red Cross and other charities helping the wounded) as an "important agent of victory." Picasso gained a foothold in this "international

nobility" that consisted of "the solid British monarchy, the traditional Romanian royal family, some Italian and Spanish pretenders, and the exiled Russian nobility, enabling the survival of a cosmopolitan high society."[17] Sensing in this new enclave a window of opportunity, Picasso would join them for a while, steering clear of institutions through which the aristocracy had previously supported artistic creativity. Étienne de Beaumont appeared as a paradigmatic figure in that world. "For the sort of liberation that his class felt it needed," the composer Georges Auric would write, "the bold but prestigious Count de Beaumont was undoubtedly the one to deliver it [. . .]. Amid the happiness, hope, and euphoria of the war's end, Étienne de Beaumont opened his mansion [. . .] and gave a series of extraordinary parties. For the grandes dames who naturally attended these events, the count's lifestyle made it clear that it was now fashionable to know Mr. Picasso, to chat with Mr. Satie [. . .]. Its walls hung with paintings of surprising quality and audacity [. . .]. A sort of unexpected collective lightheartedness took hold of all the guests."[18]

One might wonder: why the French aristocracy? Should we believe, with Arno Mayer, in a continuation of the values of the ancien régime in nineteenth-century France? Should we, like him, analyze World War I as a "consequence of the recent remobilization of the anciens régimes of Europe"?[19] The example of Picasso's sequestered cubist works suggests a more complex explanation. If it's true that it was agents of the rising bourgeoisie (Paul Léon and consorts) who, using institutions inherited from the ancien régime (Académie des Beaux-Arts), decapitated the avant-garde, then it was those aristocrats from civil society who, from 1913 onward, would engage in cultural subversion within French society. And in that sense Arno Mayer is correct in his perceptions of the particular case of the French aristocracy: despite its demotion to the second rank in political society of the Third Republic, it "maintained its social and cultural preeminence," and, "as if to compensate for its fall from political power and its relative economic decline," it "displayed its knowledge and its pride more than any other European nobility."[20] The example of an Étienne de

Beaumont (the bust of whose great-uncle Marc Antoine, an imperial general and peer, is featured on the Arc de Triomphe) tells a story in itself: the house of de Beaumont, with a direct line of descent going back to 1450, is from Touraine and includes among its ranks some pages to the king of France, members of Louis XV's Grande Écurie, and of course that imperial general, but in its modern incarnation the family is perhaps most famous for the night of May 29, 1913, the first-night performance of *The Rite of Spring* at the Théatre de Champs-Elysées. Amid the boos, whistles, and jeers, Beaumont was one of the few who supported Stravinsky's work. Not long after that, he showed similar courage in expressing his support for the publication, by Éditions Grasset, of a book rejected by Éditions Gallimard: *Swann's Way,* by Marcel Proust, another frequent guest at the Hôtel de Masseran.

The Count de Beaumont had no official mandate; he was simply moved by his intuition and his ability to combine the most audacious aesthetic movements of his time, as well as an enthusiasm for transgressing the received tastes of his class. Étienne de Beaumont, then, was the aristocratic equivalent of the bourgeois Roger Dutilleul. He sold the family's eighteenth-century paintings to buy works by Picasso, Picabia, Braque, and Gris, and on August 30, 1918, he caused another sensation when he organized a party featuring "forty-five gold and silver trombones," which "some claim was the first event in Paris [. . .] to promote jazz music"—played by Black, off-duty American soldiers—in the garden of his mansion, next to the Jardin des Invalides.[21] Not only that, but during World War I, as leader of the convoys of the Société Française de Secours aux Blessés Militaires, one of the forerunners of the Red Cross, he was sent on a medical mission for the ambulances of the queen of Romania. According to Bernard Faÿ, the count's Saturday afternoon meetings were memorable: "Everyone received a king's welcome, and thereafter the time was devoted to delicate pleasures, in a perfect harmony that occasionally shaded into teasing. In that vast, gilded salon with its Louis XVI stucco and its admirable furniture, one never knew

who one might meet [. . .]. No play or movie or any other entertainment offered me a more varied, stimulating spectacle."[22]

■ ■ ■

How could Picasso have remained indifferent to this phenomenon, he whose participation in the scandal of *Parade* had cast him in the seductive role of provocateur, thus eclipsing, for some, the xenophobic protests against "Kubism" that had prevailed prior to this? But did the artist attend the most banal high-society events to which the count and countess invited him, such as the dance-and-greet with the shah of Persia on December 29, 1919, or the evening with the marquess of Jaucourt and the countess of Nicolai in 1929? Did he attend the traditional Mardi Gras costume balls at the Hôtel de Masseran, like the Dance of Games on February 27, 1922, the Celebration of Tiaras on May 27, 1922 (at the Ritz Hotel, with profits going to the Red Cross), the Baroque Ball of February 1923? Did he accompany them to the Material Ball held on June 19, 1929, by Charles and Marie-Laure Noailles in their mansion on the Place des États-Unis? Did he accept the countess's invitation to attend the opera on March 14, 1925, in the company of Lady Cunard in one of her private boxes? Was he tempted by a dinner with Massine and Mr. Placei, the count's Italian friend, who, Étienne de Beaumont wrote, was "burning to make your acquaintance"?[23]

And what can be said about the harpsichord concert featuring the great Wanda Landowska, which took place on March 9, 1920, or the piano recital given by Arthur Rubinstein on October 6, 1921? "The new social change, in the euphoria of the postwar moment," wrote the sociologist Raymonde Moulin, "was the altered attitude of Parisian high society toward avant-garde art; a change that began with the scandal of *Parade* [. . .]. The brilliant career of the Ballets Russes was decisive for avant-garde art. The social group that called the shots began hosting their parties in décors created by the boldest artists. The origin of this snobbery was a few wild, enlight-

ened aristocrats and some very Parisian writers who were amused by scandal. Between 1917 and 1930, the cursed values were revised, and they became the values of high society."[24] No doubt there was an element of snobbery in the aristocrats' passion for Picasso. In this new milieu, with Beaumont, Errázuriz, Diaghilev, and Rosenberg (in other words, aristocrats, bourgeoisie, and nouveau riche), Picasso probably felt the same ambivalence (halfway between attraction and irony) that Marcel Proust had felt as he navigated with the same Count de Beaumont, and even Princess Soutzo, whom Étienne de Beaumont introduced him to in March 1923, a few months after Proust's death.

Standing haughtily in front of Adolf de Meyer's camera lens in 1924, dressed in top hat and tails, the count is the archetypal good-looking aristocrat. But in Man Ray's 1925 portrait, the almost Greek profile, the thin lips, the cleft chin all contrast with the patterned black tie, the impeccable white shirt and pocket handkerchief, presenting an image of the count as a frowning, almost fanciful poet. This is the same angle taken by Picasso in his pencil portrait of his friend Étienne looking a little disheveled, almost bohemian. It is likely that the artist was influenced by certain events involving the Beaumonts, such as the partial creation of Arnold Schoenberg's *Gurrelieder* on March 20, 1923 (ten years after its Vienna premiere), or the private showing of Fritz Lang's *Metropolis* on May 8, 1927, only a few months after its premiere in Germany). "How can we explain the audacity of aesthetic choices and the accuracy of taste [demonstrated by] a milieu that rescued rejected artists, thus filling the gaping void left by a power subordinate to the Académie?" asked Myriam Chimènes.[25] In those years, it was the Beaumonts, the Polignacs, the Noailleses, the Greffulhes who became talent-spotters, trailblazers, opinion makers. "Artistic patronage," remarked Marc Fumaroli, "is itself an art, requiring good taste and knowledge, that in all circumstances reflects and highlights the quality of the patron."[26]

■ ■ ■

In 1923 Beaumont commissioned Picasso to make some panels for his salon, just as the American collector Hamilton Easter Field had done in 1911. "Dear friend, here are the measurements for the panels. Shall I take care of getting the frames made? This idea pleases me so much that I would like to see it happen as soon as possible. Particularly since, financially, it will be easier for us now, thanks to an unexpected windfall. Would you like to tell me the price for these panels? I would like to say that money is no object, but alas I have a limited budget. Large panel, right side 2.13 x 1.48 m; left side 2.11 x 1.78 m; small panel, right side 2.12 x 1.31 m; left side 2.12 x 1.41 m [. . .]. You know that if you prefer to make the canvases on site, nothing would be simpler for us than handing that room over to you for some time; you could make yourself at home there. You know you have all my affection and admiration. I would like to give you another proof of it, Étienne."[27] Then, in February 1923, Beaumont suggested to Picasso that he team up with Erik Satie for another adventure. "Very happy to meet up with the admirable Picasso, whom I see too seldom," replied the old hermit from Arcueil-Cachan.[28] On May 30, 1923, to a storyline written by the count, to be played on his gilded, eighteenth-century organ, which had just been restored, Satie presented his very brief composition—an entertainment "for trumpet in C and organ"—with set design and costumes by Picasso, and choreography by Massine. This would be *The Discovered Statue*. "When one finds/reaches the wonderful chemistry of both Satie and Picasso," wrote the count, "one should not look elsewhere."[29]

A year later, Beaumont changed pace, neighborhood, audience, and size: he launched his "Paris Soirées," which took place at the La Cigale theater on Boulevard de Rochechouart, with a fireworks display and all profits going to war widows and Russian refugees; the evenings were melting pots for the cultural avant-garde, with a bold program of events. "The fear of not being understood by the public," the count wrote, "usually engenders many compromises and reductions, and we end up with those hybrid spectacles where all too often much of the art displays itself almost ashamedly, appearing

apologetically in flashy coverings that are considered likely to win over a greater number of people, while at the same time disappointing the connoisseurs and the ordinary spectators. We believed that in seeking to please only the former we would not necessarily displease the others, and that it is a grave mistake to underestimate one's audience; they will be grateful, we hope, to be offered only the best."[30] There was also a profoundly nationalist dimension to Beaumont's project, an aspect that would resurface when he joined forces with Marshal Pétain's France in 1940. "The spectacle, the series of spectacles, that we are presenting to the public this spring is the result of patient efforts and the happy gathering of the most diverse set of wills," he added. "Dance, painting, music, poetry all tend to reveal the new soul and youngest face of our country. Our aim was to bring their efforts together." At this point, Beaumont was dreaming of a Picasso-Stravinsky collaboration on the myth of Mercury, but the Russian composer balked at this. "My dear count [. . .] How should I reply? I am greatly tempted by the idea of working with Picasso, for whom I have a limitless admiration. However, the idea of rendering the music of my octet in visual form seems to me a less happy prospect, and here is why. All my other recent symphonic compositions (which in truth are enough in themselves) have existed too little in that symphonic quality for them to be offered to listeners in a visual form. That is why, my dear count, I beg you not to be angry with me if I feel obliged, for the reason I have just explained, to decline (with all my regrets at not being able to satisfy you) your kind proposal."[31]

Exit Stravinsky, then. But that's no problem for the count! In a highly elaborate letter, Étienne de Beaumont explained his conception of the project to Picasso. One can only admire the power of his audacity, the complete artistic freedom he is prepared to offer the creator, his determined desire to provoke. "My starting point for the mythological dance was your drawings," he assured the artist. "I didn't want to mix it up with literature or for the musician or the choreographer to do that either. What I want from you are TABLEAUX VIVANTS. For me, mythology is simply a universal alphabet. Our lives are still based on that old alphabet. It is the only one to have trans-

lated the human soul in simple terms that everyone can understand. Let's use it. Let us also use the elements of translation that we have to hand. A dancer is a pure Mercury. So let us take Mercury rather than Jupiter or Saturn. That said, however, you should do whatever you want and consider this story I am suggesting to you only as a collection of letters given to a child so that he can make words. So what I am asking you for is a series of drawings. Since you have transposed the horrible nudes of the Folies-Bergères into your admirable drawings, you will undoubtedly find a way to dress the admirable nudes of your drawings, unequaled by any human being, for the music hall."[32] This model for the relationship between creator and agent was a thousand miles away from the dictatorial attitude of a Diaghilev, of whom Picasso would soon grow weary.

On June 12, 1924, Picasso met his team for *Mercury*, again including Massine and Satie (who agreed to embark on the adventure that had terrified poor Stravinsky). In shades of beige, blue, and white, as if on a flying carpet, Picasso drew a Harlequin playing the guitar and a Mercury on violin, dynamic, dancing, floating, and as if frozen in the midst of their movements, to which he appended a white ghost above a weightless banjo—thus reinventing, as his friend Étienne had suggested, the old alphabet of classical mythology. But might we not also decipher in these images a perfect allegory of his own situation between the wars: a mercurial artist in a distraught state? "Are we at La Cigale or in the home of the Count de Beaumont?" wrote a Belgian journalist. "The most aristocratic thoughts are united here with the powerful popular instinct, and this meeting has sparked a series of quintessentially French spectacles. Who, then, will dare assert that France is in decay? One need only visit La Cigale for a single night [. . .] to be convinced that French art has never been greater, more active, more generous. Name one city in the world where there are so many living treasures! France and Paris remain the world's heart and brain. Like it or not, this is the starting point for all directions and the destination for all efforts and attempts."[33] This critic would be proved correct.

The premiere of *Mercury* caused a scandal. A review by the

pseudonymous critic Armory describes an "epic assault by a crowd of young protesters, one of whom jumped onto the proscenium, where the Count de Beaumont was seen going over to speak with him. [. . .] Was it a conspiracy? The count welcomed him with a smile [. . .]. His disdainful lordship [. . .], the amiable gentleman thinks there is no victory without a battle . . . The young conductor [. . .] sank into his pit, silencing the chords . . . A minute that might have proved sensational [. . .] fell deplorably into sudden calm."[34] Some avant-garde poets were angry with Beaumont, whose profits were being used to support White Russians, while others started booing Erik Satie, and in the *Paris-Journal* André Breton implored his troops to fly to Picasso's rescue: "I wish to profess my total and profound admiration for Picasso, who, scorning accolades, has never ceased creating the modern anxiety while granting it the highest form of expression. Here, with *Mercury*, he has once again provoked incomprehension with the full measure of his audacity and genius. [. . .] Far more than all those who surround him, [he] appears today the personification of youth and the undisputed master of the situation."[35]

For a few years, then, Beaumont became a lucrative source of funds for Picasso (10,000 francs per performance) and an enlightened patron who allowed the artist absolute freedom of creation along with numerous side benefits. The last work that Beaumont commissioned from Picasso was *Bal de la Mer*, in February 1928: an immense composition (2.13 x 2.89 meters) in the tradition of "magical paintings" but toned down and humorous. Painted in white, blue, and brown, it features, on the left-hand side, a geometric, tiny-headed Neptune with tridents for legs, holding his fish; and, on the right, a stocky, laughing, radiant Sun King with a diamond-shaped belly. This was the end for the unlikely Picasso-Beaumont partnership. When Diaghilev died in 1929, Massine asked Étienne de Beaumont to take over the Ballets Russes, but that is a story for another day.

At a time when, in the mainstream press, the critic Camille Mauclair castigated the "almost Jewish Picasso," it was once again

the Count de Beaumont who flattered, celebrated, and respectfully served the genius of the artist he so admired. Among the mass of archives, two letters from 1920 are particularly revealing about this intriguing friendship—two letters with which I will regretfully end this chapter. The first, from Étienne, begs the artist's forgiveness for two typing errors. "Dear Friend, my admiration blinded me last night and prevented me seeing two mistakes that must have been made by my typist: 1. *Gnossiene* written with two S's; 2. The editor has written DEMETS instead of *Deuts*. Could you correct them and hand the new draft to the waiting porter so that I can, in turn, give them to the editor? Edith finds the writing sublime. Yours, Et. B." To truly appreciate the count's elegance here, we must remember the first police report from 1901, which stated that this "foreigner" spoke very bad French and could hardly be understood, and those despairing letters written in 1903 from Barcelona to "dear old Max," in which Picasso described how "difficult" it was for him to write in French.

The second letter, from Edith de Beaumont, reveals an unexpected side to the count and countess's feelings toward the artist— a mix of deference, respect, and humility: "I have one other thing to tell you [. . .] something that Étienne, who is never intimidated, has not dared bring up with you [. . .]. We have never thought of mentioning the drawing, the drawing and its frame, of course! Deep down, neither of us is shy. What bothers us a little is the admiration that leads us into an area where material issues become ridiculous. And yet, ridiculous or not, they have to be dealt with."[36] This is a curious paradox indeed: if, in the classical era, seeing one's works prized by the aristocracy ennobled the artist, in the middle of the twentieth century, the artist-collector relationship shifted. It was the aristocrat who enhanced his status by purchasing art from a renowned artist. For someone like Étienne de Beaumont, it was trendy to socialize with Picasso, to commission from him panels for one's mansion, a curtain for *Bal de la Mer*, mythological tableaux for *Mercury*, costumes for *The Discovered Statue*: this was an opportunity to contribute to the avant-garde, to outshine one's peers, to become something

more than a simple aristocrat. All this is in stark contrast to the inertia and spinelessness of the official French art world at that time. Ironically, the names of civil servants like Paul Léon and Léon Bérard, who did nothing positive for the avant-garde at all, were nevertheless printed in the programs that accompanied Beaumont's "Paris Soirées" as a sort of official endorsement, lined up alongside the name of Picasso, that foreign artist stubbornly ignored by French institutions but idolized by a young aristocrat.

35.

ARTIST-MAGICIAN (IN THE ORBIT OF THE SURREALIST INTERNATIONAL)

Picasso is the only authentic genius of our age, and an artist like no other that has ever existed except perhaps in antiquity.[1]

—André Breton

Surrealism, if it wishes to assign itself a moral line of conduct, must simply go where Picasso has gone and then go there again.[2]

—André Breton

In the archives of the Musée Picasso, on a tiny scrap of graph paper torn from a notebook, a few lines have been scrawled in haste: "Max Ernst, Paul Éluard, André Breton will come back at a quarter after twelve. Affectionately, André Breton."[3] This minuscule message, probably dating from the early 1920s, provides a foretaste of the cult surrounding the now forty-something Picasso by the most radical creators of the period, most of them ten to twenty years younger than him. After the sequestration of his works in 1914, the artist lived in Diaghilev's orbit, then in Étienne de Beaumont's, on the margins of institutional France. Around 1923, however, in Paris, Picasso was

pulled into a new orbit by the friends of André Breton, followers of Dadaism, who enabled him to return to his original milieu—the land of poets.

Scouted, admired, celebrated, and coopted by Louis Aragon, André Breton, Paul Éluard, and the others in this perpetually shifting group of surrealists, Picasso belonged for a few years to a subversive galaxy studded with legendary names—Rimbaud and Baudelaire, Artaud and the Marquis de Sade, Freud and Lautréamont, Alfred Jarry and Ferdinand Cheval, Apollinaire and Arthur Cravan—all figures who cemented their reputations in magazines such as *Littérature*, *La Révolution surréaliste*, *Le Surréalisme ASDLR*, and *Minotaure*. After World War I, Picasso's cubist works were, of course, much better known to avant-garde artists and intellectuals in the countries of the former Austro-Hungarian empire and in the former German empire than they were to their French equivalents. The Romanian poet Tristan Tzara was a very early cubism disciple: he had been friends with Kahnweiler in Switzerland even before meeting Picasso at Étienne de Beaumont's home when he arrived in Paris in 1920. "The new artist protests: he no longer paints," he wrote in Zurich in 1915. "He creates directly in stone, wood, iron, tin, rocks, locomotive organisms turned in every direction by the limpid wind of the momentary sensation."[4] In Berlin, in 1920, under the pseudonym Alexander Partens, he analyzed the contribution of Picasso's works to the genealogy of the Dadaists: "From the fragile and delicate, almost transparent portraits of his early years, Picasso extracted details and fragments that he twisted until connecting them again in his new painting [. . .]. The old artistic methods seemed worn out. Something radically new was happening."[5]

Throughout the 1920s and 1930s, every member of the Dadaist group would scan the newspapers for true-crime stories—Violette Nozière's murder of her abusive father, the Papin sisters' murder of their bosses after years of daily humiliations—as if they were symptoms of a society on its last legs. "What do they expect of us?" wrote Louis Aragon in his journal after a conversation while walking across

Paris with Breton and Soupault. "Trying to do things so as to avoid indulging the desires of others, and so becoming in their eyes pariahs, thugs, suspects, adventurers in an adventure that they do not understand [. . .]. Breton defines the undertaking of destruction that we are going to begin, with whoever wants to join us, but solely among ourselves, never breathing a word to anyone."[6]

As for Picasso, he contributed to the surrealist movement through his creation of extravagant anthropomorphic shapes, "mineral" women turned geometric and transformed into dinosaurs (with tiny heads and enormous limbs). Familiarizing myself with the 150 "magic paintings" (1926–1930)[7] presented in the exhibition at the Musée Picasso, I feel as if I am being swallowed up by a sudden vortex. Is it the presence, in Room 6 of the museum, of the artist's collection of "magic objects" (Grebo mask from the Ivory Coast, Mukuyi mask from Gabon, Nimba mask from Guinea, Sepik statue from New Guinea, bronze head from the ancient kingdom of Benin), that makes them seem different? The comments of Carl Einstein and Michel Leiris guide our gaze. "Everywhere echoes the polyphonic law of opposites," wrote the former.[8] "The work of art has no other goal than the magical evocation of inner demons," wrote the latter.[9]

For more than a decade, then, Picasso was a hero and an inspiration to the surrealists—an unwitting figurehead. "We returned from the war," noted Breton, "but what we didn't return from was the brainwashing that had turned us in four years from beings that wanted only to live, into wild extremists, not only exploited but capable of being decimated at will."[10] In truth, Breton's journey toward Picasso, though inevitable, came in stages: a young medical student who became a nurse and stretcher-bearer on the Meuse front, then an auxiliary doctor in Paris, he was a powerless spectator to the first horrors in the trenches, before "asking the poets for help"—beginning with Apollinaire, whom he met the day after his trepanation, on May 10, 1916. It was Apollinaire who pointed him toward Picasso. Almost simultaneously, at the neuropsychiatric center in Saint-Dizier where he had been assigned, Breton discovered the dazzling usefulness of

Freudian thought in military hospitals, all while celebrating the po-
etry of Alfred Jarry with his first acolytes: Pierre Reverdy, Louis Ara-
gon, and Philippe Soupault. Finally, on November 1, 1918, Breton
visited the studio in Montrouge for his first face-to-face meeting with
Picasso, before seeing him again a few days later at Apollinaire's fu-
neral at the Père-Lachaise Cemetery. So the young apprentice doc-
tor had turned first to psychoanalysis, then poetry, then art, joining
planet Picasso in what would for him be a genuine epiphany.

The first messages from Louis Aragon reveal a young poet torn
between admiration and guilt when confronted with this man he con-
sidered a "giant." "My editor is pressing me to ask you for the drawing
that you were generous enough to promise me," he wrote to the artist
on February 11, 1919. "So I am doing that, but please believe me
when I say I am ashamed of rushing you, and that had I been alone
in this endeavor I would never have dared bother you so soon. I will
not be at peace until I am certain that you can forgive me. [. . .] If
you are too busy at the moment to take care of this, please send me a
note that I can use to shut the mouth of my tyrant editor who keeps
writing to me, phoning me, etc. I don't know how to apologize or
thank you enough. My regards to Madame Picasso. Yours respect-
fully, Louis Aragon."[11] Six months later, he reiterated his request: "I
have always caressed the dream of seeing my poems beside a few of
those mirages with which you embellish life, and, as I have recently
been gathering the few verses that I have for now, I have enjoyed
imagining my book decorated with one or two drawings by Pablo
Picasso. I know I have done nothing to deserve such a favor and that
I have no right to hope for it. I know all too well that you have bet-
ter things to do than satisfy the desires of all the young people who
don't have enough poems to fill a book. I will fully understand the
thousand reasons you may have to refuse me such an exorbitant show
of support. But despite my certainty that this letter will prove useless,
I feel compelled by principle not to let the slightest opportunity pass
me by, however slim it may be, so I am making this vain request while
praying that you will forgive me and quickly send me the NO that will

put my mind at ease. [. . .] My poor French and the ceaseless repetitions in this letter will prove to you the difficulty I have in writing to you and, even more so, speaking to you. Louis Aragon."[12]

In Paris, paradoxically, the younger generation of artists and poets had only discovered Picasso's work in fits and starts: *Les Demoiselles d'Avignon*, for example, had been shown publicly for the first time in August 1916 at the Salon d'Antin.[13] After that, the public was able to discover his costumes and set designs (at the Ballets Russes and La Cigale) and a few of his paintings (exhibited in Parisian galleries, notably those belonging to the Rosenberg brothers, in 1919). In 1920, 1921, and 1923, during the four auctions of the sequestered Kahnweiler collection, Breton, Aragon, and Éluard would be amazed upon their first viewings of Picasso's cubist paintings, which, after ten years hidden away, were now being sold off amid controversy, score settling, and tensions. Since these poets were systematically dismembering traditional syntax, it is no surprise that it was the papiers collés, with their protosurrealist aspect, that they would feel compelled to possess. From the beginning, Breton and his friends perceived in the prewar Picasso a "courageous precursor [. . .] who could be moved by a newspaper or a pack of cigarettes" because he had felt "that fascination for the hieroglyphs on the walls" that "tell the destiny of an era,"[14] and had spotted the signs and portents of their own disgust before the collapse of the West. In this way, Picasso's work would become one of the engines and one of the cogs in the surrealist machine, even if the young poets would also attempt to drag it into their own explorations in order to stimulate, provoke, challenge, spur, and sometimes preempt it.

But the connection went deeper than that. To construct his models of emerging political and artistic trends, Breton had also looked to Moscow ("of the organized social systems, only communism allowed the greatest social upheaval to take place"),[15] to Vienna (where he would meet Freud in 1921), and to Zurich (supporting the first Dada Manifesto in 1918 and corresponding with Tristan Tzara from 1919 on). An international array of artists including Man Ray (United

States), Tristan Tzara (Romania), Joan Miró and Salvador Dalí (Spain), Max Ernst (Switzerland), and Hans Arp (Germany) would move to Paris to join the local artists and poets (Breton, Aragon, Éluard,[16] Tanguy, Soupault, and Crevel) in idolizing Picasso.

For Picasso, it was the controversy surrounding *Mercury* that provoked yet another volte-face and his move toward this latest group, this latest identity. On June 17, 1924, Erik Satie wrote: "Big fuss yesterday at La Cigale. The Fake Dadaists came to boo me. Those gentlemen Breton & Co. muddle things up so much it's laughable."[17] If the elderly composer blamed André Breton for having booed him while favoring Picasso, it was because the Paris Soirées at La Cigale were the locus of much score settling, sectarianism, and excommunications. "Was he the father of Dada?" Satie asked rhetorically. "Right now he seems more like the son of Abdul Hamid." A few months later the composer added that it had "become almost indecent to talk about Breton," whose role was "now considered so venerable": "He's a pope. He has a modest Vatican, not far from Place Clichy."[18] There were axes to grind on all sides: some of the surrealists with Communist affiliations sniped at Picasso for compromising himself with an aristocrat who supported war widows and White Russians in Paris. Breton wrote the solemn "Homage to Picasso" to change these people's minds; this text, the first of its kind, was signed by fourteen writers and artists including Aragon, Desnos, Naville, Péret, and Soupault.[19]

Ironically, a few months after this controversy, an even more boundary-pushing artistic intervention rocked the city of Bucharest.[20] At a party organized by the avant-garde magazine *Contimporanul*,[21] there were drumrolls and sirens in the darkness, jazz played by Black musicians, a disorienting amalgam of colors that resembled "a gigantic collection of multicolored butterflies." For the spectators, these were not merely theatrical effects but "the genuine modernist ritual of a Dadaist event."[22] How could it have been otherwise, since the people responsible for this soirée were none other than Max Hermann Maxy and Marcel Janco? The former had worked in Berlin with the

constructivists, the latter in Zurich with the Dadaists. In 1924, Bucharest was still being rocked by the Dadaist wake left behind by one of its native sons, Samuel Rosenstock, alias Tristan Tzara, who went on to spread the message through many cities in Europe and beyond: in Cologne with Max Ernst and Otto Freundlich; in Barcelona with Francis Picabia; in Weimar with the Bauhaus group; and in Paris with Hugo Ball, Arthur Cravan, Marcel Duchamp, Man Ray, and surrealists including René Crevel, Louis Aragon, and André Breton.

In Paris, the dynamic that drove young creators to publicly glorify and celebrate the genius of Picasso—a dynamic that was born in those years and would never die—was spread through the influence of artists, sculptors, poets, critics, photographers, dealers, collectors, and editors, but it was powerless to stop the insidious rise of xenophobia secretly fomented by French reactionaries. In the fight against this, it was undoubtedly Breton, with his mane of "nobly swept back" hair (according to Adrienne Monnier), his basso profundo voice, and his rigid sense of discipline, who played the leading role. Acting as a liaison and leader of first the Dadaists and then the surrealists, while also advising the art collector Jacques Doucet, Breton became highly influential among French avant-garde circles and eventually took over the role once played by Apollinaire as celebrator-in-chief of Picasso's art.

Meanwhile, Picasso also became a financial godsend to these young poets, who bought, sold, and exhibited his works. Between July 1925 and August 1934, Éluard wrote a series of letters to his ex-wife Gala, exhaustively detailing his money worries and the deals that he made with those "treasures": "Tonight I am seeing [René] Gaffe to sell him the Picasso. I got 10,000 francs on account (I'll give you 5,000 tomorrow at the bank, maybe 8,500 if the Picasso sells)";[23] "managed to sell the *Métamorphoses d'Orphée* illustrated by Picasso for 4,000 francs but we'll only get 1,200 now, the rest in four months";[24] "I am eagerly waiting to find out if our little green Picasso has been sold [. . .] I'll send you half";[25] "the little Picasso has apparently been sold, but we won't get the money until September 15."[26]

This financial dependence would go on until March 31, 1936. "After not doing the aqua fortis for my little book, Picasso has suddenly absconded and won't be back for a long time—destination unknown," a shocked Éluard wrote. "The hope of getting 500 francs on a regular basis has gone with him."[27] Picasso, as we can see, had become a financial asset, for which Éluard acted as broker, intermediary, and promoter altogether.

In this context, how are we to understand the obsequious nature of the letters with which Breton began to bombard the artist? At the archives of the Musée National Picasso-Paris, there are many examples of his reverential prose. In January 1923, he invited Picasso to join the editorial committee for the magazine *Littérature*, alongside Aragon, Brancusi, Cendrars, Desnos, Duchamp, Ernst, Man Ray, Picabia, and others. And on September 18 of that year, he wrote with a very precise request: "Very dear Gentleman and Friend, In October I am publishing a collection of poems entitled *Clair de terre* and I would do the impossible for you if you would agree that the book should open with a portrait of me by you—a dream I have nurtured for a long time and which I have never dared bring up with you before."[28] To obtain this portrait, Breton wrote another letter on October 9, which demonstrates just how worshipful he had become of the artist to whom he had dedicated the collection's final poem, "Le soleil en lasse": "Dear Gentleman and friend, You have such a remarkable maid that, even though she told me to return tomorrow, I already fear I am bothering you, so I am writing to you to apologize in advance." Finally, on October 29, thrilled to have finally convinced Picasso to illustrate the book, and despite being aware of his relentlessness, the poet wrote again: "Very dear friend, here is the other plate, so soon after the last one that you haven't even had time to draw breath . . ."[29]

■ ■ ■

After the rupture of the war, Picasso's connections to French society were slowly reestablished by way of his new network of disciples. At

times it was a little like being back in the days of the Bateau-Lavoir. For Apollinaire, read André Breton, who orchestrated the cult of Picasso. For Max Jacob, read Michel Leiris, a young poet who would become one of the finest interpreters of the artist's work.[30] He became friends with the artist André Masson and went to meetings in his studio on Rue Blomet with Dubuffet, Miró, Kahnweiler, Artaud, Elie Lascaux, Armand Salacrou, and later Georges Bataille—all of them born circa 1900; only Max Jacob and Kahnweiler, twenty years older, played the role of intermediaries between the historical cubists and these inchoate young artists. Leiris, Miró, and others would go to Boulogne every Sunday, at Kahnweiler's invitation. Before becoming the ethnographer of the Dogons, Leiris married Kahnweiler's daughter-in-law Louise and thus penetrated even more deeply into Picasso's orbit, the two men becoming close friends during World War II. When a new "Homage to Picasso" appeared in the magazine *Documents* in 1930, Leiris immediately categorized the artist as a "genius"—a description from which he would never depart, only adding extra qualifiers to it until settling on the phrase "genius without a pedestal."[31] Even then, he refused to define Picasso, since "the nature of a genius is to cut short all commentary."[32]

■ ■ ■

Among Picasso's new legion of admirers were also now, for the first time, some Catalan artists, rekindling his links with Barcelona. Joan Miró had become friends with Leiris after moving to Paris in 1919, and he joined his voice to the surrealist homage that followed the controversy surrounding *Mercury*. But he did so in his own individualistic way: "My dear Picasso, It is with joy that I read [. . .] the homage that some young men [. . .] wrote to you.—It is also with joy that I join it with all my heart.—It was a beautiful goodbye to Paris on the night of *Mercury*! [. . .] Terrible cowardice—those idiotic critics—those castrated artists (half-eunuchs, half-babies).—Children scared of a scratch!—You have to be able to take a punch from a heavy-

weight, for God's sake!—The stench of those newspapers in Paris and elsewhere contaminates the vault of my sky-blue house! [. . .] You know that I admire the artist and love the man."[33]

Miró's friendship with Picasso was marked by great passion and respect and the closeness of fellow expatriates. "Friend and master, I spent a few days in Barcelona. An absolutely devastating effect, after living in Paris," he wrote in Spanish on June 27, 1920. "The intellectuals there are fifty years behind the times, and the artists strike me as amateurs. Not enough character and too many pretentions! [. . .]—You sense a real lethargy affects the poor souls who spend their lives here." During periods of professional insecurity, Miró would sometimes turn to his "friend and master" to be a spiritual guide. In one of his despairing, disarmingly honest letters, he confided: "You helped me so much this morning. Before going to see you, I was sunk in dark thoughts, but you chased them away. You spoke to me so sincerely. I couldn't care less if I make a mistake. I don't mind walking all my life in darkness if at the end of my existence I discover some spark, some ray of *pure sunlight*, instead of walking like all young people in *artificial lighting from arc lamps*. I feel again the overriding need to work. Thank you. Sincerely, Miró."[34]

Miró acted as a messenger between Picasso and his family, even visiting Doña María. This letter was written in French: "During my stay in Barcelona, I had the pleasure of going to visit your mother and handing her your order. I also told her about my plan to bring her to Paris and my offer to accompany her myself on my next trip [. . .]. Your *Harlequin*, which you gave as a gift to Barcelona, has still not been placed in the museum. I have looked into this [. . .] it is not anyone's fault."[35] Let us focus for a moment on the role of María Picasso y Lopez, who was happy to remain central to the complex network of her son's transactions, even while rebelling occasionally against the status of intermediary that she was assigned by her son. Absence and silence were the artist's methods for dealing with her, while for her part she unwaveringly felt the same expectations, letter after letter, day after day, from 1900 until 1939, as the following letter proves: "Dear Pablo, I am writing to you once again today

because your friends use me as a go-between when they need you for something; I don't like to disturb you, and yet I am doing it because I have no other choice. What I would like is for you to explain something to me. I know this is going to annoy you, but I'm going to tell you anyway: as far as I'm concerned, despite your affection, your generosity, and all your other qualities, you don't write to me; as far as the others are concerned, I don't understand how you can do them so many favors without it seeming to bother you; but I am advising you to open your eyes: you know that he who is in need will seek out any support, but later he will sell out all his 'friends,' including you. Doing good for others is a great satisfaction, isn't it?"[36] In this peculiar relationship, Picasso's mother is only able to reach her own son via his "friends." Her frustration and pride, undimmed by the years, leave her unsatisfied by this sinecure, even if she takes refuge behind Christian morality as a way of comforting herself.

With another Catalan, Salvador Dalí, Picasso's relationship was extremely complex, a mix of complete fascination and brutal irreverence. Laurence Madeline, who edited their correspondence, uses phrases such as "ambiguous admiration,"[37] "fake or calculated allegiance,"[38] "feverish attentiveness and infatuation."[39] In April 1926, Dalí met Picasso for the first time and assured the older artist of his "unconditional admiration." "When I arrived at Picasso's studio on Rue La Boétie," Dalí wrote in his autobiography, "I was as moved and respectful as if I were being granted an audience with the pope himself. 'I come to see you before visiting the Louvre,' I told him. 'You're right to do that,' he replied."[40] Already, here, we can see the ironic distance Picasso was imposing upon the younger artist, who was, like him, an ambitious, provocative, virtuoso talent. "To Picasso, devotedly SDalí," read his first message; it was followed by a tidal wave of postcards bearing images of corridas, fans, landscapes of the Catalan coast, women in mantillas with red carnations in their hair. During that first meeting, Dalí showed the appreciative Picasso his *Girl from Figueres*—a Vermeer lace-maker transplanted to modernist, industrialized Catalonia.

From his days as a student in Madrid (1922–1926), along with

his friends Federico García Lorca and Luis Buñuel, Dalí was an early adherent of the Communist revolution. He also embraced cubism early: he wasn't even twenty when he painted *Self-Portrait with "L'Humanité"* and *Cubist Self-Portrait*, revealing his dazzling mastery of papier collé techniques. And it was due to his allegiance to cubism that he was initially perceived as a "supernatural being,"[41] brilliant, provocative, an idolizer of modernity. With *Pierrot Playing the Guitar* in 1925 and *Neo-Cubist Academy (Composition with Three Figures)* in 1926, he exhibited his borrowings from the new Picasso-esque syntax that he'd discovered in the studio on Rue La Boétie, before joining Miró in "murdering painting" by using extrapictorial materials to explore the subconscious. Later, Dalí would exist in a permanent state of rivalry with Picasso, even if his (ambiguous) evolution toward fascism, his (unambiguous) support of Franco, and his (openly displayed) passion for American dollars would distance him from Picasso, who claimed himself Republican first, Communist second. "Spain has always had the honor of offering the world the most vivid and violent contrasts," Dalí wrote in 1957 in "Picasso and Me." "In this century, they are embodied in the two persons of Pablo Picasso and your humble servant."[42] And then, in 1960: "Picasso appeared at a time when the Académie artists had lost touch with originality [. . .]. Picasso was one of them before becoming *Picasso*. Then this destructive genius gave the Académie a kick in the ass. He destroyed perspective. He took pleasure in bringing together nonharmonious colors [. . .]. Picasso had a considerable influence on the other artists [. . .]. It was always that way with them: Velázquez, Goya, Picasso, and Dalí. We possess a feeling for life that is unique to Spain [. . .]. I am certain that Picasso has not finished surprising the world."[43] Picasso would remain silent throughout all these calls for attention. Refusing to have any contact whatsoever with the Franco dictatorship, he broke off his relationship with the man who had been one of his protégés in the 1930s.

■ ■ ■

The effects of this Picasso-mania went far beyond a small circle of artists, however: the entire avant-garde began to change the way it thought about his work. One of the first to surrender to André Breton's powers of persuasion was the collector Jacques Doucet.[44] It was in 1921 (when Breton was twenty-four years old) that Doucet offered him a job as his "artistic advisor and librarian,"[45] choosing to close the door on the nineteenth century and all its "old stuff" in favor of the twentieth century and the most disturbing aspects of modernity. André Breton had been working with Doucet for less than a year when he tried to convince him to give up acquiring "tiny pieces" by Picasso and to show an interest in a more important work. "You know how regrettable I find it," he wrote to his employer, "particularly when I think about your future house, that you have not acquired any of Picasso's most important works (I especially mean a work whose historical importance is absolutely undeniable, such as *Les Demoiselles d'Avignon*, which marks the origin of cubism and which it would be vexing to see leave the country)."[46]

Two years later, Breton tried again, describing his vision for Doucet's collection. "I believe," he wrote, "that one cannot have enough Picassos, and that his work is the touchstone of any collection. The character that the collection will develop—fascinating or not, rich or poor—depends upon what Picassos it includes." Then, admitting that the choice of which work to buy is "extremely arduous," he states that he knows "only one thing for sure": his employer should acquire *Les Demoiselles d'Avignon* "because it takes us directly into Picasso's laboratory and because it's the heart of the drama, the center of all the conflicts that gave birth to Picasso and that [according to him] will continue: for me, this is one work that goes beyond painting; it is the theater of everything that has happened in the last fifty years; it is the wall transcended by Rimbaud, Lautréamont, Jarry, Apollinaire, and all those whom we still love. If that work were to disappear, it would take with it the greatest part of our secret."[47]

In January 1924, Jacques Doucet finally bought *Les Demoiselles d'Avignon* directly from Picasso for the sum of 25,000 francs. The

artist was disappointed by this price, but Breton intervened on his employer's behalf, explaining that Doucet had already bequeathed his entire collection to the Louvre. "I am the only collector," Doucet himself added, "with the authority to make the Louvre exhibit avant-garde art."[48] For this reason, Picasso accepted the offer. On April 16, Doucet took possession of the painting. Around the same time, he wrote to André Suarès: "The Germans have come to France en masse and are buying up everything that can be bought. I had many offers, but I stand firm in my convictions. It would be ridiculous to let everything go. On the other hand there were two or three pieces that were a little too scandalous, too advanced for them [. . .]. I bought them; in two years, I will be proved right. A large Picasso, *Les Demoiselles d'Avignon*, a large Matisse, some goldfish in a bowl, and the sketch of *The Circus* by Seurat. With those, I have what I need and I can wait. They won't get these pieces in America."[49] Jacques Doucet was a complex character, enigmatic and possessive, jealously protective about his collections, categorical in his refusal to let them out of France. André Breton cunningly insisted on this motivation when he was convincing Doucet to purchase the Picasso. At the end of the year, Breton again congratulated the collector on his acquisition: "Picasso is the only authentic genius of our age, and an artist like no other that has ever existed, except perhaps in antiquity."[50]

Barely ten days later, however, Breton had to again soothe Doucet's anxieties: "I understand that it seems desirable to you to have in writing the place that this painting occupies in the history of modern art," he wrote. "Without it, as I have said many times, there is, to my mind, no way of representing the current state of our civilization from this particular angle [. . .]. Even though I generally concur that poetry is preeminent when it comes to determining the thrust of an era, I cannot help seeing in *Les Demoiselles d'Avignon* the single most important event of the early part of this century. This is the painting that will be carried through the streets of our capital, as Cimabue's *Maestà* once was [. . .]. For me, it is a sacred image."[51] As we see, it was only at the insistence of his very young, bold, and impertinent advisor that

Doucet bought the painting. After that, he had his private gallery built with extreme care; he wanted a pure and minimalist setting for his treasures. Important visitors from the United States, India, and all over the world requested the opportunity to visit. However, as we will see, the power of the forces ranged against Picasso's works in France was such that in the end nothing could prevent the key work in the history of cubism from going west.

Breton's unremitting passion for the painting and for the artist who had created it remained intact until World War II. "Very dear friend, for several days I have been putting off asking if I can see you. I think about it every day, and I tell myself: perhaps there is an hour in the day when Picasso will see me with at least a little pleasure, so why is it so difficult to agree [on] a time?" he wrote on September 29, 1935. "You know how much I admire you and how I have dreamed, ever since I was young, of occupying a small space in your life. One day being one of your friends: that was pretty much my one hope during the war [. . .]. The morning you came to see me, I was so touched." On August 11, 1940, on his way to Poitiers, the poet sent the artist a small note that requires no commentary: "Spent last Sunday in Royan, and I spent a long time looking at your windows as if I hoped to see through your eyes [. . .]. Until very soon, I hope [. . .]. Always with passion, your friend, André Breton."[52] And yet Françoise Gilot would describe how, in 1947, at Juan-les-Pins, upon bumping into the poet on his way back from the United States, Picasso moved toward him, smiling warmly, hand held out, only to discover to his shock that Breton refused to greet him.[53] For the surrealist poet, a member of the French Communist Party, Picasso had become the archetypal traitor.

■ ■ ■

The *Mercury* scandal had revealed the climate of score settling, sectarianism, and excommunications so common in that period: Breton attacking Satie, Germain attacking Tzara, Breton's friends attacking

Picasso, Breton ordering his friends to praise Picasso. The tensions between subversive groups (surrealists vs. Dadaists, surrealists vs. Communists) would not start to relax until the mid-1930s, when the country began its journey toward the Front Populaire. "Stop the war in Morocco!" demanded the surrealists during the Rif War in a joint statement with the Communists in protest against France's colonialist policies. Two years later (in January 1927), Aragon, Breton, Éluard, and Péret all joined the Communist Party.[54] During this period of "class war," the Communists became highly suspicious of bourgeois intellectuals, often labeling them "class traitors." "Should we make laborers read Racine? Or Virgil?" wrote the critic Paul Nizan at the time, eager to show his worth to the party (by attacking Henri Barbusse's magazine *Monde*) before becoming a permanent member. And in one noteworthy passage, which we will remember later, he added: "When a laborer likes Picasso, he will be more effectively corrupted than if he liked Gozzoli. This danger spread across the pages of *Monde* has not yet been described."[55]

But Picasso remained on the margins of all this, despite Breton's best efforts to draw him into the surrealists' controversies. On January 5, 1932, the Association of Revolutionary Writers and Artists was founded, a group that included Communists and surrealists (Éluard was a member, as were Breton, Crevel, Gide, and Malraux). More generally, though, the 1930s were marked by confrontation. There were clashes between established groups and certain surrealists (such as Aragon and Dalí) who flirted with the anarchists. On December 3, 1930, the premiere of Buñuel and Dalí's film *L'Age d'Or* was protested by right-wingers yelling slogans such as "Death to Jews!" and "Let's see if there are any Christians left in France!" These right-wingers included "officials" from the League of Patriots and representatives of the Anti-Jewish League. They vandalized the movie theater, Studio 28, in protest at "the immorality of this Bolshevist film" that attacked "religion, nation, and family." The anarchist surrealists clashed with the police after Aragon's poem, "Front rouge," was published in the magazine *Surréalisme ASDR* (Surrealism in the

Service of the Revolution) in July 1931; the poem led to Aragon being charged (on January 16, 1932) with "provoking soldiers" and "incitement of murder for the aims of anarchist propaganda." Dalí's text "Paranoid Dream," published in the same magazine and described by some as "particularly difficult," also led to a clash with the French Communist Party. Following its publication, Aragon and three others were summoned to the party headquarters on February 2, 1932, and ordered to "renounce surrealism."[56] They then had to publicly denounce, in the pages of *L'Humanité*, "those pretentious intellectuals who do not stir when workers are oppressed but move heaven and earth as soon as their own precious person is disturbed."[57]

So life wasn't simple for Breton and Éluard, who had to steer a path between the excesses of some of their friends and the reactions of others. "We are still dealing with the difficulties caused for us by Aragon," complained Éluard on January 30,[58] although he and Breton still supported their friend by compiling a list of signatures "against any attempt to interpret a poetic text for legal ends." Two days later, Éluard lamented: "Everything is going wrong for surrealism [. . .]. We sent out 2,000 papers for Aragon, but until now we have had only 25 signatures [. . .]. When will we get out of the shit that Aragon has dragged us into?"[59] On February 6, a relieved Éluard wrote to his ex-wife Gala: "We now have 150 responses in support of Aragon [. . .] the most famous ones are Giraudoux, Reverdy, Paul Fort, Jules Romains, etc." Aragon's indictment brought to mind the "evil laws" targeting anarchists at the end of the nineteenth century—an intolerant atmosphere that Picasso knew all too well.

As usual, Éluard and Breton called upon Picasso to support Aragon. The artist hesitated for a long time: the case brought back memories of his years at the Bateau-Lavoir: the imprisonment of Apollinaire for the stolen Iberian statues in 1911, their terror at the idea of being expelled. But the young surrealists didn't understand at all the reasons for Picasso's hesitation. The precariousness of his status escapes them entirely. How would they perceive the vulnerability of their mentor, their supreme asset? In a letter to Gala, Éluard

fumed: "Picasso is asking to consult a lawyer before signing. He's afraid of being expelled. Pathetic, isn't it? If he doesn't sign, we'll denounce him, we'll attack him violently."[60] That didn't happen . . . Picasso's secret wound, the fragility that he didn't reveal to anyone, was the scar he bore for his status as a *métèque*. And no matter how rich and famous he became, that scar never truly healed.

In interwar France—that victorious but wounded country, bled dry, and swept by a wave of xenophobia that stoked suspicion of "the immigrants busy ruining French taste"—Picasso remained fragile. Though for some he was a charismatic leader, for others he was merely a foreigner; since April 1917 he'd had to carry a foreigner's identity card. Idolized by artists such as Breton, Éluard, Miró, and Dalí, but ignored by France's cultural establishment and ostracized by the police—such was Picasso's fate during those years. In the 1950s, in a different context, he would enthusiastically sign petitions, behavior that casts a different light on his mindset during this difficult period. By 1924, for example, Picasso was being attacked by the French artist Maurice de Vlaminck. "Picasso is a con artist par excellence, a born plagiarist [. . .]. If he was in Spain and he'd continued sending a cubist painting to Paris from time to time, everyone would say: 'How wonderful, he's a genius!' But he thought: 'France won the war, I should do an Ingres!' That's why nobody takes him seriously anymore."[61] At the fringe of French society, Picasso became the archetypal menace because he increasingly represented everything the patriots hated: he was rich, famous, unfathomable, uncontrollable, cosmopolitan.

With the rise of fascism in the 1930s, the surrealists' responses to the attacks they sustained would be paradigmatically divided between the "national" and the "cosmopolitan." From 1931, the stamp on Picasso's foreigner's identity card stigmatized him as "SPANISH." "In the 1920s and beyond, the card became a key tool in immigration policy," explained the historian Marianne Amar. "Between 1924 and 1933, the texts changed almost every year [. . .]. Nevertheless, the overall trend was toward the strengthening of administrative con-

trol [. . .]. In this way the card traced a border within the foreign population of France, dividing those who were in a 'regular' situation from the others: illegal immigrants living secretly in France without papers."[62] On April 24, 1934, the publication of a surrealist tract entitled "The Planet Without a Visa" (signed by quite a large number of foreign comrades) argued that Trotsky's expulsion from France was an act that "marks the point of departure for repressive measures against Communist immigrants and prepares the ground for outlawing revolutionary organizations." In January 1939, another tract entitled "No Homeland!" published by the FIARI (International Federation of Independent Revolutionary Art) emphasized the number of "artists from all over the world" living in Paris and argued that the city remained "a truly international laboratory of ideas. Art, like the worker, has no homeland. Advocating a return to 'French' art, as the fascists do today, means opposing the continuation of this close relationship necessary for art; it means working to divide and confuse people; it represents a premeditated attempt at historical regression."

Despite the tributes, celebrations, and endless praise, despite the succession of exhibitions (the Paul Rosenberg gallery, the Pierre Colle gallery, the Gradiva gallery, and the Percier gallery [opened by André Level in 1924]), nothing could turn back the rising tide of xenophobia or break the deafening silence of French officials, or remedy the glaring absence of Picasso's works in French institutions. In 1939 the state of play was simple: the Jeu de Paume museum had bought *Portrait of Gustave Coquiot* (1901) from Coquiot's widow; the Museum of Grenoble had *Woman Reading* (1920), donated by Picasso. And that was all. When, in 1929, the Louvre rejected Jacques Doucet's offer of *Les Demoiselles d'Avignon*, it seemed a death knell.

36.

SCULPTOR, MINOTAUR, DEVOTED ARTIST

> Painting is supported only by Picasso, but how wonderfully
> he supports it. We saw at his studio two paintings he'd
> just completed [. . .]. They were neither cubist nor
> naturalist [. . .] they were magnificently erotic. We left
> his studio crushed.[1]
>
> —Daniel-Henry Kahnweiler to Michel Leiris

In April 2011 the Gagosian Gallery in New York presented *Picasso and Marie-Thérèse: L'Amour Fou*. This was where I really got to know Marie-Thérèse Walter, hitherto one of the most mysterious figures in Picasso's orbit,[2] thanks to the eighty wonderful works gathered in the gallery, almost half of them completely unknown. In the six vast halls of the Chelsea gallery, I witnessed, along with many others, the sudden entrance of this seventeen-year-old girl into the artist's life, when they happened to meet outside the Galeries Lafayette department store. "You have an interesting face," the artist told her. "We are going to do great things together. Would you pose for me?"[3] In 1927, this episode opened yet another door in Picasso's already highly complex world, and, as Brassaï put it, "everything started to undulate": Marie-Thérèse Walter's arrival on the scene signaled a creative shift.[4] Picasso began using new tools, and, to continue making his way through the troubled 1930s, he found a solution that was, this time, geographical: in June 1930 he bought Boisgeloup, a

large "eighteenth-century manor house with outbuildings including a sculpture studio" (uninhabited since 1912). Here, he worked with an unprecedented dynamic rage. Those "Marie-Thérèse" years at Boisgeloup brought forth classical Ingres-esque drawings, powerfully sensual sculptures (in plaster, bronze, bas-relief, and Etruscan-style carved wood), paintings, engravings, pastels, photographs, collages, drawings on wooden doors, still lifes, portraits, one after another at an incredible rate—Picasso prowling around his model, embellishing her, transforming her, deforming her, annexing her, like a wild animal circling its prey.

■ ■ ■

The acquisition of Boisgeloup—a fortress transformed into a château in the seventeenth century, substantially reconstructed at the end of the eighteenth century following a fire, with a small chapel dedicated to the Virgin Mary, and a "barn open to the elements, impossible to heat"[5]—is a crucial stage in Picasso's trajectory: it was his first property on French soil. It was also a catalyst and accelerant in his creativity—there were enormous sculptures with Marie-Thérèse as model, engraving work with Paul Fort, ironwork with Julio González, and a return to recovered materials (tennis balls, chicken wire, bits of a rabbit cage). "Once he had Boisgeloup, a three-hour car trip took Picasso far from the frenzy and noise of the capital," his grandson Bernard Ruiz-Picasso explains. "People sent him images from all over the world. Zervos, Tériade, his Spanish friends, and many others would supply him with books, about the discoveries of Iberian sculptures, for example [. . .], and Picasso lived surrounded by books, magazines, newspapers, objects [. . .] that he didn't always have time to read or look at, but that stayed there, like a universe of shapes."[6]

Roland Penrose is one of many who have described "the Saint Bernard dog that he was very fond of" and everything at Boisgeloup that "satisfied Picasso's taste for the monumental [. . .] the gray walls and the beautiful masonry [. . .] the things he surrounded

himself with [. . .] the hippopotamus skull displayed in the entrance hall, and a majestic example of Baga sculpture from French Guinea. That sculpture, with its exaggeratedly hooked nose and its head almost detached from the neck, was echoed in the monumental plaster heads on the other side of the courtyard."[7] Boisgeloup became a protective space where his work took center stage (with its own laws and rhythms), free from the control of his wife and his art dealer Paul Rosenberg, providing Picasso with his first territorial conquest. There he was able to bring together all the attributes of a sort of principality (with, so it's said, a luxury car, chauffeur, and pedigree dog), prefiguring his future territorial conquests that would consecrate his victory over stigmatization. "I think [. . .] Boisgeloup perfectly illustrates the Picasso paradox, the contradiction that exists between the man and his media image," his grandson continues. "On the one hand, he now had the status of a star, but on the other hand, in reality, he hadn't traveled much and spent all his time working in his houses."[8]

■ ■ ■

In 2017, like the wider Parisian public, I was intrigued by the chronological angle of the exhibition entitled *Picasso 1932: Erotic Year*, which followed the events of a single year, revealing—day after day—the artist's production and life; the exhibition's thesis was supported by paintings, documents, archives, and photographs. We discovered the extraordinary productivity of that period and the different aesthetic strata of the works he developed, including the strange *Crucifixion*, with themes that would return five years later in *Guernica*. "The only metaphors to describe his work are geological," said Laurent Le Bon, "such as layers, strata, faults, folds, and metamorphic rocks."[9] The public was granted a voyeuristic glimpse of the farcical situations created by Picasso's double life at the time, marked by increasingly interwoven networks; a cluster of paradoxical situations in which Picasso was torn between his erotic obsession with Marie-Thérèse Walter

(80 percent of his artworks that year featured her as a model, including 111 paintings) and Catholic tradition, with the communion of his son Paulo celebrated in the presence of his mother, who had traveled from Barcelona for the occasion. The public was also able to gauge the fearlessness of his work, and the numerous friends and colleagues around him who in one way or another ensured its distribution (Éluard, Zervos, Tériade, Rosenberg, Kahnweiler, Brassaï, and Leiris, who was in Africa at the time) and finalized the publication of the first volume of his comprehensive annotated catalog. The public was amused by the conjunction of the most prosaic elements of daily existence (receipts from hotels and the butcher, a publicity pamphlet for luxury cars such as the Hispano-Suiza, which he would buy for himself) and the most glorious and symbolic elements, like the artist's pride at becoming an entry, at the age of fifty-one, in the Larousse dictionary, or the fact that he himself, for the first time, hung the 136 paintings of his first retrospective at the Georges Petit gallery.

This "first retrospective of an artist who is becoming a contemporary megastar," this "tour de force of one man's creative imagination,"[10] was a society event that would draw collectors from all over the world, with Picasso playing the role of sole curator of his own entire oeuvre, organized by a consortium of art dealers in the luxurious galleries behind the Madeleine Church, an exhibition that began one year to the day after Matisse's retrospective. Thanks to his rapid emergence in the United States (between 1921 and 1929, the prices of his paintings increased by a factor of four while Matisse's stagnated),[11] Picasso was able to gauge in concrete terms just how far ahead of his rival he had now surged. The pomp and splendor of the Georges Petit gallery in fact owed a great deal to American dealers, partly funded as it was by the man who had become one of the foremost collectors of Picasso's work in the United States: Chester Dale. In February 1931, he had bought the legendary painting *Family of Saltimbanques* (formerly bought by André Level at the Bateau-Lavoir for his La Peau de l'Ours consortium) for a knockdown price from a German dealer in rather unusual circumstances,[12] afterward show-

ing it off like a trophy. For the previous three years, this aggressive businessman-collector had also managed to insinuate himself into the world of French art dealers such as Étienne Bignou and Josse Bernheim by helping them fund the Georges Petit gallery.[13]

For this premiere in 1932, Picasso took things in hand: measured by the sheer number of works exhibited, he surpassed Matisse by one-third. And while the hanging of Matisse's retrospective had been carried out by his dealers, Picasso himself took care of his own hanging, while also choosing which works would be displayed (the selection spanning from 1901 to the most recent months of 1932). One critic, attempting to visit the gallery before the opening, described an incredible scene: "Almost as soon as I entered, I bumped into Picasso, who was ordering a group of exhausted men to hang, take down, and rearrange paintings. Apparently, they had been doing this for the past week, trying to meet his demands."[14] Picasso was determined to present his work as an organic whole, organizing it thematically rather than chronologically. So the biomorphic shapes of the 1920s rubbed shoulders with *Girl with a Basket of Flowers* from the Rose period and *Mother and Child* from the neoclassical period; meanwhile, the cubist *Harlequin* from 1915 was in a dialogue with *Boy Leading a Horse* from the Rose period; and *The Adolescents*, painted in Gósol, was hung next to *The Kiss* (from the "Marie-Thérèse period"). Now fully in charge, Picasso took up the reins of his own work, putting an end to random amputations, arbitrary categorizations, and pointless confusions to state with absolute authority the coherence and unswerving power of his genius. In 2017 at the Musée Picasso, the *1932: Erotic Year* exhibition reconstructed that retrospective, and the results were impressive, giving visitors a sense of Picasso in all his glory, but one important element is lacking: the representation of Picasso in the 1930s by the French police—an additional entanglement, an anomaly, a scandal, but also a key to understanding this already quite muddled situation.

On the sixth and then the eleventh of July 1932, newspaper coverage of Picasso's success provoked a resurgence of interest from

French authorities, just as his exhibition at the Vollard gallery had done in June 1901. This correspondence, kept in the National Archives, comes from the cabinets of the foreign minister and the president of the council. "My department would be interested to know what information you possess on the nationality of the artist Mr. Pablo Picasso, who resides in Paris at 28 Rue La Boétie," wrote the assistant director of the foreign ministry to the prefect of the Paris police (department of foreigners), demanding an investigation at the Ministry of the Interior. "Please provide me with this information as soon as possible," he insisted. On July 12, the director of the Sûreté Générale replied to the minister of the interior with an insipid report on the artist's personal information, before adding a few remarks about his status as a foreigner, revealing the xenophobic venom of French bureaucracy in the 1930s: "Picasso is considered to be in possession of a considerable fortune. He pays 70,000 francs in rent for an apartment on Rue La Boétie and employs four servants. He recently acquired a vast property in Gisers [sic] (Eure). Spanish by birth, it does not appear that MR. PICASSO has acquired another nationality. Indeed, research undertaken at the Ministry of Justice (naturalization department) and in other official departments has not enabled us to establish that he has changed nationality."[15] Yet another memo emphasizing once again the stereotypical reactions—suspicion, jealousy, arbitrary stigmatization—to the Other in a France that would see fascist parades less than two years later. After demanding a supplementary investigation that did not immediately materialize, the director of the French intelligence agency became annoyed, and on November 25, 1932, he angrily scrawled in red pencil: "Respond urgently to the foreign ministry." On January 13, 1934, he received his department's handwritten response. One week later, after typing the definitive report, the prefect of the Paris police decided to delete two significant elements of the first draft: that Picasso was a "well-known" artist and that "information provided on the party in question was not unfavorable."[16]

Since 1918 there had been consternation in France about the

"state of fatigue left by the war."[17] In the 1920s, to replace the dead
or mutilated men (a deficit of almost 3 million workers), the demand
for foreign labor became an urgent necessity. From a figure of
1.5 million foreigners (4 percent of the country's population) in 1921,
within ten years the number of foreigners in France had reached
3 million (7 percent). During the recession of the 1930s, however,
foreigners began to be regarded as a threat: "Faced with growing un-
employment," historian Claire Zalc notes, "foreigners were accused
of 'stealing jobs from French people.'"[18] In 1931 a wave of xenopho-
bia swept the country, with a proliferation of newspaper reports on
crimes committed by foreigners.[19] "Three Italians rob the mayor's
office in Pierrefitte"; "Chinese man kills a dentist"; "Violent brawl
between Poles"; "Spaniard strangles 50-year-old man to death" . . .
These were some of the headlines in *L'Oeuvre* and *Le Populaire* in
1931.[20]

Three years prior to that, Albert Sarraut, the minister of the in-
terior, had given a speech to an audience of policemen deploring the
growing number of foreigners in the capital and justifying the po-
lice's severity toward "those who impose their customs, their habits,
their faults and their vices, making life more and more difficult for
the forces of law and order."[21] Necessary for the country, but disturb-
ing and criminal: this is how the three million Italian, Polish, and
Spanish workers were perceived in France in 1931, having migrated
en masse to the mining regions of the north and northeast and to
factories and farms all over the country. "Welcome, or not made too
unwelcome while times were good and unemployment low," writes
Eugen Weber, "outsiders were swiftly resented once jobs became
scarce."[22] But that was true not only for the working classes. The
art world was subject to the same rules. Let us recall the papers by
critic Camille Mauclair, who made it his specialty to target "the false
aesthetics of so-called modern painting," the "pictorial Soviet of the
École de Paris," the "*métèques* busy spoiling French taste," the "im-
porters of hideous expressionist works," the "half-Jews like Picasso
[*sic*]," the "Masons," the "Communists (Signac), and other Bolshevik

agents." "You don't have to be xenophobic," he explained in 1930 in his article "*Les Métèques* Against French Art," to be concerned about "the growing number of *métèques* who, brandishing a naturalization certificate whose ink is scarcely dry, install themselves in France to judge our artists without an intimate sense of our race."[23]

Twice, in the summers of 1924 and 1927, new laws were decreed,[24] reminding Picasso that what the texts of these laws described was some sort of terrible affliction—his *foreignness*. And yet, during those years, no one among his friends, colleagues, or admirers even thought about it. Let us return to the archives of Le Pré-Saint-Gervais and reopen file number 74,664—"Name: Ruiz Picasso, a.k.a. Picasso Pablo"—so that we can have some idea of the minefield of bureaucracy through which the French police made him walk, with the following summonses to his local police station: on October 10, 1917, to fill out a police form; on July 1, 1918, in preparation for his wedding to Olga Khokhlova; on September 6, 1918, for the renewal of his foreigner's identity card, and again on December 2, 1919, on July 4, 1927, on July 3, 1931, on June 26, 1935, on November 23, 1937, and on November 30, 1939. So many appointments given, so many fingerprints taken, so many mugshots of him looking like an ex-con—and yet he seems to have submitted to these visits without protest. How did Picasso put up with these encounters with the police? Internationally renowned but stigmatized within his country of residence, he found himself in a paradoxical situation. In the world of French galleries and critics, he was idolized, while among official institutions he remained invisible, and in the eyes of French law and order he was considered with suspicion. Thanks to his political analysis, and then to his construction of an autonomous domain where he could live as master of all he surveyed, he was able to control the situation and finally to turn it to his advantage. On December 2, 1919, his signature on the receipt of his identity card was a large, flourishing "Pablo Ruiz Picasso," its elegance perhaps a reaction to the humiliation he felt, an attempt to refuse his status as a victim. And what did the fearless artist feel when, on July 3, 1931, he saw for

the first time, on the new receipt, the police bureaucrat stamping the word "SPANISH" in big black capital letters?

In the last decade of the nineteenth century, at the time of the anarchist attacks, Alphonse Bertillon introduced new bureaucratic practices to the foreigners department of the Paris police. Soon, police representatives from all over Europe would visit the French capital to admire this model—the centralization of legal dossiers, a system of small, standardized cards labeled "Parisian files" that enabled the police to index a variety of information including photographs, fingerprints, and anthropometrics. With this Bertillon system, three decades of accumulated information could be organized, presenting a picture of the tempestuous period from the Dreyfus Affair to the anarchist attacks (1880 to 1910). With the 1888 decree that required foreigners to present themselves at the local police station as soon as they arrived in Paris, and with the successive waves of immigration, this department had, by 1921, stockpiled the impressive number of 2.5 million files, making immigrants the population group with the largest presence in the archives of the Paris police.[25] It was also this Bertillon system that was responsible for the first reports by the informers Finot, Bornibus, Foureur, and Giroflé on a certain young artist about to have his first exhibition.

A particular mention must be made here of Célestin Hennion, who was named prefect of the Paris police on March 31, 1913, and nicknamed the "apostle of modernity" (just as Picasso was ushering in a different kind of modernity with his papiers collés). On June 2 of the same year, Hennion announced his intention to reorganize, as he put it, "a house weighed down by its aging constitution and by rules that it can't change as quickly as it would like"[26] before creating the first police department in the world expressly designed to monitor foreigners. In 1917, the foreigner's identity card was voted into law, but until 1921 the department was understaffed. Things only changed when the nationalist deputy Émile Massard (vice president of the Paris local council and, most important, budget rapporteur for the police prefecture) provided the financial, human, and technical

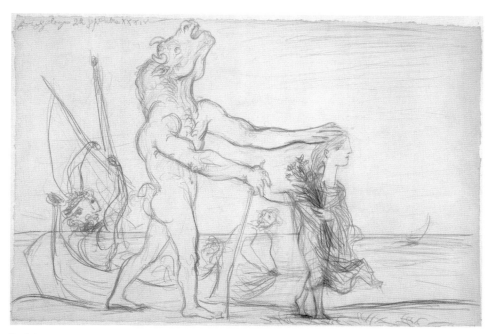

Pablo Picasso, *Blind Minotaur in Front of the Sea Led by a Little Girl*, 1934
(Musée National Picasso-Paris / © Succession Picasso 2022)

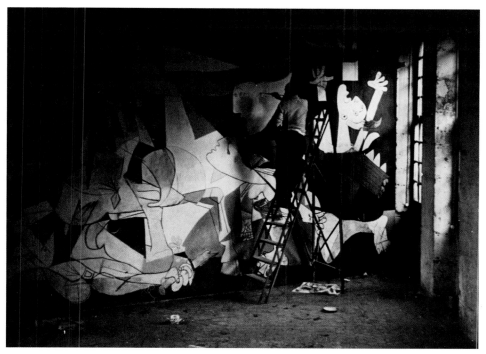

Picasso painting *Guernica* in his studio on Rue des Grands-Augustins,
May–June 1937. Photograph by Dora Maar (Musée National Picasso-Paris /
© Succession Picasso 2022)

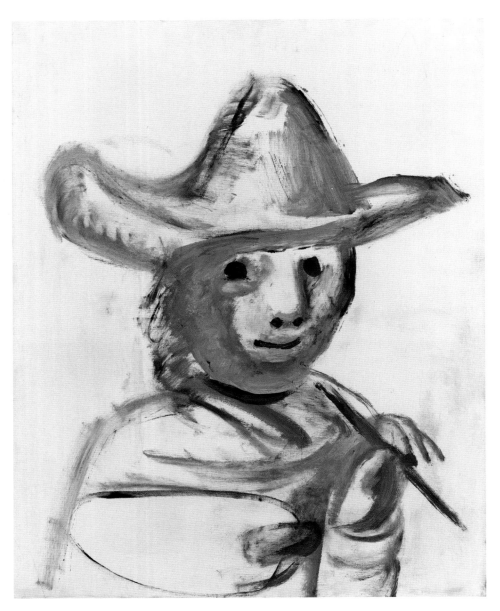

Pablo Picasso, *The Young Painter*, 1972 (Musée National Picasso-Paris / © Succession Picasso 2022)

resources that the police needed. It was during this more prosperous period that the legendary room number 205 was created, on the third floor of staircase F, in the police headquarters at 9 Boulevard du Palais on the Île de la Cité. The walls of this room were completely covered in specially built, dark wood shelves housing endless rows of files—a colossal bank of cross-referenced data that, in the absence of any technology that could sort through it all, was something of a white elephant. On these shelves, however, were to be found all the documents that—during the 1920s, 1930s, and 1940s—would supply the police's dossier on Picasso.

In 1923, the immigration department was considered by Robert Leullier, the police prefect at the time, the most important in the force. In 1925, Alfred Morain, his successor, made the final touch by connecting it to the intelligence services in order to control the political threat represented at the time by immigrants who were joining the French Communist Party.[27] The next two police prefects, Jean Chiappe (May 1927) and Roger Langeron (March 1934), devoted ever greater resources to the surveillance of foreigners in Paris, with the budget for the department increasing exponentially from 2.5 million francs in 1922 to 8 million in 1939.[28] All over the world, the extreme sophistication of French surveillance of foreigners was admired as a "laboratory of police modernity."[29] For Picasso, this police modernity would mean that, after seeing his identity card stamped with the word "SPANISH" in 1931, he had his fingerprints taken in 1938 (as a consequence of the Daladier decree).

During this period, it was once again André Level who protected and guided Picasso. In their correspondence, we can trace the underground xenophobia that would, a few years later, come to the surface of French politics. In the summer of 1924, Level interrupted Picasso's family vacation to remind the artist of the publication of a new law on rents, enabling tenants to keep their apartment until January 1, 1926. This law "does not appear to make any distinction for foreigners," he noted on September 3. "But it does oblige all tenants to inform their landlords by bailiff's order within three months

that they intend to benefit from the extension offered to them by the law. Since your lease expires [. . .] in October [. . .], you must tell your landlord you intend to stay *by the end of September.* [. . .] If you won't be back in Paris before then, you can send me a note with the name and address of your landlord and your intention to benefit from the entitlement to keep your apartment until January 1 [. . .] [and I will talk to] my lawyer about what step we should take next."[30] Two weeks later, the now anxious Level returned to the same theme. "I have examined the new law," he wrote, "and I have discovered that the benefit it offers can only be applied to foreigners *admis à domicile.* This is a very rare legal situation that precedes naturalization and can be obtained only by decree. I am convinced that you do not fit into this category of foreigner, and to obtain *admission à domicile*, you would have to go through quite a few formalities, and the decree would have to be issued, which would take a long time. I am annoyed that I wasn't able to study the law earlier because I was on vacation, and I fully apologize for my delay in informing you about the situation following this unfortunate combination of circumstances. Again, I am very sorry for this involuntary mistake, and I hope you will believe that I am, my dear friend, ready and willing to help you in any way I can."[31] It is clear from this letter that Level was all too aware of the precariousness of Picasso's situation in the country.

Some research into the French law archives enlightens us on that rare legal situation: *admission à domicile* (meaning "settlement of residence") was the "authorization, granted by the French government to a foreigner, of establishing France as his place of residence and enjoying civil rights there." Since Year XI of the revolutionary era, in application of the Napoleonic Code, article 13, decreed on Ventôse 17, Year XI (March 8, 1803), requests for *admission à domicile*, investigated by the Ministry of Justice, ensure "the foreigner allowed by the government to establish his domicile in France [that he] will enjoy all civil rights as long as he continues to reside there." Did Picasso understand the significance of this statute? Having lived in France for more than twenty years, he could easily have begun

such a procedure, and it would certainly have been in his interests to request an *admission à domicile*. But he was so fixated on his work that perhaps he never noticed the rumble of the coming storm. Five days later, another letter from Level: "Dear friend, I was finally able to speak with my lawyer [. . .]. He agrees with me that you should seek to reach an agreement with your landlord or his representative. But if he remains intransigent, my lawyer confirms that, even though you are a foreigner, there are numerous options open to him and that you are not about to lose your home. Nevertheless he strongly advises you to contact the manager before October 15. I remain, of course, always at your disposal, and do not think that your return cannot wait until that date."[32] I need hardly emphasize, yet again, the demeaning status of the foreigner in 1920s and 1930s French society. In 1927, a law was decreed to facilitate the integration of the recent wave of immigrant manpower, making it easy to be granted French nationality by reducing the minimum residence period to three years. Between 1927 and 1938, the number of naturalizations rose from an average of 38,000 per year to 81,000. Did Picasso realize then, as well, that it would have been in his interest to use the fact that he had lived in France since 1904 to request naturalization? No, not yet.

■ ■ ■

How do we analyze the "Boisgeloup effect" in the history of Picasso's various residences? Since settling in Paris in 1904, he had worked furiously to have his works exhibited and sold, and then—from 1906—to be the leader of the city's avant-garde. Step by step, over the course of fourteen years, his Parisian trajectory was marked by an impressive modification of his geographical position in the capital, following the gradually rising curve of his income. The list speaks for itself: 1904–1909: 13 Rue Ravignan; 1909–1912: 11 Boulevard de Clichy (while maintaining a studio on Rue Ravignan until 1912); 1912–1913: 242 Boulevard Raspail; 1913–1916: 5a Rue Victor-Schoelcher; 1916–1918: Rue Victor-Hugo in Montrouge; from 1918

(an apartment, then a studio): 23 Rue La Boétie—a textbook socio-logical ascent from working-class neighborhoods to chic neighbor-hoods; a long list of rentals preceding the purchase of Boisgeloup in June 1930. Gradually, in a quarter century, Picasso managed to escape the degrading assigned place where he began in 1904, exhibit-ing all the signs of someone who had made it in French society.

Still, the police made a habit of stigmatizing foreigners by iden-tifying them with their type of residence, trapping them in a vicious circle. And Picasso's case is no exception to this rule. Later, a po-lice officer would be baffled: this "foreigner" was renting two apart-ments on Rue La Boétie (in the same neighborhood as the Élysée Palace) for the astronomical sum of 7,000 francs per month, as well as (from 1936) a studio on Rue des Grands-Augustins, close to Place Saint-Michel. And that was before he discovered that he also owned a seventeenth-century manor house in Boisgeloup. Perplexed, the police officer ended up doing a lot of crossing-out as he tried to work out the correct designation for this property in the official docu-ments. What was Boisgeloup, exactly? Was it a manor house? A prop-erty? His hesitations, his ironic remarks on the foreigner's real-estate property and rentals make it clear that, for him, he represented an anomaly.

■ ■ ■

But Picasso the strategist had more than one trick up his sleeve. And this is the hidden side of the story revealed to me as I read through the contents of boxes 120, 121, 122, and 123 in the archives of the Musée Picasso. After the phenomenal growth of the artist's income in the 1920s (as revealed in his correspondence with Paul Rosenberg), this was another level altogether. In 1926, Max Pellequer (who, along with his brother Raoul, was a nephew by marriage of André Level) became Picasso's benevolent financial, legal, and administrative advisor—a position he would keep until his death. The artist's extreme wealth in the coming years would be due in part to Max Pellequer,

who in his office at the Banque Nationale de Crédit also worked for Picasso. The archives at the Musée Picasso give us an insight here into a little-known side of the infrastructure and mechanics of the Picasso factory. "Dear Mr. Picasso, Excuse me for disturbing your rest and momentarily forcing you to leave your dream domain in order to listen to the friendly voice of your banker," Max Pellequer wrote in August 1927. "I must admit that I have been trying to defend your interests as if they were mine without bothering you about the details, but now I have to update you, I can tell you that I bought on your behalf 50 shares in Crédit Général des Pétroles at 1,870–80 and that I sold them again at 2,205, producing a profit of more than 300 francs per equity, which represents an overall gain of about 15,000 francs. The day before yesterday, I bought on your behalf 150 shares in Chemins de Fer Orientaux at 1,400 francs, and today those shares have a value of 1,500, in other words another profit of 15,000 francs. Naturally I sold those shares because I considered the profit sufficient; I act on your behalf as I would act on my own. All the same, I felt I owed you a few explanations. I think you will approve of what I am doing. I know from my uncle André that you are settled principally in Cannes, but according to the newspapers the Côte d'Azur appears to be unbearably hot. I sincerely hope you have not been bothered by the weather. It would be agreeable to hear your news."[33] Emboldened by this first success, Pellequer reassured Picasso constantly: "I am still taking care of your affairs as if they were my own and things are going well. I will give you more details when you return."[34]

In the space of a few hours, without Picasso even asking him to, the banker had procured for the artist the equivalent in today's money of 28,000 euros, thanks to two judicious investments. "From the family property in Touraine, where I am spending a few highly enjoyable days, I am sending to you and Mrs. Picasso my best regards and hoping to see you soon in Paris, where I will return on Monday," the friendly banker wrote on the back of a postcard showing the eighteenth-century Château de Poulesse in Braye-sous-Faye (in the Indre-et-Loire department) next to a twelfth-century Romanesque

church.[35] After that, Picasso's finances became dizzying: "Dear friend, in the little fishing port of Morbihan, for your information I received a check for 120,000 francs, which I am sending to your bank so that your account can be credited with said sum" (August 6, 1928); "I received the check for 663,000 francs, which I am sending today to Paris" (August 11, 1928); "Berr took care of your residence permit and hopes that you will be able, as soon as possible, to bring two small photographs of Mr. and Mrs. Picasso. I will explain the result of these initiatives when I see you. Your exhibition at R is magnificent" (July 2, 1931); "If you have any difficulties whatsoever, please do not hesitate to let me know. You know that I share all your sadnesses and troubles and that I understand them" (August 7, 1935); "My dear Picasso, I am sending you a checkbook in the name of Pablo Ruiz. Don't worry, I won't give your address to anyone; I perfectly understand your desire for tranquility. As we discussed, I saw Vollard and asked him to transfer the sum that will be due to you in accordance with our agreement; he immediately assented and I myself performed the necessary action. [. . .] I would ask you to forget all your worries and think sometimes of your good friend Pellequer who feels a sincere and profound affection for you" (April 6, 1936); "Before leaving, I took care of your account. There is no need to worry, you may draw checks upon it—they will all be paid" (undated, postcard sent from Port Haliguen); "My dear friend, news from your mother, today I received a visit from 'your friend,' I had the check endorsed, I signed it, and I handed over the money, I did what had to be done" (August 19, 1936); "I received your information, and I will rewrite the history of your case. Your tax assessor Tixier promised me he would eat lunch with his friend the inspector Rousselot and let me know immediately afterward the results of that discussion. Please find enclosed checks for 40,100 francs" (August 19, 1937). In the space of a few years, from the evidence of these letters (and without being able to exhaustively check the relevant bank accounts), it appears that Pellequer sent the equivalent of 850,000 francs (or a half million euros in today's money) to Picasso's account—a sum

that, if he invested it again, as seems probable, would transform the man from the Bateau-Lavoir into a millionaire.

With Max Pellequer having overseen a substantial increase in Picasso's income and found a spatial solution to his personal, professional, and bureaucratic difficulties, it was again to the friendly banker that the artist turned first for advice. "Paris, October 25, 1929. Dear friend, It isn't possible for me to go tomorrow to see the property that interests you," Pellequer replied. "But come to see me on Monday to send the check to the tax assessor and to sign a letter." Was Picasso buying more land in an attempt to head off the threats to his freedom? Only he could answer that. Incidentally and indirectly, some of his works suggest his initially precarious and then extremely complex living conditions. During the first period, we have already discussed the allegory of blindness that crops up in certain paintings. Later, we saw the artist embodied in the figure of Harlequin (the versatile genius of the commedia dell'arte), who reappeared sporadically with the saltimbanques and other travelers.[36] In the 1930s, he personified himself in the figure of the Minotaur, often interacting with Marie-Thérèse Walter. Responding to Tériade's commission (for the cover of the first issue of the newspaper *Minotaure*), he drew in pencil, reworked in charcoal, then engraved a menacing figure, bestial and savage to human eyes. With the definitive image published in June 1933, he created a powerful, hairy, misshapen animal, brutally wielding a phallic dagger in its right hand. The evolution of his double in those years was complex. In the *Vollard Suite* (commissioned by the art dealer in 1930), presented in a "narrative series,"[37] the Minotaur became "the incarnation of an ambivalence,"[38] a figure simultaneously fragile and powerful, filled with desire and close to death, which returned gently, then raging, then ever more violent—Picasso opposing pairs such as bestiality/femininity, physical brutality/the sleeping woman's abandon, intensified sexuality/vulnerability. For evidence of this, see: *Wounded Minotaur VI* (May 29, 1933), *Dying Minotaur and Compassionate Young Woman* (May 30, 1933),[39] *Minotaur Caressing the Hand of a Sleeping Girl with His Face, Vollard Suite* (June 18,

1933),[40] *Minotaur Raping a Woman* (same day), and *Minotaur Ravishing a Female Centaur.*[41] A few weeks later, he returned to clashes between horse/bull, man/woman, and even the figure of the female bullfighter (embodied by Marie-Thérèse) dying gored by the bull's horns with *Corrida: Death of the Female Torero* (September 6, 1933),[42] *Minotaur Ravishing a Female Centaur*, and *Bacchic Scene with Minotaur* (May 18, 1933, until the end of 1934).[43]

He returned to the project in December 1934 and January 1935 for *Minotauromachie*, perhaps his most disarming sequel, which brought together the characters of his previous stories with *Blind Minotaur in Front of the Sea Led by a Little Girl* (July 22, 1934),[44] *Blind Minotaur Guided by a Young Girl* (September 22, 1934),[45] *Blind Minotaur Guided Through a Starry Night by Marie-Thérèse with a Pigeon* (December 3, 1934–January 1, 1935),[46] and *Minotauromachie* (March 23, 1935).[47] So, with the fate of the mythological figure now dependent, wounded, dying, lost in the hands of a child at another moment of crisis, the theme of blindness returned. Producing *Female Bullfighter: Last Kiss?* (June 12, 1934),[48] *Marie-Thérèse as Female Bullfighter* (June 20, 1934),[49] *Female Torero V* (June 22, 1934),[50] and *The Large Bullfight, with Female Bullfighter* (September 8, 1934),[51] Picasso began a quirky, hypnotic ballet whirling between desire, death, destructive and predatory impulses, physical relentlessness, and wild violence.[52] "Picasso's feasting, loving, fighting Minotaur is Picasso himself," said Kahnweiler. "He wishes to show himself naked, in a communion that he intends to be complete."[53]

■ ■ ■

Picasso built his professional entourage according to his own tastes, integrating other exiles into his inner circle, surrounding himself with an army of admirers, colleagues, experts, and friends who would become the promoters of his work in France and beyond. Though they had various functions, they were all devoted to him, while some admired him so much that they worked for free. It was

as if, despite the fragility of his status as a foreigner, he was already functioning like a nation-state, each member of his entourage running one or several "ministries." In addition to his old dealers (Vollard, Kahnweiler), he was also exhibiting his works in Paris with the Rosenberg brothers, with André Level (who opened the Percier gallery in 1924), with Pierre Loeb (from 1926), with Pierre Colle, and then at the Georges Petit gallery. To this professional circle would soon be added the art historian Christian Zervos, who arrived from Greece in 1926 and founded *Cahiers d'Art*, the first magazine of the era devoted to contemporary art, before beginning the first catalogue raisonné of Picasso's work; the photographer Brassaï, who arrived from Hungary in 1932 and who, upon entering the studio on Rue La Boétie ("I was expecting an artist's studio but it was an apartment transformed into pure bedlam")[54] and the studio on Rue des Grands-Augustins, became an intimate friend of Picasso who could straddle his different worlds; the critic and editor Tériade, who arrived from Greece in 1933 and became the artistic director of *Minotaure* and *Verve*, two magazines that proved themselves essential in spreading Picasso's work; his Catalan friend from adolescence, Jaume Sabartés, who arrived in Paris in 1935 in response to Picasso's call for help and became his roommate on Rue La Boétie, and then his personal secretary; Marie Cuttoli, who in 1936 began a tapestry business in Algeria (in partnership with the Gobelins) using Picasso's designs to produce wonderful work that was exported to the United States; and that's not even counting the Pellequer brothers, those unconditional admirers, collectors, friends, and financial and legal advisors; and so much more. But the best news came from the United States, with the exhibitions of 1934 at the Wadsworth Atheneum in Hartford, Connecticut, and at Paul Rosenberg's gallery in New York. "Yesterday, 304 people visited the exhibition, even though it was Saint Patrick's Day," the art dealer announced proudly, "and 220 were lined up in the street waiting to come in."[55]

The interwar period was pivotal in Picasso's rise, with the artist organizing a system of spectacular relays—which would continue

ramifying in a highly sophisticated way until his death—that demonstrated his knack for persuading others to do his bidding, gratifying them with a signed drawing, a portrait, an engraving, a painting. They were all instrumentalized, of course, but they were instrumentalized in the service of a genius.

37.

POET AND POLITICAL ARTIST
(WITH THE SPANISH REPUBLICANS)

In the painting I am working on, which I will call *Guernica*
[. . .] I clearly express my horror of the military class that has
sunk Spain into an ocean of pain and death.[1]

—Pablo Picasso

It is very important that *Guernica* resembles a photograph: it is
a resolutely modern work.[2]

—Dora Maar

Zurich, September 9, 1932. White pocket handkerchief against beige
suit, dark tie against white shirt, Borsalino hat tipped slightly to the
right, cigarette holder delicately held between index and middle fin-
gers. What is concealed behind this dandyish pose, Picasso looking
triumphant in front of a Swiss lake? We last saw the artist in Paris,
hanging thirty years of his artworks in the Georges Petit gallery in an
attempt to dazzle the collectors who were descending on the French
capital from all over the world. Three months later, Zurich's Kunst-
haus (his "first museum exhibition") signaled another step for-
ward in his quest for international legitimacy. However, Paris in those
years remained—despite appearances—a disaster zone. "We weren't
selling anything [. . .] nobody came to the galleries," Kahnweiler

recalled of that "lean period."[3] The government, poorly equipped to combat the economic crisis, organized a succession of currency devaluations that left the franc, in 1938, worth only half what it had been worth in 1928. But that was only one symptom of the deep-rooted crisis affecting the whole of Europe.

Hence the dandyish, jubilant artist standing in front of the lake in Zurich, proclaiming his rejection of politics to a Spanish journalist: "I will never make art with the preconceived idea of serving as the political, religious, or military art of any particular country," he declared.[4] In 1933, he was producing ever bigger and ever more phallic sculptures of Marie-Thérèse Walter. Then, in 1934 and 1935, he was playing with the two sides of his Minotaur—the repugnant, bestial rapist, wielding its erect dagger, and the loving, tender, disarmed, blind creature, guided by a child through the maze. Meanwhile, in Germany, with the Night of the Long Knives on June 30, 1934, Hitler pursued his fevered march forward. By February 1935, the collection of friends and lovers that Picasso had arranged around him took on a new aspect when he learned that Marie-Thérèse Walter was pregnant. Suddenly the situation became untenable. With the announcement of the birth of his daughter Maya on September 5, 1935, the neat compartmentalization of his life as a married-man-with-mistress collapsed. He moved away from drawing, painting, and sculpture, and began to develop his taste for words, directing all his energy toward writing poetry during a strange "sabbatical year."[5] Unnerved by the financial risks of a courtroom divorce, he drew up an inventory of his works, envisaged various scenarios to escape the trap in which he found himself, and lived a secret life, sometimes abruptly vanishing from Paris, as in the spring of 1936: "Picasso, weighed down by worries, suddenly left a few days ago for an unknown destination," wrote Éluard, "and I don't know when he'll be back."[6]

First an arrangement was reached with Olga Khokhlova: to avoid losing half his fortune, half his work, Picasso let her keep Boisgeloup. Now, dispossessed of his sculpture and engraving studios, he was at the same time dispossessed of the geographical solution offered by

his retreat outside Paris. This was the third impasse of his career—after his inability to join the avant-garde in 1906 (solved by his stay in Gósol) and the amputation of his work in 1914 following the Kahnweiler sequestration. But for the first time, this impasse was personal. An arrangement was made with his old friend Sabartés, to whom Picasso wrote in 1935, asking for his help. "Friend Sabartés, would you like to come with us to the countryside tomorrow with your wife? You can see the sculptures there and we can spend the day together [. . .]"[7]—thus began the first attempt to contact his childhood friend, a critic and writer who, after living in Latin America, was now back in Europe. Picasso made Sabartés his personal secretary and, in 1936, convinced him to live as his "roommate" on Rue La Boétie. Gradually the *"Amigo Jaumet,"* the *"Señor don Jaime Sabartés,"* the *"Amic Jaumet,"* the *"Amigo Sabartés,"* the *"Querido Amigo Sabartés"* was absorbed into the Picasso nebula. A note slipped under his bedroom door on March 9, 1936, offers a wonderful glimpse of this relationship, somewhere between two best friends and master-and-slave: "Sabartés, you who know the hours one by one, can you jump on my bed at 8:30 a.m. so I wake up, it is now 2:00 in the morning and it's March 7 of the year XXXVI."[8]

During the summer of 1936, Picasso's tangled personal situation grew even more complicated. He began a new romantic relationship with Dora Maar, whom he spotted in a café in Saint-Germain-des-Prés (in December 1935 or January 1936? Even now, the question remains unanswered) and to whom Éluard introduced him. Maar was a fellow artist, a well-known surrealist photographer who had worked with Man Ray, Max Ernst, Georges Bataille, and Brassaï. Pierre Daix mentioned a "perfect communion," recalling Picasso's fascination with her in that first scene: Dora Maar at the café, an emancipated woman, intense, provocative, disturbing, playing at stabbing a large knife between the fingers of her gloved hands.[9] Picasso asked for the gloves and she gave them to him.

While I was researching Dora Maar, gathering information on her presence near Picasso during the creation of *Guernica*, I found

many of her portraits in the dark, discordant paintings of the Occupation; I found Chemin de la Barielle, then Chemin du Portail as I went to visit her house in Ménerbes[10] (in the Luberon); I listened to Hélène Klein talking about the quality of her voice on the telephone—when, as a recluse, she refused to receive visitors—and the pathetic handful of people gathered around her coffin on July 27, 1997, at the cemetery in Clamart. But it was at the Pompidou Center, at the first exhibition devoted entirely to Maar, that I truly discovered her work. There was a woman in evening dress, dancing, arms in the air, her back bare, her head replaced by an enormous star, sparkling as brightly as her clothes.[11] There was an infinitely sensual portrait of Leonor Fini, enveloped in a baroque décor of black velvet, breasts surging from a silk bustier, stockinged legs apart (the right one laddered), holding a small black angora cat between her thighs,[12] and much more besides. At that point in my investigation, I decided to question Violette Andrès, the photography expert at the Musée National Picasso-Paris; she knows everything about technique, everything about Dora Maar. Could she enlighten me regarding the photographer's impact on Picasso during those years? "Dora Maar never explained . . . she minimized her role . . . but look at the photos from March 1936 at Boisgeloup . . ." Violette begins, before bombarding me with links that suddenly open up an immense world.

I wasn't aware of those photographs from March 1936. Through Picasso's lens, I discovered a calm, intense young woman sitting in the evening shade, with regular features, pale eyes, dressed in a comfortable cardigan, focused on reading a newspaper, and emanating a vibrant, almost charismatic presence. But I discovered another side to her in the portrait sessions that the two of them conducted together at Boisgeloup—Maar photographing Picasso, Picasso photographing Maar[13]—and in a series of joint experiments that followed in Maar's darkroom on Rue d'Astorg, playing games with the photographer-model and subject-object relationships, taking turns in front of lens and behind the lens, games that she had already played with Man Ray. Picasso was still shell-shocked from the loss of his Norman do-

main, but she provoked him by turning him into her model: sitting, elbows on the back of a period chair, or standing, his whole body leaning, held in balance only by his right shoulder against the wall. And suddenly it occurred to me that Picasso was ceding some of his power to Maar in this particular game. Maar produced some incredible photographs in *Portrait of Picasso, Winter 35–36*, inverting his image, scrawling a halo of black ink on his face to steal one of his eyes and transform him into a Cyclops, playing with him the way he used to play with his models. Thus, Picasso became an object that she could distort at will with beautiful use of shading, contrasts, abstractions, chiaroscuros.

Unlike Breton and the others, there was no obsequiousness in her attitude to Picasso. It was more like two equals jousting. As a subversive daughter of a respectable family, Maar was aware of her superiority and affirmed it with confidence, aplomb, audacity, and wit. A few years earlier, according to Daix, Brassaï had forgotten a blank photographic plate at Boisgeloup, and Picasso, ever eager to experiment, had not been able to resist "the urge to attack this smooth, uniform surface like the top of a frozen lake."[14] Three years later, it was Dora Maar who was teaching him the technique. In the hands of this photographer who had now become his subject and guide, Picasso was, I believe, suddenly destabilized, his legendary fearlessness lost as he was subjugated and stimulated in turn by this political activist[15] who challenged him, this photographer more expert in technique than he was, this respected surrealist (the D of whose first name was one of the initials of the seven surrealist women chosen by Breton for the name of his gallery GRADIVA. With *Dora Maar in Three-Quarter Profile* (spring 1936), *Dora Maar and Antique Figure* (August 1, 1936), *Dora and the Minotaur* (September 5, 1936),[16] and *Dora with Mantilla* (September 20, 1936), by "subjecting her to her own rayogram technique, invented by Man Ray,"[17] Picasso gradually, haltingly attempted to imprison the photographer in his own universe.

The artist found himself caught between two competing demands. New familial and geographical connections linked him to

France (two French children, a property in Normandy, three apartments in Paris), while all the old connections continued to link him to Spain.[18] Emotionally and financially he was torn by these opposing forces, while even within France there was a three-way battle for his money and love, pitting Olga Khokhlova and their son against Marie-Thérèse Walter and their daughter, and now Dora Maar and their joint projects. Politically, with the rise of fascism, he felt drawn by necessity toward engagement. In 1937 he was to be found, nervous and fervent, in his new (but cramped and old-fashioned) studio on Rue des Grands-Augustins, surrounded by Spanish Republicans, desperate to stop the advance of fascist troops in Spain, just before producing what most critics consider his ultimate masterpiece and becoming the archetype of the politically engaged artist, whom José Bergamín and many others would equate with Goya: "To my mind, there is very little difference between the unreasonable Spaniard Goya and the no less Spanish and unreasonable Picasso. [What they share] is Spain's revolutionary intelligence."[19] A change of scenery, a change of characters . . . Picasso's inner circle was now composed of his friend Sabartés, his lover Dora Maar, the poet Paul Éluard, and a young critic named Jean Cassou.

Picasso's abrupt shift into political engagement remains a mystery for some, but it seems to me that his hand was forced by the rise of fascism. It was happening in Spain where, in July 1936, General Franco staged a coup against the Republic that tipped the country into the horrors of civil war. It was happening in Germany where, later that same month, Hitler promised to supply Franco with arms, and where the following year, in Munich, the Degenerate Art exhibition featured Picasso among the list of artists targeted for execution. It was happening in France where the exodus of Spanish refugees to internment camps, which began in the summer of 1936, continued with the advance of Francoist troops until the spring of 1939. "Picasso knows, we all know, that we will be among the first victims of fascism, of French Hitlerism," wrote the critic Georges Hugnet in 1935 in the magazine *Cahiers d'Art*.[20] Picasso's fears, his fence-sitting

and wait-and-see attitude (which, in 1932, saw him ask for help from André Level before he committed to supporting Aragon), along with his general reluctance to become politically active, were swept away by the rise of totalitarianism in Germany, Spain, and France because the reality was that he was under threat no matter where he went. The situation was now completely inverted: the foreigner was about to become the bridgehead for political activism. And if we exclude his Communist phase, this was the only real period of determined, intransigent political engagement in his life. Picasso produced *Dream and Lie of Franco* in January 1937, then five months later he painted *Guernica*, a work of art that would become—that still is—the definitive banner of resistance against all forms of fascism.

■ ■ ■

From 1933, events accelerated around Picasso. In April 1933, the artist celebrated the second anniversary of the Spanish Republic with friends in Paris (after the eight-year dictatorship of Miguel Primo de Rivera), then traveled through Spain during the summers of 1933 and 1934. Solicited by an association of young Catalan artists and poets (the ADLAN), he agreed in principle to a traveling exhibition in Spain. Éluard, Sabartés, Breton, and Zervos all helped in the selection of works. But Picasso remained in Paris, and it was Éluard who, invited there for a series of conferences, arrived in Barcelona on February 14, 1936, giving four speeches in eight days—on Picasso, surrealism, and poetry—just as the election of February 16 was won by the left-wing Frente Popular. For Picasso, this represented a very brief window of political well-being, an unprecedented moment when the situation in his two countries was favorable to him, with the rise to power of the Left in both Madrid and Paris. The respite was fleeting, however, with the Spanish election swiftly followed by Franco's coup (July 1936), the alliance between Hitler and Mussolini (August 1936), and the fascist victory in the Spanish Civil War (April 1939). In France, despite the sympathy of Léon Blum, the new president

of the Socialist council, the French government (dominated by the Front Populaire from June 1936 to April 1938) practiced a policy of nonintervention when it came to the Spanish Republic.[21] Things worsened on November 12, 1938, when Édouard Daladier (the prime minister) decreed "the internment [. . .] of foreigners considered 'undesirable' [who have been] subject to permanent surveillance" in camps in Rivesaltes, Argelès-sur-Mer, Bram, Septfonds, Le Vernet, Rieucros, and Gurs in the southwest of the country— a situation to which Picasso was especially sensitive. "The misfortune of Spanish Republicans was to arrive just as France, their hoped-for asylum, was closing in on itself," explains the historian Geneviève Dreyfus-Armand.[22]

But let us go back in time a few months. In France, in the context of worsening relations with Germany since Hitler's rise to power in January 1933, right-wing elements were ridiculing the "ministerial waltz" of the Third Republic. On February 6, 1934, they surged into action, with violent riots that left 15 dead and 1,500 injured. Six days later, the Left reacted with a general strike and a series of protests, and on May 3, 1936, the Front Populaire was elected to power. The new minister of culture, Jean Zay, had four Bonnard paintings hanging on the walls of his office[23] and was involved, through numerous associations, in democratizing access to museums and theaters. "I'm leaving for Zurich, but I will drop by to see you at Rue des Grands-Augustins on Monday so that we can chat and you can open your heart to me," wrote Jean Cassou to Picasso—the letter was written on ministerial letterhead because Cassou was now a government policy officer for the visual arts. "You should know that, thanks to Georges Huisman, the atmosphere at the Beaux-Arts has completely changed where modern painting is concerned, and that you not only have admirers there, but friends, too. So everything will be done with your full and complete agreement. *Un abrazo de su fidel amigo que le admira y le quiere.*"[24]

By this point, Cassou had spent several years assuring Picasso of his admiration and affinity (his own mother was Andalusian), celebrating the artist "as the last representative of that quintessen-

tially Spanish baroque tradition, *tan castiza*."[25] With Jean Zay and Georges Huisman, two other decidedly progressivist intellectuals acting in his interests, would he be able—during the brief era of the Front Populaire—to counter the manifestations of rejection, indifference, and suspicion that the country's institutions had shown toward his work since 1901? In the spring of 1936, despite the "window of political well-being" between France and Spain, Picasso was going through what he would describe to Brassaï much later as the hardest years of his life. He was living in fear that his work might be amputated again (this time because of a potential divorce agreement), and he kept disappearing from Paris, then returning and dumping the daily pressures of all his business on Sabartés. Personal pressures, professional pressures, political pressures: because this was the moment when politics fully penetrated his life. To celebrate Bastille Day that year, Cassou commissioned him to paint a stage curtain for the Théâtre du Peuple. It would be inaugurated for the performance (at the Alhambra de Paris) of Romain Rolland's play *Le 14 Juillet*, which dramatized the storming of the Bastille on July 14, 1789. Picasso became part of a prestigious team, alongside Rolland himself, a pacifist author and Nobel Prize winner whose seventieth birthday had been celebrated by the Front Populaire at the Maison de la Mutualité. By inviting Picasso to participate in such a significant event for the French Republic, Jean Cassou was classifying him as a national treasure. This would be France's second (and last) official commission for the artist.[26]

Picasso prepared a powerful sketch for the curtain: a tangle of raised fists, arms, and faces in a human pyramid culminating in a crenellated tower.[27] Let's pause for a moment on that drawing, dated June 13, 1936, and take a closer look: it shows a group of piled-up people, in the highly Catalan tradition of those *castells* that, since the eighteenth century, have constructed an ephemeral monument (the toughest men at the bottom, the lightest on top) of six, seven, or even eight stories to the rhythm of music called *toc de castells*, each *casteller* following the melody to hoist himself to a standing position on the

shoulders of the men in the *pinya* (i.e., the "pine cone," at the base of the tower). Why would he tap into such an old tradition? Because, in 1936, this symbol of Catalan resistance to the Spanish monarchy was, like the Catalan national anthem, flag, and language, forbidden under Franco's dictatorship. In this way, Picasso was offering something that answered the political urgency of both the French and the Spanish situation. But Picasso changed his mind, and instead decided to give Cassou a different image: *The Remains of the Minotaur in a Harlequin Costume*, a colored drawing he had finished a few weeks earlier. They asked him to produce an image for the French Revolution, and he gave them a complex, arcane, mythological work that included the figures of the Harlequin and the Minotaur, his favorite doubles, illustrating the national epic with a personal drama.

So it was that, for the first time in her life, María Picasso y Lopez began a fast-paced correspondence. With the Spanish Civil War, history trampled a life that had previously been governed by the calendar of the saints; the present with all its contingencies, its unexpected events, destroyed the comforts of her religious rituals. So disturbed was she that on July 30, 1936, she did something else for the first time in her life: she asked her son about his political opinions: "As we now receive letters every day, I hope you will write to me soon to tell me how you are and what you think of this situation."[28] A few days before this, she even wrote a vivid description of the horrors surrounding them, depicting scenes of civil war with the talent of a professional writer, even though, as a devoted Catholic, she was appalled by the way the Republicans treated the Church and its representatives. But while she did manage, with her sensitivity to events, to herald in an almost prophetic way the infinitely precise iconography of war that her son would dramatize a year later with the creation of *Guernica*, can we really say that mother and son were, in political terms, on the same wavelength? All that is certain is that history—in the form of this civil war—had knocked them both out of the familiar comforts of their private worlds, leading to the first and last moment of real complicity in their long correspondence.

Suddenly, then, Picasso's mother, driven from her sheltered Catholic refuge, became an amateur war reporter. "Dear Pablo [. . .] We are doing better since the gunfire has died down. We now hear only a few scattered shots from time to time. The fires continue, however, and as far as I know, there are still sixteen of them [in the city], including the one that is burning opposite our gallery; but I will also tell you that twelve nuns were executed by a firing squad, standing against the shared wall of our house. And that is without even mentioning those who have been burned or those who were killed on the Paseo de San Juan, simply for the pleasure! These things never appear in the newspapers. Some troops left for Zaragoza, flanked by trucks and medical teams. We'll see how that goes, with teenage boys in shirtsleeves, some wearing uniforms, others only in military jackets, standing crowded together in the trucks, after four days of intense combat. So much blood has been spilled (Barcelona is in mourning!). It is so painful to see all this destruction! How many beautiful objects destroyed by fire have been thrown from balconies! I would tell you more about these horrific scenes of massacres, but I am afraid that certain people might read this letter. Who would have thought we would end up here? Not so long ago, I counted the fires I'd seen, and there were more than sixty. We are in good health, and still thinking of you. I send kisses and all your mama's affection. María."[29]

We should not be surprised by Picasso's silence in the face of his mother's questions. Amid the raging xenophobia of interwar France, foreigners had to be doubly careful when it came to expressing political opinions. In fact, the artist's allegiance to the Spanish Republicans was regarded by the French police, as we have seen, as an additional reason for suspicion. Twelve years before, in a more conciliatory age, the police were already signaling "the growing number of foreign elements in Paris and its suburbs who infringe upon the political neutrality required by visitors in a host country."[30]

■ ■ ■

Within a few months, Picasso would be entrenched in the movement. The mobilization of artists and writers in the Alliance of Antifascist Intellectuals (AIA), their call for poets to pay tribute to the struggles of the Spanish people, a few interventions, and the sheer gravity of the situation (Franco's coup took place on July 19) were enough to push him over the line. While the nationalists had taken over parts of Andalusia (Córdoba, Grenada, and Cádiz), they had been driven back from Barcelona by workers' militias before the defeat in Valencia. The fascist general Mola planned to take Madrid by sending four battalions to converge on the capital before combining their forces with an uprising of Madrileños in favor of the movement. But this plan was scuppered by the inhabitants' spontaneous mobilization. After the "three days of July" (the 18th, 19th, and 20th), Spain appeared split in two, with the government holding a slight advantage, since it still controlled the main industrial zones and the capital.

On September 5, 1936, a coalition government was formed around Francisco Largo Caballero, a former worker and now Socialist Party leader (nicknamed "the Spanish Lenin"), uniting Socialists and Communists, but the progress of Franco's troops—and the terrible atrocities they inflicted on the civilian population—provoked the fall of Toledo. Despite the arrival of legions of foreign volunteers (sent by Moscow), this defeat was followed by the Battle of Madrid. The writers Juan Gil-Albert, Sanchez Barbudo, and Arturo Serrano Plaja, attempting to define the philosophical significance of the conflict, admitted: "A series of contradictions torments us." They went on to underscore the importance of artists in their ranks: "Today in Spain—and this is not the least of the victories won over fascism—our struggle in all its nuances responds to a profoundly resolute idea [. . .]. This produces poetry that is absolute in terms of its quality, as well as increasingly passionate and intelligible paintings and intellectual creation."[31] We do not know whether the idea came from Manuel Azaña or Jesús Hernández Tomás (minister of education) or Josep Renau Berenguer (a Communist artist who had recently become director-general of the Beaux-Arts), but in September 1936 Picasso

was named "honorary director of the Prado museum," with a salary of 15,000 pesetas.[32] Even Éluard was stunned by this news. "It said in the newspapers this morning that Picasso has been appointed the director of the Prado," he wrote to Gala, by now living in Cadaqués. "Is it true? If so, he'll have to go back there. He's still in Mougins."[33]

The appointment came as a shock. "In other circumstances," explained one of Renau's friends, "the idea of offering the directorship of the museum to someone who was so antithetical to the world of officialdom and who had for so long been so distanced, physically and morally, from Spain would seem like a joke."[34] But the Communist intellectuals in Spain were seeking to bolster international solidarity against Franco and to influence Western democracies in their favor, and they knew the symbolic importance of Picasso's name. Immediately, in *El Mono Azul*, the AIA's magazine, the "Picasso case" was discussed in terms of "this first official recognition from Spain" being a "strategic" decision: "The aim is not to offer Picasso the directorship of the Prado museum but to win Picasso over. The revolution needs him, and it has to get him [. . .] we need Picasso, so it is essential to incorporate him, to bring him back to Spain, to make him ours."[35] And in those weeks of horror, the Communist intellectuals who needed Picasso were proved correct: their gamble paid off. The artist was flooded with expressions of gratitude. For example, Francisco Ruiz (a pilot in the third squadron, Alas Rojas) congratulated Picasso on his new position, hailing him "the right man in the right place" before adding a handwritten note in red ink: "*Viva la libertad. Viva la República Socialista. Por une gigantesco triunfo de la Cultura y el Progreso.*"[36]

Day by day, more and more passionate, insistent letters were sent from Spain to Paris. Picasso did not reply to them, but there can be no doubt that they had an effect on him. The epic tragedy revealed in those missives strongly suggests what their impact must have been on Picasso's political engagement. On September 24, the culture minister Josep Renau Berenguer instigated an operation designed to win Picasso over to the Republican side. "Dear Master, Among the gen-

eral aims of this government's artistic policy, our most urgent duty, as legitimate representatives of the Spanish people, is to nurture a relationship with the most eminent man, the most open mind, and the most heroic and universal artist, and as such I feel deeply moved as I write you these lines," he began. "In our Spain, the upheaval that we are experiencing at the moment was inevitable," he explained before describing a "holy war against fascism" for which, he said, "we are ready in this ministry to renew and undertake, unwaveringly and unfailingly, the immense share of the burden that is ours in order to rebuild Spain, this heroic Spain, with heart and fist raised, for which we will abundantly spill the ancient blood that runs through its veins in prelude to the new dawn rich with unlimited possibilities." What effect did such rhetoric produce on Picasso, who was at the time wrestling with a number of competing demands? How did he react to this artist-minister who kept soliciting his support? "This directorship of the Beaux-Arts offers you everything, absolutely everything; starting with material and spiritual elements (which you will need) so that you can decide to come and live with the magnificent Spanish people who are giving themselves wholeheartedly to this cause and who, by birthright and heroic analogy, deserve the best—in other words, you. I await your decision and I do not forget that, through this invitation, I am also transmitting to you the noble eagerness of Spanish artists who know what art represents for life and for history. Farewell. Very affectionately, Josep Renau Berenguer."[37]

The next day, it was Antonio Rodríguez Morey (the deputy secretary of state for education) who, on behalf of Manuel Azaña and Jesús Hernández Tomás, went on the offensive: "We have the honor of sending you a copy of the decree of September 19 announcing your appointment as honorary director of the Prado. We are delighted to reiterate with great enthusiasm our invitation for you to come to Spain to witness for yourself the work that the government of the Republic is doing for the defense of our national artistic heritage. The government would be delighted to invite you here for several days as our official guest. [. . .] Thank you for informing us of your ar-

rival by telephone so that we can organize your reception."[38] Nobody would be able to convince Picasso to return to Spain, but the full extent and generosity of his political engagement with the Republicans (both in artistic and financial terms) was widely underappreciated at the time.

Paul Éluard grew increasingly close to Picasso, representing the artist in Madrid and in Barcelona for his February exhibition, and communicating his commitment to Spain in particular and to politics in general. In September 1936 he began by dedicating a poem to Picasso, before writing "November 1936": "Look the builders of ruins are working / They are rich patient tidy dark and ugly / But they do their best to stay alone on earth / Detached from man they heap the dirt upon him / Without a mind they fold up mansions flat."* A few days later, Éluard finally expressed to Gala his satisfaction and gratitude because "it's the first time one of [his] poems has had a print run of 450,000," but he also added an important detail: "I don't know what Breton will think of it. But I don't see why, without changing my poetry, I shouldn't work for *L'Humanité*, which is read by workers, rather than *NRF* or any other publication read exclusively by the bourgeoisie."[39] Little by little, Éluard detached himself from Breton and moved toward the Communist Party. As for Picasso, the information he received from his family (his Vilato nephews had come to take refuge in Paris; his mother wrote to him ever more often and sent him newspapers; his studio became a gathering place) touched him deeply, and he began to actively support exiled Spanish artists, including Pedro Florès, Miguel Angeles Ortiz, Joaquín Peinado, Mercedes Guillén, Baltasar Lobo, Antoni Clavé, Joan Rebull, Enric Casanovas, Antonio Rodríguez Luna, Eleuterio Blasco Ferrer, and Apel·les Fenosa. Picasso bought their works, invited them into his home, advised them on how to become part of Parisian artistic life, supported them, offered help (often through Jean Cassou) with their bureaucratic formalities, while at the same time doling out money

* Translation by Gilbert Bowen.

and encouragement and help with publishing.[40] Finally, on December 5, 1936, the commissary for propaganda in the government of Catalonia, Jaume Miravitlles, wrote to him personally. He emphasized "the responsibility that is incumbent on all intellectuals in these painful times" as well as their "duty" to be politically engaged, before "suggesting the creation of an organism [that would make] possible the union of all intellectual workers."[41] At this point, Picasso made the decision to commit, with intensity and without qualms.

In January 1937, the artist received a commission from Josep Renau on behalf of the Spanish people. He was expected to create a monumental work for the Spanish pavilion at the Exposition Internationale in Paris, which would be inaugurated on July 12, 1937. On January 8 and 9, he produced his first directly political work, *Dream and Lie of Franco*, in the form of fourteen vignettes, like a cartoon strip; six months later he would transform them into postcards that were sold to support the Spanish Republican cause. On January 17, Franco's forces led a first air raid on his native city, Málaga: in a single day, he painted *Figure of a Woman Inspired by the War in Spain*, a brightly colored work that he gave to Dora Maar—she kept it until her death. Day after day during the month that followed,[42] Picasso's disgust also took the form of a long poem, every word of which was filled with horror—"shit and shit more shit equal to all the shit multiplied by shit," "pestilential hate," "pustules," "despair," "in the soft light of her eyes horror and despair," "anxiety hung out to dry on barbed wire forgotten by the enemy of her happiness," "belly stuffed with dirty old newspapers and disgusting old pillows spewing fear and stinking of snot."[43] The charismatic, provocative, and politically engaged Dora Maar soon became a godsend for this rudderless Picasso, suggesting a new studio for him—or rather an attic on Rue des Grands-Augustins—a place that was already legendary as the studio of Frenhofer, the fictional artist described by Balzac in his short story "The Unknown Masterpiece" (a text that Picasso, on Vollard's advice, had "illustrated" in 1931). When Christian Zervos commissioned Maar to produce a reportage on Picasso and his new studio for *Cahiers d'Art*, the photographer immediately set to work.[44]

In April, while he was spending a few weeks at Tremblay-sur-Mauldre in the company of Marie-Thérèse Walter and Maya, Picasso took some photographs of his daughter in an angora hat,[45] then slowly developed his first ideas for the Spanish pavilion: twelve studies in pencil on blue vellum provide us with its genesis.[46] Initially conceiving it as a spatial installation on the theme of the artist's studio, Picasso envisaged an immense canvas (showing an artist and his model stretched out on a couch) flanked by two large sculptures of Marie-Thérèse Walter. Twelve precise drawings, taking into account the dimensions of the space (1,500 square meters), were produced on April 18 and 19 because "the wall reserved for him in the pavilion was long and low, and, although there was a window to the right, the setting was dim enough at ground level to require lighting."[47] On April 19, however, apparently having reached an impasse, Picasso changed his mind and—on a copy of *Paris-soir* carrying a report of France's foreign minister Yvon Delbos giving a speech about France's nonintervention policy in the Spanish Civil War—Picasso drew a figure with a raised fist, holding a hammer and sickle.[48]

Back in Paris ten days later, his imagination was inflamed by a sudden escalation of the horror in his homeland. The deliberate destruction of the Basque town of Gernika-Lumo[49] by forty-four Nazi bombers, assisted by thirteen Italian planes that dropped 2,500 incendiary bombs, antipersonnel bombs, and high explosives quite literally caused the liquidation, in less than four hours, of the entire civilian population, which was out enjoying that sunny Monday afternoon, the town's market day. The photographs and reports of this massacre instantly mobilized all Picasso's resources. "A thousand incendiary bombs dropped by Hitler's and Mussolini's planes reduced the town of Gernika to ashes. The number of dead and wounded is incalculable. How long will we tolerate the horrifying deeds of international fascism?" read the front page of *L'Humanité* on Wednesday, April 28, 1937. "All that remains of Guernica are five houses," wrote Gabriel Péri the following day. In *Ce Soir*, the French Communist Party's other newspaper, the journalist Mathieu Corman described "a crime of indescribable horror": "The town was nothing but an

immense blaze, gigantic flames leaping skyward, turning the clouds blood-red [. . .]. It appears that all the inhabitants were burned alive. About fifty refugees were stuck there. The cries of women and children were unbearable."[50] Picasso worked quickly, day and night, developing his preparatory drawings at an astonishing pace: *Composition Study* on May 1 was followed by *Horse's Head* (May 2); *Horse with Mother and Dead Child* (May 8); *Composition Study (VI), Sketch for Guernica* (May 9); *Study for Guernica (Horse)* (May 10); *Mother and Her Child Dead in Front of a Ladder* (May 10); *Woman's Head (I)* (May 13); *Study for Bull's Head* (May 20); *Dead Mother and Child* (May 28); *Weeping Face* (May 28); *Study for Weeping Face* (June 3); *Soldier's Head and Horse's Leg* (June 3); *Study of Hands* (June 4).[51]

In thirty-five days, in the cramped space of his studio, solemnly calling on centuries of sources, summoning all the references of his prodigious literary, pictorial, and religious erudition[52]—Baldung, David, Delacroix, Géricault, Grünewald, Ingres, Manet, Michelangelo, Piero della Francesca, Poussin, Raphael, Rubens, not to mention the more obvious references such as Goya, El Greco, and Velázquez, plus Roman Catalan art, ancient Greek art (and the inevitable figure of the Minotaur), ancient Persian art (and the cult of Mithra), and all the *Mater Dolorosa* (which he had collected for years), the pietà, the crucifixions, the nativity scenes[53]—Picasso set to work creating a huge, tragic fresco that said quite simply (in Leiris's words) that "the Old World has committed suicide."[54] This was an opera of which he was at once the composer, the conductor, all the musicians, and all the singers—assisted, for the one and only time in his life, by another artist, the activist-photographer Dora Maar. In the photographic reportage she made of the painting's creation, Maar recorded the different states of the canvas—the final stage of this already intense start, with difficult working conditions, a cramped space, and poor light. "The immense frame didn't fit in that studio, which was in fact an attic room with huge beams on the ceiling. The canvas could only be put in that confined space when it was tilted to one side, which

prevented Dora Maar from placing herself in its axis," explained Violette Andrès. "Maar overcame these technical difficulties through a fairly complex development process, using negatives on overexposed glass plates [. . .], making several prints and copies of each stage so she could reproduce as faithfully as possible the painting's shades of gray. In all, there were fifteen negatives [. . .] as well as forty-five paper prints [. . .] corresponding to eight different stages of the painting."[55]

On May 9, with *Composition Study (VI)* Picasso had prepared a small sketch—a powerful bull standing with its tail in the air next to an open window, staring wide-eyed at the center of the scene, while in the foreground, isolated by the window, a woman in tears and a woman lying on the ground signal the massacre. The next day, he transferred these early intuitions onto the largest canvas he had ever used (almost eight meters long and four meters wide). On May 11, with her first photograph of the work-in-progress, Dora Maar recorded some interesting modifications—the disappearance of the window, a shift in the bull's position to the left, the turning of its head toward the outside, the appearance of a mother and child, the woman's head now touching the animal's[56]—which, in total contrast with the smaller sketch, brutally imprison the tragedy. Later, with collages on the canvas, Picasso would even study the possibility of using color.[57] It is easy to see the influence of Dora Maar's photography (notably some street scenes taken in Barcelona, London, and Paris in 1934)[58] in these new directions taken by Picasso. "It would be interesting to record photographically, not the various stages of a painting, but its metamorphoses," Picasso had said two years before this to Christian Zervos, who later mused: "Perhaps here we can glimpse the path taken by a mind toward the realization of its dream."[59] With her black-and-white images subtly shaded with gray, with her predilection for the strange (a huge hand and face on paper, stuck to an apartment window in a deserted street; the appearance of an armless shop-window mannequin seen from a low angle, against a silent, crumbling wall), Dora Maar was already recording the disturbing

intrusions of the fantastical into ordinary reality—the very thing that tipped Picasso's first *Guernica* sketches into something timeless and universal.

My research into Dora Maar gradually takes on a clear direction: the genesis of *Guernica* is revealed as a form of artistic "co-construction." As we have seen, there were plenty of examples in Picasso's career of cross-fertilization with another artist—with Max Jacob, Apollinaire, and Gertrude Stein during the Rose period; with Braque in the cubist years; with Julio González (iron sculptures) and Roger Lacourière (engravings) during the surrealist years—but Dora Maar's role was on another scale altogether. She was an activist who outshone the surrealist group in terms of the audacity of her political engagement, and she was a resourceful partner who saved Picasso from drowning, metaphorically, when he reached his personal impasse: by finding the "Grands-Augustins solution," she provided Picasso (then in a dangerously fragile phase) with a locus for his life and creativity, an indispensable remedy that gave him a sense of direction again. But she was also a cosmopolitan woman (she studied in Argentina and spoke with Picasso in Spanish); an experimentalist who became a teacher (initiating him into the *cliché verre* technique in her darkroom); a documentary photographer (who had done street reportage and would encourage Picasso to give up color to work only in black and white);[60] and, lastly, a surrealist, with no fear of the fantastical intruding into reality. During the development of *Guernica*, Dora Maar penetrated deeply into Picasso's creative imagination, so it would be an understatement to say she played a major role; today, I would have no hesitation in characterizing her role as that of an inspiration, an advisor, but also a sort of Pygmalion, and even a co-creator. On June 4, 1937, in the enclosed space of that tiny attic room, at a remove from the chaos of blown-up bodies, wounded animals, and murdered women developed over five weeks and altered on seven occasions, during which time the photographer's gaze had influenced the artist in an unprecedented dialogue that enabled him to take the path toward the realization of his dream, Picasso finally put down his paintbrush.

"No words can describe this summary of our catastrophe," Michel Leiris later wrote. "In a black-and-white rectangle resonant of ancient tragedy, Picasso sends us our mourning letter: everything we love is going to die [. . .] between Picasso's fingers the black-and-white vapors crystallize and sparkle like the breath of a dying world."[61] Once *Guernica* had been completed, Picasso returned to poetry, and his words, recalled by Androula Michaël—a "sorbet of fried cod" or a "soup of nails"—became the metonymy of horror, with a "litany of cries of pain, where familiar things now alive expressed with him their grief and sadness": "Children's cries women's cries birds' cries flowers' cries cries of wood and stone cries of bricks cries of furniture beds chairs curtains pans cats and papers cries of smells that claw cries of stinging smoke at the neck cries that boil inside the cauldron and cries of the rain of birds flooding the sea."[62] For his part, Jean Cassou would choose to anchor the artist in a long Spanish tradition, urging him to live in Spain. "Goya brought back to life in Picasso, but, at the same time, Picasso reincarnated in Picasso," he wrote in *Cahiers d'Art*. "It had been the prodigious ambition of this genius to remain perpetually absent from himself, refusing his own flesh, forcing himself to live and play beyond his own limits, like a drunken ghost contemplating its uninhabited house, its lost body. But now the house has been found, and the body, and the soul; everything is together again, and its name is Goya, its name is Spain."[63]

■ ■ ■

Sunday March 25, 2018. As I leave the *Guernica* exhibition at the Musée National Picasso-Paris, I find myself obsessed with the half-frame of the painting displayed on the floor in the lobby, opposite a reproduction underlined in red. A wooden half-frame, like a shipwreck washed up in Paris, in the studio on Rue des Grands-Augustins. Along with a few preparatory drawings and lots of documents, this is all that remains of the work in France, where *Guernica* was conceived, produced, managed in the throes of a horribly complex period. It would become a universal artwork that would travel the world and

epitomize resistance to all forms of fascism in a spectacular odyssey, while also acting as political and financial leverage for the Spanish Republicans. Between January and April 1938, it was shown in Norway, Denmark, and Sweden; between October 1938 and February 1939 it was in Britain before touring the United States between May and October 1939: New York, Los Angeles, San Francisco, Chicago. From August 27 to September 19, for example, *Guernica* traveled to San Francisco to be displayed at the San Francisco Museum of Art, then it joined the Museum of Modern Art's retrospective, *Picasso: Forty Years of His Art*, along with 334 other works, from November 1939 to December 1940; after that, it was carried like an icon to St. Louis, Boston, Cincinnati, Cleveland, and other cities before Picasso agreed to leave it, temporarily, with his preparatory studies, at MoMA.

As Édouard Daladier became prime minister of France on April 10, 1938, as France reacted with passivity to the Spanish Civil War, as refugees converged on camps, Picasso became even more engaged, supporting Spanish artists in Paris, making up with his own acts for the cowardice of a pacifist country. Many of his friends and acquaintances were involved in the civil war—among them Carl Einstein, who, after his battle with the Spartacist movement in Berlin, left for Barcelona in August 1936 where he fought in the Durruti Column. "The war is okay. Patience; it'll be fine [. . .] little by little people are understanding the importance of a republican Spain," he wrote to Kahnweiler in the summer of 1938. "We will defeat the Francoists, in other words the Krauts and the Romans, who everyone was so afraid of. People have to be able to breathe finally. The service that the Spanish are doing for the world is remarkable."[64] Picasso fully shared this conviction—that the fate of democracy in Europe would depend on the fate of Spain.

On July 24, 1939, back in Paris and working with the printmaker Stanley William Hayter for the Spanish cause, Einstein sent Picasso a wonderful request, written in haste, which speaks volumes for the artist's place within the support network for the Republican cause:

"Dear friend, we apologize for disturbing you during your vacation. But we are in Paris again, and every day we witness the poverty of your brave compatriots. We wanted to talk to you about a Spanish officer, a former division leader [he was on the front with Einstein for a long time in Madrid and in Catalonia]. This guy lives with his wife and children in a village in Saône-et-Loire. The people could leave for Mexico (we have procured him a visa), and we have 6,000 francs for the trip. Unfortunately that sum is insufficient. He needs another 10,000 francs. Those are the facts. It would be wonderful if you were generous enough to contribute once again to save those good people whose Mexican entry visas are valid only until the start of August. Please be good enough to send your response to the address of Bill Hayter, 17 Rue Campagne Première in Paris. Enjoy your vacation, and while we await your favorable response, we send you our friendly greetings, Carl Einstein."[65] To this message, Hayter added one of his own: "Dear friend, Einstein asked me to write to you too. I know the officer in question, and it would be highly regrettable if he was prevented from leaving. Unfortunately, even though I made some 20,000 francs with a second edition of engravings and yet more with the exhibitions in London that you helped us to set up, that money was sent immediately to the Office of Childhood, otherwise we could have used it. I apologize for appealing to you yet again, but I know that this cause interests you as much as it does me. Best regards, Bill Hayter."

A few months ago, the account book labeled "Donations for the Spanish," which had remained in the Picasso archives, was analyzed by the art historian Géraldine Mercier.[66] The results paint a little-known portrait of the multinational organization that Picasso created in Paris to support his compatriots who had been imprisoned or sentenced by the fascist regime, functioning once again as a state within the State. But how many people were aware of this at the time, in a country where the artist's own situation was increasingly precarious? "Dear friend Picasso!" wrote Henri Laugier (then central department head of scientific research at the Ministry of Education) in

a letter dated February 13, 1939, that unveils the artist's growing anxiety: "I don't dare phone you since the events in Spain, which fill me with shame and humiliation before everyone, but particularly before a Spaniard. I don't want to lose hope, but I am extremely worried. However, I can't let your exhibition pass without telling you what great joy it brought me. It is a very great thing; you know my old passion for your paintings, since I learned to love them: please accept my wholehearted congratulations, my friendship, and my best wishes. Faithfully, Henri Laugier."[67] Five years after he was immortalized as a dandy posing elegantly in front of the lake in Zurich, we now find Picasso, his hair unkempt, soaked with sweat, wild-eyed after a day and a night of work, in a black shirt with the sleeves rolled up, slumped on his old stool in front of *Guernica*, staring into Dora Maar's lens in the studio on Rue des Grands-Augustins—a politically engaged artist, his days of "wait-and-see" ended by fascist violence.

Epilogue: On Alfred Barr's diagram

Unlike trees or [their roots], the rhizome connects a given point
with another given point, and its features are not necessarily
reflected in features of the same nature; it offers very different
systems of signs and even states of non-signs.[1]

—Félix Guattari and Gilles Deleuze

New York, November 9, 1930. "Picasso is for the present the idol of
collectors of modern art," stated *The New York Times*.[2] In the United
States, there was a surge of interest in his work during the 1930s.[3] Since
his first exhibition—at the Stieglitz Gallery in New York in the spring
of 1911 (followed by the Armory Show in February 1913)—Picasso
had been picking up ever greater numbers of fans in America. In the
spring of 1923, at the Chicago Arts Club, one of the owners of the
Ballets Russes, Prince Vladimir Argutinsky-Dolgorukov, displayed
fifty-three of his drawings,[4] and starting in 1920 Paul Rosenberg
began his own promotional operations. First he decided to give the
market what it wanted, with some strictly neoclassical paintings (as
in December 1924 at the Art Institute of Chicago), then he gambled
on the image of the "modern master" (mixing cubist and neoclassical
works along with the occasional painting from his Rose period). And
while business was slow at first (due to the excessively high prices),[5]
Rosenberg did succeed in growing his client's value:[6] between 1921
and 1929, Picasso's prices quadrupled. Just before the global financial

crisis of 1929, with its destabilizing effect on the art world,[7] Picasso became a very, very rich man.

Major collectors such as Frank Haviland, John Eastman, and John Quinn, followed by the likes of Duncan Phillips (in Washington, D.C.), Albert Barnes (in Philadelphia), Walter P. Chrysler (in Richmond, Virginia), Chester Dale, John D. Rockefeller, Albert E. Gallatin, Sidney Janis, Lillie Bliss, and Mary Callery (in New York), competed for Picasso's works—as did museum directors like Alfred Barr; Chick Austin (with the *Pablo Picasso* exhibition in February–March 1934 at the Wadsworth Atheneum in Hartford, Connecticut); Conger Goodyear, the director of the Albright Art Gallery in Buffalo, who congratulated himself, in a letter to the artist, for having led "one of the first institutions to buy a painting, *La Toilette* (1906), by your hand";[8] and Daniel Catton Rich (director of the Art Institute of Chicago), who wrote to the artist—in French—on March 1, 1939: "My dear Mr. Picasso, I am enchanted to know that America will finally have the opportunity to admire a complete retrospective exhibition of your work [. . .] and that we will have the privilege of hosting that exhibition with MoMA (November 1939) and Chicago (February 1, 1940) [. . .]. As these two cities are the artistic capitals of our country, we confidently anticipate a remarkable public participation [. . .]. It is an era-defining artistic event."[9] It was Chester Dale who, in the 1930s, had the most aggressive buying strategy. We have already seen how he bought *Family of Saltimbanques* in 1930 for a fairly low sum and in somewhat unusual circumstances (the painting had been sold by Hertha Koenig to a German bank, which had—through the intermediary of the Valentine Gallery[10]—sold it to Dale). Now he was to be found in New York, where he funded, for several months, a museum on Park Avenue that in 1929 was baptized "The Museum of French Art," of which his Francophile wife, Maud, became chair. On February 21, 1931, *Family of Saltimbanques* made the cover of *Art News* magazine, while a *New York Times* reporter described it as "the pièce de résistance that the Dales have just added to their ever-widening collection."[11] The following year, it was the Georges Petit gallery in Paris that Dale chose to support.

The financial crisis had no effect on Picasso's rise in North America: the baton was simply passed from gallery owners to museum directors. Alfred H. Barr Jr., one of Picasso's most fervent disciples, became the director of the newly opened Museum of Modern Art in November 1929, at the age of twenty-seven. He immediately began his ritual visits to the studio on Rue La Boétie. "Dear sir, You will perhaps recall my visit to your studio last year with Mr. Gallatin and Mr. Mauny," he wrote courteously in French on June 30, 1931. "It would be an honor and a pleasure for me to be able to visit you again and see your new paintings. I will telephone you next Wednesday, and I hope it will be possible for you to agree to my keen desire without disturbing you. Respectfully yours, Alfred Barr."[12] With his exhibition *Painting in Paris from American Collections* in January 1930, Barr crusaded for Picasso's work with a new kind of intelligence. And as a true scholar educated in the best schools, he demonstrated his enthusiasm, boldness, and self-confidence by including many cubist works in the history of modern art. His vision of the art scene, as outlined at MoMA in 1930, followed in the footsteps of Kramář's at the Thannhauser in Munich in 1913. "A little later than the *fauve* movement and partially as a reaction to it came *cubism*, an invention of Picasso and Braque," he wrote. "The latter had been one of the *fauves* while Picasso previous to 1907 had passed rapidly through three or four more easily intelligible periods. Inspired by negro sculpture and Cézanne's paintings, cubism [. . .] had passed through three or four distinct phases, each more complicated in appearance and in explanation [. . .]. From 1908 to the present day, Picasso has continued to experiment and [. . .] so rapid has been the succession of styles that it is now customary to date Picasso's work by the month as well as by the year."[13]

Commenting on the fourteen Picasso paintings presented in the show (all of them borrowed from American collectors, galleries, or museums), Barr concluded with an analysis of *Seated Woman* (1927), a work that was "more or less 'abstract' in technique," but whose abstraction, he emphasized, "retains a distinct, almost terrible, psychological power which in earlier cubistic figures Picasso was careful

to eliminate [. . .]. [This] extraordinary masterpiece [. . .] combined classical austerity, values of abstract design, and a quality of Surrealist magic which makes it an epitome of Picasso's development."[14] In 1932, Barr ceremoniously invited the Georges Petit retrospective to be presented at MoMA . . . but the artist preferred the Zurich Kunsthaus. Refusing to give up, Barr asked his wife, Margaret, to visit Paris and bring him back a detailed report on Picasso's exhibition, with lots of photographs and commentary.[15] But he would not have to wait long to continue his exploration of Picasso's world: every summer, he went to Paris to meet collectors, visit galleries, and buy paintings, and on March 2, 1936, he inaugurated *Cubism and Abstract Art*, promoted by MoMA as a "revolutionary" exhibition.[16] In the catalog, the first diagram offered by Alfred H. Barr Jr. to establish a "pedigree of modern art" was composed of horizontal timelines (from 1895 to 1935) on which he placed the avant-garde art movements organized by cities and dates, before using red and black arrows to demonstrate the reciprocal influences among them. In this diagram, which dealt with "art being made now," Barr attributes considerable influence to cubism (born in Paris circa 1907), with its ideas providing inspiration to suprematism and constructivism (Moscow, 1913 and 1914, and therefore Bauhaus in Berlin and Dessau), De Stijl and neoplasticism (Leiden, 1916), orphism and purism (Paris, 1912 and 1918), and most of all Dadaism (Zurich, Paris, Cologne, Berlin) and therefore surrealism (Paris, 1924); this was a key event because it represented the first formal affirmation of cubism's place in art history. Picasso was represented in the exhibition by more than thirty paintings and sculptures (not to mention all the theatrical costumes and sets) produced over a period of twenty-two years, definitively presenting him as the essential cog in the machine of European modern art.

While Picasso's career continued its onward march in New York (with MoMA perhaps the one museum in the world whose curators truly understood the artist), in Paris the exhibition *Contemporary Spanish Art* opened at the Jeu de Paume museum, three weeks before *Cubism and Abstract Art*, on February 12, 1936. An official event

intended to celebrate the friendship between France and Spain (with ministers, ambassadors, and representatives of institutions), it was a conventional one, with Picasso named one of the members of the "Spanish school in Paris"[17] (albeit the most modern member, obviously), but imprisoned in a monolithic categorization. How different it was from Barr's diagram—a cosmopolitan model of interlocking influences charted through space and time, in which Picasso's far-reaching significance was fully appreciated. Jean Cassou, as we have seen, chose in his critique of *Guernica* to place Picasso within a purely Spanish genealogy, in the tradition of art history inherited from the nineteenth century. Later that same year—on December 9 —Barr inaugurated *Fantastic Art, Dada, Surrealism,*[18] a new exhibition that would become legendary, tracing European fantastic art back to its medieval origins (to the fifteenth and sixteenth centuries, with Arcimboldo, Baldung, Bosch, and Dürer) before culminating in the very latest of contemporary art, including thirteen works by Picasso—one of which, *Minotauromachie*, had been finished only a few months before. And then there was the saga of *Les Demoiselles d'Avignon*, which will necessitate a brief flashback.

Six years after the death of the collector Jacques Doucet, Alfred H. Barr Jr. requested a meeting with his widow. This happened during Barr's stay in Paris in the summer of 1935, when he was drawing up the lists of works for *Cubism and Abstract Art*, which would open the following year. Barr went to 33 Rue Saint-James in Neuilly. "Doucet has encased the painting in the wall of the staircase in his home," he wrote in his notebook. In his initial notes, Barr had awarded *Les Demoiselles d'Avignon* three stars—the mark he gave to all major works. So he was eager to borrow the canvas, but Mrs. Doucet refused his request. It was not until September 1937 that, exhausted by endless negotiations with the Louvre (which, as already related, had rejected Jacques Doucet's donation), she decided to sell a cache of five Picasso paintings, including *Les Demoiselles d'Avignon*, to the New York art dealer Jacques Seligmann for the sum of 150,000 francs. The painting left France aboard an ocean liner, which sailed

from Le Havre on October 9, 1937. When the work was first put on public display in New York—as part of the exhibition *20 Years in the Evolution of Picasso, 1903–1923*—it won (almost) unanimous praise from the local press. A month later, on November 9, 1937, the curators of MoMA attended a meeting of the museum's advisory committee, where—during a discussion of the museum's visibility in its new building—they decided to acquire "the highest number of first-rate paintings possible." So it was that Barr suggested buying "the most important painting of the twentieth century." Two days later, the museum's trustees voted in favor of its acquisition.[19]

At the inauguration of MoMA's new building on May 10, 1939, the exhibition *Art in Our Time* featured a reproduction of Picasso's masterpiece as number 157 in its catalog. "*Les Demoiselles d'Avignon*," wrote Barr, "is one of the rare paintings in the history of modern art about which one can justly say that it defined the era. [. . .] It is a work of transition, in which one can see Picasso's ideas appearing directly before us. [. . .] It is, however, not for its historic importance that the museum decided to acquire this extraordinary work of art, but for the vehement dynamism of its composition. *Les Demoiselles d'Avignon* remains one of Picasso's most formidable achievements. There are few works of art in which the arrogance of genius presents itself with such power."[20] So while it was the city of Paris, in the seething first years of the century, that provided Picasso with the aesthetic conditions that led to the conception and creation of the work, it was not until it reached New York thirty years later that its magnitude and impact were fully appreciated. The Americans who ran MoMA had spotted, evaluated, and paid for it because, unlike their French counterparts, they possessed in a single institution that essential combination of aesthetic expertise and economic power. On May 10, 1939, the entire board posed proudly in front of the canvas. In the photograph, its president, Conger Goodyear, looks like a general reviewing his troops. The young and elegant Mrs. W. T. Emmett smiles tensely, surrounded by drunken sailors, the nude women of Ingres's *Turkish Bath*, among a flowering of African

and Iberian art, in front of those ladies of the night who fill Picasso's "philosophical brothel."[21]

After visiting the artist's studio every year, each time he passed through Paris, Alfred H. Barr was proud to finally present *Picasso: Forty Years of His Art*, the major retrospective that he'd been planning since 1930, on November 15, 1939. Two months earlier, on September 12, 1939, Barr had insisted on sending a letter (in triplicate, delivered by three different messengers) that read as follows: "Dear Monsieur Picasso, First let us express our hope that you are safe and in good health. Possibly our writing you now is futile, but despite the war—and even more because of it—we are not relaxing our efforts to make your exhibition as complete as possible [. . .]. You will be glad to know that all American lenders have cooperated most generously in lending to the exhibition. Let me assure you again that your pictures arrived without damage. At your request, we are cleaning some of them with great care. Everybody is looking forward with great excitement to the exhibition [. . .]. With friendliest regards, I am Sincerely, Alfred Barr."[22] Germany had invaded Poland nine days before this, provoking France and Great Britain to declare war, and Picasso's works—which had, during World War I, played the role of war booty—now became distress signals sent out to the New World at a critical moment. While his works were internationally acclaimed, Picasso was ordered to present himself to the police station in Royan to clarify his status so that he could be given safe conduct back to Paris.

In his essay for the catalog, Barr described Picasso as "so fecund and versatile a genius" that no retrospective "can lay [. . .] claims to completeness [. . .] even with more than 300 works." To be precise, the exhibition presented 362 of Picasso's works, including sets and costumes from ballets, illustrated books, engravings, tapestries using his designs, and photographs of his sculptures, which, owing to the war, could not be transported across the Atlantic; the exhibition also featured a list of all his addresses, a list of his works in American collections, a list of all his exhibitions, a complete bibliography, and

several interviews. It was, in other words, as perfectly chronological, impeccably organized, and (almost) exhaustive as an art-history thesis. However, among all the loans from private collections (including those of Gertrude Stein and of Meric Callery, Picasso's American sculptress friend who lived part time in France), it was notable that the largest number were labeled "lent by the artist."

These included number 190, *The Three Dancers* (1925); number 213, a running *Minotaur* (January 1928); number 232, *Female Acrobat* (January 18, 1930); number 233, *Crucifixion* (February 7, 1930); number 237, *Figure Throwing a Stone* (March 8, 1931); number 240, *Still Life on a Table* (March 11, 1931); number 241, *Reclining Woman* (November 9, 1931); number 242, *Seated Nude* (December 21, 1931); number 245, *Girl Before a Mirror* (Paris, March 12, 1932); number 247, *Figure in a Red Chair* (1932); number 255, *Two Figures on a Beach* (Paris, January 11, 1933); number 342, *Portrait of Woman* (1937); number 280, *Guernica* (May to early July [?] 1937); along with the next sixty works (numbers 281 to 341), *Studies for Guernica*. It was as if, through his active and generous participation in Barr's exhibition, by agreeing to release certain masterpieces from his private pantheon at this crucial moment in history, Picasso was signaling once again that he believed "the Old World had committed suicide."

Then, unexpectedly, another event increased the artist's visibility in the United States. In May 1936, the Barnes Foundation in Philadelphia (which had opened its doors in 1925), followed by Chicago, Cleveland, and New York, organized a "first ever exhibition of tapestries" that the collector Albert Barnes, when invited to speak on an NBC television show, described as "an event in the history of art," celebrating their place as "a link in the chain of tradition, between the descendants of the weavers in Beauvais and Aubusson" and "the paintings of contemporary artists such as Picasso and Matisse," emphasizing their "spiritual and educational" qualities, and celebrating "the perspicacity, knowledge, and courage of a woman, Mrs. Paul Cuttoli," who had scored a "victory over the inertia characteristic

of the entire world's bureaucracy."[23] Marie Cuttoli had, since 1928, gradually become a central figure in Picasso's new organization.

With the aid of her husband, who was a deputy and then a (radical Socialist) senator and the mayor of Philippeville in Algeria, she had invented a unique business that brought together designs by major contemporary artists (Braque, Matisse, Dufy, Chagall, Picasso) and the work of indigenous female artisans in Algeria (or sometimes the Aubusson tapestries in France). It was an immediate success upon its launch in 1935, when the art dealer Étienne Bignou opened his gallery on East Fifty-seventh Street in New York (in the Rolls-Royce Building) for her first American exhibition, before Paul Claudel, the French ambassador at the time, offered her his patronage (subsidized by the Société des Amis de Blérancourt). Thanks to her key position on three continents (Europe, Africa, and the United States), thanks to her private connections to two important men (senator Paul Cuttoli and professor Henri Laugier), thanks to the soirées she organized in her house on Rue Babylone in Paris and at her villa, Shady Rock, in Antibes on the Côte d'Azur, Marie Cuttoli quickly came to be seen by Picasso as a vital resource. And so, as World War II was beginning, as Picasso was preparing to live a reclusive life in the attic studio on Rue des Grands-Augustins, almost all his masterpieces were being sent to the United States, including *Family of Saltimbanques*, *Les Demoiselles d'Avignon*, and *Guernica*, along with hundreds of works in all styles and from all periods that had been collected, regularly and systematically, by private individuals and museums since 1910—not to mention the eighty on loan from the artist's personal collection.

■ ■ ■

Is there any need to underline, yet again, the stark contrast with French museums? A donation from the artist and a purchase from Coquiot's widow had enabled the French public to see *Woman Reading* (1920) at the Museum of Grenoble and *Portrait of Gustave Coquiot* (1901) at the Jeu de Paume museum—a grand total of two works

(neither of them masterpieces) that would, until 1947, represent Picasso in public collections in France. There had been a few lamentable failures, notably the loss of *Les Demoiselles d'Avignon*, the painting that Jacques Doucet had bought in 1924 precisely because he didn't want it to go to America, but which—when he offered it to French museums—was rejected. Since 1904, Picasso had been producing his art in France as if it were a political, aesthetic, and social transaction, brilliantly negotiating his status as a foreigner in the city, befriending and dazzling critics, poets, collectors, and dealers in spite of the sheer indifference of official institutions, as if the acceptance of his works by a national museum might somehow represent a "territorial offense."[24] In his memoirs, the art dealer René Gimpel describes the visit of one of his friends to Jacques Doucet just after the collector had learned that his offer to French museums had been rejected: "At the Louvre, at the Luxembourg, none of the officials want to hear a word about Picasso. He is reviled."[25] This anecdote is telling for all those interested in the sociology of the Other. Edward T. Ross points out the way in which the foreigner's "muddled ethnological knowledge" collides with the rigidity of the host institutions (for which he does not have the codes), forcing him to belong to "spaces of interference" where "he makes the adjustments necessary to escape collision."[26] Picasso was a natural at this game. With the help of his dealers and his friends, he would find legitimacy beyond France's borders.

I should, however, highlight the persistence of André Dézarrois, one of the few French curators to show an interest in Picasso's work. Between 1921 and 1926, Dézarrois held a position at the Musée du Luxembourg, before becoming director of the Jeu de Paume museum.[27] In 1937, in *The Masters of Independent Art (1895–1937)*,[28] he managed to celebrate Picasso by including nine of his works in the exhibition. In the catalog, this visionary curator wrote of Picasso: "More anxious than he has ever been before, more perspicacious, too, perhaps, with his mind freed and sharpened by the successive discoveries of the last fifty years, the artist's explorations now know no boundaries."[29] That same year, the Council of Museums refused

(by nine votes to five) the acquisition of *Still Life with Jug and Bread* (Fontainebleau, 1921), a painting that Dézarrois had spotted on sale to the public. According to Androula Michaël, Picasso decided that this painting did not represent his work and that it was unworthy of inclusion in a museum's collection, so he generously offered to provide them with a more important painting for the same price . . . but the State refused.[30]

After so many vain attempts at conciliation, such was the epilogue to the relationship between Picasso and French institutions. In closing, let us recall one last ironic episode: in the archive file at the Musée Picasso labeled "French Institutions," the first letter addressed to the artist is dated 1923. For the exhibition *Indigenous Art from the French Colonies*, organized at the Marsan pavilion under the patronage of the Ministry of Colonies, Picasso was asked to lend his wooden tiki statue, originally from the Marquesas Islands, valued at 10,000 francs, before being invited to attend, with his exhibitor's ticket, on Saturday December 12, 1923, the reception for the prime minister Raymond Poincaré.[31] After living in France for more than twenty years, after his work had been hailed all over the rest of Europe and in the United States, Picasso the Artist was still ignored by French institutions, who were interested only in Picasso the Collector.

In 1938, André Level, aging but as sharp as ever, wrote a letter to Picasso expressing his personal dismay: "Dear friend, I was at Mrs. Callery's place yesterday and saw a dozen of your paintings, most of them immense and half of them previously unknown to me. I was astonished. What a beautiful selection, displayed on such vast walls! It was better than the exhibition at the Petit gallery. Thank you for telling me about that collection, which is so impressive as to be humiliating for the collections of my country. [. . .] Affectionately, André."[32]

■ ■ ■

At the start of this chapter, we saw the artist throwing his pursuers off the scent with the diversity of his work, the sudden changes in style,

forcing them to split up or give up the chase. Now here he is protecting his rear, organizing his troops, creating a multipolar geography for his work amid the chaos of the world, while constructing the foundations for a global network and for his cosmopolitan personality. Despite remaining almost totally invisible to the French public, despite two major impasses that forced him to change paths a decade later, Picasso achieved the impressive feat of surviving the interwar period while producing more art in more innovative styles than ever before, while functioning like a state (by surrounding himself with a network of collaborators who acted as his ministers, secretaries of state, and advisors) and while strategizing from his creative redoubts, which gave him the illusion of extraterritoriality. With most of his works safely gathered in the New World, organized and orchestrated by the country's leading art historian, he was in an ideal position to dazzle the American public.[33]

Picasso's work defied genealogy and hierarchy, and corresponded perfectly to Barr's diagram, a world away from Jean Cassou's simplistic model of national schools, which presented him merely as the heir to Goya. Barr had been educated at Harvard by Paul J. Sachs, renowned for his "museum training" course, which he developed over the course of forty-four years. His aim was nothing less than the creation of a new profession, training an army of American "connoisseur-scholars"[34] by revolutionizing the stagnant art world that had prevailed in his country during the first two-thirds of the nineteenth century—a program that would be accelerated by the events of World War I. According to Sachs, this new American curator would be "first and foremost a broad, well-trained scholar and a linguist, and then in due course, a specialist." Likewise, a new museum in the United States of the nineteenth century "should not only be a treasure house, but also an educational system." Sachs's course was established during an economic boom in America. Having been educated in the world of finance by his German-Jewish family, Sachs acutely sensed the imminent importance of economic forces in the art world. "In every prosperous municipality in the land," he

wrote, "in the next ten years the call is likely to come for thoroughly equipped curators and directors. Harvard must maintain its leadership in this new profession, the dignity of which is as yet imperfectly understood."[35]

So it was that Picasso's work, particularly in the interwar period, did not follow a linear trajectory or any coherent plan, but shifted from one style to another, taking its inspiration from multiple sources and even, as with *Guernica*, from the most heterogeneous sources, using them all at once for a single painting, without concern for categorization or hierarchy. Picasso borrowed from a thousand sources in his own way, as if the global history of art was, for him, merely an immense toolbox. Faced with a body of work that successively and simultaneously embraces a breathtaking variety of systems of meaning, all while revealing its own rich, disconcerting systems of temporality, how can we visualize it historically? Not, surely, in any model that resembles traditional genealogy. No, we must seek something in the vein of Alfred H. Barr Jr.'s diagram, a model that integrates chaos, heterogeneity, and sudden shifts—a rhizomatic cartography.

IV

FIVE YEARS AT THE EDGE
OF THE PRECIPICE

1939–1944

Prologue: In the heart of darkness

You see, now that I've started work! . . . What a mess![1]

—Pablo Picasso to Jaume Sabartés

During the years leading up to war, Picasso lived an apparently care-free life, moving between Antibes and Paris, then Royan and Paris. With the aid of Sabartés's meticulous diary from that period, we are able to reconstruct the artist's reactions on practically an hour-by-hour basis, starting in August 1939 when he was in Antibes. "August 22. *Paris-soir* arrives," wrote Sabartés, "and I suddenly see the photograph of Mr. Vollard and read the news of his death [. . .]. For a few days, that [car] accident draws Picasso out of his temporary retreat. He leaves on the 23rd, in the middle of the night [. . .] I go with him [. . .]. Apart from the day of the funeral, the mornings are spent on Rue La Boétie. Then we eat lunch at Lipp, we go to Flore for a coffee [. . .]. Rumors of his arrival have spread and soon people start to turn up [. . .]. As soon as we make contact with the outside world, their collective anxiety takes hold of us [. . .]. We are all convinced that the war is imminent [. . .]. No one believes that the catastrophe can be averted [. . .]. Each person brings their friends to Picasso's studio; everyone thinks they are better informed, more competent [. . .]. Picasso has much to do before thinking about himself. His work is scattered about, we have to bring it together and find him

a place to paint. For now, he is content to gather it in the studio on Grands-Augustins."[2]

Picasso's panic-stricken urge to gather up and protect his paintings obviously recalls his anguish after World War I, when the contents of Kahnweiler's gallery were sequestered. And yet, by 1939, with the renown he'd gained through *Guernica*, Picasso had become a reference point, a moral compass, and it was to him that people turned when they wanted to decipher the future. Yes, since the signing of the Molotov-Ribbentrop Pact and the outlawing of the French Communist Party, Picasso's situation had become critical: everyone knew that the Spanish minister, Josep Renau Berenguer, who had named him honorary director of the Prado in 1936, was a Communist. Everyone knew, too, the decisive role played by the Communist Party in sending the International Brigades to Spain during the Civil War. Everyone knew of the artist's support for numerous Spanish Communists exiled in Paris. Picasso wavered between insouciance and anxiety, between calm and fear of the imminent war, sometimes refusing to accept the reality of the growing threat in order to continue to create undistracted. Sabartés's journal continues: "Friday 28th: Picasso receives a telegram from Saint-Raphaël inviting him to return immediately to the Côte d'Azur to see a corrida on Sunday. [. . .] There are official posters appearing on walls now with mobilization orders [. . .]. 'You see, now that I've started work! . . . What a mess!' [. . .]. Troops and yet more troops arriving. Schools, garages, and all other large buildings are being requisitioned to accommodate the soldiers." Picasso grew increasingly anxious and impatient, and three days later returned to Paris. Then, on August 19, there was another departure. "Picasso has decided to leave Paris," notes Sabartés. "You know there's a risk we'll have German planes over Paris tonight?" His destination was Royan.

In the archives of the Musée Picasso, in the file marked "Studios E 11," a small and very simple card, sent from Royan during that time, testifies to the difficulty of the situation. Beside the printed words "Ministry of the Interior, Director of National Security, Office

of the police chief of Royan (Charente-Maritime)," a few words have been scrawled in black ink by Royan's police chief: "September 7, 1939. Sir, Please come to my office as soon as possible. Yours sincerely." Despite everything, despite the pleasures of the corrida, despite the opportunity for a new studio in Royan and for painting supplies (easel, canvases, colors), Picasso had yet again been caught up by events: the Royan police chief's card was a warning shot for him—and for all those foreigners in a precarious situation who were called *métèques*. He was now under close surveillance and could not travel without a letter of transit for every journey. And *Guernica*, the work that had raised him to new heights of fame on the other side of the Atlantic, that standard of resistance to all forms of fascism, was now going to put him in danger.

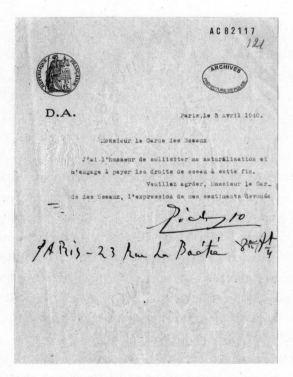

Picasso's request for a foreigner's identity card, 1935 (Archives de la Préfecture de Police de Paris)

38.

TAKING SHELTER

I work, I struggle, and I get fucking bored.[1]

—Pablo Picasso to Jaume Sabartés

On April 3, 1940, for the first and last time in his life, Picasso filed a request for naturalization. Why on that particular day? Who dealt with his application? Why did it become bogged down? Among the many books devoted to Picasso during those dark years,[2] very few include the story of the police. Yet it is to the police archives in Le Pré-Saint-Gervais that we must return if we are to find the answers to those questions.

We remember the dossiers on Picasso drawn up in 1901, 1911, and 1932 as waves of xenophobia swept across France; we remember his fearful hesitation to sign petitions, and all the other anxieties that gripped him even until 1940; but he had never been in such a serious situation before, and he knew it. Despite the growing threat to foreigners, which could easily have struck him down, Picasso also knew that he was lucky to have his network of supporters. He was still a very rich man, and he found the time to manage his various financial emergencies with his banker, Max Pellequer.

If Picasso remained optimistic despite his awkward administrative status, it was probably because he knew he could depend on friends in high places, notably Henri Laugier, a scientific expert who

had, for the past fifteen years, been part of the establishment as right-hand man to the minister Yvon Delbos, who had occupied positions with the secretary of state for technical instruction and fine arts, the minister of public instruction and fine arts, the minister of justice, the foreign minister, and the minister of education. For Picasso, Laugier was ready to use all of his contacts. One of them was Maurice Toesca, a former student of Alain—the pseudonym of Émile Chartier, a philosopher and journalist who pursued a career in the prefectural administration from 1934 to 1946 and during the Occupation, while also devoting himself to writing. Above all, there was the prefect André-Louis Dubois, the trusted sidekick of the minister of the interior, Albert Sarraut: in January 1938, Dubois was a policy officer, then deputy director of the cabinet, before becoming—from August 30, 1939, until June 25, 1940—deputy director of the French secret police, the Sûreté Nationale, as well as director of the police and general affairs, before being dismissed by Pétain. So Picasso was not lacking in political support during those dark years. However, the circumstances brutally exposed the limits of his strategic talents. From August 1939 to August 1940, he traveled several times between Royan and La Rochelle, and then between Royan and Paris (November and December 1939, February 1940), apparently in an attempt to change this status. But it is the last of these trips to Paris that concerns us—the period from March 15 to May 17, 1940. It was during this trip that, on April 3, 1940, Picasso made his first and last request for naturalization. Only four or five people knew about this at the time, and the artist never opened up about it later to anyone.

My first clue was a small, elegant business card, kept in a large red file with a frayed cover that is now held by the archives of the Paris police prefecture. This particular file has a remarkable history: it was evacuated on a barge along with other "sensitive files" by the Nazis, it was sent to Berlin in 1942, then recovered by the Russians and transported to Moscow in 1945, before being bought back by France in 2001. "FOREIGNER'S FILE Ruiz Picasso, a.k.a. Picasso, Pablo, born 25.10.81 in Málaga, artist, number 74,664," stated the

words on the red cover. But back to the business card. It was such an elegant object that it seemed to belong to another world. It read: "Paul Cuttoli Senator 55 Rue de Babylone." Indeed, this business card also bore another clue: in front of the name, in pencil, someone had written "Mrs."

Why is this business card included in Picasso's police file? What was the relationship between Mrs. Paul Cuttoli—wife of the radical Socialist senator from Constantine in Algeria, and mistress of Henri Laugier—and the bureaucrats in the police prefecture? Why and how did Marie Cuttoli, who created tapestries from the designs of avant-garde artists, become involved in Picasso's administrative affairs? Was she attempting to take advantage of her husband's political position? Or her lover's? When I began investigating the naturalization dossier, this business card was what led me to the discovery of three extraordinary characters in the artist's entourage. Paul Cuttoli, Marie Cuttoli, and Henri Laugier were all involved in a delicate, highly political attempt to save a Spanish Republican artist in the time of Franco's dictatorship, in a France facing a similarly troubled period, just a few weeks before its surrender to Germany.

We have already noted the elegance of Picasso's signatures on his administrative documents, a signature that seemed to grow in confidence, even arrogance, as the situation grew more humiliating. The signature from spring 1940 is no exception to this rule: "Paris, April 3, 1940, To his Honor, the Garde des Sceaux, I request my naturalization and promise to pay the required fee. Yours sincerely," read the typewritten letter, before a magnificently exuberant "Picasso" was scrawled in black ink, the letters slightly distorted (but who would be bold enough not to recognize his name?), an all-conquering "Picasso," a "Picasso" that did not doubt for a minute the positive outcome of his request. Soon after this followed the investigation called for by the Ministry of Justice (April 23), the summons to the Madeleine police station (April 26), the completed questionnaire with the police chief's note about "good information" and "favorable opinion" (April 30), as well as with the sections labeled "property status," "legal history," "state of health," "military situation." Let's pause for a

moment to savor this bizarre dossier. In the section headed "degree of assimilation," to the question "Has he kept his national customs or has he adopted our habits?" the answer is: "Adopted our habits." To the question "Does he understand and speak our language fluently and correctly?" the response is: "Yes, fluently." Question: "Does he usually mix with French people or foreigners?" Answer: "With French people." Question: "For what reasons is he requesting naturalization?" Answer: "Desire to live permanently in France." Up to this point, Picasso had not put a foot wrong. But these weeks in April 1940 were marked by a race against time in the highest echelons of government, as indicated by the sticker affixed to his file: "Request for naturalization urgently recommended by the cabinet," as well as the handwritten note: "Please return the questionnaire within 4 days," and the stamp: "VERY URGENT NATURALIZATION." Everything about the file signals its exceptional nature, starting with the extreme speed with which it was processed (six weeks): a naturalization request would usually take between six months and a year.

So let us leave Picasso with the Madeleine police chief's favorable report on April 30, 1940. What happened in the weeks that followed? Picasso returned to Royan on May 17. A letter from Marie Cuttoli, dated June 1 and discovered in the archives of the Musée Picasso, underscores once again her decisive role in the process and enables us to gain a clearer view of this file. "Dear friend, After your departure I stayed another six days in Paris," she wrote. "I would still be there were it not for a female friend of my husband's who owns a house here and who offered me her hospitality [. . .]. I won't mention the events that you know about as well as I do. The Belgians' betrayal. Mussolini's threats [. . .] Hitler's desire to make a sensational entrance into Paris [. . .]. I wrote a letter to Mme Brack to find out what was happening with your case, which can no longer be delayed. Let us hope that in due course we will all be able to meet up again in Paris, that we will emerge from this nightmare and find better days." And now let's pause again on that mention of Mme Brack, wife of Pierre Brack.

Who was Pierre Brack? A former judge for the Court of Cassation,

France's court of final appeal, from 1934 to September 1940, he worked at the Ministry of Justice, first as personnel director, then as director of civil affairs, successfully carrying out a series of major reforms. Dismissed by Pétain in 1942, he would join the Resistance movement Libération-Nord and Charles de Gaulle's Free French Forces. On many occasions he would intervene to rescue French people from the enemy courts, pay their defense costs, and help them escape. In May 1940, then, Brack was just the man Picasso wanted on his side.[3] Moreover, a small sticker in the police prefecture's file confirms his key role in the process: dated May 25, 1940, and written in red pencil, the note gives urgent orders for the file to be "sent in the name of Mr. Brack."

And yet it was on that very day that the unfavorable report of the Renseignements Généraux, the French police's intelligence service, was completed—a vicious, four-page dossier by the "Chief Office, 4th section, Criminal Brigade" that ended with the words: "In conclusion, this foreigner has no right to obtain naturalization; moreover, after the foregoing, he must be considered highly suspect from a national viewpoint." Following this, the police prefect's handwritten decision—one page long, undated and unsigned—was to "postpone the examination of the naturalization request": "Mr. Ruiz Picasso Pablo, a.k.a. Picasso [. . .]. Artist, owner of a château [. . .] possesses a great fortune placed abroad," he wrote. "Mr. Picasso, whose ideas appear to have been taken from extremist doctrines, provided subsidies to the Spanish Republican government during the civil war and was named curator of museums [. . .]. Nevertheless, this foreigner has in his private life not been the object of any unfavorable remarks. I will leave it to you to gauge whether it would not be appropriate to postpone the examination of his naturalization request. Police prefect [Roger Langeron?]."

In the file, it is in fact the attached note of denunciation (dated May 7, 1940, followed by the unfavorable report that echoes the content of the note) that puts an end to Picasso's request. Here it is in full:

In the artistic circles of Montparnasse, the attitude of the artist PICASSO has been strongly denounced. He has recently, and frequently, criticized our institutions, and openly supports communism.

Several credible persons who wish to remain anonymous made the following declaration:

★A few weeks ago, as we were sitting in Café de Flore, 172 Blvd St. Germain, we heard the well-known artist Picasso make clearly anti-French remarks.

★As he railed against the government of our country, a customer (in civilian clothes) suddenly approached him and, after identifying himself as an officer in the Polish army, ordered him to stop talking.

★The artist Picasso then left the establishment, contemptuously uttering a few more words, but the next day he left Paris for a few days, no doubt fearing that this incident would get him into trouble.

★We have also learned that, during the civil war in Spain, Picasso actively propagandized on behalf of the government, which he had also apparently supported by sending them several millions from the sale of his paintings; he has a contract with an art dealer named Rosenberg.

★Lastly, this foreigner who has made a reputation while in France for so-called modern painting that has enabled him to gain considerable sums of money, declared several years ago to some of his friends that upon his death he would bequeath his collection to the Russian government and not to the French government.

★Added to the aforementioned facts, this declaration indicates the singular way in which Picasso has shown his gratitude to the country that welcomed him, and in the current circumstances his conduct is, to say the least, discourteous.

RUIZ Y PICASSO, better known by the name Picasso Pablo, born October 25, 1881, in Málaga (Spain), of Spanish nationality.

Married to Kokhlava Olga [*sic*] [. . .]

Picasso arrived in France in 1900 and complied, along with his wife, to the rulings governing the residence of foreigners in our country.

Since 1918, he has lived at 23 Rue La Boétie and he owns a château in Bois-Geloup [*sic*] near Gisors (Eure); however, he seems to be currently residing in La Rochelle. His wife recently left him and now lives at 16 Rue de Berne.

In Picasso's file, there is a note dated May 17, 1905, indicating that he was the object of a report dated June 10, 1901, mentioning that at that time he had lived with a compatriot, the anarchist Manach Pierre [*sic*], who was under surveillance, and that he himself should be considered an anarchist too.

Picasso is not registered in the old legal files.

A naturalization request is currently being processed by our departments.[4]

In the paranoid spy fever that seized France in that period, Picasso's international fame was used, as we can see, to present him as an enemy of the country, completely subservient to foreign powers. His naturalization dossier was of course supported by Laugier and Cuttoli, it was of course expected at the Ministry of Justice by Pierre Brack, but it was processed by the French bureaucracy during one of the most chaotic periods in the country's history, during which conflicts between police departments were already raging. On May 10, 1940, Nazi Germany invaded France, which fell in a matter of weeks, to general shock and dismay. On May 20, Marshal Pétain, the French ambassador to Franco, returned, and by June 17, it was all over for France. In this regard, the letter that Marie Cuttoli sent Picasso on June 1, 1940, is crucial. She mentions therein her "letter to Mme Brack to find out what is happening with your case, which can no longer be delayed." But it was five days before this, on May 25, when the vicious report that sealed the fate of Picasso's naturalization request was written.

But if Pierre Brack was contacted by Laugier and Cuttoli in April 1940 to ensure the success of the naturalization request, why was he unable to help? What happened to this file, accompanied by a favorable note and a vicious report? Was it ever transmitted to Brack? Is it possible that the case collapsed due to the acceleration of events (defeat, exodus, regime change)? Did mass naturalization continue in the months of May and June 1940? How could the wildly xenophobic climate of those weeks not have influenced matters? Perhaps naturalizations were delayed or even completely halted at that point? Did Pierre Brack, alerted by Henri Laugier, demand the police prefect's file in order to grant Picasso's request? And did the police prefecture refuse to send it? What exactly happened at that moment, between the police prefecture and the Ministry of Justice? The least we can say is that contradictory pressures that can be read in the favorable opinion of the Madeleine police chief (April 30) and in the hateful Renseignements Généraux report reflect the extreme volatility of the administration in those strange days. Why didn't Brack insist on being sent the file that had, up to that point, been treated as a high priority? And who wrote that vicious report dated May 25, 1940? For some time, as my investigation proceeded, these questions would go unanswered.

On May 17, as we have seen, Picasso returned to Royan. On June 17, Sabartés noted, "We watch, terribly anxious, as German troops arrive in Royan. They arrive on a Sunday evening. Picasso sees them march past his studio because the police station is just behind, and the Kommandantur is living just beyond the villa Les Voiliers. The Hôtel de Paris, just next door, is occupied by German officers, and immediately there is a coming and going of tanks, trucks, motorcycles, cannons, etc. [. . .] On August 23, Picasso decides to return to Paris [. . .] He leaves Royan for good on the 25th with the chauffeur, Kazbek [his elegant Afghan hound], and all the luggage."[5]

39.

SURVIVING

August 25, 1940–December 1941

The general disarray of the summer of 1940 [. . .] saw the re-emergence in broad daylight of many fascist underground movements [. . .]. It seemed like a gigantic revival of those who claimed their place in the sun, all generations combined.[1]

—Daniel Lindenberg

Beginning on June 17, 1940, with its crushing defeat and the Nazi occupation, France was plunged into the most xenophobic period in its history. It was as if all the worst moments of the 1930s, all the most inflammatory texts of Georges Mauco and his fellow anti-Semites, all Colonel de La Rocque's slogans in *Le Flambeau* and Maurice de Vlaminck's in *Paris-Journal*, all the allegations made by Xavier Vallat, who thought that France was reaching saturation, were now given free rein because—for all those xenophobes—the scapegoats for a humiliated nation were none other than those "*métèques*" who had allegedly destroyed France. We remember Camille Mauclair who, in "*Les Métèques* Against French Art" (1924), excoriated the "crowd of Montparnassians gathered in the cult of alcohol, cocaine, and performance art," presented modern art as a vast international conspiracy stirred up by Jewish art dealers and critics in opposition to France's "ethnic aspirations," and threw in the occasional denunciation of their "corrupting influence" and their "venal motivations."[2] As Daniel Lindenberg noted, the summer of 1940 signaled the "end of the

1930s with their end-times terror [. . .] and their crepuscular tonality," in addition to the emergence of voices that had previously been subterranean, with their resentments against the intelligentsia.[3]

The installation of Marshal Pétain in Vichy also brought into question the entire naturalization process as it had existed since 1927. While the law of August 10, 1927, allowed a foreigner to become French "after only three years' residence in France, instead of ten years, as before," on July 22, 1940,[4] the new minister of justice, Raphaël Alibert, created a committee to review such naturalizations. After that, successive rulings (late August 1940; September 18, 1940; October 18, 1940; April 26, 1941) "aryanized" businesses run by Jews and gave them to "good French people." The aim was to punish those "foreigners within" to whom Charles Maurras attributed the decline of the country during the previous forty years.[5] In Picasso's case, prior to April 3, 1940, there had never been the least suggestion that he would apply for naturalization.

On August 25, 1940, when he left Royan for Paris, he started living in a city occupied by the Nazis where, since June 14, the swastika had hung from the Arc de Triomphe. He would walk between Rue La Boétie and Rue des Grands-Augustins, as he'd done since 1937, until deciding in early 1942 to withdraw to Rue des Grands-Augustins, beginning a period of total confinement—the first and only genuinely reclusive period of his life. This decision would coincide with the start of the infamous "total war" launched by Hitler on June 22, 1941, and Operation Barbarossa, the German invasion of the Soviet Union. From that point on, Picasso had to confront a new kind of xenophobia—no longer structural, but open and widespread, a state-sponsored xenophobia. It was the cult of the new man, begun in 1932, that "new race" which, as Jünger wrote, "embodies energy and overflows with violence"; and it was the young SS legal expert Reinhard Hohn who would be tasked with reimagining the administration of Nazi territory. Since the *Entartete Kunst* (Degenerate Art) exhibition inaugurated on July 19, 1937, in Munich under the aegis of Joseph Goebbels, the Nazi regime had considered Picasso a stain

that had to be removed from society. In his speech that day, the artist Adolf Ziegler, president of the Reich's Academy of Fine Arts, vilified those "monstrosities of madness, impudence, inability and degeneration [. . .] the 600 works of art in this exhibition [that] shock and disgust us all."[6]

The Franco-German rivalry was reignited, and its new battlefield was the world of art, with Germany seeking vengeance. In the Franco-German "marriage," wrote the historian Laurence Bertrand Dorléac, art, "whether a dowry or a substitute for sex, [. . .] was at the center of the Nazi desire to take over France by stealing its masterpieces. [It was] a way of ending—to its advantage—an old European cultural war that had been won too often in the past by Paris."[7] Two weeks after the armistice, the Germans began "a formidable operation to pillage works of art, in accordance with the law of the jungle."[8]

It was time for France to pay for the arrogance with which she had viewed Germany in matters of art, culture, and refinement. "We are going to compensate ourselves and take back from the French what they stole from us over centuries," exulted Goebbels,[9] to whom the führer gave sweeping powers in the policy of organized pillage. But within the Nazi ranks, departments and individuals remained at loggerheads, and it was one of Goebbels's rivals, Alfred Rosenberg, who was given the task of pillaging Jewish collections in France. The plundering began on June 30, 1940: the storerooms of the major art dealers were transported to the German embassy on Rue de Lille, and almost eighty private collections were seized with the aid of the Parisian police.

By the fall of 1940, the pillage of Jewish goods was no longer enough to satisfy the insatiable German hunger, and Rosenberg's department began targeting all "abandoned" collections, in Paris and elsewhere. After being gathered at the Louvre and the Jeu de Paume museum, the artworks were then exhaustively inventoried: examined by experts, photographed, indexed (often with difficulty), then packed up and sent to Germany. In all, according to

the report by the official Robert Scholz (whose figures fall short of the truth), cited by Laurence Bertrand Dorléac, "203 collections of 21,903 objects, including 11,000 paintings—most of them belonging to Jewish collectors—were delivered to the Third Reich aboard hundreds of trains leaving the Gare du Nord between March 1941 and July 1944."[10] Certain works, however, that did not "deserve to make the journey"—notably paintings by "degenerate artists"—were physically destroyed. According to Rose Valland, who worked at the Jeu de Paume and was the sole witness, on May 27, 1943, the Nazis violently attacked "paintings marked with the seal 'E.K.' (*Entartete Kunst*—degenerate art) by Masson, Picabia, Valadon, Klee, Ernst, Léger, Picasso, Kisling, La Fresnaye, Marval, Mané-Katz, and many others,"[11] slashing them with knives before transporting them on trucks to a pyre in the heart of the city. A total of five hundred or six hundred works were burned, albeit discreetly so as not to arouse the wrath of the French.

But this policy of seizing and sometimes destroying the art that had flowered in France was not unanimously supported within the ranks of Nazis posted in Paris. Opposing Goebbels and Rosenberg were the ambassador Otto Abetz (proud at having convinced the führer to govern France in a "subtler" way than he governed other occupied countries) and various French-speaking German officials such as Gerhard Heller, the sonderführer responsible for literature at the propaganda squadron, and Ernst Jünger, a Francophile writer responsible for censoring the occupying troops. Unlike most of his friends, Picasso was treated as a privileged figure throughout the Nazi occupation. Who helped him? Was it Alfred Réty, the gardener at Boisgeloup, who regularly sent him fruit and vegetables from Normandy? Was it Luiz Martins de Souza Dantas, the Brazilian ambassador in France (a courageous man who supported the Resistance), who sent Picasso cigars on January 27, 1941?[12] Was it Julio González's widow, who sent fresh eggs and apples from Lot on September 18, 1942?[13] Could it have been the owner of the Le Catalan restaurant, where, on November 11, 1944, Picasso ate chateaubriand—on a day

of meat rationing—leading to the café owner being fined and forced to close for a month? Or Franco's ambassador to France, José Félix de Lequerica, who protected the studios on Rue La Boétie and Rue des Grands-Augustins by ordering the doors sealed? The latter case is so bizarre (since Lequerica was a fervent Franco supporter) that you have to wonder if he was playing some sort of mind game with Picasso.[14]

Among his other privileges, Picasso could still rely on his banker, Max Pellequer, who, before the armistice, diligently took care of his taxes. It is hard to overestimate the value of such a relationship in times like those. His letter to Picasso dated August 19, 1941, reveals the type of bartering that took place between the two men, with Pellequer providing his services in return for artworks by the master. "I understand how unpleasant it is for you to get mixed up in discussions about money between us and how far above such contingencies you are," he wrote. "Thank you for having given me such beautiful drawings [. . .] I think about my painting from the Blue period; I dreamed about it for years and now the dream has come true, it confirms my imagination and my memory. [. . .] I expect to return to Paris on September 1; in the meantime, if you would have time to select a few nice drawings or watercolors for me, or a few paintings of your choice, that would give me great pleasure."[15]

40.

PLAYING WITH FIRE

January 1942–July 1944

The Führer's policy toward France was absolutely right. We have to sideline the French. Flatter them and they take it the wrong way. But if you leave them in suspense, they tend to calm down.[1]

—Joseph Goebbels

On June 22, 1941, Hitler launched Operation Barbarossa, the invasion of the Soviet Union. This led directly to French Communists joining the Resistance and carrying out acts of sabotage against the Nazis. From 1942 until May 1944, France entered a "deadly spiral," with more and more executions and mass deportations of Jews and Communists to Nazi concentration camps. In occupied Paris, Picasso had to face up to a new type of state, with its chaotic institutional architecture and its "new romanticism" that sought to reestablish organic links between the member groups of a single Volk, guided by an aristocratic elite; a form of government where, in the words of the ideologue Eugen Diederichs, "the State would be the servant of the Spirit, the Volk, and its interests."

So on one side there was Goebbels with his repressive policies. On the other there were certain bureaucrats posted in Paris, alongside some Nazis, who saw themselves as knights in shining armor riding to protect the honor of imperiled French culture. Considered since *Guernica* the very embodiment of a Republican Spain that

no longer existed, confronted with a French State that rejected his naturalization request, and condemned by the Nazi occupiers as a degenerate, Picasso was more than ever at the mercy of the mercurial winds of history, an artist in a world where the political and ideological divisions of the avant-garde had given way to a thick fog.[2] In those circumstances, he knew, his margin for maneuvering was drastically reduced, and the slightest mistake could have disastrous consequences. His fame simultaneously protected and exposed him. "He was well aware that an authoritarian regime will sometimes cut off a head for symbolic reasons," noted Émilie Bouvard. "The example of the death of Federico García Lorca, executed by a Francoist militia on August 19, 1936, was undoubtedly raw in his memory."[3] The time for subtle strategy games was over. His sole obsession during the war was his work, although he did try to cover himself with support from certain friends in high places.

But how was Picasso able to protect himself from the occupier after he had so brazenly opposed fascism with *Guernica*, when he refused to recant his views to appease the new masters? Locked away in his studio on Rue des Grands-Augustins, he saw people in the mornings, then worked through the afternoon and the night, shifting between friends and acquaintances of all stripes. So Picasso existed and evolved at the center of this maelstrom: forbidden to exhibit his works by the occupying powers, he was also hated by the French fascists, who saw him as one of those responsible for the nation's degeneration ("Matisse in the trash, Picasso to [the lunatic asylum] Charenton," repeated the collaborationist press).[4] He was insulted by Maurice de Vlaminck, a figurehead of the fauvist movement who had now become an apostle for the return of order and a Vichy supporter. On June 6, 1942, Vlaminck accused Picasso of "having, from 1900 to 1930, led French painting into denial, powerlessness, and death."[5] In normal circumstances such an attack would have been "crushed under the weight of disgusted responses," noted Laurence Bertrand Dorléac, but the Occupation rendered it deadly. "As France was desperately trying to rediscover its lost unity," she added, Picasso "be-

came the scapegoat par excellence, who could embody the thousand and one facets of evil: immigration, disorder, blasphemy, all those things that France wanted no more part of. Knowing that he would be heard by the millions who regarded Picasso as the defender of decadence, Vlaminck hit below the belt—in a text that had dual aims: to denounce the modernist adventure (nothing original about that) and at the same time to attack an artist who lived in Paris, who was barely tolerated and too well-known for his political sympathies."[6] Subject to the whims of the masters of the moment, in turn a scapegoat embodying the most varied vices or an evil genius "of magical influence"[7] with whom certain Nazi aesthetes became besotted, Picasso cultivated connections, like his old friendship with Cocteau.

In the spring of 1942, the expression "playing with fire" quickly became more than a mere metaphor for Picasso: via Breker and Cocteau, only five degrees now separated him from Hitler. Arno Breker, the führer's beloved sculptor, had studied in Montparnasse between 1926 and 1932, where he was a student of Maillol and a friend of Cocteau, Calder, and Brancusi. In June 1940, Breker accompanied Hitler on his first visit to occupied Paris. He also advised Goebbels on cultural propaganda aimed at France, which was still high on Hitler's list of priorities. He wanted to humiliate the French, of course, but he also wanted to indoctrinate them. The exhibition of Arno Breker's sculptures (which opened at the Musée de l'Orangerie on May 15, 1942, and did not close until December) remains the most important manifestation of Nazi propaganda during those years. Senior officials, artists, and society collaborators all swarmed to the inauguration party, where Abel Bonnard gave a lyrical, obsequious speech, praising the "sculptor of heroes" who had emerged from a "coherent society,"[8] before Jacques Benoist-Méchin, secretary of state for Franco-German relations, delivered a panegyric to the führer for his talents as a "conductor of men" and "leader of armies," but also as a "passionate enthusiast of architecture."[9]

On May 6, 1942, a few days before the opening of that exhibition, Jacques Chardonne asked Cocteau, "in the name of the Laval

government," to write an homage to Breker that would appear on the front page of the newspaper *Comoedia* under the headline "A SA-LUTE TO BREKER." "I salute you, Breker! I salute you from the noble homeland of poets, the homeland where homelands do not exist," he started, "except insofar as each inhabitant brings to it the trea-sure of national endeavor." In his diary, Cocteau even confided his admiration for "an artisan, a goldsmith, whose love of detail and contour contrasts with the boring volumes of his masters [. . .] He will shock aesthetes. That is why I love him."[10] Cocteau also reveals an additional advantage to knowing this sculptor: he could "call him on a special telephone line to Berlin in case anything serious hap-pens to me or to Picasso."[11] What's clear here is that Cocteau, who had become the idol of the occupiers, was playing a dangerous game of seduction between Éluard and Picasso, Chaïm Soutine and Max Jacob, all while patronizing Breker and Chardonne—happy to be "attacked by everyone, to be free (?) and penniless."[12]

Picasso and Cocteau had drifted apart after the Ballets Russes adventure; this estrangement continued throughout Picasso's sur-realist period—Breton, Aragon, Éluard, and the others in their group hated Cocteau for his right-wing views—and during Picasso's politi-cal radicalization at the time of the Spanish Civil War, while Cocteau was lost in a world of opiates. But when the Occupation began, in a Paris where few artists remained—many of the surrealists, in par-ticular, had fled the capital—Picasso would meet Cocteau at the Le Catalan restaurant on Rue des Grands-Augustins or in Dora Maar's studio on Rue de Savoie. At a time when food rationing affected everyone's daily life, when paper rationing was causing difficulties in the newspaper and publishing worlds, when rationing of materi-als was hitting artists hard and Jean Courtenay lamented "the piti-ful state of our painters [. . .] who are crying out for brushes and colors,"[13] Cocteau certainly offered his aid to Picasso.

When Brassaï returned to Rue des Grands-Augustins in the early months of the Occupation, he was surprised by the "multitude of statues that now filled the immense space, [including] some old ac-

quaintances from Boisgeloup [. . .]. But then I felt sick: they had been dazzlingly white back there, but here they had become darker and smaller . . . They had all been cast in bronze! [. . .] How on earth had [Picasso] managed to procure so much metal at the very moment when the occupier was toppling all the old bronze statues in Paris from their pedestals? [. . .] I saw more than fifty new bronzes, about twenty of them quite large [. . .] Me: 'But how did you manage to cast so much bronze?' [. . .] Picasso: 'It's a long story . . . A few devoted friends transported the plaster statues at night in handcarts to the foundries [. . .]. And it was even riskier bringing them here in bronze in front of German patrols . . . The "merchandise" had to be camouflaged.'"[14]

Cocteau's praise of Breker provoked disgust and anger among many writers. The most violent reaction came from Éluard, who since 1936 had been Picasso's favorite poet. "My dear Cocteau," he wrote, "Freud, Kafka, and Chaplin have been banned by the same people who honor Breker. We thought you were one of the censored. How wrong of you to suddenly take the side of the censors! Those of us who love and admire you have been horribly shocked. Please give us a reason to trust you again. Nothing should divide us. Yours, Paul."[15] The end of the letter amounted to a peace offering, but Cocteau doubled down on his views. He did the same thing again two years later, when the "purification committee" interrogated him about his war-time behavior. But how would Éluard have reacted had he been able to read Cocteau's private journal? "It would be gruesome to prevent a mind [like Hitler's] from finishing his task, to strangle him en route," the author of *Les Enfants terribles* noted on July 2, 1942, before lamenting, six months later, that this man of peace was "dragged into a war he hates."[16]

Amid the confusion and dismay that reigned at the time, some people—including Picasso—had friends in both opposing camps. On September 10, 1942, less than three months after their altercation about Breker, he invited Éluard and Cocteau to dine with him. The same men who collaborated with the occupiers, even nursing a

secret admiration for the Reich, were also capable of going to great lengths to save a Jewish friend who was in danger, leveraging their influence with high-placed friends in the Vichy administration or the Nazi intelligentsia. The actor Sacha Guitry, for example, while enjoying a rich social life with Vichy zealots and Nazi aesthetes, used the full force of his celebrity to ensure the release of the writers Tristan Bernard and Maurice Goudeket from the Drancy internment camp. And Éluard, after attacking Cocteau, would later defend him at the purification trials. In the small world of arts and letters, where long, close friendships were tested by events, it wasn't unusual to engage in shady dealings. As for Picasso, his ideological preferences were clear, but so was the precariousness of his situation as a foreigner and representative of "degenerate" avant-garde art; in dangerous circumstances, once again, immersion in his work was the only way he found to live through those troubled times with any dignity.

Two years after the death of Ambroise Vollard, Picasso's first art dealer and the man who organized the 1901 exhibition, his gallery was bought by a colleague, Martin Fabiani. Fabiani took over the contract for Buffon's *Natural History*, a book that Picasso had agreed to illustrate in 1931. On May 26, 1942, and again on May 23, 1943, Fabiani visited the studio on Rue des Grands-Augustins, where Picasso produced a series of portraits of this new dealer—long, gaunt, knifelike face, impenetrable eyes. After the Liberation, it was discovered that Fabiani had been "closely allied with the Germans during the war," that he had been involved with despoiling Jewish collectors and trafficking works of art, "making large sums of money from Matisse (with whom he had a contract) and Picasso."[17] On July 22, 1942, Picasso received the visit of the writer Ernst Jünger, a few days after that of Gerhard Heller, who had been introduced to him by the editor Jean Paulhan. One evening in 1943, it was the turn of another Nazi bureaucrat, Werner Lange (Heller's counterpart, whose job was the surveillance of artists), to meet Picasso in a well-known restaurant on Place Dauphine.

While Picasso continued to create art, he saw the prices of his

works rise and continued to manage his fortune. On July 18, 1941, one of his paintings was sold for 650,000 francs; on May 26, 1942, another went for 610,000 francs; by December that year, two works had been sold for 1.3 million and 1.6 million francs! Between the works by Picasso that had been pillaged and burned by the Nazis, and those that had sold at auction for record prices, between those that had to be destroyed and those that could be used for bartering, the artist's work became a lucrative trade, although Picasso himself did not profit from it directly except in the sense that the prices for the paintings still in his possession had increased. But how could he see his way through the maze?

41.

WORKING

I worked; I painted three still lifes with fish, a crab, eels, and a scale.[1]

—Pablo Picasso to Jaume Sabartés

How did this artist—who had been reinventing himself and the art world for forty years, cleverly avoiding all the traps set by a xenophobic society—continue to create during the war years, when he was so obviously in danger? His work during that time was not innovative, because he was drawing from genres and themes he had worked on before, but he did so in order to magnify them, push them to extremes, develop them in directions that took him close to the edge of the precipice. What was Picasso's response to the vertiginous drop below him? His discreet request for naturalization. His geographical movements, which seemed to follow the rules of common sense. His new schedule (visitors in the morning, work in the afternoons and night, when there was a curfew). His work's message. In October 1944, his response to the closeness of the precipice was to join the French Communist Party.

In his book *Asylums*, Erving Goffman noted the changes that gradually affect the "world of the inmate": isolated and deprived of "certain roles," he experiences claustrophobia in the place where he is enclosed and, in a permanent tension between interior and exterior, suffers a "civil death."[2] Picasso, however, managed to avoid this trap

as he lived reclusively in Antibes, Royan, and Paris, reducing his travel until he remained exclusively at the studio on Rue des Grands-Augustins. Despite having to grow his hair long because he couldn't get it cut, despite the frayed clothes (a colorless old jacket, brightened by an odd-looking bow tie) that made him look vaguely like a hobo, the artist always retained his dignity.[3] And while he avoided directly addressing the subject of the war, he did, as usual, continue his exploration of the present, with references to his family and friends, the view from his window, everyday objects. His *Café in Royan* (August 15, 1940) is filled with the colors of months past, but it is an empty world, devoid of life, as would also be the case, later, for *Vert-Galant Square* (June 25, 1943). With *Bust of Woman* (Paris, June 3, 1939), *Woman with Blue Hat* (Royan, October 3, 1939), *Woman Sitting in an Armchair* (Royan, February 2, 1940), *Woman with a Hat Sitting in an Armchair* (1941), *Bust of a Woman (Portrat of Dora Maar)* (May 25, 1941), and *Young Boy with Lobster* (Paris, June 21, 1941), he began the long series of quirky, disturbing portraits, some of them of children, but most featuring Dora Maar as an anguished, disjointed woman in a world out of sync.

The tone was set early with *Cat Devouring a Bird* (Paris, April 22, 1939). "The subject obsessed me, I don't know why," he would explain later. As for his depressing still lifes, *The Soles* (Paris, 1940), *Conger Eels* (Paris, 1940), *Still Life of Bull's Head* (Paris, April 5, 1942), *Still Life "The Coffee Pot"* (March 24, 1944), *Still Life of Skull and Pitcher* (1943), *Skull, Leeks, and Pot in Front of a Window* (Paris, March 17, 1945), with their gloomy titles and the precision with which their dates and places of creation were recorded, they seem to be products of a genuine obsession with everyday life, with food as the chief fixation. This subject matter had continually reappeared ever since *Sheep Skull* (Royan, October 4, 1939), representing the cheap butcher's cuts bought for his dog Kazbek as memento mori. Even back in 1890, when he stayed with his friend Pallarès in Horta de San Juan, the animals from the rural Mediterranean coast (horses, goats, cats) had begun to enter the iconography of the young Picasso.

I will mention here *Serenade* (1942), a large, chilling nude

presented with a morbidly ironic smile—another response to his walk along the edge of the precipice. But I will dwell on the sculpture *Man with a Lamb*, conceived from its origins (the first studies are dated August 18, 19, 20, and 26, 1942) as a response to Arno Breker's monumental nudes, which were then on display at the Musée de l'Orangerie. In contrast to the triumphant bodies of Nazi iconography, Picasso deliberately chose the theme of the "good shepherd" (at the crossroads between pagan and Christian sources), with this body of a humble, fragile man who, like an offering, carries a lamb in his arms. In contrast to the world of the "new man" (with his cohort of heroes and conquerors), Picasso deliberately joined the camp of the sick, the degenerate, the precarious (the Jew, the Romani, the disabled, the homosexual, the freemason, the Bolshevik)—the camp of the Other. There are references here to Francisco de Zurbaran's admirable *Agnus Dei*, and echoes, too, of the *Theses on the Philosophy of History* written by Walter Benjamin in 1940, a few days before his suicide: "Whoever until this day emerges victorious, marches in the triumphal procession in which today's rulers tread over those who are sprawled underfoot. The spoils are, as was ever the case, carried along in the triumphal procession. They are known as the cultural heritage."*,4 A challenge, an offering, a sacrifice, a step toward martyrdom? *Man with a Lamb*, a bronze cast of which Picasso would donate to the town of Vallauris when it named him an honorary citizen in February 1950, remains one of the artist's most powerful creations from those years.

But it is with *Desire Caught by the Tail*, Picasso's first play, that I will conclude this chapter. Written January 14–17, 1941 (during his first freezing winter in occupied Paris), it was not given its first reading until March 19, 1944, in the apartment of Michel and Louise Leiris. In the spring of 1942, the couple had moved to 53a Quai des Grands-Augustins, a very short walk from Picasso's studio. That first performance was dedicated to the memory of Max Jacob, who had

* Translation by Dennis Redmond.

just died in Nazi captivity, and it took place under the portrait of him
that Picasso had drawn.

With its allegorical characters named Big Foot, Onion, Tart,
The Cousin, Round End, the Two Bow-Wows, Silence, Fat Anguish,
Skinny Anguish, and The Curtains, Picasso's play, according to the
philosopher Jèssica Jaques Pi, poses the same fundamental question
as Plato's *Symposium*—particularly in Act IV, when Tart says: "You
know I met love. He has skinned knees and goes begging door to
door. He's penniless and he's looking for a job as a bus driver in the
suburbs. It's sad but try helping him . . . he turns around and stings
you . . ."[5]

A blend of Dadaism and absurdist collage, Picasso's play takes
place in the Sordid Hotel and shows "a banquet of hunger and cold
that represents a flight from reality, contrary to most of his artistic
production."[6] The reading of *Desire Caught by the Tail* allowed him
to pay tribute to Max Jacob while defying—for one evening, in a
private home, in front of a few privileged spectators—the Nazis who
ruled the city beyond his friends' apartment. Then, braving the "civil
death" imposed by the hated occupiers, the "degenerate *métèque*" be-
came master of ceremonies, the painter became playwright and direc-
tor of his own creation, compelling his famous writer friends Michel
Leiris, Georges Bataille, Albert Camus, Jean-Paul Sartre, Simone
de Beauvoir, Raymond Queneau, and others to become actors, thus
brilliantly affirming the superiority of his own creativity. Perhaps it
was also a response to the controversy that raged after Max Jacob
was deported to the internment camp in Drancy, when Picasso was
invited to sign a petition asking the German ambassador to save his
friend—and the artist refused. Some accused him of ingratitude, cit-
ing his supposed response to the gallery owner Pierre Colle, who had
asked him to sign: "There's no point doing anything. Max is an imp.
He doesn't need us to fly away from his prison."[7] Did Picasso abstain
because he knew that the support of the painter of *Guernica* would do
more harm than good?[8]

42.

FINDING HIS PLACE,
IN A DIFFERENT WAY

In 1942, the exhibition of Arno Breker's sculptures at the Musée de l'Orangerie (did Picasso really visit it, as some have claimed?) heralded the dawn of the "new man" in the Nazi dynamic. This crazed celebration of the victorious body induced deference in Cocteau and repugnance in Éluard. Picasso's response, meanwhile, was clear: it was *Man with a Lamb*. But let us return, for a moment, to the beginning of World War II. We remember the artist's insouciance during the Phoney War, his agitation when he read about the Nazi-Soviet pact, his vain rush to seek shelter by applying for naturalization. How did he live during the difficult months that followed, just before the USSR entered the war, months that were especially hard for French Communists, who found themselves labeled as outlaws? Picasso followed events closely: the "government of national liberation" created by the Communists in August 1941, the "national military committee" run by Charles Tillon, the first acts of sabotage against the occupiers, the intensification of armed struggle—trains derailed, Kommandantur leaders assassinated, and then the immediate, terrible German reprisals: "On October 22, 1941, twenty-seven hostages were taken from the Châteaubriant camp and shot. Almost all of them were Communists."[1]

As the conflict intensified, Picasso began to find his place, but in

a different way: he felt the same disgust that he'd felt when Guernica was destroyed by the Condor Legion and he mechanically drew a hammer and sickle on the page of *L'Humanité*. In Vichy, Marshal Pétain condemned the Communist attacks, while in London General de Gaulle declared bluntly: "It is absolutely normal and absolutely justified that Germans should be killed by the French."[2] Meanwhile the Germans pursued their policy of terror after the mass execution in Châteaubriant: on December 15, 1941, ninety-two hostages were shot at Fort Mont Valérien, among them the remarkable Gabriel Péri, journalist, deputy, and member of the French Communist Party's central committee.

Was Picasso—with his phobia of being arrested and executed, his obsessive reading of underground newspapers, his friendship with Paul Éluard—drawn into the emotional spiral that surrounded Gabriel Péri's execution? The reading of Péri's last letter—patriotic and Communist, courageous and selfless—quickly led to a mythical celebration of his heroism within the Communist Party. This was undeniably a turning point for Picasso. "Let my friends know that I remained faithful to the ideal of my life; let my compatriots know that I am going to die so that France may live," wrote Péri.[3]

On January 5, 1942, *L'Humanité clandestine* reminded its readers that "Gabriel Péri [. . .] and dozens of other patriots were executed [. . .] all of France should proclaim its indignation and its anger at the Nazi oppressors and their Vichy accomplices." It was in exactly this climate of antifascist mobilization, political romanticism, and intense secrecy that Picasso's political development occurred. But the artist must undoubtedly have been aware of how the Communist Party had, since 1936 (when he began to grow close to some Spanish Communists), supported immigration, calling on the government to create a legal status for foreigners[4] while condemning the "inhuman harassment"[5] they had suffered: "Today more than ever the foreigner in France is deprived of the most basic human rights," declared Marcel Livian, the immigration spokesman for the French Section of the Workers' International socialist party.[6] The

rise of the MOI (Main-d'Oeuvre Imigrée, the Communist-backed trade union), a union created in 1921 to bring together immigrant workers, also encouraged some within the Communist Party to regard that population of political refugees (Spaniards, Italians, German Jews, and Polish Jews) as a reservoir of revolutionary energy and the ideal breeding ground for the party's recruiters. "On the eve of World War II, France was home to a large part of the European Communist elite: leaders exiled from the main Communist parties of Europe, along with thousands of fanatical activists, the same ones who had enrolled in the International Brigades to defend the Spanish Republic," we read in *The Foreigner's Blood*, "so many Communist leaders and hardened combatants, so many networks operated by MOI activists in their communities, so many advantages when the time came to resist."[7]

By April 1944, Brassaï reveals in his memoirs, the studio on Rue des Grands-Augustins had become a destination, a port of call, a rallying point where Picasso held court while Marcel (his chauffeur) brought in dozens of paintings, Inès (his maid) carried armfuls of lilacs to different rooms, and Sabartés (his friend and secretary) tried to monitor the various comings and goings.[8] In 1944, the whole of Parisian society paraded through the artist's studio, people of all ages, all professions, all political tendencies, providing him with a foretaste of what his life would be for the next thirty years.

Postscript

After this overview of Picasso's complicated relationships and contacts, we will leave the artist busy with his work. In a climate of extreme confusion, in a place of maximum precariousness, in a liminal state, he floats between two worlds, always pragmatic, giving us works that convey his sense of distress. The two chapters that follow belong to World War II. They explore unpublished archival files that reveal certain truths about the underworld at the time. They reveal unexpected and gloomy characters, shady profiteers, and networks so tangled that they remain, for now, almost impossible to elucidate. As the archivist Yves Pérotin rightly points out, "In the midst of this cosmopolitan crowd that gravitated around the Germans, where people were duping each other at the drop of a hat, it is very difficult to unravel the truth."

43.

JUDGMENT TIME, PART I: BRIGADIER CHEVALIER'S PURIFICATION TRIAL

Paris, June 27, 1945

I believed in Pétain, hero of Verdun. After the chaos of the invasion, I believed in Pétain . . . [1]

—Émile Chevalier

Why have I persisted in a search for which I was completely unprepared? Why have I sought to discover the person hiding behind that policeman's indecipherable signature? "Cherabi"? "Cheraki"? "Chorali"? For several days running, I went back to Le Pré-Saint-Gervais, slashing my way through the dense, disorienting jungle of police archives because everything about that letter of rejection (dated May 25, 1940) revolted me: it reeked of xenophobia, jealousy, bitterness, gossip, insinuations, pettiness, and its most vicious lines kept nagging at me; I couldn't get them out of my head. Picasso was described as "a so-called modern painter who has earned millions, apparently placed abroad," a man who "did not serve our country during the war," and who "retained his extremist ideas while being drawn to Communism." This report, typed in blue ink by a secretary, had been annotated and corrected by its author in black ballpoint before being signed, and had then been revised with underlinings in blue and red pencil, as if to make it more expressive. It was a cowardly report, written by a police bureaucrat in Paris, a member of the fourth

section of the Renseignements Généraux; cowardly in the same way as so many of the other texts that clutter up the archives of the Paris police prefecture, cowardly in the same way as those letters by informers who hide behind anonymity or a pseudonym. "Cherabi"? "Cheraki"? "Chorali"? That illegible signature, small and cramped, was undoubtedly the same one that would bring an end to Picasso's naturalization request. That hateful, three-page report stopped the process in its tracks, a process that had been close to reaching a successful conclusion, that had required the intervention of five or six high-placed acquaintances, and that had involved entire days spent fastidiously filling out supplemental administrative forms before hitting a dead end less than two months later.

The history of French bureaucracy in the age of Vichy is the domain of expert researchers who, after years of poring over dossiers, have learned to decode names and decipher handwriting, putting together entire dictionaries to navigate their way through the shadiness of those years; investigating, unmasking, starting over. This morning, a bald, bearded man stands behind the counter of the archives of the Paris police prefecture. He wears a small earring in his left ear, an enormous, Tibetan-looking ring on his right hand; his clothes—skintight yellow sweater, red pants, sneakers—are cheerfully out of place. Every ten minutes he goes out to smoke a cigarette, and when he comes back he reeks of tobacco. Inside the room, four researchers examine and photograph pages while the clock ticks loudly in the background. It's a Wednesday morning—November 22, 2017—and outside the weather is beautiful. I receive a text from Vichy specialist Laurent Joly that enables me to finally crack the enigma of the policeman's name. I had read his signature as "Cherabi," but Laurent thinks it looks more like "Chira" or "Cheva." After cross-checking, he works out that the bureaucrat in question was a certain Émile Chevalier, whose purification file I am able to find. "Great—you've got your man! I'm so happy," writes Laurent, who recently denounced "the ordinary ignominy of the Parisian informer,"[2] demonstrating that the blank wall of bureaucracy

conceals a swarm of individuals with their own lives and choices, that it is men who make irreparable decisions—as in Hannah Arendt's *Eichmann in Jerusalem*, where the author unmasks those bureaucrats who, by stigmatizing the Other, depersonalize their prey before destroying it. I don't notice the time passing on that autumn Wednesday in 2017, because I have been transported back to June 27, 1945.

In that sun-filled office, I discover the improbable identity of the man who rejected Picasso's naturalization request. Because, beyond his official title of "principal assistant inspector at the Renseignements Généraux," Émile Chevalier is a completely unexpected person—bland, pathetic, fearful, cowardly . . . and—would you believe it?—a (mediocre) artist who, even now, has a Wikipedia page, a website that presents him as "a twentieth-century impressionist, member of the Society of French Artists," and still has regular exhibitions in a gallery on Quai des Orfèvres. Chevalier knew several other police bureaucrats who "liked to paint," including "M. Marcel Gaucher, second-in-command at the personnel, budget, and equipment department; his son, a temp in the same department; and Tantal, a policeman seconded to the national police shoe store." All of them were denounced, arrested by the Gestapo, and deported. "Chevalier is strongly suspected to be the author of those denunciations," Inspector Guy Litarje testifies.[3] Litarje also states that Chevalier belonged to a secret organization within the police prefecture whose aims were to fight Communism, to propagandize on behalf of Pétain, to work toward a policy of reconciliation and collaboration with Germany, and to purge the police of suspect or antinational elements, i.e., "Gaullist resistance fighters." All of the oral and written testimonies collected in Émile Chevalier's file converge to paint a portrait of a low-level bureaucrat and amateur artist with openly pro-Nazi views who did not hesitate to denounce any of his colleagues (whether to his superiors in the police hierarchy or to the Gestapo) who were less than enthusiastic in their support of the Vichy regime or who could potentially be seen as his artistic rivals. So what was the outcome

of Émile Chevalier's purification trial? His retirement pension was suspended for two years, a verdict that—given the evidence against him—does not seem particularly harsh.

Who could have guessed that a second-rate policeman and painter—a manipulative, jealous, xenophobic snitch with "an intelligence [that was] far from first-rate" (the expression employed by Litarje)—could have managed to thwart the armada launched at the Ministry of Justice in April 1940 (not the ideal moment, admittedly) by Marie Cuttoli, Paul Cuttoli, Henri Laugier, and other influential people to make Picasso a French citizen and thus save him from the coming terror? Taking a closer look at the website devoted to Chevalier Milo, discovering his bouquets of wildflowers, his peaceful landscapes of Île-de-France with their cows and poppy fields, his church interiors, his poplar-lined country roads, his cottages and villages and steeples, his boats moored on nostalgic rivers, it occurs to me that the discovery of this unexpected character is not as insignificant as I'd thought. Because in this unremarkable man are to be found all the notions of conformism, "good taste," arrogance, and canonical imperialism that were prevalent in the Académie des Beaux-Arts, and the feelings of xenophobia that stalked the larger French society to protect the peaceful "values" of this country (in other words, roots, blood, and earth) against the dangers of "this foreigner who has made a reputation while in France for so-called modern painting that has enabled him to gain considerable sums of money," whose ideas "appear to have been taken from extremist doctrines," and who, "subservient to foreign powers," continued to proclaim his "anti-French" opinions.

I didn't invent this story—this bad thriller, this sordid discovery—I just followed the intuitions I first felt after finding the reports written by Finot, Foureur, Bornibus, and Giroflé, those informers who, back in May 1901, began feeding police chief Rouquier scraps of gossip (the artist's paintings representing "the sloven, the drunkard, the thief, the murderess" or "beggars, abandoned by the city") that constituted the first elements of the police file against

this "very young Spanish artist" who was "considered an anarchist." That first text provided the basic outline for the report written by Émile Chevalier (a second-rate police agent with exorbitant powers) on May 25, 1940, when he refused the application for French naturalization filed by one of the greatest artists of the century.

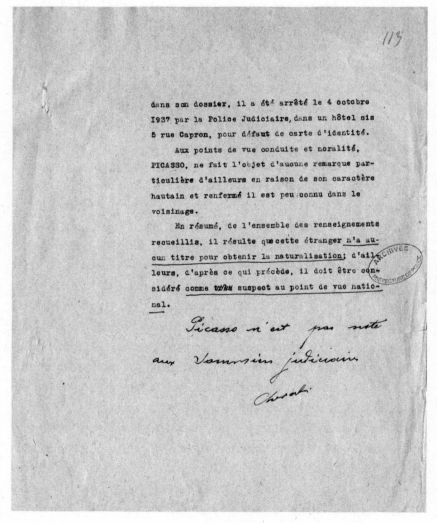

Rejection of Picasso's request for naturalization by brigadier Émile Chevalier, May 25, 1940 (Archives de la Préfecture de Police de Paris)

44.

JUDGMENT TIME, PART II: COMMITTEES FOR THE CONFISCATION OF ILLICIT PROFITS

I do not understand this request. My solidarity tax was declared within the recommended deadlines, and yet the address indicated is 23 Rue La Boétie, my private residence. I was taxed following my declaration (number 9,946), and I even made two different payments to provide the sums demanded.[1]

—Pablo Picasso

After the discovery of Émile Chevalier, after the revelation of the kind of mystery that could easily have remained buried, I decided to keep digging. I wanted to understand what happened during the Occupation years between the art dealer André Schoeller and the painter Chevalier Milo, or between the art dealer Martin Fabiani, who bought Vollard's business in 1941, and Picasso. There have been many studies written on the shameless trafficking in art carried out by Alfred Rosenberg with his *Einsatzstab Reichsleiter Rosenberg*.[2] So, once again, I go in search of the truth, beginning with an investigation at the diplomatic archives in Saint-Denis.

The art expert André Schoeller, of 13 Rue de Téhéran, was the director of the Georges Petit gallery until 1930—the gallery later

supported by Chester Dale, where Picasso organized his first major retrospective in July 1932—then an art dealer and director of public sales from 1939 until 1945. In 1946, Schoeller was accused by Albert Henraux, president of the commission for art recovery, of having "assessed on behalf of the Germans and sold to them, during the Occupation, a certain number of paintings acquired in auction rooms on behalf of private collectors" (including seven for the infamous war profiteer Hildebrand Gurlitt), "as well as German museums, worth a total of 1.5 million francs."[3] His file in the Paris archives, created by the Committee for the Confiscation of Illicit Profits, describes his lavish lifestyle, before 1939, "with two cars, three servants including a chauffeur, a rent of 20,000 francs [. . .] and a racing yacht," but most importantly it describes "a substantial increase in his profits during the Occupation," a period when he advertised in *Pariser Zeitung* as an art dealer, art expert, and intermediary. The file also describes Schoeller's rush, in 1944, to obtain "evidence of resistance" and to establish a personal history of patriotism (including the Croix de Guerre 1914–18) to prove his innocence once the war was over.

Little by little, I learn (among other things) that during the Occupation, Schoeller sold to various German officials, for sums ranging between 800 and 11,000 francs, paintings by Chevalier Milo—*while he was working for the police prefecture.* On January 23, 1941, he made a profit of 800 francs from Colonel Spiessbach in Dijon; on February 13, 1941, 200 francs from Dr. Goldschmidt in Cologne; on April 29, 1941, 2,500 francs from Major Heitschmidt in Evreux, on behalf of the prefect of Eure; on December 9, 1941, 700 francs from Dr. Koehler in Dijon; on October 21, 1943, 2,500 francs from Dr. Lohse in Paris . . .

As for Martin Fabiani, presented from the outset as a man "without scruples, with the mind and behavior of a gangster (approximately forty-four years old),"[4] I learn from his file that he had married the rich widow of a northern businessman, that he "possessed a stable of ten racehorses" and "assiduously courted the favors

of Dr. Lange (head of artistic propaganda in France) by arguing at dinners" with other art dealers such as Louis Carré, and that he "often visited his artists with Dr. Lange and several members of his entourage." After his brother, the mayor of Ajaccio, was executed by Gaullists, however, "Fabiani became more friendly [because he was] worried." Moreover, "a long time before this, [. . .] he had started to establish a relationship with Picasso [. . .] then he'd adroitly protected himself, making an ally of Aragon by subsidizing the literary magazine *Les Lettres Françaises*, which he later owned."[5] With its denunciations, its references to illicit profits, its "large sums of money" made from Matisse and Picasso, its collaboration with the occupier, its opportunistic manipulation of famous left-wingers, etc., the Fabiani file is a gold mine of shady dealings. A list handwritten in pencil reveals that he did indeed sell many Picasso paintings, including two on one very lucrative day: on June 16, 1944, he sold *Obsession* and a still life for 100,000 francs each.

His file was analyzed on October 12, 1945; after an appeal, it was verified on October 31, 1947, and Fabiani was condemned "for unjustified profits amounting to 32 million francs." His sentence, "despite his 'acts of resistance,'" was the "maximum fine of 34 million francs."

I am just extricating myself from that world when I am given another file, the one for the national solidarity tax created in 1945 to tax wealth accumulated during the war, for which an economist at the Paris I Panthéon-Sorbonne University has discovered certain elements pertaining to Picasso. It is thanks to Isabelle Rabault-Mazières, then, that I am able to end my investigation into the Occupation years by noting that Picasso's wealth increased by 5.5 million francs (which might sound like a lot until you compare it to the profit of 32 million francs made by someone like Fabiani). She explains, for example, that the largest fortune amassed during that period in the 6th arrondissement of Paris was made by a hairdresser, while in the 3rd arrondissement it was a charcutier who knew how to play the black market.

On June 26, 1947, it was finally decided that Picasso would have to pay 1.2 million francs in solidarity tax to the French State, staggered in four payments. It is worth noting, however, that in those years when phrases such as "the blood tax" and "the party of the executed" were endlessly repeated, a man refused French naturalization in 1940 was nevertheless expected to contribute to national solidarity in 1947.

V

THE ARTIST AS HERO

1944–1973

Unhappy is the land that breeds no hero.
Unhappy is the land that needs a hero.[1]

—Bertolt Brecht

RADIO CORPORATION OF AMERICA

R.C.A. COMMUNICATIONS, INC.

EXHIBITION HUGE SUCCESS SIXTY THOUSAND VISITORS SURPASSING VAN GOGH'S EXHIBITION STOP SINCE WAR PREVENTS SENDING YOUR PAINTINGS HOPE YOU AGREE THEIR INCLUSION IN TRIUMPHANT TOUR GREAT CULTURAL CENTERS UNITED STATES STOP PLEASE WIRE PRICES FOR BUYERS CATALOGUE NUMBER 142 BAIGNEUSES DEBOUT 1929 CATALOGUE 230 NAGEUSE 1922 CATALOGUE 235 STOP MUSEUM PRICES FOR DIAGHILEV PORTRAIT 1917 CATALOGUE 130 COURSE 1922 CATALOGUE 217 FIGURE 1927 CATALOGUE 212 ETUDES DEMOISELLES D'AVIGNON CATALOGUE 28 29 SENDING NEWS-PAPER CUTTINGS WILL BE [ILLEGIBLE] PLEASE WIRE BARR[1]

DECEMBER 15, 1939

"PICASSO: FORTY YEARS OF HIS ART"
ITINERARY

Edition I
1940

February 1–March 5: The Art Institute of Chicago, Chicago (Illinois)

March 16–April 14: City Art Museum, Saint Louis (Missouri)

April 26–May 25: Museum of Fine Arts, Boston (Massachusetts)

June 25–July 22: San Francisco Museum of Art, San Francisco (California)

Edition II
1940

September 28–October 27: Cincinnati Museum of Art, Cincinnati (Ohio)

November 7–December 8: Cleveland Museum of Art, Cleveland (Ohio)

December 20–January 17: Isaac Delgado Museum of Art, New Orléans (Louisiana)

1941

February 1–March 2: Minneapolis Institute of Art, Minneapolis (Minnesota)

March 15–April 13: Carnegie Institute, Pittsburgh (Pennsylvania)

Edition III
1941

November 1–24: Munson-Williams-Proctor Arts Institute, Utica (New York)

November 29–December 20: Duke University, Durham (North Carolina)

1942

> January 24–February 14: William Rockhill Nelson Gallery of
> Art, Kansas City (Missouri)
>
> February 20–March 13: Milwaukee Art Institute, Milwaukee
> (Wisconsin)
>
> March 23–April 13: Grand Rapids Art Gallery, Grand Rapids
> (Michigan)
>
> April 27–May 18: Dartmouth College, Hanover
> (New Hampshire)
>
> May 20–June 15: Vassar College, Poughkeepsie
> (New York)

Edition IV
1942

> September 27–October 18: Wellesley College, Wellesley
> (Massachusetts)
>
> October 28–November 18: Sweet Briar College, Sweet Briar
> (Virginia)
>
> November 28–December 19 : Williams College, Williamstown
> (Massachusetts)

1943

> January 1–22: Indiana University, Bloomington
> (Indiana)
>
> February 5–26: Monticello College, Alton (Illinois)
>
> April 1–30: Portland Art Museum, Portland
> (Oregon)

Special Loan of Guernica *Murals and 59 Studies*
1941

> November 4–30: Columbus Gallery of Fine Arts, Columbus
> (Ohio)

1942

> September 24–October 30: Fogg Museum, Cambridge
> (Massachusetts)

Attendance Figures[1]
 Chicago: 67,661
 Saint Louis: 47,530
 Cincinnati: 21,528
 Cleveland: 22,958
 Minneapolis: 21,500

45.

THE VIEW FROM NEW YORK?
ADOLF HITLER'S SWORN ENEMY

Do you know that Hitler himself once did me the honor of calling me in one of his speeches as a wicked corrupt[er] of youth?[1]

—Pablo Picasso to Peter D. Whitney

Picasso: Forty Years of His Art, the exhibition organized by Alfred H. Barr Jr., which opened at MoMA on November 15, 1939, had an unusual fate. When war was declared, Barr consulted Picasso and came to a major decision: to take full advantage of the treasures he had amassed in the United States, he arranged for an improvised tour of the country before the works were sent back to New York, where they would be exhibited again in a reduced version, to meet public demand.[2] The whole thing was like a lap of honor for the all-conquering Picasso.

The exhibition brought together *Family of Saltimbanques*, *Les Demoiselles d'Avignon*, and *Guernica* for the first and only time anywhere in the world, and also included many of his best cubist and surrealist works (not to mention all the costumes, sculptures, engravings, etc.). A total of twenty-six museums hosted these exhibitions,[3] and—if you include the tour for *Guernica* that preceded this one—Picasso's art had by that point been seen by almost a half million people.

"Despite the war—and perhaps also in defiance of it" (as the director of MoMA wrote to the artist),[4] Picasso's work, safe in the New World, now found its place in the history of art, thanks to its exegete supreme, Alfred Barr. Its presentation to the American audience lasted not six months but five years—a success augmented by the museum's department of publications, department of traveling exhibitions, and most of all its department of education. It is no surprise that, from August 25, 1944, Picasso became—for Americans of all ages in all regions—the most sought-after artist in the world.

But Barr's enthusiastic support of modernist European artists had, from the moment he took over at MoMA, aroused the indignation of certain American artists. During the war, he had transformed the museum into a refuge for exiled artists, working with Varian Fry at the American consulate in Marseille to offer financial support for their travel expenses. Those artists discovered, within MoMA's resolutely modernist architecture, a collection that brought together for the first time the various facets of the European avant-garde (French surrealism, Russian futurism, German expressionism, and so on). Among the artists who came to admire that first "encyclopedia of European art" were Nicolas Calas from Greece, Max Ernst from Switzerland, Piet Mondrian from the Netherlands, Victor Brauner from Romania, Salvador Dalí from Spain, André Breton and André Masson from France, and Roberto Matta from Chile. "It was in the United States that everything fell into place for me, it was there that I matured," admitted Masson.[5] But Barr would continue to be attacked, and in 1943 he was dismissed from his position as director of the museum, while remaining director of collections. In 1948, Thomas Craven, one of the most nationalistic of American critics, dismissed him as the "master of a style that is one part mock erudition and nine parts pure drivel, writes books on Picasso, the red idol deified by the Parisian bohemia which he rules, and other such deadly phenomenons. His museum is a glittering depot of exotic importations and the claptrap of a few culled Americans who have nothing American about them."[6]

Almost five years after his radiogram of December 15, 1939, Barr contacted Picasso with the first message he'd written since the Liberation: "Now at last we are allowed to send you a postcard," he sighed before adding, a few weeks later: "I am writing to you on behalf of MoMA to ask you to allow us to make the first offer for some of your works that we kept here during the war [. . .]. We would particularly like to buy *Guernica* and the drawings numbered 280 to 326 in our catalog. Next [. . .] *Two Women Running on the Beach* 1922 (number 167), *Three Dancers* 1925 (number 190) [. . .] *Crucifixion* 1930 (number 233), and a print of the 1935 *Minotauromachie* engraving which we don't have in the museum. It is highly likely that the museum will not have enough money to buy all these works, but even so we would be grateful if you could let us know the prices for any that you are willing to sell."[7] With his American-tinted glasses, however, Barr found it hard to decipher the reality of the new Europe. The proof of this is that he began compiling the reactions of the anglophone press to his favorite artist in a strange, nine-page document, "Picasso 1940–1944: A Digest with Notes," which he published in *The Bulletin of the Museum of Modern Art* in January 1945.[8]

Having not seen Picasso during the five years of the war, Barr found himself for the first time out of sync with reality. Why would such an aesthete care about the opinions of the mainstream press? The anecdotes he repeated (which would become internationally famous)—such as the one about the German ambassador to Paris, Otto Abetz, who looked at a photograph of *Guernica* and asked, "Mr. Picasso, was it you who did that?" to which Picasso replied, "No, it was you"—undoubtedly captured Picasso's wit, verve, and jubilant exhibitionism, but they said very little about his art.

Barr's interpretation of the 1944 Autumn Salon (named the Salon de la Libération that year) was, likewise, completely arbitrary and out of touch. But how could it have been otherwise, given that he was analyzing the situation using tools from 1939, when so much water had flowed under the bridge since then? While "Picasso's prestige as the heroic symbol of the Resistance movement is still at its

peak," the MoMA director stated, his art remained unappreciated by politicians and the "people of Paris, who before the war were far less familiar with him than many New Yorkers," a situation "aggravated by collaboration." Even more oddly, Barr invented a "disparate trio" composed of Picasso, Matisse, and Bonnard that would represent "post-Liberation art" in order to contrast the art of the "two Frenchmen," which he characterized as "friendly, happy, charming, pretty," with Picasso's, which he described as "strange, foreign, modern, and difficult," rejected by French populists and museum curators. This situation would continue for a while, with the works from the artist's personal collection that had been loaned to MoMA remaining in the museum until 1956, when Picasso began to inquire about their fate during the Cold War,[9] but that is a story for another chapter.

Picasso, as a skilled juggler of multiple affiliations, was peculiarly suited to such tangled situations. The Salon de la Libération opened in Paris on October 5 and was a good example of Picasso's juggling skills. Organized in an extremely tense atmosphere, amid purification trials, the exhibition was—in the words of its president, the artist and architect Pierre-Paul Montagnac—aimed at "reforming a number of abuses and erasing a number of shameful behaviors in spite of humanity's petty, pathetic cowardice." Montagnac rubbed shoulders with Picasso at the purification meetings of the Front National des Arts, and on September 14, 1944, he enthusiastically told one of his colleagues: "As far as Picasso is concerned, we are organizing an exhibition of his works with him."[10] Alongside paintings by Le Fauconnier, Fernand Léger, Henri Manguin, Nicolas de Staël, and others, Montagnac decided to promote Picasso as the hero of the salon, inviting him to exhibit seventy-four works (one-third of the total) in a room devoted entirely to him. But how would the Parisian public react to the sudden elevation of an artist whose work they barely knew? Featuring only works produced during the Occupation, this event, which had been prepared amid the privations of the war, was utterly lacking in curatorial and educational support. A very short radio report by the journalist Michel Droit, broadcast on October 8, gives us a glimpse of its prim, obsequious, old-fashioned tone: "We

have beside us the great Spanish painter Pablo Picasso, who needs no introduction. Sir, are you happy to have your work exhibited for the first time at the Autumn Salon and to celebrate our liberation at the same time?" Answer: "I am happier than I have ever been." Second question: "Sir, how many works do you have at the salon?" Answer: "Seventy-four."

So while the American public had been given the tools and education to analyze and understand the 362 works created by the artist between 1901 and 1939, which demonstrated the full palette of his aesthetic virtuosity, the Parisian public—who knew nothing of those works except perhaps *Guernica*—were suddenly exposed to *Cat Devouring a Bird, Young Boy with Lobster, Flayed Sheep Head, Woman with Artichoke, The Serenade, Child with a Dove, Still Life with Skull and Pitcher*, and *Woman with a Striped Hat*, a gathering of powerful, despairing, tortured, disturbing works that bore the indelible mark of the Occupation years. Some visitors were rendered speechless by this danse macabre, while others took the paintings off the wall to express their anguish. Worshipped abroad, Picasso remained controversial in his adopted homeland. "These are the works I have produced in the last four years," the artist told *The New York Times*. "And they seem to have ruffled a few feathers." There was nothing new about the disparate reactions in France and America, but the war did appear to have amplified them. In the end, Picasso's paintings had to be protected by policemen.

"Sir, Thankfully being a foreigner it is impossible for you to dishonor France, but your vile paintings disgust everyone who has any awareness of the values of art," wrote one anonymous visitor to the exhibition in a letter conserved by the Musée National Picasso-Paris. "In France, we have true composers of value such as Henri Dutilleux [. . .] and I think we have painters of value, too."[11] An undisputed master to some, a false prophet to others: this was Picasso's image in October 1944. Did the Salon de la Libération really spark anger among former fascists and among students at the Beaux-Arts, as has been suggested? In any case, Picasso remained a controversial figure. And yet, during the Occupation, he had received more than a

thousand letters asking for money or support, becoming "the imagi-
nary rallying point for a broken-up artistic society."[12]

The best summation of the reaction to this salon came, once
again, from Michel Leiris, who decried the critics' characteriza-
tion of Picasso's works as "monstrous, aggressive, inhuman, incom-
prehensible for the vast majority of the French public." "It would
seem," Leiris observed, "that Picasso is more than ever regarded as
the enemy of art, even while he occupies a unique place in the artis-
tic scene."[13] Emphasizing the artist's "capacity for reinvention," he
questioned "the real motivation for such an outcry," since the role of
art was "not to represent [. . .] nature, [but to] create a gap [. . .].
Picasso's art attacks the world where we live and the people we are
[. . .]. [It] rejects the deference necessary to flatter lazy minds [. . .].
Whence this subversiveness, this playful destructiveness and sacrile-
gious humor." This is a thoughtful portrait of the scandalous Picasso,
in conflict with narrow-minded France, and in conflict, too, with all
those—Alfred Barr among them—who persisted in considering Pi-
casso as "Spanish" or "foreign" in the liberated Paris,[14] whereas the
reality was that everything had changed. That was only one of many
paradoxes surrounding this artist who was now extremely rich, who
had friends in high places, and who had become adept, even in the
most complex and dangerous circumstances, at turning all possible
situations to his advantage.

46.

THE VIEW FROM MOSCOW?
FRANCO'S SWORN ENEMY

You understand, I am not French, but Spanish. I am against Franco. The only way to make this known is to show people—by joining the Communist Party—that I am on the other side.[1]

—Pablo Picasso to Geneviève Laporte

In late October 2010, *L'Humanité* celebrated the seventy-second anniversary of the day Picasso joined the French Communist Party (PCF)—a decision often derided as opportunistic, the journalist wrote, since it took place "amid the enthusiasm of the Liberation." Indeed, there was a very mixed reaction to the news of Picasso's membership, which was unlike anyone else's in the sense that it truly *was* news. Later, the historian Fred Kupferman noted ironically: "Picasso was promoted to the Resistance due to his membership in the Communist Party."[2] At the time, many people attempted to interpret his decision. The shocked Jean Cocteau described it as "the event of the month." "*L'Humanité* devoted its entire front page to the story," he wrote, "with an article [. . .] on the joy of the Communist family to extend its arms to the greatest artist in the world. This is Picasso's first antirevolutionary action, the first time that a *trust* (isn't Picasso a whole trust by himself?) joins the Communist Party."[3]

During the four years of the Nazi occupation, Picasso rubbed

shoulders with people on the side of the enemy, sent checks to refugees in need, and was introduced into the mysteries of the Communist Party by his poet friends who saluted the courage of Resistance assassins and saboteurs, the heroism of Gabriel Péri. All the same, it's true that Picasso could hardly be described as an "active member" of the Resistance. If he was acclaimed for a victory won in large part by French Communists, it was partly because he had been fighting his own war against Francoism since 1936, using the weaponry of his art but also his unpublicized donations to Spanish refugees. And his involvement in the Spanish Civil War, like his position as leader of the artistic avant-garde, marked him indelibly as a "degenerate artist"—a status that automatically transformed him into a pariah when the Germans invaded France.

On August 19, Picasso left his studio on Rue des Grands-Augustins and symbolically chose to watch the parades of the Liberation from the balcony on Boulevard Henri-IV, between the Seine and the Place de la Bastille, where Marie-Thérèse Walter lived with their daughter, Maya—a location far more open to the city than the medieval courtyard of the Saint-Michel neighborhood. A new place, a new identity, a new era, new works of art: *Tomato Plant* (which Marie-Thérèse Walter had grown on her balcony), and *Bacchanales (The Triumph of Pan)*, which depicted the jubilation on the streets of Paris, the face of a boy in the Liberation ceremonies.[4]

During this period, besieged by American photographers and journalists on Boulevard Henri-IV as well as on Rue des Grands-Augustins, Picasso did not get much work done. The visits were incessant, excessive, exhausting: "Every morning, the long, narrow room on the first floor [. . .] became an antechamber filled with dozens of new arrivals all waiting for Picasso to appear."[5] When he opened the doors of his studio to warmly welcome the American journalists who were hailing him as the "hero of a revolutionary moment," it was the start of a phenomenon that surely owed its existence to Alfred Barr, whose skills as a pedagogical art historian had raised Picasso to the status of an essential artist in the United States, laying

the first stones of the enduring legend. And this was the crux of the problem. Because the representation of Picasso's art and personality in the United States bore no resemblance whatsoever to their representation among most French people.

Before we set sail upon the calmer waters of the coming decades, we must first retrace our steps. Some people, like Cocteau, were irritated by the fact that Picasso publicly took part in the protest marches that followed the war, that he was fully in tune with the mass movements of Europeans who were swept up by a vast wave of hope and euphoria after the Allied victory, but also by the expiatory rites (purification, sacrifice, catharsis, etc.) that attended the war's end. Many criticized his ubiquity during the purification trials. Why would Picasso, who had always been so reluctant to show his art in the salons like other artists, who had spent his whole life restricting himself to small, marginal circles, suddenly—in August 1944—start giving himself so generously to all-comers? Why this total about-face in the management of his image?[6] Why, on October 5, 1944, when asked by the Communist painter André Fougeron, did he agree to become president of the executive committee of the Front National des Arts, tasked with purifying the art world? Why, on October 16, 1944, did he join the march to the Père-Lachaise Cemetery in memory of the victims of Nazism, dressed elegantly in a beige raincoat, black Borsalino hat, and tie, walking at the front alongside the tall, dignified Éluard? After all the restrictions and deprivations of the war years, he became one of the most visible signs of this new dawn. Not only that, but he wore his new Communist identity like a medal of honor, an official declaration, a manifesto. What information was he signaling, implicitly?

Let us return to his membership in the PCF in October 1944. Should it be considered simply opportunistic? My answer would be: on the whole, yes, but it wasn't only that. Do the artist's detractors possess all the information necessary to comprehend his point of view? The reason Picasso officially rallied to the Communist cause was that he very quickly sensed that this membership would serve

simultaneously as a passport, a springboard, and a shield. The series
of political events that he lived through after 1936 was extremely
onerous. He found himself torn between Spain, for which he had
fought so hard (his mother had died in 1938, but he maintained close
connections with his sister and his Vilato nephews), France, where
his naturalization request had given him cold sweats for four years,
as had his repeated requests to the police for letters of transit, and the
United States, where most of his work was now kept. So he reached
the end of the Occupation in a state of mild shock, particularly since
the last hopes that Spain would be liberated by the Allies ended in
defeat at Val d'Aran. But Picasso had never been imprisoned, nor
had he ever run the risk of becoming an expiatory victim. To which
world did he now belong? He had been victimized in some way by
the rejection of his naturalization request. His membership in the
PCF gave him a sense of agency over his own life, and he often com-
mented on this fact. But let us examine one in particular—the inter-
view in *L'Humanité* that appeared on October 29—in which he used
the metaphor of the foreigner: "I was so eager to find a homeland! I'd
always been an exile. I'm not anymore. While I waited for Spain to
be able to welcome me back, the Party opened its arms to me [. . .]
and I am among my brothers again."[7]

It seems that, around 1939, Dolores Ibárurri (a.k.a. La Pasion-
aria, elected as a Spanish Communist Party deputy for Asturias in
1937) suggested to her Muscovite handlers that it was of the greatest
importance to catch Picasso in the web of the Communist Interna-
tional.[8] While it was true that Picasso grew closer to Communists in
Spain and in France between 1936 and 1944, there was also, in par-
allel, a concerted attempt by the Moscow-based Comintern to draw
Picasso toward them. The person who would complete the process
of rapprochement between Picasso and the French Communist Party
was Laurent Casanova. He was one of the most powerful members of
the PCF, and during the Occupation, in 1943, he was secretly staying
in the apartment of Michel and Louise Leiris at the corner of Rue
des Grands-Augustins. The right-hand man to Maurice Thorez, the
PCF's secretary-general from 1934 to 1939, then to Charles Tillon

(leader of the FTP—Francs Tireurs et Partisans) during the Resistance, Casanova was given a difficult mission: to liaise between the Communists and General de Gaulle while remaining in permanent contact, by telegram, with Thorez, now exiled in Moscow. Laurent Casanova, then, had three important advantages: he was close to Maurice Thorez; he was the high priest of French intellectuals; and, lastly, he was married to Danielle Casanova, a famous Resistance fighter arrested by the Germans in 1942, who died of typhus at Auschwitz in 1943 and would soon be celebrated as a heroine by the PCF on the same day as the national celebration of Joan of Arc. Laurent Casanova was, in other words, a very powerful go-between who, during his frequent conversations with Picasso, allowed the artist to understand that the entire Communist hierarchy was eager to welcome him into its ranks.

When he met Casanova, Picasso immediately sensed the opportunity offered by this alliance, as well as the numerous additional benefits he could draw from it. He officially became a member of the French Communist Party on October 4, 1944, a few days before his sixty-third birthday. That very year, what the party (which would remain an extremely powerful organization until 1947, hand in hand with the Gaullists) was proposing was nothing less than a social reconstruction. The PCF of 1944 bore no resemblance to that of 1939. And Picasso was at the heart of this new dawn.

But few people could comprehend the multiple strata and experiences that were behind his decision. Few could discern Picasso's threefold otherness in French society—foreigner, politically engaged intellectual, avant-garde artist—that left him so vulnerable to the waves of xenophobia, to the delays of French bureaucracy, and most of all to wars. His membership in the PCF brought an end to all these worries. But Picasso never directly referred to that threefold otherness. And even if the question of his aesthetic freedom remained in the air, even if the first skirmishes with the PCF's orthodoxy would soon begin, his membership was still a powerful response to the question of his precarious state within French society. "I went to Communism like a thirsty man to a drinking fountain," he said,[9]

presenting his act as something necessary, spontaneous, natural, and vital. Picasso joined the only party that had, since the 1930s, welcomed and protected (and used) refugees from Germany, Austria, Romania, Czechoslovakia, Poland, and Spain in one of its most important organizations, the MOI. He signaled his empathy with the party that had, since November 1936, sent almost ten thousand men (one-third of the total number) into the International Brigades, while in France only Léon Blum had offered any support to the Spanish Republicans. He was drawn to a genuine community, not only a political party but a whole society, offering a new model at a time just when the PCF became, along with the Gaullists, one of the two "great organizers of [French] civil society."[10] Picasso's choice was also a confession of his own vulnerability—the Achilles' heel he had never wanted to reveal—and in joining the party he also glorified his status as a foreigner.

The Liberation turned foreigners into heroes for the first time in France. "All their sacrifices give immigrants the right to feel at home in France,"[11] announced the General Confederation of Labor trade union delegate during a conference on September 19, 1944, that brought together representatives of the French Resistance as well as fourteen immigrant associations. That day, speakers denounced "the poison arrow of xenophobia" and highlighted the price paid in lives by immigrants who had fought so valiantly for the Resistance. And the Action Committee in Defense of Immigrants (CADI), founded during the time of the Front Populaire and now comprising three million members, launched a major political campaign in support of a new legal status for immigrants. "We are happy today to state with pride," declared the CADI's secretary-general, "that we have, with our blood and our sacrifice, contributed to the liberation of this country, that we have paid the debt of gratitude to French hospitality, and that we have earned the moral right to march with our French brothers in the final battle for victory and to climb the hard path, alongside our faithful companions the people of France, that will lead to the rebuilding of this country."[12] This seems a crucial aspect of

Picasso's conversion, particularly since a half million Spanish refugees had been interned in camps during the Vichy regime, and one of the Spanish tanks that helped liberate Paris had been baptized *Guernica* in the artist's honor.

This dimension of his decision was underscored by Picasso's painting *Monument to the Spaniards Who Died for France* (1946–1947), which also highlighted the fact that Republican Spain—which had fascinated Europe during its fight against fascism from 1936 to 1939—had now been wiped from the map. The French Communist Party had sought him out, and Picasso had immediately understood the opportunity on offer: by joining them, he was joining the side of the heroes. (As an aside, he also signed a check for 200,000 francs to Marie-Louise Cachin for the FTP.) Until his death, despite the many visible and invisible tensions that marked their relationship, Picasso would never question his agreement with the PCF. Examined more closely, it is revealed as a complex alliance, strategic and even luminous. Picasso entered it with brio, playing several chess games at the same time, on several boards, against several opponents. Picasso would win every game he played, triumphing over all the obstacles that had barred his way during his first four decades in France. He would triumph, not with a bitter aftertaste of vengeance but with panache.

47.

THE VIEW FROM SAINT-ÉTIENNE, NICE, ALÈS, AUBERVILLIERS? BENEFACTOR OF THE WORKING CLASSES

I will come to knock at your door on Monday, November 13, around 10:00 in the morning.[1]

—Hubert Guillet

During the 1940s and 1950s, Picasso became a kind of benefactor of France's many regions. At the archives of the Musée Picasso, in file E 14, behind the off-putting title of "Relations with Institutions— Provincial Institutions," I find a procession of mayors and museum directors expressing their admiration, their appetite for action, but also their frustration and consternation, revealing an asymmetrical, poverty-stricken cultural landscape, to which only Picasso seemed able to offer any solution. It was as if, emerging now from the confinement into which he had been forced for forty years by the Académie des Beaux-Arts and the National Council of French Museums, inspired by the radiance of the French Communist Party at the time of the Liberation, and backed by the power of the press and his own decentralized organization, Picasso was reborn.

It all began very early—on October 21, 1944—with a letter from Saint-Étienne sent by Claudius Buard, first assistant to the mayor,

who asked Picasso to donate one of his works and introduced him to Hubert Guillet, the curator of the town's Municipal Museum of Art and Industry, who had previously run the Louvre. The file is missing more detailed evidence, but Picasso seems to have responded almost immediately because, a few days later, the curator sent the artist a spontaneous message bursting with enthusiasm.

"I will come to knock at your door on Monday, November 13, around 10:00 in the morning to pick up the painting that you are donating to us," he wrote. I can imagine the curator, having arrived by train or car, ringing the doorbell at the studio on Rue des Grands-Augustins, to take possession of *Still Life with Jar, Glass, and Orange*, a pretty example of late cubism (33 x 41 cm) painted by Picasso on July 23, 1944. Later that day, it was the mayor himself—Dr. Henri Muller—who thanked the artist in person for his "precious gift," a sign of his "generous sympathy toward the working-class population." The still life, he promised, would have "a place of honor in this great industrial French city" and would "give a new impetus to the artistic education of Saint-Étienne's workers." Thus began, after a delay of forty years, through the work of Communist activists and former Resistance fighters, the spread of Picasso's name and art through the museums of regional France.

How natural, genuine, and enthusiastic these letters appear compared to the prim, stuffy missives sent to Picasso by certain Parisian officials. Take Jules Paublan, for example, the curator of museums in Boulogne-sur-Mer, engaged in the "battle for modern art," who sends the artist an SOS because, he says, Picasso "is not insensible to [our] distress." He describes the "crumbling façade" of his museum and begs the artist to help him "rebuild it from its ruins" (July 24, 1947). Later, we find his successor, Robert Delagneau, who explains the local situation with great acuity. His letter expresses the desolation of a province abandoned by the capital and the bitterness felt by "good people" toward "snobs" in a cultural class war in which Picasso is solicited as a natural ally: "Dear Sir, [. . .] the working masses aspire to see not your reproductions but your original works

[. . .]. To satisfy the persistent desire of a public that is nothing like the snobs who buy your works for their venal value, a public mostly comprised of fishermen and steelworkers, it is not possible to delay any longer. These good people, who do not have the means to travel to Paris to see your exhibitions, are demanding an exhibition, even a limited one, of your many activities [. . .] a selection of your works (paintings, ceramics, drawings, engravings). All transportation costs will be paid by the city" (April 2, 1958).

Next, we have Jacques Leblanc, curator at the Musée Antoine Vivenel, in Compiègne, who reveals his difficulties in assembling a collection in the face of bureaucratic obstacles. In the margin of this letter, Picasso draws a long vertical line in red pencil, testament to his sympathy with the curator's opinions. Other officials—such as Charles Tillon, mayor of Aubervilliers, among many other distinctions—seem to feel entitled. Tillon, organizing an exhibition of painting "with the support of the Arc en Ciel group," asks Picasso to "send a few of his works to give to the population of Aubervilliers, for whom the great exhibitions are too seldom accessible, the opportunity to enjoy, in a familiar setting, the resources of modern art" (May 19, 1949). I loved the beautiful relationship forged with the city of Nice when Magdeleine Ferry, the director-general of libraries (she boasted of her acquaintance with Pellequer, Sabartés, the printers Gili and Mourlot, and even Kahnweiler), managed—through sheer inventiveness, vitality, and faith—to mobilize Picasso (by reminding him of his connection with Daumier) to help with the accomplishment of a visionary project—an in-depth collection, unique in France: "Dear Mr. Picasso, you are enabling me to fulfill my dream: founding a museum of engravings in Nice!" (June 8, 1959).

I must also mention Louis Arcaix, curator at the Musée du Colombier in Alès (a coal-mining town in the Cévennes): "We are organizing a museum of modern art [. . .]. I have the honor of soliciting your generosity to ask if you would donate one of your works to honor our new walls. The workers' city of Alès would be grateful to you" (May 27, 1949); and the letter from Mrs. Ligier, secretary of the

work and culture group in Malmaison, who wrote asking "where to find [your] artworks" (May 25, 1953); and from Jacqueline Albert André, a curator in Bagnols-sur-Cèze, writing at the suggestion of her friend, the Communist journalist Georges Besson, who had informed her that they would "perhaps have the joy of possessing" one of the artist's works: "I am very happy about this, and I thank you in advance" (August 20, 1957).

When Picasso decided to move to the south of France in 1955, the locals remembered his donation of *Man with a Lamb* to the civic square in Vallauris (August 6, 1950), and of seventy-six ceramics, and in 1956 he painted his *War and Peace* fresco in the medieval chapel there. Later, it was G. Borios, the secretary-general of the mayor's office in Port-de-Bouc, who, on the advice of the mayor of Vallauris ("our friend and comrade"), invited Picasso to an art exhibition taking place from August 25 to August 27, for which his "participation could consist of the lending of certain works as well as a personal visit [. . .]." "Please confirm with a yes or a no, the cars will be escorted," he added on August 5, 1962. André Jacquemin, a painter, engraver, and curator at the departmental museum of the Vosges in Épinal (as well as a personal friend of Paul Derigon, the mayor of Vallauris), reminded Picasso how, for the artist's eightieth birthday, he "had the great honor of awarding Picasso a pamphlet of contemporary popular imagery recounting the sufferings of the region." He in turn asked for a work—and received one.

And then there were the representatives of Aix-en-Provence and Biot and La Rochelle and Saint-Denis and Saint-Jean-Cap-Ferrat and Sèvres and Strasbourg and Vincennes who wrote to him. And all these neglected museums were given works by Picasso. All of them— mayors, assistants, museum curators—contrasted the genuine interest of the workers with the blasé corruption of the "rich snobs" in Paris, and emphasized the dignity of their public and their desire to bring their local museum into the twentieth century; they cleverly highlighted the diversity of Picasso's works (tapestries, costumes, engravings, drawings, etchings, paintings, sculptures, ceramics,

posters, theater curtains, and theater sets) and asked for the help of
the great artist, who generously played along, allowing the construc-
tion of an extraordinary collection of Picassos in the museums of
France, and in the process thumbing his nose at the archaic system
of the Académie and the other Parisian art institutions. In 1944, Pi-
casso, the long-snubbed foreigner, became suddenly accessible, func-
tioning as the supreme agent of decentralization and an accelerator of
the modernization of French taste. While he soon felt stifled by the
aesthetic rigidity of the French Communist Party, Picasso the Red
became the darling of regional French towns, and it was his art that
was hung on the walls of their museums.

48.

THE VIEW FROM CÉRET, GRENOBLE, LYON, ANTIBES? THE ARTIST-PROPHET

I am going to Paris [. . .] to ask for [. . .] *money*!!! I am becoming a beggar, indiscreet, ignoble [. . .] But I will build your temple![1]

—Romuald Dor de La Souchère

And yet, after revealing this Picasso hailed by the working class, the E 14 file still had more to tell me. There were more stacks of letters from impassioned curators, some of them going beyond mere requests and flirting with the zealotry of missionaries seeking the words of their prophet. The towns that already had a connection with Picasso before World War II set about celebrating that fact. In Marseille, Magdeleine Ferry helped acquire a strong collection at the Musée Cantini. Grenoble was another place of interest for the artist: from 1932, the curator of the city's museum, Andry-Farcy, had assembled "the only cubist collection in France [. . .] a collection loaned [to the museum] by numerous foreigners passing through"—an homage to which Picasso had responded with the donation of a painting, *Woman Reading (Olga)* (1920). Andry-Farcy, who'd been arrested in 1943 for having exhibited "degenerate works of art," visited the studio on Rue des Grands-Augustins after the Liberation and left his calling card, on which he scrawled: "After a year imprisoned by the Krauts, would love to see you. Hotel de Bretagne, 10 Rue Cassette."

As for Lyon, in 1949 René Jullian, curator at the Musée des Beaux-Arts, asked Picasso to loan two major works for its exhibition *The Main Trends in Contemporary Painting from the Impressionists to the Present Day*. Three years later, Jullian organized one of the most ambitious projects of the era, which succeeded in outdoing the Parisian museums. "Sir, my friend J. J. Lerrant told me about the warm welcome you gave the idea he suggested to you regarding a large exhibition of your work at the Musée de Lyon," he wrote. "I am thrilled by your positive response, and I have come without further ado to ask you to give this project your patronage, without which it will obviously be impossible to carry it out at the scale we wish. We would like this exhibition to illustrate every period of your career, from its beginnings until the present day, and in its most varied forms: paintings, drawings, engravings, sculptures, ceramics" (October 4, 1952).

And so, from June 30 to September 15, 1953, the Festival of Lyon-Charbonnières presented an impeccable retrospective of works by Picasso dating from 1900 to 1953, a French premiere that finally gave the change to Alfred Barr's American exhibitions. As usual, Picasso made a handsome donation, which earned him a beautiful thank-you letter. Then there was Céret, where Picasso had lived during several summers at the height of cubism; Céret, where his American friend from the Bateau-Lavoir, Frank Burty Haviland (perhaps the last survivor of that era), was appointed "delegate to the functions of museum curator" in February 1957. "I hope you won't be too critical when we have the Pablo Picasso exhibition next summer," he wrote. Céret, a city in which Picasso transformed geography, pushed boundaries, reinvented space, in a visceral attachment to the place itself, had associations for the artist that could be described as personal, almost familial. Just after the exhibition, Haviland nostalgically recalled their shared past: "I told you about a letter that you wrote to me back in 1909, a blessed era, and that letter is one of my most precious belongings."

But far beyond the cities that had celebrated the artist before the war, there were dozens and dozens of communities of all sizes,

in all the regions of France and Navarre, that suddenly wanted to honor Picasso, show their citizens his work, and glorify his genius. Everywhere, curators of small galleries and large museums tried to outdo one another to obtain the artist's favors. I might mention Marc Sandoz, at the Musée de Poitiers, who asked for Picasso's studies for the ballet *The Three-Cornered Hat* to arouse public interest in his museum of contemporary art (November 18, 1949); or Gabriel Couderc, at the Musée de Sète, who—for the inauguration of the Paul-Valéry Room, where Picasso was already "represented by an engraving, Lacourière's *The Lobster*"—asked for a print of his lithograph of Paul Valéry (May 26, 1949); or A. Astruc, at the Musée des Cultures Taurines in Nîmes, who asked Picasso to be a jury member for the first international competition of bullfighting art (May 13, 1957).

But I must also cite Gérard Collot, curator at the Musées de Metz, who announced "a major exhibition on the evolution of painting in France from 1905 to 1914" and admitted that he'd been having "the greatest difficulties obtaining loans of paintings from before 1914": "We are not able to bring paintings in from abroad. Only one collector in Tourcoing has promised me one of your works. Obviously it is essential that you are represented," he concluded, before shrewdly adding: "Would it be possible to obtain, in addition to some paintings, a papier collé from that period?" (March 29, 1958). And then there was Jean Claparède, at the Musée Fabre in Montpellier; Ernest Gaillard, an architect and former curator at the Musée de Cambrai; Martin Richard, at the Musée des Beaux-Arts de Libourne; Pierre Chanel, at the Musée du Château de Lunéville; R. Lefèbre, director of the museum and school of drawing in Laval; Christiane Marandet, who worked for the museums of art, ethnography, and history in Clermont-Ferrand; and so many others that the full list of their names would make your head spin.

Clearly, the artist enjoyed this involvement with the people and institutions of provincial France; he was thrilled to expand his list of contacts. This was also the period when Picasso met a twenty-four-year-old Communist intellectual, recently liberated from the

Mauthausen concentration camp, who would become one of his closest friends and perhaps his best interpreter. His first letter to Picasso is like no other: straightforward, sincere, and respectful, but without the slightest hint of flattery or fawning: "Fresnes, May 10, 1946. Dear comrade, obviously I couldn't make it to the opening of your exhibition, and obviously this little note is not to apologize for that, but simply to express my regret. We don't know each other very well, personally. But I have always understood you. Such is our era that I have sometimes loved what you do, even when I've disapproved of it. This is not a paradox but, I believe, the crux of a problem. Only cheats could deny that contradiction, which is difficult to overcome, between individual taste and the autonomy of literature and art. That is why I understand you, and love you always as a man, comrade, and exemplary creator. Fraternally, Pierre Daix."[2]

Ironically, six months before the end of the war, before the reconstruction of the country had even begun, before General de Gaulle went to Moscow to negotiate the return of Maurice Thorez with Stalin, before Thorez gradually got his bearings again in a France that he had left five years earlier, and before Gaullists and Communists found a precarious balance between their "two great political powers" so that they could revive a damaged country, Picasso began to occupy a role that he had never before played in France—a role to which he'd been driven, for the first time, not by his artistic work but by his political affiliations: that of protector-benefactor-advisor to the municipal museums of provincial France. Alerted by the recent news stories in *L'Humanité*, *Ce Soir*, and *Les Lettres Françaises*, the decision makers in small towns and large cities all over the country, most of them Communists, bombarded the artist with spontaneous, enthusiastic messages, invitations, and solicitations, and brought this new Picasso to life, a jack-in-a-box springing up to distribute his works like emergency supplies to the farthest reaches of postwar France.

But perhaps the strongest and most beautiful relationship was the one he forged with a young professor of Latin and Greek, Romuald Dor de La Souchère, a curator at the Château Grimaldi in

Antibes, who addressed Picasso as "Boss" or "Dear boss." Dor de La Souchère was a politically committed man (a PCF member, decorated for his Resistance activities),[3] a cultivated, witty, extraordinary man who managed—with a mix of wisdom, patience, and enthusiasm—to create the first Picasso museum in France (to which the artist donated sixty-six works). The curator began to offer Picasso what he had always dreamed of—his first large, dedicated space—and during the summer of 1946, Picasso became the "artist in residence" at the château. A friendship blossomed between artist and curator. Through his perseverance, creativity, and political vision, Dor de La Souchère would succeed against all expectations, skillfully picking a series of bureaucratic locks, balancing the demands of Antibes and Paris, working within the limits of a local budget while winning the assent of national museums and Parisian authorities.

Together, they would poke holes in the fortified walls of the French bureaucracy, miraculously transforming a small fishing port into a major cultural destination. This brief letter will give you a taste of their triumph: "Dear Boss, I am on the verge of exhaustion but I think that unless something breaks, it will last forever. After some epic battles, everything is working perfectly [. . .]. You won't recognize the place. We owe you that, and this is just the beginning of a five-year plan [. . .]. I am going to Paris at Easter to work and to ask Salles★ for tapestries and the Monuments Historiques for *money*!!! I disgust even myself. I am becoming a beggar, indiscreet, ignoble, like the monk in *L'Abbé Jules*. But I will build your temple, and after that, I will go to the Champs-Élysées and finally get some rest" (Antibes, March 27, 1949).[4]

★ Georges Salles was then director of the Musées de France.

49.

THE VIEW FROM PARIS? "GENIUS" (FINALLY) RECOGNIZED BY THE STATE

1947-1955

It was inconceivable to open the Museum of Modern Art [in Paris] without being able to display works by Pablo Picasso, one of the most audacious inventors of forms in the contemporary age [. . .] and one of the most controversial and disturbing artists in the world.[1]

—Jean Cassou

While Picasso was busy helping Claudius Buard in Saint-Étienne, Jules Paublan in Boulogne-sur-Mer, and Magdeleine Ferry in Nice, while cultural youth centers were being built all over France, the capital too was evolving. In less than two years, thanks to the determination of two enlightened men working together—Jean Cassou (director of the Musée National d'Art Moderne) and Georges Salles (director of the Musées de France)—the insulting attitude that France's national museums had shown toward Picasso for the previous forty years was dramatically changed, and, with the artist's support, the slate was wiped clean. Cassou and Salles, quickly catching off guard a conformist milieu that they knew very well, decided to finally open the floodgates to the French collections with their priority to irrigate them with contemporary art in order to transform the new museum of modern art[2] into something alive. "The creation of the National

Museum of Modern Art is the story of modern art taking revenge on the public authorities," Cassou would later explain. After the Liberation, he went on, "I told people like Matisse, Braque, and others, who had almost nothing on display in the official Luxembourg museum: I am going to build a museum that will be your museum."[3]

On November 3, 1945, in front of the official body of the Artistic Council of Museums (the very same body that had refused to let André Dézarrois's Picasso enter the Jeu de Paume collections in 1937), Salles unambiguously denounced "the previous generation's mistake," suggested buying a selection of work directly from Matisse, Bonnard, Braque, Picasso, and Rouault, and was immediately granted a budget of 6 million francs that was doubled a few days later. So while his colleagues Matisse (seven paintings), Bonnard (three), Braque (four), and others sold their works to the French State, at the usual 10 percent discount, Picasso alone decided that the ten paintings he chose from his output of the previous twenty years would be a gift. For the opening of the first national museum of modern art in France (almost twenty years after MoMA in New York), Picasso chose to present himself as mercurial, elusive, ever-evolving, with a highly varied and important selection of his work. There was *The Dressmaker's Workshop* (January 1926), a very large painting in black, white, and gray, with its network of forms like an "organic labyrinth";[4] there was *Figure* (circa 1927), also from his surrealist period; and then *The Muse* (January 21, 1935), *Woman Reading* (January 9, 1935), as well as several portraits of Dora Maar from 1937 and 1938, which formed the transition toward the war period represented by the imposing *Woman in Blue* (April 15, 1944) and particularly *The Serenade* (May 5, 1942), an immense and magnificent evolution of an odalisque, in the tradition of Ingres, Titian, and Manet but darkened by the discordant, claustrophobic tones of the Occupation. Picasso added some still lifes from various periods (1936, 1945, 1946), as well as a large number of preparatory drawings.

What are we to make of this decision as Picasso is finally entering, after so many years, the hermetic world of French public art

collections? I would say that it's a shrewd, bold, audacious choice that highlights the artist's continued evolution. It is also a decision that should be considered in light of an anecdote told by Pierre Loeb about Picasso in the 1930s at a moment of anger and frustration with the conformism of French culture's official apparatchiks: "The State had at last decided to buy a painting from him, and to devote a budget of a few hundred thousand francs to it," he wrote, "so Picasso arranged a meeting [. . .] but immediately afterward, he told me in a fury: 'There were four of them, and as soon as I saw them, with their gray pants, their detachable collars, their timid, distant mannerisms, I saw myself as a young man again, when life was so hard. And I thought that these people, for a few hundred francs, could have done me more good then than they can now do with hundreds of thousands [of francs]. I began to show them some paintings, my best paintings, but I could sense that they wanted something from the Blue period. We vaguely agreed to meet again, but I won't go.'"[5] All Picasso's repressed emotions during the previous decades find their release in the triumphant fireworks display of 1947—the invisible man turned generous donor, the pariah transformed into patron of the arts, the renegade now a benefactor, the ignored, excluded artist now become a great tutelary lord.

On May 5, 1947, Picasso's works were presented in the Salle des Sept-Cheminées at the Louvre before the curators' committee, which approved his donation. On May 8, the same scenario was repeated before the Artistic Council of National Museums, which also approved the donation—unanimously, except for one man who "insisted that it be noted in the minutes that he had voted against the acceptance of this donation."[6] That man was Jean Savin, an archetypal French senior official, born in the Vendée two years after Picasso, who—after a career working in embassies (Portugal, Turkey, Switzerland, the United States)—became a counselor at the Court of Auditors. Despite being noted by his superiors as a bland, mediocre bureaucrat, the influence he exercised over the national art collections is, even now, quite breathtaking. According to a report (dated November 15,

1905), Savin, from "a famously reactionary clerical family with a large fortune and an honorable reputation,[7] shared the ideas of his family and jeered the Republican candidates in his district," wrote the prefect for Deux-Sèvres to the director of the cabinet at the foreign ministry (at the request of the latter)—at a time, let us note in passing, when Picasso was about to revolutionize painting.

"In certain ways, our colleague belongs to the lineage of great judges in the ancien régime," General Lesage would declare in 1955 during his eulogy to mark the end of Jean Savin's career. It is true that Picasso was mostly surrounded by other foreigners as he rose to prominence, but his interactions with certain sociologically significant French individuals are quite remarkable. On one side, there was André Level, Roger Dutilleul, Max Pellequer, Étienne de Beaumont, Romuald Dor de La Souchère; on the other, the likes of Camille Mauclair, Émile Chevalier, Maurice de Vlaminck, and Jean Savin. And this full-frontal attack on him by an eminent representative of institutional France in 1947 testifies to the obstinate and archaic insistence on "backward ideologies" stemming from the "spineless, sneaky worldview [. . .] of a certain [element of the] bourgeoisie that wants to justify its privileges."[8]

Filled with gratitude for Picasso's gesture, Georges Salles was willing to break every rule. "You will be the first living painter to see his own work in the Louvre," he told the artist, before inviting Picasso and his new partner, Françoise Gilot, to visit the museum one Tuesday, when it was closed to the public. The attendants would transport his paintings wherever he wished. "Next to which paintings would you like your work to be hung?" Salles asked. Picasso chose Zurbarán (*Displaying the Body of Saint Bonaventure*), Delacroix (*The Death of Sardanapalus*; *The Massacre at Chios*; *Women of Algiers in Their Apartment*); Courbet (*The Painter's Studio*; *A Burial at Ornans*); and Paolo Uccello (*The Battle of San Romano*).[9] On June 9, 1947, the National Museum of Modern Art opened its doors with *The Serenade* hung majestically above the main staircase in the Palais de Tokyo—an attempt to compensate for the painting's sad presentation

at the 1944 Autumn Salon, when it had to be permanently guarded
by police. In his official speech that captured a paradigm shift, the
director of the Musées de France declared: "Today marks the end
of the divorce between the State and the genius." Following Pi-
casso's magnanimous gesture, other collectors (Rosenberg, Éluard,
La Roche) started donating their Picassos as well.

A few months later, on November 20, 1948, a letter from the
minister of the interior reached the police prefect in Paris: "Dear
friend, would you be so kind as to receive Mr. Picasso, the famous
artist (or his representative), who is requesting a privileged residence
card, since his ordinary foreigner's residence card is due to expire
on the twenty-eighth of this month? I have just seen Mr. Pagès who,
owing to the gentleman's importance, has agreed that we should pre-
sent him with said card without any further formalities."[10] And so the
"famous artist Picasso" suddenly becomes a "VIP" in France, he and
his adopted homeland united in a sort of social contract (due to his
donation? Who cares!) seven years before the Musée des Arts Déco-
ratifs prepared a spectacular exhibition of his work.

"Paris, May 10, 1954. Dear Sir, Since the long-ago and conse-
quently partial retrospective at the Galerie Georges Petit, no single
exhibition in Paris has brought together all the diverse aspects of
your work. Rome, Milan, São Paulo, and soon Munich have all given
us an example to follow. Paris cannot wait any longer without losing
its traditional role, and I would be grateful if you would give your
agreement and your support to the exhibition that the MAD [Musée
des Arts Décoratifs] aims to present in 1955. This exhibition could
precede the one in Munich, and it would be the main event of the
season in Paris, and [. . .], with your assent, we would like our friend
Mr. Jardot to personally take care of it. Yours sincerely, The Presi-
dent of the Central Union of the Decorative Arts, François Carnot."[11]

Picasso: Paintings 1900–1955, timed to celebrate the artist's
seventy-fifth birthday and the fiftieth anniversary of his move to
Paris, made a huge impact and accomplished a feat. On October 1,
for the first time in France, reported *L'Information*, "the exhibition

set a new record for Picasso, the leading contemporary artist," by attracting more than one hundred thousand visitors: "For the one hundred thousandth time since the opening of the Picasso exhibition, the turnstile at the Musée des Arts Décoratifs yesterday made its usual clicking noise as another visitor entered [. . .]. The tall young man, Jacques Pauchet (an industrial designer), who had that honor, was immediately surrounded." François Mathey, the chief curator, shrewdly recruited Maurice Jardot, who used to work at the Louise Leiris gallery and used his contacts in the Kahnweiler network to open doors and obtain some crucial loans of paintings. They acted with audacity and panache, successfully persuading Alfred Barr to lend them *Guernica* (no mean feat given that this was the first time the painting had ever been shown in a French museum),[12] and throwing the weight of modernity at the retrospective—a promotional campaign costing 2 million francs (run by an American public-relations agency, James Jones & Company); an educational section (a workshop for those under thirteen years of age), still at the time a completely new phenomenon in France; and a radical new form of presentation, masterminded by a thirty-year-old graphic designer called Massin, who—for the promotional poster—placed the letters "PICASSO" in bold capitals, off-center, and much larger than the name of the museum (displayed in lowercase and relegated to the lower right-hand side), and illustrated the white background with three full-length photographs of the artist staring out at the spectator,[13] each brightly colored (yellow, magenta, cyan), presenting Picasso as simultaneously accessible and godlike, and dragging the Parisian art world into the twentieth century.

The journalist Hélène Parmelin, in her letter of December 18, 1955, confessed to her "dear Picasso" that she had "just seen *Guernica*, at last": "Never had I imagined it so huge. Nor would I ever have guessed how fully I now understand that I had never seen *Guernica* before [. . .]. And the crowds! [. . .] I even saw Mauriac staring silently, for a long time, at *Harlequin*."[14] That exhibition became a crucial marker of France's appropriation of Picasso and a barometer of his recognition by the general public. But it was also the setting

for a battle between various collectors and curators, in Paris and in the provinces, and between national Parisian museums and others.

Better still, it appeared to be a power struggle between France (where the work was produced) and the United States (where it had been appreciated and collected)—two countries that were simultaneously battling their own demons: in the United States, Rosa Parks's refusal to give up her seat on a public bus to a white person had helped spark the Black civil rights movement, while in Algeria the second year of violent unrest had culminated in the Philippeville massacre of 7,500 people in August. The exhibition was also a celebration, the opening party bringing together collectors from different generations, the oldest being Alice B. Toklas, who lent ten works and attended the party looking tiny and stooped, as if under the weight of her immense black hat decorated with a black flower, accompanied by Janet Flanner, famous for her regular "Letter from Paris" in *The New Yorker*. The Noailleses were there, too, as was Douglas Cooper, one of the lenders who had sent an elegant letter expressing his surprise at not being invited to the vernissage, while asking if he could bring his friend John Richardson, who was planning to write a report on the event for *The Burlington Magazine*.

"We are being bombarded with requests for exhibition posters," complained the mayor's office in Bordeaux as excitement spread throughout France. As for the publicist from James Jones & Company, he sent a report on the work carried out from May 16 to May 25, advising that more money should be invested in publicizing the exhibition while also suggesting that they time the openings to coincide with the tourist season. On July 27, 1955, he even tried to rope in Charlie Chaplin and the famous Tour de France cyclist Louison Bobet. But the recriminations of certain American museum curators would leave a bitter taste in the mouth of the French curator. "I noted with surprise that the frame for our Gertrude Stein had been removed," wrote Theodore Rousseau, director of the Metropolitan Museum of Art, to Jacques Guérin. "I am writing to ask you to give orders [and so that] you understand my concern."[15]

The most serious criticisms came from Alfred Barr, who empha-
sized the cultural difference between museums in the United States
and in France by recalling his past misadventures: "Let me say in
confidence that I very seriously hesitate to recommend the loan of the
Three Musicians to a Paris museum because I have little confidence in
the care with which French museum personnel handle paintings lent
to them. (It was not only the irresponsible lack of precautions taken
at the Musée d'Art Moderne two years ago, but also the casual way
in which the damaged pictures were handled after they were cut to
pieces.) I have a good deal of experience with exhibitions in Paris and
I know that my misgivings are justified. In spite of all these problems, I
have secured permission to lend the *Three Musicians*. It should be
insured for $80,000 [. . .]. Believe me, none of the above remarks are
meant for you personally, since I have real faith in your care and love
for Picasso's work, but I hope you can prevail upon the French person-
nel to take care."[16] Later, in a letter to François Mathey, he returned
to the subject: "It would be ungracious on my part to insist that you
reframe the *Three Musicians*."[17] Finally, three months after the exhi-
bition's end, Barr again showed his irritation with the Frenchman:
"Please do not think that my protest against the way our paintings
have been handled in the MAD in any way affects our friendship. You
are not responsible for the handling of the works of art. Unfortunately,
the carelessness of the MAD in this matter is just one more example
of a number of incidents which are making American museums and
collectors more and more resistant to lend to exhibitions in France.
With very kind regards to you, Alfred Barr."[18]

50.

THE "GREAT STALIN" VERSUS "COMRADE PICASSO"?

"How do you expect me to paint a portrait of Stalin?" he asked, irritated. "First of all, I've never seen him, and I don't remember what he looks like, other than the fact that he wears a uniform with lots of big buttons on the front, and a cap, and he has a big mustache."[1]

—Pablo Picasso, quoted by Françoise Gilot

It is possible that [the *Portrait of Stalin*] didn't go down well. I did what I felt, because I've never seen Stalin. I played on the resemblance. Apparently it didn't go down well. Oh well.[2]

—Pablo Picasso

You could count the number of doves, of course (reproduced in their hundreds of thousands, they became the universal symbol of the peace movement after 1949), or all the portraits of activists[3] that Picasso quickly sketched in pencil after joining the French Communist Party. You could inventory all the posters, petitions, and political paintings that fitted within the strict lines of socialist realism (*The Charnel House*, February–Summer 1945; *Monument to the Spaniards Who Died for France*, 1945–1947; *The Rape of Europa*, 1946; *Massacre in Korea*,[4] January 12, 1951). You could also list all the work

he produced from the context of the war or the Cold War in a more independent aesthetic (illustrations for Reverdy's *Song of the Dead*, 1948; the *War and Peace* fresco in the Vallauris chapel, 1952–1954; *Women of Algiers*, after Delacroix; *Rape of the Sabine Women*, after Poussin, October 25, 1962, to February 7, 1963). You could even mention his less successful works, darkly ironic in their depiction of the cult of the leader (*Stalin, to Your Health*, November 1949; *Portrait of Stalin*, March 12, 1953; *The Fall of Icarus*, 1958, for the UNESCO building). You could decode the political content in some of his later projects, such as the series based on Velázquez's *Las Meninas* (1656), which he executed between August and December 1957; was that an attack on Franco's decision to allow Juan Carlos to be educated in Spain and, in doing so, to identify himself with the Bourbon-Habsburg dynasty?[5] You could regret the fact that the world's supreme avant-garde artist should have let himself be gagged for a time by the aesthetic line of a party obeying orders from Moscow, until he cast off the moorings of the PCF in 1953. You could probably also recall, one after another, the bitterest pills that the artist had to swallow, as at the 1948 World Congress of Intellectuals in Defense of Peace, in Wrocław, which Picasso had been reluctant to attend, when he heard Fadeyev calling Sartre a "hyena with a fountain pen"— words so harsh and unexpected that Picasso tore off his headphones in contempt and rage. Lastly, you could get trapped in ideological controversies, trying to quantify his degree of belonging to the Communist mystique of the era.

After examining the final third of his career in France (1944–1973), and after considering the impact that his precarious status played in his decision to join the party, and after visiting the places he lived during that time and gathering the works he produced, however, I have come to the conclusion that Picasso's Communist affiliations went far beyond the strictly ideological domain. For him, it was a highly personal project: trying to transform the PCF into a sort of Swiss Army knife of personal conquest. From 1944 on, with the aid of his party membership, he built for himself a symbolic utopian

territory within the French State, a territory composed of audacious choices, in which his relationship with the PCF was no longer simply that between a political activist and an institution, between an artist and a political party. It was something much more complex, as was always the case with Picasso. As with his confrontation with Spain or with France, he refused the authority of the established powers, rejected their laws and their rigidly academic thinking (which might work for other people, but not for him), and decided to impose his own rules and choices, by whatever means necessary. The proof of this is his categorical refusal, in 1968, to allow *Guernica* into Spain while Franco was still in power. There were numerous attempts from Madrid to claim the painting, since, as his lawyer Roland Dumas explained, *Guernica* had been commissioned by the Spanish people and legally belonged to them, irrespective of its politics. However, Picasso was so utterly intractable that in the end Dumas found a way to bend the law to his client's will: *Guernica* remained at MoMA, as Picasso wished, until Franco's death.[6]

But the secret connection that bound Picasso so warmly to the French Communists was, above all, I believe, the unwritten pact that the artist developed with another extraordinary man, another force of nature, another statesman, another brilliant strategist who built his own myth with his bare hands: Maurice Thorez. Twenty years younger than the artist, Thorez was a miner in Noyelles-Godault who became a member of the PCF's politburo at the age of twenty-five, a meteoric rise that owed everything to his courage and his political shrewdness, his hard work and erudition, his hunger for knowledge and his daily discipline in reading and studying, his talent as an orator, his charisma and what some defined as his "populist behavior (like singing at the end of a feast)"; it is not difficult to see how such qualities would have won Picasso's admiration. And Thorez felt the same gratitude for the artistic prestige Picasso conferred on the Communist Party. (In fact, the PCF's resistance to accepting Picasso's mischief and indiscipline coincided with the years of Thorez's exile when, after suffering a stroke, he chose to remain

in Moscow for medical care.)[7] But let us go back a little farther in time: for the young deputy from Ivry, the secretary-general of the PCF whose autobiography, *Son of the People*, was published during the Front Populaire, the cause célèbre of the 1930s was without doubt the Spanish Civil War.

In the spring of 1937, the destruction of Gernika by the Condor Legion—a precursor of the coming horrors of fascism throughout Europe—was the key event, galvanizing both Picasso and Thorez at the same time, though they didn't know each other then. The Spanish Civil War was their war, and on the French front each of them played perfectly symmetrical roles as heralds, virtuosos, brothers-in-arms—Thorez, the moving orator at the National Assembly and at protest meetings; Picasso, the virtuoso whose radicalization took him to a higher plane of fame. It was also Thorez who, at the request of Moscow, succeeded in mobilizing more than thirty thousand combatants for the International Brigades that were sent to Spain, an act that undoubtedly left a permanent impression on the artist's memory.

Another element in common between the two men was their nonparticipation in the two world wars, and particularly Thorez's forfeiture of his French nationality on February 17, 1940, after he was found guilty of desertion in November 1939—a strange echo of the rejection of Picasso's naturalization request. Both men, too, had histories of multiple affiliations: in Thorez's case, he went from Paris to Moscow and back—after de Gaulle negotiated his return to France in November 1944.[8] Their friendship and their reciprocal affection went through several phases; first, the time of the Spanish Civil War when they didn't yet know each other but were walking parallel paths. In 1945, when Thorez became minister of state during the reconstruction of France, Picasso was being hailed by working-class communities all over the country. The artist produced his first sketch of the politician in 1945, and Thorez attended one of Picasso's vernissages (for a 1949 exhibition of ceramics, pottery, and sculpture) before visiting the artist's studio in Vallauris the following summer—a visit that did not escape the attention of the police.

However, apart from one quick sketch of a hand raising a glass— *Stalin, to Your Health*—there was no trace of Picasso during the crazed seventieth birthday celebrations for "Stalin, the man we love the most" in 1949, when the cult of personality was at its height, orchestrated in France by Thorez and Paul Éluard. "Every man and woman in favor of peace acclaims the name of Stalin, synonym of bravery and generosity, the man of socialism who is leading the people toward joy and happiness. Dear comrade Stalin, the miners of Pas-de-Calais swear never to attack their brothers in the Soviet Union, and it is a promise of glory and long life to the liberating leader of the people, because our passionate love for Stalin is proof of our unshakable trust. Live forever, our dear and great Stalin! Long live Communism!" declared the first secretary of the PCF from the podium of the Palais de la Mutualité, sending the crowd into a frenzy.

Thorez's stroke, followed by his stay in Moscow (October 10, 1950, to March 28, 1953), brought an end to Picasso's time as a VIP within the French Communist Party. Things grew particularly difficult for him when the young artist Fougeron was encouraged by the General Confederation of Labor to produce a series of forty paintings called *The Land of Coal Mines* (1951)—a work of "working-class martyrdom and propaganda" that obeyed the strict line set out by Moscow and strongly promoted by the PCF. In an article entitled "The Artist to His Niche," the Communist leader Auguste Lecoeur (who ruled the PCF in Thorez's absence, along with Billoux, Duclos, Fajon, and Marty) wrote that "it is to his niche as a combatant of peace that Picasso [. . .] painted the dove," while "it is to his niche as a militant Communist that Fougeron painted *Le Pays des Mines*, a reflection on certain aspects of life, the sufferings and class war endured by miners."[9] The day after this article appeared, Picasso—his arm clearly twisted by Lecoeur—produced his most disciplined and least Picasso-esque work, *Massacre in Korea*. Not that it would spare him criticism from the party: Aragon reproached him for painting a "massacre of innocents," while Hélène Parmelin complained that it "missed its mark."[10]

On March 5, 1953, Joseph Stalin died. Aragon, who edited the cultural weekly magazine *Les Lettres Françaises*, commissioned Picasso to produce *Portrait of Stalin*. The artist, then living in Vallauris, was given a very short deadline. He sketched the dead leader based on a photograph of a much younger Stalin, wearing an open shirt—a metaphorical portrait, let us say. This drawing sparked a massive controversy within the French Communist Party, uniting writers such as Aragon and Daix, party apparatchiks such as Lecoeur and Billoux, and artists such as Taslitzky, Fougeron, Léger, and Bauquier in their condemnation of Picasso. They attacked him for his "profanation," the "outrage" of his "horrible drawing," his "indecent caricature," his "lack of respect."[11] This all seems somewhat overblown now, but as the sociologist Jeannine Verdès-Leroux points out, during the era of Stalin's cult of personality, portraits of the leader were not expected to be realistic but to "highlight the subject's qualities": a portrait was expected to idealize, to emphasize the epic. Therefore, by offering the portrait of "an ordinary man" that "did not depict Stalin's moral, intellectual, and spiritual qualities," by offering a representation in which—to quote one of Picasso's Communist critics—"the generosity and nobility that characterized the immortal face of Stalin are completely absent,"[12] Picasso was guilty of a sort of treason.

Thorez, however, had other ideas. From Moscow, he declared his steadfast solidarity with Picasso and absolved him of any crime, inaugurating the era of "Picasso the untouchable," while Aragon—who had been ordered by Lecoeur to offer a public apology—was the only one officially sanctioned by the party ("he was on the verge of suicide," said his wife, Elsa Triolet). When Thorez returned to Paris, he settled his scores with Lecoeur. It hardly seemed to matter that it had been Thorez himself who, at the Strasbourg Congress in 1947, had laid out the rules for those Cold War years: as far as he was concerned, Picasso had to be spared no matter what he did because of his global symbolic importance for the Communist Party.[13] The historian Annette Wieviorka's analysis of this period, based on Thorez's archives—with his annotations and red-pencil underlinings

on every letter, every file—reveals how closely involved he was in this affair. The entire controversy, Wieviorka writes, "bisects Thorez's archives just as it bisects the history of the relationship between the Communist Party and the artists."[14]

Thorez dealt with the controversy in a calm, precise way, diplomatically balancing the importance of the Great Stalin's memory and the pride of Comrade Picasso. The first artist to support Picasso was Édouard Pignon, who grew up in the same region as Thorez and who attacked Fougeron ("he is scaring all the artists away"), before his comrades André Verdet and Jean Auricoste in turn reviled the "boorishness" and "self-importance" of Fougeron, "whose inadequacies as a painter are universally acknowledged." All these declarations were underlined in red by Thorez; he emphatically chose the symbolic weight of Picasso, the irreverent genius, over the banal mediocrity of the follower Fougeron. Picasso, moreover, was one of the first people invited to greet Thorez upon his return to France, on April 23, 1953, the two of them photographed together for *L'Humanité*. For three years, Fougeron's socialist realism had been sanctified because it obeyed Zhdanov's strict party line, and now it was suddenly cast aside—a major blow to Lecoeur, who had named Fougeron the party's official artist.

After 1953, the friendship between Thorez and Picasso only grew stronger, since for health reasons the politician spent longer and longer periods in the south of France, where Picasso moved in 1955. Pierre Thorez, Maurice's youngest son, still remembers that period with pleasure: "Picasso was a familiar face around the house. He was a close friend of the family. My father would go to see him whenever he felt like it. There was a great deal of mutual respect between them, and they would laugh like brothers, talk about everything and nothing. Picasso was very relaxed with the children. 'Climb up on it!' he would tell me, pointing to the famous [sculpture of a] goat. 'That's what it's for!' I used to play with Paloma, too. One day, on the beach, Picasso drew a face on my mother's knee, a face that smiled when she straightened her knee. Another day, during a walk in the forest,

Picasso picked up two sticks and instantly turned them into a sculpture. For me, that's pure genius!"[15]

There are also a series of documents from 1963 and 1964 that demonstrate the continued warmth between the two men. In one, "friend Pablo" sketched two funny little drawings (of an artist with a monkey as his model) for Maurice.[16] In another, he wrote a dedication in the catalog of his most recent paintings: "I'd be happy to find out if you're well [. . .] tell me what you think. With love, and until soon, I hope, Picasso."[17] In yet another, Thorez thanked Picasso for his portrait of the director of *L'Humanité*: "Dear Pablo, I heard from Marcelle Hertzog that you have drawn Marcel Cachin's portrait. I wanted to thank you fraternally. It will be a magnificent illustration for the posthumous book of our late, great pioneer. My regards to Jacqueline. With great affection, Maurice. P.S.: I wasn't able to get through to you on the phone—there was always an engaged tone. That's why I decided to write you this little note."[18] And, finally, there were these words, written by Thorez while he was aboard the cruise ship *Latvia* with his wife, Jeannette Vermeersch, on their way to the Black Sea for their vacation in the USSR in the summer of 1964. On July 9, after departing Sorrento, Thorez reread Balzac, whose love of work reminded him of his friend Picasso. "Picasso is more productive than ever, at eighty-two!" he wrote in his journal.[19] Two days later, Maurice Thorez died suddenly in the port of Varna, in Bulgaria.

Protected by his status as a privileged member of the French Communist Party, which he owed to his relationship with Thorez and also to the major sums of money that he donated to the party every year, Picasso was never given any of the tasks assigned to other militants, nor was he ever sanctioned or scolded for his behavior. For Picasso, the PCF remained what he had always sought, fulfilling its threefold function as springboard, passport, and shield, and solving the three problems that had besieged him during the years 1900 to 1944. His membership in the PCF fixed the issue of his public invisibility and the way he was snubbed by the Académie des Beaux-Arts;

it fixed the permanent police monitoring of him as a "foreigner"; and it (almost) fixed the hostility he received as a leftist, because it immediately gave him recognition, mobility, and protection. For Picasso, the Communists were the party of "wielders of tools and builders of cathedrals," but being a Communist also meant choosing the south of France with its craftsmen, its villages, and its local celebrations.

The cult of Stalin remained the unspoken issue between Thorez and Picasso, but they found a way to live with it: the former closed his eyes and the latter smiled. "To Comrade Stalin," Thorez wrote in the copy of *Son of the People* that he dedicated to the leader of the Soviet Communist Party in 1937, "the brilliant constructor of socialism, the leader beloved of workers all over the world, the people's guide, the Master and friend who, on the happiest day of my life, paid me the great honor of receiving me, in testimony of my absolute fidelity and my filial love." Almost seven decades after the huge controversy sparked by Picasso's *Portrait of Stalin*, it is impossible to look back on that absurd symptom of the Soviet leader's cult of personality and keep a straight face. To his credit, Comrade Picasso couldn't (or wouldn't) do that at the time, adopting a posture of complete irreverence toward the Great Stalin and, somehow, yet again emerging unscathed.

Beyond his obvious affection for Thorez, Picasso maintained the habit of using friends and acquaintances (for example, the journalist Hélène Parmelin) as his personal emissaries and representatives. Parmelin was head of the cultural department at *L'Humanité* (she would later become a famous reporter) and the wife of the artist Édouard Pignon: she and her husband were both publicly critical of the Communist Party's excesses and, in private, were openly derisive about Stalin's cult of personality and supportive of Khrushchev's speech denouncing his predecessor's crimes. "How many times, with Picasso, did we imitate our leaders at their solemn events! We artists, poets, writers, and academics had a way of greeting one another with the words 'But did you read the editorial in *L'Humanité* this morning?'"[20] When Picasso moved to the south of France, it was

Parmelin who kept him informed on a daily basis about the latest Parisian Communist news. (Theirs is the sixth-largest correspondence in the archives of the Musée National Picasso-Paris.) The letters from the "Parmelin gazette," as she called herself, provide us with a glimpse of the complexity in the tensions that existed between the PCF's intellectual critics and its hardline leaders. Far from the stiff, stuffy language employed by party apparatchiks, Parmelin expressed herself with humor and freedom, and Picasso clearly enjoyed her letters. "Until now, it has been relatively easy for me to be a Communist," she admitted on June 26, 1956. "We were free when Stalin was alive because we acted the way we felt. But his legacy imprisons us, and courage must become diplomatic, careful, calculated [. . .] both with his supporters and with the others."[21]

The situation worsened after the Hungarian Uprising of 1956, and it was always in letters to Parmelin that Picasso confessed his doubts. "Things there are horrible," she wrote. "People being killed and hanged. The vengeance is terrible, and there are Communists among the bodies hanged and thrown in the Danube [. . .]. Please don't blame me for this interminable account. There's nobody else in the world to whom I can—to whom *we* can—say what we think."[22] Reading this correspondence, particularly the letters relating to the tragic events in Budapest, I gained a much denser and more nuanced appreciation of the political questions that touched Picasso's life. "So the truth is multiple," Parmelin wrote, "and it may be the case that by shooting at the Hungarian people, the USSR has saved the revolution, but in Hungary it is a precarious, imposed revolution."[23] In this labyrinth of rival powers, Parmelin described the tensions between Parisian intellectual Communists while revealing to Picasso the symbolic importance of his own name within the party. "As for us, we're part of an 'oppositional platform,'" she wrote. "I like that phrase. I was imagining it yesterday as a sort of *Raft of the Medusa* [. . .] the menacing shadow of Picasso glided over the meeting: we were visibly under your wing, and the delegate was terrified that a few of the Stalin supporters would go too far."[24] Let us tiptoe away from this

bewitching world by reading a few particularly choice barbs fash-
ioned by the "gazette" for the pleasure of her "dear and beloved
master." In October 1956, when the Martinican poet Aimé Césaire
wrote a magnificent open letter to Maurice Thorez, resigning from
the PCF, Parmelin predicted: "They're spitting on Césaire. And I
bet you anything they'll end up calling him a Black bastard. He was
wrong, but they were wrong, we were wrong—who was right, my
master?"[25] At the time of the famous "Lettre des Dix" (Letter from
the Ten), denouncing the Soviet intervention in Hungary, she had fun
demystifying Communism's literary first couple, Louis Aragon and
Elsa Triolet: "Aragon and Elsa are in a perpetual panic [. . .] they
were thinking of sending me to you to keep you in the loop, but I said
that, based on our phone calls, you seemed to know everything about
the current political situation!"[26] Picasso still had plenty of tricks up
his sleeve.

EPILOGUE

The Mediterranean as his kingdom

1955–1973

At his factory in Vallauris, [Picasso] basked in the posture of one of those great Athenian *métèques*,* Douris, Euphronios, Amasis, Nikosthenes, composers of forms and decorators of vases, owners of one of those ceramics workshops that flooded the Ecumene market with their rare and precious products, inventors of techniques and secrets of fabrication that even now amaze the world.[1]

—Romuald Dor de La Souchère

* In this case, "*métèque*" (English: metic) is used by Dor de La Souchère (who studied classics and read Greek) in reference to the original Greek etymology to describe a foreigner living in ancient Greece, having some of the privileges of citizenship.

51.

FROM POLICE CHIEF ROUQUIER TO J. EDGAR HOOVER

With Maurice Thorez and other Communists named as ministers in General de Gaulle's government, and with Picasso now a famous, assimilated man, police surveillance of him switched from France to the United States, the baton passed from the police chiefs of Paris to J. Edgar Hoover himself. The man who headed the FBI for almost a half century launched the American investigation into the artist after reading "Why I Became a Communist," the article that Picasso wrote for the American Marxist magazine *The New Masses* just after he joined the French Communist Party.[1] While the first decades of Hoover's reign had been dedicated to the fight against organized crime, "the man who held American presidents in the palm of his hand" switched his objectives after World War II: Communism became public enemy number one[2] as Hoover hunted down "alien radicals, intellectuals, and provocateurs" (as well as all suspect American citizens), with the "Communist subversive" Pablo Picasso close at the top of his list of targets.

On January 16, 1945, Hoover sent a memo to the U.S. embassy in Paris: "In the event information concerning Picasso comes to your attention, it should be furnished to the Bureau in view of the possibility that he may attempt to come to the United States." Labeled "SECURITY MATTER—C" (for "Communist") and "SUBVERSIVE," file

number 100–337396 (which would end up being 187 pages long)
presents the artist as nothing less than "a threat to the national se-
curity of the United States."[3] In Paris, in 1947, the man described
by the French minister of the interior as "the famous artist Picasso"
received a privileged residence card. Meanwhile, the Americans were
mobilizing both the FBI and the CIA to monitor and investigate him.
However, two diplomats posted in Paris—Nathalie Grant in 1945,
then William A. Crawford in 1951—found it impossible to mount a
plausible case against the artist, though the historian Sarah Wilson
described them as "totally unsuited to the task" and "culturally il-
literate." So what did they send to Washington? Nothing more than
a compilation of press cuttings from North America, Hungary, Ven-
ezuela, Brazil, and Cuba.

In contrast with these pitiful FBI reports, the political inter-
ventions carried out on French soil by members of the CIA began
in 1947 with a precise analysis of the PCF's cultural strategies. In
September 1950, CIA agents created the Paix et Liberté (Peace and
Freedom) movement, which produced counterpropaganda distrib-
uted around the world. One of its posters directly targeted Picasso's
famous dove, created for the congress of the World Peace Council
in 1949 and printed in the millions of copies during the next two
decades. In 1951, this CIA-backed organization released "The Dove
that Goes BOOM," a poster showing—against a red background (of
course)—a riveted metal dove holding an olive branch in its beak but
looking ominously like a Soviet tank, with a gun for a beak and the
hammer and sickle painted on its side. More than 300,000 copies of
this poster were plastered on the walls of Paris, parodying the only
Picasso artwork that had, among Communists, ever been universally
acclaimed.[4]

To understand the sudden hysteria surrounding Picasso in the
United States, one must consider the roots of this philistine men-
tality toward art, with its origins dating to the nineteenth century.[5]
This tendency was massively aggravated by the crazed atmosphere of
Senator Joseph McCarthy's anti-Communist witch hunt. For Ameri-
can conservatives, then, Picasso personified two major taboos: first,

he was an artist (and more specifically, an avant-garde artist, vaguely and disparagingly described as a "modernist"); and secondly, he was a Communist who had openly declared his membership in the French Communist Party. For these conservatives, "Picasso's power—and here, the FBI's operations were largely redundant—resided precisely in the fact that his membership in the PCF" was a potential threat to public opinion, given that he "always refused [. . .] to renounce the party."[6]

One of the leaders of this anti-art and anti-Communism drive was the Republican congressman George Dondero who, in a speech given on August 16, 1949, in the House of Representatives, unambiguously declared that "Cubism seeks to destroy by designed disorder," that "Dadaism aims to destroy by ridicule," and (somewhat oddly) that "Abstractionism aims to destroy by the creation of brainstorms."[7] Three years later, Dondero told Congress that modern art was nothing other than a "conspiracy by Moscow to spread Communism" in his country. It's no surprise, then, that the FBI files on Picasso include a document marked "SECRET" that features Dondero's wild accusations. The congressman rages against "so-called modern art" which "contains all the isms of depravity, decadence and destruction."[8] It is hard not to laugh at this simplistic conflation of Communism with modernism. And yet, as we have seen in previous chapters, it was precisely because of his aesthetic freedom (his "modernism," if you will) that Picasso ended up at odds with Communist leaders on two occasions: in 1948, at the World Congress of Intellectuals in Defense of Peace in Wrocław, when he was brought in line by Zhdanov; and in 1952, during the furor over his *Portrait of Stalin*, when he was lectured by Lecoeur. Both of those apparatchiks scolded him for transgressing party rules.

Picasso became the subject of an international diplomatic incident in 1952 when—as part of a European delegation of twelve members—he requested a U.S. visa so that he could attend the World Peace Congress. The U.S. State Department refused his request since Picasso and his comrades belonged to what it described as "the most powerful Communist organization in the world," whose

members were "notorious Communists or fellow travelers who risk extradition." However, on February 23, 1950, in a coded diplomatic telegram addressed to the secretary of state, Dean Acheson, the American ambassador in Paris, David K. Bruce, assessed the harmful consequences on public opinion of such a rejection, precisely because of Picasso's symbolic importance: "In view [of] his worldwide reputation, refusal of visa to Picasso would certainly cause unfavorable comment here, particularly in intellectual and 'liberal' circles. It would also tend to suggest that we have something to fear from Communist 'peace' propaganda. However, if decision is negative, we believe that Departmental spokesman and V.O.A. [Voice of America][9] should point out that proposed visit is a brazen propaganda stunt for purely political motives which have no connection with professional activities of applicants. In either event, we would urge that decision be made as rapidly as possible, since the longer it is postponed, the easier it will be for the Communist Party to exploit its nuisance value, which of course is their essential objective."[10] Picasso would not be given a U.S. visa and would never visit the country that had amassed the largest collections, offered the most interesting exhibitions, and produced the most penetrating analyses of his work.

As a barometer of the relationship between these two great nations during the Cold War, Alfred H. Barr himself began to worry about the personal consequences of organizing a new Picasso exhibition at the MoMA in 1957. "We do not want to put Picasso in an embarrassing position by inviting him, only to have his entry questioned by our Government," he wrote in an internal note that inevitably ended up clipped to an FBI memo labeled "Cultural activities" and marked "Secret."[11] Confronted by some of his more right-wing collectors who were disturbed by Picasso's Communist affiliations, Barr often appeared at such a loss that he went so far as to claim the artist was politically naïve.[12]

52.

AN APPRENTICE CERAMIST IN A POTTER'S VILLAGE

Far from the debates raging in the United States, Picasso was rarely in the French capital; he was beginning a major transition in his life. Between 1946 and 1955, he still stayed in Paris on a regular basis but spent more time in various parts of Provence—Golfe-Juan, Antibes, and Vallauris (all three towns grouped within a radius of about twenty miles)—before settling on Vallauris in 1948. Though famous in America since the first decade of the century, though widely admired by Communists for his political convictions, though one of the most respected and esteemed people in the whole of France, he chose to leave Paris to work with southern artisans. A new image arose of a relaxed, bare-chested Picasso, in shorts and old slippers, clowning around for photographers, with his partner Françoise Gilot and their two children, Claude and Paloma. One thing is clear: after 1955 (the year he turned seventy-four), Picasso chose the south of France as his home, pursuing his professional experiments with young craftsmen, most of them from Vallauris itself.

It would take an entire book to analyze all the reasons for this choice. But the move began in 1946 when Romuald Dor de La Souchère offered him a custom-made studio at the Château Grimaldi in Antibes, built on the foundations of the ancient Greek town of Antipolis. With its perfect location overlooking the Mediterranean,

its walls marked indelibly with the artist's handiwork, it would in 1966 become the Musée Picasso, the first museum in France dedicated to his work. It was in Vallauris that Picasso's new professional interests would be crystallized, resolving some of the conflicts that had hindered his career since 1904, and weaving together most of the threads of the last two decades of his life.

Picasso was a man who saw everything, so it is no surprise that he immediately saw in this village of potters the glimmer of a micro-utopia where he could anchor his new identity. In 1866, this "small, unknown town in the Alpes-Maritimes" had been highly praised in the ultra-serious *Journal de l'Agriculture*. Vallauris "could serve as a model for all the communes of France," the article stated, before noting that the three thousand inhabitants had "sold land [. . .] to foreigners settled in this part of the region [. . .]. The municipal spirit, well-managed, has turned this isolated, inaccessible commune into a hive of activity and practical intelligence" with its model mayor's office, its "free evening classes," its orange trees, and its "forty-two pottery factories (employing 1,500 people) [. . .] where agriculture and industry thrive together, [. . .] education is being developed, [. . .] goods are made, wealth is accumulated, thoughts are brought to life, ideas fertilized, minds broadened, and progress is visible everywhere [. . .] in the moral and intellectual improvement [of the people]."[1]

By the time Picasso discovered Vallauris almost eighty years later, the town's life was centered around its craftsmanship, the thick black plumes of smoke signaling its incessant productivity. At regular intervals, sirens would call workers to their posts; the windowless brick and cob walls of workshops scattered over the hillside sheltered the spaces where pottery was made, dried, decorated, and displayed; and at the center of this little world stood the municipal cooperative, enabling potters and farmers to sell their products direct to customers.

While he was working in Antibes, Picasso visited Vallauris and was led to the Madoura pottery workshop that Suzanne Ramié had run since 1938.[2] The date was July 26, 1946. Georges, her

husband, would later describe the artist's first visit as a true epiphany. "He introduced himself with the radiant simplicity of a medieval minstrel, knocking at the door to ask for water and shelter, bringing with him the warmth of his presence, the fervor of his intentions, and the brilliance of his exploits."[3] During the months that followed, Picasso began to think seriously about the possibilities of this medium (which he had explored a little earlier):[4] he visited the rooms in the Louvre devoted to Greek pottery; he studied a number of books, including *Art in Greece* (written by Christian Zervos and published in 1936); and he filled entire notebooks with sketches—of young goats, vultures, owls, and other animals that would end up on his zoomorphic vases in 1947. And so, under the guidance of this mentor who taught him "eleven traditional methods" of "baking and enameling earth," Picasso was a diligent, obedient student until he started subverting everything he'd learned, provoking Suzanne Ramié to exclaim one day: "A potter who worked like Picasso would never get a job with us!"

53.

EXPERIMENTATION AND PRODUCTIVITY

During his period of collaboration with the Madoura workshop, Picasso produced more than two thousand pieces between July 1947 and October 1948, and more than four thousand during the years after that. He explored past ages (beginning with the Neolithic), steeping himself in ancient works from which he would consciously draw inspiration in ceramics and pottery workshops all over the Mediterranean region—in Greece, Egypt, Apulia, Etruria, Mesopotamia, Turkey, and the Arabic-Andalusian world (in Málaga, Paterna near Valencia, Elvira near Granada, and Madinat al-Zahra north of Córdoba). He measured himself against all the most talented and prolific potters in a region well-known for its multiple identities, following the same method he'd used with *Guernica*: assembling a dizzying number of sources and skillfully integrating them into his work,[1] placing himself in the history of the medium's long lineage while bending it to his own radically iconoclastic ends.

For his wonderful *Standing Bull* (1945), he took his inspiration from *Vase in the Shape of a Bull*, from the Marlik necropolis in Iran (1400–1100 B.C.E.). As for *Standing Woman* (1948), it looks like the twin to one of those small feminine figures produced in the first half of the Early Cycladic II (2700–2400 B.C.E.). And who could not fall for that white Tanagra that Picasso produced in 1948, drawing inspiration from still more ancient sources—the Mesopotamian era

(7000 B.C.E.) and the workshops of Tell Halaf—and representing the theme of those fertility goddesses who cross their arms to hold up and display their swollen, milk-filled breasts?

Partnered with Robert Picault,[2] another talented Vallaurian ceramist, Picasso would even co-create an *Etruscan Vase (Pablo and Françoise)* in 1950, made from "*chamotée* and painted with engobe," following the methods used in the workshops of Tarquinia or Chiusi in the seventh century B.C.E. Some pieces, such as the *Slab Decorated with a Woman's Face* (1952), bear traces of his surrealist period; others, such as *Nature Morte sur une Sphère* (1948), in unpolished terra-cotta decorated with a still life of a wine bottle, seem free of all influences, a solitary exploration of abstraction. One expert noted: "Picasso sought traditional objects in neighboring workshops or even in garbage dumps: cooking pots, frying pans with holes in them, fragments, and so on. It was one of those paradoxes the artist liked so much, mixing the most popular forms of traditional ceramics with reminiscences of the great Attic ceramics."[3] At the Madoura workshop, Picasso wasn't involved in the molding of the clay; he often used models conceived by Suzanne Ramié but applied his own techniques to them (patinas, sgraffito, the combination of enameled areas and bare areas). He sometimes created shapes, modeling certain parts of terra-cotta sculptures that came from the hands of Jules Agard, the workshop's master molder, or assembling elements picked up from anywhere he could find them, subverting the functions of traditional ceramics—frying pans transformed into masks, flasks taking the shape of colorful insects, bricks and cinder blocks turned to ceramic sculptures, parts of gutters metamorphosed into portraits. Hence the three works titled *Brick Fragment Decorated with a Woman's Face* (July 12, 1962).

54.

THE APPRENTICE TURNED LEADER

"Dear and great friend," wrote Suzanne Ramié to Picasso one day in March 1955, "Perhaps you know that the International Academy of Ceramics [. . .] is organizing a congress and an exhibition in Cannes where about twenty nations will be represented. For months, the commissioner [. . .] has been coming to see us in the hope of learning that you've returned to Vallauris and to ask us to exhibit there. Like everyone else, he knows that almost all the current experimentation in our art form is under your influence, and he hopes that you will loan a few pieces for the exhibition."[1] After eight years of practice, Picasso, now a leader in the ceramists' world, gave his consent, taking part in the exhibition and attending the keynote speech by Manuel González Martí,[2] one of the foremost ceramics collectors in the world. In recognition of this, González Martí offered the artist a copy of his encyclopedic work, *Cerámica del Levante Español*, a three-volume book containing two thousand pages of text and three thousand illustrations, which Picasso would eagerly pore over. The artist in turn gave the collector a few of his works.

Back in Valencia, at his beautiful National Museum of Ceramics and Decorative Arts, González Martí wrote Picasso about the many reactions that his work had provoked: "In my interviews with journalists, sponsors, artists, and critics, in all the conversations I've had [about your works], those people have talked about your originality as

well as the very unusual, mysterious techniques used in your ceramics, which all the specialists admire. For my part, I spoke about how warm and friendly you were to me, the many reminiscences in your conversations about Spain and Valencia, and of course about your generosity in letting me have four of your exceptional works which, since last Sunday, have been on display, admired, and argued over by the public."[3] Two years later, Picasso produced a series of decorated squares, in the tradition of Arabic-Andalusian *soccarats*,[4] such as the wild, lively *Terra-Cotta Hexagon Decorated with a Dancer and a Musician's Head*, dated March 6, 1957. But perhaps Picasso's most intoxicating work was his fish plate, so similar to certain twelfth-century plates he'd found in González Martí's book. Despite the Franco regime, despite everything, Picasso made his return to Spain, in that Valencian museum situated three hundred miles from Málaga, itself one of the historic capitals of ceramics in antiquity. Naturally the artist was pleased to find his place in the long history of the Mediterranean region; once, in an interview on Radio Nice, he talked about the history of Vallauris, "a region that, since ancient times, has always made ceramics." He then added that he and "a few friends who are also real workers [. . .] have tried to revive something that had fallen into [. . .] decline."[5]

Thanks to his meetings with local artisans, and to his own urge to experiment, to subvert and transcend canons, Picasso extended his field of activities during the final two decades of his life: after ceramics came linocut with the printer Hidalgo Arnéra; photography with André Villers; metal sculpture with the designer Tobias Jelinek; the bending of sheet metal with the artisan metalworker Joseph-Marius Tiola; filmmaking with Paul Haesaerts, Frédéric Rossif, and Henri-Georges Clouzot; and sheet-metal cutouts with Lionel Prejger. He even became a genuine "organic part" of this village of potters, which gradually became an annex of the "Picasso blast furnace." And when he settled in Cannes, then in Vauvenargues, then in Mougins with his wife Jacqueline Roque, Picasso remained in contact with the local artisans and activists through his extensive network of friendships.

As he entered his eighties, Picasso was creating a new realm of art, producing more and more works, perfecting each technique, exhausting all of his partners, mixing ceramics and linocut into linoceramics, navigating between iron sculptures and fiber-reinforced concrete, pushing the envelope of every conceivable craft and genre, teaching the young craftsmen to explore, innovate, outdo themselves, experimenting with imprints, engobe, patinas, lacquers, glazes, incisions, sgraffiti, collages, stamps, sugar-lift aquatints, impressions on clay, enamel coverings, metallic oxides. One day, with the ceramist Robert Picault, he discovered "some pure alquifou, which gave the pieces a pale yellow color, but if you added iron oxide they turned a pretty red. A drop of manganese oxide gave a warm brown, and copper oxide a deep green."[6] Another day, working with the printer Hidalgo Arnéra, he produced the admirable *Portrait of a Young Lady* after Cranach the Younger.[7] This was a linocut, obtained using a new technique and created by Picasso with the "layering of five plates." "Without you, I can't do anything, and without me, you can't do anything," the artist told the young printer, in a sort of anointment.[8]

All these experiments fascinated one of Picasso's new friends, the gallery owner Heinz Berggruen, who met the artist in 1949 through Tristan Tzara. There was something of Kahnweiler in Berggruen, a Jewish intellectual from Berlin who emigrated to the United States in 1936 and who, as a newcomer to the art world, opened his first gallery in Paris in 1948. "I was just over thirty. I came from elsewhere [. . .]. I had no reputation or experience. I wanted to live in Paris [. . .] where I'd decided to set myself up in the art trade."[9] He was erudite, passionate, curious, and stubborn, with a strong literary bent. There was also something of Barr in this exile who, in 1944, in U.S. military uniform, liberated Paris from the Nazis. Besides, he was totally convinced of the primacy of cubism in the emergence of modernity. "He was interested in all of Picasso's work—paintings, papiers collés, lithography, engravings, sculpture, ceramics, everything," wrote his son Olivier.[10] As a collector, Berggruen began by spotting a few small gems, and acquired some works from Paul Éluard, Dora Maar, André

Lefèvre, and Alice B. Toklas, as well as from the Rosenberg brothers' auctions "at a time when those first [Picasso] collections were coming onto the market."[11]

As a gallery owner, he sold bronzes of the little Rose period sculptures, just as Ambroise Vollard had done before, and then did the same for the cubist period. He also published Buffon's *Histoire Naturelle* illustrated by Picasso (1942), given to Dora Maar and enhanced with forty-two drawings;[12] in this way he grew closer to Christian Zervos and Douglas Cooper. But it was by publishing a facsimile of the 1906 Catalan notebook (which he bought from Dora Maar, to whom Picasso had given it), then by editing *Diurnes* (a work containing seven hundred photograms, produced by Picasso in collaboration with the young photographer André Villers),[13] that Berggruen succeeded in making Picasso's work a seamless ensemble, building bridges between the key periods—the first pre-cubist experiments in Gósol joined with the latest innovations in Vallauris more than fifty years later.

One last story from this important phase: with the help of Suzanne Ramié, Picasso decided to democratize ceramics, choosing 633 pieces of his pottery to be mass-produced,[14] enabling anyone on the streets of Vallauris to buy one of his works, "wrapped in Kraft paper and slipped into a hessian bag," for a modest sum.[15] On the back of a plate that he gave to his mentor in 1961, the artist engraved a dedication: "For Suzanne Ramié. Her faithful subject. Picasso. Her student."[16] Guided by a woman in the south of France, Picasso had made his choice: the south over the north, the provinces over Paris, the craftsmen over the Académie, democratic mass production over the cult of the unique work.

55.

FROM THE COLOR LINE TO THE SUBALTERN WORLD

Within the walls of his studio in Fournas, to which only he possessed the key, Picasso was exploring the tension that had always interested him between "minor" arts and "noble" arts (today, one would say between "high and low"). At the time of the Exposition Universelle in 1900, two men with rich cultural backgrounds—Picasso arriving from Barcelona and W.E.B. Du Bois from Boston—spotted the first signs of the decline of the great French empire, arrogantly boasting of its "genius" and overweeningly proud of its school of painting and sculpture. "It is a characteristic of old societies to bask in the evocation of the past [. . .]," we read in the catalog for the Petit Palais that year. "Without veering into a complacent optimism [. . .] wouldn't it be better to applaud the considerable results acquired, and to rejoice that once again, and despite so many obstacles, we have been able to provide a categorical proof of the vitality of our genius and the pre-eminence of the French school during the nineteenth century?" As for what the curators of the time designated as the "minor" arts— "ironwork, weaponry, ceramics, tapestries, fabrics and embroideries, leather," etc.—all the examples that they chose to present in the catalog were of purely French objects.

With Aimé Césaire, another "broken intellectual," Picasso recognized the similarity of their multiple affiliations. "Dear Pablo Picasso,

It was with great joy that I learned from our mutual friend Pierre Loeb that you have agreed to make the monument that Martinique wishes to erect in memory of the abolition of Black slavery," wrote the newly elected deputy for the island in 1947. "My compatriots will welcome this news with pride and gratitude. It would be a wonderful thing—facing the Americans, lynchers of Blacks, and their statue of liberty—to build our LIBERTY on Black land, which would be, purely and simply, liberty. To us, nobody seems more qualified than the painter of *Guernica* to celebrate this vengeance of life over oppression. Martinique plans to devote a sum of five to six million francs to this enterprise. Unfortunately, time is rather short—the four parties must take place in July. But don't let that stop you. There will be no other limits than those you set yourself. Yours with gratitude and admiration, Aimé Césaire."[1]

A year later, they collaborated on the poetry collection *Corps Perdu*—ten of Césaire's poems illustrated by thirty-two Picasso engravings. The artist imagined hybridizations, flower-women, plant-men, root-genitalia, in echoes of Césaire's poetry, which is filled with volcanic explosions, botanical blossomings, and telluric forces rooted in a land of luxuriant vegetation. On the frontispiece, Picasso placed the effigy of a Black poet crowned with laurels, based on the portrait of Aimé's son, the young Jacques Césaire—thus rewarding Black art with the supreme European accolade, given to the winner of the Greek poetry and singing contests.[2] In September 1956, when the First Congress of Black Writers and Artists was being held at the Sorbonne, Picasso reused the portrait of the laurel-crowned Jacques Césaire when he designed the poster. "Artists and poets always return to the same homeland, no matter their color. Brotherly greetings to the congress of men of culture from the Black world," he wrote in his dedication. Aimé Césaire took part in the congress, as did other West Indians,[3] some Africans[4] such as Alioune Diop, and some African-Americans.[5] But neither Paul Robeson nor W.E.B. Du Bois were able to make the trip to Paris. "I am not present at your meeting because the United States government refuses to give me a

passport," wrote Du Bois in a letter that was read aloud at the opening ceremony. "A Black American traveling abroad must either not talk about Black people or only say what the State Department wants him to say."[6]

After Picasso's death, the president of Senegal, Léopold Sédar Senghor, organized the first exhibition dedicated to the artist's work on the African continent. It took place at the Musée Dynamique, in Dakar, and extended the list of tributes to Picasso from Africa and the West Indies. Seeing him take root in the south of France, it is possible to detect, in that late version of Picasso, a pioneer of the anthropological forms of the twenty-first century, celebrating his own "sphere of belonging"[7] with the world that is today described as "subaltern"[8]—shifting gears; pushing the envelope; discovering the historical depths of the Mediterranean region with the original syncretism of his mingled identities; exploring the model of great craftsmen of the past through collective, horizontal work; ennobling the "minor" or prosaic arts used to fertilize the "noble" disciplines (such as painting and sculpture, which had been regarded as sacred since the Renaissance); demonstrating the pariah's capacity for *agentivity*—in a "diaspora of hope," celebrating his constantly renewed empathy with Aimé Césaire and others.

"The theme of Picasso searching for—creating—open worlds is key," wrote my friend the historian Jeremy Adelman after reading the first draft of this text. "It's what draws him to Paris in the first place as the nineteenth-century city of exiles, from Argentines to Prussians. It's all the other pariahs who offer and open the spaces, galleries, collectors, the Jews, that enable him to create his networks. He is invisible to the closed official world but ever more visible in the shadow, informal, networked world. This, it seems to me, is important to underscore because so many people automatically infer that an *étranger* is one who has no agency. Yours is a story of Picasso as an agent."[9] In fact, despite being born in the nineteenth century, despite living through all the great European conflicts of the twentieth century, the way Picasso assumed his cultural and social identities

was totally new. At a time when the issue of migration was reactivating the topic of modern European identities, Picasso—with his early sense of belonging to a long-lasting global order, with his frequent use of mythology, reinventing himself as the chief of a Mediterranean tribe—helped explode the traditional borders between states and heralded, in the words of the anthropologist Arjun Appadurai, the new "cosmopolitan cultural forms of the contemporary world."

56.

AN HONORARY CITIZEN WHO NEVER FORGOT THE HARDSHIP OF THE WINTER OF 1907–1908

Sometimes, Picasso's new friends discovered his past life almost by accident—as was revealed by Georges Tabaraud, editor of the Communist daily newspaper *Le Patriot de Nice*, for which Picasso drew a full-page illustration every year at carnival time. "On a sideboard, in the antechamber of the Villa La Californie, was a full, corked bottle with no label that intrigued me," Tabaraud wrote. "I had been seeing it ever since Picasso moved to Cannes. Every time I walked past it, I wondered what it contained and if Pablo had forgotten it there . . . It was not until 1958 that I [. . .] asked him what 'genie' was kept locked up in that bottle. 'It's not a genie,' Picasso replied in a serious voice. 'It's Père Frédé who's inside that bottle!'" He added that "the winter of 1907–1908 was exceptionally cold. There were ice cubes in the Seine. It was a particularly difficult winter for him, he recalled, since after *Les Demoiselles d'Avignon*, there had been a negative reaction to his aesthetic experiments [. . .] he was selling fewer and fewer paintings, the studio was unheated, he couldn't afford to buy any more canvases or paint, his meals were as frugal as those of any saltimbanque." Tabaraud then described Picasso's desperate visit to Leo Stein, who might, perhaps, agree to pay him "an advance on a

painting that he or his sister could buy one day." "'Why do you keep painting horrors that nobody wants?' Stein asked him, handing the artist a 20-franc coin as if he were a beggar. 'I had not gone there to beg,' Picasso explained. 'I was wondering if I should throw the money back in his face along with the chair and the nightstand. But I had no paint, no canvases, no fire in my hearth, no bread on my table, so I took the 20 francs and went away. It's fifty years ago, but you can see I've never forgotten it [. . .]. That same winter, one morning when the stove in the studio was still unlit, someone knocked at my door. It was Père Frédé [who was] worried because he hadn't seen me recently. He'd asked my neighbors, and he'd come to see me. On the back of his donkey, I saw an enormous sack of coal, and in the saddlebags enough food to last me for days. I also found a 20-franc coin in there and a bottle of absinthe—the real stuff [. . .]. I wanted to cry [. . .]. I have never let anyone open it. And as you see, it has followed me everywhere. For me, even after fifty years, Père Frédé is still inside that bottle.'"[1]

What are we to make of that bottle from Père Frédé, transported by Picasso from studio to studio, from home to home, like a talisman? Was the trauma of that winter actually what drove Picasso—more than success, more than wealth—through all the years and works that followed? In the hinterland around Vallauris where, for four centuries, the role of the foreigner has been a positive one—since, according to local legend, after the Black Death, the depleted community invited families from Ventimiglia in Italy to repopulate its fields and workshops—Picasso became an organic part of a Communist municipality. What revenge on the national museums, the French police, the snobbery of Paris, the Académie des Beaux-Arts and its "good taste"! It was undoubtedly in Vallauris that the image we have of Picasso now was first conjured. He was working flat out, releasing all the urges bottled up after the trauma of 1914, the trauma of 1940, inhabiting his new and lasting status as a universal genius, in a heroic echo of the experimental years of cubism that he'd lived through with Braque.

In 1949, he donated a bronze of *Man with a Lamb* to Vallauris—the first Picasso sculpture to be publicly exhibited in France. It was placed on a white pedestal in the center of an empty esplanade during a ceremony that would, a year later, make him an honorary citizen of the town. In 1952, invited to decorate the medieval chapel, he painted a fresco on eighteen hardboard panels screwed to a curved wooden cradle frame and called it *War and Peace*. The fresco was officially inaugurated in 1959.

57.

INTEGRATION, INFLUENCE, AND SUBVERSION IN CANNES, VAUVENARGUES, AND MOUGINS

After Vallauris, Picasso quickly bought three impressive properties in which he could host the works that had remained in Paris: in 1955, the Villa La Californie, in Cannes; in 1958, the historic château and its estate in Vauvenargues (near Aix-en-Provence); and in 1961, the Provençal domain "Notre-Dame-de-Vie" in Mougins (near Cannes). Picasso would live on the Côte d'Azur, an area with which he shared a long history, except for three years spent in Vauvenargues. The artist occupied the three residences sometimes simultaneously, sometimes successively, but he did not sell any of them before his death on April 8, 1973. Having accumulated this impressive real-estate portfolio, he used the properties to house personal documents and souvenirs, but also, most importantly, the mind-boggling riches of his collection (several thousand works by other artists and also, of course, by himself—"Picasso's Picassos")—in other words, all the traces of a long life lived by someone who never threw anything away!

"There is a Picasso collection," Kahnweiler revealed. "He has some very beautiful things. There are lots of Cézannes, some Renoirs, some Degas, two Le Nains. But it's only now that he's in Vauvenargues that any of it is hung on the walls."[1] Other witnesses

testify to his determination to extend his territories during the last two decades of his life. For Nicolas Pignon, son of Hélène Parmelin and Édouard Pignon, Picasso's last few houses, "beautiful and immense, had a huge number of rooms, and in every one of those rooms, artworks were piled up, lying on the floor, everywhere you looked, filling up all the space."[2]

From 1954 on, Picasso lived with Jacqueline Roque, whom he had met two years earlier in Vallauris. She became his last muse, then his wife in 1961. Anchored by the south of France and Jacqueline, Picasso became interested in photography and bullfighting with Lucien Clergue ("Picasso helped my father into the wagon of creation," Anne Clergue told me; "my father was nineteen at the time, so afterward he always helped young people"),[3] and in engraving with the Crommelynck brothers, while continuing to produce pictures at an undiminished rate, whether alone or in dialogue with the old masters. And the variations he produced around masterpieces by Delacroix, Velázquez, Manet, Goya, Rembrandt, and others were always very much in his own style (affectionate, brutal, cannibalistic). He defied all conventions, including that of age, when he painted explicitly erotic works for his final exhibitions at the Palais des Papes (1970, and a posthumous exhibition in 1973).

Very few people understood this project, however. Some talked of "obscene daubings," others of "disastrous scrawlings," still others of "senile sexual obsession." Quentin Laurens, who now runs the Louise Leiris gallery, thinks differently: "I remember an extraordinary exhibition. In fact, what I remember most is an atmosphere, of that gigantic space with all those paintings thrown randomly onto the walls, like a real installation, creating a dense body of work in that oversized building, and a feeling of absolute freedom. Picasso worked feverishly, insatiably, obsessively. With his back to the wall, he produced extraordinary, dazzling paintings. It was his climax, the exclamation point to his career—an artist facing death."[4] Among so many others, two paintings in particular—*The Painter and the Child* (October 1969) and *The Young Painter* (April 1972)—stand out for

their majesty, in a flash evoking the urgency of a trajectory that nothing seems to have been able to subdue or destroy.

In contrast to all those artists who shrink in ambition as they get old, Picasso extended his. He undertook an all-encompassing project, articulating spaces, eras, continents. He invented a grand opera of which he was simultaneously the composer, librettist, and conductor, filling it with his favorite characters: matadors, musketeers, animals, women, overturning all conventions, deliberately imposing his own units of time and space. "The first time I went to Notre-Dame-de-Vie," says Christine Piot, one of the four experts who inventoried Picasso's works after his death, "I was immediately struck by the central presence, in front of the elevator, of the painting *Monument to the Spaniards Who Died for France*, standing on an easel, and I felt as if I was in Spanish territory; no, actually I felt as if I were in an intermediary space, the kind of space you find in an embassy or a consulate."[5]

At the same time, "Picasso rituals" had been established and took place with great enthusiasm in his immediate circle and beyond: on October 25, 1956, he celebrated his seventy-fifth birthday at the Madoura gallery with the potters of Vallauris; five years later, festivities for his eightieth birthday were organized in Vallauris; in 1966 and 1971, there more parties were thrown for his eighty-fifth and ninetieth birthdays. There were also corridas in Arles, Nîmes, and Vallauris, parties with the bullfighter Luis Miguel Dominguín, musical soirees with the flamenco guitarist Manitas de Plata. In October 1971, the Grande Galerie in the Louvre presented a selection of eight of his works that belonged to French public collections, and the city of Paris made him an honorary citizen. Then there was the installation of public sculptures in Oslo, Stockholm, Chicago; the opening parties for major retrospectives in London, Toronto, Montreal, Tokyo; the celebrations when he won his second Lenin Peace Prize.

Meanwhile, there were more and more "Picasso stopovers" all over the world. On March 9, 1963, enabled by Sabartés's personal collection, and above all by political negotiations with his local

friends, the Museu Picasso opened in Barcelona's thirteenth-century Aguilar Palace. Five years later, when Sabartés died, the artist would donate to the museum his astonishing series *Las Meninas*, based on the Velázquez painting and comprising fifty-eight separate works,[6] before adding a large quantity of his juvenilia, thus secretly invading Franco's territory. One sunny winter day in 1971, Picasso was visited in Mougins by William Rubin (then the director of the painting and sculpture department of MoMA), who offered to give the artist a small Cézanne from the museum's collection in exchange for *Guitar* (1912–1913), an experimental sculpture made from cardboard, paper, rope, wire, and metal, produced during his cubist phase. Picasso decided to simply donate the work, securing his privileged place with MoMA and extending his presence in the city of New York, which he had never visited.

58.

OLD DEBATES REVIVED

No matter how much Picasso might have liked to disappear into the world of Mediterranean potters, the worries of the past would sometimes resurge unexpectedly, as was the case with this message from Marie Cuttoli and Henri Laugier (now president of UNESCO) on February 1, 1959: "Dear Pablo! [. . .] General de Gaulle's right-hand man continues to want to grant you French nationality. So if you're in agreement, happy and honored and all that, it seems there would be no difficulties on this end . . . And France would raise no objections to you maintaining your Spanish nationality at the same time. The problem is this: it is unfortunately probable (although not certain) that the Spanish government will strip Spanish nationality from any citizen who accepts a foreign nationality. We are currently sounding out State Council members and Spanish UNESCO representatives. And as soon as we have more detailed information, I will send it to you."[1] But Picasso never replied to Laugier. He was no longer interested in becoming a French citizen: he had decided to fully embrace his status as a foreigner.

Yet another entanglement with French bureaucracy lay in wait, this time involving his children, another onomastic ordeal that would feature prestigious institutions such as the State Council and illustrious individuals such as the minister of justice, who would issue an official decree on the subject.

"Dear Pablo! [. . .] Here is the dossier on the name Ruiz-Picasso

that will soon be used by Claude and Paloma," wrote Henri Laugier on January 10, 1961. "Naturally you will feel—and we feel this, too—that things are not moving fast enough; communications between departments are always slow. But the ministerial decision has been made, and I don't know of anything now that could prevent it going through. We are very happy about that. The dossier contains:

1. For information only (I) the decision, consultative, of the State Council, unfavorable.
2. The handwritten letter sent to me by the Minister of Justice (II) in which he makes his decision to disregard the State Council's recommendation. In my opinion, this minister, Edmond Michelet, has behaved very, very well, and I thanked him sincerely for it; he came to eat lunch at the house a few days before.
3. A letter from Coblentz, a policy officer from Edmond Michelet's cabinet (III); [. . .] he is monitoring the case as it makes its way through the ministry's bureaucratic maze. I don't think we will have long to wait before we can invite to lunch those who wish to join Claude and Paloma Ruiz Picasso. Fingers crossed, with all our love, Henri Laugier."

I. State Council's unfavorable recommendation

Change of name: Gilot to Ruiz-Picasso

"The Chancellery received a request from Lady Gilot (née Simon) on behalf of the Gilot minors with a view to changing their surname to Ruiz-Picasso. The applicant explains that the minors, [. . .] currently being raised by their mother, were constantly in possession of the Picasso name during the ten years that their mother was married to the artist. They frequently go to stay with their biological father. There are two opposing arguments here:

– The first, favorable, takes into account the illustriousness of the name and the certainty that it will endure. Since the blood ties are not in question, it seems fair to allow Picasso's children, even those born of adultery, to benefit from their father's fame.

This is the opinion of the Paris public prosecutor.

*– The opposing argument (to reject the request) is based on the rec-
ommendations of the State Council and the Seine prosecutor. This
judge divides his recommendation into two separate arguments:*

1. *It would be paradoxical for France to take away children's
 French nationality and their French surname in favor of a
 foreign name. (This argument is somewhat weak since the
 Germinal Law does not, like the 1950 Law, pertain to the
 Francization of names.)*
2. *The second, more serious argument is as follows: to accept this
 request would mean bending the rules as set out in Article 335
 of the Civil Code by giving children born of adultery at least
 the appearance of legitimacy."*

Included with Laugier's letter was a small card from Edmond Mi-
chelet, the minister of justice, who had written to Laugier: "My dear
professor and friend, Here is the note from the Chancellery. Upon
reflection, and since it would take six months to reach the Gillot-
Picasso [*sic*] solution, I plan to give my agreement to the requested
Ruiz-Picasso. Unless the master has a different opinion, then, I ex-
pect to sign this decree in the coming days. In exceptional situations
like this one, one must know when to bend the rules! It brings me
great joy to bring great joy to the old master. Edmond Michelet."[2]
Laugier later noted that Françoise Gilot had to pay 45,000 francs
to give "children born of adultery the appearance of legitimacy" by
taking away their good "French surname" in favor of a foreign name
(however illustrious it might be)!

As for Malraux, who during Braque's funeral oration had rel-
egated Picasso to a vague group of "friends from 1910," in 1966
he would generously orchestrate the vast exhibition *Tribute to Pablo
Picasso* (at the Grand Palais, the Petit Palais, and the National Li-
brary of France, with more than five hundred works), which the art-
ist didn't visit. Malraux also recommended Picasso for Chevalier de
la Légion d'Honneur, an honor the artist refused with a few words
quickly scrawled on some pink paper torn from a notebook, with
some spelling mistakes thrown in for good measure.

But Malraux's most important gesture was the so-called *"loi sur la dation en paiement"* (cancellation of the inheritance tax by forfeiture of the property), issued on December 31, 1968. This law allowed the payment of succession rights by works of art, with the aim of keeping objects "of the greatest importance" on French soil. After the decree enabling the transmission of Picasso's name to his children, this new law made it possible to integrate his art within the national heritage. Less than three years before Picasso's death, the French State finally acknowledged his genius, a belated compensation for decades of internal exile.

"Any heir or beneficiary," states the law, "may settle succession rights through the handing over of works of art, books, collectibles, or documents of high artistic or historical value." On April 8, 1973, when Picasso died, his legacy, estimated at more than a billion francs, included 1,880 paintings, 1,335 sculptures, 7,089 separate drawings, about 200 notebooks containing roughly 5,000 drawings, 880 ceramics and engravings, and archives that, when piled up, measured more than 120 feet in height, all of them kept in the artist's various homes. In the space of five years, the list of pieces reserved for the French State was drawn up by Maurice Aicardi, president of the interministerial certification commission for the conservation of the national heritage, in agreement with the family. To house the collection, the secretary of state for culture, Michel Guy, suggested the Hôtel Salé, a seventeenth-century mansion in the Marais registered as a historic monument in 1968, owned by the city of Paris, and located at 5 Rue de Thorigny. After that, Dominique Bozo, director of curation, with the aid of Roland Penrose, Pierre Daix, Maurice Besset, and Jean Leymarie, began selecting, inventorying, and classifying what would become the collection of the Musée National Picasso-Paris. On September 28, 1985, the public was finally granted access to a beautiful selection of those works in the heart of Paris.[3] What better sign could there be of the foreigner's vindication?

59.

PORTRAIT OF THE "OLD MASTER" AS A *MÉTÈQUE* (METIC)

In his letter to Henri Laugier in 1961, Edmond Michelet described Picasso as "the old master," highlighting the consecration of this new era between France and Picasso—a sort of official adoption by the Fifth Republic of an artist now indisputably accepted as a genius. The first line of the catalog for the 1966 *Tribute to Pablo Picasso* exhibition, written by Jean Leymarie, read: "Picasso dominates his century as Michelangelo dominates his own."[1] In December 1968, the *"loi sur la dation en paiement"* was the next step to erasing the four dark decades to which most of this book was devoted. On the day of the artist's death—April 8, 1973—superlatives rained down upon his name. At the last minute, the French State had appropriated Picasso's work into the nation's history.

"Far from being uniform," wrote François Hartog, one's relationship with one's present "is experienced very differently depending on the place one occupies in society." On the one hand, there are people living in a time of "acceleration and upward mobility," and on the other, the *"precariat,*[2] [occupying] a present in deceleration, without past—or with a complicated past (even truer for immigrants, exiles, the displaced)—and without a future either [since] the time for plans is not open to them."[3] Picasso had experienced this time of precariousness, back when he was the "anarchist under surveillance" (1901),

the "foreigner," the "SPANIARD" (1932), the "individual highly suspect
from a national point of view" (1940), monitored by the police and
ostracized by other French institutions. Once the French State took a
very different view of him—from the 1960s onward—he also experi-
enced an opposite configuration, that of "acceleration and upward
mobility." How did Picasso process such disparate experiences? How
did he cope with the precariousness during those rare moments when
his fear of expulsion resurfaced, when the sense of his own fragility
was heightened by the monolithic power of the institutions he was
up against? How did he navigate the hostile waters of the two world
wars (a collateral victim of Germanophobia in 1914; pariah status as
a Spanish Republican and "degenerate" artist under Vichy in 1940),
or that period between the wars when xenophobia was on the rise?

At the age of sixteen, on one of his first visits to the Prado mu-
seum, Picasso had measured himself against Velázquez—the "art-
ists' artist," according to him—by brilliantly copying the Spanish
master's portrait of Philip IV, from 1653.[4] Young Picasso joyfully
lengthened the king's face, protruded his eyeballs, fattened his lower
lip, thickened his chin, extended his pointed mustache, presenting
the Golden Age Spanish monarch as a weak, bland, dull, staid char-
acter, bundled up in his courtly clothes; a very strong version, indeed,
far exceeding the critical irony of Velázquez. Over the years, Picasso
would pursue these tête-à-têtes with the masters of the past—artists
and writers from all times and places: Cézanne, El Greco, Balzac,
Góngora, Rembrandt, Cervantes—reaching an apotheosis with the
"communion of saints" in *Guernica*. Much later, during his first ten
years working in the vast studio at Villa La Californie, in Cannes
(1954–1963), Picasso entered a period described by Marie-Laure
Bernadac as "pictorial cannibalism without precedent in the history
of art," as if the artist, pressured by "the urgency of defying the
past," felt "the need to accomplish a duty [. . .] a heritage to be cap-
tured and transcended."[5]

With his powerful, prolific, exhilarating variations on *Women of
Algiers in Their Apartment*,[6] *Las Meninas*,[7] and *Le Déjeuner sur l'Herbe*,[8]

Picasso conceived of his work as a series of private meetings with Delacroix, Velázquez, and Manet, his acolytes. But we should also remember the extreme fastidiousness of his dating of poems (and his works more generally), writing at the top and bottom of each page what seemed like milestones marking his implacable progress: "xxix October MCMXXX (III)";[9] "7 Diciembre xxxv (I)";[10] "April 24 xxxvi";[11] "9.9.58."[12] If Brassaï is to be believed, this was a way of "conferring upon all his acts and gestures a historic value in his history as a man-creator" in order to "insert them himself—before anyone else—in the annals of his prodigious life."[13] It is perhaps also worth mentioning here his mania for conservation, his fear of losing even the tiniest part of his accumulated paraphernalia, however insignificant or precious (circus tickets, postcards, used address books and old newspapers, sketchbooks, letters, artworks). All of this is brought together in the catalog for the exhibition *Les Archives de Picasso: "On est ce que l'on garde"* (Picasso's Archives: "You Are What You Keep").[14] And then there were his many transnational networks, carefully woven by the artist through his friends beyond France and designed to help spread his work outside the borders of the land where he was stigmatized, his work ignored. And what are we to make of his letters to his mother, or the family rituals from which he always managed to extract himself?

Romuald Dor de La Souchère perceptively described Picasso the Vallauris ceramist basking "in the posture of one of those great Athenian 'metics,'" comparing him to the best artisan potters from ancient Greece like Douris, Euphronios, Amasis, and Nikosthenes. In fact, in his dazzling productivity and immense range, Picasso combined the talent of the first (a virtuoso draftsman, unrivaled in his prolific output), the dexterity of the second (a bold, innovative artisan who loved challenges), the ingeniousness of the third (a brilliant miniaturist), and the know-how of the fourth (a magnificent painter of cups, with original themes and impeccable execution).[15]

But Dor de La Souchère was right about more than that. An expert on ancient Greece, he described Picasso as a "metic" in the classical sense, a word coined from the Greek *met-oïkos*—a neutral term,

without any derogatory implications, for a man who has "changed house," a term used to distinguish him from a "citizen," a "foreigner," a man who has arrived from outside and has settled in a new territory to live permanently with those of another community. After the denial of his naturalization request, made in a panic during the spring of 1940, Picasso in turn rejected all the French State's generous offers of citizenship. He was a man of many cultures, and he continued to integrate them in his own way, in public and in private, always transcending the simplistic divide between "French" and "foreign"—and refusing, like W.E.B. Du Bois, to be either "separate" or "assimilated." Picasso preferred a third way, visible in his beautiful *Plate with Three Faces*.[16] To me, that image is the perfect allegory of his options. To the right, a classical profile, perhaps that of the citizen. To the left, a more pronounced profile, perhaps that of the foreigner. And in the center, the joyous, playful face of an imp, its devilry signaled by the horns on its head; is this, perhaps, the face of the *met-oïkos*? Three faces, inside the perfect circle of time and the hybrid universe, which Picasso—a "master," undoubtedly, but above all a *met-oïkos*—always inhabited.

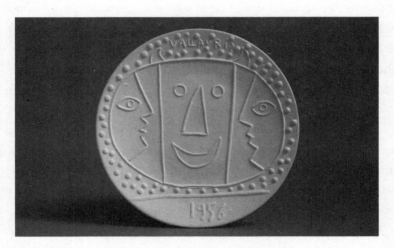

Pablo Picasso, *Plate with Three Faces*, 1956 (Musée Magnelli, Musée de la Céramique, Vallauris / © Succession Picasso 2022)

ARCHIVAL COLLECTIONS CONSULTED

Archives of American Art (AAA), Smithsonian Institution, Washington, D.C., and New York

Archives de la bibliothèque Kandinsky/Centre Pompidou, MNAM/CCI (Correspondence concerning the Sales of the Collections of Daniel-Henry Kahnweiler and Wilhelm Uhde), Paris

Archives de la bibliothèque littéraire Jacques-Doucet, Paris

Arxiv del Centre de Coneixement i Recerca, Museu Picasso Barcelona

Archives départementales de l'Aude, Carcassonne

Archives départementales de la Seine-Saint-Denis, Bobigny

Archives diplomatiques, La Courneuve

Gertrude Stein and Alice B. Toklas Papers, Beineke Library, Yale University, New Haven

Getty Research Institute, Douglas Cooper papers, Los Angeles

Archivio Gino Severini, Rome

Archives Henri Laugier, Institut Charles-de-Gaulle, Paris

Archives de l'Institut Mémoires de l'édition contemporaine (IMEC), fonds Étienne de Beaumont, Caen

Archives de l'Institut national de l'audiovisuel (INA), Bry-sur-Marne

Archives de la Légion d'honneur, Paris

Archives of the Leonard A. Lauder Research Center, Metropolitan Museum, New York

Archives du ministère de la Justice, Fontainebleau

Archives municipales d'Ivry (AMI) (fonds Thorez-Vermeersch), Ivry-sur-Seine

Archives du musée d'art moderne de Céret (AMAMC), Céret

Archives du musée national Picasso-Paris (MnPP), Paris

Archives du musée d'Orsay (AMO), Paris

Archives du musée des Arts décoratifs (MAD), Paris

Museum of Modern Art (MoMA) Archives, New York

Archives Lille Métropole musée d'art moderne, d'art contemporain et
 d'art brut (LaM) (fonds Roger Dutilleul), Villeneuve-d'Ascq

Archives of the National Gallery of Art, Washington, D.C.

Archives nationales (AN), département du Moyen Âge et de l'Ancien
 Régime (Centre de topographie parisienne)

Archives nationales (AN), Pierrefitte-sur-Seine

Archives de Paris (ADP), Paris

Personal archives of Sylvia Lorant on Max Jacob

Archives du Petit Palais (for the exhibition *Hommage à Picasso*, 1966)

Archives de la Préfecture de police de Paris (PPP), Le Pré-Saint-Gervais

Archives of the Pushkin State Museum of Fine Arts, Moscow

William Bullitt Archives (Barnes Foundation)

NOTES

ENCOUNTER WITH AN ALIEN SUSPECT

1. *Yo, Picasso*, Paris, May or June 1901, private collection; see Laurent Le Bon et al., *Picasso: Bleu et rose*, exhibition catalog, Paris/Vanves, Musée d'Orsay/Musée national Picasso-Paris/Hazan, 2018, p. 351.
2. *Autoportrait*, Paris, winter 1901, Musée national Picasso-Paris.

I. INTO THE LABYRINTH OF PARIS

1. Alfred Schütz, *L'Étranger*, tr. B. Bégout, Paris, éditions Allia, 2003, pp. 35, 38; originally published as *The Stranger*, Berlin, Kluwer Akademic, 1966, 1975.

1. WITH THE CATALANS OF MONTMARTRE

1. Louis Chevalier, *Montmartre du plaisir et du crime*, Paris, Robert Laffont, 1980, p. 301.
2. After Baron Haussmann's reorganization of central Paris, "new immigrants and working-class Parisians were forced out into the city's outskirts." It was this forced concentration of immigrants into specific urban centers that allowed the police to monitor certain zones in particular, and to intensify their practice of what would eventually be considered "racial profiling" in those areas. Clifford Rosenberg, *Policing Paris: The Origins of Modern Immigration Control Between the Wars*, Ithaca, Cornell University Press, 2006, p. 28; see also Jean Bastié, "La croissance de la banlieue parisienne," in Alain Fauré (ed.), *Les Premiers Banlieusards: Aux origines des banlieues parisiennes (1860–1940)*, Paris, Créaphis, 1991, pp. 213–23.
3. Francis Carco, in Chevalier, *Montmartre du plaisir*, p. 22.
4. Roland Dorgelès, *Le Château des brouillards*, Paris, Albin Michel, 1932, p. 33.
5. Santiago Rusiñol, *Desde el Molino*, Vilafranca del Penedes, Edicions i Propostes Culturals Andana, 2017, pp. 451–52.
6. Marilyn McCully and Malén Gual (eds.), *Picasso i Reventós: Correspondencia entre amics*, Paris, Musée national Picasso-Paris/Barcelona, Museu Picasso Barcelona, 2015, p. 28, letter of 25 October 1900.
7. Alain Fauré and Claire Lévy-Vroelant, *Une chambre en ville: Hotels meublés et garnis à Paris (1860–1990)*, Paris, Créaphis, 2007, pp. 69, 102.

8. McCully and Gual, *Picasso i Reventós*, p. 28.
9. McCully and Gual, *Picasso i Reventós*, p. 27.
10. McCully and Gual, *Picasso i Reventós*, p. 31, letter of 11 November 1900.
11. McCully and Gual, *Picasso i Reventós*, p. 31, letter of 11 November 1900.

2. THE MOVING WALKWAY AND THE "GENIUS OF FRANCE"
1. *Le Temps*, 18 August 1900.
2. *Le Temps*, 18 August 1900.
3. Robert E. Park and Ernest W. Burgess (eds.), *The City: Suggestions for Investigation of Human Behavior in the Urban Environment*, Chicago/London, University of Chicago Press, 1967.
4. André Hallays, *En flanant à travers l'Exposition de 1900*, Paris, Perrin, 1901, pp. 6, 9.
5. Hallays, *En flanant*, p. 15.
6. Miquel Utrillo, *Pèl & Ploma*, no. 14, 15 December 1900.
7. Miquel Utrillo, *Pèl & Ploma*, no. 11, 1 November 1900.
8. Utrillo, *Pèl & Ploma*, no. 11.
9. Émile Berr, "Le dernier banquet," *Le Figaro*, 16 November 1900.
10. Vincent Dubois, "Le ministère des Arts (1881–1882), ou l'institutionnalisation manquée d'une politique artistique républicaine," *Societés & Representations*, vol. 11, no. 1, 2001, p. 232.
11. Dubois, "Le ministère des Arts, p. 236.
12. Émile Molinier, Roger Marx, and Frantz Marcou, *L'Art français des origines à la fin du XIXe siècle*, Paris, Librairie centrale des beaux-arts/Émile Lévy editor, 1900.

3. "THE RIDE FROM COACH DRIVER BECKER REMAINS UNPAID"
1. Archives de la Préfecture de police de Paris (PPP) [hereafter cited as PPP], commissariat de quartier du XVIIIe arrondissement, CB 69 24.
2. This was probably Pallarès.
3. PPP, commissariat de quartier du XVIIIe arrondissement, CB 70 40.
4. Jaime Sabartés, *Picasso: Portraits et souvenirs*, Paris, L'École des lettres, 1996, in Pierre Daix, *Le Nouveau Dictionnaire Picasso*, Paris, Robert Laffont, 2012, p. 551. Daix cites the first edition of Jaime Sabartés, *Picasso: Portraits et souvenirs*, Paris, Louis Carré et Maximilien Vox, 1946.
5. PPP, commissariat de quartier du XVIIIe arrondissement, CB 69 24.
6. See chap. 1, "With the Catalans of Montmartre," note 10.
7. Letter of Picasso to Joaquín Bas, quoted in Daix, *Nouveau Dictionnaire Picasso*, p. 95.
8. Bulletin of 25 June 1907, in Claire Lévy-Vroelant, "Un siècle de surveillance des garnis à Versailles: 1830–1930," in Marie-Claude Blanc-Chaléard, Caroline Douki, and Nicole Dyonet (eds.), *Police et migrants*, Rennes, Presses universitaires de Rennes, 2001, p. 40.
9. Jean-Marc Berlière, "La Généalogie d'une double tradition policière," in Pierre Birnbaum (ed.), *La France de l'affaire Dreyfus*, Paris, Gallimard, coll. "Bibliothèque des Histoires," 1994, pp. 198, 217.
10. Marilyn McCully, *Picasso: The Early Years 1892–1906*, Washington, D.C., National Gallery of Art/New Haven, Yale University Press, p. 222, note 3.

4. FINOT, FOUREUR, BORNIBUS, AND GIROFLÉ, POLICE CHIEF ROUQUIER'S INFORMANTS

1. PPP, dossiers de naturalisation d'étrangers célèbres, IC 5, in Daix and Israël, *Pablo Picasso: Dossiers*, p. 47.
2. Archives nationales (AN) [hereafter cited as AN], F/7/12723.
3. AN, F/7/12723.
4. Sabartés, *Picasso: Portraits et souvenirs*, p. 106.
5. PPP, affaires liées à l'anarchisme, menées anarchistes (1899–1901), BA 1498.
6. Sabartés, *Picasso: Portraits et souvenirs*, p. 106.
7. PPP, affaires liées à l'anarchisme, menées anarchistes (1899–1901), BA 1498.
8. Sabartés, *Picasso: Portraits et souvenirs*, p. 107.
9. See the comments of Marianne Enckell, of CIRA (International Research Center on Anarchism), about Vivien Bouhey's book, *Les Anarchistes contre la République: Contribution à l'histoire des réseaux sous la Troisième République (1880–1914)*, Rennes, Presses universitaires de Rennes, 2008.
10. Gustave Coquiot, "La vie artistique," *Le Journal*, 17 June 1901.
11. Speech of Maurice Barrès in Nancy in 1898.
12. PPP, dossiers de naturalisation d'étrangers célèbres, IC 5, in Daix and Israël, *Pablo Picasso: Dossiers*, p. 44.
13. PPP, dossiers de naturalisation d'étrangers célèbres, IC 5, in Daix and Israël, *Pablo Picasso: Dossiers*, p. 47.
14. Gérard Noiriel, "Français et étrangers," in Pierre Nora (ed.), *Les Lieux de mémoire*, Paris, Gallimard, 1992, vol. 3, pp. 275–92.
15. Chevalier, *Montmartre du plaisir*, p. 210.
16. On David Raynal, see Pierre Birnbaum, *Les Fous de la République: Histoire politique des Juifs d'état, de Gambetta à Vichy*, Paris, Fayard, 1992.
17. AN, F/7/12723, *Journal officiel*, Chamber of Deputies, meeting, Saturday, 27 January 1894.
18. Jean-Paul Sartre, "Qu'est-ce que la littérature?," *Les Temps modernes*, 1947, in Jean-Paul Sartre, *Situations, II: Littérature et engagement*, Paris, Gallimard, 1948, pp. 158–59.

5. THE "MYSTERIOUS LOOKS" OF ANARCHISTS

1. AN, F/7/12723.
2. AN, F/7/12512.
3. AN, F/7/12723.
4. "Du calme!," *L'Intransigeant*, 27 June 1894.
5. AN, F/7/12723.
6. *La Justice*, 23 May 1894.
7. "Du calme!," *L'Intransigeant*, 27 June 1894.
8. Jean-Marie Domenach, *Barrès par lui-même*, Paris, Seuil, 1969, p. 133.
9. Gérard Noiriel, *Le Creuset français: Histoire de l'immigration (XIXe-XXe siècle)*, Paris, Seuil, 2006, p. ix.
10. Patrick Weil, *La France et ses étrangers*, Paris, Calmann-Lévy, 1991, p. 24.
11. Caroline Douki, "Identification des migrants et protection nationale," in Blanc-Chaléard, Douki, and Dyonet, *Police et migrants*, pp. 107–13.

12. Douki, "Identification des migrants," pp. 91–104.
13. Douki, "Identification des migrants," pp. 107–13.
14. Gérard Noiriel, *Le Massacre des Italiens: Aigues-Mortes, 17 août 1893*, Paris, Fayard, 2010.
15. Ralph Schor, *Histoire de l'immigration en France de la fin du XIXe siècle à nos jours*, Paris, Armand Colin, 1996, p. 13.
16. Vincent Duclert, "1896–1906: histoire d'un événement," in Vincent Duclert and Perrine Simon-Nahum (eds.), *Les Événements fondateurs: L'affaire Dreyfus*, Paris, Armand Colin, 2006, p. 33.
17. AN, F/7/12504; see also Marie-Josèphe Dhavernas, "La surveillance des anarchistes individualistes (1894–1914)," in Philippe Vigier (ed.), *Maintien de l'ordre et polices en France et en Europe au XIXe siècle*, Paris, Créaphis, 1987, p. 348.
18. AN, F/7/12723.
19. *La Plume*, in Guillaume Apollinaire, *Les Peintres artistes: Méditations esthétiques*, Paris, Eugène Figuière & Cie, 1913.
20. See Marianne Amar (historian, scientific co-curator for the redesign of the Permanent Galleries, and head of research at the National Museum of the History of Immigration (MNHI), in "Les populations qui ont fait la France," *Les Collections de L'Histoire*, no. 88, July–September 2020.

6. "A BLIND MAN SITTING AT A TABLE"

1. Hélène Seckel, Emmanuelle Chevrière, and Hélène Henry (eds.), *Max Jacob et Picasso*, Paris, RMN, 1994, p. 23, letter of 6 August 1903.
2. Seckel, Chevrière, and Henry, *Max Jacob et Picasso*, pp. 12–13, *Étude de Chiromancie*, 1902, Museu Picasso Barcelona.
3. Patricia Sustrac, *Max Jacob : Biographie (enfance bretonne)*, Les Cahiers Max Jacob, Association des Amis de Max Jacob, 2021.
4. These notes date from 1935, during which year Max Jacob decided to give a series of speeches and to prepare a work on Picasso and Apollinaire. See Seckel, Chevrière, and Henry, *Max Jacob et Picasso*, pp. 232–33.
5. According to Richardson and McCully, the date was July 1902 (see *Vie de Picasso*, vol. 1, Paris, Éditions du Chêne, p. 9).
6. Saint Augustin, *Les Confessions*, bk. 10, chap. 40, Paris, Flammarion, 1999, p. 248.
7. Seckel, Chevrière, and Henry, *Max Jacob et Picasso*, p. 18, letter from Picasso to Max Jacob, 1 May 1903.
8. Alexis Nouss, *La Condition de l'exilé: Penser les migrations contemporaines*, Paris, Maison des sciences de l'homme, 2015.
9. Seckel, Chevrière, and Henry, *Max Jacob et Picasso*, letter of 29 August 1903.
10. Seckel, Chevrière, and Henry, *Max Jacob et Picasso*, letter of March 1903.
11. Seckel, Chevrière, and Henry, *Max Jacob et Picasso*, letter of 1 May 1903.
12. Seckel, Chevrière, and Henry, *Max Jacob et Picasso*, p. 23, letter of 6 August 1903.
13. Seckel, Chevrière, and Henry, *Max Jacob et Picasso*, p. 23, letter of 6 August 1903.
14. Seckel, Chevrière, and Henry, *Max Jacob et Picasso*, p. 23, letter of 6 August 1903.

15. Seckel, Chevrière, and Henry, *Max Jacob et Picasso*, letter of 28 September 1903.

16. Seckel, Chevrière, and Henry, *Max Jacob et Picasso*, p. 27, letter of 19 March 1903.

17. Nels Anderson, *The Hobo: The Sociology of the Homeless Man*, Chicago, University of Chicago Press, 1923.

18. Fauré and Lévy-Vroelant, *Une chambre en ville*, p. 313.

19. Archives du Musée national Picasso-Paris (MnPP), Gift of the Picasso Estate, 1992, personal archives of Pablo Picasso [hereafter cited as MnPP, Picasso personal archives], 515AP/C/66/1 January 1903.

20. Seckel, Chevrière, and Henry, *Max Jacob et Picasso*, p. 20, letter probably dating to summer 1903.

21. Seckel, Chevrière, and Henry, *Max Jacob et Picasso*, p. 27, letter of 31 March 1904.

22. Seckel, Chevrière, and Henry, *Max Jacob et Picasso*, letter of 3 April 1904.

23. Seckel, Chevrière, and Henry, *Max Jacob et Picasso*, letter of 3 April 1904.

24. Seckel, Chevrière, and Henry, *Max Jacob et Picasso*, p. xxii, letter of 23 December 1936.

25. Josep Palau i Fabre, *Picasso vivant*, Barcelona, Polígrafa, 1980, p. 226.

26. Palau i Fabre, *Picasso vivant*, p. 375.

27. Seckel, Chevrière, and Henry, *Max Jacob et Picasso*, pp. 295–97.

28. The beautiful expression of Hélène Klein in Seckel, Chevrière, and Henry, *Max Jacob et Picasso*, p. xxv.

29. Seckel, Chevrière, and Henry, *Max Jacob et Picasso*, p. 23, letter of 6 August 1903.

7. THE BATEAU-LAVOIR AND OTHER DISGRACEFUL LODGINGS

1. PPP, dossiers de naturalisation d'étrangers célèbres, IC 5, report of 24 May 1905, in Daix and Israël, *Pablo Picasso: Dossiers*.

2. Fernande Olivier, *Picasso et ses amis*, Paris, Pygmalion, 2001, p. 26.

3. Archives de Paris (ADP) [hereafter cited as ADP], property register, D1P4 4298.

4. ADP, property register, D1P4 4298.

5. Fernande Olivier, *Souvenirs intimes: Écrits pour Picasso*, Paris, Calmann-Lévy, 1988, p. 114.

6. Claire Lévy-Vroelant, "Le logement des migrants en France du milieu du XIXe siècle à nos jours," *Historiens et geographes*, no. 385, January 2004, pp. 147–65.

7. Lévy-Vroelant, "Le logement des migrants," "Inventaire des types de logement des migrants," p. 155.

8. Ministère français de la Culture, Archives des Monuments historiques, PA00086734.

9. PPP, dossiers de naturalisation d'étrangers célèbres, IC 5, report of 24 May 1905, in Daix and Israël, *Pablo Picasso: Dossiers*, p. 51.

10. Abdelmalek Sayad, *L'Immigration ou les Paradoxes de l'altérité*, vol. 1, *L'Illusion du provisoire*, Paris, Raisons d'agir, 2006, p. 95.

11. *Family of Saltimbanques* is today held at the National Gallery of Art in Washington, D.C.

12. "Picasso was always nostalgic for Rue Ravignan. I remember when he was living on Rue des Grands-Augustins, showing me the ceiling, which was in a bad state, and he said to me: 'It's Rue Ravignan, isn't it? It's just like Rue Ravignan.' Wherever he went, he would re-create Rue Ravignan, with its disorder and everything that stemmed from it." Daniel-Henry Kahnweiler and Francis Crémieux, *Mes galeries et mes peintres: Entretiens*, Paris, Gallimard, coll. "L'Imaginaire," 1961, p. 139.
13. Kahnweiler and Crémieux, *Mes galeries et mes peintres*, p. 51.
14. *Le Monde*, 31 August 2005.

8. LETTERS FROM MARÍA: THE ADORING MOTHER AND THE GOLDEN BOY

1. MnPP, Picasso personal archives, 515AP/C/dossier réservé/11 August 1904.
2. According to his official title, Pierrot Eugène was "charged with the material and technical management of the collections."
3. MnPP, Picasso personal archives, 515AP/C/dossier réservé/11 August 1904.
4. MnPP, Picasso personal archives, 515AP/C/dossier réservé/1 March 1905.
5. Picasso's cousin who lived in Málaga.
6. MnPP, Picasso personal archives, 515AP/C/dossier réservé/27 January 1906.
7. MnPP, Picasso personal archives, 515AP/C/dossier réservé/29 September 1906.
8. MnPP, Picasso personal archives, 515AP/C/dossier réservé/18 March 1907.
9. Cécile Dauphin and Danièle Poublan, "L'éloignement rapproche: Rhétorique de l'espace et du temps dans une correspondance familiale au XIXe siècle," in Jean-François Chauvard and Christine Lebeau (eds.), *Éloignement géographique et cohésion familiale*, Strasbourg, Presses universitaires de Strasbourg, 2006, pp. 153–78.

9. MONTMARTRE BARS AND BELLEVILLE APACHES

1. MnPP, Picasso personal archives, 515AP/C/dossier réservé/12 May 1910.
2. *Journal officiel*, Débats, 13 June 1911, p. 662.
3. Henry Fouquier, "Les Apaches," *Le Matin*, 2 October 1907.
4. Dominique Kalifa, *L'Encre et le Sang*, Paris, Fayard, 1995, p. 116.
5. MnPP, Picasso personal archives, 515AP/C/dossier réservé/12 May 1910.
6. It must be emphasized here that, during the first two decades of the twentieth century, the powers of those tasked with policing immigration continued to grow, even though, on a bureaucratic level, this happened for "administrative measures without any legal basis." See Rosenberg, *Policing Paris*, p. 26. This could be compared to what Foucault would later describe as the transition from a sovereign power to a system of "governmentality" and discipline: see Michel Foucault, *Sécurité, territoire, population: Cours au Collège de France [1977–1978]*, Paris, Seuil, 2004; Michel Foucault, *Naissance de la biopolitique: Cours au Collège de France*, Paris, Seuil, 2004.
7. MnPP, Picasso personal archives, 515AP/A.
8. Ardengo Soffici, *Ricordi di vita artistica e letteraria*, Florence, Vallechi, 1942, pp. 365–66.
9. Dorgelès, *Château des brouillards*, p. 13.
10. *Le Matin*, 28 July 1900, p. 4.

11. Jean-Marc Berlière, "Les brigades du Tigre," in Marc-Olivier Baruch and Vincent Duclert (eds.), *Serviteurs de l'État: Une histoire politique de l'administration française (1875–1945)*, Paris, La Découverte, 2000, p. 316.

10. "ANY MAN WHO TAKES HIS MOTHER'S NAME IS HEADED TO RUIN . . ."

1. MnPP, Picasso personal archives, 515AP/C/dossier réservé/20 [??] 1912.
2. AN, Surveillance des anarchistes antimilitaristes, F/7/12722.
3. MnPP, Picasso personal archives, 515AP/C/dossier réservé/8 February 1909.
4. MnPP, Picasso personal archives, 515AP/C/dossier réservé/1 January 1908.
5. MnPP, Picasso personal archives, 515AP/C/dossier réservé/undated.
6. MnPP, Picasso personal archives, 515AP/C/dossier réservé/10 December 1908.
7. MnPP, Picasso personal archives, 515AP/C/dossier réservé/26 April 1909.
8. MnPP, Picasso personal archives, 515AP/C/dossier réservé/18 March 1907.
9. MnPP, Picasso personal archives, 515AP/C/dossier réservé/10 December 1908.
10. MnPP, Picasso personal archives, 515AP/C/dossier réservé/27 April 1912.
11. MnPP, Picasso personal archives, 515AP/C/dossier réservé/20 [??] 1912.
12. MnPP, Picasso personal archives, 515AP/C/dossier réservé/27 April 1912.
13. Among his older Catalan friends, the one who had the strongest influence on Picasso was Nonell. "He was a very good friend of mine [. . .] a true artist, a great artist [. . .]. It's a disaster that he died so young," Picasso would later remark. In 1896, Nonell went to work in the Vall de Boí (a craggy, remote region of the Catalan Pyrenees), and he brought back works representing mentally ill patients with frightening appearances, a subject that would later influence Picasso's paintings of prostitutes at the Hôpital Saint-Lazare. See Juan José Lahuerta, "On Futility of Comparisons: Notes on Picasso, Bohemian Barbarism and Mediaeval Art," in Juan José Lahuerta and Émilia Philippot (eds.), *Romanesque Picasso*, Barcelona/Paris, Museu Nacional d'Art de Catalunya/Tenov Books, Musée national Picasso Paris, 2016, pp. 34–95.
14. Arnold Van Gennep, *Les Rites de passage*, Paris, Émile Nourry, 1909, p. 726; Didier Fassin and Sarah Mazouz, "Qu'est-ce que devenir français? La naturalisation comme rite d'institution républicain," *Revue française de sociologie*, vol. 48, no. 4, 2007, pp. 723–50.
15. A concept developed by Arjun Appadurai in his *Modernity at Large: Cultural Dimensions of Globalization*, Minneapolis, University of Minnesota Press, 1996.

11. ON THE SIDE OF THE SALTIMBANQUES, WITH "THE GREATEST OF LIVING POETS"

1. Guillaume Apollinaire, *Le Poète assassiné*, Paris, Gallimard, coll. "Poésie," 1947.
2. Gustave Flaubert, *Correspondance*, Paris, Gallimard, coll. "Bibliothèque de la Pléiade" vol. 5, 2007, pp. 653–54, letter of 12 June 1867.

3. Picasso told Palau i Fabre that seeing a group of itinerant street performers on the Champ de Mars esplanade in late 1904 had been "the trigger for those characters entering his work" (Palau i Fabre, *Picasso vivant*, p. 398, cited in Peter Read, *Picasso et Apollinaire: Les métamorphoses de la mémoire* [1905–1973], Paris, Jean-Michel Place, 1995, p. 45).

4. This is a preparatory drawing belonging to the collection of the National Gallery of Art in Washington, D.C., under the name *The Circus Family with a Monkey*, not the painting that would form part of Gertrude Stein's collection.

5. One notes here Picasso's use of French references for the commedia dell'arte, a genre of Italian origin; already there is a tendency to draw from multiple sources.

6. Laurence Madeline (ed.), *Les Archives de Picasso: "On est ce que l'on garde!"*, Paris, RMN, 2003, pp. 188–89.

7. It should be noted that the Serrurier gallery also displayed furniture (which at the time was considered a minor art form).

8. John Richardson, *A Life of Picasso*, vol. 1, *1881–1906*, New York, Random House, 1999, p. 328.

9. Michel Décaudin in his preface to Apollinaire, *Poète assassiné*, p. 8.

10. Max Jacob, *Les Lettres françaises*, 22–28 October 1964.

11. Guillaume Apollinaire, *Œuvres complètes*, Paris, Gallimard, 1984, vol. 4, p. 895, letter to Raimondi, 29 February 1918.

12. For this chapter, see Maurice Raynal, *Picasso*, Paris, G. Crès, 1922; and Read, *Picasso et Apollinaire*.

13. From Baudelaire's description of caricature, written six decades earlier. See Charles Baudelaire, "De l'essence du rire et généralement du comique dans les arts plastiques" [1855], in Charles Baudelaire, *Curiosités esthétiques*, ed. H. Lemaître, Paris, Garnier, 1986, pp. 241–63.

14. Guillaume Apollinaire, "L'esprit nouveau et les poètes" (1917), in *Œuvres en prose complètes*, Paris, Gallimard, 1991, vol. 2, pp. 944–45.

15. Guillaume Apollinaire, "Art et curiosité, les commencements du cubisme," *Le Temps*, 16 September 1912, in *Œuvres en prose complètes*, vol. 2, p. 1515.

16. Guillaume Apollinaire, *La Plume*, 15 May 1905, in *Chroniques d'art (1902–1918)*, Paris, Gallimard, pp. 35, 38.

17. Apollinaire, *Poète assassiné*, chap. 10, pp. 62–68.

18. Read, *Picasso et Apollinaire*, p. 44.

19. Guillaume Apollinaire, "Saltimbanques," in *Alcools*, Paris, Gallimard, coll. "Poésie," 1920, p. 68.

20. For an identification of the characters, see Read, *Picasso et Apollinaire*, and Elmer Arthur Carmean Jr., *Picasso: The Saltimbanques*, Washington, D.C., National Gallery of Art, 1980.

21. Seckel, Chevrière, and Henry, *Max Jacob et Picasso*, p. 23, letter of 6 August 1903.

22. Are these characters a true family of saltimbanques, as suggested by the English title? Until 1931, in France and in Germany, the painting's title, *Les Bâteleurs* (The Street Performers), was neutral. But when the canvas was sold to the American collectors Maud and Chester Dale, Mrs. Dale (who

knew some French) decided to rename it *La Famille des Saltimbanques*, which was later translated as *Family of Saltimbanques*. See Annie Cohen-Solal, "L'Odyssée méconnue d'un groupe de saltimbanques," in Annie Cohen-Solal, *Picasso l'étranger*, Paris, Musée national Picasso-Paris, Musée national de l'histoire de l'immigration, Fayard, 2021, pp. 63–65.

23. See also Yve-Alain Bois, "Picasso the Trickster," *Cahiers du Mnam*, no. 106, winter 2008–2009, and Theodore Reff, "Harlequins, Saltimbanques, Clowns and Fools," *Art Forum*, 10 October 1971, pp. 30–43.

24. Michel Foucault, *Le Corps utopique*, followed by *Les Hétérotopies*, Paris, Nouvelles éditions Lignes, 2009, p. 23.

25. Foucault, *Corps utopique*, p. 25.

26. Foucault, *Corps utopique*, p. 30.

27. With this group composition set in a landscape, Picasso used perspective for the first time; an interesting point, suggested to me by Émilia Philippot.

28. Rainer Maria Rilke, "Die fünfte Elegie," in *Duineser Elegien*, Leipzig, Insel Verlag, 1923, p. 20, lines 1–3.

12. A STORY OF MANTILLAS AND FANS

1. MnPP, Picasso personal archives, 515AP/C/dossier réservé/1 November 1905.

2. Pierre Daix, *Picasso*, Paris, Fayard, coll. "Pluriel," 2014, pp. 92–93.

3. Letter from Picasso to Leo Stein (April 1906?): "My dear Stein, we will go to your apartment next Monday to see the Gauguins and to eat lunch beforehand" (Gertrude Stein and Pablo Picasso, *Correspondance*, ed. L. Madeline, Paris, Gallimard, 2005, p. 31).

4. Pierre Daix, *Picasso et Matisse revisités*, Lausanne, Ides et Calendes, 2002, p. 30.

5. Irene Gordon, "A World Beyond the World: The Discovery of Leo Stein," in Margaret Potter et al., *Four Americans in Paris*, New York, MoMA, 1970, p. 27, letter from Leo Stein to Mabel Foote Weeks, 29 November 1905.

6. Leo Stein: *Appreciation: Painting, Poery & Prose*, New York, Crown Publishers, 1947, p.186.

7. Stein and Picasso, *Correspondance*, p. 37, letter of 11 August 1906.

8. Stein and Picasso, *Correspondance*, p. 41, letter of 4 February 1907.

9. Stein and Picasso, *Correspondance*, p. 25.

10. Stein and Picasso, *Correspondance*, p. 31, letter from Picasso to Leo Stein, 1905 or 1906 (?).

11. MnPP, Picasso personal archives, 515AP/C/164/March 1906.

12. Gertrude Stein, *Autobiography of Alice B. Toklas*, New York, Harcourt, 1933, p. 60.

13. Daix, *Picasso et Matisse revisités*, pp. 30–39.

13. "MILLIONS OF FEET ABOVE SEA LEVEL" . . . GÓSOL!

1. Fernand Braudel, "Ordre social et politique, économie monétaire," in *La Méditerranée et le monde méditerranéen à l'époque de Philippe II*, Paris, Armand Colin, 1982, vol. 1, p. 30.

2. "Communitas," according to the definition provided by the anthropologist Victor Turner in *Dramas, Fields and Metaphors: Symbolic Action in Human*

Society (Ithaca/London, Cornell University Press, 1974, pp. 201–202): "I call this modality of social relatedness 'communitas,' borrowing the term, though not its meaning, from Paul Goodman, and distinguishing it from 'community,' which refers to a geographical area of common living. Liminality, the optimal setting of communitas relations, and communitas, a spontaneously generated relationship between leveled and equal total and individuated human beings, stripped of structural attributes, together constitute what one might call anti-structure. [. . .] Communitas strains toward universalism and openness. [. . .] In its genesis and central tendency, communitas is universalistic [. . .] it remains open and unspecialized, a spring of pure possibility as well as the immediate realization of release from day-to-day structural necessities and obligatoriness."

Likewise, Peter Sahlins describes how, in the seventeenth and eighteenth centuries, in certain villages in the Ariège (the region next to French Catalonia), the sense of community was "dramatized" by wild carnivals. These could take the form of a "language used to subvert the political order" (Peter Sahlins, *Forest Rites: The War of the Demoiselles in Nineteenth-Century France*, Cambridge, Harvard University Press, 1994, p. 92).

3. Jèssica Jaques Pi, *Picasso en Gósol, 1906: Un verano para la modernidad*, Barcelona, Machado Libros, La balsa de la Medusa, 2006, p. 17.

4. Jèssica Jaques Pi organizes Picasso's work into three aesthetic stages (which she classes as naturalism, classicism, and primitivism) and shows the uniqueness of his experience in Gósol by championing her theory that this was a moment of rupture—between a period when he was affiliated with the representative tradition that stretched from the Renaissance to the various impressionisms of the late nineteenth century, and the period when he became fully committed to his own modernity. Her work consists of a systematic investigation as well as a local inquiry and a strong, evidence-backed theory, since revisited in an article in which she insists on the omnipresence of the Cézannean genealogy.

5. Pablo Picasso, *Carnet catalan* (summer 1906), Paris, Berggruen, 1976 (500 copies), preface and notes by Douglas Cooper, comments by Josep Palau i Fabre; see also Jaques Pi, *Picasso en Gósol*.

6. Picasso, *Carnet catalan*, p. 33.

7. Picasso, *Carnet catalan*, p. 33.

8. Picasso, *Carnet catalan*, p. 33.

9. An epistemological approach similar to Sartre's, as described in 1939: "Each of my 'theories' was an act of conquest and possession. I believed that, if I lined them up end to end, I would make the world submit to me alone" (Jean-Paul Sartre, *Carnets de la drôle de guerre*, Paris, Gallimard, 1982, pp. 282–83). It is interesting here to introduce a parallel (the relevance of which will become clear throughout the course of this book) between two equally ambitious mechanisms: Picasso's in the field of art, and Sartre's in the field of philosophy.

10. Jaques Pi, *Picasso en Gósol*, p. 124, and *Carnet catalan*, 2 R°.

11. Picasso, *Carnet catalan*, p. 20.

12. Picasso, *Carnet catalan*, p. 15.

13. According to Pierre Daix, after "neglecting" Picasso following the 1901

exhibition, but apparently alerted by the Steins' interest in his new works, Ambroise Vollard woke up and "rushed over to the Bateau-Lavoir to swipe twenty-seven paintings for 2,000 gold francs" (Daix, *Picasso*, p. 97).

14. Teresa Camps and Susanna Portell (eds.), *Les Cartes de l'Escultor Enric Casanovas*, Barcelona, Publicacions i Editions de la Universitat de Barcelona, 2015, p. 150, letter of 27 June 1906.

15. Camps and Portell, *Cartes de l'Escultor*, pp. 151–53, letter conjecturally dated 13 August 1906, but I would date 17 July 1906, since on Sunday, 11 August, of that year Picasso told Leo Stein: "We've been here for three weeks" (Stein and Picasso, *Correspondance*, p. 37).

16. Pablo Picasso and Guillaume Apollinaire, *Correspondance*, ed. P. Caizergues and H. Seckel, Paris, Gallimard, coll. "Art et artistes"/RMN, 1992, pp. 52–53.

17. Olivier, *Picasso et ses amis*, p. 116.

18. Braudel, *La Méditerranée*, vol. 1, p. 30.

19. Picasso and Apollinaire, *Correspondance*, pp. 39–41.

20. Stein and Picasso, *Correspondance*, p. 34.

14. "A TENOR WHO SINGS A NOTE HIGHER THAN THE ONE WRITTEN IN THE SCORE: ME!"

1. Picasso, *Carnet catalan*, p. 27.

2. Peter Sahlins, *Frontières et identités nationales: La France et l'Espagne dans les Pyrénées depuis le XVIIe siècle*, Paris, Belin, 1996, p. 6; originally published as *Unnaturally French: Foreign Citizens in the Old Regime and After*, Berkeley, University of California Press, 1989.

3. Sahlins, *Frontières et identités*, p. 28.

4. Sahlins, *Frontières et identités*, p. 28.

5. Laurence Bertrand Dorléac, "Le Verre de Picasso," in Emmanuel Guigon et al. (eds.), *La Cuisine de Picasso*, Barcelona, La Fabrica, 2018. Analyzing *Le Verre d'absinthe* (1914), Laurence Bertrand Dorléac notes Picasso's cultural empathy with the city's marginal population (from 1904 to 1914).

6. Berlière, "Les brigades du Tigre," pp. 313–23.

7. Laurence Fontaine, *Histoire du colportage en Europe (XVe–XIXe siècle)*, Paris, Albin Michel, 1993, p. 19.

8. Jèssica Jaques Pi, interview with the author, Paris, 4 September 2018.

9. Francisco Comin, "Contrebande et fraude fiscale en Espagne," in Gérard Béaur, Hubert Bonin, and Claire Lemercier (eds.), *Fraude, contrefaçon et contrebande de l'Antiquité à nos jours*, Paris, Droz, 2006, pp. 145–63.

10. Emmanuel Grégoire, "Les chemins de la contrebande: études sur des réseaux commerciaux en pays hausa," *Cahiers d'études africaines*, no. 24, 1991, pp. 509–32.

11. "Pau" is the Catalan translation of Pablo.

12. Camps and Portell, *Cartes de l'Escultor*, pp. 151–52, postcard to Enric Casanovas between 27 June and 13 August 1906. My thanks to Jèssica Jaques Pi for allowing me access to this text.

13. ". . . marked by bureaucracy, legal precedent, archives, with weighty and inextricable effects; in other words, orderly societies with offices, careers, scales, orders; societies based on accountancy, in which the social contract

is a compromise" (Roger Caillois, *Les Jeux et les Hommes: Le masque et le vertige*, Paris, Gallimard, 1958, p. 131).

14. ". . . ruled by masks and possession, simulacra and dizziness, pantomime and ecstasy, in which collective life is held together by intensity" (Caillois, *Les Jeux et les Hommes*, p. 131).

15. ". . . presiding over the contract, precise, balanced, meticulous, conservative, a severe and mechanical guarantor of standards, laws, regularity, whose action is connected to the necessarily honest and conventional forms of the agon [. . .] by impartial application of the law" (Caillois, *Les Jeux et les Hommes*, p. 131).

16. Peter Sahlins, *Boundaries: The Making of France and Spain in the Pyrenees*, Berkeley, University of California Press, 1989, p. 288.

17. David A. Bell, *The Cult of the Nation in France: Inventing Nationalism 1680–1800*, Cambridge, Harvard University Press, 2001.

18. Georges Dumézil, in Caillois, *Les Jeux et les Hommes*, p. 155.

19. Braudel, *La Méditerranée*, vol. 2, p. 35.

20. Stein and Picasso, *Correspondance*, p. 34, letter of "early summer 1906," per the editor.

21. Camps and Portell, *Cartes de l'Escultor*, p. 150, letter of 27 June 1906.

22. This is the thesis of Jèssica Jaques Pi, "When Pablo Picasso was *Pau de Gósol* or the Birth of Cézanne's Grandson," *Ojo, le journal*, www.picasso.fr, June 2021.

23. Jaques Pi, *Picasso en Gósol*, pp. 68–69.

24. Jaques Pi, *Picasso en Gósol*, p. 105.

25. Braudel, *La Méditerranée*, vol. 2, pp. 153–54.

26. Gerard Bidegain (author, director), *L'Afinador*, with Laia Vidal, soprano, Jordi Vmos, baritone, Alicia Daufi, piano, 2018. My thanks to Laia Vidal for her help with this text.

15. SIXTY WORLD LEADERS VISITING THE BATEAU-LAVOIR

1. David Levering Lewis, *W.E.B. Du Bois: Biography of a Race*, New York, Henry Holt & Company, 1993, p. 247.

2. Later, they were permitted to attend the expositions in Atlanta (1895) and Nashville (1897), but since those events attracted only local audiences, the impact of the African-American presence was far less powerful than at the Exposition Universelle in Paris. See Eugene Provenzo Jr., *W.E.B. Du Bois's Exhibit of American Negroes: African Americans at the Beginning of the Twentieth Century*, Plymouth, Rowman and Littlefield, 2013; Jeremy I. Adelman and Kate Reed, *Earth Hunger: Global Integration and the Need for Strangers*, Princeton, Princeton University Press, 2021.

3. Lewis, *W.E.B. Du Bois*, p. 248.

4. Sarah Frioux-Salgas, "Paris 1900. Une autre Amérique à l'Exposition universelle," in Daniel Soutif (ed.), *The Color Line: Les artistes africains-américains et la ségrégation (1865–2016)*, exhibition catalog, Paris, Flammarion/Musée du Quai-Branly, 2016.

5. Lewis, *W.E.B. Du Bois*, p. 250.

6. By 2003, the centenary of its publication, the book had gone through more than 119 editions.

7. W.E.B. Du Bois, *The Souls of Black Folk*, Chicago, A. C. McClurg & Company, 1903; Boston, Bedford Books, 1998.

8. Pap Ndiaye, *La Condition noire: Essai sur une minorité française*, Paris, Gallimard, coll. "Folio Actuel," 2009, pp. 378–79.

9. Picasso could have sought to become a French citizen much earlier, but he didn't.

16. "PROFOUNDLY SCULPTURAL WORK!" . . . VINCENC KRAMÁŘ

1. "Vincenc Kramář, Notes on Picasso's exhibition at the Thannhauser Gallery, 1913," Transcription Leonard A. Lauder Research Center for Modern Art, The Metropolitan Museum of Art, New York, 2019. Copyright © The Metropolitan Museum of Art. https://www.metmuseum.org/art/librar ies-and-research-centers/leonard-lauder-research-center/research/digital -archives/kramar-project.

2. "Vincenc Kramář, Notes."

3. Claude Lévi-Strauss, "New York post-et préfiguratif," in *Le Regard éloigné*, Paris, Plon, 1983, p. 350.

4. François Hartog, *Régimes d'historicité: Presentisme et expériences du temps*, Seuil, coll. "Points," 2012, p. 22.

5. Arthur I. Miller, *Einstein, Picasso: Space, Time, and the Beauty That Causes Havoc*, New York, Basic Books, 2001.

6. André Malraux, *La Tête d'obsidienne*, in *Œuvres complètes*, vol. 3, Paris, Gallimard, 2010, p. 697.

7. "A Collector's Story, Leonard A. Lauder and Emily Braun in Conversation," in Emily Braun and Rebecca Rabinow, *Cubism: The Leonard A. Lauder Collection*, New Haven, The Metropolitan Museum/London, Yale University Press, 2015, pp. 2–19.

8. Wilhelm Heinrich Riehl, "Das landschaftliche Auge" [1850], in *Culturstudien aus drei Jahrhunderten*, Stuttgart, J. G. Cotta, 1859, p. 74.

9. Heinrich Wölfflin, *Kleine Schriften*, ed. J. Gantner, Bâle, Schwabe Verlag, 1946, p. 164.

10. Heinrich Wölfflin, *Autobiografie, Tagebücher und Briefe: 1864–1945*, ed. J. Gantner, Bâle, Schwabe Verlag, 1984.

11. Michel Espagne and Bénédicte Savoy (eds.), *Dictionnaire des historiens d'art allemands*, Paris, CNRS Éditions, 2010, p. 369.

12. Vincenc Kramář, *Le Cubisme*, Paris, École nationale supérieure des Beaux-Arts, 2002, p. xxiv.

13. Jana Claverie, Hélène Klein, Vojtěch Lahoda, and Olga Uhrová (eds.), *Vincenc Kramář: Un theoricien et collectionneur du cubisme à Prague*, exhibition catalog, Paris, RMN, 2002, p. 202, travel notes and letter of 24 September 1910.

14. Claverie et al., *Vincenc Kramář*, p. 203, letter of 8 October 1910.

15. Claverie et al., *Vincenc Kramář*, p. 208, set of travel notes.

16. Claverie et al., *Vincenc Kramář*, p. 207, letter of 1 May 1911.

17. "Friend Zuloaga, Could you show your Grecos to Mr. Kramář, who lives in Vienna, and who I want to introduce you to? He practically came to Paris just to see them [. . .]. Thank you, master, your friend Picasso, May 27, 1911" (Claverie et al., *Vincenc Kramář*, p. 208).

18. Claverie et al., *Vincenc Kramář*, p. 211, letter of 28 November 1911.
19. This refers to *Self-Portrait*, 1906, charcoal on paper.
20. Claverie et al., *Vincenc Kramář*, p. 211, travel notes, 1906–1909.
21. Claverie et al., *Vincenc Kramář*, p. 212, letters of 2 December 1911 and 30 November 1911.
22. Claverie et al., *Vincenc Kramář*, p. 217, letter of 27 April 1912.
23. Claverie et al., *Vincenc Kramář*, p. 218.
24. Claverie et al., *Vincenc Kramář*, p. 217, pamphlet of 30 April 1912 with the heading "Place Étoile Goudeau."
25. Claverie et al., *Vincenc Kramář*, p. 220.
26. Claverie et al., *Vincenc Kramář*, p. 220.
27. Claverie et al., *Vincenc Kramář*, p. 225, letter of 5 December 1912.
28. In his masterly *Picasso*, Philippe Dagen recalls Thannhauser's preface to the exhibition catalog: "It is often thought that Picasso's work is at the origin of all the expressionist, cubist, and futurist movements. In fact, Picasso has nothing to do with any of them, other than providing the first artistic impulse, and he does not wish any further connection with them," *Picasso*, Paris, Hazan, 2008, p. 189.

17. THE MYSTERY OF 28 RUE VIGNON . . . DANIEL-HENRY KAHNWEILER

1. Kahnweiler and Crémieux, *Mes galeries et mes peintres*, p. 46.
2. Kahnweiler and Crémieux, *Mes galeries et mes peintres*, p. 46.
3. Kahnweiler and Crémieux, *Mes galeries et mes peintres*, p. 48.
4. Kahnweiler and Crémieux, *Mes galeries et mes peintres*, p. 46.
5. Kahnweiler and Crémieux, *Mes galeries et mes peintres*, p. 46.
6. Kahnweiler and Crémieux, *Mes galeries et mes peintres*, p. 49.
7. Brassaï, *Conversations avec Picasso* [1964], Paris, Gallimard, 1997, p. 81.
8. Kahnweiler and Crémieux, *Mes galeries et mes peintres*, pp. 49–50.
9. His nickname in the art world.
10. The merchant, who had given Picasso his first exhibition in 1901 and then regularly bought his work, did not follow him when he developed a more avant-garde approach.
11. Kahnweiler and Crémieux, *Mes galeries et mes peintres*, p. 51.
12. Béatrice Joyeux-Prunel, "La construction internationale de l'aura de Picasso avant 1914: Expositions différenciées et processus mimétiques," presented at the symposium "Revoir Picasso," Musée national Picasso-Paris, 25–28 March 2015.
13. A term borrowed from gallery owner Leo Castelli, whose reticular organization would resemble Kahnweiler's. However, the connections between Kahnweiler and his international collaborators are in fact quite opaque. A precise reading of their correspondence suggests a system similar to a consignment store, at the center of which Kahnweiler would choose the works to be displayed and sold, setting a low price—which he would receive—and to which the foreign gallery would add its "commission." If the work wasn't sold, Kahnweiler would retain ownership of it and could demand its return at any moment. After initially relying on his regular clients and friends who, by collecting Picasso's paintings, participated in the artist's international promotion, in 1910 the merchant put in place a distribution system based

on loans and sales through the intermediary of other gallery owners whom he called his "representatives" or his "correspondents" (Alfred Flechtheim in Düsseldorf, but also in Berlin, Frankfurt, Cologne, Vienna; Heinrich Thannhauser in Munich; Brenner at the Washington Square Gallery in New York).

14. Pierre Assouline, *L'homme de l'art: D. H. Kahnweiler (1884–1979)*, Paris, Gallimard, coll. "Folio," 1988, p. 88.

15. Kahnweiler and Crémieux, *Mes galeries et mes peintres*, pp. 27–28.

16. Kahnweiler and Crémieux, *Mes galeries et mes peintres*, pp. 24–25.

17. Karl Benz, automobile patent (1886); Robert Bosch, founded Bosch in 1886; Gottlieb Daimler, inventor of the gas engine for automobiles (1887), Daimler Motoren Gesellschaft; Wilhelm Maybach, "King of Designers 1890."

18. Enzo Traverso, *Les Juifs et l'Allemagne: De la "symbiose judéo-allemande" à la mémoire d'Auschwitz*, Paris, La Découverte, 1992, p. 32.

19. Werner Spies, "Vendre des tableaux—donner à lire," in Isabelle Monod-Fontaine and Claude Laugier (eds.), *Daniel-Henry Kahnweiler: Marchand, éditeur, écrivain*, Paris, Éditions du Centre Pompidou., 1984, p. 18, letter from Daniel-Henry Kahnweiler to Michel Leiris, 19 March 1932.

20. Walter Benjamin and Gershom Scholem, *Walter Benjamin, Gershom Scholem: Théologie et utopie. Correspondance (1933–1940)*, ed. S. Mosès, Paris, Éditions de l'Éclat, 2010, p. 294, letter from Gershom Scholem to Walter Benjamin, 30 June 1939.

21. Kahnweiler and Crémieux, *Mes galeries et mes peintres*, p. 28.

22. George L. Mosse, *Confronting History: A Memoir*, Madison, The University of Wisconsin Press, 2000, p. 17.

23. In the towns and villages of Rockenhausen, Mannheim, Stuttgart, Nussloch, Ansbach, and Fürth.

24. Kahnweiler and Crémieux, *Mes galeries et mes peintres*, pp. 26–27.

25. Kahnweiler and Crémieux, *Mes galeries et mes peintres*, p. 33.

26. Espagne and Savoy, *Dictionnaire des historiens*, p. x.

27. Christophe Charle, "Introduction," in Christophe Charle and Daniel Roche (eds.), *Capitales culturelles, capitales symboliques: Paris et les expériences européennes (XVIIIe–XXe siècles)*, Paris, Publications de la Sorbonne, 2002, p. 18.

28. "Born Jewish, a Hamburger at heart, with the mind of a Florentine." See the long entry on Warburg in Espagne and Savoy, *Dictionnaire des historiens*, pp. 352–56.

29. Kahnweiler and Crémieux, *Mes galeries et mes peintres*, p. 31.

30. Kahnweiler's understated account of his own rise can be compared to the much more detailed and eulogistic account offered by Yve-Alain Bois: "The important thing was that [Kahnweiler] had a theory, unlike his French colleagues [. . .]. By combining the formalism of a Fiedler or an Einstein and the historical concepts of a Simmel or a Riegl, Kahnweiler effectively became the only critic, until the 1958 publication of Clement Greenberg's essay on the papiers collés, to understand anything at all about the evolution of cubism" (Yve-Alain Bois, "La leçon de Kahnweiler," in *La Peinture comme modèle*, Dijon, Mamco/Geneva, Les Presses du réel, 2017, pp. 142, 143).

31. Kahnweiler and Crémieux, *Mes galeries et mes peintres*, pp. 41–42.

32. Kahnweiler and Crémieux, *Mes galeries et mes peintres*, pp. 41–42.

18. RETURN TO THE BATEAU-LAVOIR

1. Olivier, *Picasso et ses amis*, p. 195.
2. Bouhey, *Anarchistes contre la République*, p. 350.
3. Berlière, "Les brigades du Tigre," pp. 311–23; see also his "Ordre et sécurité: Les nouveaux corps de police de la Troisième République," *Vingtième siècle: Revue d'histoire*, no. 39, 1993, pp. 23–37, as well as Vigier, *Maintien de l'ordre*, and more specifically Dhavernas, "Surveillance des anarchistes," pp. 347–60.
4. Berlière, "Les brigades du Tigre," p. 315.
5. MnPP, Picasso personal archives, 515AP/C/dossier réservé/26 March 1907.
6. MnPP, Picasso personal archives, 515AP/C/dossier réservé/10 December 1908.
7. Jacqueline Stallano, "Une relation encombrante: Géry Piéret," in Michel Décaudin (ed.), *Amis européens d'Apollinaire*, Paris, Presses de la Sorbonne Nouvelle, 1995, pp. 14–15, undated letter from Paris, Wednesday.
8. Stallano, "Une relation encombrante." p. 17, letter of 4 April 1907.
9. Olivier, *Souvenirs intimes*, p. 248.
10. Olivier, *Souvenirs intimes*, p. 248.
11. Olivier, *Picasso et ses amis*, p. 194.
12. *Le Petit Journal*, 9 September 1911, p. 2.
13. Olivier, *Picasso et ses amis*, p. 196.
14. PPP, dossiers de naturalisation d'étrangers célèbres, IC 5.
15. MnPP, Picasso personal archives, 515AP/C/dossier réservé/10 July 1909.
16. Stein and Picasso, *Correspondance*, p. 70.
17. MnPP, Picasso personal archives, 515AP/C/dossier réservé/1909.
18. Fernande Olivier, "L'atelier du boulevard de Clichy," *Le Mercure de France*, 15 July 1931, p. 355.

19. A DUET OF REVOLUTIONARY VIRTUOSOS . . . PICASSO AND BRAQUE, BRAQUE AND PICASSO

1. Roland Penrose, *Picasso*, Paris, Flammarion, 1996, p. 273.
2. Brigitte Léal (ed.), *Dictionnaire du cubisme*, Paris, Robert Laffont, 2018, p. 102.
3. Kahnweiler and Crémieux, *Mes galeries et mes peintres*, p. 59.
4. MnPP, Picasso personal archives, 515AP/C/17; and Daix, *Nouveau Dictionnaire Picasso*, p. 121.
5. Stein, *Alice B. Toklas*, p. 29.
6. *Donation Louise et Michel Leiris: Collection Kahnweiler-Leiris*, Paris, Éditions du Centre Pompidou, 1984, p. 168, letter from Picasso to Daniel-Henry Kahnweiler, 12 June 1912.
7. André Salmon, "Histoire anecdotique du cubisme," in *La Jeune Peinture française*, Paris, La Société des Trente, 1912, p. 56.
8. William Rubin, *Picasso and Braque: Pioneering Cubism*, exhibition catalog, New York, MoMA, 1989.
9. Olivier, *Picasso et ses amis*, p. 120.
10. *The Terrace at the Mistral Hotel* (1907), *Trees in l'Estaque* (summer 1908), and others.
11. "Picasso made a number of paintings deeply influenced by Cézanne, and, between 1908 and 1909, it was almost impossible to distinguish to what

extent Braque or Picasso was responsible for the change," stated Rubin in 1996. "The most extraordinary aspect of this business was that elements such as Africanism—in other words, the type of tribal art that Picasso brought to cubism—on the one hand, and Cézanne on the other, could have seemed completely impossible to mix. And yet the two melted together in a way in the crucible of the 1908 paintings, one of the most remarkable episodes in the history of early cubism" (William Rubin, from a 1996 speech, in Pierre Daix, *Braque avec Picasso*, Paris, RMN, 2013, p. 18).

12. The expression is from Daniel-Henry Kahnweiler; see Léal, *Dictionnaire du cubisme*, p. 103.

13. For Yve-Alain Bois, the explosion of the homogeneous form was a strategy to avoid "the spectre of abstraction" (Bois, "La leçon de Kahnweiler," in *La Peinture comme modèle*, pp. 135–82; Yve-Alain Bois, "Picasso et l'abstraction," in the records of the symposium "Revoir Picasso," Paris, Musée national Picasso-Paris, 27 March 2015, pp. 1–6).

14. Léal, *Dictionnaire du cubisme*, p. 103.

15. Penrose, *Picasso*, p. 273.

16. Jean-Claude Lebensztejn, "Périodes," in Pierre Daix (ed.), *Picasso cubiste*, Paris, Flammarion/RMN, 2007, p. 43.

17. Rubin, *Picasso and Braque*.

18. Guillaume Apollinaire, "Je dis tout," 19 October 1907, in Daix, *Nouveau Dictionnaire Picasso*, p. 123.

19. Étienne-Alain Hubert, "Braque, Apollinaire, Reverdy," in Brigitte Léal (ed.), *Georges Braque (1882–1963)*, Paris, RMN/Éditions du Centre Pompidou, 2013, pp. 96–105.

20. In an undated letter probably written in 1936, Cassou wrote to Picasso: "I am leaving for Zurich, but on Monday I will drop by to see you at Rue des Grands-Augustins so that we can have a chat and you can tell me what's on your mind. Never forget that right now at the Beaux-Arts, thanks to Georges Huisman, the attitude toward modern painting has completely changed, and that you have not only admirers there, but friends, too. Everything will be done in full agreement with you." MnPP, Picasso personal archives, 515AP/C/22 [??] 1936.

21. Jean Paulhan, *Braque le patron*, Paris, Gallimard, 1952, pp. 126–27.

22. André Malraux, "Funérailles de Georges Braque," in *Œuvres complètes*, vol. 3, *Oraisons funèbres*, Paris, Gallimard, coll. "Bibliothèque de la Pléiade," 1996, p. 935.

23. Malraux, "Funérailles de Georges Braque," p. 935.

24. Daix, *Picasso cubiste*, pp. 26, 27.

25. Léal, *Georges Braque*, p. 13.

26. Lara Marlowe, "Braque Is Back: French Cubist Finally Escapes Picasso," *Irish Times*, 11 November 2013.

27. Brigitte Léal, "Introduction," in Brigitte Léal, Christian Briend, and Ariane Coulondre (eds.), *Le Cubisme*, exhibition catalog, Paris, Musée national d'art moderne/Éditions du Centre Pompidou, 2018, p. 14.

28. Françoise Gilot and Carlton Lake, *Vivre avec Picasso*, Paris, Calmann-Lévy, 1964, pp. 68–69.

29. Kahnweiler and Crémieux, *Mes galeries et mes peintres*.

20. "A BOTANIST [LOOKING] AT THE FLORA OF AN UNKNOWN LAND" . . . LEO STEIN

1. Leo Stein, *Appreciation: Painting, Poetry and Prose*, Lincoln, University of Nebraska Press, 1996.
2. Leo Stein, *Journey into the Self: Being the Letters, Papers and Journals of Leo Stein*, ed. E. Fuller, New York, Crown Publishers, 1950, p. 203.
3. Stein, *Appreciation*, p. 143.
4. Stein, *Appreciation*, p. 157.
5. Potter et al., *Four Americans in Paris*, p. 21, letter to Mabel Weeks, 2 December 1900.
6. Stein, *Appreciation*, p. 188.
7. Stein and Picasso, *Correspondance*, p. 63.
8. Stein and Picasso, *Correspondance*, p. 54.
9. Stein and Picasso, *Correspondance*, p. 62.
10. Stein and Picasso, *Correspondance*, pp. 64–65.
11. Brigitte Léal, "Les carnets des *Demoiselles d'Avignon*," in Brigitte Léal (ed.), *Carnets: Catalogue de dessins*, Paris, RMN, 1996, vol. 1, p. 110.
12. Apparently it was acquired in 1907 and immediately dismembered (see Brigitte Léal, "Carnets," in Hélène Seckel [ed.], *Les Demoiselles d'Avignon*, Paris, Musée national Picasso-Paris/RMN, 1988, bk. III, vol. 1, p. 103).
13. Malraux, *La Tête d'obsidienne*, p. 697.
14. Stein and Picasso, *Correspondance*, p. 62, letter of 13 September 1908.
15. Stein and Picasso, *Correspondance*, p. 69, letter of 26 May 1909.
16. Stein and Picasso, *Correspondance*, p. 77, letter of 5 or 12 August 1909.
17. Stein and Picasso, *Correspondance*, p. 79, letter of mid-August 1909.
18. Stein and Picasso, *Correspondance*, pp. 81–82, letter of 13 September 1909.
19. Stein and Picasso, *Correspondance*, p. 90.
20. Stein, *Appreciation*, p. 187.
21. Stein, *Appreciation*, p. 157.
22. Annie Cohen-Solal, *"Un jour, ils auront des peintres"*: *L'avènement des peintres américains (Paris 1867–New York 1948)*, Paris, Gallimard, 2000, pp. 313–31.
23. Arthur B. Carles, John Marin, Max Weber, Marsden Hartley, Alfred Maurer, Abraham Walkowitz, Andrew Dasburg, Morgan Russell, Arthur Lee, Arthur Dove, Stanton MacDonald Wright, and Patrick Henry Bruce were all members of this circle.
24. Rebecca Rabinow, "Les Stein à la découverte de l'art modern: Les premières années à Paris, 1903–1907," in Cécile Debray, Janet Bishop, Gary Tinterow, and Rebecca Rabinow (eds.), *Matisse, Cézanne, Picasso: L'aventure des Stein*, exhibition catalog, Paris, RMN/Grand Palais, 2011, p. 62.
25. Paula Modersohn-Becker, *Briefe und Aufzeichnungen*, ed. B. Jahn, new edition, Leipzig/Weimar, G. Kiepenheuer, 1982, letter from Paula Modersohn-Becker to her husband, the painter Otto Modersohn, 27 February 1906.
26. Emily D. Bilski and Emily Braun, "Introduction," in Emily D. Bilski and Emily Braun (eds.), *Jewish Women and Their Salons: The Power of Conversation*, exhibition catalog, New York, Yale University Press, 2005.
27. Max Weber, *The Matisse Class*, Washington/New York, Archives of American Art (AAA), Smithsonian Institution, Max Weber Papers.

28. Mabel Dodge Luhan, *Intimate Memories*, vol. 1, *European Experiences*, New York, Harcourt, Brace, 1935, pp. 321–22.
29. Apollinaire, *Chroniques d'art*, p. 42.
30. Stein, *Appreciation*, p. 170.
31. Andrew Dasburg Papers, Archives of American Art (AAA), Smithsonian Institution, Washington/New York, interview of Andrew Dasburg.
32. Marsden Hartley Papers, Archives of American Art (AAA), Smithsonian Institution, Washington/New York, letter of 22 September 1912.
33. Seckel, *Les Demoiselles d'Avignon*, p. 560, letter of 28 December 1908.

21. "AS PERFECT AS A BACH FUGUE" . . . ALFRED STIEGLITZ

1. Sarah Greenough and Charles Bock, *Modern Art and America: Alfred Stieglitz and His New York Galleries*, Washington, National Gallery of Art, 2000, p. 118, letter from Alfred Stieglitz to Arthur Jerome Eddy, 10 November 1913.
2. Cohen-Solal, "Le va-et-vient transatlantique des photographes," in *"Un jour, ils auront des peintres"*, (II, 12), p. 341.
3. Pictorialist photography developed between 1888 and 1914 as the medium's technical difficulties were gradually mastered. The members of this movement, essentially amateurs who formed clubs, attempted to gain recognition for photography as an artistic discipline in its own right, on the same level as painting, toward which they tried to move closer—whether through framing and composition or through retouching the negative or the print. Pictorialist theorists included Heinrich Kühn in Germany and Constant Puyo and Robert Demachy in France.
4. In reaction to the Künstlerhaus—the society of Austrian artists then monopolizing the art world and its market—a group of young artists centered around Gustav Klimt (1862–1918) founded the Vereinigung Bildender Künstler Sezession in 1897 to open up the local scene to the latest European trends, particularly art nouveau.
5. Alfred Stieglitz, *Camera Work: The Complete Illustrations (1903–1917)*, Cologne/New York, Taschen, 1997, pp. 63–64.
6. Nathan Lyons, *Photographers on Photography: A Critical Anthology*, Englewood Cliffs, Prentice Hall, 1966, p. 120.
7. Greenough and Bock, *Modern Art and America*, p. 117.
8. Richard Whelan, *Alfred Stieglitz: A Biography*, New York, Little, Brown and Company, 1995, p. 255; Greenough and Bock, *Modern Art and America*, p. 118.
9. Espagne and Savoy, *Dictionnaire des historiens*, pp. 81–89, 363–72.
10. Espagne and Savoy, *Dictionnaire des historiens*, p. 118.
11. Gelett Burgess, "The Wild Men of Paris," *The Architectural Record*, no. 27, January–June 1910, pp. 407–408.
12. Burgess, "The Wild Men of Paris," pp. 407–408.
13. Only nine of which would be completed. See Brigitte Léal, "Hamilton Easter Field," in Léal, *Dictionnaire du cubisme*, p. 290.
14. Marius de Zayas, "The New Art in Paris," *Camera Work*, no. 34–35, April–July 1911.
15. Greenough and Bock, *Modern Art and America*, p. 118, letter of 28 October 1910.

16. Greenough and Bock, *Modern Art and America*, p. 147, letter of 28 October 1910.

17. Greenough and Bock, *Modern Art and America*, p. 146, letter of 22 July 1911.

18. Greenough and Bock, *Modern Art and America*, letter from Edward Steichen to Alfred Stieglitz, January or February 1911.

19. Marius de Zayas, "Picasso" (1911), in Stieglitz, *Camera Work*, pp. 677–79.

20. J. Edgar Chamberlin, *Evening Mail*, 1911, in Greenough and Bock, *Modern Art and America*, p. 122.

21. Greenough and Bock, *Modern Art and America*, p. 123, letter from Alfred Stieglitz to Marius de Zayas, 4 April 1911.

22. Greenough and Bock, *Modern Art and America*, letter from Marius de Zayas to Alfred Stieglitz.

23. Greenough and Bock, *Modern Art and America*, p. 499, letter from Alfred Stieglitz to Edward Alden Jewell, December 1939.

24. Greenough and Bock, *Modern Art and America*, p. 124, letter from Alfred Stieglitz to Sadakichi Hartmann, 22 December 1911.

25. Greenough and Bock, *Modern Art and America*, letter from Alfred Stieglitz to Heinrich Kuhn, 14 October 1912.

26. *"The fire escape,"* Greenough and Bock, *Modern Art and America*, letter from Alfred Stieglitz to Heinrich Kuhn, 14 October 1912.

27. Greenough and Bock, *Modern Art and America*, letter from Alfred Stieglitz to Arthur Jerome Eddy, 10 November 1913.

28. Archives du Musée d'Orsay (AMO), fonds Paul Burty Haviland, letter of 6 August 1911.

29. On the conditions in which the Armory Show was organized, see Cohen-Solal, "Un vent glacial venu de l'est," in *"Un jour, ils auront des peintres"* (III, 2), pp. 364–77.

22. "KNEE TO KNEE," PORTRAIT TO PORTRAIT . . . GERTRUDE STEIN

1. Gertrude Stein, *Everybody's Autobiography*, Cambridge, Exact Change, 1993.

2. Stein, *Journey into the Self*, p. 148, letter of 20 October 1930.

3. Stein, *Journey into the Self*, p. 134, letter to Mabel Weeks, December 1933.

4. MnPP, Picasso personal archives, 515AP/C/164/1 August 1910.

5. MnPP, Picasso personal archives, 515AP/C/164/18 July 1909.

6. MnPP, Picasso personal archives, 515AP/C/164/1 August 1911.

7. Stein and Picasso, *Correspondance*, p. 18.

8. Stein, *Alice B. Toklas*, p. 79.

9. Stein, *Alice B. Toklas*, p. 53.

10. Stein, *Alice B. Toklas*, p. 53.

11. Stein, *Alice B. Toklas*, p. 85.

12. Gertrude Stein, *Everybody's Autobiography*, Cambridge, Exact Change, 1993, p. 21.

13. Ulrich Gineiger: "Ein Weltroman wurzelt in Franken," *MainPost*, 17–18 January 1987; and Rudolf Ganz: *The German Jewish Mass Emigration, 1720–1880*, American Jewish Archives, Clifton Ave, Cincinnati, Ohio, 45220, https://www.alemannia-judaica.de/images/Images%20430/Weickersgrueben%20Weltroman.pdf.

14. Gertrude Stein, *The Making of Americans: Being a History of a Family's Progress*, Normal, Illinois, Dalkey Archive Press, 1996, pp. 46–47.
15. Stein, *Alice B. Toklas*, p. 100.
16. "Americans," so Gertrude Stein says, "are like Spaniards, they are abstract and cruel. They are not brutal they are cruel. They have no close contact with the earth such as most Europeans have. Their materialism is not the materialism of existence, of possession, it is the materialism of action and abstraction. And so Cubism is Spanish." *The Autobiography of Alice B. Toklas*, New York, Random House, 2000, p. 81.
17. Claudine Grammont, "Matisse comme religion: Les 'Mike Stein' et Matisse, 1908–1918," in Debray et al., *Matisse, Cézanne, Picasso*, p. 216.
18. Laurence Madeline, "Le peintre et ses mécènes," in Stein and Picasso, *Correspondance*, p. 26.
19. Gertrude Stein, "Picasso," *Camera Work*, no. 34–35, 1912, in Stieglitz, *Camera Work*, pp. 665–66.
20. Stein, "Picasso," p. 109.
21. Stein, "Picasso," p. 112.
22. Stein, *Everybody's Autobiography*, p. 21.
23. Georges Braque, Eugene Jolas, Maria Jolas, Henri Matisse, André Salmon, and Tristan Tzara, "Testimony Against Gertrude Stein," *Transition*, 23 February 1935, pp. 13–14.

23. "ONLY PARIS WAS OUR COUNTRY" . . . RUPF, UHDE, HESSEL, AND EVEN DUTILLEUL!

1. Franz Hessel, *Romance parisienne: Les papiers d'un disparu*, Paris, Maren Sell, 1990.
2. Grammont, "Matisse comme religion," p. 219.
3. Grammont, "Matisse comme religion," pp. 219, 223.
4. Grammont, "Matisse comme religion," p. 223.
5. Stein, *Alice B. Toklas*, p. 64.
6. Grammont, "Matisse comme religion," p. 223.
7. Hessel, *Romance parisienne*, pp. 24–25, 30.
8. Wilhelm Uhde, *De Bismarck à Picasso*, Paris, Éditions du Linteau, 2002.
9. Uhde, *De Bismarck à Picasso*, p. 152.
10. Julius Meier-Graefe, *Spanische Reise*, Berlin, Rowohlt Verlag, 1910. See Espagne and Savoy, *Dictionnaire des historiens*, pp. 146–47.
11. Meier-Graefe, *Spanische Reise*, in Espagne and Savoy, *Dictionnaire des historiens*, p. 141.
12. Edward Fry, *Le Cubisme*, Bruxelles, La Connaissance, 1968, p. 51.
13. Jeffrey Weiss, *The Popular Culture of Modern Art: Picasso, Duchamp, and Avantgardism*, London/New Haven, Yale University Press, 1994, pp. 52–53.
14. Alphonse Roux, "Propos d'Art—Le Salon d'Automne," *La Renaissance contemporaine*, 10 November 1911, p. 1302.
15. Michel Espagne, *Le Paradigme de l'étranger: Les chaires de littérature étrangère au XIXe siècle*, Paris, Cerf, 1993, p. 8.
16. Bois, "La leçon de Kahnweiler," in *La Peinture comme modele*, pp. 142–43.
17. Espagne, *Paradigme de l'étranger*, p. 14.

18. Jeanine Warnod, "Dutilleul, un amateur de génie," *Le Figaro*, 25 October 1979.

19. Daniel-Henry Kahnweiler, in Jean Grenier, "Un collectionneur pionnier," *L'Œil*, no. 15, 1956, pp. 40–44.

20. Corinne Barbant, "Pour l'amour de la peinture moderne, portrait de Roger Dutilleul en lecteur," in Jeanne-Bathilde Lacourt, Corinne Barbant, and Pauline Creteur (eds.), *Picasso, Léger, Masson. Daniel-Henry Kahnweiler et ses peintres*, Villeneuve-d'Ascq, LaM, 2013, p. 103.

21. Barbant, "Pour l'amour," p. 104.

22. This expression was coined by Laurence Bertrand Dorléac, in "L'École de Paris, suite," *L'École de Paris 1904–1929: La part de l'Autre*, exhibition catalog, Paris, Musée d'Art moderne de la Ville de Paris, pp. 148–57. This article provides a detailed, three-step analysis of the motivations behind the "School of Paris" name, coined in turn by the critic André Warnod: on January 4, 1925, in the magazine *Comoedia*, he wrote that it was intended to "champion living French art against the Académie and official art"; on January 27, in the same publication, he added that it would include foreign artists "alongside French artists [. . .] even if it is very difficult to be sure about what the foreigners borrow from us and what we borrow from them," while reaffirming "the supremacy of French art and France's position as the center of the world"; in October of the same year, in his book *Les Berceaux de la jeune peinture: Montmartre, Monparnasse*, Warnod created a portrait of this group based on the topography of the city. The name "School of Paris," used by others, would evolve through the waves of xenophobia that marked the 1930s. "In reality," Bertrand Dorléac states, "the apparently generous baptism by André Warnod of the School of Paris was already undermined by a desire to sort the wheat from the chaff: good foreigners from bad, and the 'other' from the French."

23. André Warnod, *Les Berceaux de la jeune peinture: Montmartre, Montparnasse*, Paris, Albin Michel, 1925.

24. Archives of American Art, Smithsonian Institution, Washington/New York, Walter Pach Papers.

25. Gino Severini, *Tutta la vita di un pittore*, Milan, Garzanti, 1946, pp. 53–54.

26. Marina Burnel, "Picasso et Bergson, du savoir au savoir-faire," *Ojo, le journal*, no. 38, November 2020: https://www.picasso.fr/ojo-les-archives -novembre-2015-ojo-31.

27. Giovanni Papini, "Enrico Bergson" (1911), in Giovanni Papini, *24 cervelli*, Milan, Facchi Editore, 1919, pp. 285–95.

28. Giovanni Papini, "Enrico Bergson" (1911), in Giovanni Papini, *24 cervelli*, Milan, Facchi Editore, 1919, pp. 285–95.

29. For a more detailed analysis, see also Gino Severini, "L'action de Picasso sur l'art," *Nova and Vetera*, 1931, pp. 125–30; and Gino Severini, *Ragionamenti sulle Arti figurative*, Milan, no publisher, chapter 19, 1942.

30. Monod-Fontaine and Laugier, *Daniel-Henry Kahnweiler*, p. 27.

24. A DUET OF REVOLUTIONARY VIRTUOSOS . . . PICASSO AND BRAQUE, BRAQUE AND PICASSO

1. "Conversations avec Picasso, 1959, *25 rue La Boétie, 5 fevrier 1933*," in Marie-Laure Bernadac and Androula Michaël, *Propos sur l'art*, Paris, Gallimard, p. 90.

2. In contrast to the previous period, which he would later describe as a time of "painting," "well-made pictures" with "charm"; see "Entretiens avec Picasso au sujet des *Femmes d'Alger, 1955*," *Aujourd'hui*, no. 4, September 1955, cited in Bernadac and Michaël, *Propos sur l'art*, p. 73.

3. Isabelle Monod-Fontaine, cited in Léal, *Georges Braque*, p. 76.

4. A correspondence already cited in William Rubin, "Picasso and Braque: An Introduction," in *Picasso and Braque*, and notably "The Surviving Correspondence," in *Picasso and Braque*, pp. 47–51. But returning to the original archives enabled me to gain a completely new view of the interaction between the two artists.

5. MnPP, Picasso personal archives, 515AP/C/17/undated.

6. MnPP, Picasso personal archives, 515AP/C/17, 1912.

7. Penrose, *Picasso*, p. 205.

8. According to the brand's website, "it was a Dutch chemist [. . .] who in 1888 invented a linseed oil paint that dried quickly; ten years later, it was bought by a French company, and the artist Eugène Vavasseur designed a poster representing three house painters that was so successful it quickly became part of advertising history. The product grew so popular that in 1907 its name entered the dictionary. Ripoliner became a verb, and ripolin a common name for the action of applying enamel paint."

9. The Italian etymology, *ciarlatano*, is derived from the adjective given to the inhabitants of an Umbrian village, Cerreto di Spoleto, who, during the Middle Ages, achieved economic prosperity through shrewd and sometimes abusive methods; so, *charlatan* describes "a man who profits from the credulity of others to sell a worthless product."

10. Kahnweiler and Crémieux, *Mes galeries et mes peintres*, p. 60.

11. Jean-Paul Sartre, *Les Mots*, Paris, Gallimard, coll. "Folio," 1964, pp. 98–104.

12. Jennifer Wild, *The Parisian Avant-garde and the Age of Cinema: 1900–1923*, Oakland, University of California Press, 2015, "Seeing through Cinema: Projection in the Age of Cubism," pp. 22–28.

13. In Spanish, *ojo* means eye, but also, by extension, "watch out." It is common for Spaniards to make notes, often drawings, similar to those of Picasso. They will sometimes accompany the sketch with a play on words: *ojo con los ojos* (use your eyes to watch out). This ordinary gesture is nonetheless a sign of proximity and affection, even complicity, toward the addressee. Even today, grandmothers continue to leave such messages for their grandchildren.

14. *Donation Louise et Michel Leiris*, p. 166.

15. *Donation Louise et Michel Leiris*, p. 165.

16. *Donation Louise et Michel Leiris*, p. 169.

17. See the text of Ariane Coulondre in Léal, Briend, and Coulondre, *Le Cubisme*, pp. 78–79.

18. Quoted in the documentary chronology of Judith Cousins in William Rubin, *Picasso and Braque*, p. 379.

19. *Donation Louise et Michel Leiris*, p. 26.

20. Daix, "Papiers collés," *Nouveau Dictionnaire Picasso*, p. 660.

21. Daix, "Braque," *Nouveau Dictionnaire Picasso*, p. 130.

22. Rubin, *Picasso and Braque*, p. 407.

23. Émilie Bouvard, "Les chefs-d'oeuvre de Picasso," in Émilie Bouvard and

Coline Zellal (eds.), *Picasso: Chefs-d'oeuvre!*, Paris, Musée national Picasso-Paris/Gallimard, 2018, pp. 12–13.

24. Daix, *Nouveau Dictionnaire Picasso*, p. 130.
25. Kahnweiler and Crémieux, *Mes galeries et mes peintres*, p. 60.
26. Bernard Zarca, *L'Artisanat français: Du métier traditionnel au groupe social*, Paris, Economica, 1986, p. 124.
27. http://extranet.intercariforef.org/previous/peintre-decorateurtrice-en-batiment/artemisia-formation/formation-14_AF_0000002318_SE_0000430372.html.
28. Uhde, *De Bismarck à Picasso*, p. 227.
29. Hélène Seckel in Daix, *Nouveau Dictionnaire Picasso*, p. 124.
30. Malraux, *La Tête d'obsidienne*, pp. 18–19.

25. 28 RUE VIGNON, A DISTINCTLY SUBVERSIVE GALLERY

1. Kahnweiler and Crémieux, *Mes galeries et mes peintres*, p. 31.
2. Daniel-Henry Kahnweiler, *Les Années héroïques du cubisme*, Paris, Éditions Braun & Cie, 1950 (unpaginated).
3. Pierre Assouline, *Daniel-Henry Kahnweiler: L'homme de l'art*, Paris, Gallimard, coll. "Folio," 1988, p. 184.
4. My thanks to Isabelle Monod-Fontaine for her analysis of the contract.
5. Spies, "Vendre des tableaux," pp. 21–24.
6. Kahnweiler and Crémieux, *Mes galeries et mes peintres*, p. 31.
7. Spies, "Vendre des tableaux," p. 24.
8. Daniel-Henry Kahnweiler, "L'État et les arts plastiques" [1916], in Spies, "Vendre des tableaux," pp. 17–44.
9. Others included Konrad Fiedler, Heinrich Wölfflin, Aloïs Riegl, and Wilhelm Worringer.
10. The precise date of Carl Einstein's arrival in Paris is not known. According to Liliane Meffre, 1905 is the most probable date: "If we put our faith in the rare mentions that we possess, those by Kahnweiler in his book *Juan Gris* (Gallimard, 1946) and the less reliable memories of Einstein himself in *Kleine Autobiographie*, one may suppose that it was in 1905 that Einstein journeyed to Paris for the first time. Kahnweiler writes: 'Carl Einstein came back to France after the war in Spain, in which he took part. We saw each other quite often: we have been friends for thirty-five years'" (Liliane Meffre, *Carl Einstein [1885–1940]: Itinéraire d'une pensée moderne*, Paris, Presses de l'université Paris-Sorbonne, 2002, pp. 37–38).
11. Carl Einstein, *Georges Braque*, Paris, Éditions des Chroniques du Jour, 1934, p. 15.
12. In *L'Art du XXe siècle* (1926), according to Isabelle Kalinowski and Maria Stavrinaki, Carl Einstein "would exalt Picasso and his art of metamorphosis, [. . .] in a ceaseless struggle between the passive, fluid principle of hallucination and the active, constructive principle of tectonics." And he would rejoice that "the ancient 'tragic' sense," which had disappeared from "modern, secularized society, is resurgent in an artistic form, in the painting of Picasso" (Isabelle Kalinowski and Maria Stavrinaki, *Carl Einstein et les primitivismes*, Paris, Musée du Quai-Branly, 2011).
13. Carl Einstein, *L'Art du XXe siècle*, text published in German in 1926, quoted

and translated by Liliane Meffre (*Carl Einstein*), after the reworked 1931 edition, Berlin, Propyläen, p. 70.

14. Carl Einstein, "Picasso," *Documents*, no. 3, 1930, p. 156, note 93.

15. Carl Einstein and Daniel-Henry Kahnweiler, *Correspondance (1921–1939)*, Marseille, André Dimanche Éditeur, 1993, p. 48.

16. Even if the latter rejected his thesis.

17. Dieter Hornig, "Max Raphael: théorie de la création et production visuelle," *Revue germanique internationale*, no. 2, 1994, pp. 165–78.

18. François Roth, *La Guerre de 1870*, Paris, Fayard, coll. "Pluriel," 2019, p. 617.

19. *Journal officiel*, 5 December 1912.

20. Béatrice Joyeux-Prunel, "L'art de la mesure: Le Salon d'automne (1903–1914), l'avant-garde, ses étrangers et la nation française," *Histoire & Mesure*, vol. 22, no. 1, 2007, http://journals.openedition.org/histoiremesure/2333.

21. "Le Salon d'automne est un scandale," *Le Matin*, 5 October 1912, and *Le Mercure de France*, 16 October 1912.

22. Louis Vauxcelles, "M. Frantz Jourdain et le 'salon d'Automne,'" *Gil Blas*, 9 October 1912.

23. Pierre Mortier, in *Gil Blas*, 1912.

24. Vauxcelles, "M. Frantz Jourdain et le 'salon d'Automne,'" *Gil Blas*, 9 October 1912.

25. *Gil Blas*, 21 October 1912.

26. CHARLATAN OR GENIUS? PICASSO ALL OVER THE PLACE

1. Nicolai Berdyaev, "Picasso," in *Sophiya*, 1914, no. 3, pp. 57–62, translated by Fr. S. Janos, http://www.berdyaev.com/berdiaev/berd_lib/1914_174.html.

2. *L'Occident*, May 1912: "La main passe," in Anne Baldassari, "Le rose et le noir, Chtchoukine, les Stein, Matisse, Picasso," in *Icônes de l'art moderne: La collection Chtchoukine*, exhibition catalog, Paris, Gallimard/Fondation Louis Vuitton, 2016, p. 91.

3. Four Picasso works were loaned by the collector Marcell Nemes.

4. Two Picasso works were borrowed by the critic Roger Fry from Clovis Sagot.

5. Joyeux-Prunel, "La construction internationale."

6. A group of people that also included Morozov, Mamontov, Riabouchinski, and Soldatenkov.

7. Kasimir Malevich, "Le nouvel art et l'art représentateur" (1928), in *Kasimir Malévitch: Écrits*, vol. 1, Paris, Allia, 2015, pp. 438–67.

8. The 1913 publication of two successive translations of *Du Cubisme* (a work of vulgarization written by Gleizes and Metzinger and published in France in 1912) also contributed to the discovery of this new movement, which became a hot topic among neo-primitivists, cubo-futurists, futurists, suprematists, and constructivists.

9. Baldassari, "Le rose et le noir," p. 93.

10. Leo Steinberg, "La résistance à Cézanne: les *Trois femmes* de Picasso," in Daix, *Picasso cubiste*, pp. 71–103.

11. Yakov Tugendhold, "Frantsuskoe sobranie S. I. Shchukina," *Apollon*, 1914, no. 1–3, p. 3, in Steinberg, "La résistance à Cézanne."

12. Two opposing interpretations of this painting: according to William Rubin,

it was in November 1908, after visiting the Braque exhibition in the gallery on Rue Vignon, that Picasso announced his revelation of "Cézannean syntax"; for his part, Leo Steinberg sees in it the proof that "Picasso as a young man [. . .] was preparing to escape from Cézanne."

13. Yve-Alain Bois, "Préface," in Kramář, *Le Cubisme*, p. xx.

27. GUTENBERG 21-39: FROM ONE BUSINESS CARD TO ANOTHER

1. André Level, *Souvenirs d'un collectionneur*, Paris, A. C. Mazo, 1959, p. 5.
2. Level, *Souvenirs d'un collectionneur*, p. 10.
3. Level, *Souvenirs d'un collectionneur*, p. 18.
4. Michael C. FitzGerald, *Making Modernism*, New York, Farrar, Straus & Giroux, 1995, pp. 15–46; Jori Finkel, *The Art Newspaper*, 31 July 2014; Vérane Tasseau, "Les ventes de séquestre de la galerie Kahnweiler," *Ojo, le journal*, September 2016; "La vente aux enchères exceptionnelle de La Peau de l'Ours," *La Peau de l'Ours, Andre Level et Pablo Picasso*, no. 11, July 2010.
5. The *droit de suite* is the remuneration received by the creators of original artworks that are resold via a professional art dealer. The law was passed in France in 1920, and in 2007 a European directive integrated into French law extended it to include online sales.
6. Level, *Souvenirs d'un collectionneur*, p. 17.
7. Level, *Souvenirs d'un collectionneur*, p. 23.
8. Level, *Souvenirs d'un collectionneur*, p. 23.
9. Baldassari, *Icônes de l'art moderne*.
10. André Warnod, "La vente de la Peau de l'Ours," *Comoedia*, 3 March 1914; André Salmon, *Souvenirs sans fin*, Paris, Gallimard, 2004, pp. 658–59.
11. "La vente aux enchères exceptionnelle de la Peau de l'Ours," https://www.picasso.fr/details/ojo-les-archives-juillet-2010-ojo-11-a-lire-la-peau-de-lours-andre-level-et-pablo-picasso-la-vente-aux-encheres-exceptionnelle-de-la-peau-de-lours.
12. Raymonde Moulin, *Le Marché de la peinture en France*, Paris, Éditions de Minuit, 1967, pp. 34–36.
13. In the pages of the conservative daily *Paris Midi*. See Pierre Cabanne, *Le Siècle de Picasso*, vol. 2, *L'Époque des métamorphoses (1912–1937)*, Paris, Gallimard, coll. "Folio essais," 1992, p. 435.
14. Cabanne, *Siècle de Picasso*, vol. 2, p. 440.

28. "A SPLENDID SERIES. FREE AND JOYOUS AS NEVER BEFORE . . ."

1. Claverie et al., *Vincenc Kramář*, p. 150.
2. Isabelle Kalinowski, "Introduction: une esthétique inédite," in Carl Einstein, *Vivantes figures*, Paris, Éditions Rue d'Ulm/Musée du Quai-Branly, 2019, p. 17.
3. *Donation Louise et Michel Leiris*, p. 170, letter of 5 May 1913.
4. MnPP, Picasso personal archives, 515AP/C/dossier réservé/15 May 1918.
5. MnPP, Picasso personal archives, 515AP/C/dossier réservé/21 May 1918.
6. MnPP, Picasso personal archives, 515AP/C/dossier réservé/2 November 1913.
7. Dauphin and Poublan, "L'éloignement rapproche," p. 172.

8. Kankonde Bukasa Peter, "Transnational Family Ties, Remittance Motives and Social Death Among Congolese Migrants: A Socio-Anthropological Analysis," *Journal of Comparative Family Studies*, vol. 41, no. 2, 2010, pp. 225–43.
9. El Hispano Africano was a Madrid bank founded in 1900.
10. MnPP, Picasso personal archives, 515AP/C/dossier réservé/4 September 1918.
11. Claverie et al., *Vincenc Kramář*, p. 230.
12. Claverie et al., *Vincenc Kramář*, p. 228, letter of 16 February 1913.
13. Claverie et al., *Vincenc Kramář*, p. 228.
14. Claverie et al., *Vincenc Kramář*, p. 231.
15. FitzGerald, *Making Modernism*, p. 44.
16. FitzGerald, *Making Modernism*, p. 278, letter from Quentin Laurens to Michael C. FitzGerald, 27 April 1991.
17. Claverie et al., *Vincenc Kramář*, p. 231.
18. Daix, *Nouveau Dictionnaire Picasso*, p. 623.
19. Claverie et al., *Vincenc Kramář*, p. 232.
20. Claverie et al., *Vincenc Kramář*, p. 231, articles published in *Les Soirées de Paris* or *Le Mercure de France*.
21. Claverie et al., *Vincenc Kramář*, p. 232.
22. Claverie et al., *Vincenc Kramář*, p. 23, letter of 15 November 1913.
23. Claverie et al., *Vincenc Kramář*, p. 236, letter of 16 March 1914.
24. Claverie et al., *Vincenc Kramář*, p. 236, letter of 16 March 1914.
25. Claverie et al., *Vincenc Kramář*, letter of 14 April 1914.
26. Claverie et al., *Vincenc Kramář*, letter of 14 April 1914.
27. Guillaume Apollinaire, *Paris-Journal*, 26 May 1914.
28. "L'avant-gardisme et la critique," *Les Écrits français*, no. 5, 5 April 1914, quoted in Ariane Coulondre, "Roger Allard," in Léal, *Dictionnaire du cubisme*, pp. 10–11.
29. Bertrand Dorléac, "*Verre* de Picasso."
30. Werner Spies, *Les Sculptures de Picasso*, Lausanne, La Guilde du Livre/Clairefontaine, 1971, p. 48.
31. Baldassari, *Icônes de l'art moderne*, letter of 18 June 1914.
32. Baldassari, *Icônes de l'art moderne*, letter of 18 June 1914. According to Anne Baldassari, the archives of the Pushkin Museum in Moscow include a collection of photographs, numbered and laminated on cards, from the Kahnweiler gallery, some of which are reproductions of Picassos. Shchukin acquired only number 379, *Compotier et citron*, now entitled *Composition with a Bunch of Grapes and a Sliced Pear* (1914) and displayed in the Musée de l'Ermitage.
33. Claverie et al., *Vincenc Kramář*, p. 238.
34. Claverie et al., *Vincenc Kramář*, p. 150.
35. Stefan Zweig, *Le Monde d'hier: Souvenirs d'un Européen*, Paris, Le Livre de poche, 1966, p. 260.
36. *Donation Louise et Michel Leiris*, p. 28.
37. Monod-Fontaine and Laugier, *Daniel-Henry Kahnweiler*, p. 123.
38. Claverie et al., *Vincenc Kramář*, p. 237.
39. MnPP, Picasso personal archives, 515AP/C/dossier réservé/3 August 1914.

DISMANTLING THE PICASSO INTERNATIONAL
1. Isabelle Monod-Fontaine, "Pablo Picasso," in *Donation Louise et Michel Leiris*, p. 171.

29. WITH THE WOMEN, THE RETIREES, AND THE EXPATRIATES
1. Stein and Picasso, *Correspondance*, p. 164.
2. Stein and Picasso, *Correspondance*, p. 164.
3. Stein and Picasso, *Correspondance*, pp. 165–67.
4. Stein and Picasso, *Correspondance*, pp. 168–70.
5. Stein and Picasso, *Correspondance*, p. 171.
6. Stein and Picasso, *Correspondance*, p. 172.
7. Christian Dominicé, *La Notion du caractère ennemi des biens privés dans la guerre sur terre*, Geneva, Droz, 1961, p. 112, memorandum of 13 October 1914.
8. Monod-Fontaine and Laugier, *Daniel-Henry Kahnweiler*, p. 123, letter of 6 September 1919.
9. Kahnweiler and Crémieux, *Mes galeries et mes peintres*, p. 68.
10. Monod-Fontaine and Laugier, *Daniel-Henry Kahnweiler*, p. 123, letter of 6 September 1919.
11. Stein and Picasso, *Correspondance*, pp. 182–83.
12. For the debate over the date of the first wave of globalization, see Harold James, *The End of Globalization*, Cambridge, Harvard University Press, 2002, and particularly Adelman and Reed, *Earth Hunger*. Some historians such as Sanjay Subrahmanyam describe the first globalization as the period of great discoveries in the sixteenth century, while other experts regard this period, prior to the nineteenth century, as "archaic globalization" or "proto-globalization" (Tony Hopkins). For them, the first economic globalization necessitated greater autonomy, both for market forces and for the free movement of resources, than those put in place in the sixteenth century—two crucial notions for the economic exchanges of the nineteenth century.
13. Kahnweiler and Crémieux, *Mes galeries et mes peintres*, p. 102.
14. Norman Angell, *La Grande Illusion*, Paris, Nelson éditeurs, 1911, pp. 25–26; Suzanne Berger, *Notre première mondialisation: Leçons d'un échec oublié*, Paris, Seuil, coll. "La République des idées," 2003, pp. 80–85.
15. Milorad M. Drachkovitch, *Les Socialismes français et allemand et le problème de la guerre (1870–1914)*, Geneva, Droz, 1953, p. 106, speech of 13 January 1911.
16. Georg Simmel, "The Stranger," in Kurt Wolff (ed.), *The Sociology of Georg Simmel*, New York, Free Press, 1950, pp. 402–408.
17. Simmel, "The Stranger," pp. 402–408.
18. MnPP, Picasso personal archives, 515AP/C/86/1 December 1914.
19. Guillaume Apollinaire and André Level, *Lettres*, ed. B. Level, Paris, Lettres modernes, 1976, p. 7.
20. Apollinaire and Level, *Lettres*, p. 7.
21. MnPP, Picasso personal archives, 515AP/C/86/21 March 1916.
22. *Donation Louise et Michel Leiris*, p. 28, letter to Kahnweiler, 15 July 1919.
23. *Donation Louise et Michel Leiris*, p. 29, letter to Kahnweiler, 17 September 1919.

24. MnPP, Picasso personal archives, 515AP/C/dossier réservé/22 December 1914.
25. MnPP, Picasso personal archives, 515AP/C/dossier réservé/1 September 1914.
26. MnPP, Picasso personal archives, 515AP/C/dossier réservé/1 January 1915.
27. Stein and Picasso, *Correspondance*, p. 185.
28. Apollinaire and Level, *Lettres*, p. 100, letter of 7 February 1915.
29. Archives musée de Céret, letter of 12 July 1915, in *Pablo Picasso: Dessins et papiers collés. Céret (1911–1913)*, Céret, musée d'art moderne de Céret, 1997, p. 366.
30. Archives musée de Céret, letter of 25 October 1915, p. 369.
31. Stein and Picasso, *Correspondance*, pp. 188–89.
32. Stein and Picasso, *Correspondance*, pp. 191–92, letter of 8 January 1916.
33. MnPP, Picasso personal archives, 515AP/C/86/11 December 1914.
34. MnPP, Picasso personal archives, 515AP/C/86/30 May 1915.
35. MnPP, Picasso personal archives, 515AP/C/86/undated (1915).
36. MnPP, Picasso personal archives, 515AP/C/86/30 May 1915.
37. Tony Tollet, *De l'influence de la corporation judéo-allemande des marchands de tableaux de Paris sur l'art français*, Lyon, Imprimerie de A. Rey, 1915.
38. Quoted in Angell, *La Grande Illusion*, p. 3.

30. TOWARD A NEW TRANSNATIONALISM

1. Christian Derouet, "Le cubisme 'bleu horizon.' Correspondance de Juan Gris et Léonce Rosenberg: 1915–1917," *Revue de l'art*, 1996, pp. 40–64.
2. AN, AJ/28/CCSG/1.
3. Kenneth E. Silver, *Vers le retour à l'ordre: L'avant-garde parisienne et la Première Guerre mondiale*, Paris, Flammarion, 1991, pp. 36–38.
4. *Le Mot*, no. 7, 23 January 1915, unpaginated.
5. Jean Cocteau, *Œuvres poétiques complètes*, Paris, Gallimard, coll. "Bibliothèque de la Pléiade," 1999, p. 21.
6. In Erik Satie, *Correspondance presque complète*, ed. O. Volta, Paris, Fayard/Imec, 2000, p. 254.
7. Jean Cocteau, *Le Rappel à l'ordre*, Paris, Stock, 1926, p. 286.
8. Quoted in John Richardon, *A Life of Picasso*, vol. 2, *1907–1917*, Jonathan Cape, London, 1996, p. 422.
9. Jean Cocteau, *La Corrida du premier mai*, Paris, Grasset, 1957, p. 178.
10. Jean Cocteau, *Lettres à sa mère*, vol. 1, *(1898–1918)*, Paris, Gallimard, 1989, pp. 295–96.
11. Cécile Godefroy, "1915–1925: Picasso, dall'*Arlequin* a *Les Trois Danseuses*," in Olivier Berggruen and Anunciata von Liechtenstein (ed.), *Picasso: Tra Cubismo e Classicismo, 1915–1925*, Rome, Scuderie del Quirinale, 2017; Valentina Moncada, "Picasso a via Margutta: l'atelier negli Studi Patrizi," in Berggruen and von Liechtenstein, *Picasso: Tra Cubismo*.
12. Jean Cocteau, *La difficulté d'être*, Paris, Morihien, 1947, p. 38.
13. Maurice Barrès, *La Terre et les Morts: Sur quelles réalités fonder la conscience française*, Paris, La Patrie française, 1899, p. 27.
14. My thanks to Marianne Amar for this information: "It would nevertheless be wrong," she makes clear, "to regard the April 2 decree as a clean break. The beginnings of the identity card in 1917 proved rather chaotic, and var-

ied between army zones and rear zones [. . .]. In fact, it would be better to consider the decree as a founding event, as the start of a medium-term process." Marianne Amar, *1917: La création, avant celle des Français, de la carte d'identité des étrangers,* permanent exhibition, Musée national de l'histoire de l'immigration (MNHI).

31. ART DEALERS IN WARTIME: BETWEEN PATRIOTISM, PERFIDY, AND DENUNCIATION

1. MnPP, Picasso personal archives, 515AP/C/140/6 March 1916.
2. Picasso's words to Brassaï (see Daix, "Clovis Sagot," in *Nouveau Dictionnaire Picasso*).
3. MnPP, Picasso personal archives, 515AP/C/140/30 October 1914.
4. MnPP, Picasso personal archives, 515AP/C/140/24 December 1914.
5. MnPP, Picasso personal archives, 515AP/C/140/2 March 1916.
6. MnPP, Picasso personal archives, 515AP/C/140/6 March 1916.
7. MnPP, Picasso personal archives, 515AP/C/141/24 March 1916.
8. MnPP, Picasso personal archives, 515AP/C/141/30 May 1919.
9. MnPP, Picasso personal archives, 515AP/C/140/23 July 1920.
10. Tasseau, "Ventes de séquestre de la galerie Kahnweiler."
11. MnPP, Picasso personal archives, 515AP/C/140, undated letter (1920).
12. Centre Pompidou/MNAM-CCI/Bibliothèque Kandinsky, Correspondence concerning the Sales of the Collections of Daniel-Henry Kahnweiler and Wilhelm Uhde, LROS 22.
13. MnPP, Picasso personal archives, 515AP/C/140/29 September 1923.

32. A COLLATERAL VICTIM OF GERMANOPHOBIC HYSTERIA

1. AN, AJ/28/CCSG/1.
2. Exhibition "De Picasso à Séraphine, Wilhelm Uhde et les primitifs modernes," Villeneuve-d'Ascq, LaM, 2017.
3. Jean-Jacques Becker, "Les conséquences des traités de paix," *Revue historique des armées*, no. 254, 2009, http://journals.openedition.org/rha/6303.
4. Roger Dutilleul collection at the Lille Métropole musée d'art moderne, d'art contemporain et d'art brut. My thanks to Francis Berthier and Marie-Amélie Sénot for their precious help with this dossier. By adding up every work in the Roger Dutilleul catalogs, we can make the following breakdown: for the first sale, 26 paintings and 88 sculptures by Picasso; for the second, 37 paintings and 12 papiers collés; for the third, 33 paintings, drawings, or watercolors; for the fourth, 50 paintings, 350 aqua fortis, and 55 engravings. To this, we can add the Uhde sale on May 30, 1921 (13 paintings and 3 drawings), as well as the 39 non-inventoried paintings from the Kahnweiler reserves, which were still at the apartment of the photographer Émile Delétang before August 1914 so that he could photograph them. See Christian Derouet, "Picasso et le spectre des ventes des biens allemands ayant fait l'objet d'une mesure de séquestre de guerre (1914–1923)," in Annette Becker (ed.), *Picasso et la guerre*, Paris, Gallimard/Musée de l'Armée/Musée national Picasso-Paris, 2019, p. 68. According to Jeanne Laurent, "the Kahnweiler sequestration alone included more than 1,500 pieces. Considering only paintings, there were 124 Braques, 111 Derains, 56 Gris, 43 Légers, 132 Picassos, 22 van Dongens,

315 Vlamincks. To this total can be added watercolors, gouaches, drawings, etchings and illustrated books by the gallery's artists" (Jeanne Laurent, *Arts et pouvoirs en France de 1793 à 1981: Histoire d'une démission artistique*, Saint-Étienne, CIEREC, 1982, p. 118).

5. Marius Boisson, "La vente Kahnweiller" [*sic*], *Comoedia*, 18 November 1921.

6. Kahnweiler and Crémieux, *Mes galeries et mes peintres*, pp. 93–95.

7. Vérane Tasseau, "Les ventes de séquestre du marchand Daniel-Henry Kahnweiler (1921–1923)," *Archives juives*, vol. 50, no. 1, 2017, pp. 26–40.

8. Tasseau, "Ventes de séquestre du marchand," pp. 26–40.

9. Tasseau, "Ventes de séquestre du marchand," p. 33, citing "Le carnet d'un curieux: Notes diverses," *La Renaissance de l'art français et des industries de luxe*, vol. 4, no. 9, September 1921, p. 486.

10. The estimation for lot 72 was in fact 500 francs, but it went for 800 francs (acquired by Léonce Rosenberg on behalf of André Lefèvre).

11. *Comoedia*, 18 November 1921, Archives Roger Dutilleul.

12. Tasseau, "Ventes de séquestre du marchand," p. 34.

13. Robert Desnos, *Paris-Journal*, 13 May 1923, in Christian Derouet, "Picasso et le spectre des ventes."

14. MnPP, Picasso personal archives, 515AP/C/86/15 October 1919.

15. MnPP, Picasso personal archives, 515AP/C/86/29 December 1917.

16. MnPP, Picasso personal archives, 515AP/C/86/undated (1918).

17. MnPP, Picasso personal archives, 515AP/C/86/15 October 1919.

18. MnPP, Picasso personal archives, 515AP/C/86/4 November 1919.

19. MnPP, Picasso personal archives, 515AP/C/86/25 November 1919.

20. MnPP, Picasso personal archives, 515AP/C/86/23 June 1920.

21. MnPP, Picasso personal archives, 515AP/C/86/7 April 1921.

22. Kahnweiler and Crémieux, *Mes galeries et mes peintres*, pp. 92–93.

23. Philippe Dagen, *Le Silence des peintres: Les artistes face à la Grande Guerre*, Paris, Fayard, 1996, p. 326. Later, in the United States and Great Britain, it was the turn of Kenneth E. Silver, in his *Esprit de Corps: The Art of the Parisian Avant-garde*, London, Thames and Hudson, 1989; *Vers le retour à l'ordre*; and *Picasso: The Great War, Experimentation and Change*, New York, Scala, 2016; and of Christopher Green, "Cubism and War: The Crystal in the Flame," exhibition at Musée Picasso de Barcelone, 2016.

24. Green, "Cubism and War."

25. Like the fascinating Wolfgang Schivelbusch, *The Culture of Defeat: On National Trauma, Mourning, and Recovery*, New York, Metropolitan Books/ Henry Holt & Company, 2003.

26. Archives of estates, goods, and private interests.

27. Anne Ducret, "Justice; Direction des affaires civiles et du sceau (1918–1958). Répertoire (19970343/1–19970343/7)," Pierrefitte-sur-Seine, 1997.

28. Laurent, *Arts et pouvoirs*.

29. Paul Léon, *Du Palais-Royal au Palais-Bourbon*, Paris, Albin Michel, 1947, p. 124.

30. Léon, *Du Palais-Royal*, p. 175.

31. Christophe Charle, *Les Élites de la République*, Paris, Fayard, 1987, p. 418.

32. As he had done, for example, during the same period for the Chambord estate; see Laurent, *Arts et pouvoirs*, p. 119.

33. It would be interesting to know what led Picasso, in his administrative issues, to ask Level for help rather than Olivier Sainsère (one of his first collectors), as Kahnweiler did. According to Pierre Daix, Sainsère stopped buying Picassos once the artist entered his cubist period, but protected him during the case of the stolen *Mona Lisa* in 1911. Daix, *Nouveau Dictionnaire Picasso*, p. 801.

34. Kahnweiler and Crémieux, *Mes galeries et mes peintres*, pp. 92–96, particularly p. 93.

35. This sum (in German, *Wiedergutmachung*) was paid to German citizens by their government in compensation for goods lost during the war. Kahnweiler received the sum of 20,000 marks, representing a tiny percentage of the value of the works he lost in the sequestration. But he decided to use it to pay off his debt to Picasso (which, it is worth repeating, was caused by cash-flow problems—and, in particular, the debts owed to him by Shchukin and Léonce Rosenberg). See Douglas Cooper and Gary Tinterow, *The Essential Cubism: Braque, Picasso & Their Friends. 1907–1920*, London, Tate Gallery, 1983, p. 27.

36. Laurent, *Arts et pouvoirs*, pp. 84–88, 120–121.

37. The Caillebotte Affair (1894–1897) concerned the dispute surrounding the refusal by Henry Roujon, head of the Beaux-Arts, of the artist Gustave Caillebotte's bequest, comprising twenty-nine impressionist paintings—despite the fact that the consultative committee for the Musées Nationaux had agreed to accept the entire bequest.

33. "COUNTING THE HOURS": NOTRE-DAME DE PARIS, THE EMMANUEL BELL, AND THE PICASSO INTERNATIONAL

1. Francesca Trivellato, *The Familiarity of Strangers: The Sephardic Diaspora, Livorno, and Cross-Cultural Trade in the Early Modern Period*, New Haven: Yale University Press, 2012.

2. Berger, *Notre première mondialisation*, pp. 86–87.

3. Claverie et al., *Vincenc Kramář*, p. 329, letter of 6 July 1920.

PROLOGUE: LIKE A SMASHED MOSAIC

1. Jean-Paul Sartre, *L'Idiot de la famille*, vol. 1, Paris, Gallimard, coll. "Tel," 1971, p. 8.

2. Émilie Bouvard, Marilyn McCully, and Michael Raeburn, *Tableaux magiques*, exhibition catalog, Paris, Musée national Picasso-Paris/Skira, 2019.

3. Carl Einstein, "Picasso," *Documents*, no. 3, 1930, pp. 155–57, in Bouvard, McCully, and Raeburn, *Tableaux magiques*, p. 170.

4. Einstein, *L'Art du XXe siècle*, p. 149.

5. André Warnod, *Berceaux de la jeune peinture*, pp. 92–93.

6. Maurice Sachs, *Au temps du Boeuf sur le toit: Journal d'un jeune bourgeois à l'époque de la prospérité*, Paris, Grasset, 1939, p. 11.

7. Eugen Weber, *La France des années 30: Tourments et perplexités*, Paris, Fayard, 1994, p. 21.

8. Christophe Charle, "Préface," in Alice Bravard, *Le Grand Monde parisien: 1900–1939; La persistance du modèle aristocratique*, Rennes, Presses universitaires de Rennes, 2013, p. 9.

34. MERCURIAL DESIGNER (FROM THE BALLETS RUSSES TO SOCIETY BALLS)

1. Serge Diaghilev, *L'Art, la musique et la danse: Lettres, écrits, entretiens*, Paris, Vrin, 2013, p. 406.
2. Diaghilev, *L'Art, la musique*, p. 307.
3. Diaghilev, *L'Art, la musique*, p. 12.
4. Diaghilev, *L'Art, la musique*, p. 291.
5. Marina Tsvetaïeva, in Jean-Claude Marcadé, "Serge Diaghilev et l'avant-garde russe," in John E. Bowlt et al., *"Étonne-moi!": Serge Diaghilev et les Ballets russes*, Paris, Skira, 2009, p. 89.
6. Marina Tsvetaïeva, in Marcadé, "Serge Diaghilev," p. 93.
7. Madeline, *Archives de Picasso*, p. 166.
8. Madeline, *Archives de Picasso*, p. 163.
9. MnPP, Picasso personal archives, 515AP/C/96/21 January 1917, letter quoted in Madeline, *Archives de Picasso*, p. 163.
10. Diaghilev, *L'Art, la musique*, p. 412.
11. Eugenia Errázuriz et al., *Lettres d'Eugenia Errázuriz à Pablo Picasso*, ed. A. Canseco Jerez, Metz, Centre d'études de la traduction, 2001.
12. Errázuriz et al., *Lettres d'Eugenia Errázuriz*, pp. 22–23, letter of 27 February 1917, no. 4.
13. Jacques Leenhardt, "Simmel et la théorie du mécénat. Le mécénat peut-il avoir une place dans la théorie de la sociologie?," in Errázuriz et al., *Lettres d'Eugenia Errázuriz*, p. 194.
14. Errázuriz et al., *Lettres d'Eugenia Errázuriz*, pp. 38–39, letter of 25 November 1917, no. 12.
15. MnPP, Picasso personal archives, 515AP/C/10/2 March 1923.
16. Since, due to its military tradition, the aristocracy paid a "blood tax" twice as high as the rest of the nation. See Bravard, *Grand Monde parisien*, pp. 187–88.
17. Bravard, *Grand Monde parisien*, p. 261.
18. Georges Auric, *Quand j'étais là*, Paris, Grasset, 1979, p. 207, in Myriam Chimènes, *Mécènes et musiciens: Du salon au concert à Paris sous la IIIe République*, Paris, Fayard, 2004, p. 157.
19. Arno Mayer, *La Persistance de l'Ancien Régime*, Paris, Flammarion, 1982, p. 11.
20. Mayer, *Persistance de l'Ancien Régime*, p. 108.
21. Chimènes, *Mécènes et musiciens*, p. 158.
22. Bernard Faÿ, *Les Précieux*, Paris, Perrin, 1966, pp. 41–42, in Chimènes, *Mécènes et musiciens*, p. 156.
23. MnPP, Picasso personal archives, 515AP/C/10/undated.
24. Moulin, *Marché de la peinture*, p. 36.
25. Chimènes, *Mécènes et musiciens*, p. 15.
26. Marc Fumaroli, introduction to Jean Mesnard and Roland Mousnier (ed.), *L'Age d'or du mécénat (1598–1661)*, Paris, CNRS Éditions, 1985, p. 9.
27. MnPP, Picasso personal archives, 515AP/C/10/15 [??] 1923.
28. Archives de l'Institut des mémoires de l'édition contemporaine (IMEC) [hereafter cited as IMEC], 197BMT/1.
29. Caroline Potter, *A Parisian Composer and His World: Erik Satie, Music, Art, Literature*, Suffolk, Boydell & Brewer, 2013.

30. IMEC, 197BMT/1–13.
31. IMEC, 197BMT/1–13, 5 February 1934.
32. MnPP, Picasso personal archives, 515AP/C/10/21 February 1924.
33. Paul Collaer, "La Saison de Paris," in *Arts et lettres d'aujourd'hui*, vol. 2, no. 23, 15 June 1924.
34. IMEC, collection Rondel, bibliothèque de l'Arsenal, untitled, undated.
35. Cited in Daix, *Nouveau Dictionnaire Picasso*, p. 581.
36. MnPP, Picasso personal archives, 515AP/C/10/14 June 1920.

35. ARTIST-MAGICIAN (IN THE ORBIT OF THE SURREALIST INTERNATIONAL)

1. Archives de la bibliothèque littéraire Jacques-Doucet, Paris, letter from André Breton to Jacques Doucet, 2 December 1924, in Hélène Seckel, "Chronologie," in Seckel, *Les Demoiselles d'Avignon*, pp. 548–50.
2. André Breton, *Le Surréalisme et la Peinture*, Paris, Gallimard, 1965, p. 7.
3. MnPP, Picasso personal archives, 515AP/C/18/undated.
4. Affirmation of the *Dada Manifesto*, which, embracing the contradiction, claims to be "against manifestos."
5. Alexander Partens, *Dada Almanach*, 1920, in Marc Dachy, *Archives dada: Chronique*, Paris, Hazan, 2005, p. 160.
6. Pierre Daix, *La Vie quotidienne des surréalistes (1917–1932)*, Paris, Hachette, 1993, p. 51.
7. Sylvie Ramond, "L'extrême des artistes: *Femme assise sur la plage*, *La Baignade* et *La Grande Baigneuse au livre* de Picasso," in Bouvard and Zellal, *Picasso: Chefs-d'oeuvre!*, pp. 117, 119, 135.
8. Carl Einstein, quoted on a wall plaque, but we can find the entire argument behind this pretty phrase in his essay "Pablo Picasso," about this surrealist period: "One can talk about a divinatory, psychographic genesis of things. Picasso offsets the subjective with a tectonic construction that turns his discoveries into models. To the inevitability of the unconscious, he opposes the will of precise forms, and his paintings are characterized by a tension between these two extremes. One can talk here of an internal dialectic, a polyphonic psychic construction," in Einstein, *L'Art du XXe siècle*, pp. 154–55.
9. Michel Leiris, *Journal (1922–1924)*, Paris, Gallimard, 1992, p. 41, 1 April 1924.
10. Excerpts of radio interviews with André Parrinaud, March–June 1952, in Daix, *Vie quotidienne des surréalistes*, p. 15.
11. MnPP, Picasso personal archives, 515AP/C/6/11 February 1919.
12. MnPP, Picasso personal archives, 515AP/C/6/30 August 1919.
13. At the initiative of André Salmon.
14. Louis Aragon, "Du décor," in *Le Film*, 16 September 1918, in Daix, *Vie quotidienne des surréalistes*, p. 62.
15. Daix, *Vie quotidienne des surréalistes*, p. 223.
16. André Breton and Paul Éluard, *Correspondance (1919–1938)*, ed. É.-A. Hubert, Paris, Gallimard, 2019.
17. Dachy, *Archives dada*, pp. 534–35.
18. IMEC, 197BMT/1–13.
19. *Paris-Journal*, 20 June 1924; see Werner Spies (ed.), *La Révolution surréaliste*, exhibition catalog, Paris, Éditions du Centre Pompidou, 2002.

20. Ioana Vlasiu, "Bucharest," in Timothy O. Benson (ed.), *Central European Avant-gardes: Exchange and Transformation 1910–1930*, Cambridge, MIT Press, 2002, pp. 248–54.

21. And thanks to the support of Alexandru Bogdan-Pitești, a contemporary art collector with anarchist sympathies.

22. Vlasiu, "Bucharest."

23. Paul Éluard, *Lettres à Gala (1924–1948)*, Paris, Gallimard, 1984, p. 134, February 1931.

24. Éluard, *Lettres à Gala*, p. 219, 17 August 1933.

25. Éluard, *Lettres à Gala*, p. 246, 15 August 1934.

26. Éluard, *Lettres à Gala*, p. 248, 20 August 1934.

27. Éluard, *Lettres à Gala*, p. 262, 31 March 1936.

28. MnPP, Picasso personal archives, 515AP/C/18/18 September 1923.

29. MnPP, Picasso personal archives, 515AP/C/18/29 October 1923.

30. Michel Leiris, "Réponse au questionnaire de René Bertelé," in *La Règle du jeu*, Paris, Gallimard, coll. "Bibliothèque de la Pléiade," 2003, pp. 1269–70.

31. Michel Leiris, "Un génie sans piédestal," in *Le Dernier Picasso (1953–1973)*, Paris, Éditions du Centre Pompidou, 1988, pp. 14–15.

32. Michel Leiris, "Toiles récentes de Picasso," *Documents*, vol. 2, no. 2, 1930, pp. 57–71.

33. Victoria Combalia, *Picasso-Miró: Miradas cruzadas*, Madrid, Electa, 1998, p. 118, letter of 15 November 1924.

34. Combalia, *Picasso-Miró*, p. 118, letter of 10 February 1925.

35. Combalia, *Picasso-Miró*, p. 115, letter of July 1921.

36. MnPP, Picasso personal archives, 515AP/C/101/24 January 1934.

37. Salvador Dalí, *Lettres à Picasso (1927–1970)*, ed. L. Madeline, Paris, Gallimard, 2005, p. 143.

38. Dalí, *Lettres à Picasso*, p. 144.

39. Dalí, *Lettres à Picasso*, p. 151.

40. Salvador Dalí, *La Vie secrète de Salvador Dalí*, Paris, La Table Ronde, 1969, p. 227.

41. Eugenio Carmona, "Le jeune Dalí, la Residencia de Estudiantes et les stratégies de la différence," in Jean-Hubert Martin (ed.), *Dalí*, exhibition catalog, Paris, Éditions du Centre Pompidou, 2012.

42. Carmona, "Le jeune Dalí," pp. 350–51. "Picasso et moi," unpublished manuscript (about 1957), Fondació Gala-Salvador Dalí, Figueres, RI 225.

43. Carmona, "Le jeune Dalí," pp. 352–53.

44. Cohen-Solal, *"Un jour, ils auront des peintres"*, pp. 467–82.

45. For an analysis of the relationship between Doucet and Breton, see Yves Peyré, "L'absolu d'une rencontre," *Cahiers de la bibliothèque littéraire Jacques-Doucet*, no. 1, 1997, pp. 92–96.

46. Archives de la bibliothèque littéraire Jacques-Doucet, Paris, letter of 3 December 1921, in Hélène Seckel, "Éléments pour une chronologie de l'histoire des *Demoiselles d'Avignon*," in Seckel, *Les Demoiselles d'Avignon*, vol. 2, p. 583.

47. Archives de la bibliothèque littéraire Jacques-Doucet, Paris, in Seckel, "Éléments pour une chronologie," p. 585, letter of 6 November 1923.

48. Archives de la bibliothèque littéraire Jacques-Doucet, Paris, letter from André Breton to Jean-François Revel in 1961. He recounts this episode from

memory: *"Les Demoiselles d'Avignon*, for example. I remember the day he bought that painting from Picasso, who—strange thing—seemed intimidated by Doucet." Hélène Seckel adds: "Breton quotes Doucet remarking to Revel: 'After my death, my entire collection will go to the Louvre and I am the only collector with the authority to make the Louvre exhibit avant-garde art'" (Seckel, "Éléments pour une chronologie," pp. 590–91).

49. Archives de la bibliothèque littéraire Jacques-Doucet, Paris, letter of 9 March 1924, in Seckel, "Éléments pour une chronologie," p. 587.

50. Archives de la bibliothèque littéraire Jacques-Doucet, Paris, in Seckel, "Éléments pour une chronologie," p. 590, letter of 2 December 1924.

51. Cohen-Solal, *"Les Demoiselles* s'en vont en Amérique," in *"Un jour, ils auront des peintres"*, pp. 467–82.

52. MnPP, Picasso personal archives, 515AP/C/18/11 August 1940.

53. Gilot and Lake, *Vivre avec Picasso*, pp. 140–42.

54. At this stage, Picasso was not close to the Communist Party because, as Clifford Rosenberg emphasizes, the French Communists in the 1920s, preoccupied by differentiating themselves from the Socialist Party and forging their own identity, relied on the know-how of more experienced activists (Rosenberg, *Policing Paris*, pp. 64–65).

55. *Europe*, July 1930.

56. Maxime Alexandre, *Mémoires d'un surréaliste*, Paris, La Jeune Parque, 1968, p. 109.

57. "L'inculpation d'Aragon," *L'Humanité*, 9 February 1932, see Thibault Boixière, "'Front rouge': quand Aragon était accusé de propagande anarchiste," *The Conversation*, 19 February 2018, https://theconversation.com/front-rouge -quand-aragon-etait-accuse-depropagande-anarchiste-90833.

58. Éluard, *Lettres à Gala*, p. 154, 30 January 1932.

59. Éluard, *Lettres à Gala*, p. 156, 2 February 1932.

60. Éluard, *Lettres à Gala*, p. 158, 6 February 1932.

61. Maurice de Vlaminck, *Paris-Journal*, 1924 (*Le Petit Journal des grandes expositions*, p. 7).

62. Amar, *1917: La création*.

36. SCULPTOR, MINOTAUR, DEVOTED ARTIST

1. Quoted in Pierre Daix, *Pablo Picasso*, Paris, Tallandier, 2007, p. 335. The work to which Kahnweiler alludes is undoubtedly *Girl Before a Mirror*.

2. Some portraits of whom now sell for more than $100 million.

3. Diana Widmaier-Picasso, "The Marie-Thérèse Years: A Frenzied Dialogue for the Sleeping Muse, or the Rebirth of Picasso's Plastic Laboratory," in John Richardson (ed.), *Picasso and Marie-Thérèse: L'Amour Fou*, exhibition catalog, New York, Gagosian Gallery, 2011, p. 61.

4. Some critics, including Pierre Daix, talk of a "new graphic laboratory."

5. Brassaï, *Conversations avec Picasso*, p. 30.

6. Interview with Bernard Ruiz-Picasso, in Sylvain Amic (ed.), *Boisgeloup: L'atelier normand de Picasso*, exhibition catalog, Paris/Rouen, Artlys/Musée de Rouen, 2017, p. 20.

7. Roland Penrose, "Boisgeloup: Sculpture, et le Minotaure (1930–1936)," in Penrose, *Picasso*, p. 316.

8. Interview with Bernard Ruiz-Picasso, in Amic, *Boisgeloup.*

9. On the podcast *Invité culture*, RFI, 28 May 2013.

10. Tobia Bezzola (ed.), *Picasso: Sa première exposition muséale de 1932*, Munich, Prestel, 2010, p. 77.

11. In 1929, when a Picasso was selling for 60,000 francs, a Matisse of the same size remained stuck at the price of 6,000 francs, as in 1921 (FitzGerald, *Making Modernism*, p. 156).

12. In 1930, Chester Dale was told by his dealer Valentine Dudensing that "one of the most beautiful paintings of the twentieth century" was on the market, a very large canvas by Picasso, of which he showed him a photograph, explaining that it was being held in a Swiss bank as security. Dale decided to buy it without even having seen it and managed to preempt all the other interested buyers by sending his secretary with a check for $20,000 to the port of New York. See Kimberly A. Jones, "Cultivating the Chester Dale Collection," in Kimberly A. Jones and Maygene F. Daniels, *The Chester Dale Collection*, Washington, D.C., National Gallery of Art, 2012, p. 14. See also National Gallery of Art, Washington, D.C., Curatorial Records, Chester Dale Collection, *Family of Saltimbanques*; and Archives of American Art (AAA), Smithsonian Institution, Washington/New York, microfilm #3969.

13. FitzGerald, *Making Modernism.*

14. Bezzola, *Picasso: Sa première exposition*, p. 80.

15. AN, 19940472/325.

16. PPP, dossiers de naturalisation d'étrangers célèbres, IC 5; Daix and Israël, *Pablo Picasso: Dossiers*, pp. 77–82.

17. A cry soon taken up by the daily newspaper *Paris-soir* (March 26, 1930).

18. Claire Zalc, interview in the course of the exhibition *1931: Les étrangers au temps de l'Exposition coloniale*, for which she was the curator at the Musée national de l'histoire de l'immigration (MNHI), https://www.histoire -immigration.fr/musee-numerique/expositions-temporaires/1931-les -etrangers-au-temps-de-l-exposition-coloniale.

19. Claire Zalc, "La République est assimilatrice," in Marion Fontaine, Frédéric Monier, and Christophe Prochasson (eds.), *Une contre-histoire de la IIIe République*, Paris, La Découverte, 2013, pp. 164–65, 166–67.

20. Zalc, "La République est assimilatrice," pp. 164–65, 166–67.

21. Archives départementales de l'Aude, Carcassonne, 12 J, fonds Albert Sarraut, 36, "Discours de M. Albert Sarraut, Ministre de l'Intérieur," in Rosenberg, *Policing Paris*, pp. 80–81.

22. Eugen Weber, *The Hollow Years: France in the 1930s*, New York, Norton, 1994, p. 88.

23. Camille Mauclair, "Les métèques contre l'art français," *Nouvelle Revue critique*, 1930, p. 62; Eugen Weber, *The Hollow Years*, p. 88.

24. The law of August 10, 1927, on French nationality, for example, was unprecedentedly liberal, requiring only three years of residence on French soil (instead of ten, as previously) before naturalization could be requested, and it enabled a million foreigners to become French. See Claire Zalc, "Quand la France 'assimilait' les étrangers," *L'Histoire*, August 3–9, 2017, pp. 79–81.

25. Rosenberg, *Policing Paris*, p. 51.
26. Clovis Bienvenu, *Le 36, quai des Orfèvres: À la croisée de l'histoire et du fait divers*, Paris, PUF, 2012.
27. Rosenberg, *Policing Paris*, p. 58.
28. And where did this money come from? For the most part, from the increase in fees received from foreigners for the renewal of their papers, their residence cards, and any fines they might pay. In 1938 alone, the Parisian authorities collected the formidable sum of 14.82 million francs for identity cards, and 4.01 million francs in fines. PPP, Cons. mun., rap. et doc., no. 39, 1939, cited in Rosenberg, *Policing Paris*, pp. 62–63.
29. Rosenberg, *Policing Paris*, p. 42.
30. MnPP, Picasso personal archives, 515AP/C/86/3 September 1924.
31. MnPP, Picasso personal archives, 515AP/C/86/17 September 1924.
32. MnPP, Picasso personal archives, 515AP/C/86/22 September 1924.
33. MnPP, Picasso personal archives, 515AP/C/120/20 August 1927.
34. MnPP, Picasso personal archives, 515AP/C/120/9 September 1927.
35. MnPP, Picasso personal archives, 515AP/C/120/20 April 1927.
36. Bois, "Picasso, the Trickster."
37. Coline Zellal, in Émilie Bouvard and Géraldine Mercier (ed.), *Guernica*, Paris, Musée national Picasso-Paris/Gallimard, 2018, p. 42.
38. Marie-Laure Bernadac, *Picasso et le taureau*, exhibition catalog *Picasso Toros y Toreros*, Paris, Musée national Picasso-Paris, 1993, p. 13.
39. Alain Mousseigne, *Rideau de scène pour le Théatre du Peuple dit "Rideau de scène pour le Quatorze-Juillet" de Romain Rolland*, Milan, Skira, 1998, p. 30.
40. Mousseigne, *Rideau de scène*, p. 31.
41. Jean Clair, *Picasso sous le soleil de Mithra*, Paris, RMN, 2001, p. 66.
42. Mousseigne, *Rideau de scène*, p. 23.
43. Bouvard and Mercier, *Guernica*, p. 42.
44. Bouvard and Mercier, *Guernica*, p. 34.
45. Mousseigne, *Rideau de scène*, p. 36.
46. Timothy J. Clark, "Le meurtre," in Bouvard and Mercier, *Guernica*, p. 52.
47. Mousseigne, *Rideau de scène*, p. 20.
48. Mousseigne, *Rideau de scène*, p. 32.
49. Mousseigne, *Rideau de scène*, p. 33.
50. Mousseigne, *Rideau de scène*, p. 34.
51. Mousseigne, *Rideau de scène*, p. 35.
52. *Murder* (7 and 10 July 1934, Boisgeloup), *Minotaur Injured, Horseman and Characters, Bust of a Faun* (8 May 1936), and *Minotaur Injured, Horse and Characters* (10 May 1936) followed; Timothy J. Clark, "Le meurtre," in Bouvard and Mercier, *Guernica*, pp. 36–37; and Mousseigne, *Rideau de scène*, p. 36, then p. 18.
53. Daniel-Henry Kahnweiler, in Pierre Cabanne, *Le Siècle de Picasso*, vol. 2, *L'Époque des métamorphoses (1912–1937)*, Paris, Denoël, 1975, p. 687.
54. Brassaï, *Conversations avec Picasso*, p. 13, in Daix, *Nouveau Dictionnaire Picasso*, p. 134.
55. Daix, *Pablo Picasso*, p. 353.

37. POET AND POLITICAL ARTIST (WITH THE SPANISH REPUBLICANS)

1. Interview of Félix Píta Rodriguez and Pablo Picasso, unidentified source, May or June 1937, quoted in Margaret Palmer and Garnett McCoy, "Letters from Spain, 1936–1939," *Archives of American Art Journal*, vol. 26, no. 2/3, 1986, p. 16.

2. Dora Maar, interview with Frances Morris (1990), in Emma Lewis, "Dora Maar et Picasso, la chambre noire et l'atelier," in Damarice Amao, Amanda Maddox, and Karolina Ziebinska-Lewandowska (eds.), *Dora Maar*, exhibition catalog, Paris, Éditions du Centre Pompidou, 2019, p. 145.

3. Kahnweiler and Crémieux, *Mes galeries et mes peintres*, pp. 143–44.

4. Felipe Cossío del Pomar, *Con los buscadores del camino*, Madrid, Ulises, 1932, in Michael FitzGerald, "Après 1932: des rétrospectives de Paris et de Zurich à *Guernica*," in Bezzola, *Picasso: Sa première exposition*, p. 135.

5. From January 1935 to March 1936, in the beautiful phrasing of Elizabeth Cowling, "Portraying Maya," in Diana Widmaier-Picasso (dir.), *Picasso and Maya*, Paris, Gagosian, p. 135.

6. Éluard, *Lettres à Gala*, p. 469, letter to George Reavey, 4 April 1936.

7. Emmanuel Guigon and Margarida Cortadella (eds.), *Sabartés por Picasso por Sabartés*, Barcelona, Museu Picasso Barcelona, 2019, p. 172.

8. Guigon and Cortadella, *Sabartés por Picasso*, p. 173. Thanks to Margarida Cortadella, curator of the exhibition *Sabartés por Picasso por Sabartés* (Museu Picasso Barcelona), who, with Jèssica Jaques Pi and Àger Perez Casanovas, introduced me to this story, during two beautiful March days in Barcelona in 2019.

9. Daix, *Nouveau Dictionnaire Picasso*, pp. 529–34.

10. A private mansion built in the eighteenth and nineteenth centuries by the general Baron Robert, governor of Tortosa, during the Napoleonic Wars in Spain. My thanks to Élisabeth and Jean-Philippe Bouchaud for this discovery.

11. Amao, Maddox, and Ziebinska-Lewandowska, *Dora Maar*, fashion photography, about 1935, p. 21.

12. Amao, Maddox, and Ziebinska-Lewandowska, *Dora Maar*, p. 137, *Leonor Fini, 1936*.

13. In March 1936, in Boisgeloup and Paris.

14. Brassaï, *Conversations avec Picasso*, 1907, pp. 93–95.

15. Notably on the occasion of the reaction to the fascist demonstrations of 6 February 1934 with the tract "L'appel à la lutte," written with André Breton and Chavance; see Patrice Allain and Laurence Perrigault, "Dora Maar aux multiples visages," in Amao, Maddox, and Ziebinska-Lewandowska, *Dora Maar*, p. 51.

16. Anne Baldassari, *Picasso/Dora Maar: Il faisait tellement noir*, Paris, Flammarion/RMN, 2006, pp. 54, 55, 84, 85.

17. According to Pierre Daix in his *Nouveau Dictionnaire Picasso*, p. 530.

18. In 1932, he rejoiced in the acquisition by the Generalitat de Barcelone of the Plandiura collection with twenty of his drawings—the first Picasso works to be displayed in a Spanish museum. In April 1933, he and some friends celebrated the second anniversary of the Spanish Republic. During the summers of 1933 and 1934, he went back to Spain to see his family.

19. José Bergamín, "Tout et rien de la peinture," *Cahiers d'art*, no. 1–3, 1937,

in Amanda Herold-Marme, "L'Identité artistique à l'épreuve: Les artistes espagnols à Paris et l'engagement à partir de la guerre civile (1936–1956)," doctoral thesis, Institut d'études politiques, 2017, p. 147.

20. FitzGerald, "Après 1932," p. 148.
21. While secretly providing the Republicans with arms. My thanks to Maurice Vaïsse for his advice on these complex political details.
22. Geneviève Dreyfus-Armand, "Les camps d'internement d'exilés espagnols. Interview with Geneviève Dreyfus-Armand by Valentin Rodrigez and Annabelle Ténèze," in Bouvard and Mercier, *Guernica*, pp. 236–37.
23. Pierre Girard, "Le goût du ministre," in *Le Front populaire et l'art moderne: Hommage à Jean Zay*, Orléans, Musée des Beaux-Arts, 1995, pp. 67–72.
24. MnPP, Picasso personal archives, 515AP/C/22/undated.
25. MnPP, Picasso personal archives, 515AP/C/22/22 August 1927.
26. After the *Monument to Apollinaire* (1928), which ended in failure.
27. Mousseigne, *Rideau de scène*, p. 8. The drawing is found in the Musée national Picasso-Paris.
28. MnPP, Picasso personal archives, 515AP/C/dossier réservé/30 July 1936.
29. MnPP, Picasso personal archives, 515AP/C/dossier réservé/25 July 1936.
30. PPP, B/a 1711, doss. 138.000-L25, "Au sujet de l'activité politique des Italiens résidant en France," mimeographed report of October 15, 1924; and PPP, B/a 65p, doss. 51.343–10, letter of November 28, 1933, from the police prefect to the minister of the interior (head of the Sûreté Générale, 2nd office), official letters denouncing foreigners who "get mixed up in political agitation and do not show the respect required of visitors to our country," in Rosenberg, *Policing Paris*, p. 91.
31. "Ponencia colectiva," *Hora de Espana*, no. 8, pp. 87–90.
32. www.laberintosvsjardines.blogspot.com, letter of 26 September 1936.
33. Éluard, *Lettres à Gala*, p. 270, letter of 15 September 1936.
34. Renau's personal secretary at the time was Antonio Deltoro. Quoted in Herold-Marme, *L'Identité artistique*, p. 122. The document—undated, held at the Archivo Historico Nacional—was itself cited in Miguel Cabañas Bravo, "Picasso y su ayuda a los artistas españoles de los campos de concentracion franceses," *Congreso international La Guerra Civil Española*, 1936–1939, Madrid, Sociedad estatal de conmemoraciones culturales, 2006, p. 2.
35. *El Mono azul*, 24 September 1936, no. 5, p. 7, in Herold-Marme, *L'Identité artistique*, p. 122.
36. www.laberintosvsjardines.blogspot.com.
37. www.laberintosvsjardines.blogspot.com, letter of 24 September 1936.
38. https://guernica-admin.museoreinasofia.es/en/document/antonio-rodriguezmoreys-manuel-azanas-and-jesus-hernandez-tomass-letter-pablo-picasso.
39. Éluard, *Lettres à Gala*, p. 271.
40. Laurence Bertrand Dorléac, "Le monument aux Espagnols morts pour la France," in Bouvard and Mercier, *Guernica*, p. 245.
41. Herold-Marme, *L'Identité artistique*, p. 121.
42. From 25 January to 25 February.
43. Pablo Picasso, *Écrits*, ed. M.-L. Bernadac and C. Piot, Paris, RMN/Gallimard, 1989.

44. Émilie Bouvard, "*Guernica* in situ," in Bouvard and Mercier, *Guernica*, p. 14.
45. Widmaier-Picasso, *Picasso and Maya*, p. 80, photos from 25 February 1937.
46. Preserved in the archives of the Musée national Picasso-Paris, MP1178–1191.
47. Anne Wagner, "Mater Dolorosa: Les femmes de *Guernica*," in Bouvard and Mercier, *Guernica*, p. 116.
48. Emilia Philippot, "Les premières études pour le pavillon espagnol," in Bouvard and Mercier, *Guernica*, pp. 122–29.
49. *Gernika* is the Basque name of the town used by the locals, while the Spanish, in Castilian, call it *Guernica*.
50. Mathieu Corman, "Visions de Guernica en flammes," *Ce Soir*, 1 May 1937, in Bouvard and Mercier, *Guernica*, p. 13.
51. Bouvard and Mercier, *Guernica*, p. 167.
52. From his "internal mnemosyne atlas," the pretty phrase of Émilie Bouvard, in Bouvard and Mercier, *Guernica*, p. 13.
53. Émilie Bouvard, "*Guernica* de A à Z: dictionnaire non exhaustif des sources iconographiques du Vatican à la guerre d'Espagne," in Bouvard and Mercier, *Guernica*, pp. 23–31.
54. Bouvard and Mercier, *Guernica*, p. 69.
55. Violette Andrès, "Les métamorphoses de *Guernica* dans l'objectif de Dora Maar," in Bouvard and Mercier, *Guernica*, p. 148.
56. Bouvard and Mercier, *Guernica*, p. 151.
57. Bouvard and Mercier, *Guernica*, state IV, p. 153; state VI, p. 154.
58. Mary Ann Caws, *Les Vies de Dora Maar: Bataille, Picasso et les surréalistes*, London, Thames and Hudson, 2000, pp. 40, 41.
59. Christian Zervos, "Conversations avec Picasso," *Cahiers d'art*, 1935, in Andrès, "Métamorphoses de *Guernica*."
60. Violette Andrès, interview with the author, Paris, 11 February 2020.
61. Michel Leiris, "Faire-part," *Cahiers d'art*, no. 4–5, in Bouvard and Mercier, *Guernica*, pp. 168–69.
62. Androula Michaël, "'Mais quel silence ferait plus de bruit que la mort': Les textes poétiques de Pablo Picasso contemporains de *Guernica*," in Bouvard and Mercier, *Guernica*, p. 100.
63. Jean Cassou, "Le témoignage de Picasso," *Cahiers d'art*, no. 4–5, 1937, pp. 112–13.
64. Einstein and Kahnweiler, *Correspondance*, p. 95.
65. MnPP, Picasso personal archives, 515AP/C/43/24 July 1939.
66. Géraldine Mercier, "Picasso au coeur du réseau d'aide aux républicains," in Bouvard and Mercier, *Guernica*.
67. MnPP, Picasso personal archives, 515AP/C/81/13 February 1939.

EPILOGUE: ON ALFRED BARR'S DIAGRAM

1. Félix Guattari and Gilles Deleuze, *Rhizome*, Paris, Éditions de Minuit, 1976, pp. 60–62.
2. "The Art of Picasso," *The New York Times*, 9 November 1930.
3. There was also interest in Great Britain, thanks to the historian Roland Penrose and his exhibition *Surrealism*, inaugurated in June 1936, at the same time as the International Surrealist Exhibition, at New Burlington Galleries in London.

4. FitzGerald, *Making Modernism*, p. 121.
5. The collector John Quinn dealt directly with Picasso, bypassing Rosenberg and recovering 50 percent of the profit for artist and collector (FitzGerald, *Making Modernism*, p. 125).
6. *21 rue La Boétie: Picasso, Matisse, Braque, Léger*, exhibition catalog, Paris, Hazan/musée Maillol, 2017, based on the book by Anne Sinclair.
7. FitzGerald, *Making Modernism*, p. 125.
8. MnPP, Picasso personal archives, 515AP/E/16/17 August 1937.
9. MnPP, Picasso personal archives, 515AP/E/16/1 March 1939.
10. The Valentine Gallery presented "Abstractions of Picasso" from 5 January to 5 February 1931.
11. Kimberly Jones, interview with the author, Washington, D.C., 24 May 2018; and Jones and Daniels, *The Chester Dale Collection*, p. 14. See also National Gallery of Art, Washington, D.C., Curatorial Record, Chester Dale Collection, *Family of Saltimbanques*; and National Gallery of Art, Washington, D.C., Gallery Archives, Chester Dale Papers, RG 28C (particularly Chester and Maud Dale Life and Travels 28C2 and Maud Dale Files 28C3, 4–2).
12. MnPP, Picasso personal archives, 515AP/E/16/30 June 1931.
13. Alfred H. Barr Jr., *Painting in Paris from American Collections*, New York, MoMA, 1930, pp. 13–14, 35–37.
14. Barr Jr., *Painting in Paris*, p. 37.
15. Bezzola, *Picasso: Sa première exposition*, pp. 83, 87.
16. Exhibition held from March 2 to April 19, 1936.
17. Herold-Marme, *L'Identité artistique*, p. 118.
18. Exhibition held from December 9 to January 17, 1937.
19. Seckel, "Éléments pour une chronologie," p. 614.
20. Seckel, "Éléments pour une chronologie," p. 618.
21. Cohen-Solal, "*Les Demoiselles* s'en vont," in *"Un jour, ils auront des peintres"*, p. 482.
22. MnPP, Picasso personal archives, 515AP/E/16/12 September 1939.
23. Dominique Paulvé, *Marie Cuttoli: Myrbor et l'invention de la tapisserie moderne*, Paris, Éditions Norma, 2010, pp. 90–93.
24. Erving Goffman, *The Presentation of Self in Everyday Life*, New York, Anchor Books, 1959.
25. René Gimpel, *Journal d'un collectionneur marchand de tableaux*, Paris, Calmann-Lévy, 1963, p. 384.
26. Edward Ross (*Social Control*), as quoted in Goffman, *La Mise en scène*, p. 21.
27. André Dézarrois, who wrote about Catalan art (from the tenth to the fifteenth centuries), first worked at the Musée du Luxembourg—Musée des artistes vivants (1818–1937)—as assistant to Léonce Bénédite from 1921 to 1925, then alone from 1925 to 1926. In December 1926, he became director of the Musée des écoles étrangères au Jeu de Paume, which had been created in 1921 (as an annex to the Musée du Luxembourg).
28. MnPP, Picasso personal archives, 515AP/E/14/22 July 1937.
29. Organized in a few weeks, *The Masters of Independent Art* offered—for the first time in France—a coherent overview of modern European art. Ironically, it began two weeks before the inauguration of the exhibition *Entartete Kunst* (Degenerate Art) in Munich, which showed, as if in a negative, the

modern European art rejected by the Nazis and yet illogically exhibited by them. Although the Parisian exhibition included only 177 works and was visited by only five thousand people, it owes its place in history to being the first attempt to present modernity, just after *Cubism and Abstract Art*, organized by Alfred H. Barr Jr. at MoMA in New York, in 1936; see Laurence Bertrand Dorléac, *L'Art de la défaite (1940–1944)*, Paris, Seuil, 2010, pp. 213–14.

30. Androula Michaël, *Picasso poete*, Paris, École nationale supérieure des beaux-arts, 2008, p. 25. For the details of these transactions, see Jean-Hubert Martin, "Picasso et les institutions françaises," in *Picasso, l'etranger*, exhibition catalog, Paris, MNHI/MnPP/Fayard, 2021.
31. MnPP, Picasso personal archives, 515AP/E/14/30 October 1923.
32. MnPP, Picasso personal archives, 515AP/C/86/20 November 1938.
33. Neil Harris, *The Artist in American Society*, Chicago, University of Chicago Press, 1982.
34. "Connoisseur-scholars," see Paul Sachs, "Tales of an Epoch," unpublished memoir, 1956, Fogg Museum Archives, Harvard University, p. 43. Many thanks to Justin Vaïsse for his assistance with this research.
35. Sachs, "Tales of an Epoch," pp. 150–73.

PROLOGUE: IN THE HEART OF DARKNESS

1. Sabartés, *Picasso: Portraits et souvenirs*, p. 233.
2. Sabartés, *Picasso: Portraits et souvenirs*, pp. 224–36.

38. TAKING SHELTER

1. Sabartés, *Picasso: Portraits et souvenirs*, p. 275.
2. Bertrand Dorléac, *L'Art de la défaite*; Becker, *Picasso et la guerre*; Jonathan Petropoulos, *Artists Under Hitler: Collaboration and Survival in Nazi Germany*, New Haven, Yale University Press, 2014; as well as various biographies, memoirs, and exhibitions (*Picasso et la guerre*, Musée de l'Armée, Paris, 2018; *Au cœur des ténèbres*, Musée de Grenoble, December 2019), to mention only the most recent.
3. "The qualities required for judges at the Ministry of Justice," wrote Claire Zalc, are very precise. "Each agent is specialized, because naturalization issues are very different from the experiences of those trained in the courts [. . .]. The task of admitting foreigners into the French community is vitally important, particularly after two wars that have created such gaps in our population" (Claire Zalc, *Dénaturalisés*, Paris, Seuil, 2016, p. 68, note 63).
4. PPP, dossiers de naturalisation d'étrangers célèbres, IC 5.
5. Sabartés, *Picasso: Portraits et souvenirs*, pp. 279–80.

39. SURVIVING

1. Daniel Lindenberg, *Les Années souterraines (1937–1947)*, Paris, La Découverte, 1990, pp. 12, 24, 54.
2. This moment of intensifying xenophobia is remarkable in a state occupied by the Nazis that was already xenophobic. And it goes hand in hand with the fact that modern art had already been denounced as a threat to France's "ethnic" aspirations by someone as xenophobic as Mauclair, since it lambasted the logic of domination behind the colonial system by modifying the

way we regarded non-Western objects, societies, and systems of thought. See Julia Kelly, "The Ethnographic Turn," in David Hopkins (ed.), *A Companion to Dada and Surrealism*, Chichester, West Sussex, Wiley Blackwell, 2016.

3. Laurence Bertrand Dorléac even writes that Picasso "served as a nationalist bogeyman who could be twisted to provide an acceptable idea of his uniqueness, if not his strength," Laurence Bertrand Dorléac, "Picasso espagnol en France," in Marie-Claude Blanc-Chaléard et al. (eds.), *D'Italie et d'ailleurs: Mélanges en l'honneur de Pierre Milza*, Rennes, Presses universitaires de Rennes, 2014, p. 227.

4. Zalc, *Dénaturalisés*, p. 11.

5. Robert O. Paxton, Olivier Corpet, and Claire Paulhan, "Au fond de l'abîme," in *Archives de la vie littéraire sous l'Occupation: A travers le desastre*, Paris, Tallandier/Imec, 2009, pp. 6–17.

6. During the postwar trials, Ziegler admitted to having given this speech but claimed that he had been forced to do it by the Ministry of Propaganda. See Jonathan Petropoulos, *The Faustian Bargain: The Art World in Nazi Germany*, London/New York, Oxford University Press, 2000, p. 259.

7. Bertrand Dorléac, *L'Art de la défaite*, p. 21.

8. Bertrand Dorléac, *L'Art de la défaite*, p. 21.

9. Joseph Goebbels, *Journal (1939–1942)*, Paris, Tallandier, 2009, 31 August 1940, p. 189.

10. Bertrand Dorléac, *L'Art de la défaite*, pp. 25–26.

11. Bertrand Dorléac, *L'Art de la défaite*, p. 27.

12. Sophie Bernard (ed.), *Picasso: Au coeur des ténèbres (1939–1945)*, exhibition catalog, Paris, In Fine éditions, p. 135.

13. Bernard, *Picasso: Au coeur*, p. 170.

14. Lequerica started his job in Paris in March 1939, to the great joy of Parisian Franco supporters. His counterpart in Spain, appointed by Daladier, was none other than Marshal Pétain. On March 27, Lequerica and Bonnet negotiated the return of Spanish refugees, whom France wanted to send back to Spain as soon as possible (after an initial total of 500,000, there were still 260,000 remaining in mid-June 1939). Lequerica, as a good fascist, blamed the European conflict on the Jews and Bolsheviks, allies of "French radicalism, eternally Jacobin and warmongering, ready to resort to violence to restore freedom in the world, as they did in 1793." During his embassy receptions, Lequerica would end his speeches with cries of "Long live Franco!" and "Down with Blum!," and he often expressed his concern that Reynaud and Mandel were capable of "allying with American Jewry to ignite the conflict on another continent and unleash the slaughter that the catastrophic genius of the chosen people loved so dearly."

15. MnPP, Picasso personal archives, 515AP/C/120/27 June 1940.

40. PLAYING WITH FIRE

1. Goebbels, *Journal*, 2 April 1942, p. 529.

2. Martin Broszat, *L'État hitlerien*, Paris, Fayard, coll. "Pluriel," 2012.

3. Émilie Bouvard (with Sandrine Nicollier), "Pablo Picasso, 'correspondant de guerre,' 1 September 1939–25 August 1944," in Becker, *Picasso et la guerre*, p. 150.

4. André Lhote, *La Peinture libérée*, Paris, Grasset, 1956, p. 11.

5. Maurice de Vlaminck, "Opinions libres . . . sur la peinture," *Comoedia*, 6 June 1942, p. 6.

6. Bertrand Dorléac, *L'Art de la défaite*, pp. 187–89.

7. Gerhard Heller, Ernst Jünger, and Hans Kuhn (a corporal in a department of the Kommandantur at the Hôtel Meurice), eating dinner together at La Tour d'Argent after all three of them had recently visited his workshop, had a long discussion on Picasso's "magical influence" (Bertrand Dorléac, *L'Art de la défaite*, p. 196).

8. Abel Bonnard, speech at l'Orangerie des Tuileries, 15 May 1942, p. 5.

9. Jacques Benoist-Méchin, speech at the opening of the exhibition *Arno Breker*, at l'Orangerie des Tuileries, 15 May 1942, pp. 7–9.

10. Jean Cocteau, *Journal (1942–1945)*, ed. J. Touzot, Paris, Gallimard, 1989, Monday 10 May 1942, p. 112.

11. Cocteau, *Journal*, p. 127.

12. Cocteau, *Journal*, Saturday 23 May 1942, p. 132.

13. *Le Journal*, 6 September 1941.

14. Brassaï, *Conversations avec Picasso*, pp. 76–78.

15. Cocteau, *Journal*, Thursday 2 July 1942, p. 175.

16. Cocteau, *Journal*, p. 173.

17. Cocteau, *Journal*, 9 January 1943, p. 234.

41. WORKING

1. Sabartés, *Picasso: Portraits et souvenirs*, p. 275.

2. Erving Goffman, *Asiles*, Paris, Éditions de Minuit, 1968.

3. Bernard, *Picasso: Au coeur*, p. 155.

4. Walter Benjamin, *Sur le concept d'histoire*, Paris, Plon, 1990, thesis VI.

5. Pablo Picasso, *Le Désir attrapé par la queue*, Paris, Gallimard, 1945, acte VI, p. 66.

6. Jèssica Jaques Pi, "Repenser Picasso," *Proceedings of the European Society for Aesthetics*, no. 7, 2015, pp. 297–315; Jèssica Jaques Pi, "Ce qui mijote dans *Le Désir attrapé par la queue* ou la dramaturgie gastro-poïétique sous l'Occupation," in Guigon et al., *La Cuisine de Picasso*, pp. 203–15.

7. Daix, *Nouveau Dictionnaire Picasso*, p. 473. On this entire sequence, see the discussion of Seckel, Chevrière, and Henry, *Max Jacob et Picasso*.

8. This is what Georges Prade's testimony would suggest. Prade, a notorious collaborator, who could hardly be suspected of harboring any sympathies for Picasso, was the one who dispatched Cocteau's petition. See Georges Prade, "Picasso réhabilité," *Le Figaro*, 19 March 1982, p. 26.

42. FINDING HIS PLACE, IN A DIFFERENT WAY

1. Stéphane Courtois, *Le PCF dans la guerre*, Paris, Ramsay, 1980, p. 233.

2. Charles de Gaulle, *Discours et messages*, Paris, Plon, 1970, vol. 1, p. 122.

3. Gabriel Péri, *Les lendemains qui chantent*, autobiography, ed. L. Aragon, Paris, Éditions sociales, 1947.

4. By introducing measures including residence permits, identity cards, social legislation, rules on expulsions, and civil and political rights.

5. Stéphane Courtois, "Les partis politiques et la question de l'immigration:

1936–1948," in Pierre Milza and Denis Peschanski (eds.), *Italiens et Espagnols en France (1938–1946)*, Paris, IHTP-CNRS, 1991, pp. 197–214.

6. Courtois, "Les partis politiques," pp. 197–214.
7. Stéphane Courtois, Denis Peschanski, and Adam Rayski, *Le Sang de l'étranger: Les immigrés de la MOI dans la Résistance*, Paris, Fayard, 1989, p. 57.
8. Brassaï, *Conversations avec Picasso*, p. 168.

43. JUDGMENT TIME, PART I: BRIGADIER CHEVALIER'S PURIFICATION TRIAL

1. PPP, KB23.
2. Laurent Joly, *L'Antisémitisme de bureau*, Paris, Grasset, 2011.
3. Marcel Gaucher (1894–1944) and his son Jacques (1920–1944), Socialists and Resistance members from the earliest days of the Occupation, helped create the first intelligence and communication organizations between the nascent networks. Almost certainly denounced by Chevalier, arrested and deported, the father died at the Gross-Rosen camp, the son after leaving Buchenwald. On April 29, 1947, the mayor of Fontenay-sous-Bois, where they had lived, decided to pay tribute to their memory by naming part of Rue Castel after them (from Boulevard de Vincennes to Rue Émile-Roux). Their names can also be found engraved on the commemorative monument to the victims of World War II, the Mémorial de la Liberté, located on the corner of Avenue de Neuilly and Boulevard Gallieni in Fontenay. More recently, *Stolpersteine* have been embedded in the sidewalk outside Marcel and Jacques Gaucher's former residence. See https://archives.fontenay-sous-bois.fr/actualites/actualites-etzoom-archives/archives-2020/roger-se-souvient-de-marcel.

44. JUDGMENT TIME, PART II: COMMITTEES FOR THE CONFISCATION OF ILLICIT PROFITS

1. ADP, Impôt de solidarité nationale (ISN),1600W488/9946 (dossier Picasso). Many thanks to Vincent Tuchais for showing me this dossier, and to Isabelle Mazières for helping me decipher it.
2. Emmanuelle Pollack, *Le Marché de l'art sous l'Occupation*, Paris, Tallandier, 2019.
3. Archives diplomatiques (AD), Fonds de la commission de récupération artistique 209SUP/3 (dossier 45.35).
4. ADP, Comité de confiscation des profits illicites de la Seine (CCPI) 112 W 14 (dossier Fabiani), appearance of 7 February 1945.
5. ADP, Comité de confiscation des profits illicites de la Seine (CCP) 112 W 14 (dossier Fabiani), appearance of 18 April 1945.

V. THE ARTIST AS HERO

1. Bertolt Brecht, *Vie de Galilée*, 1947, Scène 12.

RADIO CORPORATION OF AMERICA

1. MnPP, Picasso personal archives, 515AP/E/16/15 December 1939.

"PICASSO: FORTY YEARS OF HIS ART" ITINERARY

1. Archives du Musée national Picasso-Paris (MnPP), Don Succession Picasso, 1992, 515AP/E/16.

45. THE VIEW FROM NEW YORK? ADOLF HITLER'S SWORN ENEMY

1. First interview of Picasso after the Liberation, with Peter D. Whitney, in the *San Francisco Chronicle*, in Alfred H. Barr Jr., "Picasso 1940–1944: A Digest with Notes," *Bulletin of the Museum of Modern Art*, vol. 12, no. 3, January 1945, p. 3.
2. Thomas C. Linn, "Picasso Exhibit Returns to City," *The New York Times*, 13 July 1941.
3. MnPP, Picasso personal archives, 515AP/E/16.
4. MnPP, Picasso personal archives, 515AP/E/16/12 September 1939.
5. André Masson, interview by Martica Sawin, *André Masson in America, 1941–1945*, New York, Zabriskie Gallery, 1996, p. 4.
6. Thomas Craven, "The Degradation of Art in America," in *Art-20th Century-Reactionary Criticisms*, New York, MoMA, 1948, in Ester Capdevila et al., *Be-bomb*, exhibition catalog, Barcelona, Museu d'Art Contemporani de Barcelona, 2007.
7. MnPP, Picasso personal archives, 515AP/E/16/31 October 1944.
8. Barr Jr., "Picasso 1940–1944."
9. MnPP, Picasso personal archives, 515AP/E/16/9 July 1956.
10. Pierre-Paul Montagnac to Marcel Mouillot, 14 September 1944: https://www.traces-ecrites.com/document/le-salon-d%C2%92automne-en-pleine-epuration-organise-une-exposition-picasso/.
11. MnPP, Picasso personal archives, 515AP/E/16/7 December 1944.
12. Émilie Bouvard, "Picasso, correspondant de guerre," pp. 150–55.
13. Michel Leiris, *Écrits sur l'art*, Paris, Gallimard, 2011, p. 318.
14. Martin Scheider, "Picasso libre," in Thomas Kirchner and Laurence Bertrand Dorléac, *Les Arts à Paris après la Libération: Temps et temporalités*, Heidelberg, arthistoricum.net, 2018, pp. 106–27.

46. THE VIEW FROM MOSCOW? FRANCO'S SWORN ENEMY

1. Geneviève Laporte, *Si tard le soir le soleil brille*, Paris, Plon, 1973, p. 15, in Daix, *Pablo Picasso*, p. 587.
2. Fred Kupferman, *Les Premiers Beaux Jours (1944–1946)*, Paris, Calmann-Lévy, 1985, p. 126.
3. Cocteau, *Journal*, p. 565.
4. Victoria Beck Newman, "'The Triumph of Pan': Picasso and the Liberation," *Zeitschrift für Kunstgeschichte*, no. 62, 1999, pp. 106–22.
5. Penrose, *Picasso*, p. 414.
6. Martin Schieder, "Photo Press Liberation. La libération de l'atelier parisien de Picasso en août 44," in Bernard, *Picasso: Au coeur*, pp. 52–59.
7. Picasso, interview by Pol Gaillard, *L'Humanité*, 29 and 30 October 1944.
8. Testimony of Stéphane Courtois, from the Komintern archives in Moscow, consulted by Sylvain Boulouque.
9. Annie Kriegel (with Guillaume Bourgeois), *Les Communistes français dans leur premier demi-siècle (1920–1930)*, Paris, Seuil, 1985, p. 140.
10. Daniel Lindenberg, *Les Années souterraines (1937–1947)*, Paris, La Découverte, 1990.
11. Courtois, "Les partis politiques," pp. 197–214.
12. Édouard Kowalski, *Les Immigrés au service de la France*, Paris, CADI, 1945, in Courtois, "Les partis politiques," pp. 197–214.

47. THE VIEW FROM SAINT-ÉTIENNE, NICE, ALÈS, AUBERVILLIERS?
BENEFACTOR OF THE WORKING CLASSES

1. MnPP, Picasso personal archives, 515AP/E/14/7 November 1944.

48. THE VIEW FROM CÉRET, GRENOBLE, LYON, ANTIBES?
THE ARTIST-PROPHET

1. MnPP, Picasso personal archives, 515AP/C/38/March 1948 or 1949.
2. MnPP, Picasso personal archives, 515AP/C/24/10 May 1946.
3. During the war, he notably took in a young Jewish teenager from Paris, Francis Lévitan, and then an artist escaped from Auschwitz, Michal Smajewski (alias Michel Sima), who introduced him to Picasso in 1946.
4. MnPP, Picasso personal archives, 515AP/C/38/27 March 1949.

49. THE VIEW FROM PARIS? "GENIUS" (FINALLY) RECOGNIZED
BY THE STATE

1. Jean Cassou, "Don de Picasso au musée d'Art moderne," *Bulletin des musées de France*, no. 6, 1947, p. 14.
2. Based on the collections of the Musée du Luxembourg (for living artists) and the collection of the Jeu de Paume museum (for "foreign schools").
3. Jacques Michel, "Jean Cassou et les cimaises de l'art vivant," *Le Monde*, 27 January 1986.
4. Rosalind Krauss, *The Picasso Papers*, London, Thames and Hudson, 1998, p. 227.
5. Pierre Loeb, *Voyages à travers la peinture*, Paris, Bordas, 1946, p. 54, in Moulin, *Marché de la peinture*, pp. 271–72.
6. Laurent, *Arts et pouvoirs*, p. 154.
7. An ancestor whose name he shares, Jean Savin, a Poitiers landowner and career soldier, joined the counterrevolutionary war in the Vendée as part of the "Catholic and Royal Army of Bas-Poitou and the Pays de Retz" in 1793, before being executed by firing squad in 1796.
8. Jean-Paul Sartre, *Questions de méthode*, Paris, Gallimard, 1986, p. 20.
9. Daix, *Pablo Picasso*, p. 444, quoting Françoise Gilot.
10. PPP, dossiers de naturalisation des étrangers célèbres, IC 5.
11. Archives du Musée des Arts décoratifs (MAD), IY1440 and D1/296.
12. After the war, French commissioners and curators tried hard to make up for the mistakes of officials during the 1920s and 1930s, but it was often too late. *Les Demoiselles d'Avignon* was always the painting most desperately sought by France, and the one the Americans were least willing to release. Already promised to an exhibition in Buffalo, it would not be loaned to the Musée des Arts décoratifs. On February 4, 1955, Alfred H. Barr Jr. wrote to Kahnweiler: "I would recommend any loan from our collection with the exception of *Les Demoiselles d'Avignon*." Archives of the Museum of Modern Art (MoMA), Alfred H. Barr Jr. Papers, AHB, XI.B.18.
13. Based on a photograph by Willy Maywald.
14. MnPP, Picasso personal archives, 515AP/C/117/18 December 1955.
15. Archives du Musée des Arts décoratifs (MAD), Alfred H. Barr Jr. Papers, D 1/296.
16. MoMA, Alfred H. Barr Jr. Papers, AHB, XI.B.18.

17. MoMA, Alfred H. Barr Jr. Papers, AHB, XI.B.18, 28 June 1955.
18. MoMA, Alfred H. Barr Jr. Papers, AHB, XI.B.18, 26 January 1956.

50. THE "GREAT STALIN" VERSUS "COMRADE PICASSO"?

1. Gilot and Lake, *Vivre avec Picasso*, p. 283.
2. Interview in *Le Monde*, 13 March 1953.
3. Marcel Cachin, Maurice Thorez, Madeleine Riffaud, Paul Langevin, Henri Martin, Max Barel, Níkos Beloyánnis, Ethel and Julius Rosenberg, Djamila Boupacha, Madeleine Braun.
4. Aragon reproached him for painting a "massacre of innocents."
5. Lynda Morris and Christoph Grunenberg, *Picasso: Peace and Freedom*, London, Tate Publishing, 2010.
6. Roland Dumas and Thierry Savatier, *Picasso: Ce volcan jamais éteint*, Paris, Bartillat, 2018.
7. Such is Maurice Vaïsse's theory: "From 1951, Picasso's relations with the PCF grew tense, as—in the absence of its general secretary Maurice Thorez—the party perceptibly drifted. The workerist section, led by André Fougeron, reached its apotheosis with the exhibition *Le pays des mines*, organized by the party in 1951" (Maurice Vaïsse, "Picasso et la guerre froide," in *Picasso et la guerre*, Paris, Gallimard, Musée de l'Armée/Musée national Picasso-Paris, p. 220).
8. My thanks to Maurice Vaïsse, Rachel Mazuy, and Souria Sadekova for the documents on de Gaulle, Thorez, and Jean-Richard Bloch circa 1944 in Moscow.
9. Auguste Lecoeur, "Le peintre à son créneau," *L'Humanité*, 8 December 1950.
10. Jeannine Verdès-Leroux, *Au service du Parti*, Paris, Fayard/Éditions de Minuit, 1983, p. 314.
11. Pignon was the only artist in the party who supported Picasso.
12. Verdès-Leroux, *Au service du Parti*, p. 304.
13. Jeannine Verdès-Leroux rightly recalls the "obvious relationship between his independence from the institution and the capital he accumulated in his own right" (Verdès-Leroux, *Au service du Parti*, p. 356).
14. Annette Wieviorka, "Les Thorez et les peintres," in *Maurice et Jeannette: Biographie du couple Thorez*, Paris, Fayard, 2010, pp. 489–522.
15. Pierre Thorez, telephone interview with the author, 26 May 2020.
16. Archives municipales d'Ivry (AMI), fonds Thorez-Vermeersch, document of 6 December 1963.
17. Archives municipales d'Ivry (AMI), document of 24 January 1964.
18. MnPP, Picasso personal archives, 515AP/C/168/6 March 1964.
19. Wieviorka, *Maurice et Jeannette*, p. 437.
20. Hélène Parmelin, *Libérez les communistes!*, Paris, Stock, 1979, p. 255.
21. MnPP, Picasso personal archives, 515AP/C/117/26 June 1956.
22. MnPP, Picasso personal archives, 515AP/C/117/25 October 1956.
23. MnPP, Picasso personal archives, 515AP/C/117/October 1956.
24. MnPP, Picasso personal archives, 515AP/C/117/October 1956.
25. MnPP, Picasso personal archives, 515AP/C/117/5 October 1956.
26. MnPP, Picasso personal archives, 515AP/C/117/October 1956.

EPILOGUE

1. Romuald Dor de La Souchère, "Picasso au musée d'Antibes," *Cahiers d'art*, no. 1, 1948, p. 16.

51. FROM POLICE CHIEF ROUQUIER TO J. EDGAR HOOVER

1. Picasso, "Why I Became a Communist," *The New Masses*, 24 October 1944.
2. Claire A. Culleton, *Joyce and the G-Men: J. Edgar Hoover's Manipulation of Modernism*, New York, Palgrave Macmillan, 2004.
3. Herbert Mitgang, "When Picasso Spooked the FBI," *The New York Times*, 11 November 1990.
4. Sarah Wilson, "Loyalty and Blood: Picasso's FBI File," in Jonathan Harris and Richard Koeck (eds.), *Picasso and the Politics of Visual Representation: War and Peace in the Era of the Cold War and Since*, Liverpool, Tate Liverpool Critical Forum, 2013, p. 133.
5. This tradition criticized art in general, while denigrating artists in particular as useless citizens. See Harris, *The Artist in American Society*.
6. Wilson, "Loyalty and Blood," p. 140.
7. Richard Hofstadter, *Anti-Intellectualism in American Life*, New York, Alfred A. Knopf, 1963, pp. 14–15.
8. *Chicago Daily Sun-Times*, 17 August 1949; see Wilson, "Loyalty and Blood," p. 134.
9. Voice of America, created in 1942, is an official propaganda agency that broadcasts federal government policy to an international audience in forty-seven languages.
10. Mitgang, "When Picasso Spooked."
11. Mitgang, "When Picasso Spooked," p. 1, document of 11 August 1957.
12. MoMA, Alfred H. Barr Jr. Papers, AHB, XI.B3.

52. AN APPRENTICE CERAMIST IN A POTTER'S VILLAGE

1. Marie Sincère Romieu (pseudonym of Marie Dubreuil de Saint-Germain, who became Madame Philarète Chasles, writer and agronomist), "La commune et la mairie de Vallauris (Provence)," *Journal de l'agriculture, de la ferme et des maisons de campagne, de la zootechnie, de la viticulture, de l'horticulture, de l'économie rurale et des intérêts de la propriété*, no. 1, 1866 (newspaper founded and edited by J. A. Barral with the support of farmers from all over France and abroad).
2. What must have drawn Picasso to Suzanne Ramié's work was her invention of audacious and purified forms. Her training as a designer soon led her to imagine forms that bore no resemblance to anything created locally. The pieces are either purefied and refined, such as slender bottles or vases shaped like spinning tops, or they are fantastical: coffeemakers with a sort of goiter, constructivist teapots, lamps shaped like women, candlesticks decorated with protuberances. Her influences were Cycladic, Minoan, Mycenaean, and Cypriot.
3. Georges Ramié, "Ceci est notre témoignage," Imprimerie Arte, 24 October 1971, in Anne Dopffer (ed.), *Picasso: Les années Vallauris*, exhibition catalog, Paris, RMN/Flammarion, 2018, pp. 154–64.
4. Whether for ceramics or for engravings, Picasso did not discover these tech-

niques in Vallauris. In 1894, in La Coruña, when he was only thirteen, he decorated a black ceramic plate with a popular scene criticizing the clergy. For the details of this work, *Vinos El Rivero* (1894, oil on ceramic plate, collection Enrique García Herráiz), see Eduard Vallès, "Quelques notes sur l'iconographie du populaire chez le jeune Picasso: Anticipations et transgression," in *Picasso et les arts et traditions populaires: Un génie sans piédestal*, MuCEM, Marseille, April 26 to August 29, 2016, exhibition catalog, Paris, Gallimard, 2016. Then, between 1902 and 1906 in Paris, with the sculptor Paco Durrio, Picasso learned the art of baking terra-cotta. He immediately used this knowledge when he came back into contact with earth during his first visit to Vallauris for the ceramics exhibition of 1946. In the 1910s, to illustrate the works of his friend Max Jacob, he used aqua fortis (and then learned engraving), before etching and printing the famous *Vollard Suite* with the printer Mourlot between 1930 and 1937.

53. EXPERIMENTATION AND PRODUCTIVITY

1. According to Harald Theil, this was "metamorphosis through combination": "Les vases plastiques de Picasso: Survivances et renouveau de la céramique méditerranéenne," in Bruno Gaudichon and Joséphine Matamoros (eds.), *Picasso céramiste et la Méditerranée*, Paris, Gallimard, 2013, p. 71.
2. Sylvie Vautier, *Picasso/Picault, Picault/Picasso: Un moment magique entre amis; Vallauris (1948–1953)*, New York, Pointed Leaf Press, 2016.
3. Salvador Haro González, "Sources populaires de la céramique de Picasso," in *Picasso et les arts et traditions populaires*, p. 167.

54. THE APPRENTICE TURNED LEADER

1. MnPP, Picasso personal archives, 515AP/C/134/March 1955.
2. González Martí, four years older than Picasso, was an interesting character: a very learned man who trained as both a lawyer and an artist in Valencia, he became director of the school of ceramics in Manises before donating his ceramics collection to the Spanish State, which, on February 6, 1947, created the National Museum of Ceramics (of which González Martí would be director for life).
3. MnPP, Picasso personal archives, dossier E 15, letter of 18 November 1955.
4. In the culture of al-Andalus, *soccarats* were used to decorate ceilings.
5. Interview on Radio Nice, INA, PHD 99103942.
6. Vautier, *Picasso/Picault, Picault/Picasso*, p. 96.
7. 4 July 1958.
8. Anne-Françoise Gavanon, "Arnéra, Picasso et la linogravure," in Dopffer, *Picasso: Les années Vallauris*, pp. 198–211.
9. Pierre Daix, "Entretien avec Heinz Berggruen," in Anne Baldassari (ed.), *Picasso-Berggruen: Une collection particulière*, Paris, Flammarion/RMN, 2006, p. 15.
10. Olivier Berggruen, "Heinz Berggruen, le regard d'un fils," in Baldassari, *Picasso-Berggruen*, p. 201.
11. Daix, "Entretien avec Heinz Berggruen," p. 201.
12. As facsimiles.

13. André Villers, Pablo Picasso, and Jacques Prévert, *Diurnes*, Paris, Éditions Berggruen, 1962.
14. To reproduce them at a rate of 25 to 500 copies at the Madoura workshop.
15. Yves Peltier, "L'édition de céramiques de Picasso par Madoura, un outil de démocratisation de l'art," in Dopffer, *Picasso: Les années Vallauris*, pp. 164–74.
16. Salvador Haro González, "Picasso et la tradition céramique," in Dopffer, *Picasso: Les années Vallauris*, p. 148.

55. FROM THE COLOR LINE TO THE SUBALTERN WORLD

1. MnPP, Picasso personal archives, 515AP/C/23/20 October 1947.
2. In 1946, Sartre gave his preface to the first anthology of poetry from Africa, Madagascar, and the Caribbean the title "Black Orpheus."
3. Édouard Glissant, René Depestre, Frantz Fanon.
4. Léopold Sédar Senghor, Amadou Hampâté Bâ, Cheikh Anta Diop.
5. Richard Wright, James Baldwin, Joséphine Baker.
6. Robert Vitalis, *White World Order, Black Power Politics: The Birth of American International Relations*, Ithaca, Cornell University Press, 2015, pp. 139–40.
7. Arjun Appadurai, *Modernity at Large: Cultural Dimensions of Globalization*, Minneapolis, University of Minnesota Press, 1996.
8. Dipesh Chakrabarty, *Provincializing Europe: Postcolonial Thought and Historical Difference*, Princeton, Princeton University Press, 2000. See also Dipesh Chakrabarty, "A Small History of Subaltern Studies," in *Habitations of Modernity: Essays in the Wake of Subaltern Studies*, Chicago, The University of Chicago Press, 2002.
9. Archives of the author, letter dated 18 September 2018.

56. AN HONORARY CITIZEN WHO NEVER FORGOT THE HARDSHIP OF THE WINTER OF 1907–1908

1. André Tabaraud, *Mes années Picasso*, Paris, Plon, 2002, pp. 161–63.

57. INTEGRATION, INFLUENCE, AND SUBVERSION IN CANNES, VAUVENARGUES, AND MOUGINS

1. Kahnweiler and Crémieux, *Mes galeries et mes peintres*, p. 128.
2. Nicolas Pignon, interview with the author, Paris, 9 November 2020.
3. Anne Clergue, interview with the author, Paris, 9 November 2020.
4. Quentin Laurens, interview with the author, Paris, 23 October 2020.
5. Christine Piot, interview with the author, Paris, 16 and 18 October 2020.
6. Jèssica Jaques Pi, "*Las Meninas* de Picasso, 1957: calligrafies de la indisciplina," in Antoni Marí (ed.), *La Modernitat Cauta: Resignació, Restauracio, Resistencia (1942–1962)*, Barcelona, Angle Editorial, 2014, pp. 213–31.

58. OLD DEBATES REVIVED

1. MnPP, Picasso personal archives, 515AP/C/81/1 February 1959.
2. MnPP, Picasso personal archives, 515AP/C/81/10 January 1961.
3. After this, the museum would benefit from two other sizable gifts: from Jacqueline Picasso in 1990 and from the heirs of Dora Maar in 1998.

59. PORTRAIT OF THE "OLD MASTER" AS A *MÉTÈQUE* (METIC)

1. "Hommage à Pablo Picasso," ministère d'État, affaires culturelles, Paris, 1966, unpaginated.
2. ". . . according to the definition of sociologist Robert Castel," according to François Hartog, *Régimes d'historicité*, Paris, Seuil, 2012, p. 17. See also Marcel Detienne and Jean-Pierre Vernant, *Les Ruses de l'intelligence: La* mètis *des Grecs*, Paris, Flammarion, 2018, particularly "La course d'Antiloque," pp. 21–41.
3. Hartog, *Régimes d'historicité*.
4. Diego Rodríguez de Silva y Velázquez, *Felipe IV anciano*, Madrid, Museo Nacional del Prado.
5. Marie-Laure Bernadac, "Painting as a Model," in Marie-Laure Bernadac, Isabelle Monod-Fontaine, and David Sylvester, *Late Picasso*, London, Tate Gallery, 1988, p. 55.
6. Fifteen paintings, completed 1954 to 1955.
7. Fifty-eight paintings, completed August–December 1957.
8. Between August 1959 and July 1962, he produced 27 paintings, 140 drawings, 3 linocuts, and a large number of cardboard models (Bernadac, "Painting as a Model," p. 70).
9. Bernadac, "Painting as a Model," p. 45.
10. Marie-Laure Bernadac, Emmanuel Guigon, Androula Michaël, and Claustre Rafart i Planas, *Abecedario, Picasso poeta*, Barcelona/Paris, Museu Picasso Barcelona/Musée national Picasso-Paris, p. 147.
11. Bernadac et al., *Abecedario, Picasso poeta*, p. 119.
12. Bernadac et al., *Abecedario, Picasso poeta*, p. 86.
13. Brassaï, *Conversations avec Picasso*, p. 354.
14. Madeline, *Archives de Picasso*, pp. 62–63.
15. Jean Charbonneaux, Roland Martin, and François Villard, *Grèce archaïque*, Paris, Gallimard, 1968.
16. Picasso, *Plat aux trois visages* (250 prints), produced in 1956 and available in colored linocut, colored enamel, and solid silver.

ACKNOWLEDGMENTS

On December 15, 2014, seven years after opening its doors to the public, the National Museum of Immigration in Paris was finally about to be inaugurated by François Hollande, the president of the republic. That morning, on the radio, as soon as the historian Benjamin Stora began recalling the impact of immigrants on the history of France, the name of the artist came up: "Who still remembers that Picasso was denied French naturalization?" Stora admonished listeners, broaching a topic that had long remained taboo in the country. It was then, confronted with such a blunt statement, at a time when a new migration crisis was starting to hit the world, that I decided to embark on this project.

Bridging wo disciplines that often remain estranged from each other—the history of art and history of immigration—was an enthralling venture. It benefited from the opening up of the Picasso archives under the aegis of Laurent Le Bon (then president of the National Picasso Museum in Paris), and the support of the Picasso Administration, the Picasso Museum in Barcelona, the Picasso Museum in Antibes, and the Archives of the Préfecture de Police, to start with. But the journey into the universe of Picasso the foreigner would not have gotten off the ground without the enthusiastic impulse of Leonard Lauder, whose involvement started early on, when I was still struggling with an inchoate idea. For her part, Emily Braun challenged me with probing questions, incisive suggestions, and all sorts of bibliographical treasures at every stage of this quest.

As I explored Picasso's ever-expanding academic field and considered the numerous epistemological questions that kept popping up, regular consultation with colleagues proved invaluable. Historians, sociologists, anthropologists, urbanists, economists, legal scholars, geographers, historians of art: all contributed stimulating comments, fertile leads, personal insights. Jeremy Adelman was the first to underscore that "too many people automatically infer that an *étranger* is one who has no agency—yours is a story of Picasso as an agent." He also suggested that I consider W.E.B. Du Bois's experience at the 1900 Exposition Universelle in Paris. Dipesh Chakrabarty and Rochona Majumdar embraced the idea of viewing Picasso through the lens of both subaltern studies and film studies at once, providing marvelous moments of intellectual exchange. Éloi Ficquet recommended the "hobo code" before stepping into the world of foreigners in 1900s Paris and evoked, with great talent, how the pluralistic cultures of the Mediterranean defined the last part of Picasso's life. Paul Gradvohl problematized many of my intuitions with characteristic finesse, brilliance, and dexterity. Laurent Joly proved himself expert at tracking down numerous police officials as though they were old friends. Jean-Jacques Neuer patiently explained the laws governing official donations and bequests in France. Two summers in a row, Jèssica Jaques Pi and Pep Montserrat guided us to the sharp peaks of the Pyrenees and the magnificent wonders of a utopian village called Gósol. Antoine de Tarlé read, reread, and revised my writing until the early hours of the morning. Maurice Vaïsse offered corrections, suggestions, recommendations, bibliographical leads. Patrick Weil alerted me to unexpected archival resources and personal contacts in the United States while remaining constantly available. Claire Zalc located documents at the speed of light, and proved expert at deciphering the intricacies of immigration documents, shifting seamlessly between micro-sociology and global history.

Moreover, my investigation was greatly nourished by interconnections between disparate archival institutions in Paris and its suburbs, across the French territory, as well as in Spain, Russia, and the

United States. Undoubtedly, this research would never have developed as widely as it did without the eagerness of various archivists who welcomed me into their institutions, listened, and suggested new and little-known caches of documents to explore, as well as names of other specialists at still more institutions. They were indispensable guides to the world of foreigners in France. Anne Liskenne (at the diplomatic archives of France, then at the Grande Chancellerie of the Legion of Honor), Sébastien Chauffour (at the archives of the Ministry for Europe and Foreign Affairs), Vincent Tuchais (at the archives of the city of Paris), Ines Rotermund-Reynard (at the Institut National d'Histoire de l'Art), Valentine Weiss (at the Centre de Topographie Parisienne at the National Archives), and Céline Delétang (at the collections of the Department of Justice and the Department of the Interior at the National Archives) are foremost among them.

When it came to capturing the scope of Picasso's international reach and influence, American colleagues took to heart the task of guiding me. At the Museum of Modern Art in New York, Michelle Elligott (in the steps of Rona Roob, the legendary first archivist) never failed to offer a warm welcome when I visited Fifty-fourth Street to view the papers of Alfred H. Barr Jr. At the National Gallery of Art, home of Picasso's remarkable *Saltimbanques*, Harry Cooper (senior curator and head of modern art) was an impeccable guide to the museum's collection and introduced me to Ann Hoenigswald (conservation), Kimberly Jones (curator), Michele Willens (senior archivist), and Kurt G. F. Helfrich (in charge of the Dale Papers at the National Gallery's archive), as well as Ann Halpern and Jennifer Henel (curatorial records), and Andrea Gibbs (in the Department of Image Collections). At the library of the University of California, Santa Barbara, Bruce Robertson, Chair of Art History and director of the museum, opened wide the doors of their collections to me— where I was able to consult original catalogs from the 1900 Paris Exposition Universelle.

How could I possibly have absorbed the infinite number of books and catalogs devoted to Picasso without the formidable resources of

the library at the École Normale Supérieure in Paris, the prestigious institution in which I lived. I wish to offer my warmest thanks to Emmanuelle Sordet, its director, as well as Danielle Ablin, Sandrine Iraci, and Sofiane Belilita, for their thoughtfulness over the course of my near-daily visits. At the Centre d'Archives en Philosophie, Histoire et Édition des Sciences, thanks to the assistance of Mathias Girel and Nathalie Queyroux, I was allowed to work on rare items that belonged to Georges Canguilhem's library. Once again, at the École Normale Supérieure, I would also like to thank Isabelle Kalinowski of the "Translitterae" project for her judicious advice on the work of Carl Einstein, and Annabelle Milleville for her infallible help with administrative matters. At the Institut d'Histoire Moderne et Contemporaine, I was welcomed with open arms by the entire team, in particular Claire Zalc, again, but also Jean-Luc Chappey and Daniela Caccioferra.

Once it came time to fact-check and solicit critical comments on the manuscript, I turned to officials from the museum world, who proved responsive, empathetic, and very gracious. I am particularly grateful to Jean-Louis Andral, Marga Cortadella, Dorothea Elkon, Brigitte Léal, Sylvia Lorant, Henri Loyrette, Jean-Hubert Martin, James Mayor, Isabelle Monod-Fontaine, Marie-Laure Bernadac, Hélène Klein, and Gérard Régnier, who generously offered their suggestions and comments. Other experts graciously responded to all kinds of queries during the editorial process: Sandra Benadretti, Céline Graziani, and Stéfany Laurent (at the Musée de la Céramique de Vallauris), Sylvie Colomb (at the archives of the Petit Palais), Pilar Ortega (at the Miró estate in Barcelona), Souria Sadekova (at the Pushkin Museum in Moscow), Marie-Amélie Senot (at the LaM Museum in Lille), Eduard Valles (at the Museu Nacional d'Art de Catalunya), Quim et Nouria Vidal (at the Gósol archives), Vérane Tasseau (at the Picasso Administration), Christine Piot, Agnès Magnien (at the archives of the Institut National de l'Audiovisuel), Aude Marchand (at the Musée de Céret), Stéphanie Rivoire (at the Musée des Arts Décoratifs), Michèle Rault (at the municipal archives

of Ivry-sur-Seine, which hosts the Thorez-Vermeersch collection), and Chantal Morelle and Frédéric Fogacci (at the Institut Charles de Gaulle).

In the academic world, many other experts accompanied me on all phases of my journey. Marianne Amar, Barbara Cassin, Myriam Chimènes, Stéphane Courtois, François Croquette, Geneviève Dreyfus-Armand, Didier Francfort, François Hartog, Philippe Joutard, Claire Lévy-Vroelant, Erika Martelli, Gabriel Martinez-Gros, Rachel Mazuy, Isabelle Rabault-Mazières, Peter Read, Mathilde Rivière, Henry Rousso, Marie-Caroline Saglio-Yatzimirsky, Peter Sahlins, Rosanna Warren, Annette Wieviorka, and Sarah Wilson generously volunteered their time to revise the various strata of Picasso's singular corpus.

But there was more to it. Numerous witnesses provided firsthand accounts of Picasso's world—among them Francis Berthier, Dominique Bourgois, Anne Clergue, André-Marc Delocque-Fourcaud, Gilles-Léon Dufour, Françoise Gilot, Georges Helft, Quentin Laurens, Christine Marquet de Vasselot, Nicolas Pignon, Romana Severini, Alessandra Franchina Severini, Martina Brunori Severini, and Pierre Thorez. Collectively, they shared and analyzed their memories of the artist and his circle, and described hitherto unknown moments of his life—clearing the way for my own account, and confirming some of my original intuitions. Many of my friends and relatives, including Frédéric Baleine du Laurens, Irène Bizot, Marc Blondeau, Élisabeth and Jean-Philippe Bouchaud, Colette and Édouard Brézin, Élisabeth Burgos, Laurence Calmels, Connie Caplan, Jerome Charyn, Lyne Cohen-Solal, Élisabeth de Farcy, Victor Halberstadt and Masha Trebukova, Liesl Frank, Jasper Johns, Sabine Mézard, Giorgio Parisi, Fransje van der Waals, and Hala Wardé, read and reread passages of this book; weighed in on my intuitions; provided books, ideas, and psychological support during periods of doubt; and kept the work afloat. Thank you also to the team of assistants and interns—Andrea Delaplace, Diana Murray Watts, Lucia Nino, Violette des Roseaux—who, over the course of their studies,

dedicated weeks of their time to making this project a reality. Thank you as well to those who spent months working alongside me, especially Matthieu Meunier and Gabriel Delattre. And thank you to Alex Prados-Linde for his Catalan genealogy and his postcolonial erudition. I would like to single out, in particular, the affectionate support of those whom I consider my dearest mentors—Pierre Caro, Herman Daled, Daniel Lindenberg, and Raymonde Moulin—who did not live to see the publication of the book. Thanks to my wonderful agent, Catherine Lapautre, who guided this project to a safe harbor, I met Sophie de Closets (CEO at Fayard), who enthusiastically embraced the idea.

Over the course of six years, with sharp wisdom, true elegance, and a little bit of magic, Sophie put the wind in my sails, and, when necessary, righted the ship. She enlisted the help of Anne Gagnant de Weck as research assistant, immediately brought on Philippe Apeloig as designer, and stepped into the museum world by editing the catalog of the exhibition based on this book. In July 2020, during the ordeal of the pandemic, a monthlong intellectual residency at the Fondation des Treilles came as a true gift. There, the librarian Valérie Dubec offered brilliant suggestions and the whole team supported our efforts with unusual alacrity. Together with Sophie, between walks in lavender fields and laps in the swimming pool in front of surrealist sculptures, we were able to complete the editing of the manuscript in the very best possible conditions. My U.S. agents, Georges and Valerie Borchardt, managed the foreign rights beautifully, and organized the book's publication with Farrar, Straus and Giroux. Jonathan Galassi and Ileene Smith welcomed with open arms the American edition of *Picasso the Foreigner*, which began with their generosity in the process of selecting the right translator. Sam Taylor's work on the manuscript was superb: not only did he suggest necessary comments, cuts, and alternatives, but he also found a true voice—for which I am extremely grateful.

Between New York and Paris, joyful encounters with Jonathan and Peter Galassi turned a professional endeavor into magnificent

moments of friendship—museum visits, intellectual exchanges, lunches, dinners, and endless discoveries with our respective intercultural families. In Jonathan's steps, the entire team at Farrar, Straus and Giroux worked for many months with impeccable professionalism and talent to publish this book for American readers. Ian Van Wye was heroic: He offered infinite suggestions and revisions at just the right moments, displaying great erudition, attention to detail, and immense kindness throughout the process. He oversaw countless checks and handled countless questions, despite the frequent changes of direction over the course of the project. Luckily, he was assisted by a crack team: Scott Auerbach, production editor; Nancy Clements, copy editor; Na Kim, jacket designer; Patrice Sheridan, interior designer; Pauline Post, senior manager of subrights; and Daniel del Valle, director of marketing. My special gratitude goes also to Rose Sheehan, associate publicist, with whom it was always a delight to work.

Finally, what to say about my four closest collaborators, Àger Pérez Casanovas, Anne Gagnant de Weck, Elsa Rigaux, and Zoe Fouquoire? Àger brought her Spanish-British philosophical training and her remarkable maturity as a young researcher to bear on this project, offering consistently judicious, sharp, and fecund observations. For her part, thanks to her experience as an anthropologist and her brilliant conceptual work, Anne contributed her insights into cultural pluralism and the culture of expatriates in France in the first half of the twentieth century. Above all, she played, with *maestria*, the indispensable role of sparring partner. As for Elsa, on top of serving as assistant curator, she deciphered documents in numerous archives, suggesting connections and resonances between disparate works. Finally, Zoe appeared with her own armada of talents: political commitment, impeccable erudition, a true cosmopolitan education, colossal curiosity, and dizzying fantasy.

This research took the form of a collective tapestry in which each one played a part: some wove one or many threads, others delicately inserted a new color, some integrated nuances, still others suggested

an unusual pattern. How can I finally account for the patient, critical, and remarkable contribution of Marc, who agreed to spend so many years of our daily life on a cumbersome guest without ever losing his immense admiration for him?

Milan, December 12, 2022

INDEX OF NAMES

INDEX OF WORKS BY PICASSO

INDEX OF WORKS BY OTHER ARTISTS

A Note About the Author

Annie Cohen-Solal is Distinguished Professor at Bocconi University in Milan (Department of Social and Political Sciences). Born in Algiers, she received a PhD from the Sorbonne and developed a joint interest in history and sociology. Her academic career led to appointments at prestigious universities in Berlin, Jerusalem, New York, and Paris. As a writer, she gained international recognition in 1985 with *Sartre: A Life*, which was translated into fifteen languages and was hailed as "monumental" by *Le Monde Diplomatique*. From 1989 to 1993, she served as the cultural counselor to the French embassy in the United States, an experience that prompted her to explore the theme of art and immigration through numerous conferences, articles, and exhibitions, such as *Magiciens de la Terre: Retour sur une Exposition Légendaire* (Musée National d'Art Moderne, Centre Pompidou, Paris, 2014). Among her books in English are *Painting American: The Rise of American Artists, Paris 1867–New York 1948* (Prix Bernier de l'Académie des Beaux-Arts, 2000), *Leo & His Circle: The Life of Leo Castelli* (Prix ArtCurial, 2010), *New York Mid-Century* (with Paul Goldberger and Robert Gottlieb, 2013), and *Mark Rothko: Towards the Light in the Chapel* (2015). *Picasso the Foreigner* was awarded the 2021 Prix Femina Essai; an exhibition of the same name, curated by Cohen-Solal and based on her research for this book, appeared at the Museum of the History of Immigration, in partnership with the Musée National Picasso-Paris (November 2021–February 2022).

A Note About the Translator

Sam Taylor is an award-winning literary translator and novelist. His four novels have been published in ten languages, and he has translated more than sixty books from the French, including Laurent Binet's *HHhH*, Leila Slimani's *The Perfect Nanny*, and Marcel Proust's *The Seventy-Five Folios*. He grew up in England, spent a decade in France, and now lives in the United States.